CRANACH: A FAMILY OF MASTER PAINTERS

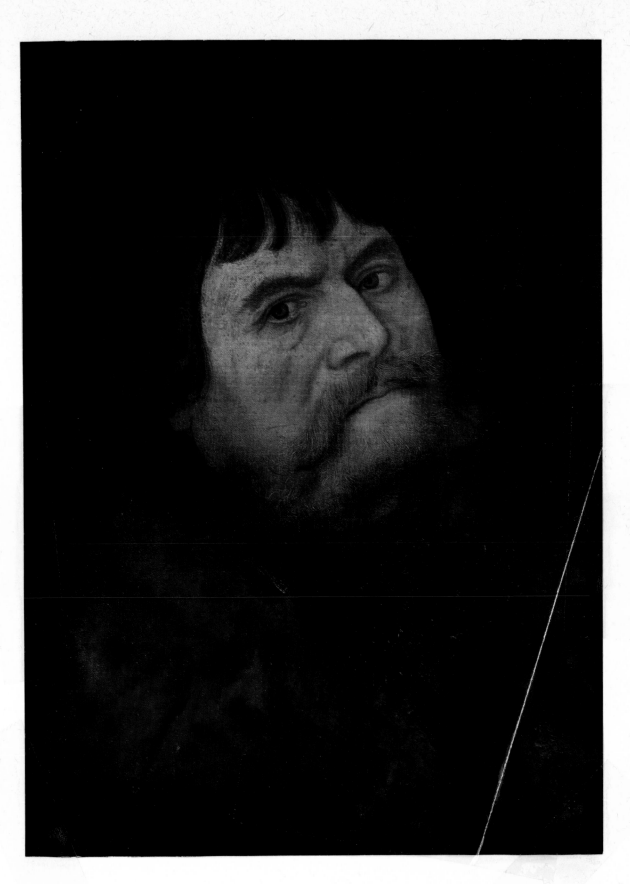

Self-Portrait
Lucas Cranach the Elder.
Circa 1530.
Schloss Stolzenfels,
near Coblenz

Werner Schade

CRANACH

A Family of Master Painters

TRANSLATED BY
HELEN SEBBA

G. P. PUTNAM'S SONS NEW YORK

First American Edition 1980
All rights reserved. This book, or parts thereof,
must not be reproduced in any form without permission.
Originally published in German, 1974, as *Die Malerfamilie Cranach*
by VEB Verlag der Kunst, Dresden, German Democratic Republic
Library of Congress Catalog Card Number: 76-17503
SBN: 399-11831-4
Printed in the German Democratic Republic
by Druckerei Fortschritt Erfurt

❡ CONTENTS

¶ INTRODUCTION

family of painters like the Cranachs can hardly provide a bird's-eye view of German history of the sixteenth century, deeply engaged though they were in its conditions and contradictions. The historical processes of their time were so far-reaching and led to decisions so momentous for Germany's future that a local focus such as the Cranach workshop in Wittenberg could never reflect the whole picture. Although Saxony did not hold a central position in European politics and was not caught up in the great current of consolidation that transformed feudal powers into centralized nations, it did play an outstanding part in the intellectual and cultural changes of the age. The force of the countercurrents produced by these processes contributed to the ferment of social conflict. Toward 1500 the need for change was generally recognized. Incisive actions in the political field shaped a culture rich in ideas and sensibilities – the most impressive witness we have of the revolution within the rising burgher class in Germany.

The artistic achievements of this period are tangible and important. Painting and sculpture, ubiquitous and accessible to all, were the first cultural media to gain a hold on men's minds, soon to be rivaled by the spoken and written word. Speaking of Dürer, Paracelsus said that there are times when heaven literally forces a man into a certain craft. [1] And what an extraordinary leap it was that landed the young artist, headed for the goldsmith's workshop, in the far greener pastures of the painter's studio! The emperor provided for his material needs; the two capitals of Europe, Venice and Antwerp, vied for him. People wanted pictures that would satisfy their heightened awareness of truth, freedom and divine grace. Humanists rhetorically celebrated a brilliant portrait or rendering of nature as something vital to life. For all that, the unpretentiousness of the artists responsible for this genuine new departure kept their creations within modest bounds. The simplicity and terseness of their work are quite different from the more elaborate greatness of later periods. The simplest of the visual arts, drawing, flourished in Germany as never before. And drawings are to the development of the arts what experiments are to the development of the sciences. It would be difficult to find a better example than drawing to illustrate art's new closeness to reality. Its direct descendants, the copperplate engraving and the woodcut, disseminated the new concept. While this new art was, of course, a product of bourgeois activity and emerging capitalism, its influence was not restricted to one social class. The heightened sense of human self-importance it embodied found the greatest response where it was suppressed by the ruling powers: among the peasants and other impoverished segments of society. This was where the secularization of culture and the mythic elevation of the human image in art found understanding and became an effective revolutionary force. [2]

During the reign of Emperor Maximilian I (1493–1519) the problem of shaping a unified German nation supported by the majority of the people did not seem unsolvable. Capitalist evolution, belated but rapid, raised the empire to the status of a great economic power. The economic expansion of flourishing cities, among which Augsburg and Nuremberg were out-

7

standing for their cultural influence as well, accounts for the fact that the differences in their power bases and vital interests were temporarily overlooked. [3] Many of them were dependent on the secular or ecclesiastical rulers within whose territory they were located. And these feudal landlords were not unaffected by change. A few of them were gaining power at the expense of smaller landholders, especially holders of church domains. The latter, being unprotected by fixed laws of succession and subject to the strong influence of the nobility on the cathedral chapters, were at a disadvantage. Historical necessity forced them to ally themselves with great secular powers like the Wettins and Hohenzollerns in central Germany, thus accelerating the process of accumulation of power in the hands of a few.

As an unfortunate result of the election of Charles V as emperor in 1519, the complex developments within Germany were bound up with the interests of the Spanish world empire – a blow which dashed the hopes of the German burghers and their allies in other social classes engaged in the struggle against the power of the feudal lords. The rising of the knights of the empire and the great Peasants' War were desperate attempts to find a last-minute solution. These uprisings originated in two entirely different classes: a doomed nobility and the broad masses of the population, now more bitterly oppressed than ever under the combined feudal and capitalist methods of expansion. Both attempts failed because their allies among the urban middle class, whose support they had counted on, were willing to make their own peace with their traditional exploiters.

Luther's Reformation, open as it was at its inception, was assured of widespread support from all revolutionary quarters, since its theological stand carried over into ethical and consequently social problems. The wide range of its aspirations corresponded at first to the heterogeneous forces which, for different reasons, were ready for action. It survived the suppression of the revolution only by breaking with the insurgents in time – first with the peasants, then with the Anabaptists, among whom revolutionary thinking persisted longest. Nor did it succeed in allying itself with the more pronouncedly Protestant movements of Zwingli and Calvin. Thus, the Lutherans' orthodox rigor cut them off from valuable allies, while their insistence on parliamentary representation (repeatedly upheld by imperial diets) curtailed their freedom of action. In this way the emerging Lutheran Church came to be a prop of princely power in the Protestant regions, while fear of it served to strengthen territorial power in the Catholic parts of Germany.

The frequent absence of the new emperor during the decisive years gave the secular princes a free hand, and they were able to turn the defeat of all the revolutionary classes to their own advantage. Church domains and certain indispensable elements of middle-class thought and culture became keystones in the structure of absolutist feudal territorial rule erected by the secular princes – a structure which was to remain dominant for centuries. Within this framework, middle-class action and thinking were largely preserved. What vanished was the conviction of acting in the name of humanity in general – of men whose work was indispensable but who had been excluded from all political processes. The idea of one great human community, from which the blossoming of individual creativity in the Renaissance had stemmed, collapsed. Only long and difficult developments would bring it back to life in Germany.

Cranach's masters, the electors of Saxony, were among the most powerful princes of the

empire. Their vast domain, weakened by the dynastic split into two branches, included the newly exploited silver mines in the Erzgebirge, a rich source of income. Elector Frederick the Wise was an esteemed confidant of Emperor Maximilian. Besides being a patron of Cranach, he promoted outstanding artists like Dürer and Burgkmair and invited the Italian Barbari to his court, where Greek and Roman coins were collected and humanist ideas exchanged. Though Frederick himself was a devout adherent of the Roman Church and its ways, his attitude to the Pope was free and independent. For example, he neglected to secure the obligatory papal permission for founding the University of Wittenberg until several years after it had opened. This university was an institution of humanist learning modeled on the University of Vienna, of which the emperor was a patron. Maintenance of order in the electorate depended on a supply of well-trained jurists, physicians, natural scientists, theologians and administrators and of good linguists to assist them. As a professor at the University of Wittenberg Martin Luther gained a public forum. The university's protection of the man whom the Pope and emperor had condemned became a matter of self-defense when the neighboring universities of Frankfurt-an-der-Oder, Leipzig, Erfurt and Ingolstadt rose to the attack. It should be noted here that the two rulers of the Wettin dynasty, the Ernestine branch in the part of the electorate centered in Wittenberg and Torgau and in Thuringia and Coburg and the Albertine branch in Meissen, necessarily took opposing stands on the Reformation for several decades. Except for putting down the peasants' revolt in Thuringia, the two branches never acted together on any matter of importance. In the princely alliances which were formed later, chiefly at the instigation of the king of France, the Albertines and Ernestines rarely took the same side. The Albertines, most of whom were allied with the emperor, in effect laid claim to the electoral title when the imperial court was considering taking it away from the Ernestines because of their inflexible stand on Luther. The period between the end of the Peasants' War and the outbreak of the war against the League of Schmalkalden saw countless attempts to avert the danger by negotiations and pacts and even by means of limited military campaigns like the one against the Catholic duke of Brunswick at Wolfenbüttel. Negotiations by the theologians, such as the Marburg Conference of 1529, served the same purpose. When the League of Schmalkalden was founded in 1531, the danger of a decisive military confrontation was imminent. It did not break out until after Luther's death, bringing defeat and imprisonment to Elector John Frederick, while Duke Maurice of the Albertine line was rewarded with the electoral title and vast additional lands. With the change of rulers, the very existence of the University of Wittenberg was endangered. Some supporters of the former ruling house followed the Ernestines to Thuringia; they included the family of Chancellor Brück but – interestingly enough – not the Cranachs. The new elector, recognizing the advantages to be gained by upholding the University of Wittenberg, managed to prevent all but a handful of its faculty from moving to the rival university of the Ernestines in Jena. The interest the rulers of both branches of the family took in their universities shows the importance of humanist educational institutions in territorial struggles as late as the middle of the sixteenth century. For domestic as well as foreign reasons, both the Albertines and the Ernestines wanted to be recognized as the sole rightful heirs of the Lutheran Reformation. For similar reasons the heads of both branches vied openly for the Cranach workshop in Wittenberg. After three years of hesitation the Cranachs found a way of

satisfying both sides: Cranach the Elder, now an old man, more or less retired, followed his old master into captivity and later to Weimar, while his son accepted commissions from the Dresden court. [4]

Both the Cranachs are commonly classified as "painters of the Reformation," but this description needs qualifying. If we look more closely at the dates of execution of the works, the proportion done by the masters' own hands and any discernible motivations on the part of the patron who commissioned them, we find little to go on. A better grasp of the Cranachs' work in its entirety can be derived from the ideas expressed in the works commissioned by the princely courts of central Germany and the lesser nobility and middle-class families under their rule.

The needs of the court were modest and consisted chiefly of decorative works to ornament their castles and palaces. The princes wanted "works of art not as collectors' items but as ornaments, always in the service of some specific function." [5] Many unusual features in the Cranachs' work are explained when we realize that to look at and evaluate art as a collector's object (with all the advantages of connoisseurship this entails) is to see something different from what its original commissioner had in mind. While the age appreciated the value of work done by the hand of the master himself, the successful decoration of a room or even a book was more important than the artist who executed it. Wall paintings, small painted canvases and tapestries made to an artist's design were highly prized. Since works of this type have not survived, we see only their negative effects on the artists' œuvre: the frequent schematic repetitions in easel paintings, the lack of interest in drawing and, to some extent, in woodcuts and etchings, too. Scope for artistic innovation was therefore limited.

The portrait and the landscape, two genres for which both Cranachs were brilliantly equipped, never developed autonomously. Dürer's method of composition and measurement had some practical influence but little lasting effect. Playful exploitation of the possibilities of unhampered experimentation flourished within given limits – probably along with an awareness of the precariousness of this game. Latitude, without sufficient ties to reality, made it easy to put all acquired skills to use but discouraged the replenishment of depleted reserves through continuing study. This probably explains some startlingly "modern" features in the Cranachs' work: the strongly formalized composition; the filling up of the picture space with stereotyped theatrical scenery and its autonomous proliferation. There is an element of truth in the poet Johann Stigel's description of Cranach, lost in thought, painting yews instead of shade trees and cypresses instead of apple trees, [6] because it seems to explain certain forms which can have been inspired only by spontaneous random images – threatening or grimacing faces produced by a feeling of oppression.

Middle-class experience and a humanist self-esteem accommodated themselves to the requirements of the court but in doing so produced an ambiguous culture. The naked figures of biblical and classical heroines, goddesses and gods done toward 1530 are unlike the early ones inspired by humanist exaltation. It is true, of course, that middle-class ideas stemming from the Anabaptist movement are still to be found in the court works. The free erotic behavior of one of its sects, the "Garden Brothers," seems to be reflected in the "Gardens of Love" that Cranach painted around 1530. The complex erotic mood that persisted for several years

can certainly not be ascribed to court life in general. Dates on the paintings limit the period significantly. The break with humanist themes is completed, and temporarily unusable forms are discarded, as the painter is trained in the culture of the court. Cranach's wisdom lay in being able to adjust to such changing demands without being hurt by the constant shifts of position.

Similar observations can be made about the work of Cranach the Younger. Being later in time, it shows up certain characteristics more clearly. The absence of etchings and the small number of woodcuts, the abandonment of classical themes and the limited range of Protestant ones indicate a different type of demand as well as a different temperament. Cranach the Younger was not actually a court painter, but he relied far more than his father did on commissions from the princely courts of central Germany. When the economic situation was bad, he was forced into political speculations that endangered his existence. The reputation of the Wittenberg workshop as a training school for future court painters like Königswieser, Gaulrap and Wehme was unchallenged. The training it offered in portrait painting was the best to be had in Saxony. The great achievement of Cranach the Younger is to have made the portrait a vigorously effective genre in a disillusioned age. The portrait, the landscape and the still life were not yet recognized as proper subjects of pictures by a society which took its cue from the princes. The dream of an incipient golden age, which had filled men's minds at the beginning of the sixteenth century, had vanished but lived on as a memory. Evocations of the past, which had formerly looked toward the order of things to come, [7] became merely a source of reassurance in a present robbed of one of its motive forces.

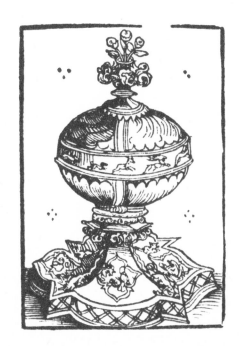

Reliquary.
Woodcut from the
Wittenberg
Heiltumsbuch.
1509

eldom has an artist family developed as productively as the Cranachs in the sixteenth century. Four succeeding generations spanned a period of more than a hundred years. Their century – all but the last five years of it – was permeated by their activity, although the figure of Augustin Cranach, who died in 1595, fades out in shadowy mediocrity. To endure like this in an age of decisive change required flexibility and a certain measure of material security. The family's work under the sign of the winged serpent was not entirely a spontaneous blossoming of artistic talent. What Goethe said of Dürer – that the excellent artist can only be fully explained from within himself [8] – does not help much here, even though we seem to be dealing with independent achievements. External forces seem always to have played a big part; they can be properly understood only through a thorough scrutiny of contemporary conditions. From time to time it becomes clear that great intellectual flexibility entails the risk of succumbing to the demands of the outside world.

The origins of the Cranach family are obscure. Even its name is uncertain. It may originally have been called Sunder [9] (Sinner) – which would explain the uncertainty. A name like that, commemorating some act of violence, would have been a stigma to be shaken off at the first opportunity. [10] Some records give the name of Lucas Cranach's father as Hans Maler (Hans the Painter). He had moved to Kronach, probably from the Bavarian dialect area. [11] Since we are told that he himself instructed Lucas, he must have been an artist; possibly he made the drawings for woodcuts. It would be interesting to know how he came by enough commissions to feed his family and acquire an imposing house on the Marktplatz. [12] The excellent location of this property indicates a self-esteem and a concern for social status that are confirmed by houses owned later by the Cranachs in Wittenberg, Gotha and Coburg. [13]

Page 417

Page 418

The town of Kronach in Upper Franconia looks like, and is, a fortified place of refuge. The great Rosenberg Fortress, probably the original nucleus of the settlement, made it an important stronghold in the defense of the Saxon border. Small even by contemporary standards, Kronach belonged to the domain of the bishops of Bamberg; it was its third most important town, after Bamberg and Forschheim. [14] Hans Maler's patrons were most likely the episcopal landholders, one of whom was later a patron of Dürer. Bamberg was of some importance in the early days of book printing; it was here, in 1461 and 1462, that Albrecht Pfister published the first books illustrated with woodcuts.

Lucas Cranach's mother, Barbara, who died by 1495, had several children. Two sons and three daughters survived her. Other children – and possibly the mother, too – died in an epidemic. [15] Lucas was born in 1472; the exact date is not known. If the inscription on the well-known Florence portrait is accurate in regard to the date when he left Wittenberg, it must have been between July and mid-October. [16] After the death of his mother Lucas seems to have acted as a kind of guardian to his brothers and sisters. He was the eldest and had to help his father support the family. This would explain why he remained in his hometown for ten years after completing his training. There are records of various misfortunes

which must have put a strain on the family. A sister-in-law who took charge of the household after the death of the mother also died. [17] A dispute over a legacy in 1492, slander suits brought against a neighbor family in 1495 and 1498 and a suit filed in Coburg in 1501 for recovery of a debt [18] suggest straitened circumstances and offer evidence of passionate distortions of character in both father and son. [19] It was during these years that Lucas acquired an aptitude for winning lawsuits.

His Kronach period includes a documented absence in 1498 and commissions in nearby Coburg after 1500. The report that he participated in a pilgrimage to the Holy Land in 1493, once regarded as apocryphal, may have some basis in fact. [20] The pilgrimage was organized by Elector Frederick of Saxony and his uncle Duke Christopher of Bavaria, and the young painter may well have been a member of their retinue, although it already included two of his artist colleagues. (Unfortunately documentation concerning the retinue is incomplete. [21]) He might also have gone as a personal aide to Duke Christopher, who died of fever in Rhodes on the way home. Duke Christopher is known to have been a patron of artists. [22] The journey, which lasted eight months, would have taken Cranach to Venice, the Mediterranean and the Holy Land – rich experience for a young man – and put him on close terms with the elector. His works offer no conclusive evidence that he made such a journey; the later woodcut depicting a map of the Holy Land was not necessarily based on personal impressions. [23] If he did indeed go, he must have achieved some measure of fame at a very early age, making it difficult to explain his return to Kronach.

What he actually did in Kronach we do not know. Perhaps he collaborated with his father in some way, as his brother Matthes seems to have done later. Tradition says that he learned painting from his father. [24] Hans Maler may indeed have done woodcut drawings, but evidence to this effect is almost impossible to pursue because such work was usually anonymous. [25]

Kronach was situated in the region of Franconia where art flourished, making its influence felt from Nuremberg to Saxony. [26] Cranach must have known the Katzheimers, the Bamberg painters to whom we owe the earliest extant landscapes with buildings. Cranach, too, had a talent for this genre, as later experiments would show. As a copperplate engraver he was indebted to Lorenz Katzheimer, the strongest personality in the family, who signed himself with the monogram L Cm. [27] Although it was 1509 or possibly later before Cranach produced his famous works in this medium, Cranach shares Katzheimer's painterly conception of the engraving; they have the same vitality, stemming from the speed at which they worked. It is remarkable that Dürer's goldsmith's dexterity in engraving never influenced Cranach, and this may be further evidence that Katzheimer was his model in his early, formative years. In painting and woodcut drawing, however, Dürer influenced him tremendously in a way that suggests that Cranach was familiar with the master's workshop in Nuremberg. [28]

Lucas must certainly have done some independent work during his Kronach years. A woodcut of Christ on the cross between St. Mary and St. John may date back to this period. This is a liturgical picture, a prayer in visual form to be inserted in the missals that individual dioceses issued for use in church services. [29] It has several novel features: the landscape, the cloudy sky, the use of trailing drapery to tie the composition together. The motif of St. John's

Plate 2

Page 422

13

robe being blown around the base of the cross by a gust of wind is very powerful. One imperfection of this work is that the drawing is poorly adapted to the woodcut medium. Four prints of this work exist, all colored, most of them on parchment. [30] One was still serving its original purpose: sometime before 1504 it had been pasted into the *Missale Cracowiense*, printed in 1494 or 1495 by the Nuremberg firm of Georg Stuch, to replace an older, less expressive woodcut. [31] This suggests an early link with Nuremberg, especially since Cranach was working for the Stuch publishing house in 1508.

❡ CRANACH AND DÜRER

Page 415

We have no evidence of Cranach's having spent any time in Nuremberg before 1505. The earliest documentation of a face-to-face meeting with Dürer is the signed portrait of Cranach that Dürer made in 1524. [32] Although Cranach is not mentioned in any of Dürer's observations that have come down to us and the few surviving letters of Cranach make no reference to Dürer, they probably knew each other in the early years. They had so many mutual acquaintances that their paths were bound to have crossed sometime, but even though the circumstances were favorable, they never became friends. These two great masters, so close in age, maintained a certain distance – probably a good thing for the lively, outgoing Cranach.

At a very early stage Cranach was deeply impressed by Dürer's great woodcuts and made a determined effort to get down to the fundamentals of some of his engravings and paintings – a confrontation which sometimes amounted almost to a bitter, if unacknowledged, contest. He avoided copying or extensive borrowing; in later instances where this did occur, it was attributable to explicit demands by his client. [33] Cranach's response to Dürer is most immediately obvious in his large formats and in the broad conception of some of his woodcuts. Here he was on unfamiliar ground and was forced to adopt some of Dürer's motifs. This led to rivalry between the two for pictorial effect – a rivalry which Cranach was well able to handle. He never succeeded in basing his work, as Dürer did, on honestly acquired experience, and his almost illusionist talent for realistic reproduction was an obstacle to deeper study. Apart from Dürer's theoretical preoccupations, which must have been foreign to Cranach, [34] their different approaches to drawing and etching, two media in which Dürer excelled, are very conspicuous. Many of the references in Dürer's writings to the lack of discipline and inadequate training of German painters might be applied to Cranach, [35] who always showed a distinct aversion to theoretical perspective.

Dürer's contribution to the development of the new visual world of art was incomparably greater, not only because of the significance of his pictures but also because they were widely

distributed in the form of technically perfect prints. His work was ubiquitous, surpassing even the works of Leonardo da Vinci, Michelangelo or Raphael in influence. [36] Melanchthon, who lived in Wittenberg at the same time as Cranach, saw Dürer as one of those personalities whose artistic talents constitute only one part of their tremendous creativity. [37] He was the first to compare Dürer, Cranach and Grünewald. Using the categories of classical rhetoric, he called Cranach the master of the low style, Dürer and Grünewald representatives of the high and middle styles, [38] an evaluation which certainly takes into account Cranach's gift for all that is simple and striking in the popular sense. He shows us creatures of startling singularity performing actions that might come out of some folk song. Judging by the praise of his humanist admirers, his paintings must have had a powerful impact.

Cranach's earliest extant works already show traces of his confrontation with Dürer. Dürer's great woodcuts of the *Apocalypse* and the *Large Passion* series, the single prints of Samson and the lion, the Holy Family with the hares, the martyrdom of St. Catherine and St. Sebastian on his column, as well as the engraving of St. Jerome in the wilderness, all done between 1496 and 1499, left their mark on woodcuts and paintings by Cranach. Interestingly enough, Cranach's confrontation with Dürer was resolved in Vienna, where Cranach worked in 1502 and 1503 and where he apparently found the stimulus that enabled him to assimilate Dürer's pictures and master them in his own way.

Thanks to the patronage of Emperor Maximilian I, Vienna was the most popular university city in Germany at the beginning of the sixteenth century. Konrad Celtis referred to it as "the biggest and most beautiful city, which I can justifiably call the Eye of Germany." [39] Celtis was nominated as poet laureate by Frederick of Saxony and crowned by the emperor in 1487. In 1497 he was appointed to the University of Vienna. Cranach became a member of his circle, possibly on the recommendation of the elector of Saxony, for whom he had still been working in Coburg in 1501. Lucas painted a portrait of Johannes Cuspinian, Celtis' deputy on the newly established faculty, and made woodcuts for Johannes Winterburger, the Viennese printer patronized by Celtis and Cuspinian.

He soon found admirers. The truth of Celtis' lines was brought home to him: "Just as manure gives the farmland strength for a bountiful harvest, generous yields of grain pay back the laborer's toil. Praise gives a lift to man's spirit. Noble minds are rewarded. Often a sentence of praise animates work still ahead." [40] Cranach's talent was so sensational that seven years later in Wittenberg Scheurl was still talking about the fame one of his Austrian works had won. [41]

The works known to have been done in Vienna are few: the woodcut decorations for the Passau Missal, completed in 1503 but begun in 1502; the twin portraits of Cuspinian and his wife, undated but probably done in late 1502 or early 1503. A documented illness proves that Cranach was living in Vienna in 1502.[42] Two other works dated 1502, a woodcut Crucifixion and the painting of St. Jerome as a penitent, must therefore have been done in Vienna. All these works mark peaks of achievement. Others lead up to them: the Crucifixion from the Schottenstift in Vienna and the rare woodcut of the same subject, which probably represents Cranach's first attempt to master the large format used by Dürer. Still others succeeded them: the woodcut of the Agony in the Garden and another pair of portraits on folding panels, done

in 1503, this time of an old scholar and his wife. This marks the end of Cranach's Vienna period.

Plate 1 The most traditional of these works is the Schottenstift *Crucifixion* [43], a small painting, compressed but strong in feeling. The composition of the group of mourners and the pose of one of the thieves are reminiscent of Dürer. [44] Variety runs rampant. One of the most extraordinary figures is the peasant on the margin of the picture gazing up at Christ, hands clasped. His gaze is the dominant motif. This work is prophetic, full of tacit presentiment. The strong colors and expressive faces make it easier to overlook the flatness of the figures.

Plate 3 In the woodcut version of the Crucifixion Cranach tried to organize this world of pictorial forms in a taut composition comparable to that of Dürer's great woodcuts. [45] Bright regional costumes and simple, forceful gestures no longer hold the stage. The bold format – a full-sized sheet – encourages unified composition. The individual motifs are closely integrated, unlike those in the painting. The exaggerated poses of the thieves can be traced through later variations to their culmination in a pair of drawings. [46] These outward transpositions foreshadow the perfected versions still to come.

Page 17 The figures in the two major woodcuts in the *Missale Pataviense* of 1503 (probably executed in 1502) are largely conceived. The figures stand out indistinctly against the quiet landscape of this canonical Crucifixion. [47] The figure of the Virgin is again taken from Dürer. [48] Still-life characteristics appear; the carefully executed grain of the wood of the cross reminds us of Cranach's later *Flasern* woodcuts imitating grained wood. [49] A single figure may be framed, *Plate 7* as St. Stephen is, in an exuberant decorative border. [50] Sinister creatures crowd around him, held in check by cherub musicians perched in the trees.

At this time Cranach began a series of woodcuts depicting the Passion of Christ, which would certainly have ranked him with Dürer. Only two were completed: the *Agony in the Gar-* *Plates 4, 5* *den* [51] and the *Crucifixion*. [52] None of the great single woodcuts of Cranach's early years seems to have been printed in large editions; one or two prints of each are all that survive. The "Passion" series was so important to Cranach that he abandoned his anonymity and signed the "Crucifixion" with his mark. This was a workshop mark of the type used by many craftsmen. Cranach's was a zigzag line with a cross resting on the base of the triangle enclosed by its first apex. [53] The 1502 *Crucifixion* and the *Agony in the Garden* are indebted to the corresponding prints in Dürer's *Large Passion*, which had appeared four or five years earlier. [54] Other borrowings, such as the rugged cliff on the Mount of Olives and the kneeling woman in the *Cruci-fixion*, show that Cranach was well acquainted with Dürer's work. [55] His own contribution consisted in integrating the happenings more closely with the contours of the landscape. A typical touch is the slanting tree trunk in the *Agony in the Garden*, which leads the eye into the picture – a device Cranach used in many of his works. [56] The same sort of border that encloses St. Stephen appears again here, slightly skewed for stronger spatial effect. The central figure, the kneeling, quaking Christ, is seen from an individual perspective, slightly from behind. Pictures of this kind required the active approach that was coming into style at this time, which appealed to the wide audience reached by woodcuts.

Plate 8 The Vienna painting of *St. Jerome in Penitence*, done in 1502, is of the same type. [57] Here again a great etching by Dürer, made about 1496, served as a model; Cranach, a born animal painter, [58] even borrowed the lion's face from it. His painting, however, makes a more vehe-

ment statement. The figure of the saint is the focus of the high-pitched emotion, while the landscape serenely unfolds behind three columnlike trees. St. Jerome, who recommended the study of classical authors, was the patron saint of humanist scholars, one of whom [59] must have commissioned this medium-sized painting. This is confirmed by the owl and parrot in the tree – symbols in a language of imagery which the scholars would understand.

In Vienna Cranach encountered in Johannes Cuspinian a man of flexible mind who knew how to use his gifts to attain an influential position. His swift rise offers a parallel to Cranach's career; the two men were the same age, came from similar backgrounds and were equally adaptable. Cuspinian studied in Leipzig, was crowned poet laureate in 1493 and served as rector of

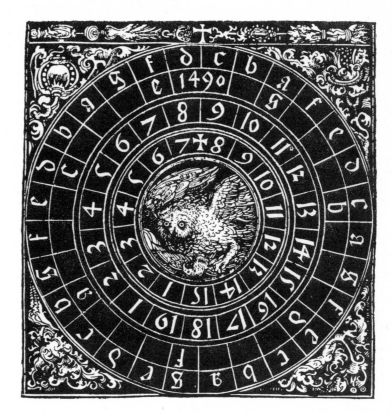

Chart for determining Sunday letters. Woodcut from the Pataviense Missal. 1503

the University of Vienna from 1500 to 1501, when the emperor, as territorial ruler of Austria, delegated him to supervise the university. In 1501 and 1502 he served as dean of the faculty of medicine. As a confidant of the emperor he was awarded a patent of nobility in 1506, represented the empire on important missions and became one of the earliest German historians. [60] Cranach got to know Cuspinian before the poet-physician embarked on his diplomatic career. In the autumn of 1502 or shortly thereafter he painted the wedding portraits of Cuspinian and his wife, Anna, daughter of an imperial official. The portraits are on twin folding panels, linked by a continuous landscape background. [61] The technical problem was not new, and Cranach did not invent the solution. What is astounding is the sparkling richness the master achieved in responding so wholeheartedly to the wishes of his humanist client. This double portrait represents one of the rare cases where client and artist saw eye to eye. The mas-

Plates 12, 13

17

terful creative treatment of all the manifold relationships implicit in the subject is unmatched in contemporary art north of the Alps. [62] The man looking upward with a presentiment of things to come and the woman waiting with an inborn sense of security are unmistakably linked by the trees that frame them, recalling the woodcut of St. Stephen. By any possible interpretation, the twin pictures represent a "cosmography" in the humanists' sense of that term, [63] which they used as a catchall to denote the quest for universal knowledge, including the prescientific observations of the time. In this sense a sentence Cuspinian wrote to the Venetian humanist Aldus Manutius in 1502 – "My spirit burns for cosmography" *(meus æstuat animus in cosmographia)* – might also be applied to Cranach's panels. [64] Cuspinian had in mind the interrelatedness of all the phenomena of this world; this was also the subject, in a more extreme form, of the alchemist's speculations. [65]

Cuspinian himself once used the image of the painter who can describe the whole world in a tiny picture. [66] The background of these two portraits contains representations of the four elements, standing for wholeness. The earth and the air are the principal components of the landscape; the water and the fire are fraught with meaning. The birds that are singled out for individual treatment – the owl, falcon, heron and parrot – may also allude to the elements. [67] The sun and the moon, embodying the male and female principles in the world, seem to be opposed, as has recently been confirmed by the discovery of the figure of the black sun-god Apollo immediately adjacent to Cuspinian. [68] The water seems to represent renewal, under the sway of Diana, the moon goddess – an interpretation which anticipates some of Cranach's later themes. [69] These statements in a symbolic language which would be understood by initiates serve to relate what might have seemed purely individual portraits to a specific social nexus and to connect them with the community of humanist burghers that extended throughout Europe. [70] The closeness of medicine and alchemy in those days may well have made Cuspinian familiar with this language. [71]

The important point is that Cranach not only gained entry into this world on the intellectual level but was able to make it his own. Only this can explain the forceful conception of the portraits, which carries through even to the coordination of the colors. The panels are described as making a bright and clear, yet at the same time mysteriously dark impression [72] – something that might be said of all of Cranach's early works. They are pervaded by a springlike mood, full of strong contrasts. The faces of Cuspinian, St. Jerome, St. Peter in the *Agony in the Garden* and St. John in the Schottenstift *Crucifixion* are all raised obliquely. These are the faces of thinkers with a sense of great impending events, explorers of unknown connections. At this point in his career Cranach identified with them completely. He must have been actively involved with the humanists in Vienna, all of whom were more excited by presentiments of a new era than by specific knowledge. To them he owed commissions and his growing reputation. It tells us a good deal about Cranach and his admirers that one of his more memorable achievements was to have painted grapes on a plate realistically enough to deceive a passing bird. [73] The humanists, of course, were delighted by the incident because it recalled the similar legend about Parrhasius. [74] The intellectual stimulus Cranach found in Vienna must have been similar in many respects to what he had experienced in the youthful university city of Wittenberg. His stay in the Austrian capital was an important preparation for his later work.

He did not remain long in Vienna. The traces of his works lead up the Danube to Bavaria, not back to his native Franconia. We do not know where the major works of 1503 and 1504 were done. They all are paintings; Cranach seems to have turned away from the woodcut for a time after leaving Vienna. The two paintings of 1503 – twin portraits of a scholar and his wife in Nuremberg [75] and Berlin-Dahlem [76] – and the Munich *Mourners at the Cross* [77] have more tranquillity and greatness. The low horizon strengthens the unfolding of the spatial background. Because there are fewer individual motifs, the statement is more concise and the mood somewhat cooler. This constitutes the major difference between these portraits (tentatively identified as Johann Stephan Reuss and his wife) and those of the Cuspinians, to which they are otherwise very close. Here Cranach was in a more sober mood. He had responded much more strongly to the intuitive expectancy of a young man of his own age than to the mature detachment of a jurist more than ten years older than himself. [78] The execution seems summary and more rectilinear, and for this reason the black brush strokes and the organization of the trees that frame the couple – springing nonchalantly from their shoulders – are more noticeable. The tree to the left of the woman gains prominence from the weakening of the tree framework. Cranach did not economize on studies for these panels. The hands look far more flexible, more portraitlike – if this expression can ever be applied to his hands. The colors are more subdued than those in the Cuspinian portraits, and the figural treatment is more straightforward. The figures themselves look simpler but seem to possess a secret vital strength surpassing that of their predecessor. Cranach had an extraordinary ability to give apparently artless figures a staggering degree of reality; this must have been one reason for his success as a portraitist. The difference between the two pairs of portraits is probably explained by Cranach's having turned again toward Dürer, although Dürer's portrait of a young man (Anton Neubauer?) which is closest to Cranach's portrait of the jurist is of doubtful authenticity. [79] The 1503 portraits mark Cranach's descent from wild forest landscapes peopled with mysteriously related creatures into the brighter, more sober plain. Although they were probably painted in Vienna, they suggest a fresh encounter with Nuremberg, the home of Dürer.

Plates 14, 15

It was at this time of impending change that Cranach painted his great scene of human leave-taking: the Munich *Mourners at the Cross*. [80] This painting has been praised as an important innovative work. For people of the Middle Ages, hope and suffering, life and death were visibly embodied in the image of the crucified Christ who died for all mankind. Christ on the cross, flanked by the Virgin and St. John, was the most sublime pictorial expression of this concept. Dürer in his woodcut introduced a change, [81] angling the cross slightly and the figure of the apostle more sharply, so that the eye was more strongly drawn toward the Virgin. In developing this idea in his Wittenberg painting of the *Seven Sorrows of the Virgin*, Dürer had placed the cross obliquely. [82] Cranach seems to have taken this as his point of departure. His cross appears in profile on the right; the two mourners stand in front of it, between the thieves' crosses. This is a place of execution, with streaming blood and horribly mutilated bodies. The dead Christ hangs above a landscape covered by spring floods; a network of bare branches stands out against a bank of storm clouds. These two powerful statements are linked together. The end of the loincloth billows like a cloud in the sky. Elements reminiscent of the folk song combine with the startling size and monumentality of the two principal figures. The towering figure of

Plate 17

Page 422

Plate 16

St. John probably derives from a North Italian model, through some unknown chain of transmission. [83] Cranach's Munich painting might be called a powerful earthly counterpart of Dürer's little panel of the dying Christ. [84] In Dürer everything points toward eternity; in Cranach, toward the bitter experience of reality. How far Cranach has come in the scant two years since he painted the Schottenstift *Crucifixion!* However much encouragement he may have received from the humanists, such progress could have been achieved only through his confrontation with Dürer. By 1503 Cranach had overcome his initial resistance and successfully assimilated the impact of Dürer's work.

*Plates 9, 10, 11*The great *Mourners at the Cross* was preceded by two panels now in the Vienna Academy: a St. Valentine with kneeling donor [85] and a St. Francis. [86] These are unresolved figures, ponderously filling the picture space – perhaps Cranach's first large-scale figures. The two pictures seem to be related by their strong contrast: the silent, looming saint in the rich red robes of a bishop and the gray friar, whose vigorous gesture becomes part of the tension of the tree *Plate 10*boldly arching across the picture plane. The figure of St. Francis was obviously taken from a North Italian model, [87] perhaps a Venetian painting that had caught Cranach's eye, although the Italian influence may just as well have been transmitted through other German paintings.

Cranach's paintings of 1502 and 1503 have a certain unity of color based on strong, simply contrasted tones. Red predominates, combined with black, gold, dark blue or a yellowish white. The background landscape, present in all the pictures, strikes the resonant chord of green and blue. In the St. Valentine unusual colors like yellow and violet are confined to minor details. The choice of colors is simpler, more compelling and passionate than in contemporary works by other German masters. [88] From this aspect, too, Cranach's works are very unified in feeling.

*Plate 21*The Berlin-Dahlem Holy Family of 1504, [89] one of Cranach's richest and most beautiful pictures, is similar in color. All the forms are joyful and light: the Virgin enclosed in the shell-like form of her red dress; the row of curly-headed angels leading the eye diagonally across the picture to the Holy Child; St. Joseph leaning against the fig tree, keeping the exuberant activity within bounds. The picture was inspired by Dürer's woodcut of the *Holy Family with Three Hares* made between 1496 and 1497, [90] as is evident from details such as the way Joseph is holding his staff and hat or the way the child stands on his mother's knee. So far as possible Cranach avoided direct borrowings. [91] He has departed from the popular motif of the Madonna seated on a grassy bench. The sense of security imparted by the enclosure, the nearby dwelling, the jewelry and book and the household pet – attributes of settled domesticity – is *Plate 20*missing, too. A rock spring replaces the well. A band of angels, the older ones dressed in costly robes, bring food and drink, music and entertainment, making one forget the poverty of the family. The darkness of the sky at the top of the picture and the little angel asleep by the spring are similar in conception to the early-morning scene in the *Flight into Egypt*, [92] although the attribute of the donkey is missing. The thistle, pushing up into the picture from outside, strikes an ominous note. Plants used in folk medicine, including the humble fumitory, [93] lend their benign presence. Cranach must have been aware that this painting was an extraordinary achievement; besides showing the date on a little cloth draped over a wet stone in the pool, he added his monogram next to it. These signatures on transparent wet cloth are excellent examples of

his bold use of illusionist details. The artist's monogram, composed of an interlinked L and C, shows that in 1504 Lucas had adopted as his last name the name of the town where he was born – an indication that he had no intention of returning and was about to settle down somewhere else.

Pages 420–421

The drawing of St. Martin and the beggar was done during the same year (1504). [94] It is somewhat overelaborate in execution, with white highlights on a bluish ground; the format is too small to permit full development of the serenity and freshness that characterize the Berlin painting. This represents Cranach's only attempt to create a drawing as self-contained as a painting. Perhaps taking this as his point of departure, the Regensburg painter Albrecht Altdorfer perfected the painterly chiaroscuro drawing. Cranach rarely worked in this genre again; when he did, he treated it very freely. [95] Even in 1508, however, the idea of chiaroscuro drawing was still so important to him that he developed the tone woodcut, though here again he left the exploitation of his invention to others.

Plate 23

Plate 22

The fact that the 1504 drawing comes from the monastery at Prüfening may indicate that Cranach spent some time in Regensburg. His early biographer states that he entered the service of Frederick the Wise, elector of Saxony, in 1504, after the Bavarian War. If the two events are connected by anything more than coincidence, then Cranach's career must have reached a turning point in Bavaria. [96] The war (which was fought for possession of part of Bavaria) was ended when Emperor Maximilian intervened and defeated the Bohemian auxiliaries of Count Palatine Rupert near Regensburg in September, 1504. The victory was celebrated in a woodcut and in a poem by Celtis. It was at this point that Cranach entered the service of the elector of Saxony, but nothing is known about the circumstances of his appointment.

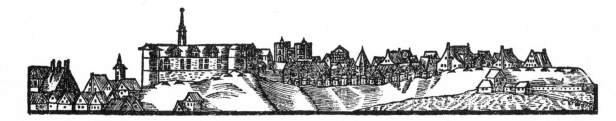

Monogrammist MS:
View of Wittenberg.
1551. Woodcut

⁋ THE EARLY YEARS
AT THE COURT OF SAXONY

Cranach's acquaintance with Elector Frederick the Wise may have gone back as far as 1493. He had worked for the Wettin family in Coburg as early as 1501. Ever since his stay in Vienna he had been highly regarded in the humanist circles the elector frequented, and he was by no means unknown in the land of Frederick's relatives the dukes of Bavaria. The elector took a particular interest in the teaching Monastery of All Saints in Wittenberg, which lent its support to the new university founded there in 1502 to promote, on the territorial level, the hu-

21

manist studies the emperor was trying to encourage. [97] The university was also intended to serve the important practical purpose of turning out good theologians, jurists and physicians at home. Ancient statutes stipulated that a university must have its own painters, who were responsible for decorating manuscripts. [98] Cranach was not a university painter in this narrow sense, although he did work for the university – perhaps in his capacity as court painter.

The seat of the electors was a treasure house of the visual arts. Its church and castle housed

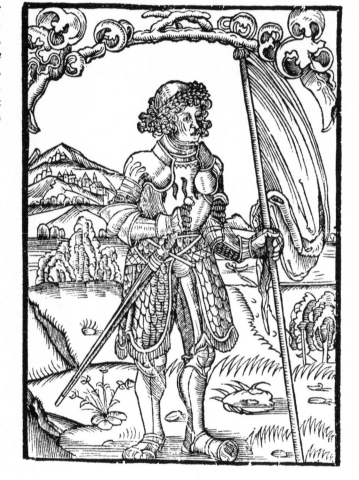

After Cranach:
Standing Knight.
Title page to Luther,
*An den Christlichen
Adel deutscher Nation*,
Leipzig. 1520.
Woodcut
(cf. Plate 28)

the most impressive collection of German painting and sculpture to be found anywhere at the beginning of the sixteenth century. [99] Between 1504 and 1509 the church was nearing completion; [100] its decoration was well under way when Cranach came to Wittenberg. Ever since the beginning of Frederick's reign in 1486, painters had worked at his court. Records list their names as Cuntz (1486–1502), Master Jan (1491–1499), Albrecht (1494-95–1505-7) and Frederick (?–1505), the last of whom was replaced by Cranach. Another artist in the service of the elector was the sculptor Claus Heffner, who, like Cranach, became a city councillor of Wittenberg. [101]

The Venetian painter Jacopo de' Barbari was also in the employ of the elector between 1503 and 1505. He was a member of the older generation – an attractive combination of the tradition of the Bellini school and humanist leanings with a mind which was almost scientific in its

precision. He had worked in Nuremberg, knew Dürer well and had come to the attention of the elector through his essay on the sublimity of painting, *De la ecelentia de pitura*. [102] Two Page 402 important works from Barbari's Wittenberg period survive: *Christ Giving His Blessing*, now in Page 424 Dresden, [103] definitely ascribed to 1503 by the Latin inscription on the Cranach woodcut of 1553, and the still life of a partridge, a mailed gauntlet and a crossbow bolt, done in 1503, Page 425 now in Munich. [104] The half-length painting of Christ was considered a particularly authentic representation; it was the counterpart of a painting of the body of Christ in the Jerusalem style which Frederick had probably brought back with him from the Holy Land. [105] Barbari's painting brought to Wittenberg an example of the Venetian tradition. The influence of Dürer's style is obvious; the Italian painter had obviously tried to surpass him in delicate, transparent painting. The still life of a hunting motif against a bare wooden wall is the earliest known example of the genre. We may imagine Lochau Palace, the elector's favorite country seat, where he went to hunt, decorated with pictures of this kind. According to Scheurl, Cranach himself executed similar paintings for the elector's palaces at Coburg, Torgau and Lochau before 1509. [106] Some of his paintings show the unmistakable influence of Barbari's still life – though only after 1530. [107] The two artists worked in Lochau at the same time; on one occasion they were paid their salaries together. Details reminiscent of Barbari that crop up from time to time in Cranach's work show his enduring respect for the Italian master, which is confirmed by the above-mentioned woodcut and by the fact that Cranach's estate included three paintings by Barbari.

Cranach's appointment to the elector's court is not documented. [108] A payment of 40 guilders on April 14, 1505, in Torgau fixes the date of his move. His income as court painter must have been a yearly salary of 100 guilders, plus fees for individual works, for which he submitted bills and signed receipts. Costly paints and the gold and silver needed for illumination were, as usual, paid for separately. [109] From 1506 on Cranach was regularly supplied with court dress, for winter and summer. [110] Such generous terms accorded to a new court painter show that he was considered an experienced artist. The elector probably also granted him the same kind of prerogative to protect his pictures against unfair imitation that Barbari is said to have enjoyed in Wittenberg. [111] This is confirmed by the fact that from this time on the elector's twin coats of arms appear on all Cranach's woodcuts and engravings, with very few exceptions. [112]

Not much survives of the work of Cranach's first year in Wittenberg, probably because he spent so much time on the decoration of Lochau Palace. The only dated work, a big woodcut of the *Adoration of the Heart of Mary*, [113] shows this palace in the background. This was the Plate 25 first single sheet of Cranach's to be printed in a large edition. Angels, which might well be siblings of those in the Berlin-Dahlem Holy Family, [114] hold a shield bearing the Heart of Plate 20 Mary, on which is superimposed a picture of Christ on the cross. Beneath the shield, apparently interceding for protection against a threatening epidemic, are the Virgin, St. John, St. Sebastian and St. Roch. [115] In spite of the vividly observed details which catch the eye everywhere, the dominant feature is the stately organization of the large figures, which again recall their models in Dürer's work. [116] The great shield bearing the heart, one of the earliest formulations of this type, dictates the perfect symmetry of the other emblems: the electoral coat

of arms and the escutcheon with the chaplet in the lower corners and the monogram enclosing the date in the center. This imposing picture, whose studied theme must have held some special meaning for whoever commissioned it, initiated Cranach's work at Wittenberg.

Cranach's output of woodcuts now increased rapidly. The year 1506 produced no fewer than eight dated sheets, some of them apparently conceived in pairs. Again Cranach's deft hand vied brilliantly with Dürer's. These eight woodcuts included the last in Dürer's large format that Cranach was to make for some time. The powerful figure of St. George [117] was inspired by the St. Eustace in Dürer's Paumgartner altarpiece and by his delicate engraving of 1502 or 1503. [118] The placing of the lance and flag parallel to the margin of the picture typifies Cranach's use of forms to fill the picture space rather than to realize a particular vision of reality. Similarly, the landscape, extending above the saint's shoulders, is not there for its own sake but as a setting for the individual episodes in the slaying of the dragon, which are shown as attributes of the great statuesque figure. An entirely different procedure is to be seen in the handling of the panoramic landscape in the St. Anthony of the same year, [119] which is believed to be a view of the Antonian monastery at Lichtenburg near Prettin. Here the landscape participates in the diagonal thrust of the saint's flight – a motif later used by Grünewald. [120] The demons attacking St. Anthony are brought to life by Cranach's delight in fantastic prodigies and monsters. His contemporaries must have taken them for revelations of creative omnipotence.

In addition to this very dissimilar pair of large-format prints, Cranach did three medium-sized sheets: a St. Michael, [121] a St. Mary Magdalene [122] and a martyrdom of St. Erasmus, [123] as well as two more modest small ones of a prince and his lady on horseback riding toward a castle [124] and a knight in a landscape [125] – a weak forerunner of Dürer's *Knight, Death and Devil* of 1513. Cranach's talent seems strongest when he is competing with Dürer on the familiar ground of saints' pictures (the *St. Michael* and the *St. Mary Magdalene*) or in the free storytelling of the torturing of St. Erasmus. Secular themes seem somewhat foreign to him, and he is at home with them only when they depict straightforward action like the *Tournament* of 1506 [126] or the great undated *Stag Hunt*, [127] where his talent for storytelling unfolds in panoramic detail. Along with this narrative element, Cranach used color to strengthen the composition of his pictures. An early print of the *Tournament* has been very successfully tinted – probably by the master himself. [128] Cranach was too much of a painter – though not in the same absolute sense as Grünewald – to confine himself to woodcuts, engravings or drawings.

The great painting of the year 1506 is the St. Catherine altarpiece. [129] From its format this must have been a counterpart to Hans Burgkmair's altarpiece for the Wittenberg Castle church painted in 1505. [130] Its principal motif can be traced back to Cranach's confrontation with Dürer's woodcuts in 1497 and 1498. The side panels show ten female saints. Each of the outer panels has a pair, set against a dark ground, like the saints in Dürer's Paumgartner altarpiece. The inner side panels have groups of three, linked to the center panel by a continuous landscape. The best figures in the center picture share the great statuesque quality of the *St. George* or of the paired *Lansquenet and Lady* [131] – the most beautiful parallel to the St. Catherine altarpiece that exists in the woodcut medium. The technique is exquisite; the colors are bright and clear despite the thunderstorm brewing over the place of execution. What is lacking,

Plate 28
Page 423

Plate 26

Page 25
Plate 29

Plate 73
Plate 24

Plate 73

Plates 32, 33

Plate 32

Plate 30

however, is a structural plan to support the richness of the panels. This commission seems to have involved demands in the way of portraits that the painter was not entirely able to meet. We recognize the likeness of the elector on the upper left of the center panel and that of his nephew John Frederick next to St. Dorothy. The Saxon fortress at Coburg appears on the right side panel, and a still unidentified electoral palace on the center one. [132] The portraits on the center panel may commemorate Elector Frederick's journey to the Holy Land (which had taken him to the sanctuary of St. Catherine). If so, the figure next to the elector probably represents Duke Christopher of Bavaria. St. Catherine was the patron saint of the faculty of philosophy. [133] A humanist interpretation of the picture would see the conspicuous elements of fire and water as representing components of the oneness of the world. [134] No doubt this work, too, could support a cosmographical interpretation, but the key to it has so far not been found.

Plate 34

Plate 35

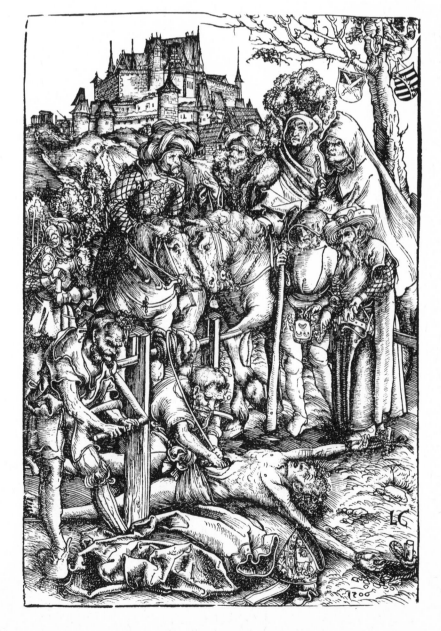

The Martyrdom of St. Erasmus. 1506. Woodcut

The elector's court painter soon found humanist admirers. The first was the poet Georg Sibutus Daripinus, a pupil of Celtis', who taught at the University of Wittenberg from 1505 to 1520. [135] In a poem he wrote in 1507 he placed "our Painter Lucas" at the head of a list of living masters, which also included Dürer (or Albertus Dusses) and a Netherlands or Lower German artist named Ernestus Trajectensis. [136] This poem, improvised in three hours, is a remarkable parallel to the most famous example of improvised humanist painting: Dürer's *Jesus Among the Scribes*, which he painted in five days *(opus quinque dierum)* in 1506. [137] The subject of Sibutus' witty impromptu poem was a fly painted by Kilian Reuter, one of his uni-

versity colleagues. It recalls the flies in Dürer's *Feast of the Rose Garlands* of 1506, [138] Baldung's St. Sebastian altarpiece of 1507 for Halle on the Saale [139] and Cranach's *Expulsion of the Money Changers from the Temple* of 1509. [140] These *trompe l'œil* flies were taken as proof of outstanding creative ability.

Cranach's other humanist admirer was the jurist Christoph Scheurl of Nuremberg, who in 1509 published a letter dedicated to the artist [141] which is an important biographical source. Scheurl had been brought to Wittenberg in 1505 by Staupitz and Pfeffinger and taught there from 1507 to 1512, also serving as rector of the university. He compared Cranach to Dürer, a personal friend of his, and ranked him above the Bolognese painter Francesco Francia. He cited cases where Cranach's pictures had deceived the eyes of animals and people and praised the speed with which he painted and his unfailing inventiveness. Scheurl is our most important witness to Cranach's rapid technique; the famous gravestone inscription of 1553 refers to

him as an extremely fast painter *(pictor celerrimus)*. [142] For Scheurl, Cranach's genius lay in his strong spiritual aura; he characterizes it in words reminiscent of those in which Melanchthon was later to praise Dürer: [143] "Even though you may possess the highest art, genius still surpasses art." [144] Pirckheimer had repeated to Dürer the advice once given to the classical painter Apelles: to sign his work with the imperfect *Apelles faciebat* rather than the past tense *fecit*. Scheurl gave the same advice to Cranach, who seems to have followed it only once: on the altarpiece of 1509. [145] The imperfect tense regularly denotes an incomplete action, suggesting in this case that there is still room for improvement – a kind of self-praise through modesty.

Scheurl rightly gives the Latinized form of Cranach's name as Lucas Chronus, which corresponds to the signature on the 1509 altarpiece. [146] This form seems to be a well-considered self-characterization on Cranach's part since the normal Latin form would have been Lucas Cronaciensis. [147] Chronus suggests Kronos, the Greek god of time, counterpart of the Roman Saturn. It is interesting to note that Emperor Maximilian glorifies himself in a similar way in his autobiographical work *Der Weisskunig*, where he says, "I do not name or call the young Weisskunig a man in his action: I call him *Time*, because he has acted in a way that surpasses the nature of man and is more like time." (*Der Weisskunig*, Chapter 21). The winged *Page 420* serpent that Cranach adopted as his artist's signature and embodied in his coat of arms in *Page 403* 1508 [148] probably stands for Kronos, the ruby ring in its mouth for well-earned pay. Like *Page 421* the emblems of Titian [149] and Burgkmair, [150] Cranach's interprets the artist's activity. His serpent symbolizes a rapid improviser on whom time has conferred its well-deserved prize. This clever humanistic invention may have been prompted by the basilisk, a favorite device of artists, first used by the Erfurt painters' guild in the fourteenth century. [151] Such an interpretation of Cranach's emblem seems justified by his familiarity with the humanist language of symbols, evident in the Cuspinian portrait. This emblematic device is apparently one of the fruits of his association in Wittenberg with the highly cultivated Barbari and with humanists like Scheurl, Sibutus, Karlstadt, [152] Engentinus, [153] Sbrulius [154] and perhaps also with Mutian of Gotha. [155]

In adopting this emblem as his signature for paintings, woodcuts and engravings but – significantly – not for drawings, [156] Cranach was departing from the usual practice. [157] Most German painters signed their works with their monogram. Barbari, however, an Italian, used a caduceus, which also had an emblematic significance, and this seems to have been the practice among Italian copperplate engravers. When German painters set their coats of arms on a work, this meant that they regarded it as a joint effort unworthy of a personal signature. [158] In a busy workshop like Cranach's this often happened. The coat of arms used as a workshop mark defined the production of a work more meaningfully and probably more precisely from the legal standpoint. [159] And in fact, the use of Cranach's monogram decreased as the workshop grew and his personal contribution to its work diminished.

At first Frederick the Wise seems to have employed his new court painter chiefly in the decoration of Lochau. After seeing samples of his work, the cautious elector confidently rewarded him with commissions intended to enhance his own prestige in the eyes of the world.

Between 1504 and 1509 the power of Maximilian I was at its peak, after his success in the

Bavarian War. His old dream of being crowned emperor in Rome seemed within his grasp. During his absence the elector of Saxony was to head the government, and with this in view he was appointed imperial governor-general on August 8, 1507. Despite the opposition (chiefly from the Republic of Venice) to this military demonstration by Maximilian, by the end of 1507 plans had been made for a regular coronation – if not in Rome, then at least in Trent. His princely retinue was to assemble in Nuremberg on the Feast of Epiphany or the Three Kings, 1507. [160] Since Cranach was granted his title of nobility on that date (January 6) in Nuremberg, he was probably a member of the elector's retinue, identified as such by the colors of his coat of arms: yellow and black. [161] Even in this truncated form, Maximilian's expedition to Rome was an event that attracted outstanding artists such as Dürer [162] and could be expected to produce reverential artistic tributes. Because of the opposition, Maximilian in the end contented himself with the title of Roman Emperor Elect, which was conferred in a modest celebration in Trent on February 3, 1508. When the emperor returned to Germany, Frederick's position as governor-general ceased to exist, although he retained the title for life. [163] The next few months brought an estrangement between the emperor and the elector. Maximilian accused Frederick of treason and may even then have been considering revoking his promise to the elector on the succession to the Rhenish dukedom of Jülich-Cleve. [164]

At this point Cranach was sent on a mission to the imperial court. Of its duration, purpose or outcome we know nothing. The only documentation we have deals with incidental events. The court painter does indeed seem to have gone on a journey that summer [165] and was in the Netherlands in late fall, although he was back in Wittenberg to receive his winter clothing on December 17, 1508. [166] Scheurl reports that Cranach was sent to the Netherlands by his master to show off his talent [167] and that he made a sensation in Antwerp with a portrait of the emperor drawn on a tavern wall. Maximilian called on the Belgian estates to pay homage to the eight-year-old Archduke Carl, the future Emperor Charles V, and on this occasion Cranach is reliably reported to have painted a portrait of the boy. [168] He and his Munich colleague Christoph received two substantial payments from Governor-General Margarethe, but we do not know for what works.

We are on firmer ground with the traces left on Cranach's work by his visit to the Netherlands. Forms reminiscent of its regional costumes occur occasionally in paintings done between 1509 and 1514. [169] Headdresses of the type he painted may have been among the objects he bought in Antwerp; he himself wore a Dutch-style coat during the summer following his visit. The high, austere interiors, often embellished with reliefs and precious stones, that occur so frequently in his paintings and woodcuts after 1509 can be traced back to impressions received in the Netherlands. The stony, monumental gray-on-gray figures on the *Plate 44* outer side panels of the Frankfurt Holy Family altarpiece stand in an old Netherlands tradition, [170] though they may also be meant as demonstrations of painting's superiority to sculpture in the humanist view.

In the course of this journey Cranach experienced the richness of the painting of the Netherlands, which he had previously known only from individual works that had made their way to Germany [171] or from the work of second-rate artists. Given a talent of the originality of Cranach's, such influences are often difficult to trace, especially when we remember that in the

The Sacrifice
of Marcus Curtius.
Circa 1507.
Woodcut

major cities of a rich country like the Netherlands art treasures of every known school were to be seen. Individual masters like Hans Memling, so akin to him spiritually, had a strong influence on Cranach over the years. Among contemporary artists he may have met Hieronymus Bosch, whose Judgment Day altarpiece he later copied, [172] and he must certainly have met Quentin Massys, the highly respected leader of the Antwerp painters – an open-minded man whom Dürer visited in 1520. [173]

Plates 44, 45

One result of Cranach's contact with Massys is the already mentioned altarpiece of 1509 depicting the Holy Family, a work which bears an unusually elaborate signature. [174] It includes portraits recalling his mission to the emperor's court. The Elector Frederick and Duke John appear as members of the Holy Family on the inner side panels, along with the emperor, whose portrait is incorporated in a similar way in the center panel, where he is shown sitting in the balcony with his court chaplain, Wolfgang von Maen. [175] Here the St. Anne altarpiece on which Massys was at work at the time served as Cranach's model. [176] The theme, the arrangement of the groups of figures, the use of architecture, the details of precious stones and fabrics – all reveal this relationship. Cranach was bolder in extending the single scene across the full width of the work, though this was facilitated by his smaller dimensions. The colors, however, reflect Dürer's clear tones rather than the splendid masterpiece of Massys, [177] and indeed, Cranach's visit to the Netherlands again brought him closer to Dürer. The picture, lightened by a few strongly accentuated patches of color, produces a luminous impression, although it is actually dull, like the Dresden *Expulsion of the Money Changers from the Temple*

Plate 60, Page 430
Plates 52, 53

painted soon afterward [178] and the *Holy Family* now in Vienna. [179] It is no accident that these three works all show unmistakable signs of the artist's self-esteem: the signature "Lucas Chronus faciebat" on the Frankfurt altarpiece, his self-portrait in the painting in Vienna [180]

Plate 52

and the *trompe l'œil* fly in the Dresden one.

Plates 48, 49
Page 29

After his visit to the Netherlands Cranach's self-confidence was so strong that in 1509 he undertook the life-size painting of *Venus and Cupid*. [181] This was the first time he had treated a classical theme in this medium, although he had done woodcuts of the *Sacrifice of Marcus Curtius* [182] and the *Judgment of Paris* [183] (1508). The former, however, is no more than a

Plate 46

halfhearted adaptation of a Renaissance plaque to a larger format. [184] The *Judgment of Paris*, on the other hand, is pervaded by a sense of untamed nature. The heavyset women come as a surprise after the slim Mary Magdalene of 1506. Their proportions and relatively dynamic poses may well reflect the forms of the great sculptor Conrad Meit, about whose work in Wittenberg we are only sketchily informed. Cranach's female nudes of 1508–09 are certainly strikingly close to Meit's later figurines. [185]

In taking this giant stride toward the big painting, Cranach had to rely pretty much on his own resources, although it seems likely that he drew on engravings by Giovanni Antonio da

Page 425

Brescia and Jacopo de'Barbari. [186] An idea of the tremendous excitement this theme inspired in him is evident from the second, much revised woodcut version, full of lively move-

Plate 50

ment, that he made the same year. [187] The painting, an astonishing early northern European attempt to portray a classical goddess in the flesh, has a protective aura of reticence. It is a fruit of the thinking underlying the candid words of the humanist Mutianus Rufus of 1505: "There

is only one god and one goddess but many divinities and names, such as Jupiter, Sol, Apollo, Moses, Christ, Luna, Ceres, Proserpina, Tellus, Mary..." [188]

In this productive year of 1509 Cranach painted portraits of two humanists – remarkable sequels to those of 1502–03. Georg Spalatin, recently appointed tutor to the young prince John Frederick, is shown in a simple half-length rendering, with an open, searching expression. [189] The portrait of the eloquent speaker Christoph Scheurl, who had recently served as rector of the university, is also half-length; the head is idealized in Dürer's manner. [190] The signet ring on his right hand bears the arms of this Nuremberg patrician – a trick Cranach liked to use in portraits from this time on. The spiral ring bearing the emblem of trust on his left hand is probably Scheurl's own, like the devices shown in the picture. Both portraits have monochromatic backgrounds – perhaps in the case of Scheurl to match an older portrait of his mother. [191] All connection with a landscape setting – still to be glimpsed in the Frankfurt altarpiece – is gone. Inscriptions and devices have replaced a physical context. This elimination of the landscape background, which occurs here for the first time, is the major difference between these portraits and the earlier ones. [192] A new air of majesty is especially noticeable in the portrait of Scheurl. Cranach still did not find it easy to depict the new type of man, no longer groping toward dawning enlightenment but radiating dignity and distinction and inviting respect. The portraits he painted of princes during this period look much more middle-class than this courtly humanist.

Two lost portraits done during those years were the subject of humanist epigrams: a portrait of Cranach's mistress, Anna, and one of Gesa Block, mistress of a professor of medicine. [193] The epigrams illustrate the freedom in erotic and artistic affairs that prevailed in this humanist milieu. "They call me lovely Anna. A second Apelles painted me. And just as we have a reversible name, anyone could turn my body heels over head." The daring picture was based on the punning possibilities of the classical palindrome. This trick of playfully turning things upside down in an attempt to discover new meanings and forms was part of Cranach's artistic technique, adding a note of wisdom and wit.

Occasional works, executed in 1511 or shortly before, included woodcut bookplates for Dietrich Block, who served as rector of the university from 1508 to 1509 but left Wittenberg two or three years later, and for Scheurl. [194] The woodcut of Spalatin before a crucifix, done in 1515, [195] completes the list of works Cranach made for members of the Wittenberg humanist circle in his early period.

His production for the year 1509 also included several engravings and numerous woodcuts, which may not all have been commissioned by the elector, even though most of them bear his coats of arms – no doubt as a kind of trademark. It looks almost as though the interlude in the Netherlands and the acceptance of other commissions had caused a temporary stoppage in the flow of prints. This is the most likely explanation for the flood of 1509. At that time the Netherlands had little to offer a graphic artist who had matured through a confrontation with Dürer. The great etcher Lucas van Leyden was just beginning his career, and all artists working in the woodcut medium themselves looked to Dürer.

A project already under way in 1507, which appeared in 1509 but was continuously revised

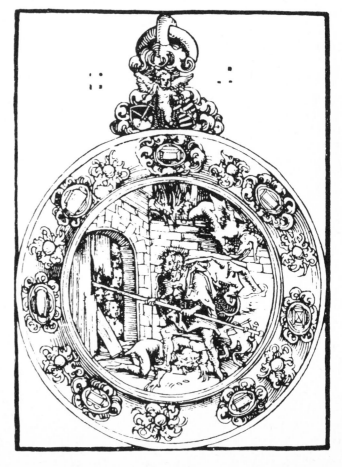

until 1510, [196] was the catalogue of reliquaries in the Wittenberg Castle church – a "presentation of the highly praiseworthy relics of the Collegiate Church of All Saints at Wittenberg." *Page 32* For this Cranach made 123 woodcuts which render in willfully elaborated forms a rich corpus of figurative and ornamental models already used for the figures of saints on the side panels of the St. Catherine altarpiece. [197] This *Heiltumsbuch* prompted his first attempt at copperplate *Plate 31* engraving. In 1509 Elector Frederick, who set great store by his collection of relics, had a portrait engraving of himself made for the title page of the little volume. [198] In 1510 he *Page 426* commissioned another one, showing him with his brother, Duke John. [199] The idea of decorating a book of woodcuts with an engraving was a novel one, and it was some time before it was imitated. Ten years before Dürer's engraved portrait of Cardinal Albrecht of Brandenburg the idea of using this medium for portraiture must have seemed unusual, too. The fact that Cranach, who seldom worked with engraving tools, successfully realized the two innovative ideas demonstrates his bold inventiveness. The first group of engravings he made consists of only five sheets; in addition to the elector's portrait and its variant, it included the *Penance of St. John Chrysostom* done in 1509, [200] an angel bearing a coat of arms, found by *Plate 67* Koepplin in the Hamburg Kunsthalle, also done in 1509, and the picture of Frederick the Wise adoring St. Bartholomew, [201] done somewhat later. Altogether they offer splendid *Plate 68* proof of Cranach's rich inventiveness and sureness of touch. The luxuriant landscape in the *Penance of St. John Chrysostom* exemplifies his method. Inspired by the subject and composition

Woodcut
from the Wittenberg
Heiltumsbuch.
1509

of one Dürer etching, [202] he borrowed the figural motif from another, [203] enriching it all with his own brilliant observation of nature.

The challenge of reproducing the goldsmith's work on the reliquaries in the woodcut medium may also have led to one of Cranach's most remarkable discoveries: printing woodcuts in gold and silver. In 1507 the Wittenberg workshop was able to print knights in shining armor, though Cranach himself apparently used the process only once: for a mounted St.

George. [204] The technique was perfected in Augsburg by Hans Burgkmair, who was already using it in 1508. [205] It was conveyed to him by the Lord Chamberlain of Saxony, Degenhart von Pfeffingen, through Conrad Peutinger. Why Cranach did not exploit this potentially profitable technique further [206] is not known.

Plates 50, 42 A by-product of this process was the tone woodcut, a medium in which three of the single sheets of 1509 were executed: *Venus and Cupid*, [207] *Rest on the Flight into Egypt*, [208] and *Plate 47, Pages 35, 34* *St. Christopher*. [209] Three others – *Adam and Eve* (also known as *The Fall of Man*), [210] *David* *Plate 41* *and Abigail* [211] and *St. Jerome* [212] – which have been ascribed to this technique, are actually not tone woodcuts. Cranach was well aware that this process was an important innovation and probably deliberately misdated the two prints that he thought would find the widest market, dating them 1506 to emphasize that he was using it before Burgkmair. [213]

The tone woodcut, in the relatively simple process used by Cranach, was the work of a painter. A first print was made from a block inked in gray or red on which the highlights had been hollowed out, supplementing the black-and-white line block. The invention may have

David and Abigail.
1509. Woodcut

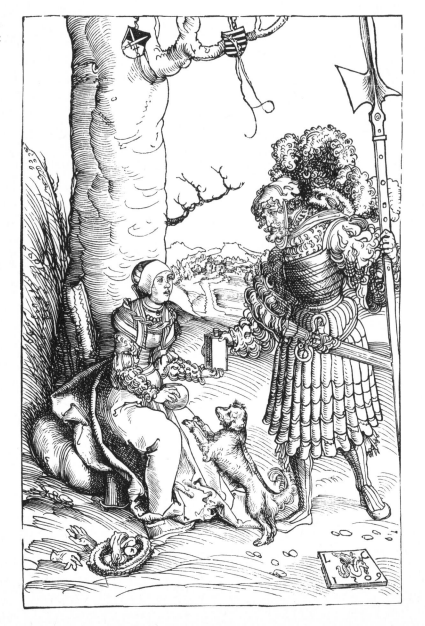

The Fall of Man.
1509.
Woodcut

been prompted by dissatisfaction with the abstract black-and-white linear woodcut and possibly also by a wish to distinguish himself from Dürer, the unexcelled master of the medium. Anyone who has observed Cranach's fondness for dark, undifferentiated shadows and his frequent use of patches of color as connective elements in paintings and drawings, together with his rich experience with black-and-white linear prints, will not be surprised at this development, for which drawings made on colored backgrounds had prepared the way.

The tone print was no more than a passing event in Cranach's total œuvre. He used the process only for works created in 1509, although prints were probably still being made years later. Completely autonomous black-and-white prints of each sheet also exist; good early tone prints of some of these woodcuts are very rare. In the graphic sheets of 1509 the landscape and figures are seen in remarkably close perspective. The plants and animals in the foreground look tangible and identifiable. A favorite motif is the strong, protective tree trunk standing *Pages 34, 35* amid the figures in an almost brotherly relationship. The Virgin, Abigail and Adam all are *Plate 41* shown leaning against a tree, while St. Jerome's kneeling pose before a tree with a crucifix propped against it introduces a note of subdued tension. Even in the *Rest on the Flight into Egypt* the landscape is already less suggestive of repudiation and rejection and is beginning to enfold the figures more protectively. If we compare the standing Venus with the St. George of 1506, we can trace the course of Cranach's development. Slowly a world emerges, in all its characteristic detail, benign and delightful, with strong still-life qualities. The abundance of *Page 35* natural forms, perceived through all the senses, in *The Fall of Man* – to take just one example – illustrates Cranach's new heartfelt feeling for nature.

After his visit to the Netherlands, architecture, which was basically alien to Cranach, became an important element in his pictures. This is evident from the fourteen-sheet *Passion* *Plate 69* series issued in 1509. Its nucleus consists of portrayals of the captive Christ before Annas, Caiaphas, Herod and Pilate, in which the artist has created an astonishing range of variations on a basic theme. His inventiveness in varying the scenery, rearranging groups and shifting the emphasis seems inexhaustible. The placing of the twin coats of arms of Saxony becomes a fascinating game; in the climactic Crucifixion they are omitted altogether. The borrowing of motifs from Dürer is concealed. A telling illustration of Cranach's self-confident confrontation *Plate 70* with Dürer is the henchman in the *Flagellation of Christ*. This is a rear view of Dürer's showpiece *Page 424* figure, on one of the panels of the *Seven Sorrows of the Virgin*, [214] of a man drilling a hole in the cross to which Jesus has been nailed. Here the borrowing amounts almost to parody. Taken as a whole, Cranach's *Passion* series represents a personal triumph over Dürer, whose *Albertina Passion* remained a fragment, who had finished only seven of his *Large Passion* series and who was only just beginning his engravings on the same theme. Using a medium-sized format well suited to his narrative talent, Cranach outstripped his rival. His language has the simplicity, vividness and impact of a folk song. Their roles seem now to have been reversed. Dürer, the great giver, now falls behind the eagerly receptive Cranach – no doubt because of the latter's greater dexterity and adaptability.

Plate 71 Rivalry with Dürer is also evident in the somewhat earlier large-format *Beheading of John the Baptist*. [215] The close spectators behind the parapet recall the *Martyrdom of St. John the Evangelist* from Dürer's *Apocalypse*, although specific references have been carefully avoided.

The executioner is almost a mirror image of the Burgundian standard-bearer in an engraving of Dürer's from about 1505, [216] except for a slight change of pose dictated by their different actions. The austere grandeur of this picture is especially striking when it is compared with Cranach's own woodcut of about 1515 [217] and with his painting of the same subject. His delight in anecdote is relegated to the narrow frieze of putti, where it is given even freer play than in the *Holy Family* painting of 1509. There is no doubt that Cranach recognized Dürer's superiority in the treatment of big groups of figures. His next version of the martyrdom of St. John on one of the huge panels of the Neustadt altarpiece done between 1510 and 1512 [218] is an adaptation of the popular Dürer woodcut of 1510. [219] In this case there is little attempt to conceal the borrowing.

In the St. Catherine altarpiece of 1506 and the martyrdom of St. John in the Neustadt altarpiece of 1512 Cranach pushed borrowing to its limits, sometimes more or less reticently, sometimes being open about it. A short time later, in the Kremsier *Martyrdom of St. John* and *Martyrdom of St. Catherine* of 1515 [220] and in the contemporary woodcut of the execution of John the Baptist, [221] little trace remains of this intense rivalry with Dürer – except for the soldier on the margin of one panel who has Cranach's own features. [222]

Plate 33

If these dated works of 1506, 1512 and 1515 represent milestones on a straight road of development, then the big woodcut of the beheading of John the Baptist, the Budapest painting of the martyrdom of St. Catherine [223] and the splendid *Altarpiece of the Princes* in Dessau [224] can be assigned to the intervening period, between 1506 and 1512. Here motifs borrowed from Dürer appear more openly. Cranach no longer took pains to introduce a gesture or a detail not present in the original but concentrated on integrating the borrowed elements into his own concept. Hence the echoes of Dürer's woodcut of the martyrdom of St. Catherine in the Budapest painting are much plainer; the king about to be thrown from his stumbling horse and the wheel partly destroyed by fire are obvious borrowings. The composition is more easily grasped; compared to the St. Catherine altarpiece of 1506, it relies more strongly on intrinsic decorative elements. These factors, as well as certain details that are obviously the work of another hand, point to a later date of execution.

Plate 71

Plates 66, 56

A sequel to this painting is the small woodcut series of apostle martyrs of 1512, [225] in which Cranach successfully exploited his narrative talent. These variations on the execution theme permitted free treatment and a wide range of settings and embellishment. During this same period Cranach treated the subject again in two single sheets, the small *Execution of John the Baptist* already referred to and the widely acclaimed *Martyrdom of St. Barbara*. [226] The picture of the aged St. John the Apostle stepping into his waiting grave after celebration of the mass stands in powerful contrast with the bloody, tumultuous events depicted in the rest of the series. The great candlestick, required by the legendary tradition that the saint was transported in a blaze of light, recalls the first vision of his revelation when he fell as dead before the seven candlesticks. Being one of a series, the subject was not freely chosen, any more than Dürer's woodcut of the revelation, but both of them are realized so masterfully that they stand in a class of their own. The grandeur of Dürer's rendering of the prophetic vision and Cranach's masterful retelling of the story of the old prophet's death epitomize the difference between the two masters. In any event their roles are not interchangeable. Cranach never created anything

Plates 74–77

Plate 75

comparable in grandeur to Dürer's St. John kneeling before his vision of the seven candle-sticks. Dürer never depicted a leave-taking with the condensed terseness of Cranach's little woodcut.

Plates 78, 79

Yet during these years Cranach never ceased to strive for grandeur. About 1510 he made a woodcut series of the twelve apostles. [227] Some of them – St. Peter, St. Andrew, St. James the Greater and St. Thomas – are descendants of the small figures in the reliquary book. This line of great human forms surrounded by strangely tenuous greenery reaches back to the St. Stephen of 1502. Much of the work of this period seems to be a realization of callow youthful dreams.

Page 39

Among the woodcuts of the early Wittenberg years are pictures of knights, [228] a mounted St. George, [229] hunting scenes [230] and tournaments, [231] no doubt commissioned by the elector. Elements of portraiture and topographical details localize many of them unmistakably, as in the picture of the little Duke John Frederick riding past Coburg Castle, at that time his father's [232] seat. Most of them anticipate themes later to be treated in paintings – the hunting scenes, for instance, which persist right up to the time of Cranach the Younger. Old in-

Plate 120

ventories list other works such as painted portraits of men on horseback. [233] So many occasional works executed for the elector's court have been lost that it is only from the wood-cuts of similar subjects that we can get an idea of their variety. It is remarkable that, except for the period between 1506 and 1509, the woodcut was not used to chronicle court life and events. We do not know the reason for this; presumably the small demand for representational works of this kind was met by more ambitious paintings. The production of woodcuts seems to have diminished as the production of paintings increased.

Page 428

Elector Frederick the Wise demonstrated his confidence in the versatility of his court painter when he asked him to collaborate in designing a medal to commemorate his illustrious appoint-ment as imperial governor-general. [234] To commission such a medal at all was unprecedent-ed for a German prince – an attempt to adapt an Italian humanist custom to a German context. But could the subject not have been treated just as impressively in a woodcut? This medium would certainly have suited Cranach's talent better. The execution of his high-relief design in struck metal proved extremely difficult. It did not take long to produce a cast medal in several different versions, but work on the one struck dragged on well into 1508, when Cranach had to leave Wittenberg for the Netherlands. In Nuremberg Hans Krug spoke admiringly of the model but was not able to complete the work before he left the mint in February, 1509. His successor, Konrad Eber, was equally unsuccessful with the revised model, and in September, 1510, the emperor passed the commission to the Innsbruck medal maker Ulrich Ursenthaler, who produced the first finished matrix for the medal. Finally, in 1513 or 1514, the elector found in Hans Kraft of Nuremberg a craftsman who could provide what he was looking for – seven years after the initiation of the project. The portrait in silver or silver gilt, suitable for state presents, surpassed the engraving or woodcut, as we see from the trouble they took with it. Cranach's development of a technique for printing in gold actually came into its own only for competing with gold and silver medals; [235] it was an attempt to make graphic art present-able at court.

Besides the medal, the elector and his brother Duke John, who shared the duties of regent,

Knight. Circa 1509.
Woodcut

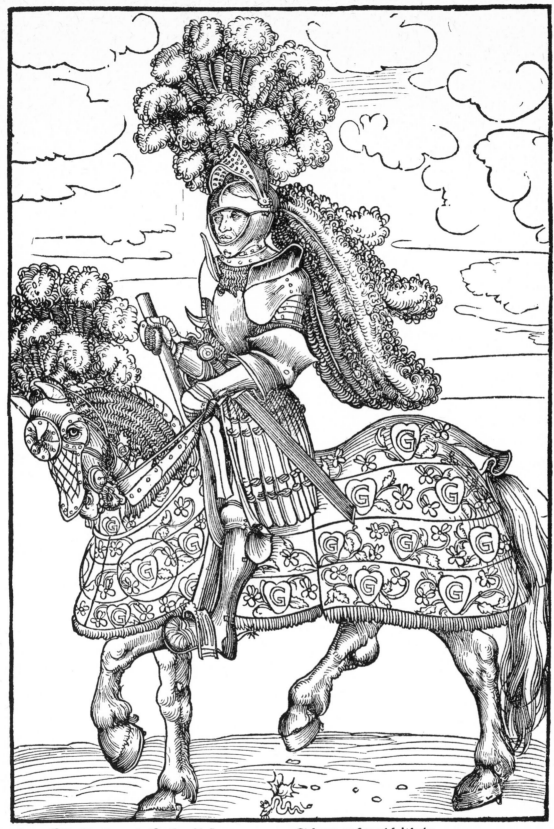

EIn Sprichwort heist / ist wol bekant
 Durchaus im gantzen Deutschenland:
Da Adam reut vnd Eua span/
 Wer war doch da ein Edelman?
Es ist wol war/ Doch weil gewis
 Der Adel Gottes ordnung ist/

Soln wir im sein gebürlich ehr
 Erzeigen/ nach S. pauli lehr/
Auch sol der Adel dencken dran/
 Wie Keiser Maximilian:
Ich bin gleich wie ein ander Man/
 Nur das mir Gott die Ehre gan.

C. M. Ot

Plate 56 commissioned a commemorative painting. This was the *Altarpiece of the Princes*, also called the *Altarpiece of the Madonna*, now in Dessau. [236] It may have been created for the small west choir of the Wittenberg Castle church built between 1510 and 1512 in memory of the elector's ancestors. [237] Its figures are drawn to a larger scale than those on the other panels displayed in the church, except for Dürer's so-called Dresden altarpiece (on canvas), whose original location is unknown. [238] Obviously this work provided the formal inspiration for Cranach's big, physically impressive figures. On the other hand the women and children on the center panel – the Virgin, St. Barbara, St. Catherine and the Christ Child and the angels – stem entirely from impressions brought back from the Netherlands. Cranach seems to have avoided all reference to Dürer's Madonna. [239] The placing of the angels, the clearly displayed attributes of St. Barbara and St. Catherine on the ledge, the big faces on the side panels, the foreshortening of the hands – all testify to the rivalry with Dürer. The big-eyed St. Bartholomew in his white robe might have come from Dürer's own hand. The details of this great work, the gold trimming and rich embroidery on the clothes, are painted with meticulous care. The colors are subdued: various tones of red and blue linked by a little green and a sumptuous gray, all embellished with gold. The most remarkable color is the white; it no longer has the usual yellowish cast but stands out sharply, even in St. Bartholomew's robe. This is the cool, form-holding color that Dürer liked to give to white cloth – the pure, immaculate white on which he painted the lifelike fly in the *Feast of the Rose Garlands*. This is Cranach's best painting; it marks the climax of his confrontation with Dürer. The transparency and luminosity of the colors are all the more astonishing for being contemporary with cluttered paintings in dull *Plates 45, 60* colors like the Frankfurt *Altarpiece of St. Anne* of 1509 and the *Expulsion of the Money Changers*. The *Altarpiece of the Princes* may represent only one side of Cranach's work but so far as his rivalry with Dürer goes, it is his supreme achievement.

Dürer's last painting for Elector Frederick, his most faithful patron, was the *Martyrdom of the Ten Thousand*, done in 1508. From then until the splendid engraved portrait of the elector made in the year of his death, 1524, there is a gap, which must have been filled by Cranach. Dürer still remained the authority; drawings were made in Cranach's workshop from his pictures, and they were looked through as a possible source of reusable ideas and motifs. [240] To meet customers' demands, famous themes of the Nuremberg master were later copied or elaborated, including his two masterpieces, *Melancolia* [241] and *St. Jerome in His Cell*. [242] *Plates 89, 90* Sometimes his formal motifs were reinterpreted, as in the pen drawings for Emperor Maximilian's prayer book. [243] Compared to the rivalry that had persisted throughout Cranach's early years in Wittenberg, this was no more than quiet deference. Since Cranach's graphic output was also decreasing at this time, Dürer may have lost sight of him. But through his works in the Wittenberg Castle church Dürer remained just as much a living presence to Cra- *Page 423* nach as Barbari, Burgkmair, Riemenschneider and perhaps Bosch.

While the Nuremberg master was striving toward ever more meticulous painting and turning again with renewed vigor to woodcuts and engravings, Cranach was increasingly occupied with commissions, which were so numerous that they could be executed only with the help of his well-trained workshop staff. His interest in graphic art diminished; the oldest, most productive field of rivalry with Dürer lay fallow.

The *Altarpiece of the Madonna* was followed by a series of half-length Madonnas. The earliest and biggest, formerly in the Breslau Cathedral, [244] is similar in type to the Madonna on Dürer's Dresden altarpiece. Its many costly details and the unexpected signature – the artist's signet ring on the parapet – link it with the paintings done soon after his visit to the Netherlands, which are full of inventive details. Later versions in Lugano, [245] near Florence (1514), [246] Karlsruhe, [247] and Cologne [1518), [248] as well as the one formerly in Glogau, [249] are more expressive of Cranach's originality. A remarkable feature of this group of private devotional pictures [250] is the long persistence of the landscape background. During this period the mood that pervades the *Holy Family* of 1504 and is evoked again in the woodcut *Rest on the Flight into Egypt* [251] dies away.

Plate 55

Plate 106

¶ DOMESTIC AND BUSINESS AFFAIRS

The obscurity that surrounds Cranach's personal life as a young man continues throughout his early years in Wittenberg. The date of his marriage is unknown. (Normally a man was required to be married before opening his own workshop.) The birth date of the first child of his marriage to Barbara Brengbier is not recorded, and it is not until the birth of his second son, Lucas, on October 4, 1515, that a specific date can be given.

Cranach's prestigious appointment as court painter would quickly have brought him material security. Before 1511 he owned one floor of a house in Coburg, at Nos. 2–4 Kirchgasse on the marketplace, [252] but in 1510 he was still not a house owner in Wittenberg. On a tax assessment for strengthening the city fortifications, the name "Lucas moler" appears on the last page, together with four other names, suggesting that the five parties lived together. An entry in the same account book for 1510 shows that Cranach bought three wagonloads of tiles, presumably for a house he was planning to build. Because of this building project, the painter was exempted from taxes on the imposing corner house at No. 1 Schlossstrasse on the marketplace for five years, from 1513 through 1517. The previous owner, City Councillor Caspar Teuschel, who had enjoyed the same routine tax exemption since 1506, had probably come to grief in the overambitious building project. [253] This large, excellently situated property was Cranach's major asset; his son Lucas inherited it; from his widow it passed, in 1607, to the theologian Polycarp Leyser. [254]

Page 417

We do not know exactly when Cranach acquired this imposing house. The account book of 1513 mentions him as the owner of two houses, and he also owned a garden. The second house had previously belonged to a certain Blasius Welmss(d)orff, and Cranach seems originally to have rented it. [255] This was probably the property at No. 3 Marktplatz. The third big property he acquired, No. 4 Marktplatz, was the site of the apothecary shop established by Martin Polich of Mellrichstadt, the personal physician of Elector Frederick and the first rector of the university. The privileges of the pharmacy were officially transferred to Cranach in 1528. The artist also owned two houses and a plot of land near Rothemark, west of Wittenberg. By 1528 the value of his real estate had increased to more than 4,000 guilders, according to his own estimate, making him the richest burgher of Wittenberg after the electoral chancellor, Gregor Brück. Caution must be used in relating this estimate to other figures, since it is

not known on what it was based. After Albrecht Dürer's death in that same year, 1528, his assets were estimated at 6,800 guilders.

Most likely Cranach married about the time he acquired his first house, between 1511 and 1513. [256] His brother Matthew (variously known as Matthäus, Matthes and Mattheus) was living in Wittenberg at the time, but it is not known whether his university studies (1511), court duties (1511) or work in his brother's workshop (1512, 1513?) had brought him there. [257] From 1514 until after 1555 [258] he again lived in Kronach.

Cranach's wife, Barbara, was a daughter of Jobst Brengbier, city councillor of Gotha, who is mentioned several times between 1512 and 1515 in letters of the humanist Mutian. Her family coat of arms was a graphic one: two hands emerging from a cloud, holding a goblet. (Bringebier-Bring-Beer.) In 1518 Cranach owned a house in Gotha, presumably the one on the marketplace in which one of his daughters, who moved to Gotha after she married, later lived. Of Barbara Brengbier little is known except for the report of the death of her first fiancé [259] and that of her death in 1541. The marriage produced two sons and three daughters: Hans, who died in Bologna in 1537, Lucas, successor to his father (1515–1586), Ursula, Barbara and Anna (1520–1574).

Cranach's prosperity and prestige are evident from the fact that he served as a city councillor from 1519 to 1549. According to the Wittenberg statutes of 1499, the council consisted of twenty-one persons, divided into three groups which served successive one-year terms as governors of the city. The year was reckoned from the first Sunday after February 2 (Candlemas) to the same Sunday of the following year. Thus, Cranach was actively engaged in the government of the city for one year out of every three. In addition, he served in 1519, 1531 and 1534 as one of the two city treasurers – an office which was a step toward a higher one. In 1537, 1540 and 1543 he began three successive terms as burgomaster, resigning from the City Council in 1545 before he could be elected to a fourth. Since his son Lucas was elected to the City Council in 1549 and served on it until his resignation in 1568, the Cranach family had a voice in the affairs of the city for almost fifty years, from 1519 to 1568. Toward the end of the century two sons of Cranach the Younger briefly resumed the tradition: Augustin from 1584 to 1595 and Christoph from 1594 to 1596.

The Cranachs were connected by marriage to many influential families and personalities. They belonged to the rich burgher class of the *Residenzstädte*, small towns where there was a princely or ecclesiastical seat; their outstanding representatives were jurists or artisans who had made money in trade. They were especially close to the family of Dr. Gregor Brück, whose father had served his first term on the City Council together with Cranach. Dr. Brück himself became the elector's confidential adviser in domestic affairs between 1519 and 1529 and was later to be known as the Reformation Chancellor. The Cranachs and Brücks of the next generation were doubly related: in 1537 Barbara Cranach married Christian Brück, the future chancellor of Elector John Frederick, while Lucas Cranach the Younger's first wife (1541–1550) was Barbara Brück. Ursula Cranach married the Würzburg jurist Georg Dasch, later a city councillor of Gotha. The youngest daughter, Anna, was married to the apothecary Caspar Pfreund and lived in Wittenberg until 1577. Her husband had begun as an associate of Cranach – and, like his brother-in-law Lucas the Younger, served as city councillor from 1551 to 1566.

In 1573 Pfreund and Cranach the Younger were among the richest burghers of Wittenberg, though ranking somewhat below the successful book publishers Vogel, Rühel and Selfisch.

The wealth Cranach had acquired was obviously well secured by this network of family alliances. The workshop, his major enterprise, was also affected by it. The decision to stay on in Wittenberg after the capitulation of Elector John Frederick in 1547 was certainly dictated by economic considerations. Like his father in Kronach, Cranach began with little to his name, soon acquiring a house. Opportunities were greater in rapidly growing Wittenberg. It was typical of Cranach that most of the wealth he acquired was profitably invested outside the workshop, and this also had important consequences for his work.

His major investment was in real estate. He had been renting out houses at least since 1513. When he made a house available to the exiled King of Denmark, Christian II, in 1523, it was no doubt on a rental basis. King Christian's interest in artists [260] and the elector's desire to offer his illustrious guest shelter without inviting him to live at his court may have accommodated one another.

Ownership of a house could be combined with prerogatives that brought in money. Cranach seems to have acquired a license to sell wine as soon as he bought his first house – as other burghers did, too, among them the sculptor Claus Heffner, [261] Cranach's astute predecessor in combining the artist's profession with solid burgher status. The apothecary shop, which the court painter had owned since 1520, seems to have been acquired together with the house of Martin Polich of Mellrichstadt, who died in 1513. Polich himself was not an apothecary, although he had an excellent knowledge of medicinal herbs. [262] For this reason an official reassignment of the apothecary privilege had to be sought from the elector – and without delay. It expressly states that the apothecary shop is to be kept by a paid employee. This employee was Johann Seiffried, who kept the shop until his death in 1539. In 1519 a man named Andreas had been engaged to take care of the wineshop. From the evidence of Cranach's later letters we can assume that a privilege authorizing him to publish books (after 1525) and his patent of nobility (1508) were the only deeds from his master's hand that the court painter possessed.

Cranach participated for a time in the principal business of the university city – the press. Wittenberg had gradually outstripped Leipzig as a printing center. Although printers worked sporadically at the palaces of Lochau (1503) and Wittenberg (1509), for many years the writings of Wittenberg scholars were published in Leipzig, where some of Cranach's woodcut illustrations were also printed. His reliquary book and the woodcut *Passion* of 1509 were among the first works to be printed in Wittenberg. Wittenberg's rise, which was to make it Germany's leading printing center, began when the neighboring universities and the nearest printing centers in Leipzig, Erfurt and Frankfurt-an-der-Oder formed a united front against it in the early confrontations of the Reformation. [263] Cranach collaborated with the printer Johann Rhau-Grunenberg until December, 1519, when Melchior Lotther, son of the Leipzig printer of the same name, opened a print shop in a house owned by the painter. Cranach and the goldsmith Christian Döring, who had worked together as artists and as city councillors, financed Luther's earliest partial translation of the Bible, the famous September Testament of 1522, to which Cranach contributed woodcuts. To produce from scratch a 5,000-copy edition of the

Page 44

New Testament took the capital of a court painter and a goldsmith. The chance of work also brought Michael Lotther, a brother of young Melchior, to Wittenberg in 1523. But a falling-out between the publishers and Melchior Lotther soon put an end to the Lotthers' activities. In the spring of 1524 Lotther, in a fit of anger, had tortured a bookbinder and had been severely punished for it. Cranach and Döring broke with him and early in 1525 succeeded in driving this excellent printer out of Wittenberg. In the meantime, Joseph Klug was doing their printing. In late 1525 or early 1526, however, he too went out of business, to be replaced not, as might have been expected, by Michael Lotther, who had remained in Wittenberg (and who moved to Magdeburg in 1528), but by the young Hans Lufft. Lufft continued to work in Wittenberg until 1584, earning success and honor. By 1533 Cranach had already retired from the business, and Döring sold the publishing house, the privilege and the stock of books to a consortium of Bartholomäus Vogel, Christoph Schramm and Moritz Goltze. The profitable business was now completely out of Cranach's hands. From 1525 to 1533 Cranach's bookshop was located in the house at No. 3 Marktplatz, and it was probably here that the orders of high-ranking customers like the elector (in 1526) and Duke Albert of Prussia (in 1526

Taking Measurements
for the Temple.
From the September
Testament of 1522.
Woodcut

44

and 1529) were filled. Döring seems to have been responsible for the bookselling – at least the city archives of Frankfurt-am-Main cite his name in this connection for the years 1526 to 1530. [264]

Trading on a big scale of the kind Cranach commissioned his associates to do for him was often risky. Expected profits might fail to materialize; loans might not be repaid on time. At least twice Cranach was sued for large sums of money; a suit initiated around 1538 dragged on until 1550, and another, begun in 1544, was settled only in 1551. In cases like this it did no harm to be connected with the city government. Both suits seem to have been actively prosecuted only after Cranach the Elder stepped down as city councillor.

¶ THE WORKSHOP

The prime evidence testifying to the existence of Cranach's workshop is the paintings themselves, production of which began on a large scale toward 1510. Archives provide additional sketchy information, which, however, can rarely be linked to specific works. Paintings and names are listed side by side, with little apparent connection.

During Cranach's early years as court painter, individual artists would work with him for a time, just as he may have collaborated with Barbari. The painter Valentin Elner did so in 1504, [265] as did Christoph of Munich in 1505; [266] the sculptor Conrad Meit [267] seems also to have been on this footing with Cranach. The first mention of apprentices comes in the summer of 1507. Like their master, they were provided with court dress, even in the summer of 1508, when Cranach was abroad. Two young men began their apprenticeship with him in the summer of 1509, and in 1512 the first journeyman, a painter by the name of Polack, received his court dress. The yearly reckoning for 1513–14 mentions a third apprentice named Jakob Tartschmacher; a fourth was the cousin of a barber in the service of the elector. Later – certainly from 1527 on – the arrangement seems to have changed, and the apprentices were not provided with court dress, except for the one engaged after Cranach moved to Weimar in 1552–53. The Wittenberg workshop must regularly have had two or three apprentices; more than that number could not have been given a thorough training. [268]

The number of journeymen, on the other hand, seems to have varied considerably. The elaborate paraphernalia of court festivities, journeys and military campaigns, as well as the decoration of new buildings, required plentiful reserves of craftsmen. The court painter and ten journeymen – and probably two or three apprentices as well – were kept busy in Torgau for almost seven weeks with preparations for the wedding of the future elector John and Margaret of Anhalt on November 13, 1513. The team charged with the painting and decoration of the John Frederick wing of Torgau Palace, built by Konrad Krebs between 1533 and 1536, was equally large. Accounts for the years 1535 to 1540 give the names of the individual workers; sometimes apprentices are mentioned, too, though as a rule there is no mention of payments to them. Cranach's journeymen included Franz Zubereiter (Timmermann?), Ambrosius Silberbart (Zubereiter), Lucas Mercker (Marx?), Jacob Abel, and Hans, Jobst and Paulus Steter, who were presumably brothers. For the most part they spent at least two years at the Wittenberg workshop. Mercker, Hans, Jobst and Ambrosius are mentioned again three years

after their original listing. The apprentices Alexander (1537) and Bartel (1540) do not appear as journeymen in later years, though a slip in record keeping may well explain this. With the virtual completion, in 1538, of the work connected with the new building, this great team of craftsmen may have been broken up. In 1540, when Cranach began painting the Mirror Room above the great spiral staircase at Torgau, he had with him two new journeymen, Paul Rüss and Hans Rentz, as well as the apprentice Bartel. Bills for 1545 covering work in the church wing of Torgau Palace show that Cranach employed six boys for twelve weeks during the summer and mention a journeyman named Thomas. Including his own sons Hans and Lucas – and by 1537 Hans was already a master painter – no fewer than ten painters worked under Cranach at Torgau. Bills for single works executed during the same period regularly show payments to six journeymen, and six (including Cranach's sons) seem to have been the maximum number the workshop employed. Four individual painters unconnected with the workshop also received payments: Master Oswald Schnitzer, Sebastian Adam, who worked with an apprentice, and Benedictus and Stephan, who may have beeen pupils of Cranach.

The names of all these artists are surrounded by obscurity. Cranach's two pupils from northern Germany, Hans Kemmer, [269] who had worked in Lübeck from 1522 on, and Franz Timmermann, whom the city of Hamburg sent to study with him from 1538 to 1540, [270] emerge more plainly. Only one great work by a master of the Cranach school can be linked with a specific name: the folding altarpiece in the chapel of Mansfeld Castle, painted by Hans Ritter, also known as Döring, of Wetzlar. This artist was in the service of the counts of Solms and Mansfeld and seems to have been close to Cranach around 1514. [271] Certain works have been grouped together in order to identify them provisionally for purposes of art history. Some years ago, for instance, three painters were included in a pseudo-Grünewald group: the master of the Pflock altarpiece, the master of the *Martyrdom of St. Erasmus* and the master of the *Mass of St. Gregory.* [272] Other examples of good school works are the altar in the church of St. Stephen at Aschersleben [273] and the New York *Martyrdom of St. Barbara.* [274] More recent studies refer to these designations but shy away from definite attributions. For the present the methodology of style analysis seems unable to make a dent in the mountain of works produced by the Cranach school. Perhaps in individual cases a tentative screening of the material can be supplemented by confirmation from the archives. This would narrow the range of possible attributions.

Attribution of the large-format panels is particularly difficult. Who should be credited with the paintings of the Neustadt altarpiece of 1510–12, [275] the panel of the Ten Commandments of 1516 from the Wittenberg City Hall, [276] the great figure of Christ in Zeitz, [277] the great panels of the Halle altarpiece, [278] the great side panels of the altarpiece in the west choir of *Plate 199* Naumburg Cathedral, [279] or the altarpiece in the Wittenberg city church? [280] The theory that an itinerant artist unconnected with the Wittenberg workshop was responsible for them cannot be taken seriously. Most of them are works of outstanding origin which could hardly have been produced without good connections, experience and the help of a well-trained team of craftsmen. These works, more than smaller pictures, would have required the organizing ability of the master himself, suggesting that Cranach had a direct hand in them – although

46

the extent of his contribution to any one work may have depended on the capabilities of the help available to him at the time.

These great panels introduce us to a strangely deformed version of Cranach's style. The proportions and limbs are exaggeratedly lengthened; poses are awkward, compositions empty, colors dull. Changes of this sort are less noticeable in small and medium-size paintings. The only exceptions are big works which were preceded by exhaustive studies, as was probably the case with the *Altarpiece of the Princes* in Dessau. The large scale shows up Cranach's typical deficiencies in composition and in the study of nature. Little attention seems to have been paid to the overall concept of the big works, but the craftsmanship is uniformly sound. The reputation for meticulous craftsmanship soon earned by paintings of the Cranach school set the seal of perfection on all its products. The customers must have known that they could not expect paintings from the master's own hand; moreover, Cranach seems to have taken a liberal attitude toward substituting journeyman's work for his own. [281]

The hasty execution of big paintings is one aspect of the laborsaving modus operandi necessitated by the unprecedentedly wide range of activity of Cranach's workshop. The master's own work – his drawings, copperplate engravings and woodcuts – accounted for only a relatively small part of the activity. Among these personal works, miniature painting was still strongly represented, [282] and in connection with it were certain heraldic specialties. Cranach and later his sons, too, were considered reliable advisers in this branch of art. [283]

Some important groups of decorative works are known to us only from secondary sources: small canvases painted in a striking technique [284] imported from Italy and the Netherlands, designs for tapestries, [285] wall hangings [286] (a tiny fragment of which survives in Torgau Castle). Cranach must certainly have directed the painting of house façades in clearly articulated designs after the fashion of the time. The most important authenticated examples are the twin houses belonging to Christian Brück and Andreas Pestel on the marketplace in Weimar, where Cranach died. [287] These houses were restored in 1549. *Page 418*

In the decoration of interiors Cranach made use of the *Flaserndruck* technique for reproducing wood grain that had developed as an offshoot of his tone woodcuts. He was probably using this process as early as 1517, although such examples of it as survive were executed several decades later. [288] In this process maple grain is simulated in a kind of wallpaper. It was also used to produce imitation reliefs. Besides collaborating with wood carvers, particularly in creating altars with figural elements, [289] Cranach himself carved models for medals [290] and *Page 428* gravestones to be cast in bronze. [291] The sketch for a chandelier belongs to this context. [292] In all these cases early archival evidence needs to be correlated with surviving works from much later periods before it is possible to gain a clear picture.

Almost the only records of accessories for court festivities and tournaments, part of a court painter's regular work, are bills and receipts. Such work is sometimes very ambitious and must have presented a strong challenge to the artist's inventiveness. [293] Some of it engaged Cranach in areas that had long been the painter's province: the painting of shields and the manufacture of arrows, for instance. [294] And Luther himself called upon the court painter's expert knowledge of costly jewelry in making his translation of the Bible. [295]

¶ CRANACH'S DRAWINGS

Such drawings of Cranach as have survived add little to his reputation. They played only a marginal role in the economics of his work and often served merely to clarify details. Drawing and painting were not separated. He made preliminary drawings for nearly all his paintings, whose layouts often have a pronounced graphic character. One often has the impression that outlines have been filled in with color and details drawn in, and this combination of techniques may well have been an essential factor in the rapidity with which he painted.

In all his long creative years Cranach produced only one-tenth as many drawings as Dürer. Real studies such as Dürer and Grünewald made are rare. Only in his early, independent years did he make use of the creative potentialities of drawing. In the easygoing atmosphere of the later workshop, his tremendous gift for pictorial creation flares up only sporadically: in three *Plates 137–139, 154* sketches for panels in the *Passion* series, [296] in a *Judgment of Paris*, [297] in a treatment of the theme of the fall and redemption of man, [298] in a sketch for the still extant painting of Christ *Plate 165* and the Canaanite [299] and in the sketchbook sheet depicting a wild boar hunt. [300] These are pen drawings superimposed on barely perceptible outlines in black pencil. The masterful pen drawing is deliberately executed, actually doing little more than fill out the penciled concept – but with what decisiveness! The sureness of touch in every definition of space is astounding. Every step he takes toward the larger-scale renderings detracts from this brilliant statement. These are sketches that seem to have been dashed off with a flick of the wrist.

The majority of Cranach's drawings differ radically from these highly personal colored sketches in their neatness of execution and carefully applied washes. In these drawings the specifications for the finished work are precisely set forth. The old German name for this kind of working drawing was *Visierung*. Contracts could be signed on the basis of such sketches, which were so definitive that the execution could be entrusted to other hands, as was the usual practice with stained-glass windows or tapestries in those days.

Examples of such finished layouts are preserved among a series of sketches for altarpieces for *Plate 140* Cardinal Albrecht of Brandenburg's collegiate church at Halle on the Saale. They even include profiles for frames and ornamental settings. The drawings are mounted on movable panels; to heighten the effect, flesh tints are suggested by a pink wash. The stock of the Cranach workshop preserved in Erlangen includes many exercises of this type. [301] Such collections of sketches sometimes included copies of other masters' work – in this case copies of paintings by Dürer in the Wittenberg Castle church. There must also have been cartoons laying out the work on a large scale. The working drawings for a chandelier [302] and a chimneypiece [303] and a sketch in luminous colors for a coat of arms presumably to be executed in stained glass [304] must do duty in our imagination for lost designs for tapestries and cartoons for wall paintings. [305] The big brush drawing of the chandelier resembles the sketches for many of Cranach's paintings. Almost every picture was blocked out in this way, with varying degrees of detail. As the paint has grown transparent with age, the outlines can often be seen quite clearly, especially in paintings or sections of paintings that were executed rapidly with thin *Plate 39* layers of paint, as, for instance, in the *Fourteen Helpers in Time of Need* at Torgau. [306]

Two types of preliminary drawing are to be found in Cranach. One is the bold brush drawing, sometimes going into considerable detail, with wash or hatching used to indicate modeling. The other is a delicate sketch almost like a silverpoint. The first type is much more common; even Cranach's early portraits were blocked out in this way, as we see from the portrait of the lady in Berlin-Dahlem. Probably none of the big altar panels was executed without such preparation. Sketches with elaborate washes in a second tone of gray, which must have looked like big detailed layouts, are rare; we find them in the early *Fourteen Helpers* at Torgau and in the two versions of the story of Judith done in 1531. [307] In both cases there must have been some special reason for such detailed preliminary work. Examples of sketches with pronounced hatching are still to be seen in the 1515 *Holy Trinity* in Leipzig, [308] the *Mocking of Jesus* in Weimar [309] and the *Man of Sorrows* in the same collection. [310]

Plate 39

Plates 84–87

Preliminary pencil drawings, on the other hand, are very rare. They were used in a free, detailed style for the naked figures in the Weimar *Silver Age* of 1527, [311] for the *Venus* of 1532 [312] and occasionally for the final drawings for portrait heads. In schematic repetitions of the latter a very sharp red chalk pencil was also used. [313] Some portraits show no trace at all of preliminary drawing, in which case the work must have been executed directly from the living model or from another painted portrait. Three such portrait heads by Cranach, painted on paper or parchment and used in paintings, have been preserved: those of Count Philipp of Solms (ca. 1520) in Bautzen, [314] Hans Luther (1526) in Vienna [315] and Martin Luther (ca. 1532) in a private collection in Scotland. [316] Before the striking, terse style of these heads – seen at its best in the Berlin-Dahlem head of a beardless man [317] – had been thoroughly developed, a freer solution to the problem seems to have been adopted. The head and shoulders of a gentleman wearing a cap, now in Vienna, [318] an impressive sample of the work Cranach was doing toward 1510, looks like an abbreviated painting. The outlines seem almost to be waiting for the colored brush strokes that will fill them out. The somewhat later head of a peasant, now in Basel, [319] is startlingly lifelike; a smoother copy exists in London, although it was very rare for Cranach to repeat himself in this way. [320] This much neglected study is one of the first lifelike portraits of the common man in German art. The court painter was nearer to country folk than one of his big-city colleagues might have been; he was familiar with their courage and determination from the elector's hunting parties. The hard peasant head with deeply chiseled features, the simple dress, portrayed without the least overstatement – perhaps spontaneously rather than as a commissioned work – are among the most impressive achievements of Cranach the painter.

Plate 149

Plates 115, 116, 117

Plate 64

Plate 72

Plate 63

The workshop models from which the studies of heads derive also include a few paintings such as the heads of Christ and the Virgin painted on a sheet of parchment between 1512 and 1514. [321] Similar works by pupils of Cranach seem to have been inspired by this double study, now in Gotha. [322] Especially worthy of note is the picture of a little seated angel, signed and dated 1526, in Dresden. [323] This study, with barely a suggestion of background, illustrates the unrelatedness of these stock models for future use in paintings. No finished work on this theme (Christ the friend of children?) is known. A model for the severed heads of John the Baptist and Holofernes, now lost, must have been in use for decades. It served for the Neustadt altarpiece of 1510–12 and reappeared, with minor changes, in pictures of Salome and Judith.

Similar files must have been kept of topographical subjects. The most recognizable example of a building carefully studied by Cranach is Coburg Castle, originally the seat of John the Steadfast. [324] Its northern aspect appears on a woodcut showing Duke John Frederick as a boy on horseback, [325] its eastern one on a woodcut of the martyrdom of St. Erasmus [326] and on the right-hand panel of the St. Catherine altarpiece in Dresden – all done in 1506. Other castles shown on early woodcuts [327] and on the center panel of the St. Catherine altarpiece remain unidentified. Mansfeld can be recognized in the 1529 *Stag Hunt*, [328] and Torgau, with its proud John Frederick wing, [329] also appears from time to time. In no case do the workshop models survive, but they must have existed from the reappearance of Coburg Castle in a picture painted by Cranach the Younger in 1558.

Plate 27

Page 25

Plate 33

Plates 162, 211

Plate 232

These workshop models also include a series of trophies of the hunt: unusually big wild boar in striking colors, [330] red deer [331] and a series of birds in their bright plumage. The bullfinches, [332] waxwings [333] and partridges [334] are shown life size, hanging on nails against a wall, with the light catching them. Although the earliest examples that survive are from 1530 or later, Jacopo de'Barbari's 1504 still life (which was probably associated with decorative wall paintings) is clearly recognizable as their model. [335] The signature on one of these sheets notwithstanding, they were probably made not as collector's items but as models for the workshop files. The dead partridges and a hanging wild duck reappear with other trophies and hunting equipment in the so-called *Payment* of 1532 and in the various versions of the Hercules and Omphale theme done in 1532, 1535 and 1537. [336] Since one of the paintings bears the signature of Hans Cranach, it can be assumed that the animal studies of around 1530 are largely the work of Cranach's sons, who provided most of the workshop repertory. The handsome series of studies for portraits from the early years of Cranach the Younger suggests that this was so. [337]

Plates 169, 170

Plates 176–179

So far as models for wall paintings go, practically nothing has survived, except a series of drawings which stand somewhere between notations of ideas and finished layouts. These represent attempts to solve the problem of making individual figures in painted niches stand out. Dramatic poses are repeatedly used: a watchman peers down from the exaggeratedly projecting balcony below a gable; [338] the legs of a sleeping watchman stick out from a niche; [339] musicians [340] or a giant [341] look down as if from behind a high ledge. Putti appear in round niches high up on walls. [342] Motifs of this sort were popular in paintings, drawings and woodcuts around 1509 [343] and probably persisted even longer in wall paintings.

Plate 100

Plates 59, 60, 65

That part of Cranach's œuvre classified as drawings consists preponderantly of sketches for paintings. Pencil or pen drawings not made with a painting in view would be totally lacking if it were not for the early studies of the crucified thieves [344] and John the Baptist in the wilderness. [345] The only pictorially autonomous drawing is the chiaroscuro one of St. Martin. [346] Except for the pair of bullfinches with a tempera wash, it is probably the only drawing signed and dated by the master.

Plates 18, 19, 22

Plate 23

However, Cranach was really challenged as a graphic artist when it came to decorating Emperor Maximilian's prayer book with marginal drawings. The work required was not extensive – only eight pages. But those eight pages were in a place of honor: they followed the forty-six pages with drawings by Dürer. [347] Probably Dürer had already completed his, be-

Plates 89, 90

50

cause Cranach's pages contain many obvious references to motifs used by the Nuremberg master. [348] Cranach's procedure is a simple one. He decorates the right-hand pages of the open book almost perfunctorily and also the first and the penultimate left-hand pages of the section assigned to him, giving himself two double spreads. The sustained, even denseness of these double pages is the most successful feature of the whole project. Other pages are fragmented into ambitious individual motifs which do not hang together. [349] Cranach's astonishing talent for drawing animals is revealed in the continuous lower borders, where a large part of the workshop's repertory of stags and deer is displayed. His most independent contribution, a view of a landscape glimpsed between two little trees which stand out like a window frame, accompanied by a cloud from which emerge the bodies of angels, has generally drawn unfavorable criticism. It introduces a completely new dimension, small scale, yet expansive, into the context of the marginal drawings. The landscape flows into this context, without being counterbalanced by the kind of statuesque figures found in the woodcut of the *Adoration of the Sacred Heart of Mary*. Even Cranach himself seems to have realized the weakness of this valiant effort. It is an isolated attempt to compete with Dürer's versatility even in abstract calligraphy, for which Cranach had no aptitude.

It seems that for this skillful painter the autonomous drawing was an idle pursuit to be avoided so far as possible. Carried along by the impetus of his painting, he never tarried in this inexhaustible garden of experience [350] from which a master like Dürer was able to harvest such rich fruit. Cranach's pictorial vision seems simple and clear. He pursued his goal straightforwardly, relinquishing the treasures to be found on more roundabout paths. His attitude seems to have been communicated to members of the workshop, for the Cranach school never produced significant exponents of the art of drawing.

¶ CRANACH, THE PORTRAIT PAINTER

Cranach's portraits testify to his pronounced gift for this genre. When he was commissioned to execute the Cuspinian portraits and the later ones of Elector Frederick adoring St. Bartholomew [351] and the Madonna, [352] his idea was to portray his sitters in a setting full of relevant allusions. The landscape closely associated with the figures, the book opened to a significant passage are characteristic subsidiary motifs. They reappear later, sometimes extremely clearly, but never again are they used so functionally. Cranach's first portraits are courageous affirmations of a new vision of the world. Nevertheless, the sitter's pose is inhibited, his facial expression subdued. The eye is drawn away from, or beyond, the subject. These are heads engaged in prayer or meditation.

The portraits of Cranach's Wittenberg period are, humanly speaking, more open. The faces, set against a neutral background, are shown only in their relationship to the viewer; they meet and answer his look. The heads have more tension, almost as though they were shaped from

Plates 12, 13
Plates 68, 81

some resistant material. Each man is unmistakably himself, a unit of human topography composed not only of sharp, craggy forms, but also of unseen valleys and quiet plains. Women's and children's faces are explored with loving devotion.

Through Cardinal Albrecht of Brandenburg, the opponent of the electors of Saxony, this type of portrait in a setting of relevant allusions was revived. Several times Albrecht commissioned Cranach to paint him as St. Jerome: before the crucifix in the wilderness, [353] in his *Plate 142* scholar's study (after Dürer's engraving), [354] as a scholar in a landscape. [355] The latter version, painted in 1527, was probably the last of the series; its brilliant richness proves that the last variations on a theme are not necessarily the least.

One of Cranach's early achievements, the portrait engraving, had already been revived by *Page 431* the cardinal in 1520. Cranach's portrait of him [356] was a copy of Dürer's work of 1519 – perhaps even a substitute for it, when the 200 copies that had been printed ran out just as Dürer was about to leave for the Netherlands. But Cranach's attempts to enlarge the format and to recast the physiognomy according to his own conception are proof of the initiative he brought to the task.

This provided an incentive to both artists to pursue the portrait engraving. The cardinal's likeness was followed that same year, 1520, by Cranach's first two portraits of Martin Luther, *Plate 108* the monk: the terse, rugged head and shoulders, with the bearded head (soon to be eliminated) in a corner of the picture, [357] and the more richly conceived variation showing Luther *Plate 109* speaking in front of a niche. [358] The attribute of the book was not appropriate for this man *Plate 110* of the spoken word; Cranach eliminated it from the great lapidary profile portrait of 1521. [359] The impact of this version, which captured all the tension of Luther's appearance before the Diet of Worms, was not lost upon Dürer. His second portrait of Albrecht of Brandenburg, the "Large Cardinal," done in 1523, is also a profile. Dürer also adopted the dark background – a painterly concept which Cranach had added later. [360] Cranach's background (probably derived from Barbari) [361] is produced by darkening the horizontal strokes with vertical ones to create a wall-like effect. This portrait of Luther was Cranach's last engraving; the etched portraits immortalizing Elector Frederick and Philipp Melanchthon were done by Dürer.

Luther was also the subject of Cranach's most important woodcut portrait – which was *Plates 111, 112* actually a by-product of the painting of 1522. [362] In his portraits of "Junker Jörg" Cranach restored to the public eye the hero who had been given up for dead. The "phoenix of the theologians" [363] seemed to have risen from the ashes, putting aside his monk's habit to continue his struggle to change things. In this time of turmoil, disguise and flight were the order of the day. The great humanist Erasmus of Rotterdam had his portrait painted in martial costume by Holbein the Elder at just about the same time, the fall of 1521. [364] *Luther as Junker Jörg* may well be the earliest portrait of a revolutionary in German art. For many years the figure of the reformer stood in the vanguard as a rallying point for the hopes of the oppressed, although after the outbreak of the Peasants' War Luther quickly allied himself with the power of the princes. The burning of his portrait [365] and the lampoon scrawled by one of his enemies on *Plate 112* the margins of the woodcut [366] reflect the strong universal interest in Luther – an interest

52

Portrait of King
Christian II
of Denmark. 1523.
Woodcut.
From the Danish
translation of the
New Testament,
Wittenberg. 1524

catered to by Cranach's print and the innumerable copies of it, some by masters as eminent as Baldung, Sebald Beham, Hopfer and Altdorfer.

Cranach's paintings of Luther reached only a small audience, even though they were reproduced in large numbers. After the *Junker Jörg* of 1522 came the bareheaded likeness of 1525–26, [367] the almost full-face portrait in a cap of 1528–29, [368] and a similar third one, half-length in three-quarters profile, done in 1532–34. [369] In addition there is the watercolor head on parchment, a vivid document which by itself would keep alive the memory of Luther's dreaded glance. [370] After 1539 Cranach the Younger added the last definitive touches to the portrait of the reformer with his bareheaded portrait, [371] which he also executed in a larger format and finally in full length. [372]

Plate 167

Page 93

Cranach's numerous portraits of Luther offer some insight into the possibilities of the portrait in the master's later years. The print, or the painting in different formats and with changes of accessory details, was called on to fill the need of the moment, whatever it might be.

Often it was paired with a portrait of someone else. The reformer appears alone only in versions made before 1522. Those of the years between 1525 and 1528 are chiefly marriage portraits, showing him together with Catherine von Bora. The earlier, small-format ones are intimately conceived and radiant; the later ones, more imposing but more indifferently executed. This theme had reached its limits by 1529. From then on Luther was shown only as a scholar, chiefly in the company of Melanchthon, who first appears in 1532.

The number of portraits of these two reformers is equaled only by those of the two electors, Frederick and his brother John. Numerous commemorative portraits were made after 1525 and 1532, the years of their deaths; they may well have been inspired by political motivations, as well as by personal gratitude. Since 1523 the emperor's entourage had been asking whether the house of Saxony should not be disinherited because of its position on the Luther question, [373] and Elector John had been refused investiture on this ground. His association with Elector Frederick, who was respected throughout the whole empire, was an important instrument in the defense of his rights.

Page 53
Plates 121, 122
The deposed King Christian II of Denmark, who was Cranach's guest in the fall of 1523, three times permitted the printing of his portrait and coat of arms in defense of lost rights. The most remarkable is the profile portrait with the Danish translation of the New Testament; [374] the most impressive, the single sheet with shield and supporters. [375] If the two paintings are included, the king was portrayed five times within a short period. Except for the profile, all the portraits apparently derive from a single model; the dress, the position of the hands, the setting and the heraldic details distinguish them. All these accessory details were interchangeable; they demanded a certain experience but no particular study.

Plates 146, 147
One portrait could inspire a whole series of variations. Sometimes a work by another artist sufficed as a model, as in the case of the portraits of Albrecht of Brandenburg and even of Elector Frederick. [376] Cranach's portraits of Duke Albert of Saxony, [377] the humanist Rudolph Agricola [378] and Erasmus of Rotterdam [379] could never have been made without the help of models by other artists. On the other hand, painters such as Holbein the Younger and Georg Pencz made similar use of portraits by Cranach. [380]

Cranach's success as a portrait painter rests on a mental flexibility which permitted him to make contact with individuals of all types. The image of the *cera Lucae*, or "Lucas' wax," which was supposed to take on the mortal features of the sitter [381] was a felicitous one. The artist always showed great openness toward his sitters, and this gives many of his portraits an unusual forcefulness. After the early portraits of scholars, the following pairs stand out: Duke
Plate 61
John the Steadfast and his son John Frederick, [382] a young man with a rosary [383] and a
Plates 62, 82, 83
woman in a Dutch hood, [384] and Duke Henry of Saxony and Duchess Catherine, painted in
Plate 119
1514. [385] The portrait known as the *Burgomaster of Weissenfels*, [386] remarkable for being painted on parchment, was done in 1515; the elegantly dreamy portrait of a young man in Schwerin in 1521. In the 1524 *Portrait of a Gentleman*, now in London, [387] a courtly type of portrait makes its appearance; it can be grouped with several portraits of ladies of the same
Plates 123, 124
period. [388] A well-tried, straightforward approach marks the portraits of Duke John Fred-
Plates 117, 118
erick and his bride, Sibylle von Cleve (1526), [389] the simple twin portraits of Luther's parents
Plate 136
of the following year, [390] and the extraordinary ones of Dr. Johannes Scheyring (1529) [391]

and Johannes Carion, [392] astrologer and historian at the court of the electors of Branden- *Plate 135*
burg. The most ambitious portraits, comparable in grandeur to Dürer's unforgettable portrait
of Frederick the Wise, [393] were those of Cardinal Albrecht of Brandenburg [394] and the
young Elector John Frederick. [395] In a last great full-length portrait painted in his old age, *Plate 134*
Cranach portrayed the gray-haired Duke Henry of Saxony. [396] After that the aging master's *Plate 187*
hand turned to smaller pictures. [397] A light, transparent portrait like that of the electoral
chancellor, Dr. Gregor Brück, painted in 1533, [398] anticipates the sober style of Cranach the *Plate 133*
Younger, although it cannot be attributed to him.

Cranach's portraits of children were often particularly successful, as we see from the fact
that Emperor Charles V is said to have carried Cranach's portrait of himself as a child on his
person during the campaign of 1547. [399] A bent for this kind of subject is already evident in
the woodcut of the three-year-old Duke John Frederick riding a horse [400] and his portrait as *Plate 27*
a flower boy in the St. Catherine altarpiece of 1506, in the children with the wicker sled on the *Plate 35*
Frankfurt altarpiece of 1509 and in the woodcut of the Holy Family. [401] The child is not
a subject for searching study; he is seen and understood in the perspective of his own world.
A capacity to identify with the young faces he painted enabled Cranach to resolve problems
extremely successfully, as in the portraits in Detroit, [402] those of Prince Joachim of Branden- *Plate 113*
burg and Prince John of Anhalt wearing armor done in 1520, [403] the portrait of a girl in *Plates 114, 143*
Paris [404] and the little Dukes Maurice and Severin of Saxony done in 1526. [405] Here again *Plates 125, 126*
Cranach the Younger nobly carried on his father's tradition.

The specific thrust of the painted portrait can best be appreciated in the life-sized, full-length
likeness, justifiably regarded as one of Cranach's triumphs. The earliest surviving example,
done in 1514, is of Duke Henry of Saxony and his wife, apparently painted on a single pan- *Plates 82, 83*
el. [406] Here Cranach probably owed his inspiration to the courtly miniature portrait, a
genre he himself continued in a family album of the house of Saxony which is still in existence.
[407] In small format his full-length figures are in no way exceptional, as we can see from the
beautiful panel of a lady with an apple, sumptuously painted in black on black, which was *Plate 132*
formerly ascribed to 1527. [408] Few full-sized pictures of this type survive. Portraits of
horsemen which Cranach is said to have painted have not survived, except for one drawing. [409] *Plate 120*

According to Scheurl, "to paint people and to paint them in such a way that they can be
recognized by everybody and seem to be alive" merited "the highest praise, not attained by
many mortals." [410] Cranach's portrait of the prince, which his subjects saluted when they
caught sight of it in the window, was a much admired achievement. A naturalistic likeness was
almost naïvely sought after – and often achieved to an astonishing degree. Cranach's skill as a
portrait painter resides in the existential vitality that emanates even from insignificant portraits.
The technique is usually simple. Only the faces and certain details of the setting, the jewelry
or the patterns on the costumes are treated in depth. [411] Cranach had the reputation of hav-
ing brought the painting of black costumes to the height of perfection. [412]

Hands, which required a lot of study, are usually indifferently rendered. Even in figural
compositions like the *Fourteen Helpers* at Torgau, they are often concealed. In the Cuspinian
portraits they are more or less hidden by the sleeves. Folded arms, pathetically deformed
fingers, perfunctory drawing are common. Hands are often used to display seal rings, demon-

strating the distinguished origin of many of his subjects. The position of the hands seems to have been governed by fixed rules. In the portrait of Frederick the Wise done about 1522, [413] *Plate 45* he is holding his hands in the same position as in the Frankfurt altarpiece of 1509, and Cranach *Plate 52* repeated this position again in his self-portrait in the Holy Family panel. [414] So it is very *Plate 14* noticeable when hands are unusually foreshortened, as in the 1503 portrait of a scholar, the *Plate 56* figures in the Dessau *Altarpiece of the Princes* and the half-length *Christ Giving His Blessing.* [415] *Plate 135* Only a few hands seem to be true likenesses; the right hand of Johannes Carion may perhaps *Plate 217* be one example. Cranach the Younger's portrait of his father, painted in 1550, is unique of its kind; [416] even in his later work it has no parallel.

This can be explained only by the fact that Cranach did not yet consider the representation of hands essential to the portrait. As long as the hand was not an organic part of the portrait, it was impossible to produce a convincing impression of action. This is why Cranach's portraits usually lack the dynamic element found in many contemporary ones, including those of Dürer, which were perhaps inferior in so far as physiognomical development is concerned. If more could be learned about the significance of the formulas used by Cranach, important insights into the convention of his time would probably be gained. A better idea of the restrictions imposed by tradition and custom can be realized from his treatment of hands than from any other item in his work.

¶ CRANACH'S SELF-PORTRAITS

Sixteenth-century art is anything but rich in self-portraits. The plentiful examples by Albrecht Dürer are the exception; other outstanding German painters are not represented at all. The convention of a painted self-portrait, individually framed and publicly displayed, did not yet exist. Only after Dürer's death was his self-portrait of 1498 hung in the city hall of his native Nuremberg. If an artist portrayed himself alone, as an isolated subject, there was always some compelling reason for it. Dürer's endeavors in this line came to an end with the famous portrait of the year 1500.

The self-portraits of Lucas Cranach known at present show him as a participant in scenes with many figures – the same kind of setting he used for portraying his patrons. Dürer too included his own portrait as a subsidiary character in some outstanding pictures painted after *Plates 52, 53* 1500. Cranach appears as Alphæus in the *Holy Family* in the Vienna Academy, [417] as a watchman with a halberd in the Kremsier *Execution of John the Baptist* [418] and as a dark, portentous *Plate 150* figure behind Holofernes at the table in the Gotha version of the Judith story. [419] In these three cases the figure bearing Lucas Cranach's features stands on the left margin of the picture – the introductory figure on which the eye first falls. Since both the Kremsier and the *Plate 151* Gotha panels were one of a pair, this position at the opening of the pictorial sequence is a very conspicuous one. There is more behind this than an artist's vanity.

The Vienna panel was painted in 1510, those in Kremsier and Gotha in 1515 and 1531. If *Page 415* Dürer's 1534 drawing in Bayonne [420] and the well-known portrait by Cranach the Younger *Plate 217* in Florence, [421] are included, the artist's appearance at the age of about forty, forty-three,

56

fifty-two, fifty-nine and seventy-seven is documented. The degree of likeness varies. In this respect the large-scale portraits are obviously superior to ones showing Cranach in subsidiary roles; the Florence portrait of 1550 is outstanding for its portrayal of the hands. Dürer's drawing and the painting of Lucas the Younger stress Cranach's active side – his energy and the straightforwardness of his nature. His self-portraits, on the other hand, show a quiet man, low-keyed, with an aura of dark foreboding; they emphasize the melancholy features which, in the humanist view, are an intrinsic part of the artistic personality.

It is startling to encounter these traces of somber self-esteem in full life size. They are to be seen in a hitherto neglected painting in the living room of Frederick William IV of Prussia at *Frontispiece* Stolzenfels Castle near Coblenz. [422] Against a black background we see a big, broad, very strong face with brown eyes, brown hair and a gray beard. The costume is brownish, but this can probably be attributed to overpainting. The picture was probably not completely finished. The loose drawing and sharp edge of the hair on the forehead and the sketchiness of the lips and earlobes tend to confirm this. The face is practically untouched by overpainting. Despite all the doubtful aspects of the work as it appears today, the original structure is perfectly clear: a big head-and-shoulders portrait without hands, showing a characteristic turn of the head. On a picture of this size, the obliquely raised head is particularly effective. The sideways glance directed at the viewer and the wrinkle between the eyebrows intensify the expression. It must be added that the forceful movement of the head now seems abruptly divorced from any connection with the upper part of the body. Of all of Cranach's portraits of individuals, the expectantly raised head of Cuspinian is the most comparable. The self-portrait in the Gotha *Plates 12, 150* panel shows the same position of the head (this time wearing a cap), but there it is linked with the pointing gesture of the hand and incorporated into the action of the picture. It is perfunctorily repeated in Cranach's self-portrait as a subsidiary figure in the *Sacrifice of Elijah* in the Dresden Gallery. [423]

The date of 1531 on the Gotha panel probably corresponds more or less to that of the Stolzenfels portrait. On both the beard is gray; later it was shown as white. Cranach still wears his hair in the same style as in Dürer's drawing of 1524, the style worn by Dürer himself at the time; by 1542 at the latest he was wearing it short. What is seen in the Gotha panel is Cranach at the age of about sixty – the man who in 1534 could say that the last time he had been ill had been thirty-two years before. [424] The shadow that seems to overhang the portrait cannot have anything to do with his personal life. The court painter's reputation was at its height. He had been a city councillor of Wittenberg since 1519 and in 1528 was listed as one of its richest citizens.

During 1528 Dürer, Grünewald and probably Cranach's father all died. A great age seemed to have come to an end. This was not merely the subjective impression of an artist who had been particularly closely connected with Dürer; Melanchthon's comparative evaluation of the originality of Dürer, Grünewald and Cranach of 1531 reads like an epitaph in which the living Cranach is flanked by two dead heroes. [425] Dark days lay ahead, as Martin Luther indicated in his words on Dürer's death. [426] The years following the suppression of the great Peasants' War brought unmistakable signs of a coming military clash between the emperor and the German princes. After much postponement it finally broke out in 1547, affecting Witten-

berg severely. With the protest of the Protestant estates at the Diet of Speyer in 1519 the fronts had been drawn. The formal coalition of the Protestant princes and the imperial estates in the League of Schmalkalden followed in 1531. This alliance was clearly directed against the threat of the emperor.

When it was asked whether resistance to the emperor was compatible with Christian principles, the theologians would cite the story of Judith, who, with God's help, freed her country from the tyrant's rule. The Swabian League had adopted Judith as a sort of patron saint. [427] The Gotha panels certainly have some connection with this argument. One of them shows the tyrant at table in the full glory of his power; the other depicts his assassination by Judith, who, in a significant reiteration, appears in the center of the first picture and again in the principal scene of the second. Cranach's personal endorsement of this Protestant moral position is emphatically declared by his self-portrait on the two Gotha pictures, which rank among the freshest and most vigorous works of his later period.

Prince on a Boar Hunt.
Circa 1506. Woodcut

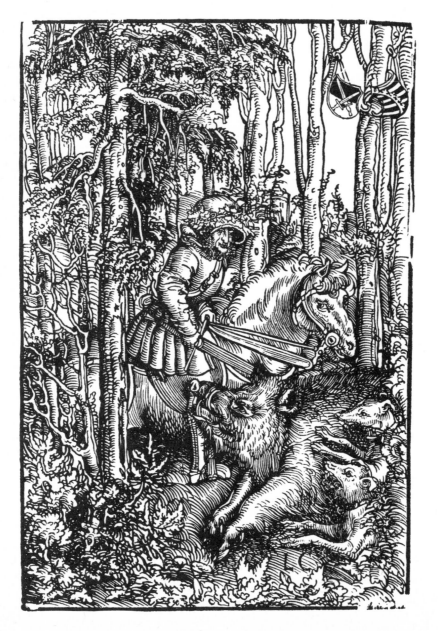

The characteristic strength and concentrated self-affirmation of this figure leave little doubt that it is a self-portrait. Giorgione, the great Italian pioneer, left a record of himself in a similar pose – a study on paper of his own head, preserved in Budapest as a fragment in a later patch-work. [428] Again, the Christ in the great *Mocking of Christ* by Hieronymus Bosch in the Escorial looks down from the picture in the same pose; Bosch's heightening of it brings it even closer to Cranach's. [429]

Is it purely by chance that one is reminded of Bosch and Giorgione, two of the most distinctive figures at the opening of a new chapter in art history? Cranach was connected with both of them. His portrait of the humanist Cuspinian, "the greatest northern emblematic portrait," [430] rests on the same foundation as the Venetian artist's emblematic portraits. In its feeling for nature his *Holy Family* of 1504 is the counterpart of Giorgione's thunderstorm. Cranach once copied Hieronymus Bosch in an altarpiece [431] and may have come to know several of his works during his visit to the Netherlands. In neither case is there any question of direct borrowing of motifs. Rather, the similar attitudes of mind, combined with strong personal emotional reactions, common to all three artists, different as they were, led them to similar solutions. Cranach's achievement is a witness to his long-standing independence of mind and artistic self-confidence.

Plate 12

LANDSCAPE

The portrayal of landscape was very important to Cranach, yet his work includes no autonomous pictures of it, nor, in fact, any landscape studies of the kind we find in drawings by Dürer. Cranach uses landscape for decorative purposes in a few portraits, all major ones, in many pictures of saints and in various miscellaneous works, notably the group of hunting scenes. The human subject or group of subjects is always associated with a clearly defined landscape – nature as a specific instance of the experienced world. In this landscape man is seen in the light of feelings inspired by nature. In Cranach's early pictures of this type the characters depicted are the entranced and the ecstatic, penitents and victims of the executioner. Even the gentlest examples are pervaded by an inner turmoil. Representations of architecture sometimes seem intended almost as stony symbols of social injustice, especially during the brief period from 1509 to 1515, in paintings and prints depicting the Passion of Christ and in the *Expulsion of the Money Changers from the Temple*.

Page 58

Cranach's formal vision of landscape was certainly shaped to a great extent by memories of Franconia and southern Germany, but step by step, the process by which it was incorporated into his pictures can be traced. The details – individual trees and bushes, castles on hilltops or rivers – change relatively little. At first – and later, too, when inspiration flagged – clouds, hills and clumps of trees are used as fillers in the scenic background. Cranach likes to show trees and bushes rising beside the figures or against the margins of the picture. Only gradually do the individual configurations begin to create a depth dimension. These endeavors bore their most beautiful fruit in the landscape views in the woodcuts of the Temptation of St. Anthony

Plate 26

Plate 41

of 1506 and the penitent St. Jerome of 1509 and in the Madonna in the Thyssen collection – rather late fruits, considering the cooler tone that was beginning to pervade his painting at that time, after his visit to the Netherlands. What Koepplin described as a marked tendency toward "composing pictures in compartments which, while not lacking in spatial depth, still retain a two-dimensional quality" obviously leaves no room for development. Cranach's infrequent use of lively configurations in his later periods deprives his landscapes of much of their sparkle. His early skies filled with angrily gathering storm clouds are replaced by simple, regularly divided planes of light. Koepplin also speaks of Cranach's "radiant structural pattern"; this too derives less from close observation of nature than from a naïve sense of effective pictorial composition.

What Cranach was trying to depict was not so much the clear spatial expanse of nature as the combination of figure and landscape in an often surprising fusion. The blending of so many different elements might almost be compared with the processes of alchemy. This style was therefore particularly effective for expressing the burning desire to understand still ungrasped connections.

St. George Killing the Dragon. Circa 1512. Woodcut. Paired with the woodcut on page 61

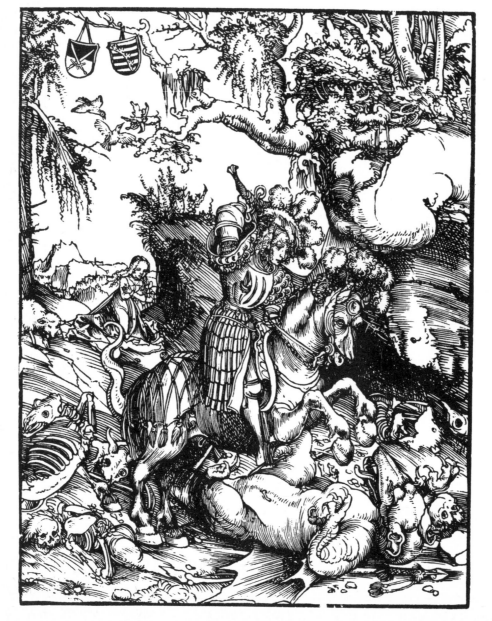

Landscape in Cranach is a receptacle that brings together all kinds of relationships. Investigation of this aspect of it has so far been confined to the study of the wealth of attributes in the background of the Cuspinian portraits. The key to the identification of an otherwise mysterious painting of a mother and child at Wartburg Castle near Eisenach as the princess in the legend of St. Chrysostom is provided by one tiny figure. In the background of the painting is the figure of the penitent, creeping about on all fours, naked, just as he is shown in the engraving of 1509. It can be assumed that in many other instances the background communicates some particular substantial meaning – in the pictures of water nymphs, for example. In this connection it is useful to note the vases where Cranach dispensed with a landscape background altogether – in the numerous pictures of nudes against dark grounds and in elegant portraits of the more conventional type suitable for family portrait galleries. Here the monotone ground serves to heighten the effect at the cost of richness of meaning. In many cases a hint of landscape is provided by the pebbly ground on which the figures stand – something Cranach probably derived from Venetian models by way of Dürer – but even this familiar spatial setting is finally eliminated. The full-length portrait of Henry the Devout of 1537 stands against the kind of

Plate 187

The Werewolf.
Circa 1512. Woodcut.
Paired with the
woodcut on page 60

elementary architectural ground that in a more highly developed form was to become Cranach the Younger's standard background.

One meaning of Cranach's landscape scenes can be explained even more precisely. The castles shown in many pictures in careful topographical detail are allusions intended to connect the picture with a certain ruler. A view of one such building suffices to transform a poetic description of nature and its anonymous forests, rivers and towns into the domain of a particular prince. Allusions of this type are casually woven into the St. Catherine altarpiece of 1506, but only in *Plate 162* the hunting pictures painted around 1529 do they begin to contribute substantially to the theme. The Hamburg triptych showing the three electors has a vast landscape background. Allusions to dynastic power are fully exploited in the important pictures endorsing the Reformation commissioned from Cranach the Younger for the Anhalt princes and the electoral house of Saxony. Most of the surviving pictures of this period showing views of various towns reflect the interest of the ruling princes. The earliest pictures of Wolfenbüttel (Cranach the Elder), Magdeburg and Leipzig are the result of their having been besieged by princely armies. At the same time the rare commemorative pictures of burghers that include a view of a city – a genre which Peter Spitzer brought to Wittenberg from lower Germany – begin to disappear. For similar reasons *Page 427* pictures of ceremonial investitures in the *Spalatin Chronicle* of 1513, illustrated under Cranach's supervision, always show a window overlooking the landscape.

Cranach's observation of nature never goes beyond his commission; it serves to fill the picture space, not to press forward into unknown country. The surviving drawings include no example of nature studied for its own sake, no studies of architecture. Cranach the Younger's descriptions of nature show considerable developmental possibilities – including even a snow landscape more or less contemporary with Brueghel's – but public interest in landscape was diminishing noticeably at this time. The upswing of interest in landscape painting at the beginning of the sixteenth century, in which Cranach played a decisive part as founder of the so-called Danubian school, did bring together a relatively large group of German painters, including Altdorfer and Huber, but it never succeeded in establishing a cohesive tradition. Cranach's case shows that this was attributable to social factors. The merit of his painting lies in his having retained the detailed description of nature which creates a setting – and a mood – for the action of his figures. The attempt – discernible from time to time – to preserve the whole fabric of middle-class achievement in the field of art beyond 1525 received little material encouragement from society.

¶ COMMISSIONED PICTURES

Cranach's œuvre rests on the foundation of his religious works and his commissions as court painter at Wittenberg. Commissions from princes – or merely their patronage – gave impetus to the decoration of the Wittenberg and Torgau churches. [432] Many surviving altarpieces in city churches in Saxony were commissioned by burghers, including large-scale works such as the one Cranach painted between 1510 and 1512 for St. Joseph's Church in Neustadt-an-der-Orla, [433] which is seven and a half feet high, and those in Zwickau (1518) [434] and Grimma;

[435] the altarpiece in Bernau is the work of a pupil. [436] Good medium-format paintings are
to be seen in the city churches of Aschersleben, [437] Jüterbog [438] and Naumburg; [439]
others, such as the Leipzig *Holy Trinity*, painted in 1515 to commemorate the plague, [440]
or the altarpiece of about 1518 in the Franciscan church in Torgau, [441] are of similar origin.
Through the generosity of noble donors, smaller altarpieces found their way to village churches
like Goseck near Naumburg, Kade near Genthin [442] and Klieken near Coswig in Anhalt.
[443] Most of these works were done between 1510 and 1520. At that time Cranach was col-
laborating with wood carvers, possibly with the Heffner workshop in Wittenberg. [444] The
altars in Neustadt, Grimma, Kade and Klieken show that the late Gothic carved altar extended
its influence as far as the Wittenberg workshop.

If the extant examples are not deceptive, nearly all the notable churches in the electorate of
Saxony must have been decorated with altarpieces from the Cranach workshop: the cathedrals
of Meissen, [445] Merseburg [446] and Naumburg, [447] the collegiate churches in Chemnitz
(now Karl-Marx-Stadt) [448] and Zeitz, [449] the Erfurt Cathedral, [450] and the principal
churches of the Hohenzollern seats at Halle on the Saale [451] and Cölln-an-der-Spree (Ber-
lin) [452] and of the Anhalt family in Dessau [453]. Cranach even seems to have done work
for two cathedral churches in the neighboring principalities to the northeast, in Kammin (now
Kamenec) in Pomerania [454] and in Fürstenwalde near Berlin. [455] If the two excellent Ma-
donnas from the cathedral of Breslau (now Wrocław) [456] and the collegiate church in Glo-
gau (now Głogów) [457] and the altarpiece for Eichstätt [458] are included, all the diocesan
churches in the region, including Brandenburg (the diocese to which Wittenberg belonged),
Magdeburg and Halberstadt, were represented.

63

This dense concentration of Cranach works has to do with the close relation the princes and the Saxon nobility maintained with the leading churches of the region, whose chapters were composed entirely of noblemen. Little is known about the specific motives of the men who commissioned the works. In the case of the Eichstätt altarpiece, the middle panel of which is identified by the coat of arms as a gift of the House of Wettin in 1520, one can assume some connection with the actions of Bishop Gabriel von Eyb in the Luther question. Frederick the Wise was acquainted with this "most learned of the German bishops," [459] the overlord of Luther's great opponent Dr. Johann Eck, professor at Ingolstadt. Eyb was the first German

Bust of St. Margaret. From the Wittenberg *Heiltumsbuch*. 1509. Woodcut

bishop to publish (on October 29, 1520) the bull Eck had brought from Rome threatening Luther with the ban. [460] The gift of the altarpiece by Frederick the Wise probably anticipated Eyb's decisive stand. The two saints of the diocese stand before the bishop as compelling, invocatory figures. The St. Sebastian on the inner left side panel is a portrait, probably that of Count Philipp of Solms, an adviser of the Saxon elector who negotiated for Luther's protection in those unsettled times. [461]

Plate 115

Similar motives probably led the Saxon electors to place the services of their court painter at the disposal of Cardinal Albrecht so frequently between 1520 and 1529. As archbishop of Mainz, Cardinal Albrecht was the direct superior of the bishop of Eichstätt. This may well explain the fact that just when Cranach's human and business ties to Luther were becoming evident, [462] he was also executing many works for the other side. [463] A striking number of models for altars include accessory pictures of saints that are clearly important elements in a carefully worked out iconological context. [464]

Plate 140

64

The number and scope of Cranach's commissioned works during this period led to a certain flattening of style. One does not feel that these pictures are the fully matured fruit of vigorous seeds. It is true that the works follow a certain sequence, since every change presupposes a model. But from this time on, the pictures seem isolated from one another rather than linked together. Mere transpositions create the illusion of lively inventiveness. Many paintings show a flaccidity which does not necessarily affect the richly elaborated component parts. Content and formal idiom fall into repetitious patterns.

In the absence of authenticated dates, the sequence of the various versions of a theme can

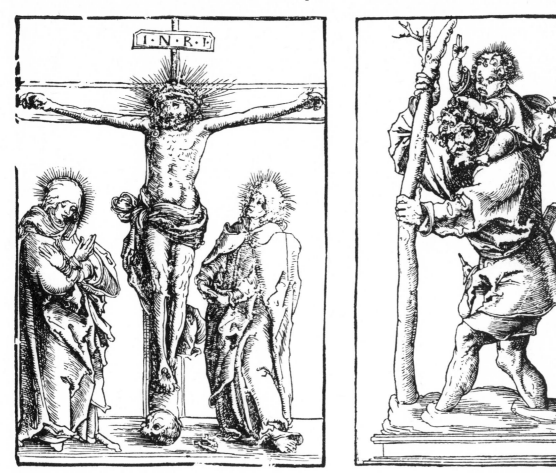

Crucifixion of Christ and Statuette of St. Christopher. From the first edition of the Wittenberg *Heiltumsbuch*. 1509. Woodcut. London, British Museum

be confusing. The pictures themselves provide little evidence of any immediately recognizable process of inner maturation. Outward forces constantly prompt sudden shifts, which obscure many lines in the genesis of the works.

Cranach's workshop in its growing years was itself a many-membered body. Well disciplined as it was, thanks to the pedagogical capacities of Lucas Cranach the Elder, the idiosyncrasies of some of its members left their mark, although often only briefly because of the regular turnover in journeymen. The Neustadt-an-der-Orla altarpiece is generally considered an early product of the workshop, and even the right side panel of the St. Catherine altarpiece of 1506 already reveals the hand of a very meticulous collaborator. [465]

Plate 330

The dilution of content is particularly noticeable in Cranach's treatment of old themes: in the pictures of the Holy Family [466] and the Crucifixion, [467] of St. Jerome [468] and St. Francis, [469] and of the holy martyrs. While there are certainly personal reasons for this, there are also many more general ones, which also affected artists like Baldung, Schäufelein

and the Dutchman Lucas van Leyden. [470] The Reformation restricted the use of pictures of saints for religious purposes so that they were no longer commissioned in large formats, although small pictures of the Virgin remained popular and were tolerated for a long time.

After years of gloomy foreboding, of pictures of the Passion and the martyrs, the new mood in German art now focused on the gentle radiance of the life of the Virgin. Dürer led the way *Plate 21* with the famous woodcuts made between 1501 and 1505; [471] Cranach's *Holy Family* of 1504 is a brilliant synopsis of early versions. The subject, broadened to include the other members *Plates 45, 53* of the Holy Family and by the addition of charming genre elements, was treated in two paintings and a woodcut. [472] The Holy Family appears again in a landscape setting in the woodcut of 1509, [473] encircled by angels in a later woodcut [474] and on the inner side panels of a little Saxon altar around 1514. [475] These two panels, usually displayed and reproduced in reverse order, show on the left the education of the Virgin and on the right the Holy Family resting at the spring. The *Birth of Christ* in Naumburg Cathedral may have been the center panel of this altarpiece. [476] It demonstrates the transition in Cranach's paintings to a more domesticated landscape. Carefully constructed walls, paths, bridges, and castles standing benignly on hilltops create a feeling of security; the figures are surrounded by costly household items, a loom or a book; the angels have lost their frolicsome look. The Dessau painting of the Madonna with saintly women, done in 1516, goes a step farther. [477] Here the figures are shown against a landscape; the color and richness of costume are subdued and more quietly treated, perhaps reflecting impressions gained in the Netherlands. The trees in the background, still brilliantly painted – the broad band extending almost halfway up the sturdy trunk is a later addition – seem unsubstantial and rootless, like a net suspended over the picture plane.

Landscape recedes, though it is still present in the pictures of Madonnas and half-length female saints which are Cranach's most beautiful achievements during this period. Forerunners of these half-length figures are to be seen in Dürer's so-called Dresden altarpiece and in *Plate 56* Cranach's *Altarpiece of the Princes* in Dessau, both of which probably stood in the Wittenberg Castle church. The Dresden altarpiece was clearly modeled on the type of Madonna portrayed *Plate 55* in Cranach's Breslau panel. [478] The cushion of rich fabric, the bunch of grapes in the Child's hands, the veils and the signet ring on the ledge bearing Cranach's coat of arms in a colorful setting – all economically suggest a sumptuous interior. Behind it, without any kind of transition, rises an untamed mountain landscape with trees and scattered clouds. Later versions of the Madonna, such as the charming panel of 1516, are simpler in structure but retain the landscape background. [479] This background seems generally to be associated with women. As *Plate 145* late as 1525 St. Barbara [480] and St. Mary Magdalene [481] are shown against landscapes, as are the most prominent saints on the inner side panels of his altarpieces. [482] In later years the landscape background in Madonna pictures is more economically treated; arborlike configurations enclose the figures; [483] black draperies screen them from the outside world, which is often represented simply by a dark ground. [484] This treatment, which occurs in countless variations, persisted long after the Reformation and in small format until about 1560. [485] Mary, Mother of God was probably the theme of the last saint picture Cranach painted. We have a record of the settlement of a bill for a Madonna picture in Augsburg in 1552.

The courtly version of the Madonna theme, the Adoration of the Magi, was treated by Cra-

nach several times, most characteristically in the Gotha painting. [486] This great composition *Plate 92*
is put together with a minimum of figures – essentially the one that balances the figure of the
Madonna and the one of the second king. The rest of the picture space is filled in with faces,
costumes, scenery and massive golden gifts mutely proffered to the Child. But everything is
pervaded by a silent presence. The setting is powerfully suggested by a diagonal arrangement
of wooden posts. The articulation of planes appears deliberate; the few quiet colors are linked
by narrow patches of green and yellow. This Gotha *Adoration of the Magi* seems so essentially
the handiwork of Cranach that the idea that it might be his answer to Dürer's panel of 1504,
then in the Wittenberg Castle church, [487] seems at first glance untenable. Yet drawings
exist of this much admired picture of Dürer's, the first truly clear picture in German art, [488]
made in Cranach's workshop. [489] (The head of Cranach's first king, though, seems to be
derived from some simplified modification of the one in Dürer's painting.) If this observation
is followed up, it seems probable that Cranach's work is simply a revered copy of Dürer's cen-
tral group. In the linking of the second and third kings, a fragment survives of Dürer's con-
cept of a figural center axis, supported in his picture by the high plane of the wall. The studied
colorfulness of the Moorish king and the recurrent patches of green are also taken from Dürer.
A comparison of the two pictures brings out not only the deficiencies of Cranach's spatial con-
struction and the woodenness of his figures, but also his power to cancel out his deficiencies
with two eloquent heads, an effectively painted robe and a tiny glimpse of landscape. The
woodcut of the elector adoring the Madonna is an impressive condensation of the basic theme *Plate 81*
of his painting. [490]

A later version of the Magi theme in Naumburg, probably done no earlier than 1520, [491]
belongs to a different context and seems strikingly indebted to another model, [492] although
certain details also go back to formulations of Dürer's. [493] By piling up detail, Cranach com-
pensated for effects he was not able to achieve by articulation. Nonetheless his pictures are
straightforward and impressive and have greater impact than many more profound master-
pieces.

The general toning down of motifs can be followed particularly clearly in pictures of the
Passion, of which examples from all periods exist. The oblique view of Christ on the cross
gradually reverted, through a series of transitional shifts, [494] to a front view, where it
remained fixed under Cranach the Younger. Highly individual angled poses, as in the figure of
Christ at prayer, [495] are later straightened out. A telling example is the profile pose in *The
Agony in the Garden*. As the movement becomes quieter, more accessory detail is used. Small *Plate 4*
formats seem richly interwoven with delicate shrubbery, moss and pebbles. This digression *Plate 88*
into detail becomes noticeable exactly at the time when a gentler tone begins to pervade Cra-
nach's work. Later it too was affected by a new conciseness, stemming partly from the large
formats Cranach was then using.

When Cranach turned to a new subject like the Mocking of Christ, which occupied him *Plates 84–86*
between 1515 and 1520, [496] he came up with a wealth of inventions, apparently quite unin-
hibited by Dürer's model. [497] The figures in the painting are very carefully and delicately
drawn, but there is so much going on, all of it apparently on the same level of significance,
that the impact of the brutality is weakened. Man's vanity and triviality – all the mechanics of

human wickedness – are brought terribly close, overwhelming the figure of Christ. Greater breadth of action is achieved by sacrificing depth. The naïvely drawn wall, with its sketchy foreshortening and clumsy window, accompanied by a column whose capital contains a squinting animal head, furnishes a meager background which has an extremely sobering effect, especially when it is compared with the strong subsidiary motifs of earlier pictures.

Plate 36 After the portrayal of Christ as the Man of Sorrows, flanked by two praying angels on the back of the *Fourteen Helpers in Time of Need*, [498] Cranach's treatment of this theme was decisively influenced by Dürer's engraving of 1509. [499] His 1505 painting of the scourging of Christ was based on it. [500] There seems to be some iconographical connection between this painting and the woodcut of the adoration of the Sacred Heart of Mary; the same group of saints is shown kneeling at Christ's feet. The first half-length picture of Christ as the Man of Sorrows must have been done shortly after this. Among the many versions, some much later,

Plate 87 the Weimar fragment with angels holding a curtain [501] stands out by virtue of the strong preliminary drawing, indicating that this is a new or a transitional treatment of the theme.

It is difficult to determine to what extent secular considerations influenced some of the pictures of female saints. Most of the pictures of Judith, Salome, Bathsheba, Adam and Eve, and Christ and the adulteress cannot be completely explained simply as biblical subjects. Along with the pictures of Venus, Diana, Lucretia and the Graces and of biblical and classical scenes, they belong to the vast field of erotic subjects that flourished in the second quarter of the sixteenth century.

Samson Pulling
Down the House.
From *Das Ander Teil
des Alten Testaments*,
Wittenberg. 1524.
Woodcut

68

¶ HUMANIST THEMES

As regular subjects in the formative education provided by the university town of Wittenberg, classical mythology and history also played a role in Cranach's range of themes. *The Sacrifice of Marcus Curtius*, *Venus and Cupid*, *The Judgment of Paris* – triumphs of the early years in Wittenberg – were the basis of whole series of later works. But the information about the early Wittenberg years that can be gleaned from the sources suggests that these were exemplary figures which had caught the interest of the artist or of his patrons rather than part of a comprehensive treatment of classical subjects. [502] To take one example, Cranach painted many Lucretias but not a single scenic representation of her story. The monumental figure of this classical heroine incorporates her tragic destiny, just as in the sphere of religion the figure of Christ the Man of Sorrows stands for the events of the Passion. This conception of the theme simplified the formal approach; varying the figure became the artistic aim in most pictures. The individual works in a series, often difficult to date, are linked not by a common inner generating force but by comparable accessories such as fashionable jewelry.

Page 29

Plate 155

Page 429

Classical themes come to the fore in Cranach's paintings only after 1510. They persist until Cranach's final productive years but after that seem to have played only a minor role, at least so far as dated examples go. We do not know as much as we should like to about the artistic stimuli that first aroused his interest. For some subjects, Italian models, which also inspired Dürer around 1514 or 1515, [503] were the decisive influence. The gently extended hand of a remarkable Lucretia [504] recalls Francesco Francia, whose painting of the same subject is preserved in Dresden. [505] The picture opens on an Italian landscape. This is not the earliest treatment of the subject by Cranach or one of his pupils. An earlier one exists in two versions, one in a Swiss private collection [506] and one in Basel; [507] it was copied by Hans Döring as early as 1514. [508] The frequently mentioned Lucretia drawings in Berlin [509] are new versions of a motif created about 1525 which had been revised to the point of exhaustion. Here for the first time – in keeping with the late date – the nude female form is revealed in full perfection, later to reappear again and again, full length, as Venus or Lucretia.

Page 429

Plates 98, 99

Plates 148, 149, 158

The mood of the early nudes is melancholy and cautionary. The gesture and the inscription of the 1509 *Venus* say: "Let Cupidos with all his strength drive out the lusts of love/That Venus may not hold sway in thy breast." [510] Pictures of recumbent water nymphs bear the warning "Here I rest, nymph of the sacred spring. Do not disturb my sleep." [511] The subsidiary motifs: the ever-flowing spring, the dark cloud, [512] and, in later versions, the pair of partridges (analogous to turtledoves), [513] the stags, the apple tree, [514] and Diana's bow and arrow suggest some connection with the lengendary spring of Bernardus Trevisanus, the alchemist. [515] Dürer's parallel drawing [516] and the inscription on the panel below the nymph "in Venetiis," recorded by Tobias Fendt in 1574, [517] may also refer to it. Water is consecrated to the virgin Diana-Luna. Her spring of wisdom is a fountain of renewal, a "king's bath," which rocks the earth and produces a dark cloud. To the worthy, those who are able to keep silent, it promises renewal; to the unworthy, ignominious transformation such as befell Actaeon, whose story Cranach also painted. [518] Lovers in the process of transformation are one of his favorite subjects – Hercules and Omphale, [519] Samson and Delilah. [520] This

Plate 48

Plates 93–97

Page 429

Plates 174–179

theme may bridge a gap in what we know of Cranach between the Cuspinian portraits and the

Plate 182 *Fountain of Youth* of 1546. [521] Over the years the Wittenberg workshop produced several versions of the goddess at the spring. The earliest, noticeably poor in subsidiary detail, are now

Plates 93, 97 in Berlin-Grunewald [522] and Leipzig. [523] In the Leipzig picture, dated 1518, the theme is perfectly integrated into the world of Cranach's ideas. The one in Berlin, like the Coburg *Lucretia*, suggests an earlier model, probably Venetian. The boldly shortened right leg, the head, and the left arm resting on the body do not occur in this form anywhere else in Cranach.

Plate 95 Other versions with closely related motifs, such as the Liverpool picture [524] and the *Fountain of Youth* of 1546, show the typical upward curve of Cranach's later style. In a later period the dark, admonitory Venus of 1509 is superseded by a Venus accompanied by a honey-stealing Cupid [525] treated in an innocuous anecdotal style.

In the relatively late period of 1532–33 Cranach turned to a gloomy theme and made several

Plate 181 paintings of Melancholy based on Dürer's engraving of 1514. [526] Dürer's powerful picture, almost like a still life, is broken up into scenes of lively action. The winged incarnation of a basic human temperament is whittling a stick; her glance passes beyond the children playing musical instruments or carrying on some kind of experiment, toward some strange dream image whose earthly counterpart is a military campaign bogged down in confusion. These pictures seem full of menace and the vanity of human effort. The dates inscribed on them – 1528, 1532 and 1533 – suggest the same kind of connection with the events of a time of stress as we find in Cranach's retelling of the Judith story in 1531. [527]

Pictures of the primeval world of man from the same period sprang from an awareness of

Plate 192 imminent change. From 1527 on representations of the Age of Silver seem to anticipate the generally expected war. [528] While the easygoing artist preferred to concentrate on describing

Plate 160 Paradise [529] or the joys of the Age of Gold, [530] he also made small-format pictures for initiates in which masculine struggles predominate, generally accompanied by women's

Plate 104 laments. Perhaps the idea of a turning point in time also underlies the pictures of Apollo and Diana, [531] in which Cranach revives – again around 1530 – Barbari's engraving [532] rather than Dürer's etching. [533]

The hero of the later pictures of classical subjects is often Hercules. In him Cranach seems to glorify the figure of the prince, whose power was decisive in the historic events of that decade. It may be cautiously assumed that Hercules at the Crossroads [534] replaced the Judgment of Paris, so long a favorite theme of Cranach's, [535] until 1548, when he brought off his

Plate 105 successful allegory of Virtue. Pictures of the struggles of Hercules, [536] one version of which

Plate 103 is derived from an Italian engraving, [537] replaced Samson and the lion. [538] During this period of imminent war there seems to have been a general preference for fighting men.

Plates 174–179 Hercules in erotic guise, together with Omphale, makes his appearance about 1532. [539]

Plate 180 Here the theme of the ill-matched couple, extremely popular at the time, [540] is superimposed on the classical one. Some representations of odd couples can be construed in a Christian sense as pictures of the Prodigal Son [541] or the sons and daughters of Job. [542] To Cranach it makes no difference where the theme comes from. Any difference in type is effaced by the use of the same moralizing presentation, as in the erotic Hercules pictures, and the same symbolic

70

imagery: pairs of partridges, [543] stags, apple trees. The multiplicity of meaning of some of
the symbols is obvious. Cranach almost seems to be deliberately trying to relate religious and
secular themes of various kinds, to combine them and to rejoice in all the shades of meaning
that can be derived from this procedure.

In some cases the symbolic decoration of the pictures is as self-contained as a still life. [544]
But unlike the Westphalian painter Ludger tom Ring, [545] the Cranachs never pressed on to
the still life as such. Their procedure might be described as the adaptation to the easel painting
of older motifs from their own decorative wall paintings. But like the topographical scenes,
these attempts were not carried far enough to become a distinct genre.

¶ PROTESTANT COMMISSIONS

To Cranach belongs the credit for having provided posterity with portraits of the Wittenberg
reformers. His pictures, often the only authentic records that survive, still shape our mental
image of the theologians, counselors, rulers and ruler-martyrs of the Reformation decades.

Lucas Cranach the Elder was close to Luther and Melanchthon, although it is hardly pos-
sible to tell from the sources whether it was in his capacity as a friend, councillor and confidant

of the princes or as a painter. He made his first portrait of Luther in 1520, in the two versions we have already discussed. In the spring of 1521 he was already at work on the *Passional Christi et Antichristi*, the first and most outspoken pamphlet of the Reformation to use pictures as weapons. [546] Luther, Melanchthon, Spalatin and the jurist Schwertfeger participated in the preparation of this work, in which tried and tested Hussite imagery and presentation found a new audience. [547] The extraordinary impact of the little volume, and of the woodcuts, was partly due to this old, battle-tried tradition. The pictures of the mounted Pope [548] and the Pope in armor [549] were to be widely distributed. The social message of an early work like

Plate 60

the Dresden *Expulsion of the Money Changers from the Temple* [550] as the center panel of an altarpiece [551] whose side panels depict the healing of the blind and the halt, [552] the confirmation of prophecies and the Resurrection of Christ can be read as a message to proreformist forc-

Plate 59

es within the Catholic Church. The same certainly applies to the early picture of the adulteress seized in the temple. [553] One is inclined to assume that the work owes something to the stand of Duke George of Saxony, who was much more passionately and decisively engaged in the Luther dispute than his Ernestine cousins. [554] The *Passional Christi et Antichristi* made it clear

Christ Preaching.
The Banquet of
Popes and Bishops.
From the *Passional
Christi et Antichristi*.
1521. Woodcuts

that the two positions were irreconcilable. Its Hussite ideas must have enormously strengthened the defensive position of Duke George of Dresden, whose personal situation was complicated by the necessity of living down the past of his grandfather George Podiebrad of Bohemia, a bitter enemy of Rome.

At first Cranach was not especially strongly committed to Luther. In 1519 he published his

early reformist work *The Wagon*, produced in collaboration with Karlstadt [555] and inspired by Schäufelein's illustrations for Hans von Leonrodt's *Hymelwag . . . Hellwag*. Karlstadt's interest in the Apocalypse probably led Cranach to illustrate that section of Luther's translation

of the Bible. [556] Luther's own position is well known; it probably had little effect on Cranach. But to the ambitious artist this was an opportunity to compete with Dürer's powerful treatment of the subject made in 1494. [557] In the creation of his own interpretation of the Revelation, Cranach was indebted to Dürer. His presentation is aimed at the Pope and at Page 44 Rome, as can be seen from his use, three times, of the motif of the papal crown – something that aroused immediate protests [558] – and his portrayal of the great city of Babylon as Page 76 Rome. [559] In the background of two of the illustrations he includes a panorama of Rome taken from Schedel's well-known *World Chronicle*. [560] Cranach's copy is an extremely faithful one – which did not prevent the Dresden printer Hieronymus Emser, a protégé of Duke George's, from buying the wood blocks from Cranach and continuing to use them. [561]

It is remarkable that Bible illustrations did not prove a fruitful field for Cranach in the following years. While the woodcuts made for the first part of the Old Testament do include Pages 76, 77 well-drawn pictures from his hand, one has the impression that he – and probably the workshop, too – withdrew from this project by 1524 at the latest. In later years Bible illustration in Wittenberg was taken over by a motley collection of illustrators. The few noteworthy contri-

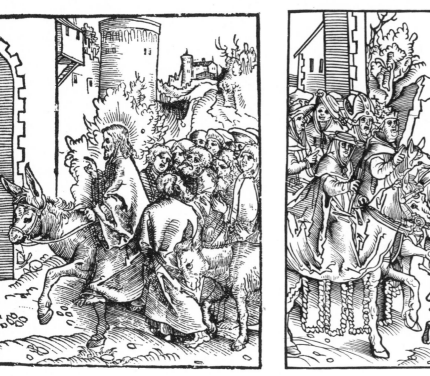

Entry into Jerusalem. The Pope's Ride to Hell. From the *Passional Christi et Antichristi*. 1521. Woodcuts

butions by Cranach the Younger, done in 1541 for the Leipzig printer Wohlrab, [562] and Page 87 those of Virgil Solis made between 1558 and 1561 [563] left no successors.

In later years the illustration of Bibles was continued almost as an act of piety toward the original Luther-inspired version – an act which also served the interests of Cranach's publishing business. Cranach himself resigned from the press and bookshop quite early, before his partner Christian Döring. It may well be that the practical help they gave Luther during a few decisive years was of more importance to him. It was to them that Luther turned when he needed something from the city government or the court. [564]

73

Information about the illustrations said to go back to Luther and Melanchthon themselves is almost impossible to come by. The pair representing the Fall and Resurrection of Man most likely reflects Melanchthon's systematically organized style. [565] Here we can still discern traces of the Hussite way of juxtaposing contrasting pictures. The first formulation of this theme appears in an excellent drawing in Frankfurt, [566] which preceded the painting of 1529. [567] Cranach's conception ultimately goes back to John the Baptist's preaching contrasting the teachings of the Old and the New Testament. This important theme, taken in a narrow sense, was treated again and again throughout almost thirty years of the history of the Reformation after which it seems to have been exhausted.

Other works met the more utilitarian needs of the Reformation: chiefly title pages for numerous publications but also some unusual sketches such as a drawing of a frieze showing women and children driving out priests, [568] which may be connected with the establishment of the reformed church in Halle, the former seat of Cardinal Albrecht of Brandenburg. [569]

The demands made upon Cranach the Elder by the reformers had no perceptible influence on his artistic development. Compared to the impoverishment of religious art owing to the

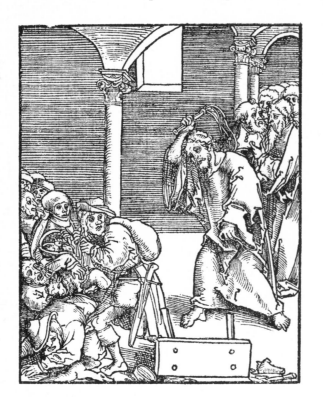

Christ Expels the Money Changers. From the *Passional Christi et Antichristi*. 1521. Woodcut (cf. Plate 60)

discontinuance of old practices of medieval piety, little was gained from the introduction of new themes, including the new preference for examples from the Gospels of predestination, such as Christ the friend of children [570] and Christ and the adulteress. [571] Moreover, Cranach does not seem to have pursued the new possibilities very seriously. The reasons are probably to be sought outside the sphere of art. Lucas Cranach the Younger may deserve a certain amount of credit for what he did to foster the realization on a large scale of a substantial part of the pictorial ideas of the Reformation.

Page 88

Plate 185

Plates 208, 186

The Wagon. After Karlstadt. 1519. Woodcut. Wittbrietzen, Kirchengemeinde (cf. page 427)

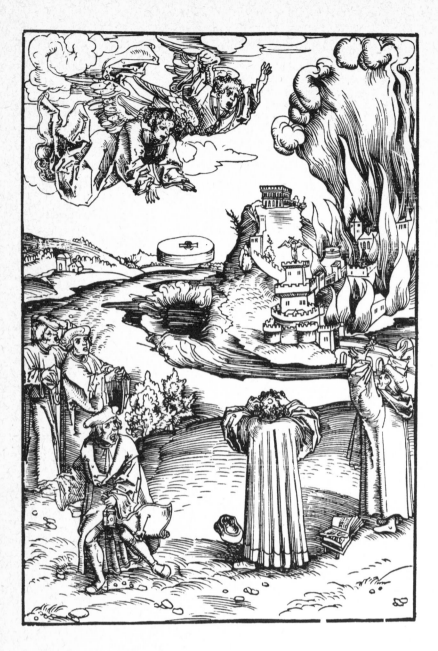

The Fall of Babylon.
From the September
Testament of 1522.
Woodcut

Joseph Interprets
Pharaoh's Dream.
From *Das Alte
Testament*, Wittenberg.
1523. Woodcut

Woodcut from the
Wittenberg
Heiltumsbuch. 1509

❡ CRANACH'S SONS

All scholars who have tried to ascertain the contributions made by Cranach's sons Hans and Lucas to his late work have met with great difficulties. It is certainly possible to identify the different hands up to a certain point but only with great expenditure of effort.

In Cranach's later years his artist's individuality was identified with the workshop to a degree unequaled in art history. Not only did the master shape the style of his staff, but in addition, his own style was influenced by his having to function in the workshop context. The main consideration was to execute current commissions with the amount and kind of help available at that particular time, while always preserving, of course, the characteristic stamp of the court painter himself.

If the generally accepted birth date of 1513 for Hans Cranach is correct, Cranach's sons must have begun their apprenticeship between 1527 and 1529 and completed their training about

1530. Hans Cranach's departure for Italy in 1537 implies that Lucas, then twenty-one, was independent by that time. In the fall of 1534 his older brother was already acting on his father's behalf and was using his own seal. The careful execution of a receipt prepared by Hans Cranach at this time is good evidence of his educational level. Hans Cranach must be the same person as the Joannes Sonder de Wittenbergk who was matriculated at the University of Wittenberg on October 9, 1517. Children of distinguished parents were often enrolled in the Saxon universities in the early years of their life, with an accompanying note that the university oath could not be administered because of their minority. [572] While the date does not prove anything about the age of Cranach's son, it does indicate the type of education his parents had in mind for him. Apparently he never actually became a student, since there is no mention of his having taken the oath later. But the record of his death in Bologna in 1537, also on October 9, must have been connected in some way with an intended course of study. Bologna enjoyed a high reputation in Wittenberg as a place where Germans might receive good legal training. Scheurl had been there earlier, and his visit to Wittenberg in 1533 on his way home from Silesia may have increased its fame. [573] Bologna would only have been a way station for the young traveling artist if he had not intended to study there – as it had been for Dürer thirty years earlier. Hans Cranach's works, however, show no trace of any marked interest in the natural sciences; in this respect he is no different from the other members of his family.

After the death of Hans Cranach, the poet Johann Stigel, who was the same age as the young painter, extolled his work in a long poem, [574] but such facts as it contains are of little help in piecing together his work. What we know of him comes from two signed paintings of 1534 [575] and 1537 [576] and from the sketchbook, now in Hanover, [577] which he had with him in Italy. These works indicate a well-trained craftsman, good enough to have one of the workshop apprentices assigned to him, but not a strong artistic talent. Judging by reproductions, *Plate 188* the portrait of 1534 (from its resemblance to pictures of his father, possibly a self-portrait) is *Plate 179* no more outstanding than the picture of Hercules with Omphale done in 1537, the year of his death. The latter painting is only one of several extant variations on the theme, the best of *Plate 174* which is the Berlin-Dahlem drawing. [578] A surprising feature is the boldness with which bodily proportions are disregarded. The figural composition amounts to little more than a dense crowding together of heads and hands – an old trick of the rapid painter. [579] While the detail is less dense, the chromatic brightness of certain planes seems to be emphasized. Perhaps Hans Cranach might have gone on to develop this stylistic trait. The master's younger son, Lucas, expanded this side of his father's heritage to good effect.

The above-mentioned sketchbook provides the greatest insight into the personality of Hans Cranach. He began the volume at both ends, and it contains maxims, sketches and experiments with forms and lines, which follow no recognizable system. Daily diary entries describe one leg of the journey to Italy: from Nuremberg to the region of Lake Garda. A few sketches of buildings and landscapes seen en route accompany the notes, beginning in the Tyrol. A *Plate 193* whole page is devoted to the impressively situated hunting seat of Sigmundsburg near Fern- *Plates 189, 190* stein; this is in effect the only fully resolved landscape in the volume. The portraits are somewhat more rigorous in execution, although they are scattered between other entries like mar-

ginal drawings. Three of these portraits show the artist's talent at its best. They can be compared to his father's only authenticated silverpoint drawing from the period around 1530, [580] *Plate 191* although they do not match it in conciseness and graphic depth. On the other hand, the silverpoint drawing of the Age of Silver formerly attributed to Lucas Cranach the Elder [581] is comparable to the sketchbook pictures, having the same formal brittleness, restlessness and lack of inward sureness.

A few maxims, some of them repeated, either in Hans Cranach's own handwriting or in that of traveling acquaintances, give us an idea of what was going on in his head. [582] Below several studies of a little monkey and a foolish-looking figure appears the date 1536 and the words *Plate 194* "If lies hurt as much as carrying rocks, plenty of painters would keep their traps shut." Most of the maxims have similar morals: "In silence and hope will lie your happiness." "I hope and keep silent." "I keep hoping." "Keep envy to yourself. Don't complain to anyone. Don't despair of God." "Joy comes every day." "Patience calms strife." "Loss brings grief." Hints of Protestant leaning are revealed in entries like "The priests make monkeys of us all" and in Hans Cranach's interest in the portrait of Savonarola with an appended inscription. [583]

Although no careful study has yet been made of this sketchbook, which also contains drawings by subsequent owners, it offers a clear insight into the restless day-to-day life of the artist. In spite of the disjointedness of the entries and the general formlessness, the outlines of a personality emerge, but of a personality who was not particularly concerned with drawing. The whole thing might be better classified as a commonplace or day book; [584] it has more in common with the personal albums of a later age than with an artist's sketchbook of the type kept by Holbein the Elder, Dürer or Baldung. The artistic talent of this son of Cranach's appears in a peculiarly diluted form, typical of the period; all the forceful vitality is gone. Only the negative side of the training Hans Cranach received in the methods of his father's workshop is brought out in these sketchbook pages. Dexterity and rapid technique appear as unsureness and inability to sustain a theme. Friedländer's words about painters who are shown up by their drawings might well be applied to Cranach's late work. [585]

If we are right in assuming that Hans and his brother, Lucas, were not far apart in age, the only criterion for distinguishing their respective works is the two pictures known to have been signed by Hans. Lucas the Younger is first mentioned as a member of the workshop in 1535. The much discussed but insufficiently studied change in the Cranach device – the substitution of bird wings for the bat wings mentioned in the patent of nobility of 1508, [586] which made its first appearance during that year – was certainly not a personal attribute of Lucas the Younger's but a change adapted by all members of the family after 1537. The reappearance of the interlinked form of the L C monogram that Cranach the Elder had used as a *Plate 198* signature only in his early years, from 1504 to 1506, [587] and an inscription signature, "Luca Cronacho pictore MDXXXVII," [588] on a painted portrait, unusual for his late period, may be more conclusive evidence that his son was working independently at an early age.

Lucas the Younger soon established himself in the middle-class life of Wittenberg. In 1541, at the age of twenty-five, he married Barbara, daughter of Electoral Chancellor Gregor Brück, a family with which the Cranachs had been connected since Barbara Cranach's marriage to

Brück's son Christian in 1537. The marriage date of 1541 may have some connection with the death of his mother, Barbara, which left no one to run the Cranach household. Especially after 1537, when Lucas the Elder was burdened with his official duties as burgomaster, [589] an equitable sharing of family responsibilities must have been very necessary.

Lucas the Younger's marriage to Barbara Brück produced four children. Two of their sons were matriculated at the university in 1554 in their boyhood. The eldest son, Lucas III, was later a city councillor in Torgau and Meissen, where he died in 1612. To distinguish himself from his own son, Lucas the Younger sometimes called himself *Cranach der Mittlere* (the middle Cranach). [590] Lucas was married to Barbara Brück for little more than nine years; in 1551, a year and a half after her death, he married Magdalena Schurff, a niece of Melanchthon, another jurist's daughter. There were five children of this marriage. The oldest, Augustin (1554–1595), was the only member of this generation to carry on the family's professional tradition. He became a painter and died a city councillor of Wittenberg, as did his brother Christian. We have no detailed account of the life of Lucas Cranach the Younger. It is clear that after the summer of 1550 he was solely responsible for the direction of the workshop, but this date is certainly too late to denote the year he took over from his father, who was then seventy-seven. Wittenberg had just gone through great upheavals. In the university city these began with unrest among students from the nobility. We have records of disturbances in 1520 in which Cranach's journeymen were involved [591] and again between 1543 and 1546, when the constant tension between students and the city authorities erupted in rioting. [592] A few months after Luther's death on February 18, 1546, the emperor attacked the League of Schmalkalden, defeating the princes at Mühlberg in 1547. Elector John Frederick lost the electoral territory of Wittenberg and was reduced to his Thuringian possessions.

After a period of feverish activity in preparation for the war, the activities of the Cranach workshop came to a halt. Cranach had received his last salary in the fall of 1546; as of Easter, 1547, his tenure was suspended, since he was obviously reluctant to follow the court to Weimar. Even when the old painter finally followed his master into captivity in 1550, he was not paid for the three intervening years. At the emperor's camp outside Wittenberg he personally interceded with Charles V himself on behalf of Elector John Frederick, who had originally been threatened with the death penalty, [593] but this produced no significant result. One of the court painter's last actions had been to take the valuable paintings from the Wittenberg Castle church, including works by Dürer, into his own keeping. Only a few of the major ones were ever returned: Dürer's *Martyrdom of the Ten Thousand*, [594] his *Adoration of the Magi* [595] and his so-called Dresden altarpiece, [596] and an altarpiece of Netherlands origin depicting Christ taken captive. [597] Parts of Dürer's *Altarpiece of the Virgin*, which passed to the Dresden collection from the estate of Cranach the Younger, suggest that Cranach sold many other sections of the works he had annexed, including the *Mary, Mother of Sorrows* from the "Passion" panels, the side panels from the *Altarpiece of the Magi*, [598] and Burgkmair's St. Sebastian altarpiece, [599] and perhaps also Conrad Meit's lost picture of the Virgin. [600] He probably kept these works as a sort of bond against his unpaid salary; they were left in Wittenberg with the tacit consent of the Weimar court, of which Christian Brück, Cranach's son-in-law, was a member.

No doubt Cranach's workshop continued to issue clandestine woodcuts glorifying the deposed prince, now loved as a martyr. [601] No doubt the new ruler, Elector Maurice, got Cranach the Younger to do similar work for him. [602] With both father and son looking after the business, it was obviously not difficult to work for both victor and vanquished during the first unsettled years.

Cranach the Younger's decision to stay in Wittenberg is confirmed by his election as city councillor in 1549. For almost twenty years he was a member of the city government: in 1555, 1561 and 1564 as one of the two chancellors; in 1565 as burgomaster. He relinquished this last office in 1568 at his own request. [603] Since Cranach the Younger was not actually employed by the Dresden court, he was anxious to have his old privileges, such as his wine license, confirmed by the new elector. [604] Elector Augustus seems to have treated the painter with consideration; in 1555 he invited him to a court hunt and from time to time he sought his advice on problems of heraldry.

Cranach the Younger secretly remained in contact with the Ernestine court in Weimar, where a plan was being hatched for a rising of the nobility against the emperor, led by Wilhelm von Grumbach, a son-in-law of the peasant leader Florian Geyer. John Frederick, son of the revered elector, hoped that this might restore his lost territorial rights and, with France's backing, perhaps even increase his power. Cranach had helped finance the court's cryptic schemes with a loan of 1,000 talers. In 1566, before the outbreak of the rising, he tried to get his money back, having perhaps been warned by his son-in-law, the influential Weimar Chancellor Christian Brück. Occasional gifts of honor to the master painter and various posthumous tributes to his father may have been an inducement to join the court. After the crushing of the "Grumbach feuds" by Elector Augustus in 1568, as a result of which Brück was drawn and quartered, connections were broken off. Cranach immediately resigned as burgomaster, but his reputation remained so high that Zacharias Wehme, holder of an electoral scholarship, was assigned to him for training from 1571 to 1581. Cranach must also have been affected by the elector's bitter confrontation in 1585 with the moderate Protestant party, the so-called Crypto-Calvinists. This brought to an end Wittenberg's "veritable Golden Age" [605] which had lasted since 1565. Humanist studies in Saxony collapsed. [606]

Page 419

Page 434

The Saxon elector's uneasy determination to cling to the power he had attained did little to open new cultural perspectives for the country. A renewed attempt, led by Electoral Chancellors Krell and Paul after the death of Elector Augustus, to establish Crypto-Calvinism in Saxony exposed the unsatisfactory state of affairs, but by that time Cranach was dead.

THE LATE STYLE OF CRANACH THE ELDER

The powerful works, based on strong planes, of Cranach's late period finally reached a wide audience as the result of the discoveries of another painter: Picasso, who made a series of variations on postcard reproductions of them. [607] In these late works the picture space is more or less conspicuously divided up, usually by curved outlines, into distinct groupings of planes. This tendency is already discernible in Cranach's early works, but only after 1520 does it appear as a system of composition. Even in the restless early work, strangely quiet planes crop up, as, for instance, in the dress of Anna Cuspinian. The flag in the St. George woodcut of 1506 is no more than a patch of semi-animated space. Extraneous festoons trailing down into the picture, as, for instance, in the woodcuts of the Holy Family and of the elector adoring the Madonna, emphasize the picture plane, as do the outlines of walls or robes, which so often run parallel to the frame, or the tree trunks that shoot up tentatively along the margins. In many cases the surprise factor is an intrinsic part of the formal concept; the extraneous is introduced as a means of heightening the illusion. This function is particularly noticeable in the fantastic frameworks used in the woodcut of St. Stephen of 1502 and in the "Apostles" series. Many of the space-filling motifs consisting of grotesque forms and monsters have yet another concrete meaning. The extraordinary framework surrounding the putto bearing the coat of arms in the 1509 engraving [608] and the dark outlines of the cloud above St. Bartholomew create a magical effect. On the woodcut map of Palestine done before 1525, the surface of the water is whipped up into a threatening, evil whirlpool beside the ships. The aura of menace, allayed by the angel heads, surrounding St. Barbara and St. Catherine in the twin woodcuts of 1519 is unmistakable. It recalls the imagery of Luther's unforgettable commentary on the Sixty-eighth Psalm: "The smoke curls up and up, willfully making its way through the air, as though to blot out the sun and take the sky by storm. But what happens? A little gust of wind springs up and the high-flown smoke disperses and vanishes, no one knows where." [609] We are reminded of Dürer's disapproving words: "The chaotic is constantly trying to insinuate itself into our work." [610] Grimacing cloud faces haunt the Apocalypse woodcuts of 1522. [611] In the marginal drawings for Emperor Maximilian's prayer book, where capricious forms of this kind would be appropriate, Cranach uses them with restraint – though the marvelously tenuous plane formed by the cloud of angels on the left-hand page of sheet 61 should not be overlooked.

Many of the strikingly effective planes in Cranach's pictures are a result of the continuous flow of forms. One might say that it was a principle with him to hide major points of articulation in the composition, to wrap the measurable in imponderables, abruptly to break continuities. Attempts at perspective often end in absurdity – and this is also true of Cranach the Younger, Strongly oriented toward Dürer as he was, Lucas the Elder never adopted his strong, rational order. Multiplicity of detail always fascinated him; he resisted the temptation to sacrifice any part of it. This must have something to do with a very strong primitive relationship to the multiplicity of phenomena that influenced him. He was more interested in objects than in the connections between them or in a sober overall view. This indifference toward the rational connection between phenomena is the origin of an odd naïveté which

Plates 13, 28

Plate 81

Page 83

82

found any kind of arrangement acceptable, even complete incoherence. So long as his imagery was inspired by elemental responses to personal experience, approximately up to the time of the great spate of works in 1509, the absurd was just one possibility among many. Later it became a reality in its own right, a compulsion the artist could never escape. Yet this propensity did not affect Cranach's amazing closeness to physical reality, which remained remarkably intact until his late period. This is especially true of the portraits, although here the closeness stops at the physiognomy of the sitter. One of the many absurdities is that in Cranach's portraits bodily structure and hands never amount to much more than willful combinations of forms.

One feels that the later portraits are in effect the customer's wishes set down in paint on can-

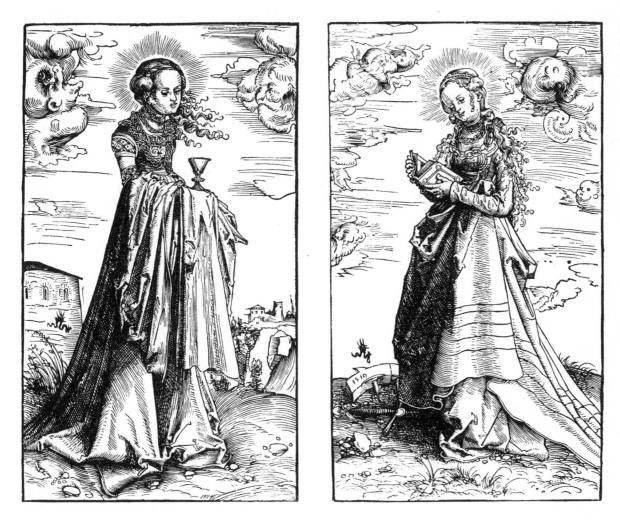

St. Barbara
and St. Catherine.
1519. Woodcut.
Leipzig

vas. Objects outside Cranach's true range of experience are used as illustrations. The morality of the times and what was probably a Renaissance attitude result in extraordinarily tortuous nudes and a weird eroticism which are highly effective but lacking in all reality. By following the classical practice of assembling his nude goddesses and heroines out of beautiful details taken from various individuals, [612] Cranach was able to realize the ideal form of his time in great purity, without paying any attention to the realities of physical structure, which Dürer tried to explore.

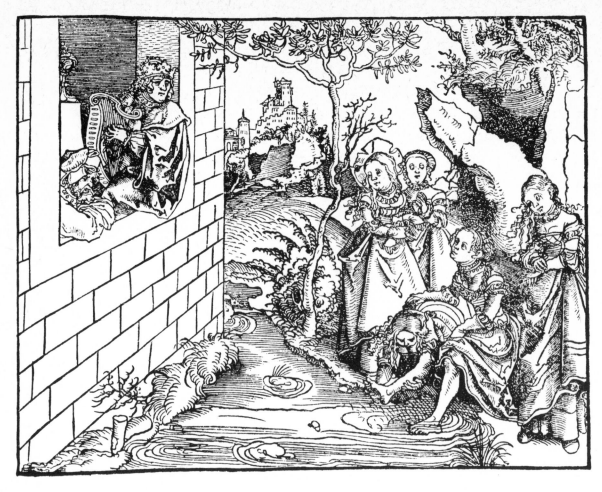

David and Bathsheba. From *Das Ander Teil des Alten Testaments*, Wittenberg. 1524. Woodcut

The formalization of Cranach's style after the 1530s probably represented an attempt to reconcile the various demands he had to meet as harmoniously as possible. It may also have been a deliberate simplification, dictated by the requirements of the workshop, to facilitate reproduction. No doubt it reflects Cranach's productive struggle to master his Dürer models. [613] Be that as it may, the narrowing of his range is striking; apart from the carefully observed details in studies, his themes are hardly ever enriched by the study of reality. "The garden of experience," [614] Renaissance man's most precious possession, was closed to Cranach, incessantly driven forward by the force of his own creativity.

In a remarkably imperceptible transition, the early pictorial world of uncanny reality turned into a world pervaded by mysterious powers. Cranach's sensitivity to the tremendous new departure of the post-1500 generation carried over into an equally sympathetic understanding of the decline of the ideals of art into the cozily idyllic after 1525.

Formal structure in the later Cranach works varies according to the format. In small-scale figural works the various objects are arranged in an apparently sound composition. The easy, relaxed tone of the small-format pictures is in striking contrast with the harsh malevolence of some of the big ones: the ill-matched pairs, for instance. [615] This is what makes the small female figures holding an apple [616] or a flower [617] so enchanting. In the 1532 *Venus*, the figure is perfectly developed within the small format. [618] Small figural compositions like the *David and Bathsheba* of 1526 [619] or the *Judgment of Paris* of 1530 [620] have an irresistible conciseness, and even the picture of Cardinal Albrecht as St. Jerome in the landscape [621] is

Plate 180

Plates 132, 131

Plate 128

Plate 142

84

brought to life by the naively self-explanatory nature of the small forms. On this scale the in-adequacies of the structural relationships and figures are camouflaged by the abundance of small forms. The happy world that existed before Cranach came to understand the large format reveals its magic. Not until the dimensions are enlarged – as in Picasso's adaptions – is the lack of coherence exposed.

The abstract clarity of the planes becomes recognizable only in the larger format. One of the works in which Cranach relied most heavily on this method of composition is the 1530 *Judith with the Head of Holofernes.* [622] Contrasting it with the earlier versions of the subject in Plates 157, 153 Vienna and Stuttgart, one notes how markedly the curves of the objects and the lines of the architecture are related. The noble shaping of the head in component planes is one of the best examples of the combination of this plane-based style with the given natural form. The extra-ordinary nature of the subject – a fine lady killing the enemy of her country – is depicted as cold-bloodedly as if it were a natural process, as if the lady, the knight, the sword and the glimpse of landscape in the background were things that, under certain conditions, could present themselves only in this way. The result is remarkable: not a still life but a monumental rendering of the cold uncanniness of things unintentionally brought together. Form unites what seems impossible.

The colors of such strongly structured pictures remain firmly immobile. One shade of red predominates; delicate as the modeling is, the planes are clearly and strongly tied together. Yet it was not long before Cranach departed from this firm, easily reproducible style. After 1530 bright colors move to the fore; the planes seem to be illuminated, and as a result, the outlines are less clearly recognizable, though still emphasized. Brightening and muting his colors in a carefully coordinated way, Cranach brings the values closer together, preparing a basis for more delicate coloristic treatment.

It is difficult to follow the various potentialities of his change in reproductions of the works. Format and chromatic mood often have a decisive influence on the modeling of the picture plane. The really small format is in a class by itself – perhaps because it was Cranach's original medium. He did not use the small-format painting or the engraving as a vehicle for exquisite miniature painting, as did Dürer, four of whose small-scale figure paintings survive. [623] The difference in their styles is already apparent in the unconcerned diffuseness of the little traveling altar Cranach made for the landgrave of Hesse, [624] where the monumental rigidity of the figures seems to be a vestige of a still unmastered gift. The tendency to simplify into planes first appears, though still in a rudimentary form, in miniature formats such as the pictures of St. Jerome and St. Leopold done in 1515; [625] here it is still unarticulated, and there is no attempt to smooth it over.

In the small format this unstructured freedom survives into Cranach's late period. In the late pictures that can be attributed to his hand, one is struck again and again by the rich devel-opment of significant details. A comparison of the little painting of Hercules with Omphale in Plate 175 Gotha [626] with treatments of the same theme by other members of the workshop supports this.

In 1550, when Cranach yielded to the wishes of John Frederick and followed him into cap-tivity, severing his connection with the workshop, did he perhaps settle down to the small

format for good? The relinquishment of the workshop to his son (which must actually have occurred earlier than 1550) must have relieved the elderly master of a heavy burden. A letter to John Frederick which Lucas dictated to his son in the summer of 1547 gives a disquieting account of his health. There is good reason to think that after this time Cranach the Elder no longer took a hand in the big paintings, although he may have worked on the small painted canvases, which could be executed rapidly and without tedious preparation. The princely suite of his old master was now much reduced. Cranach had only one or two apprentices and apparently counted on Peter Gotland to do much of the strenuous work. Judging by accounting records, many of the portraits painted during the period of captivity may have been adaptations of the portrait of John Frederick, amounting to little more than manual exercises. The panels and portraits sold for five guilders or less were probably quite small pictures. A possibly

Plate 204 authentic example is the stylish portrait of Emperor Charles V in the Wartburg, which modestly reflects an acquaintanceship with Titian. [627]

The assumption that Lucas Cranach the Younger was essentially in charge of the execution of the big paintings is supported by his adoption of the large format after his father's death. Even before that, large-scale commissions such as the Schneeberg altarpiece of 1539 [628] and the paintings of the Passion for Cölln-an-der-Spree [629] were executed under his direction.

Plate 201 He made the preliminary drawings for them [630] – perhaps partly in an endeavor to build up his own repertory of models. [631] In the finished panels the strongly outlined planes that characterized his father's late style have been discarded. The greater openness of the color and relatively unstressed facial characteristics of the Schneeberg panels are certainly attributable to Cranach the Younger. Spacious landscapes such as those in the pictures of Lot and his daughters and of the Flood had hitherto occurred only in a germinal form in the woodcut Bible illustrations. Yet the conciseness of these works goes along with a freer choice of motifs and a more harmonious color scheme, both typical of Cranach the Younger. In his cooler, brighter world, the ornamental linking of motifs had no significant function in the long run.

¶ THE MONUMENTAL WORKS OF CRANACH THE YOUNGER

Plates 186, 208 Important thematic changes show themselves in pictures of Christ and the woman taken in adultery [632] and Christ the friend of children which began to be produced in greater numbers around 1530. [633] In both, God is depicted in the abundance of His grace, with strong accompanying half-length figures. Since few of these characteristic Protestant pictures are dated, it is difficult to determine exactly how long a period they covered. [634]

The sudden emergence of an unusual version of Christ on the cross, however, is easily traced. After 1536 several pictures of the centurion who acknowledged Christ beneath the cross [635] and also one of the conventional Crucifixions with numerous subsidiary figures done in 1538 [636] show Christ as a living man with His face raised toward heaven. Finally a picture of

Page 432 Christ on the cross as a solitary figure, [637] done in 1540, [638] reveals the source of inspiration: a little crucifix panel in Dresden. [639] That picture, which will without doubt be recog-

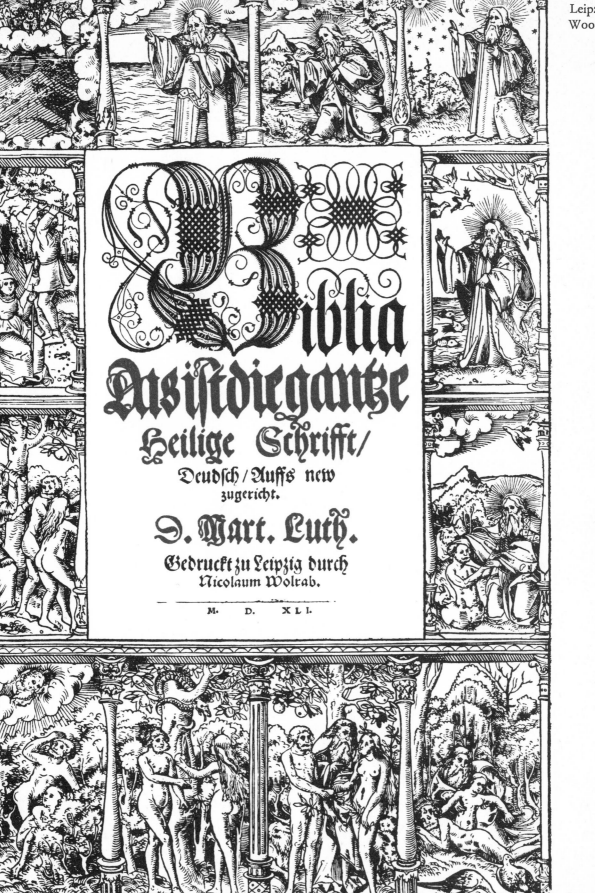

Cranach the Younger:
Title page for a Bible,
Leipzig. 1541.
Woodcut

Biblia

Das ist die gantze
Heilige Schrifft/
Deudsch/Auffs new
zugericht.

D. Mart. Luth.

Gedruckt zu Leipzig durch
Nicolaum Wolrab.

M. D. X L I.

nized again someday as the work of Albrecht Dürer, was probably painted in the year 1500 from an Italian model significantly modified on the basis of a fundamental theological interpretation. Its origin can best be reconciled with the known facts if we assume that Elector Frederick the Wise conceived the idea for it in consultation with his confidant Johannes Staupitz. Forty years later Michelangelo was to create a very similar version for Vittoria Colonna. [640] Considering Luther's strong personal feeling for the picture of Christ crucified – "Willy-nilly, when I hear the name Christ, there rises up in my heart the picture of a man hanging on the cross" – it is remarkable that Dürer's little crucifix should not have made more headway in Protestant art. Perhaps the little panel, being the personal property of the elector, was not accessible enough. It took a very stable sense of life to undertake a representation of the most sublime moment of the agony on the cross, a stability that was more prevalent at the end of the fifteenth century than after the Reformation had begun. Among the Cranachs and their followers, the figure on the cross soon reverts to the conventional pose with dropped head. The front-view Crucifixions including a half-length figure of the praying donor are typical of this phase [641] – Protestant versions of the type of Crucifixion picture showing donors praying before an obliquely placed cross that goes back to the early *St. Jerome*. [642] Contrasting the two, one realizes how much of the scenic context has been lost. The artist's chief concern now is not to depict the religious experience of the donor before the crucifix but to link him with the crucified Christ as proof of his devotion. The pictures are now divided into two sepa-

Cranach the Younger:
The Fall and
Redemption of Man.
After 1530. Woodcut

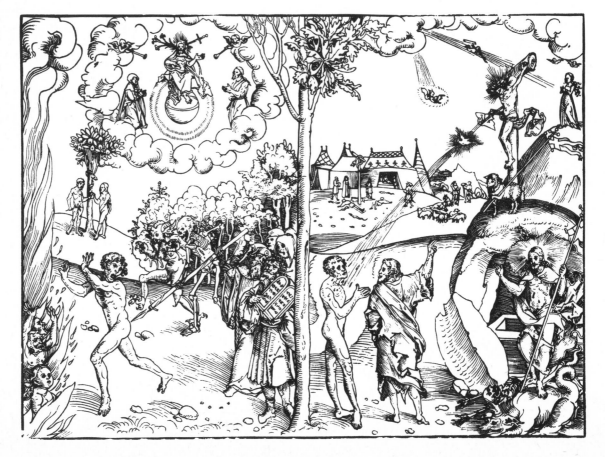

rate levels, connected spiritually but not in reality. An element of forceful palpability has degenerated into a mere pictorial expression of devotion. Cranach the Younger's "discovery" of the Dürer crucifix – whatever his motives may have been – established the front-view Crucifixion more firmly within the Protestant range of themes. From the Weimar altarpiece of 1555 to the Colditz one of 1584, Christ crucified was one of the major subjects of his paintings.

Plates 229, 253, 254

Cranach the Younger was the first (in 1539) to use the Protestant theme of the fall and redemption of man in a large format for big altar panels – an important step toward the great paintings in Weimar (1555) and Leipzig (1557). Since its inception, and probably as a result of Cranach the Elder's teatment of it, this had been a miniature subject used chiefly for illustrations or for the title pages of theological works. [643]

Lucas Cranach the Younger's development prior to his masterwork, the Weimar altarpiece of 1555, has not yet been fully explored. Important preliminaries to his mastery of the large format (the Weimar altar is almost ten feet tall) were the Dresden Hercules pictures of 1551, *John the Baptist Preaching* and *The Conversion of St. Paul*, both done in 1549 in approximately the same dimensions, and the big *Sacrifice of Elijah* of 1545. [644] The Weimar *Charity* [645] is one of his most successful early resolutions of the problems of proportion in the large-scale figure. There is nothing in his father's work to match its elegant painterly conception or the coolness of the color. The stamp of his own personal style is less evident in the small-scale figures of the *Fountain of Youth* of 1546 [646] and the various hunting scenes atttributed to him. [647]

Plates 214, 215
Plates 212, 206
Plate 196

Plates 182, 209, 210

Stylistic changes in the young master's work came in fairly rapid succession. The two versions of John the Baptist preaching of 1543 [648] and 1549 [649] are telling examples. Whether the earlier painting is a work of Cranach the Elder (as is probably the case) or of the son is immaterial. The enlargement of the format makes the effort to strengthen the articulation of the groups of figures, to enrich the motifs and to fill a wide, light picture space extremely effective. Figures seen obliquely from behind like those in the center of the Brunswick picture of John the Baptist preaching and in the *Conversion of St. Paul* [650] are a typical feature of this new compositional style. On the other hand, the tiny figures in the 1546 *Fountain of Youth* still conform completely to the Cranach tradition.

Plate 212

Plate 206

The same expansive large-plane style is recognizable in the woodcuts, a genre to which Cranach the Younger devoted even less time than his father. The prints seem to indicate that the blocks were rather roughly executed, although some of the detail work is very delicate. The introduction of restless backgrounds of clouds, which first appear in a portrait of 1537, [651] and of fabrics with big patterns is characteristic of Lucas the son. Many of the not very numerous prints are tinted; his woodcuts too relied on color. His works have even less in common than his father's with the rigorous black-and-white effects that Dürer perfected. Cranach the Younger was later to give up graphic art altogether, obviously because of his strong, almost exclusive preference for painting.

Plate 198

During this period the use of didactic thematic contrasts such as the fall and redemption of man increased. Portrayals of the centurion who acknowledged Christ, of the sinner beneath the cross and of the conversion of St. Paul are undoubtedly to be read as individual confessions of faith; the climate of the times, now approaching open conflict, demanded personal decisions.

Plate 195

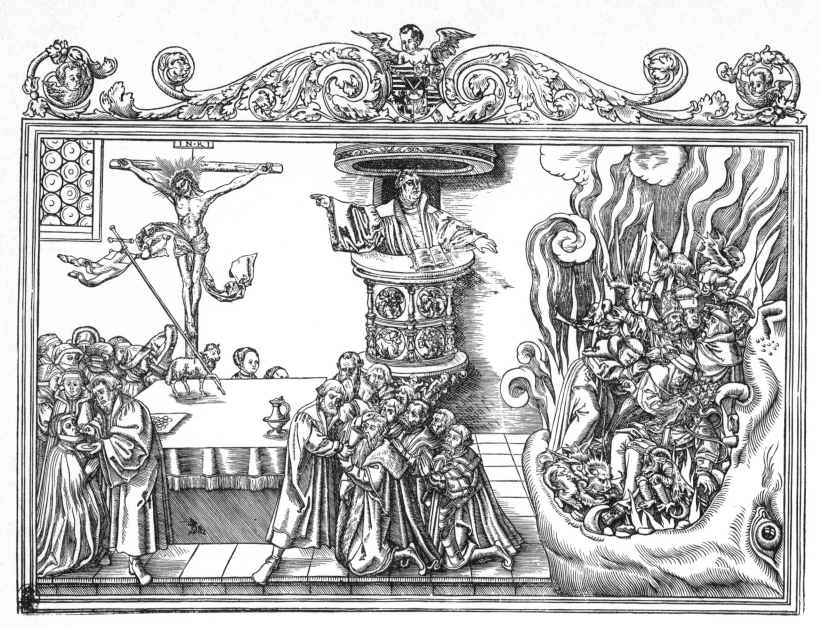

Cranach the Younger: Confrontation of the True and False Church. Circa 1550. Woodcut

The picture of Luther in the pulpit on the Wittenberg predella of 1547 [652] and in the wood- *Page 90*
cut, which probably preserves the composition of a commemorative picture of the reformer
made after his death in 1546, [653] were executed just as war was breaking out. The Torgau
Castle chapel was consecrated in 1545 with a big *Sacrifice of Elijah*. [654] This is the first example,
here in an Old Testament setting, of the irreconcilable confrontation of true and false worship.
It was the spirit of Elijah that had compelled Müntzer to take action against Luther; now the
figure of the prophet was invoked by Luther's supporters. Luther was seen as a third Elijah.
Indeed the prophet's injunction to "flee idolatry" *(Fugite Idolatriam)* is the watchword of sev-
eral of the pamphlets that Elector John Frederick arranged to have published in 1546.

The old theme of John the Baptist preaching [655] now takes on an unmistakable topical
meaning as a warning to the court and the war makers, who were being blamed for the hard-
ships resulting from the rise in the price of grain. Luther made strong representations to the
Wittenberg City Council, resulting in an urgent request to the elector by the city. [656] In the
two groups listening to St. John, Cranach included portraits of individuals, among them Georg *Plate 212*
Spalatin, who was superintendent in Altenburg in 1549. The identification of these figures will
someday provide a key to the interpretation of the picture. The tension of the last years of this
superficially stable period are reflected in the terrible picture of the victims of Wittenberg's
first witch-hunt, which took place in 1540, [657] and, shortly thereafter, in the ludicrous *Foun-
tain of Youth* for old women, [658] in which the classical theme degenerates into a piquant genre *Plate 182*
scene. The dark, tense years between the end of the war against the League of Schmalkalden
and the conclusion of the religious Peace of Augsburg produced the small *Hill of Virtue* panel *Plate 222*
of 1548, one of the lesser-known possessions of the Vienna Museum. [659] The classical
theme of Hercules at the crossroads, enlivened with Christian symbols of virtue, illustrates the
need for new moral norms to meet the social changes that had been achieved.

Humanistic themes were successfully treated again in 1551 in the three big Hercules panels
for the Dresden Palace. [660] Cranach the Younger had continued to develop the hunting pic- *Plates 214, 215*
ture along his own lines and his experience in this genre was incorporated in the Hercules *Plates 209, 210*
paintings. [661] The scenes showing the wild men of the woods fighting wild boars, bears and
stags in the expansive, bright landscape background are a triumph of detail. Their superiority
to the foreground figures is probably partly attributable to the fact that here the pictorial con-
cept has been more thoroughly thought out; Cranach's preliminary drawing shows that the *Plate 213*
picture was originally intended to show Hercules confronting the wild men. [662] Obviously
the demands of the large dimensions exceeded his experience in figure drawing. The predom-
inant impression is one of lively restlessness. The faces of the little figures seem distorted in
a portraitlike manner, although rather to satisfy the artist's fancy than from any pictorial neces-
sity. A latticework of slim tree trunks holds together the large planes on which the composition
of both the major panels is based – a composition certainly inspired by Flemish tapestries. [663]
The unusual theme, taken from Alciato's *Emblems*, [664] has a personal significance. It is an
allusion to the conferring of the electoral title on Maurice of Saxony and represents sover-
eignty being defended against usurpers. [665] The presentation of ideas of this sort in the guise
of classical mythology may be traceable to Italian models. Elector Maurice, who commis-

sioned these pictures, had himself been in Italy in 1548 and had connections with the duke of Ferrara, for whom Battista Dossi had painted a similar work.

The Dresden Hercules panels are the first fully authenticated works of Cranach the Younger. Cranach the Elder never returned to Wittenberg after he left there in the summer of 1550. The spread of the Wittenberg workshop at this juncture is remarkable. By working for both of the rival royal houses of Saxony at the same time, it managed to survive. Its sympathies, like those of most of the people of Saxony, were with the Ernestine branch of the family.

Plate 229 The Weimar altarpiece of 1555, an astounding achievement of Cranach the Younger, grew out of the large format of the Dresden Hercules panels. [666] It is no accident that both works reflect the historic taking of sides in Germany after the middle of the sixteenth century. After the defeat of the early revolutionary movement of the burghers, the princes struggled among themselves for power, some of them united by alliances, others counting on support from the emperor or from foreign powers like the king of France. Two of them claimed title to Saxony, one of the most powerful of the German states. Sole possession of this realm would guarantee a predominant position of power in the German empire, particularly since the influence of the cities of Upper Germany was on the wane.

While Elector Maurice saw himself as a modern Hercules, the Weimar altarpiece stated its programs in terms of the Protestant faith and the evocation of the heroes of the Reformation. Here there is much less use of allegorical contrast, which had been pushed to its limits in the Schneeberg altarpiece. The center panel is dominated by Christ on the cross, by the risen Christ triumphing over death and the devil and by the group of prophets proclaiming the Gospel, with Cranach himself standing out in the foreground as the redeemed sinner. The explanatory subsidiary motifs in the background play a less important role than the wild men in the Hercules *Plate 231* panels. On the inner side panels, which carry the portraits of Duke John Frederick and his family in the heavy, dark splendor of realistic interiors, the mellow chromatic radiance of the center panel is sumptuously heightened. One is reminded of the bronze tombstones of Elector Frederick and Elector John in the Wittenberg Castle church and of Cranach's emulation of the great contemporary Saxon tapestries. In contrast with the rich, subdued colors of the side panels, the center one is as radiant as a sunny day. The most delicate parts of the picture are pervaded by light; it is omnipresent, like a theological conviction. The big painting in this form is a remembering; the donors remain essentially outside it, demonstrating their presence by their devotion alone, not associated in any way with sacred figures. Historically, too, this type of work marks the end of an era, the period of the Reformation in its strict sense. The attempt to repeat it did not reach the previous standard. [667]

Otherwise, the Wittenberg workshop was not favored with big commissions for the Ernestine princes. The altarpiece was preceded by two sculptural works: the tombstones for Martin Luther, cast in bronze by Heinrich Ziegler the Younger in Erfurt, which the Albertine branch of the family prevented from being erected in Wittenberg, [668] and the stone gravestone of Cranach the Elder, [669] which was certainly designed by his son. These were not the only *Page 419* honors paid to the loyal old servants of the princely house. In 1557 a portrait medal was cast commemorating Lucas Cranach the Elder, no doubt commissioned by the Weimar court, [670] and he was also portrayed, together with Luther, on a tapestry, now lost. The carved

wooden model for Luther's tombstone is preserved in St. Andrew's Church in Erfurt; it is probably the only surviving example of the occasional sculptural works executed in the Wittenberg workshop. [671]

A work comparable in stature to the Weimar altarpiece is the commemorative painting of Prince George of Anhalt, who died in 1553. [672] The corporeality of its figures is anticipated in the sketch for an altar painting in Vienna, [673] the composition of which is closely related to the group of monumental works. It is characteristic of Cranach the Younger that he draws more heavily here on the engraving from Dürer's *Passion* series [674] than on the conventional

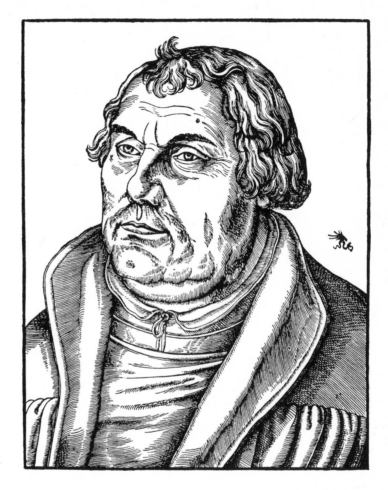

Cranach the Younger:
Portrait of Martin Luther.
Circa 1551. Woodcut

treatment of the subject in his own workshop. This is particularly obvious if we include in the comparison Heinrich Königswieser's version of the same sketch. (Königswieser had returned to his native East Prussia decisively influenced by Cranach's monumental period.) [675] This memorial to George the Devout of Anhalt introduced a new type of commemorative picture without allegorical apparatus, which was to predominate in the later work of Cranach the Younger.

The *Baptism of Christ* of 1556 is the last of this group of monumental works and at the same time a transitional one. [676] The upsurge of this important theme toward the middle of the century [677] is undoubtedly connected with the defeat of the Anabaptists after tenacious resistance. Until then the subject had been avoided in Lutheran regions, and Christ the friend of children [678] had been offered as a counterpart to the Anabaptist doctrine. Now, however,

Plate 220

Plate 208

Christ the friend of children, a subject beloved for decades, disappeared and the baptism of Christ could be restored to its rightful place as one of the most important scenes of revelation in Protestant belief.

Plate 221 The surviving sketch for the painting [679] shows only the overall layout: Christ being baptized in the presence of a group of distinguished persons of rank, three of whom, two men and a woman, are singled out. The middle distance is filled out with sketchy groups of animals in pairs and a herd of deer reminiscent of the Hercules panels. It is the details that provide the key to the theme: the view of Dessau in the background, [680] the portraits of Prince John IV of Anhalt (d. 1551; a stone memorial to him was erected in Dessau in 1556, the same year as Cranach's painting), Margrave John of Kustrin and various members of the house of Anhalt, as well as a group of reformers, which includes Cranach. This picture commemorates the wedding of John of Anhalt and Margaret of Brandenburg on February 13, 1534, in Dessau, in which John of Kustrin participated as attendant of the bride. [681] The positioning of the margrave between the bride and groom is as clear on the drawing as on the painting. The union of these two princely houses was to have been the occasion for a great Catholic celebration, with Cardinal Albrecht of Brandenburg participating, but because of a death at the Brandenburg court the wedding was solemnized more modestly. It was under the regency of this couple that the Reformation began in Anhalt not long afterward, so the marriage of 1534 was commonly regarded as its beginning.

The chromatic impact of the painting derives from its large bright planes. A gentle light like a physical manifestation of the grace of God transfigures everything. Parts of the preliminary drawing show through the brushwork in places. The whole carefully laid-out picture is executed with a rapid sureness of touch.

The Dresden Hercules panels, the Weimar altarpiece and the *Baptism of Christ* (which we may assume to be a commemoration of Prince John of Anhalt) are linked by their function of representing the various princely houses. The Dresden panels, reflecting the activist stand of the prince who commissioned them, are a glorious intimation of actions still to come; the paintings of the Ernestine and Anhalt families tend to look backward, though not without a prospect of future changes. The paintings of this period were concerned with sovereign claims, the personal prestige of princes, the interrelationships of princely houses. The tradition of using pictorial images to express wishful thinking can be traced back to the hunting scenes Cranach the Younger painted between 1540 and 1545: the people portrayed in them could certainly *Plate 209* never have all participated at once in such a scene within sight of Torgau Castle. [682] Except for a few commissions for the Anhalt princes, strong personal concerns of this kind were never again incorporated in Cranach's paintings.

The monumental form of the pictures, including to some extent even the panel for Prince John of Anhalt, was obviously dictated by the interests of princes passionately engaged in political action. After the religious Peace of Augsburg (1555) such grand gestures were no longer called for. Moreover, any attempt to foster political aspirations risked exposure – a danger which the complicated code imagery of the Hercules pictures was intended to avoid. After the accession of Elector Augustus, the policy of the electorate resulted in virtual isolation, making such deviousness even more necessary. The pictures witnessing to Lutheranism

which were popular for a time had to conceal their true social substance. The Lutheran Church of Saxony proved a useful tool for strengthening the growing power of the princes. Reigning now as unchallenged sovereigns, they conceived idealized pictures of their past history which the artists were supposed to realize.

The memorial pictures commemorating the death of distinguished burghers, brilliantly exemplified by the *Raising of Lazarus* of 1558, formerly in Nordhausen, [683] the *Resurrection* [684] and the *Fall and Redemption of Man*, [685] are adaptations – sometimes even repetitions – of those princely models. The Lazarus picture commemorating Michael Meyenburg, the humanistically cultivated burgomaster of the imperial city of Nordhausen, is the most outspoken in its portrayal of individuals. The group of disciples is balanced by a group of reformers – though a group that reflects wishful thinking rather than actuality, because in addition to Luther, Melanchthon, Spalatin, Bugenhagen, Jonas, Cruziger, Förster and Chancellor Gregor Brück, it includes Erasmus of Rotterdam, with whom Meyenburg had corresponded. From one corner of the picture the Coburg Fortress looks down – symbol of the Ernestine branch of the family. This large-scale treatment of a rather unusual theme must have required long preparation. Here again a few slim tree trunks and espaliered vines furnish the skeleton of the composition. One of the rare engravings by the sculptor Veit Stoss has been recognized as the source of the overall arrangement and the composition of certain details. [686] Variations on engravings and woodcuts of Dürer's are also recognizable in many of Cranach the Younger's paintings, especially the big ones. One of the clearest examples is the *Resurrection of Christ* in the Wittenberg city church, probably painted in 1558. [687] Another version of the Resurrection at Mansfeld, done in 1545, [688] has been more drastically modified. In paintings with small-scale figures, borrowings of this kind are rarer or more difficult to detect.

A painstaking attempt to master the pictorial world of the older generation replaced the blind repetition of workshop exercises, which at times seems to have dominated the work of the Cranachs. Such pious respect for tradition was in keeping with the concerns of a whole generation of younger patrons wishing to honor their fathers, the contemporaries of the Reformation, in a manner dictated by their own wishful thinking.

Plates 232, 224

Page 433

¶ THE LATE COMPOSITIONS

Most of the figural works of the later period use small-scale figures. Exceptions are the Nienburg Crucifixion with donors of 1570 [689] and the Augustusburg one of 1571, [690] both of which are memorial paintings, and the Wittenberg Crucifixion. [691] This small group of works had almost no influence on later paintings. At first the smaller figures may have been used to achieve greater spaciousness but their greater flexibility must have been especially attractive to the somewhat uninventive Cranach.

The outstanding late works are the Nativity memorial painting of 1564, [692] the Dessau

Page 433
Page 432

Plate 249

Plate 250
Plate 253
Plate 255
Plates 256, 254

Last Supper of 1565, [693] the inner side panels of the Kemberg altarpiece of 1565, [694] the Crucifixion of 1573, also in Dresden, [695] memorial pictures of 1575 in Dietrichsdorf near Wittenberg, [696] 1578 in Coswig (Anhalt), [697] and approximately 1580 in a Swiss private collection, [698] and the Colditz altarpiece of 1584 in Nuremberg. [699] True and false forms of worship are contrasted for the last time around 1570 [700] and in 1582 [701] in landscape pictures depicting the Vineyard of the Lord which include many tiny figures. These represent Cranach the Younger's last new departure of any importance. We cannot fail to notice the thematic uniformity of his late works. The basic Christian themes of the Crucifixion, the Agony in the Garden and the Resurrection predominate in his late period, beginning approximately

Page 433

with the Augustusburg altar painting of 1571, which combines all three subjects on one panel.

The narrowing of Cranach's range came about not because subjects were discarded but because of transitional processes. For quite a long time the workshop maintained a fairly extensive range of themes and motifs. But under Cranach the Younger the workshop, which was obviously responsible for much of the Kemberg, Salzwedel and Colditz altarpieces, lost its corporate identity and became merely a group of artists all unconcernedly following their own bent. This process was hastened by the influence of the artists at the Dresden court. [702] The elusive figure of Augustin Cranach, who received part of his training from the fantastically imaginative Goeding, [703] seems to have been an exemplary representative of his generation.

During this period Cranach the Younger himself found the ultimate expressive form for several themes. The baptism of Christ with witnesses is represented in several distinguished works: in the picture commemorating Johannes Bugenhagen commissioned by the city of Wittenberg in 1560, [704] in the Kemberg altarpiece of 1568, [705] in the commemorative picture of Prince Wolfgang of Anhalt in 1568 [706] and on the Augustusburg pulpit of 1573 [707] – to mention only works painted by the master himself. Of these only the version in the Kemberg altarpiece is artistically convincing. Its adaptation to the narrow, closed semicircular format of the side panel is a triumph of concentration. The two inner side panels of this altar are

Plate 250

excellent testimonials to Cranach the Younger as a figure painter. Along with the Dessau Last Supper of the same year (1565), [708] they mark the high points of his late work.

In the Dessau picture Cranach's treatment of the Last Supper comes to a brilliant climax. Here we have a surprising departure from the type usually preferred by Protestants, where

Plate 251
Plate 252

Christ is depicted very simply at the end of the table on the left. [709] Surviving drawings by Kreutter, a pupil of Cranach, [710] and by the master himself [711] reveal the step in the transition. The high, light interior with a loosely structured grouping of figures in the center and a view into the adjoining room was probably adopted from the sketches. The execution appears somewhat constricted. The introduction of a pillar behind the figure of Christ lends hieratic tension and radically changes the spatial relationships. Nonetheless this panel represents a high point in Cranach's mastery of interior scenes. The color scheme, in which opaque warm golden browns encounter cool grays, holds its own splendidly against the formal restlessness

Page 415

of the many portraits of reformers and princes, among whom Cranach has for once included himself. The Last Supper was not only a cardinal element in Protestant theology but also the subject of widely divergent doctrines, even within the Lutheran church. The admonition to

the theologians to reach some agreement was very timely, as the later persecution of Melanchthon's supporters by Elector Augustus proved. [712]

The middle-class counterpart to the Dessau Last Supper is the painting of 1564 commemorating Caspar Niemegk, city councillor of Wittenberg. [713] Here the story of the adoration of the Christ Child unfolds freely in a space defined by precisely articulated beams and walls, to which carefree flights of angels and a glimpse of a snow-covered landscape (one of the first in German art) lend their ambience. A big painted archway, with the donors kneeling within it, frames the miraculous scene. *Plate 249*

These two pictures make one ask whether Cranach the Younger may not have spent some time in the Netherlands between 1560 and 1563. In 1565 his pupil Königswieser applied – unsuccessfully – for a subvention from the duke of Prussia to make a journey "to Antwerp and beyond." [714] The Dessau picture obviously refers back to Dirck Bouts's *Last Supper* in Louvain [715] or to one of its derivatives. And the winter landscape in Cranach's nativity scene *Page 434* is clearly a motif that Brueghel had introduced into Flemish art at that very time. [716] Through Peter Spitzer, then living in Brunswick, Flemish pictorial ideas were very influential in Wittenberg from 1563 to 1565. [717] There is also a record from the year 1563 that Cranach had been dismissed by the Wittenberg book publishers, which would at least indicate that the production of woodcut illustrations was temporarily reduced.

The paintings executed toward 1565 have little bearing on Cranach's total œuvre. They represent brilliant variations on conclusions already reached rather than the germ of any new departure. By 1567 the veritable golden age that Wittenberg had been talking about in 1565 must already have been waning for the painter. His brother-in-law-Christian Brück, the chan- *Page 100* cellor of Duke John Frederick II, had been brutally drawn and quartered as an enemy of the Saxon elector after the "Grumbach feuds," [718] and his family had been threatened with the confiscation of their property. Although Cranach remained in the elector's favor, he resigned his offices as councillor and burgomaster. At this point, in 1568, being neither a prince's court painter nor a councillor and certainly lacking any connection with a craft guild, Cranach the Younger had himself inscribed in the matriculation book of the University of Wittenberg, then under the rectorship of Caspar Peucer. The title "Consul" was added after his name. This was probably his last hope of giving his life a secure basis. He had enrolled all his sons except Augustin, the painter, while they were still children.

The worst blow to the intellectual life of Wittenberg was the suppression of Melanchthon's supporters by Elector Augustus in 1575. Humanist studies suffered a severe setback and were generally believed to have been crushed. [719] Humanist scholars, who included people on close terms with Cranach like the above-mentioned Dr. Peucer, were imprisoned or exiled. The lawsuits in which Cranach was involved at this time offer eloquent proof of his loss of material security and authority.

The uniformity of his pictorial themes is an expression of Cranach's new, narrower attitude of mind: Any subjects that might have aroused the least suspicion were avoided. The Crucifixions, Resurrections and Agonies in the Garden which he continued to produce even during these dark years maintain the same high level but never reach the peaks. The pose of the pray-

Plate 255 ing Christ in the Augustusburg picture of 1571 is very similar to the one in Dietrichsdorf of 1575. These pictures owe much of their beauty to the landscape, still expansive and burgeoning, but the Coswig picture of 1582 is much sparser even in this respect. Between 1557 [720] and 1565 [721] portrayals of the Resurrection, which form an especially long and closely linked chain in Cranach the Younger's œuvre, developed a mature style on which the versions of 1571 [722] and 1580 [723] could still draw. Finally, in 1584, [724] perhaps under the influence *Page 434* of Augustin Cranach, a new variation in the movement of the composition of the picture was tried.

Christ on the cross, the subject least susceptible of change in the climate of the times, is *Page 433* treated particularly impressively in the Nienburg picture of 1570. [725] It was revived in the *Plate 253* amazingly animated Annaburg version in 1574 [726] and died out in the rather formless, dense-*Plate 254* ly crowded Colditz one of 1584 [727] – the last big altarpiece Cranach painted. The figural composition of the Colditz center panel does not go beyond filling up the heart-shaped format commissioned by the elector. (A book from the elector's library bound in heart-shaped covers still exists.) [728] Whether certain heart-shaped structures in the Augustusburg altar picture were suggested by the elector is uncertain. In the Colditz picture it is easy to see that demands of the difficult format were too much for Cranach. There is still a vestige of the great conception, but the brilliant detail is inadequately tied into the large form.

Augustin Cranach (1554–1595) certainly collaborated on the works of the final years. It is unlikely that the altarpieces for Salzwedel and Colditz could have been executed without his assistance. In 1571–72 Augustin worked on the decoration of Augustusburg Palace as Goeding's journeyman. Because of him, Zacharias Wehme, holder of an electoral scholarship, could not be accepted in Goeding's workshop, and Cranach undertook to train him in Wittenberg (1571–81). Goeding's talent for improvisation and his liking for insubstantial little figures and showy effects had a strong influence on certain works from the Cranach workshop. *Page 434* A case in point is the memorial picture for Nicolaus von Seidlitz of 1582, [729] which one can confidently assume to be the work of Augustin Cranach. The long wisp of hellfire smoke in the background is an unmistakable Goeding touch. In striving after effects of this kind, Cranach completely neglects the figures. The inadequate treatment of the figure of the risen Christ is evident when compared with the closely related versions by Cranach the Younger in *Plate 256* Augustusburg and in a private Swiss collection. Probably *The Conversion of St. Paul*, a memorial to the jurist Veit Oertel Windsheim painted in 1586, [730] is Augustin's most independent achievement, although here he is indebted to some extent to an engraving of Lucas van Leyden. [731] In terms of artistic composition, the picture is no great advertisement for the Wittenberg workshop, although in Wittenberg it was reputed to be Cranach the Younger's last work. The fact of the matter is probably that in executing it, Augustin still had the help of preliminary studies and collaborators of long standing. He himself can hardly have been carrying on the workshop alone. In 1586, when a copy of the St. Catherine altarpiece of 1506 was commissioned, probably by command of the elector, Daniel Fritsch executed it in Torgau. [732] Old paintings and graphic works, chiefly by Dürer, together with valuable materials used in the workshop, were transferred to the electoral art collection in Dresden in 1591 by Lucas Cranach III (1541/42–1611).

When Cranach died, the brief period of the Second Reformation [733] was beginning for Saxony under Elector Christian I. The influx of Calvinist ideas that accompanied it, together with the restriction of pictures to profane themes, might eventually have produced a strong new foundation for the arts. But for the time being Cranach's work was inevitably considered outspokenly Lutheran. This third rejection probably hastened the decline of the Wittenberg workshop.

¶ THE PORTRAITS OF CRANACH THE YOUNGER

Of all the genres in which Cranach the Younger worked, the painted portrait was the most outstanding. The woodcut played a very minor role, and while the artist was called upon from time to time to work in media besides painting, such works were only occasional. [734] His wall paintings are less well known than his father's. Commissions of this kind came from the princely courts, and Cranach the Younger would have had to be a court painter to be awarded them on any significant scale. We have records of life-sized pictures of trophies of the hunt, [735] repeated orders for hunting scenes on canvas and in cloth [736] and for tapestry and wall *Plates 225, 226* painting designs [737] – the types of art most susceptible to the wear and tear of daily life.

Thus, Lucas Cranach the Younger brought to the portrait a talent well schooled in easel painting. Comparing his portraits with his father's, one is struck again and again by their painterly quality. Other striking features are the larger scale of the half-length portraits and the monumental framing of the figure in the full-length ones. The painterly lightening of the planes and the seemingly thin and empty modulation are partly the result of the larger format that had become popular. The portrait no longer reflected the subject's sober self-esteem, as it had in Dürer's day, but denoted social prestige and status; it was governed by fixed conventions, and patrons were careful to see that these were observed. Nonetheless, the portrait did establish itself as the leading realistic genre of this period. There was a change, however, in the class of the sitters. Portraits of burghers declined. Coats of arms displayed in a context suggesting feudal lineage maintained portrait painting as a genre.

Cranach the Younger's portrait style did not really mature until about 1540, but even during the years when he must have been serving his apprenticeship he was producing works which, though relatively weak in drawing, anticipate the astonishing painterly richness of his later compositions. In fact, the dominant impression produced by his early works is one of richness, especially in costume. The ground often breaks into the contours. For a time the position of the hands is more carefully worked out, although their drawing was always to be one of Cranach's weaknesses.

The best proof of Cranach the Younger's excellent conceptual talent is the Reims portrait *Plates 218, 219* series, in which Cranach the Elder probably had no part. [738] They are more openly conceived, less fully worked out in advance than the portraits by his father. More attention is paid to the conjunction of heads and bodies. In this series the brush strokes suggesting this conjunction reach deep into the otherwise empty picture space. [739] The means by which Cranach was to master the larger format are already latent in these preliminary efforts.

CHRISTIANVS BRVCK IVRI VM DOCTOR.

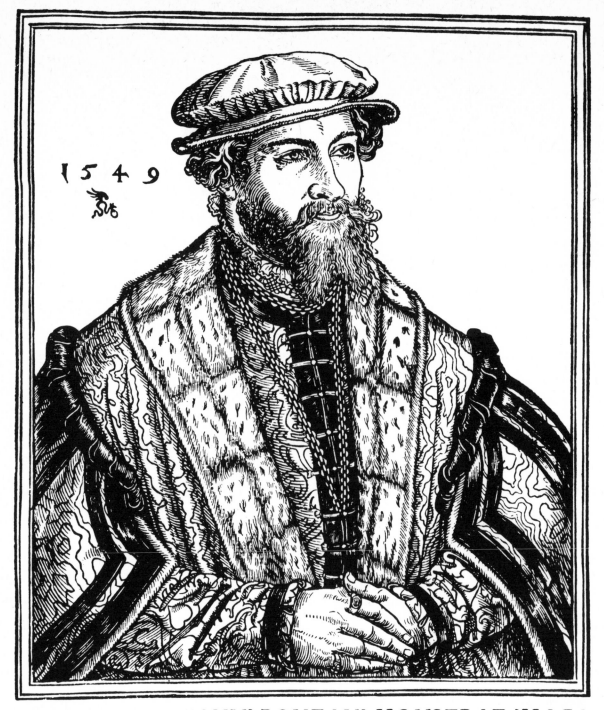

1549

HÆC TIBI CHRISTANNI PONTANI MONSTRAT IMAGO
EFFIGIEM, CLARI DOTIBVS INGENII.
VNDETRIGINTA CVM NONDVM EXEGERAT ANNOS,
VENTVRAM ÆTATEM DETQVE REGATQVE DEVS.

Only minor differences distinguish Cranach the Younger's early portraits, such as that of Justus Jonas [740] (one of a series of portraits of reformers done in 1537 [741]), from his father's study for a head of Luther made in 1532. [742] The son was eager to emulate his father. But whereas the father's contours and modeling are the product of mature experience, the son's work is sketchily abbreviated. The structural refinements of the composition are destroyed. This is particularly noticeable in his miniature portraits.

Plate 167

Cleverly thought-out relationships of planes replace the earlier system of short, strong modeling, which produced a geometric ordering of planes. The colored background is more strongly integrated with the picture. Eyes, nose, mouth and hairstyle seem to be freely drawn in. Under the young artist's hand these traits are combined into a great new concept of the portrait which emerges in the Wittenberg painting of about 1542, [743] the Stuttgart one of 1543, [744] the San Francisco one of 1545, [745] and the Warsaw one of 1546. [746]

Plates 202, 203, 205, 207

In the important portrait of 1550 in which Lucas the son took leave of his father, [747] a graphic firmness of line still predominates. Head and hands are shaped with the realistic precision usually found only in masks or casts. This picture ranks with the paternal portraits of Dürer [748] and Burgkmair; [749] nothing comparable exists at the time outside German art. The picture is by no means only a personal memento. It is in the large format used for princes and scholars at that time, although still not as big as some of the portraits of reformers and princes. [750] The unwieldy pose and contours are characteristic of Cranach's concept of the portrait at the time. The body seeks to unfold itself within the picture space instead of being merely inscribed in it. More and more frequently shadows are used to detach the figure from the background. Projecting contours, a head seen from below, [751] indicate the greater leeway that marks the new conventional form of the fashionable portrait.

Plate 217

Cranach the Younger's monumental period contributed to the remarkable development of his portrait style. The portraits he painted at this time are full of exuberant life. The unresolved tension of earlier studies gives way to an almost serene mastery. [752] The most overwhelming example of this attitude, apart from the portraits on the Weimar altarpiece, is the portrait of Joachim II, elector of Brandenburg. [753] Even in the bareheaded study for this portrait the powerful integration of observed details already stands out. The study is simply a likeness, down to the smallest movement of the eyebrows and the slightly sagging cheeks, but the formal problems have been completely mastered. The painting itself has more tension, in keeping with the subject's princely bearing and magnificent dress. [754] The forms of this large panel are gentle. Sky blue and strawberry red are the dominant colors. A serene, festive spirit emanates from the powerful picture. Seen in the light of the biography of Joachim II, it might be said to represent his claim to sovereignty rather than its incomplete realization. The picture is an active portrayal of history in the making similar to the contemporary Weimar altar painting of 1555 made for Elector John Frederick or the painting of 1556 commemorating the union of the houses of Anhalt and Hohenzollern. As a prestige-enhancing portrait of a distinguished ruling prince, this work of Cranach has few peers in German art. Among them are Dürer's marvelous portrait of Elector Frederick the Wise of around 1496, [755] Lucas Cranach the Elder's great portrait of John Frederick as Elector [756] and Holbein the Younger's por-

Plates 234, 230

Plate 229

Plate 220

Page 426

Plate 134

traits of Henry VIII. [757] The almost oppressive closeness of the half-figure portrait has a far more immediate impact than the full-figure treatment with a feeling of greater distance, which Cranach the portraitist would later specialize in. The extraordinary achievement of the portrait

Plate 260

of Elector Joachim stands out when we compare it with the portrait of Margrave George Frederick of Ansbach-Bayreuth painted about 1570. [758]

Cranach's imposing painterly concept probably owes something to the influence of certain portraits by Titian which must have come to Saxony as a result of the Italian painter's visits to Augsburg in 1548 and 1550–51. One of these, the study of the head for the portrait of the Elector Maurice of Saxony, was so much admired by artists that it was given as a present to the court painter Heinrich Goeding in 1575. It is thought to be preserved in Dresden. [759] The Dresden court at first counted on Francesco Ricchino of Brescia to fulfill its hopes for portraits. [760] When he requested permission to leave the court, portraits of the electoral couple were under way, [761] and their completion seems to have been one reason for delaying his release. Hans Krell, who worked in Leipzig and Freiberg and died in 1565, was one of the court's favorite portraitists until his later years. [762]

Only then, it seems, did Cranach the Younger take his place, notably with the six full-length

Plates 242–245

portraits of the electoral family done between 1564 and 1565. [763] The immediate predecessors of these wood-panel paintings were the portraits, painted in 1563, of Count Joachim

Plates 240, 241

Ernest of Anhalt, a great patron of the arts, and his wife, Agnes, though these were on can-

Plate 197

vas. [764] The full-length portrait had first been treated in the woodcut medium around 1547–48. [765] The paintings of 1565 are noticeably enriched by the high-rising arches of colored stone which break the angle of the shadows cast by the figures. This gives the portraits an unusual monumental structure. The secular full-length portraits of Cranach the Elder had been confined to a narrow stagelike space where such modest spatial development as existed was created by the play of the shadows. [766] The family of the elector stands for the

Plate 187

idea of dynastic rule, guaranteeing its continuing existence so far as human knowledge can foresee. A portrait series of this kind must certainly have been coordinated to fit a specific space, where the different ages were contrasted, not in pairs, but through a series of increasing or diminishing picture formats. Extant studies for three of the six portraits give an insight into

Plate 248

their genesis. In the portrait of Elector Augustus the study [767] seems to have been adapted with no loss of form or strength of characterization, but the rigid faces of Duchess Elizabeth and Duke Alexander in the paintings give barely a hint of the vividness of the studies pre-

Plates 246, 247

served in Berlin [768] and Vienna. [769] These heads are executed on light paper, unlike the earlier studies, which are on a brownish ground. They are among the most powerful and unusual works Cranach the Younger produced in the portrait genre. There is nothing naïve about them. Yet the combination of these faces, in the full-length portraits, with the dress painted in close detail and with the planes and the shapes of the shadows creates a disturbing discord.

The alert children's eyes seem to be watching the painter, who responds to their glance with attentive observation. There are hardly any other portraits of Cranach where the forms are so tightly connected, both in the treatment of the faces and in the unsurpassably free suggestion of the neck and shoulders. Everything in these sketches has an air of inevitability. The con-

ventional traits that emerge in the final painting appear subordinated here. These are vulnerable human beings, shown just as they are. One senses the destiny of Duchess Elizabeth, who was to end her days in an unhappy marriage with Count Palatine John Casimir, and of the young Alexander, dead by 1565. Between these childlike scions and the splendor of the spheres in which they had to move lay a gulf in which much remained unfulfilled.

Half-length portraits of the same period are seen at closer distance, even when the subjects are of the nobility, as is evidently the case with the couple painted in 1564. [770] The close view *Plates 238, 239* and the seated pose impart a leisurely feeling to the detail. The woman's costume is perhaps not as rich as that of the members of the electoral family, but it compensates for this by greater variety. The pure juxtaposition of strong color planes makes the figures seem bodyless. The connection between the objects is strangely undefined, though originally the contrasts must have stood out more strongly against the light blue background, which was later covered in strategic places by greenish brown curtains to hide the coats of arms underneath them.

The rarer burgher portraits of this time are more simply conceived. The material trappings – expensive costumes, jewelry, seal rings and coats of arms – are absent. The portraits of a married couple done in 1566 [771] effectively use muted detail: delicate folds of white juxtaposed *Plates 236, 237* with dark planes, which, in the portrait of the husband, typically consist of sumptuous patterns of black on black.

Portraits of the reformers are often eloquent examples of the social function of this genre. The great final statement of the Luther portrait by Cranach the Younger has already been men- *Page 93* tioned. It was followed in 1546, the year of Luther's death, by a life-sized portrait, [772] a model for various other paintings of reformers. After the memorial painting of (presumably) John of Anhalt [773] and the *Raising of Lazarus* commemorating Michael Meyenburg [774] of 1558, it is no surprise to find, in 1559, the portrait of Melanchthon being used as a vehicle *Plate 228* for a timely statement. [775]

On February 3, 1558, Melanchthon had announced an academic address on the subject of Basil the Great, one of the ancient Church Fathers. Speaking of the stormy period of the struggle against Arianism, he noted the similarity of conditions: "We too are assailed by many enemies who rely on the support of the princes and on the following of the unlearned." Basil was claimed as witness for the reformer's belief in redemption by faith alone. Melanchthon quoted, in the original Greek, his citation of the words of St. Paul to the effect that man does not have true righteousness and is justified only by faith in Christ. [776] This is the text to which Melanchthon is pointing in Cranach's portrait. It bears the solemn heading "Basilius pagina 388" and the postscript "Anno 1559." Opposite this text, on the right-hand page, is what seems to be Melanchthon's interpretation, with the concluding words: "O Gospel, be with us and set our hearts afire with thy flame." Thus, in the humanist manner, an early source of church history is opened up for use in reform argument – a characteristic attempt to establish the new doctrine as the veritable original one, relating to the pure Gospel. Melanchthon, a slim figure, appears in the painting as a scholar with a straggly gray beard and unkempt hair, yet monumentally heightened, shadowless against a light gray background. The structural pose of the upper part of the body is unclear; under the carelessly closed mantle, the body

seems to turn away from the position maintained by the head, and half of the face is even shown flat against the plane of the canvas. The lack of control over the structural elements produces a naïve play of planes which has a charm of its own, as can also be seen in contemporary art movements which also capitalize on this kind of vitality.

In many instances the "witnessing" character of certain paintings has still not been fully deciphered. In 1571 Margrave George Frederick of Ansbach-Bayreuth, at one time an ardent patron of Cranach's, commissioned a portrait in two versions of his father, Margrave George, who had died in 1543. Both were made from the same sketch. One, in large format, shows the prince bareheaded, holding his hat in his hands, his glance turned sideways as if in religious meditation. [777] The other shows him with his hat on his head, looking down at the viewer and pointing to the signet ring on his finger, [778] emphasizing that this was a ruler who succeeded in enlarging the domain of Brandenburg. [779] Margrave George (known as George the Devout) belonged to the inner circle of Protestant princes, as did Elector John of Saxony and Prince Wolfgang of Anhalt. His spiritual portrait, perhaps intended as a memorial, might have served as a monument to his upright Lutheran stand at the diets of Speyer and Augsburg in 1529–30.

Plate 257

Plate 258

The posthumous portrait is well represented in the late work of Lucas Cranach the Younger. The view of history that prevailed at the time liked to express itself in dynastic portraits of rulers or ancestors – or at least in paired portraits. As late as 1565 the painter was still being consulted by the elector in heraldic disputes. [780] Letters were exchanged between Dresden and Wittenberg concerning details of the series of portraits that had been commissioned. [781] It was often difficult to procure the models needed. Portraits displayed high on a wall of Torgau Palace had to be taken down, [782] or again it was necessary to wait for the Leipzig fair, which offered a good opportunity for buying ancestral portraits. [783] In 1674 Cranach received an inquiry from Dresden asking whether certain old models were still in his possession – an inquiry which was probably part of a rigorous investigation of the matter. In 1579, when he was commissioned to paint the portraits of Duke Alexander and Duke Christian, both long dead, the elector offered to send him their likenesses (most likely the head studies from life) with the admonition: ". . . you must not make them public but (keep them for yourself alone) and as soon as you have no more need of them send them back." The award of a commission for a noble portrait could be a great honor, which the prince needed to keep under his own control. [784] It was a favor which Cranach the Younger himself once asked of Duke John Frederick II (in 1561). In this case the commission was for a gold medal bearing a portrait of the prince. For portraits commissioned by court circles, which in general tended to favor mediocre painters like Roddelstedt and Goeding, the artistic demands were relatively high. The electress of Saxony once told the duchess of Bavaria frankly that the portraitists available in Dresden were not as good as those at the Munich court. [785]

In the case of large portrait series like those of 1572 for Augustusburg, where a series of portraits of princes was commissioned for the castle and a series of theologians and scholars of the universities of Leipzig and Wittenberg for the church, Cranach was entrusted with the execution. In 1578 the elector had the series of rulers of Saxony copied in reduced format for Archduke Ferdinand of Austria. Unlike so many of the commissions of that time, this one has been

preserved, in Ambras Castle in the Tyrol. [786] The archduke's historical interests seem to have led the elector to commission from Cranach, again in 1578, a set of four portraits showing the two opponents of 1547, Elector John Frederick and Duke Maurice, first in the armor they had *Plates 261, 262* worn in the Battle of Mühlberg, then in their regular clothing. The search for a likeness and for the favorite armor of Margrave Albert Achilles, then a friendly ally but later the mortal enemy of Duke Maurice, may also be related to this project. [787] The court of Dresden received replicas of these two pairs of portraits, still preserved in Dresden, [788] Meissen [789] and Weissenfels. [790] Two letters of the elector, dated June 6 and 16, 1578, clearly specify what is required of the artist. At first it was merely to be a pair of small head-and-shoulders pictures showing John Frederick with the scar of the wound he had received at Mühlberg. The second letter, however, states that because of the long distance the portraits would have to travel, they were to be painted on canvas, in a format to be determined by Cranach, in the two different costumes. The portraits in armor appear against a dark background; the helmets rest on a painted balustrade – an arrangement which goes back to Titian, who had painted Duke Maurice in this pose. [791] The massive figure of Elector John Frederick wearing a hat is reminiscent of Titian's magnificent portrait in Vienna. [792] The figures detach themselves darkly from the light blue ground. By shifting the usual direction of the source of light, the shadow is cast on the wall close beside the face, above the shoulder. The luckless destiny of John Frederick is suggested only by three details: the scar, the shadow, which seems to be trying to outstrip the figure that casts it, and the yielding of pride of place to Duke Maurice, the portrait's counterpart on the right. The disputed matter of coats of arms has been bypassed. Here the elector had every reason to be mistrustful: He had forbidden Cranach to depict the arms of the dukes of Saxony on the great portrait series for Ambras. [793]

The historical motivation happens to be well documented for this portrait series, but in other instances it can only be surmised. Even with regard to the posthumous portraits of Luther and Melanchthon one cannot assume that any widespread naïve feeling of veneration survived throughout those decades. The questions when, by whom and for what presumed motive portraits of this kind were commissioned lead directly to the struggle of the princes for possessions and privileges and to the theologians' quarrels which repeated these disputes on another level. In these circumstances, forms once established became unchallengeable conventions. Individual traits became secondary; the habit of thinking in simplified contrasts inhibited any kind of vitality. Only in the sketches for portraits is the pictorial rigidity still permeated with vibrant conflict.

On the occasion of his engagement to Duchess Sophie of Brunswick-Celle in 1579, Margrave George Frederick of Ansbach-Bayreuth ordered life-sized portraits of the bride in her wedding gown, of his first wife (who had died a year earlier), "in dress and jewelry as she was wont to go at the time," and of his mother. The portrait of the deceased wife, Elizabeth, was to be sent to Königsberg as the model for a memorial sculpture. This may be the splendid portrait of a princess still to be seen in Munich. [794] *Plate 235*

This portrait of a blond noblewoman is probably one of the few outstanding works of Cranach's late period. The costume, with its rich jewelry, is painted with the utmost precision, yet still subordinated to the great unified conception of the painting. Black, bright red and the

light blue of the ground are cleverly interwoven and tied together by the gold of the jewelry. This creates a formal unity which stands in stark contrast with the jarring formal conflict of earlier portraits. [795]

To produce on demand a portrait of a deceased person who had existed only on the margins of the artist's visual experience certainly required great organizational judgment. Not only the model for the portrait but notes on the costume and the individual items of jewelry had to be available and reliable. A roll of such memoranda still exists in Dessau, compiled not by Cranach himself but by a painter associated with him – quick shorthand sketches which, unlike the studies of the Dürer period, served no other purpose than to refresh the memory in executing portraits. [796]

Plate 264 Compared to the princess' portrait in Munich the portrait of Lucretia von Berlepsch, a provincial noblewoman, painted in 1580, [797] makes a more muted impression, although it is executed in almost three-quarter length. Here again the dark tone of the elderly woman's dress is heightened by gold jewelry, but in this case the plainly visible medal of the prince and the coat of arms beside the head are apparently intended to denote her social status. The radiant autonomy of the Munich portrait is gone.

Plates 263, 265 The late portraits show great unity of conception, even when we compare the portraits of Erich Volckmar von Berlepsch (1580) [797] or Hans von Lindau (1581) [798] with earlier solutions of the problem. The conventional features of the male portraits include the big turned-up fur collar, the light, intricately folded ruff, the five-strand gold chain with a pendant bearing the portrait of the subject's feudal lord, the left hand holding the hat, balanced on the other side of the painting by the hand holding the gloves beside the dagger handle. It is very significant when this uniform pattern is varied by a hand jauntily resting on a hip, as in the Lindau portrait. Yet this motif is introduced with a characteristic lack of coordination; it is almost as if the hand were intruding into the picture from outside the frame.

The portraits of Cranach the Younger are unchallengeably documented right down to his last years. Artistically the portrait was probably the backbone of his work, even though it was adversely criticized at times. In 1550, for instance, the widow of Veit Dietrich, the Nuremberg theologian, took exception to a portrait of her late husband painted after a death mask, and in 1579 Margrave George Frederick criticized the portraits of his wife, Sophie. Such failures (from which not even Dürer was exempt) [799] can be partly explained by the extremely complicated commissioning procedure already referred to and also by the habit of making replicas, which was customary at the time. Copies were certainly executed largely by workshop personnel, which varied considerably from one period to another, as we can see from the altar paintings.

None of Cranach's free figural paintings have been preserved except the *Hill of Virtue* of 1548 in Vienna. But he must have done a set of the four temperaments and their major combinations, commissioned in 1565 through Dr. Caspar Peucer and perhaps suggested by etchings of Virgil Solis. [800] This is the last time a humanist subject is mentioned in connection with the Cranach œuvre.

The widely held belief that the Venus and Lucretia pictures persisted well into the mature period of Cranach the Younger has so far not been substantiated. In 1574 the climate at the

Dresden court was such that when the Liège painter Hans Schroer presented himself with a painting of Venus and Cupid, he was asked with some concern by the elector's chamberlain why he did not paint a Bible story "instead of that poetizing." [801]

The unbending anticultural trend which prevailed during the rule of Elector Augustus and which perhaps became a model for other princes, too, was justly criticized in the brief period after 1586, when the electorate of Saxony adopted a more open foreign policy. [802] The religious upheavals after the Reformation seem to have severely damaged the credibility of art. The late work of Cranach the Younger would probably make a far richer impression if he had not had to devote much of his strength to the ephemeral task of painting portraits intended to enhance the prestige of princes – a genre which is inherently repetitive.

Cranach's work in both its light and its dark aspects would be less understandable if one failed to take into consideration its extensive range, which is still reconstructible from documentation preserved in the archives. This extensiveness must have helped to shape his experience and certainly influenced the character of many works of nondecorative art, such as the portraits.

¶ THE LAST YEARS: THE ECONOMIC SITUATION

Cranach's most important patron was the elector of Saxony. Works for other princes such as those for Count Palatine John Casimir in 1559, Count Peter Ernest of Mansfeld in 1564, the Danish king in 1573 and Archduke Ferdinand of Austria in 1578 were in all likelihood executed at his expense. Cranach's correspondence with Elector Augustus also touched on other matters: the acceptance by the artist of the office of burgomaster, appeals on behalf of a relative or business affairs. But Cranach did not enjoy the privileges of a court painter. When payment for his work was delayed, as it was in one case from 1565 to 1575, this certainly meant a greater hardship to him than it would have meant to a salaried artist.

Among the works done for other princes, the ones Cranach executed for the House of Anhalt stand out, especially the ones for Joachim Ernest, who commissioned some of his most successful pictures. The Hohenzollerns seem to have been represented not so much by the electoral court as by the Königsberg court of Duke Albert of Prussia and by that of Margrave George Frederick.

The generally uncertain situation with regard to commissions certainly must have hurt Cranach economically. It is difficult to make any precise assessment. The assets of more than 4,000 guilders which his father had declared in 1528 for taxation purposes and which may well have increased by the time he died had not passed into his son's hands in their entirety. Since Lucas', younger sister Barbara, wife of Christian Brück, received 5,000 guilders as her inheritance, [803] the estate to be divided among the four children must have amounted to at least 20,000. Of this, Lucas, the only male heir, probably received an equal share, presumably in the form of the house and the real estate that went with it, together with the equipment and

stores needed for carrying on the business. The apothecary shop, probably still located in house No. 4 on the Markt, went to the youngest sister, Anna, who had married the apothecary Caspar Pfreund in 1550. The property of the brother and sister in Wittenberg was estimated at the same level in 1575, but the sisters in Weimar and Gotha got into difficulties from which Cranach the Younger helped extricate them. All the property of the brutally executed Chancellor Christian Brück had been confiscated, until Barbara, the Cranach daughter, was able to prove that a considerable sum belonged to her as her share in her father's estate. Georg Dasch of Gotha, the husband of Ursula Cranach, seems to have been engaged in unsuccessful business enterprises which involved the family. [804] In 1575 her brother had to intervene to have his sister released from debtors' prison.

At that time Lucas himself was also threatened with a lawsuit brought by the jurist Veit Örtel Windsheim, and sometime later it was rumored that he was using his wine license dishonestly. [805] In the year 1573 Cranach was still one of the six wealthiest burghers of Wittenberg, with assets estimated for tax purposes at more than 3,200 guilders. The taxes paid by his brother-in-law Caspar Pfreund were equally high; those assessed on the fortunes acquired by the widow of Barthel Vogel and by Conrad Rühel from the book publishing company were considerably higher. Their assets amounted respectively to twice and three times the total of Cranach's.

Of Lucas the Younger's children, Lucas continued to live in Meissen until 1612. He had been matriculated at the university, and after holding a distinguished position in Torgau, he finally became administrator of the Prince's School in Meissen. Augustin, the son born in 1554 and trained as a painter, remained in Wittenberg, acquired the imposing house at No. 23 on the Markt, but lived only until 1595. His marriage to Maria Selfisch, a publisher's daughter, produced many children, including a painter, Lucas IV (1586–1645), of whose works nothing is known. A brother of Augustin married a daughter of the rich publisher Vogel; a sister married the well-known theologian Polycarp Leyser.

When Cranach the Younger died in 1586, he still held an outstanding position in Wittenberg, although there does not seem to have been any official mourning such as was declared when the well-known Bible printer Hans Lufft, another former burgomaster, died in 1584. *Page 110* For Superintendent Georg Mylius, who preached the funeral sermon, Lucas Cranach was one of the last representatives of a great epoch that had reached its end, a paragon of social conduct. Mylius was an uncompromising Lutheran, as was Leyser, who in 1581, in the bloom of youth, had married the youngest Cranach daughter, Elizabeth. It is possible that the displacement of the Lutherans, which began after the death of Elector Augustus (who died a month after Cranach), detracted from the memory of the artist. In any event, Polycarp Leyser took it upon himself to keep Cranach's memory alive as a living reflection of the age of Luther. From the young Dresden sculptor Sebastian Walther, Leyser commissioned an exceptionally large alabaster monument, [806] though probably not until after the death of Cranach's widow in 1606. By this time Zacharias Wehme, the master's last surviving pupil of any importance, was also dead. Walther's relief is the work of a new generation which was trying to emulate the freer, more lively style of southern German and Italian models. It is lacking in the authority found in the Cranachs' work.

¶ POSTSCRIPT

ranach the Elder's persistent yet yielding creativity, always true to itself, yet constantly regenerated, was carried on by his highly gifted son, who enriched its effectiveness but in the end made it static. It was the product of an age of declining revolutionary movement. The discovery of the free man in the age of the Renaissance was followed by the discovery of man as a socially conditioned being. The new balance of powers permitted the princes to act with less regard for the particular interests of their subjects. After a series of military campaigns the new order was consolidated. Domestic strengthening of authority and the economic development of the country began to take precedence. The chief concern of courtly culture, in its beginnings toward the middle of the sixteenth century, was to justify the expansion of sovereignty. Paintings in gigantic formats supported gigantic territorial claims and opposed other similarly asserted claims. The portrait of the prince and his family, serial pictures of ancestors or of coats of arms flourished. The painting of a court hunt could represent an offer of alliance; a representation of the baptism of Christ might celebrate the fraternal linking of two princely houses; the landscape background beneath a crucified Christ might commemorate the successful acquisition of a rich territory. The full importance of such pictures stemmed from their twofold meaning.

Witness to Luther's Reformation was proclaimed in great altarpieces and in commemorative pictures for Protestant princes. Here the power expansion of the Reformation could draw upon popular ideas and figures. The conversion of a prince to the Reformation, originally often hesitant and accompanied by misgivings, became an important fact to be moved as far back into the past as possible. [807] The protesting princes at the Diet of Speyer in the year 1529 – the first Protestants – were later celebrated as heroes: John the Steadfast, elector of Saxony, Prince Wolfgang of Anhalt, Margrave George the Devout of Brandenburg-Ansbach. In this way their sons honored the memory of their fathers' generation.

When the power struggle between the princes led to peace treaties, this kind of propaganda became untimely. The emergence of adjacent territories under Protestant rule in central and northern Germany reduced the possibilities of religious controversy and, hence, of pictorial propaganda. In the lands ruled by the Wettins the relaxation of tension came relatively late. When the reign of Elector Augustus opened in 1553, a cautious policy aiming at security had begun to replace the daring expansionist policy of Elector Maurice. Nonetheless John Frederick, son of the late elector, cherished hopes of regaining his lost rights, aided by France and a conspiracy among the nobility, and even envisaged an attempt to become ruler of the German empire. This fantastic plan was to be accomplished with the aid of Wilhelm von Grumbach, a knight of the empire, who revived the idea of a rising of the nobility. This attempt was easily crushed in Gotha in 1567. The brutality displayed by Elector Augustus recalls the witchhunts, but he did eliminate for good the threat to his electoral title.

In the theological controversies of the time, which faithfully reflect the splitting up of the territory, the authority of the reformers was at times sharply contested. The rival houses of

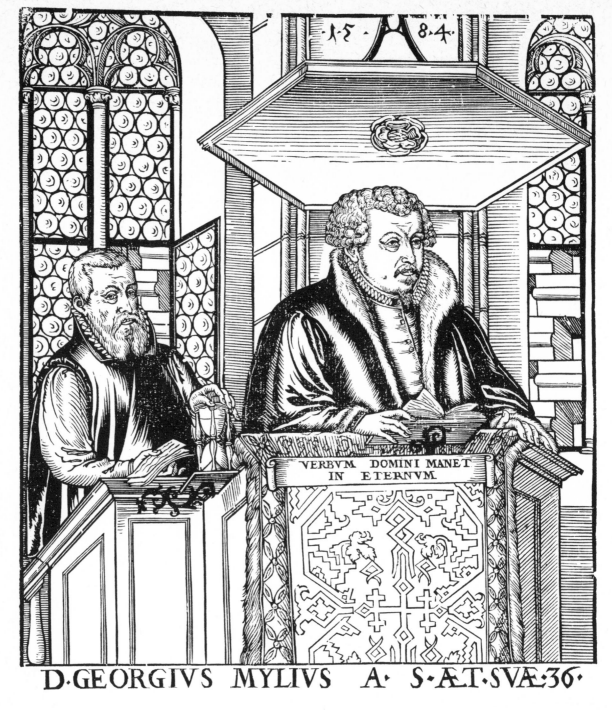

VERBVM DOMINI MANET
IN ETERNVM

D·GEORGIVS MYLIVS A· S·ÆT·SVÆ·36·

Saxony played off Melanchthon and Luther (now dead) against each other. But Melanchthon's more modern attitude, which favored compromise between the Roman and Lutheran churches, did not prevail even in the Albertine realm because the elector did not dare risk a conflict with the Lutheran position, which had been recognized under the law of the empire in the religious Peace of Augsburg. So long as Elector Augustus lived, his confidence in this outstanding man protected the liberal tendency of the Melanchthon group, which included members of the elector's intimate circle. But in 1585, when proof was produced of their sympathies for the embattled Calvinists in the West, these "Crypto-Calvinists" were cruelly persecuted. This was a heavy blow to humanist studies at Wittenberg. In the seventy years of the university's existence, leading teachers had never been so harshly disciplined. Problems whose solution might

have led the country to a flexible superregional policy appropriate to its stature were put aside. During the reign of Christian I, from 1586 to 1591, a similar attempt by burgher advisers to lead the electorate of Saxony out of its barren isolation was defeated by the provincial diets, which consisted predominantly of the nobility.

The system of spiritual tutelage and cultural impoverishment, perfected during the reign of Elector Augustus, remained intact. Such conditions hampered productive artists like Cranach and left little scope for potential development in any field except architecture or the crafts.

Artists no longer made studies because court commissions did not require them. The scientific eye, though, was not to be denied. Even if we did not possess records of the observations of the heavens by two contemporary Middle German painters, the skyscapes of the younger Cranach, drenched with light, and the studies of the seasons and of topographical motifs embodied in various picture backgrounds would suffice to prove that fact. In attempts of this type Cranach the Younger went beyond the bounds of the training he had received from his father. But the subordination of the whole development of painting to visual discoveries would have required favorable social conditions which did not exist at the time. Moreover, the prospering Wittenberg workshop was certainly no place for artistic experiments.

What faced Cranach the Younger was not the struggle to acquire property but the more difficult task of defending inherited property under unfavorable conditions. The fact that the apothecary shop was not part of his inheritance may have simplified its management, but it hardly improved his financial standing. With the loss of important extra income like his father's salary as court painter, the economic capacity of the workshop had to be exploited to the full. It took the most strenuous effort to make any profit at all. The quick collapse of the enterprise after the master's death gives an idea of the pressures connected with every decision. The involvement of the Brück and Dasch family fortunes in the disaster of the Grumbach feuds imposed an additional burden. Cranach's resignation from the city government, presumably as a result of this event, contributed to his loss of public authority and later enabled his enemies to raise serious charges concerning the way the business was run – charges which, in view of the suspiciously large assets of the Cranachs at the time, probably had some basis in fact. The funeral sermon of Georg Mylius seems to present the conditions in which Cranach <figure><figcaption>*Page 110*</figcaption></figure> spent the last years of his life in an unduly favorable light. In contrast with the funeral of the deserving Bible printer Hans Lufft, Cranach's funeral was restrained. Not until after his widow's death did his son-in-law Polycarp Leyser have his imposing monument erected.

But occasional honors could not hide the deterioration of the spiritual climate or the workshop's material difficulties. Rising seats of government like Dresden, whose institutions attracted the accumulated talents and resources of the territory, offered greater cultural opportunities. From the German viewpoint, the complex diversified culture of the imperial court at Prague was the most splendid example of the potentialities of the late sixteenth-century era, and the electorate of Saxony was eager to emulate it. Yet in the context of European culture, even the blossoming of Prague, soon to be swept away by the storms of the Thirty Years' War, was hardly more than a marginal phenomenon, with more than a touch of cultivated provincialism. Leadership in art fell to the Netherlands, chiefly, no doubt, because of the influx of strong middle-class resources which entered the courtly art of the Baroque age from a strong

capitalist base. In Flemish art a realism nourished by the artists' own experience was able to unfold and make its essential contribution to an amazing flowering of the arts. German painting of this period was little more than a reflection of the main current. What was lacking was not the stimuli but the social conditions needed to support a strong independent development. The Thirty Years' War interrupted important beginnings and hastened the transition to a competent courtly art in the Baroque manner.

It is hard to discover any broad connections leading from the art of the Cranachs into this historical development. The pictures in noblemen's private galleries, the woodcuts in the hands of artists, belonged to an established tradition which in its totality invited creative contemplation. Masters like Rembrandt and Velazquez were no doubt occasionally influenced by Cranach; later artists saw his paintings from different points of view. Finally Picasso, the graphic artist, rediscovered the living essence of Cranach's pictures of women, which became a second reality to him.

Cranach's posthumous fame did not grow entirely out of its own inner merits. One might rather say that it sprang to life over and over again, accommodating itself to the experience of different ages. The extraordinary ability of his work to stand the test of all manner of different approaches has proved to be one of its most significant qualities. It retains vestiges of a life which has long been part and parcel of history, yet in some unaccountable way still remains contemporary. Exuberance stemming from the elation of one age and subordination to the overpowering climate of the succeeding one blend in a partly naïve, partly sophisticated pattern. As our experience broadens, we shall gain from the work of the Cranachs, in its totality and in its details, an even deeper understanding of historical behavior as artistically shaped truth.

Angels
with the Twin
Coats of Arms
of the Electorate
of Saxony. 1519.
Woodcuts

 PLATES

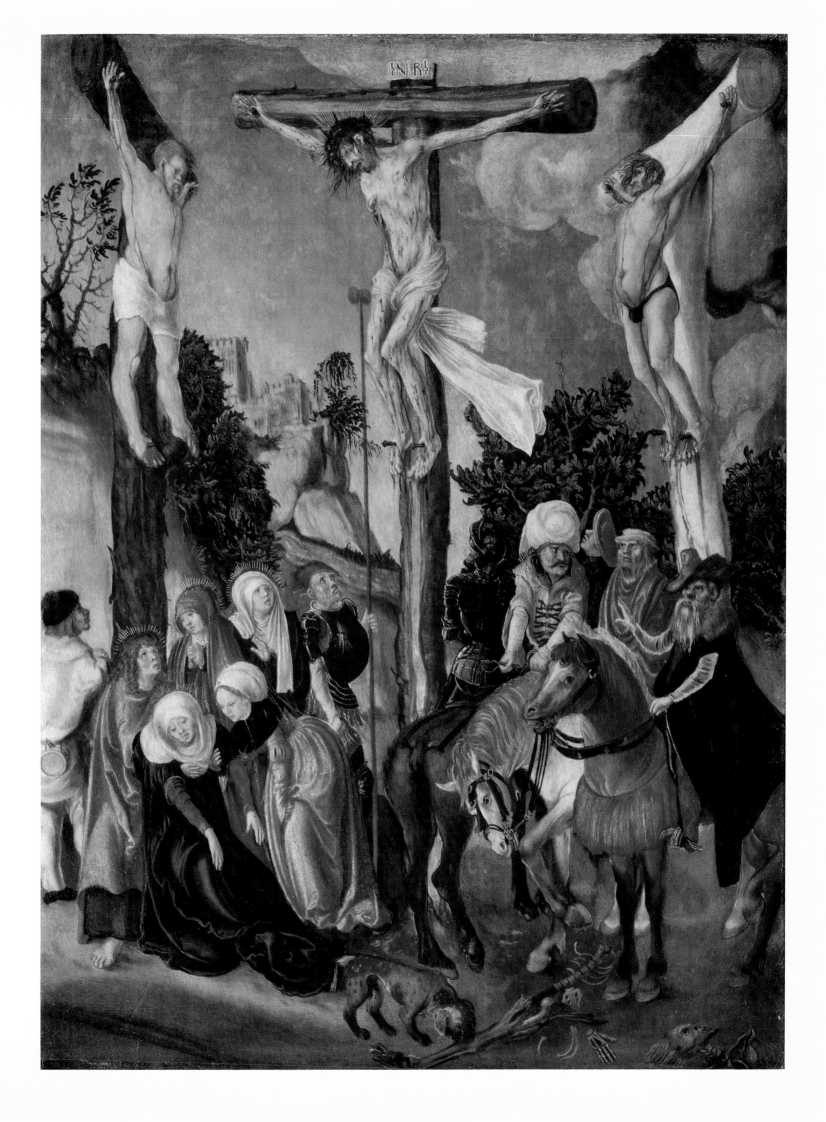

I

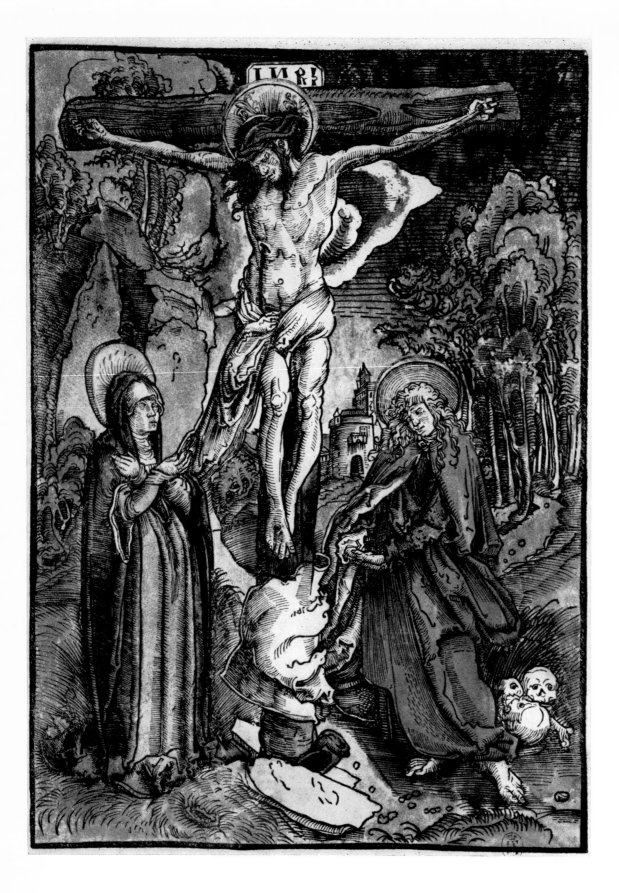

2 Christ on the Cross. Before 1502. Woodcut

Preceding page:
1 The Crucifixion of Christ. Before 1502. Vienna

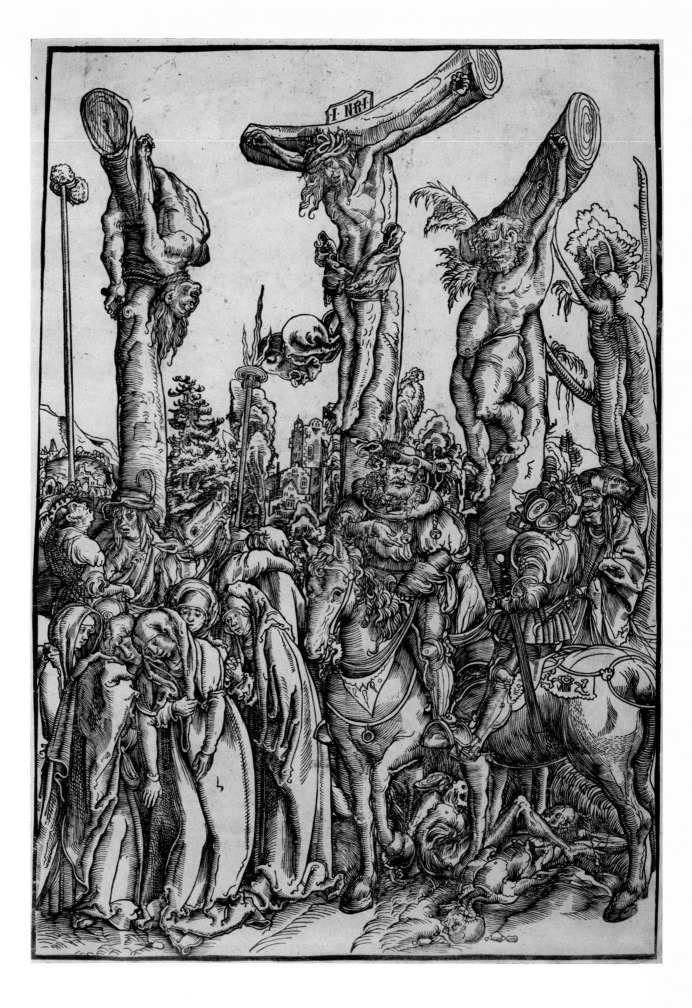

3 The Crucifixion of Christ. Before 1502. Woodcut. West Berlin

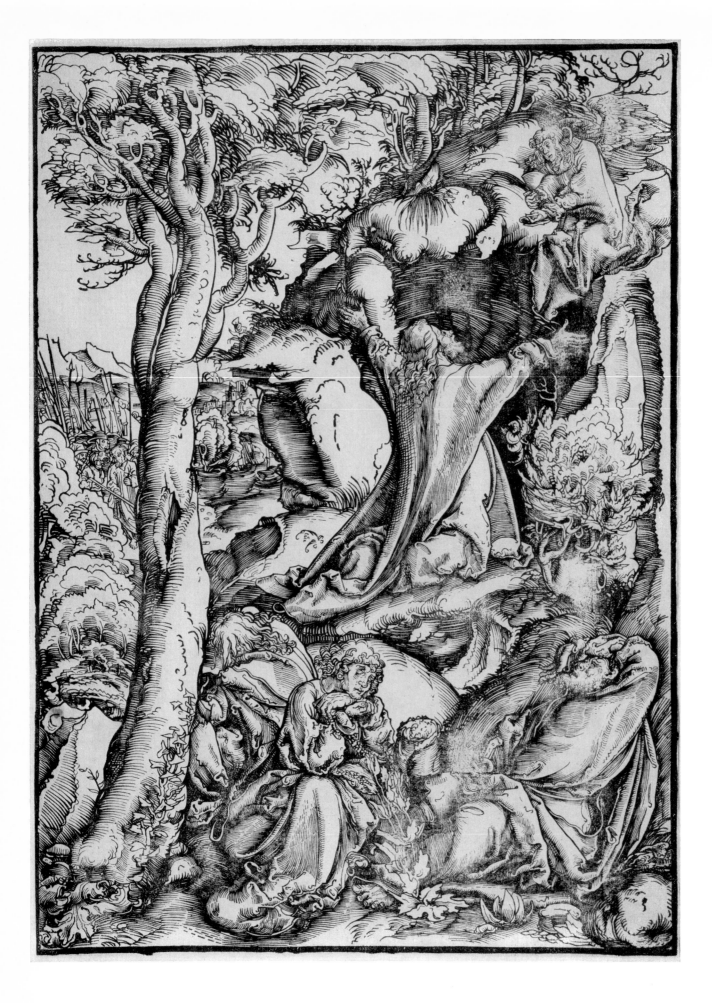

4 The Agony in the Garden. circa 1502. Woodcut. New York

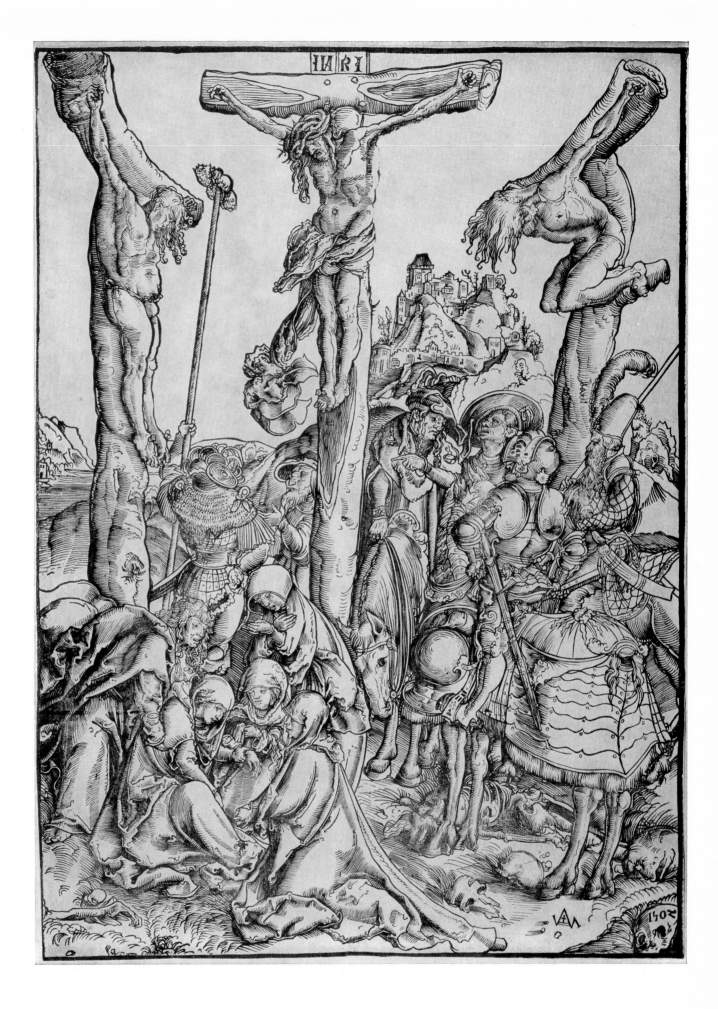

5 The Crucifixion of Christ. 1502. Woodcut. New York

6 Foolish Virgin. circa 1502. Drawing.
Nuremberg

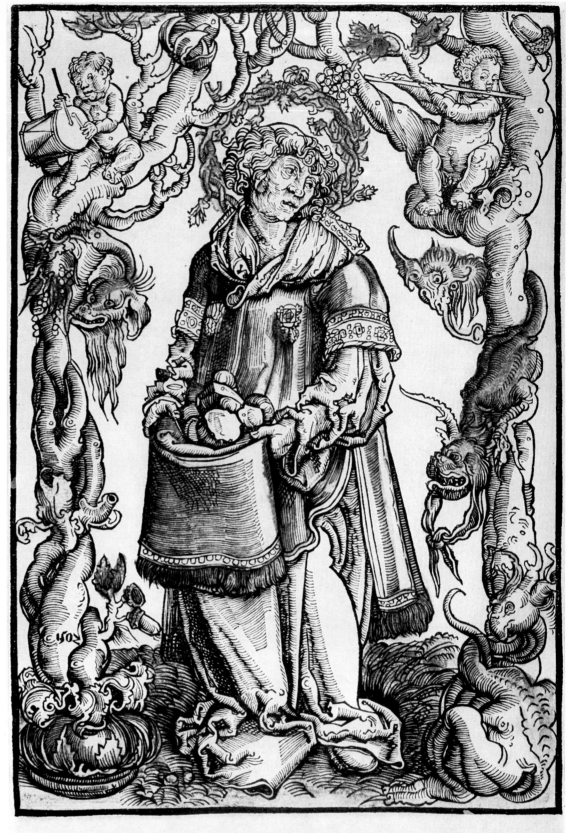

Sanctus Stephanus prothomartyr.

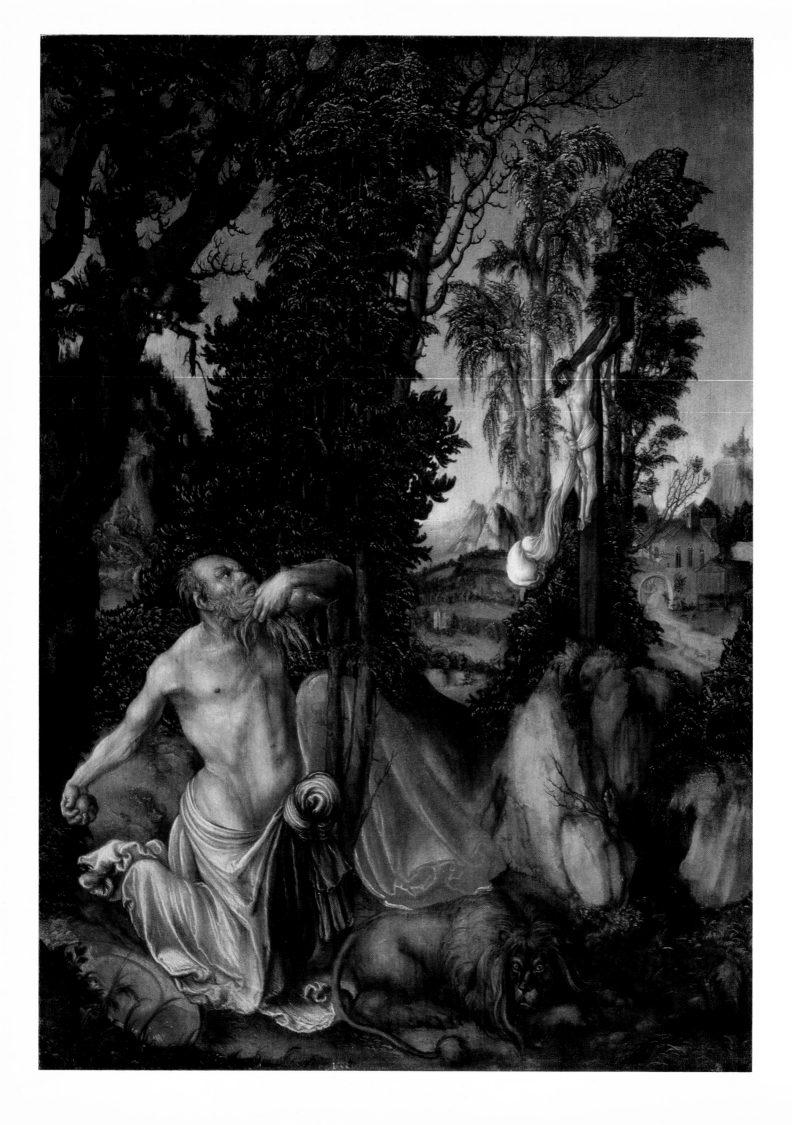

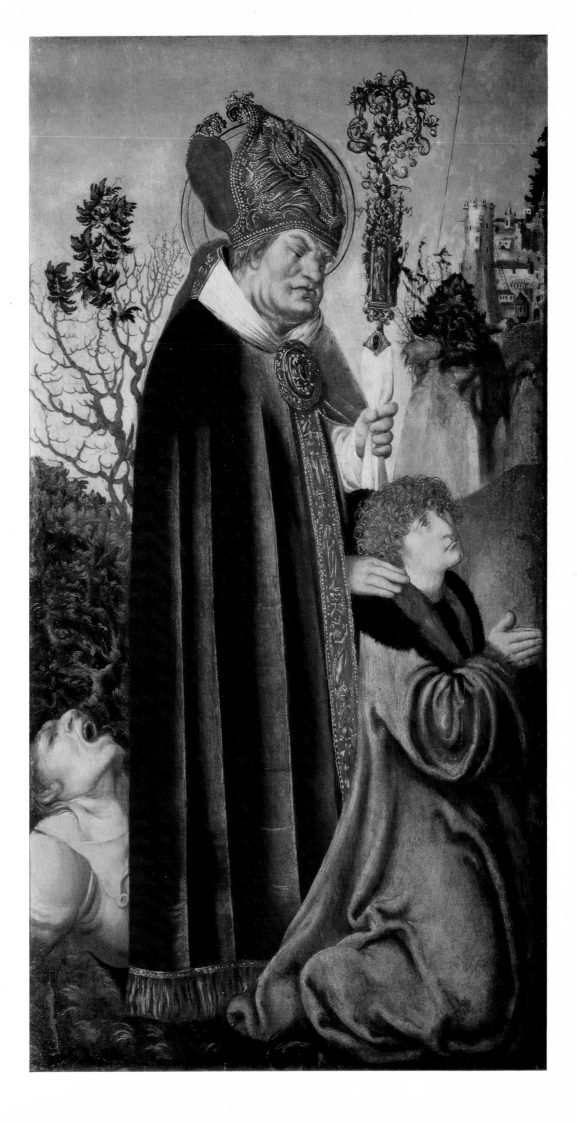

8 St. Jerome in Penitence. 1502. Vienna
9 St. Valentine with Kneeling Donors.
 circa 1502. Vienna

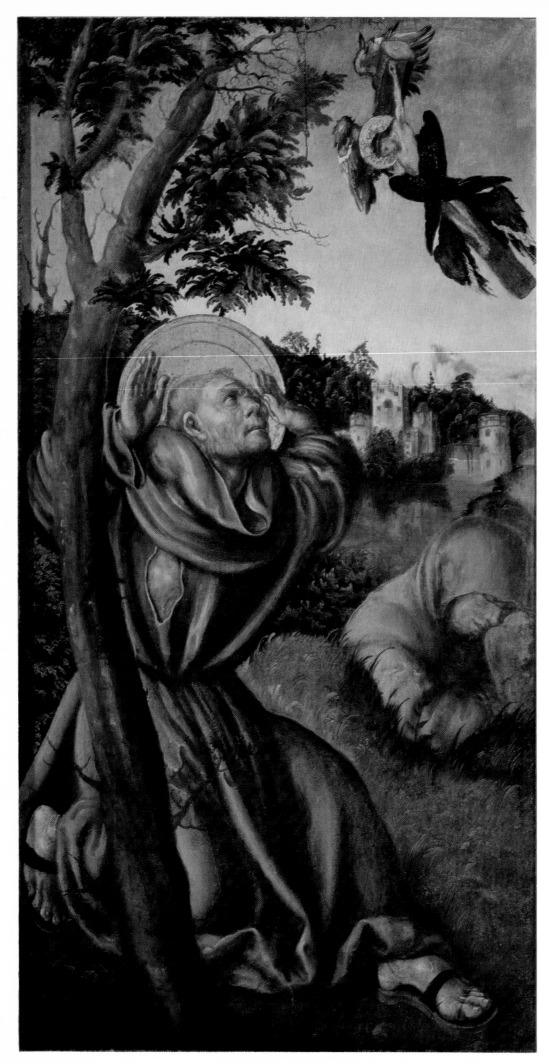

10 The Stigmatization of St. Francis.
 circa 1502. Vienna
11 Detail of Plate 10

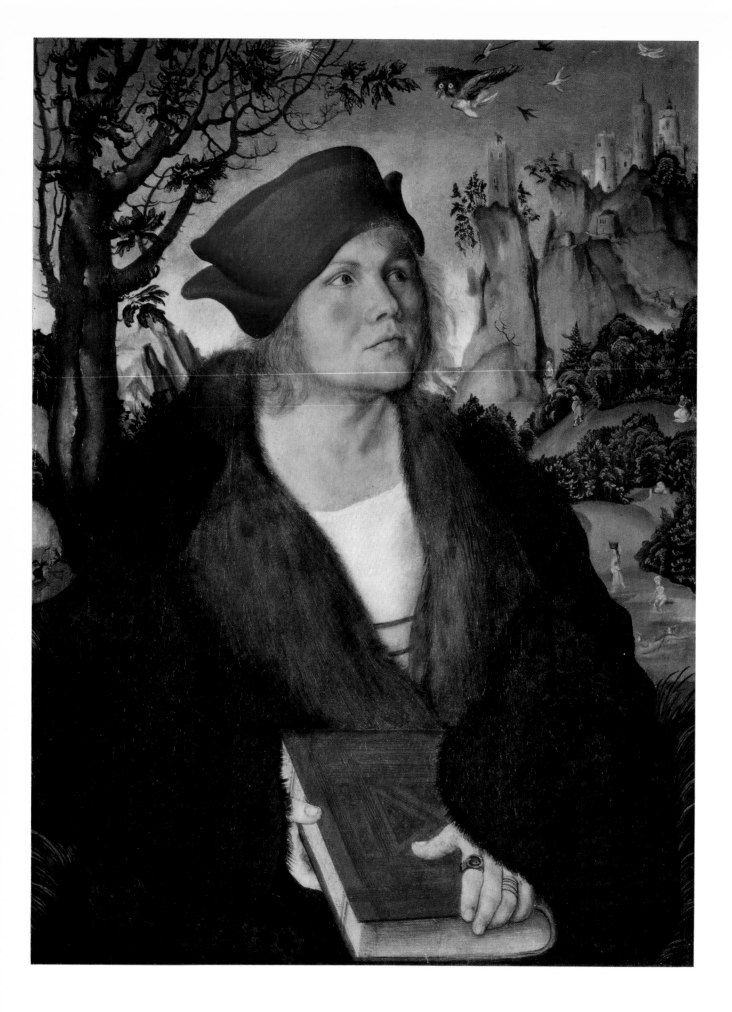

12 Johannes Cuspinian. circa 1502–1503. Winterthur

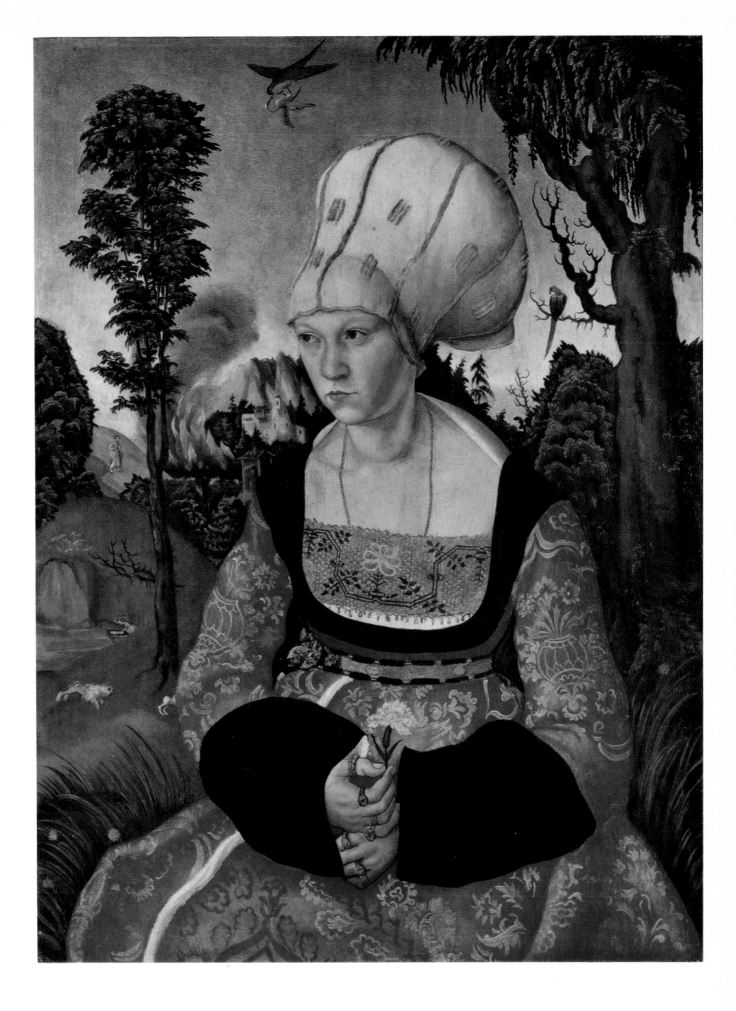

13 Anna Cuspinian. circa 1502–1503. Winterthur

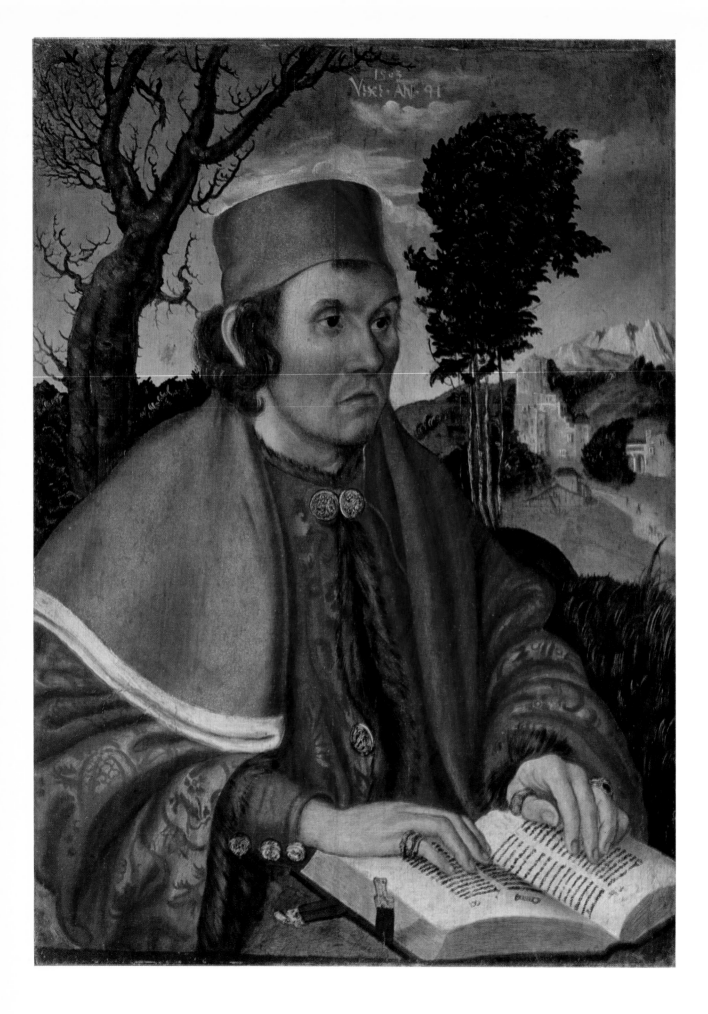

14 Portrait of a Jurist. 1503. Nuremberg

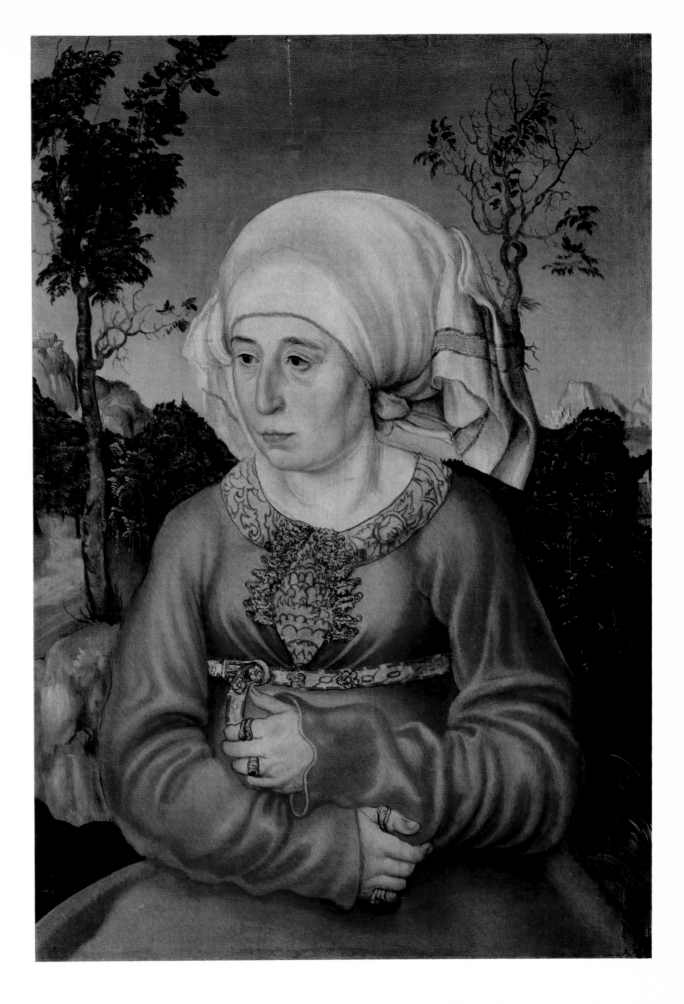

15 Portrait of the Wife of a Jurist. circa 1503. West Berlin

Following page:
16 Detail of Plate 17
17 Christ on the Cross. 1503. Munich

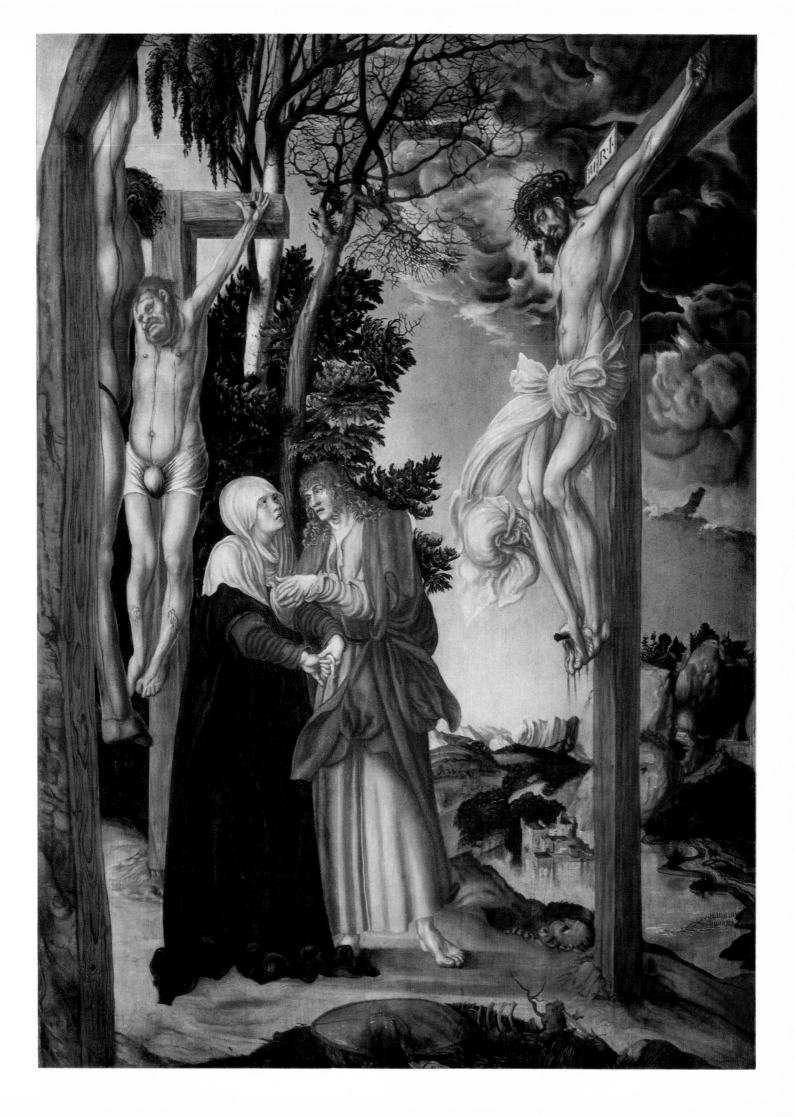

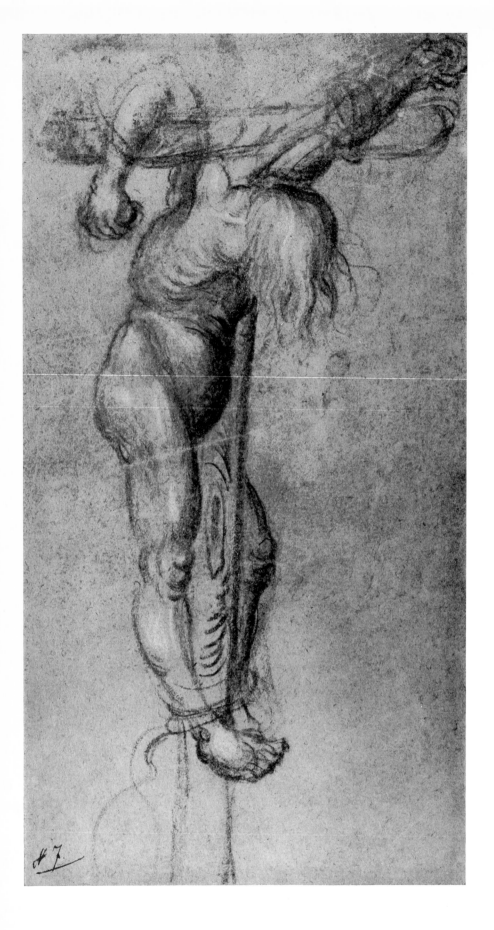

18 Crucified Thief. circa 1503. Drawing. West Berlin

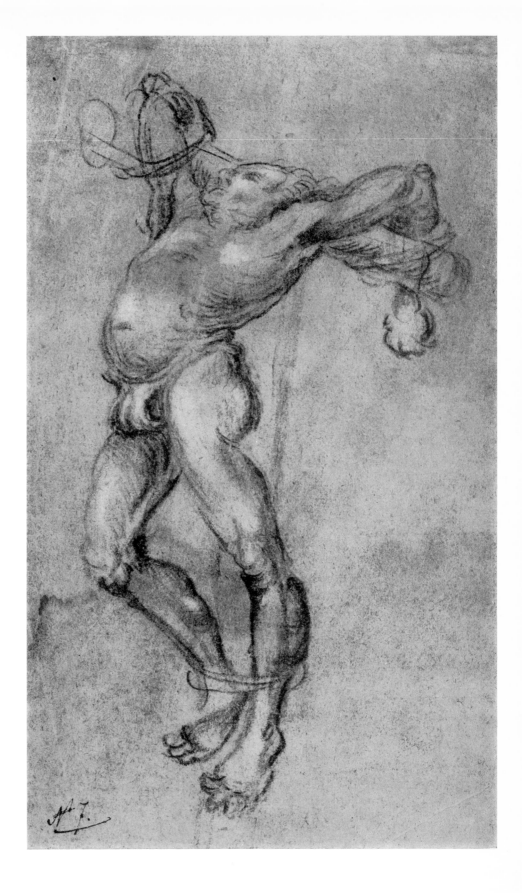

19 Crucified Thief. circa 1503. Drawing. West Berlin

Following pages:
20 Detail of Plate 21
21 Rest on the Flight into Egypt. 1504. West Berlin

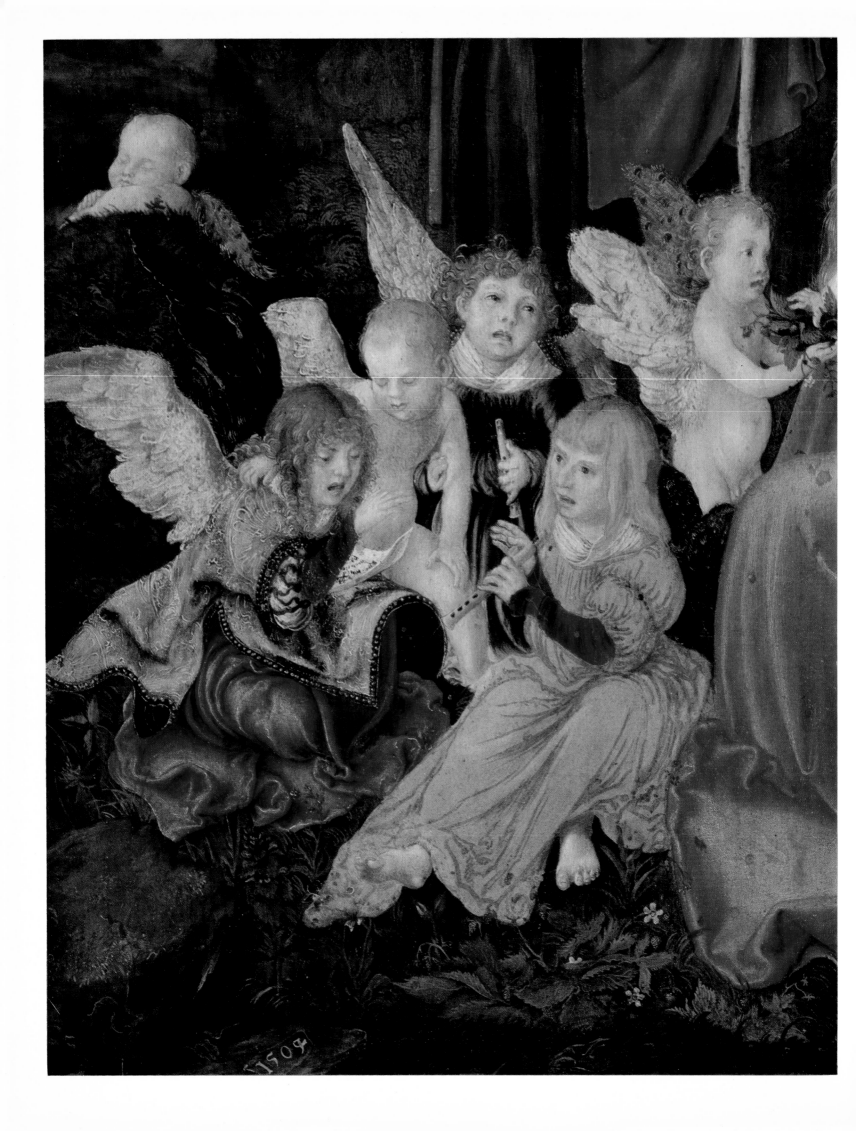

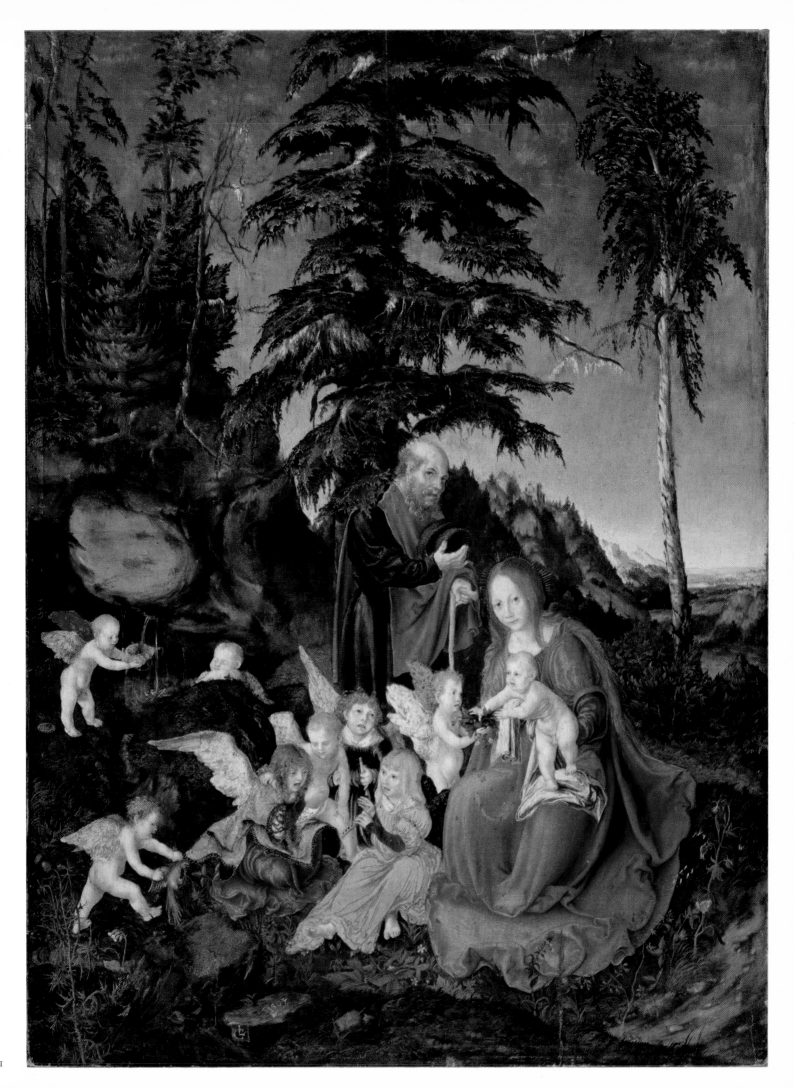

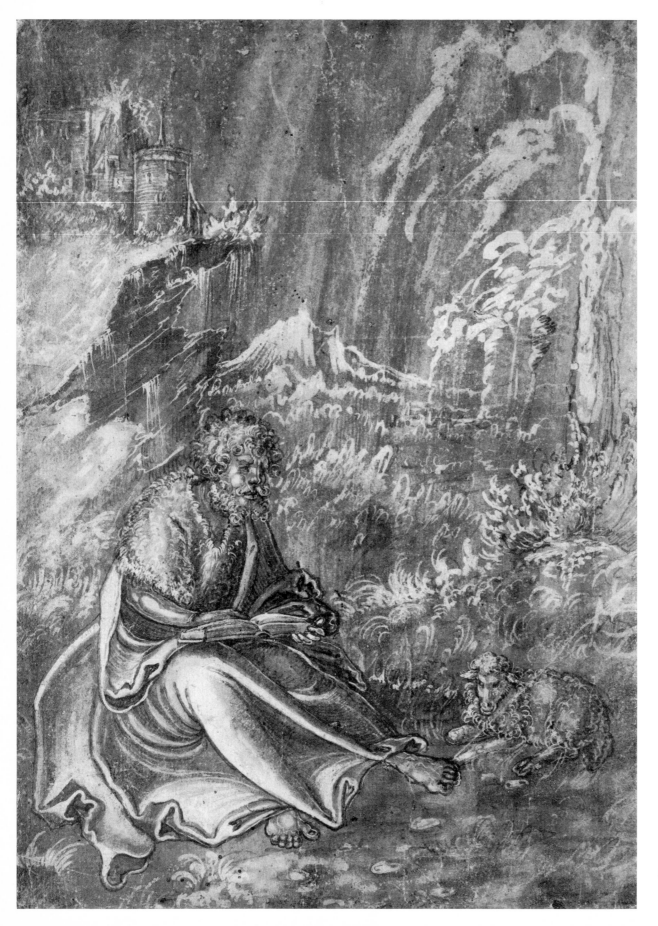

22 John the Baptist.
circa 1504.
Drawing. Lille

23 St. Martin. 1504. Drawing. Munich

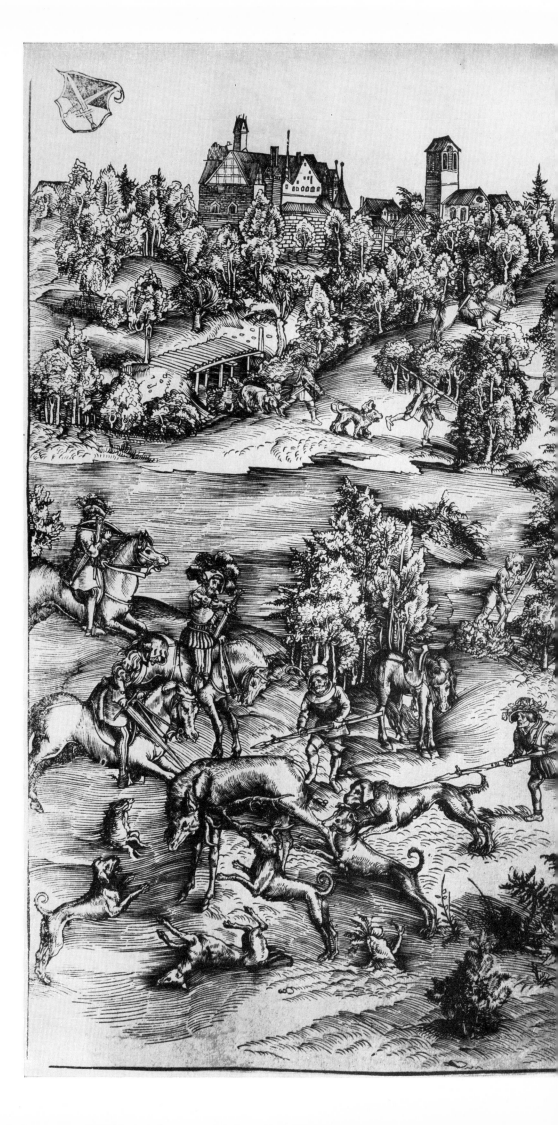

24 Stag Hunt. circa 1506. Woodcut

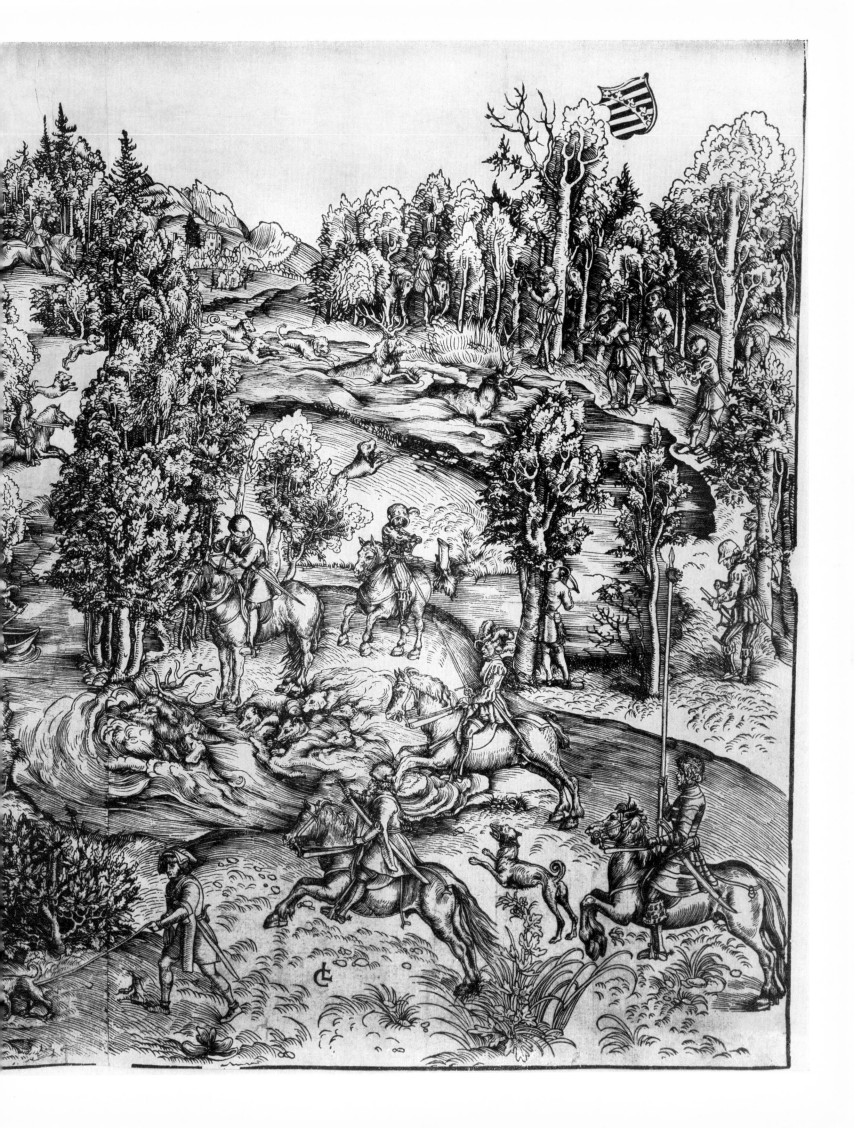

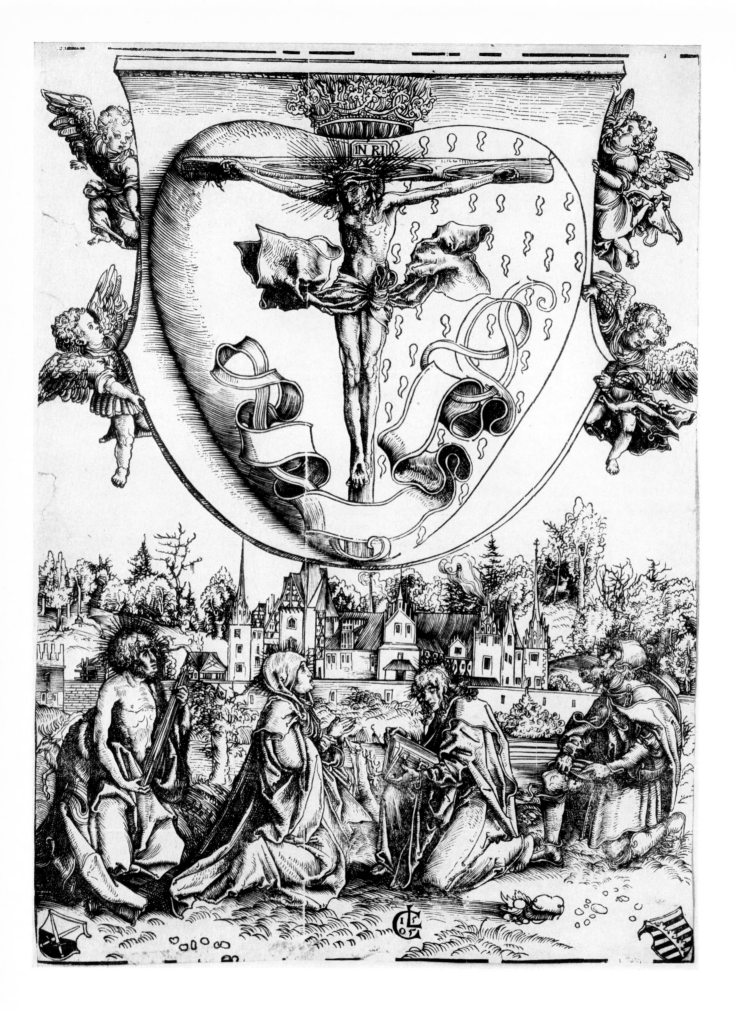

25 Adoration of the Heart of Mary. 1505. Woodcut. West Berlin

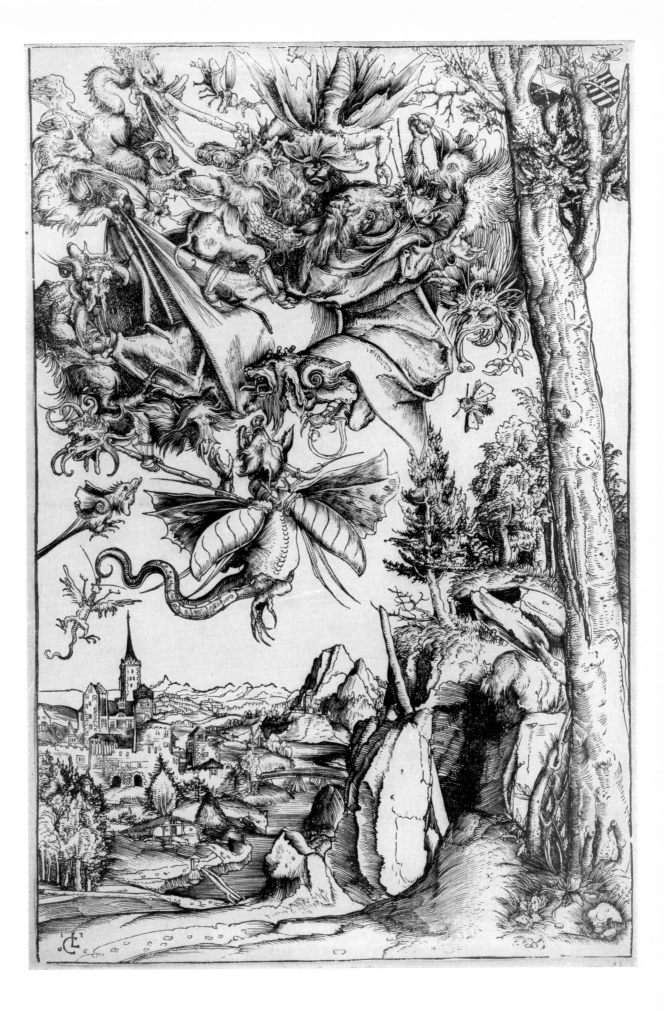

26 The Temptation of St. Anthony. 1506. Woodcut. Basel

27 Duke John Frederick on Horseback. 1506.
Woodcut. Budapest

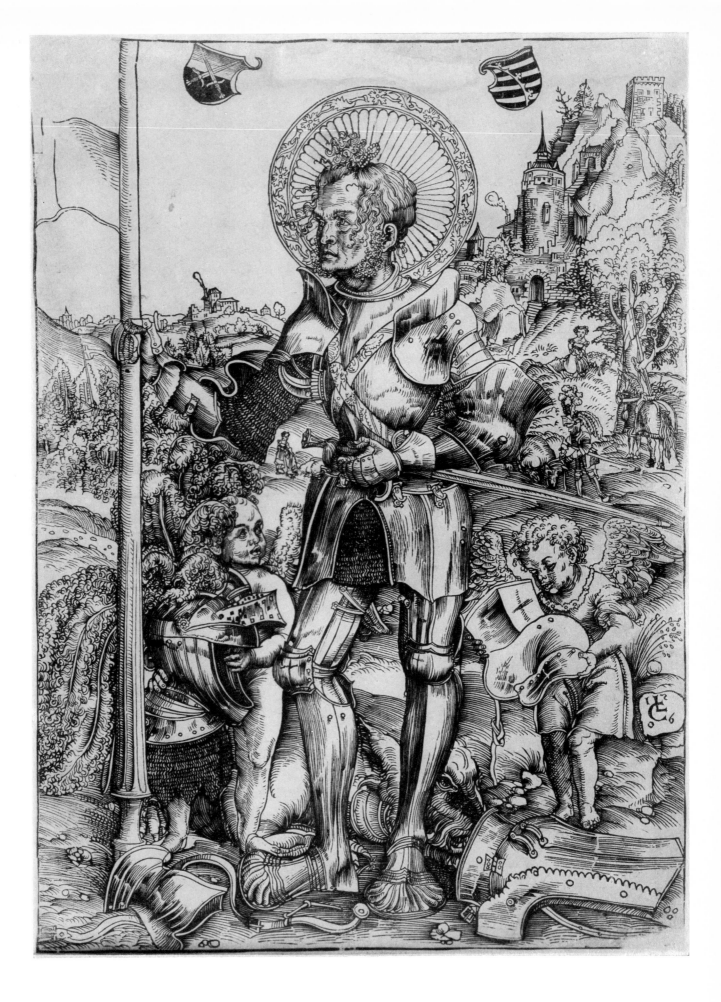

28 St. George Standing with Two Angels. 1506. Woodcut. Munich

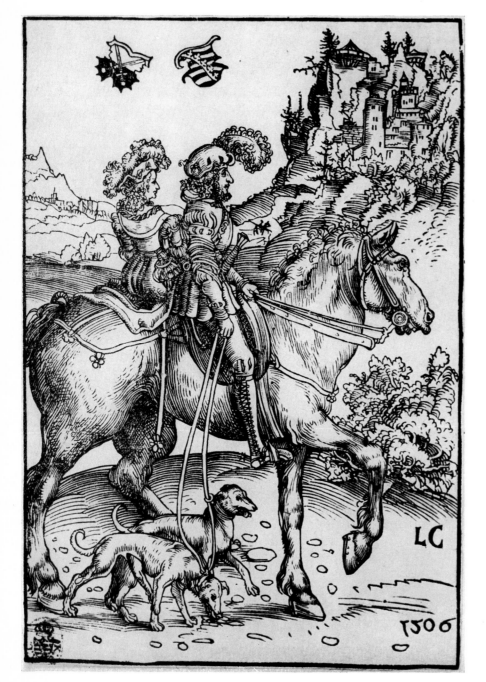

29 Knight and Lady on Horseback. 1506. Woodcut.
Dresden

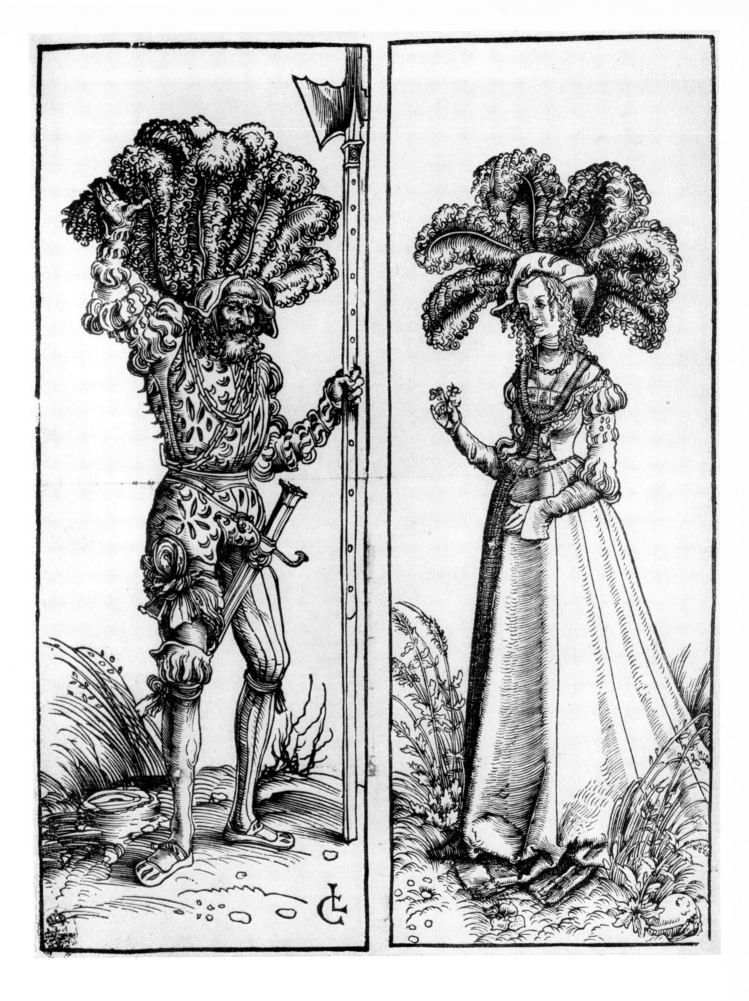

30 Lansquenet and Lady. circa 1506. Woodcut. Dresden

Zum Sibenden eyn silbern Bilde Sant Otilie Darjnn ist

Von sant Otilia ein gantz Ribbe
Item von sant Otilia vier partic.
Von dem hembde sant Otilie
Von sant Orthomaria
Von sant Officia
Von sant Ludimille ein Arm
Von sant Ludimille sunst iiij parti
Von sant Perpetua
Von sant Pelagia
Von sant Petronella drey partickel
Von sant Braxedis drey partickel
Von sant prisca
Von dem hare vnd hewpt sant py
mio se zwey paritickel
Von sant Protula

Zum zcwelften Ein Silberen Bilde sant Barbare hat jn sich

Von sant Barbara zwen zehn
Von sant Barbara xj partickel
Von dem kleyde sant Barbare Dor jnne
sy enthewßt wurden Ein mercklich teyl
Doran yre heiligsblut noch scheinbar ist

Zum dreyzcehēden ein vergulte mōstrantz mit xij steynen oben hyndē vñ forne Dor jnne ist

Von sant katherina zwen zehn
Von den haren sant katherine
Item vij partickell von sant katherina

31 From the Wittenberg Heiltumsbuch 1509. Woodcuts. London
 a St.Ottilie
 b St.Barbara

32 Side panels of the St.Catherine Altarpiece. 1506.
 Private collection
 a St.Christina and St.Ottilie
 b St.Genevieve and St.Apollonia

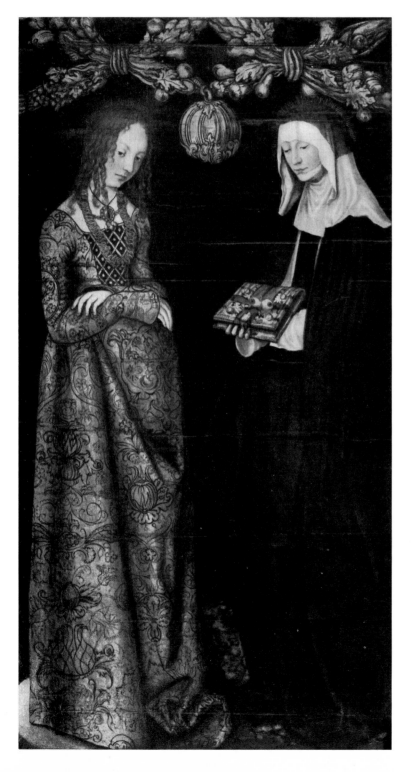

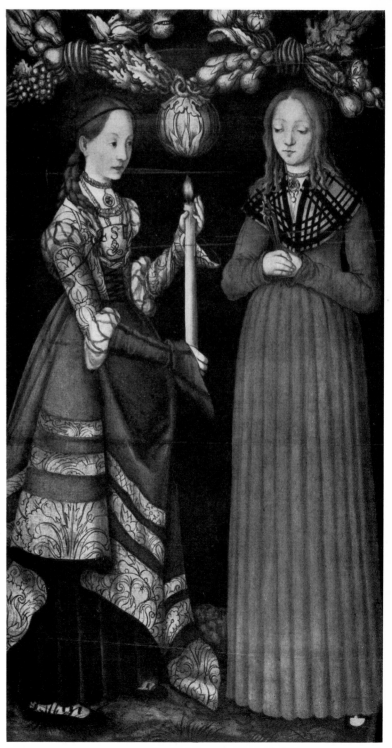

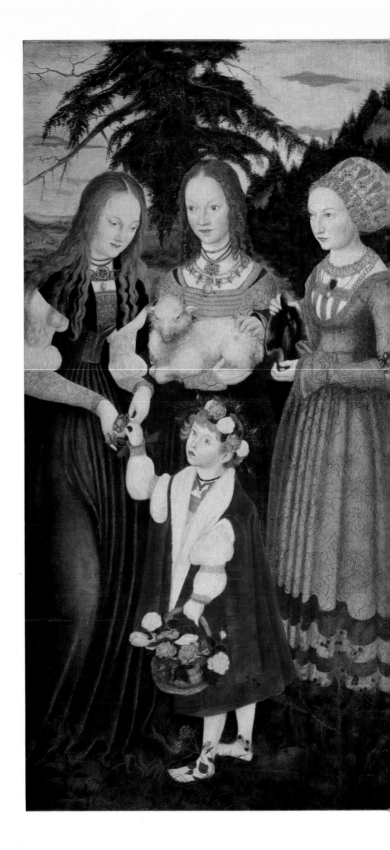

33　The St. Catherine Altarpiece. 1506. Dresden
　a　St. Dorothy, St. Agnes and St. Cunigonde
　b　The Martyrdom of St. Catherine
　c　St. Barbara, St. Ursula and St. Margaret

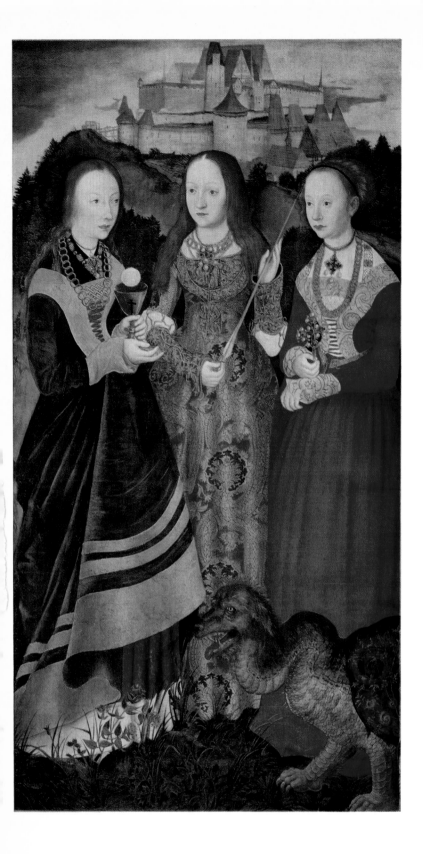

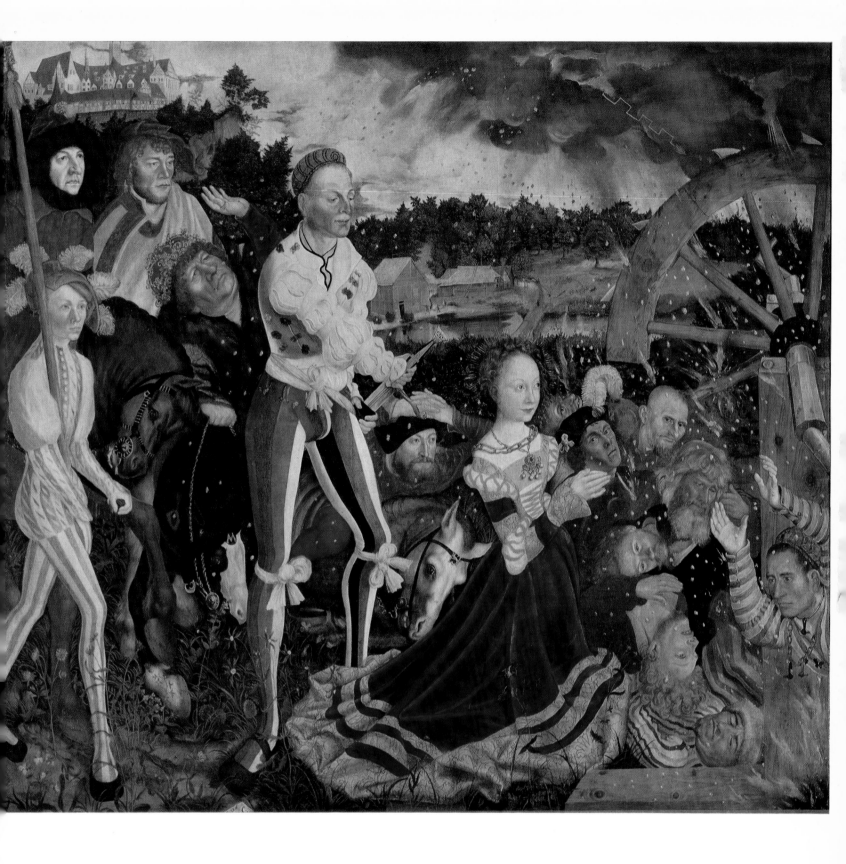

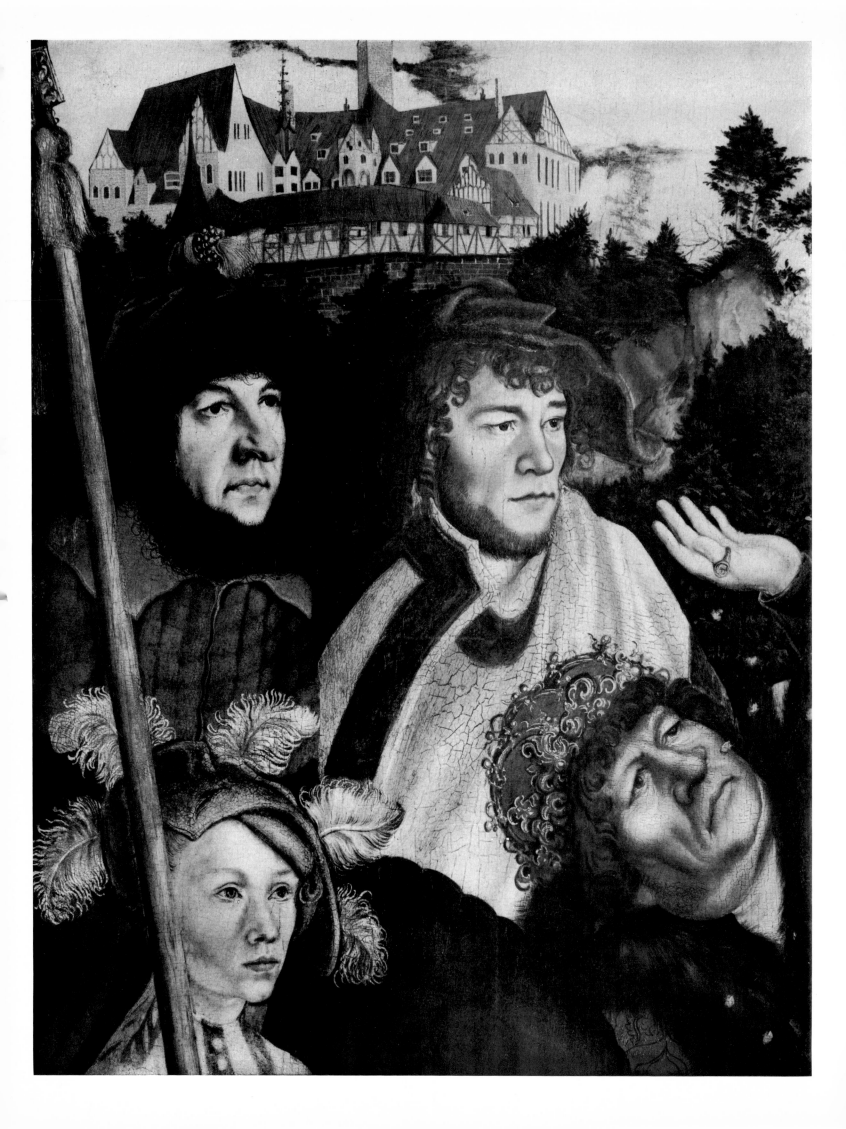

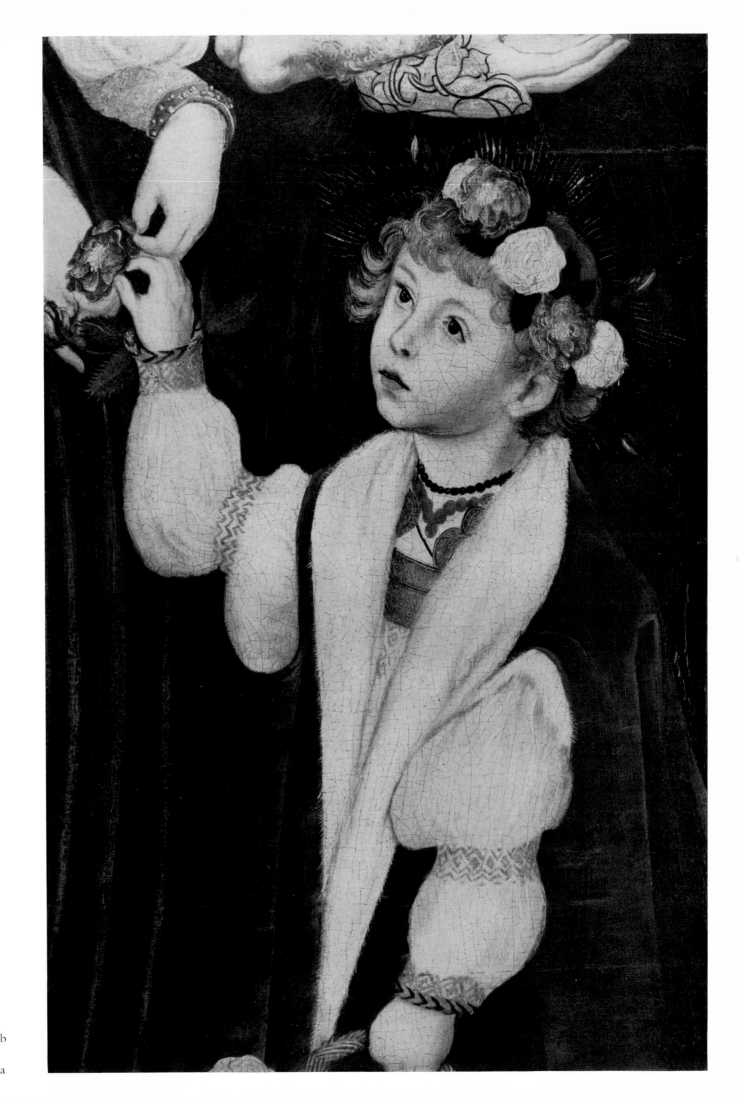

34 Detail
of Plate 33 b
35 Detail
of Plate 33 a

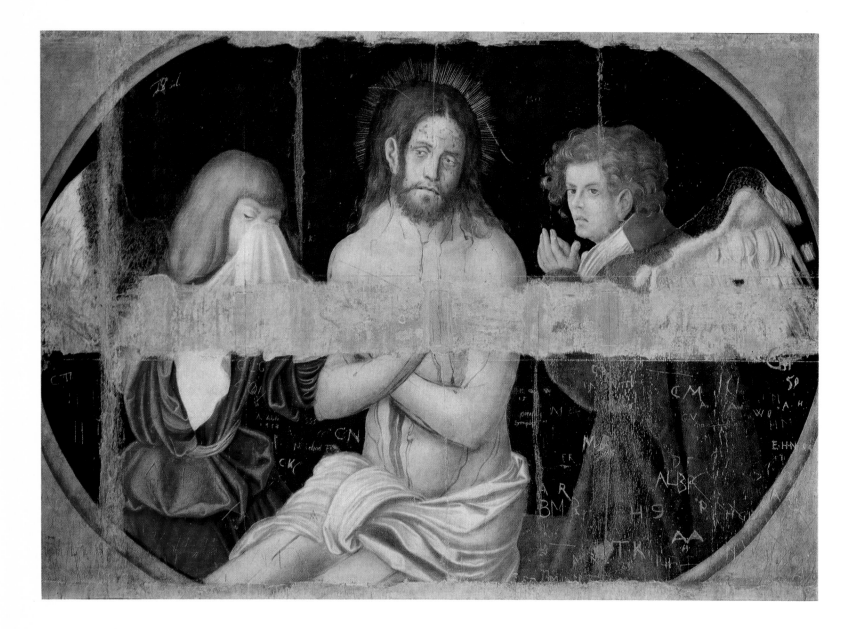

36 Christ, the Man of Sorrows. circa 1505. Torgau

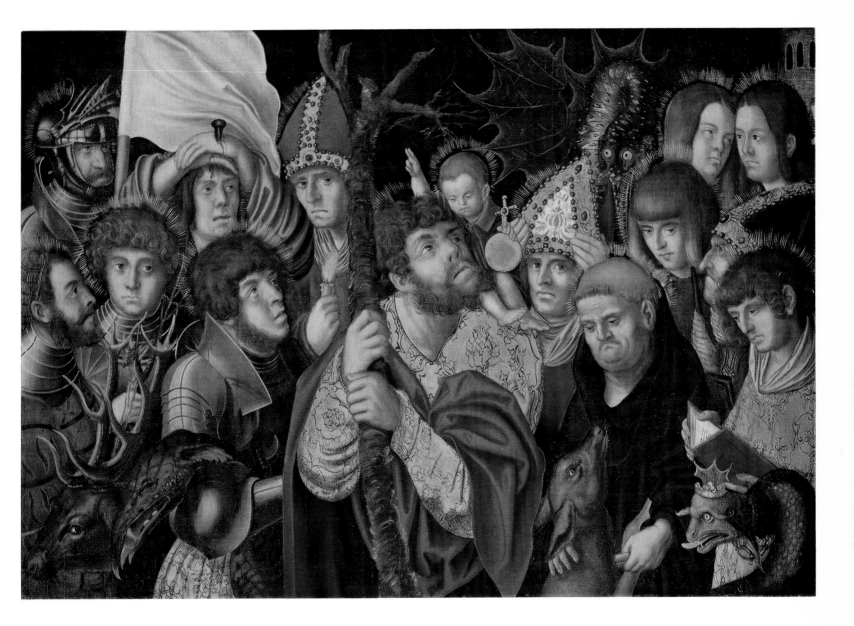

37 The Fourteen Helpers in Time of Need. circa 1505. Torgau

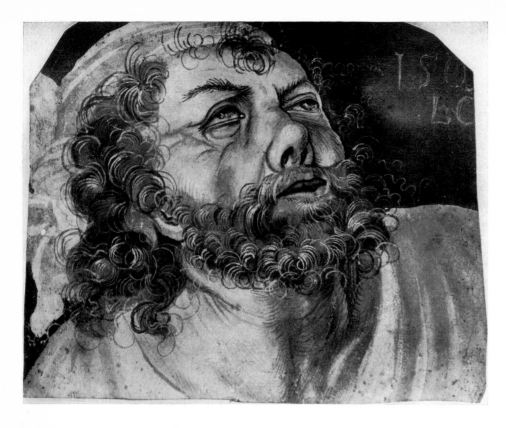

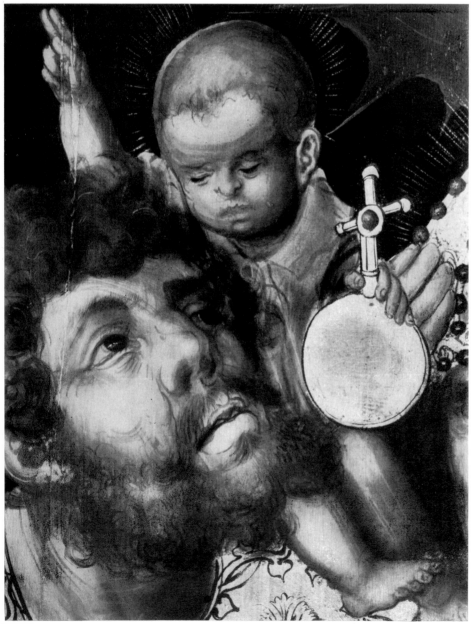

38 Head of St.Christopher. 1505 (?).
 Drawing. Weimar
39 Detail of Plate 37. Infrared photograph
40 Detail of Plate 37

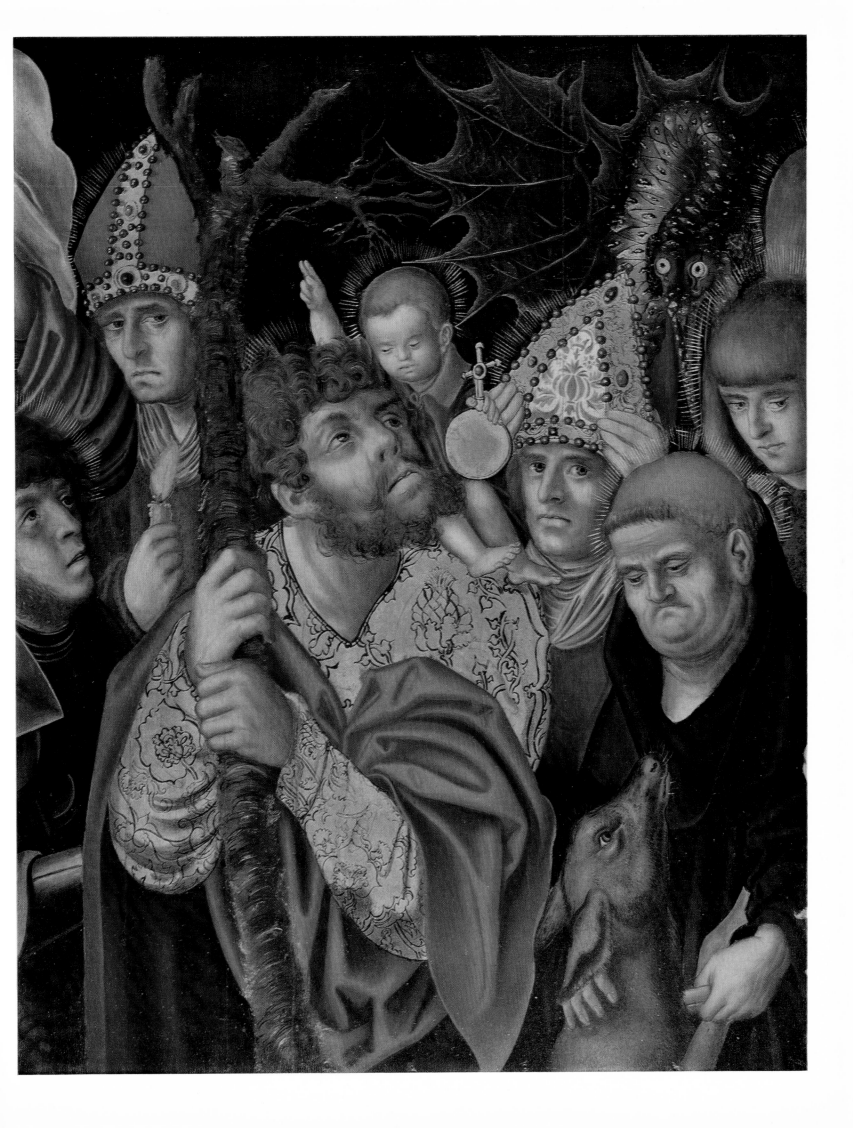

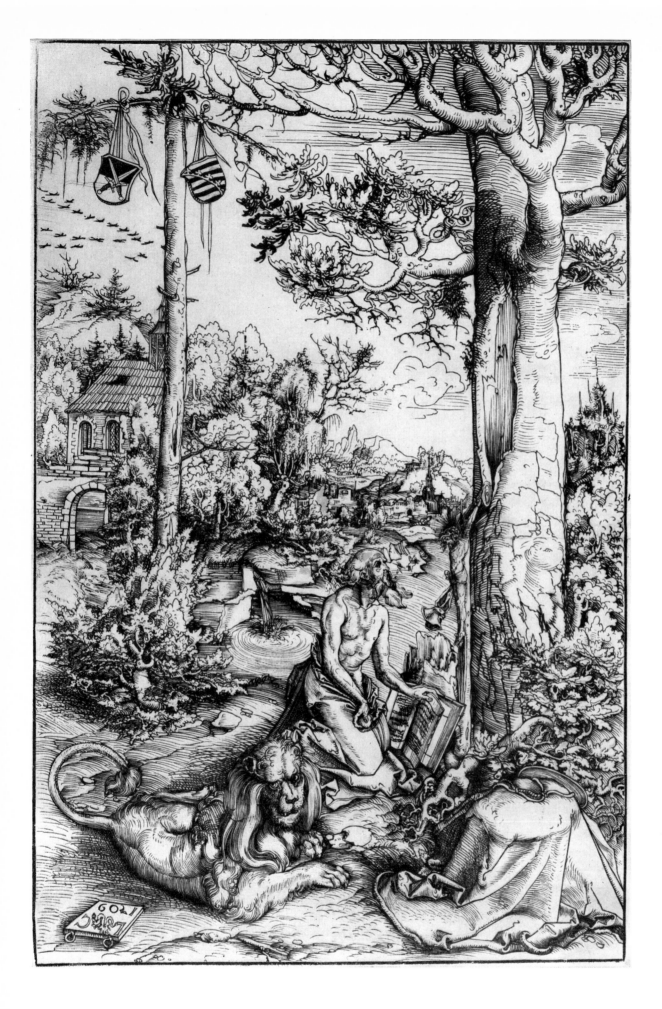

41 St. Jerome. 1509. Woodcut

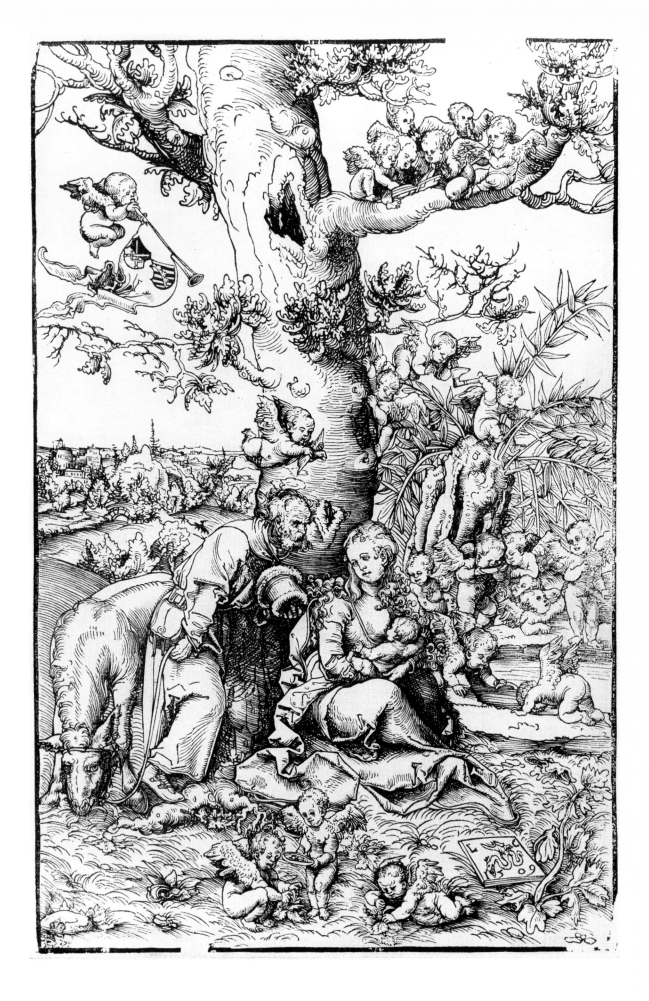

42 Rest on the Flight into Egypt. 1509. Woodcut

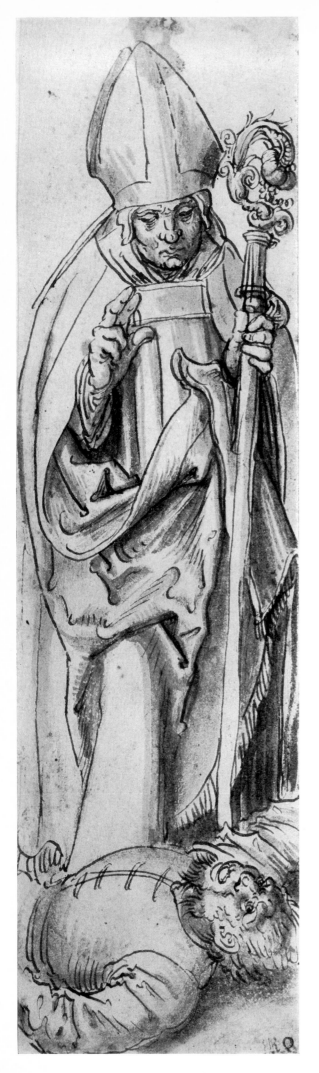

43 St. Valentine. circa 1510.
 Drawing. Munich

44 St. Anne Altarpiece:
 Virgin and Child;
 St. Anne. 1509.
 Frankfurt-am-Main

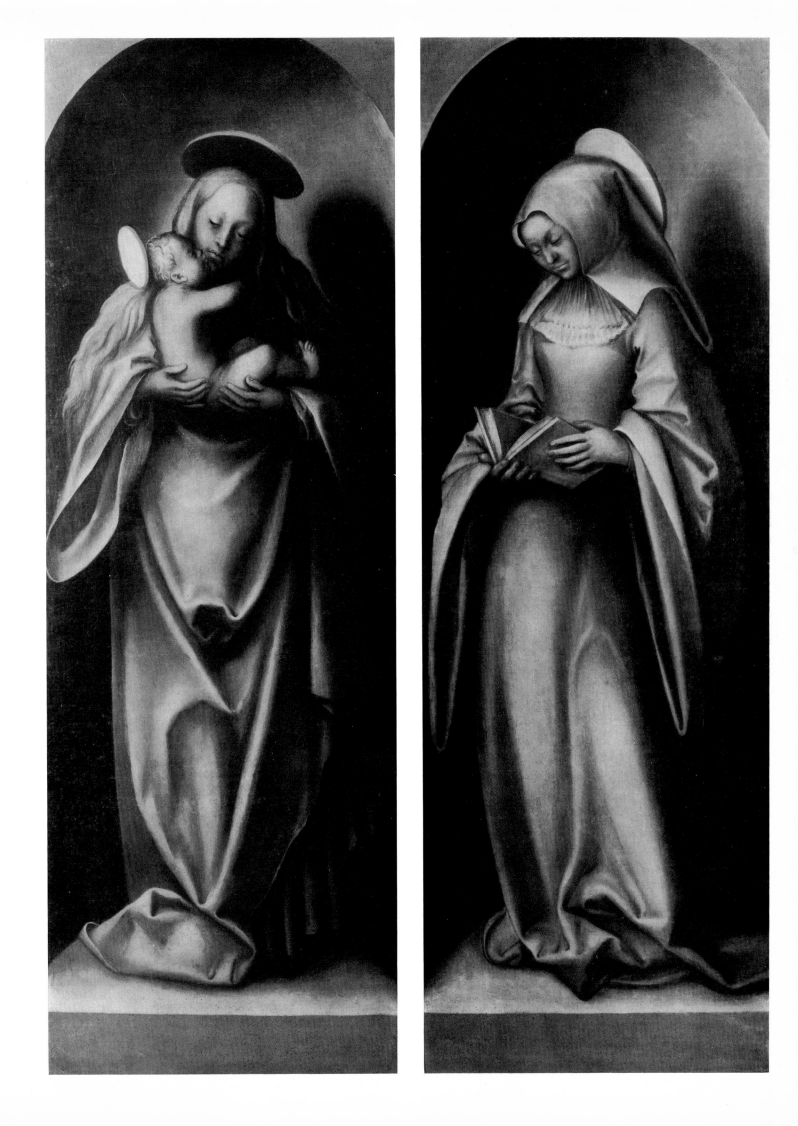

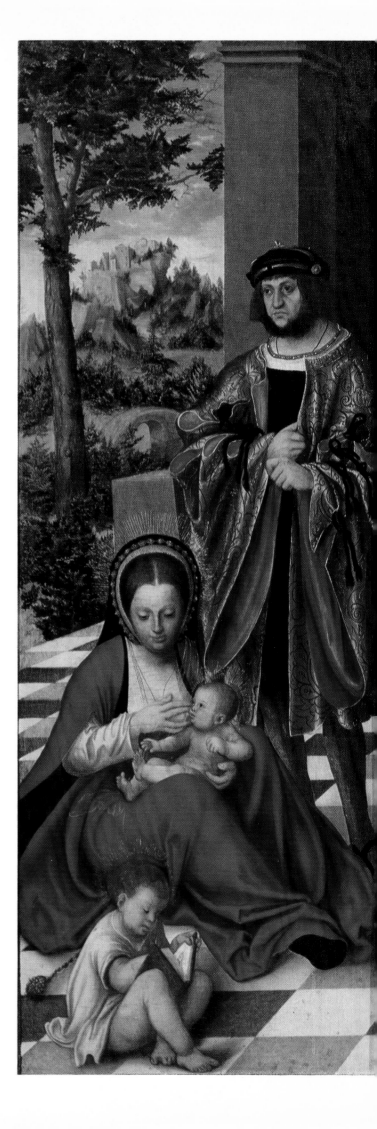

45 St. Anne Altarpiece. 1509. Frankfurt-am-Main

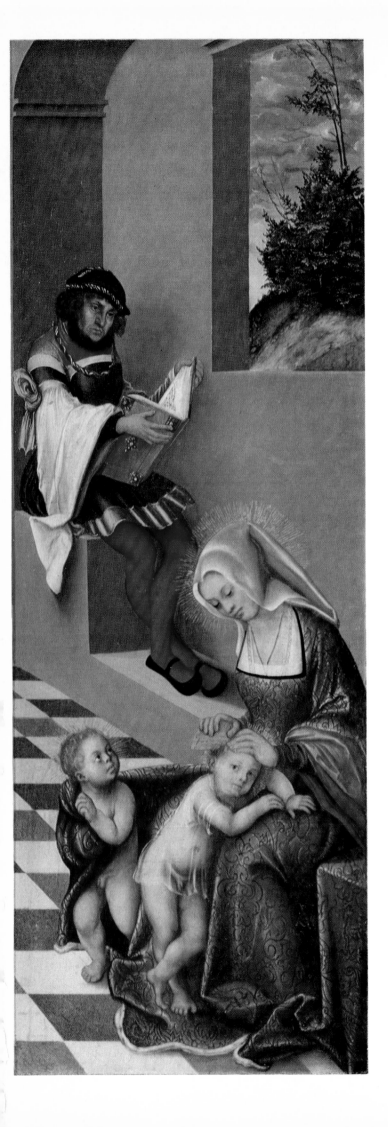

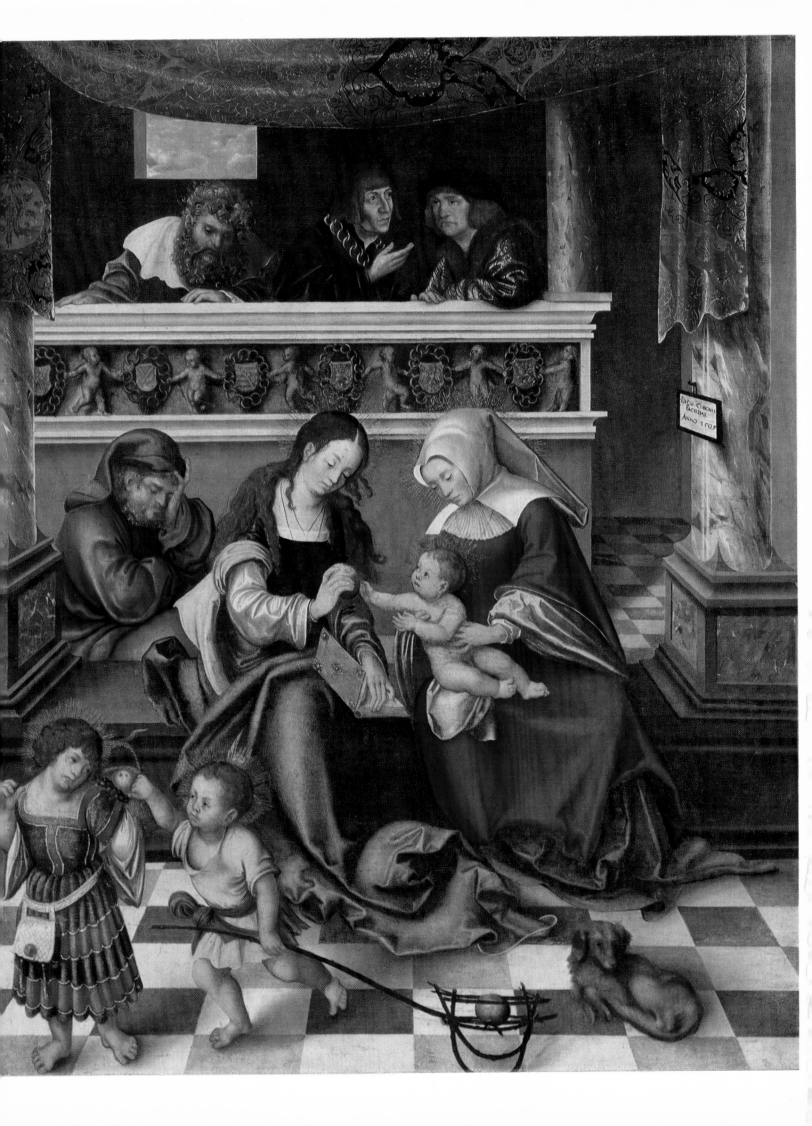

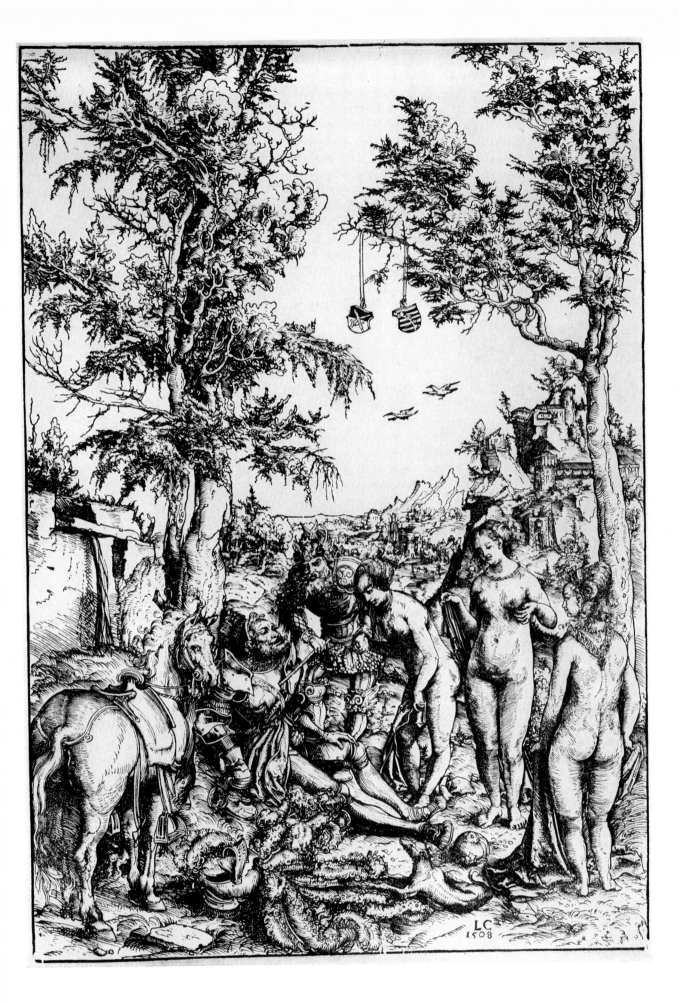

46 The Judgment of Paris. 1508. Woodcut

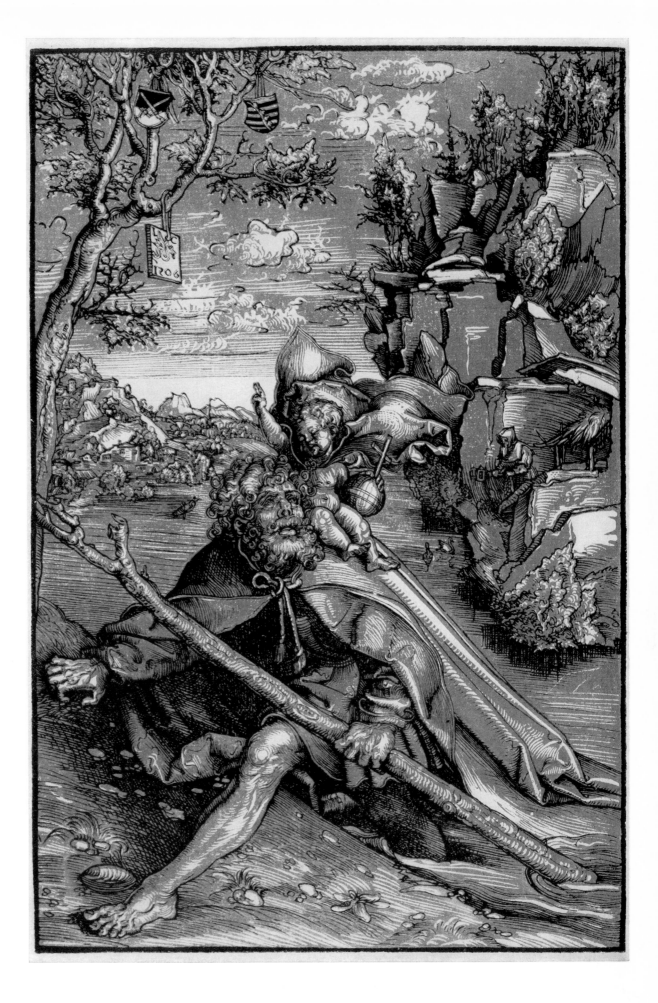

47 St. Christopher. 1509. Woodcut

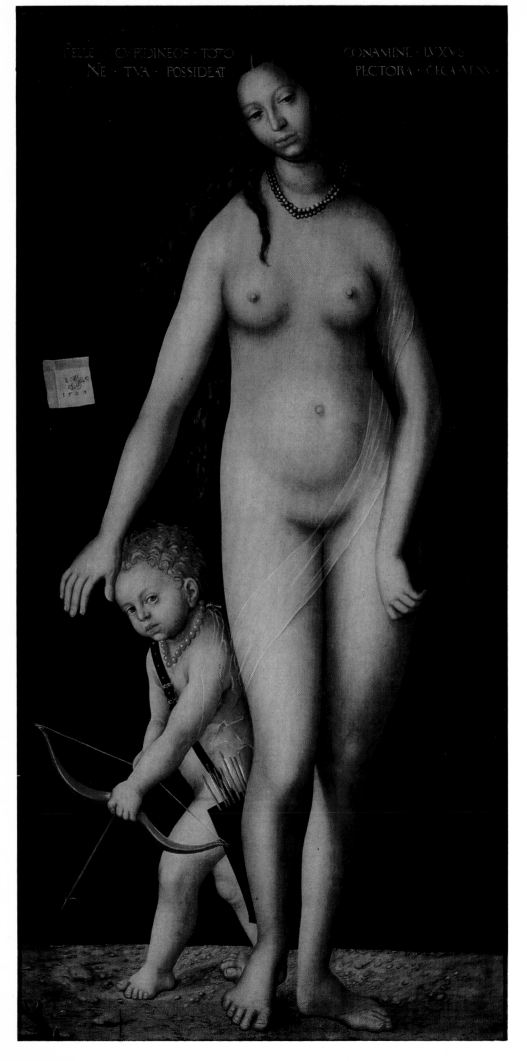

48 Venus and Cupid. 1509. Leningrad
49 Detail of Plate 48

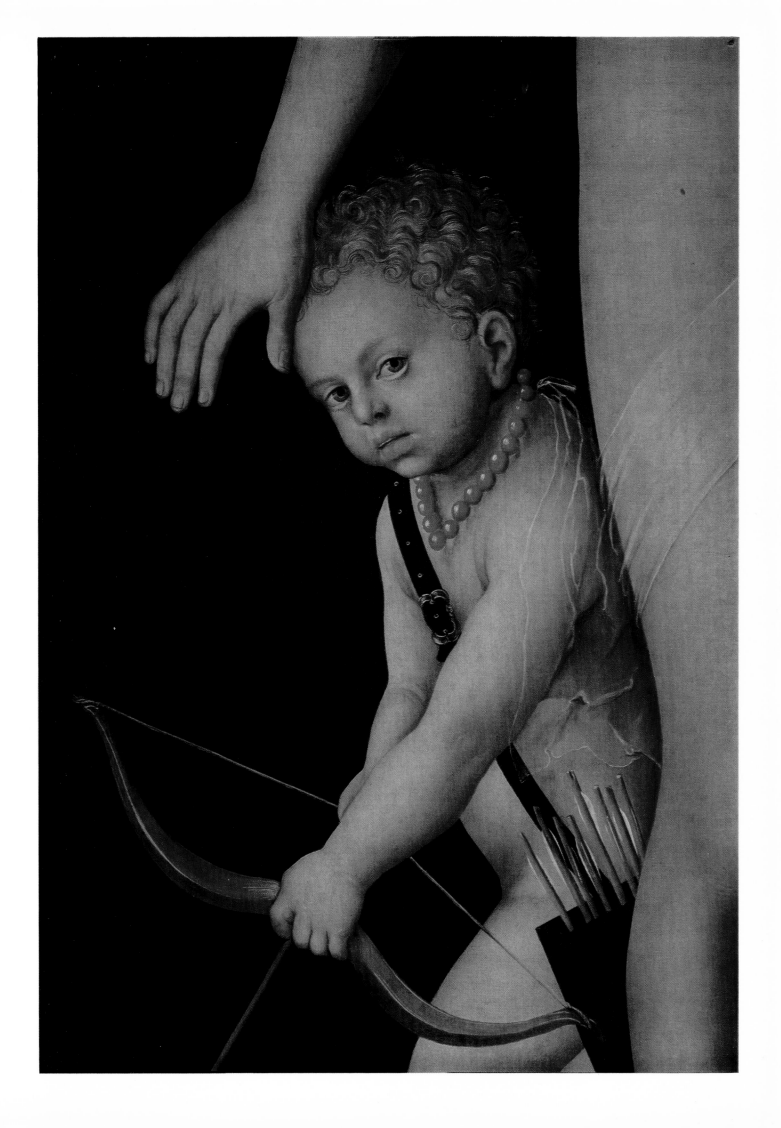

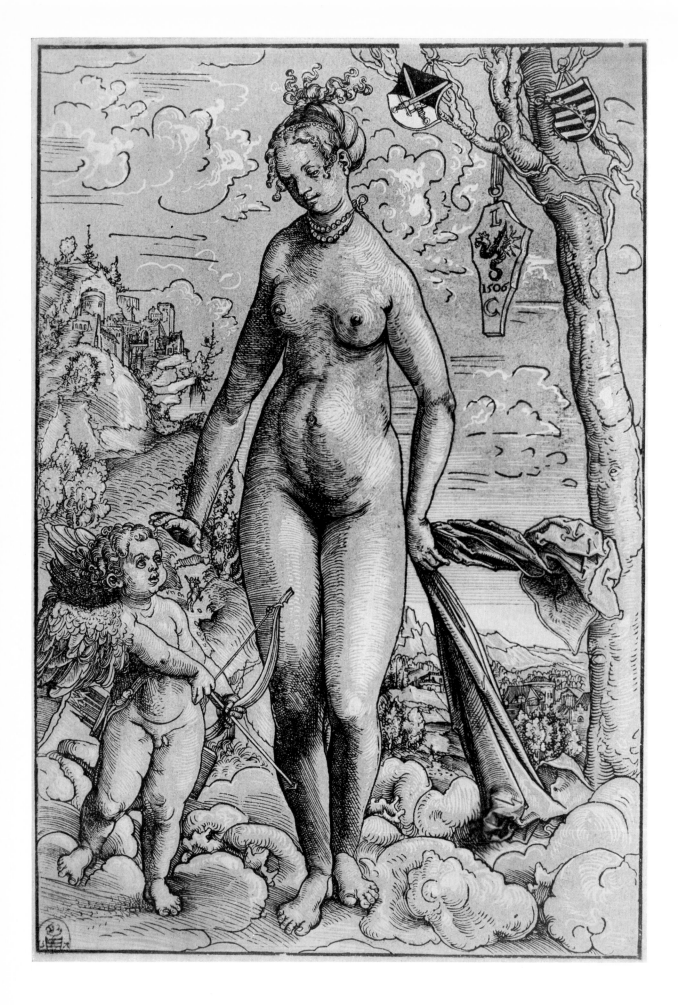

50 Venus and Cupid. 1509. Woodcut. Dresden

51 Adam and Eve. circa 1510. Warsaw

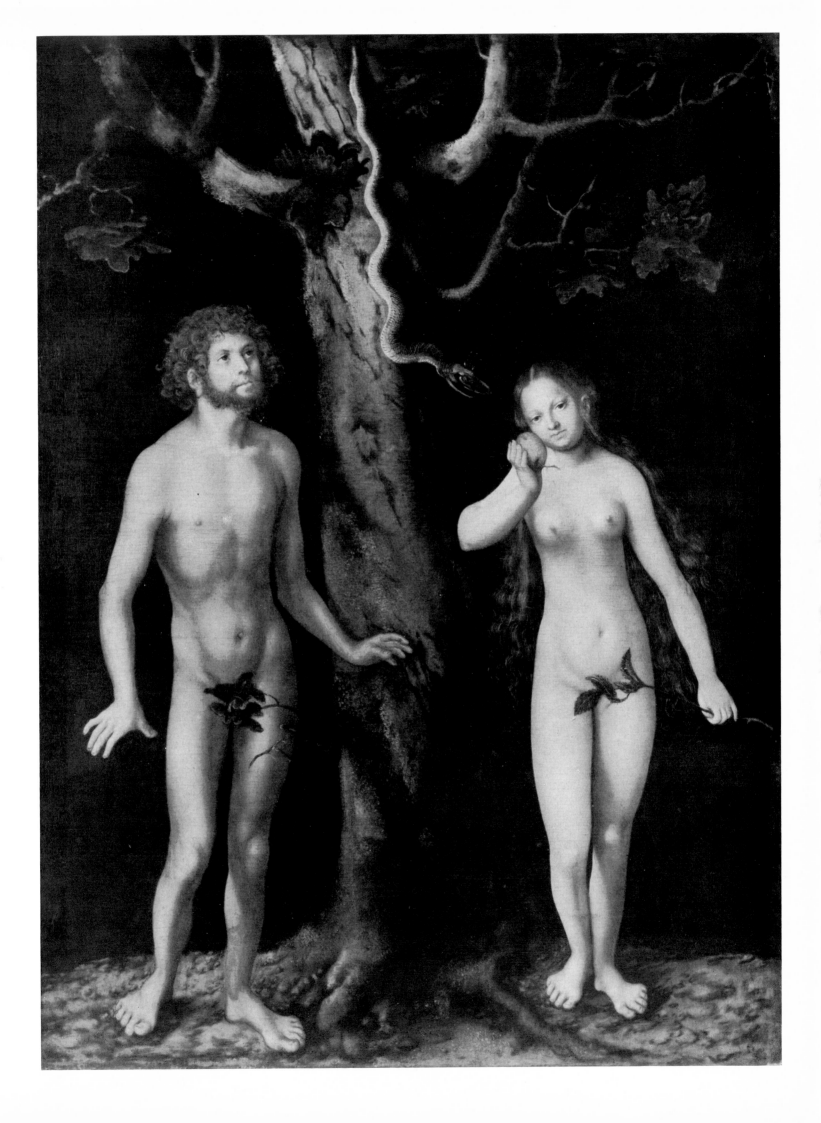

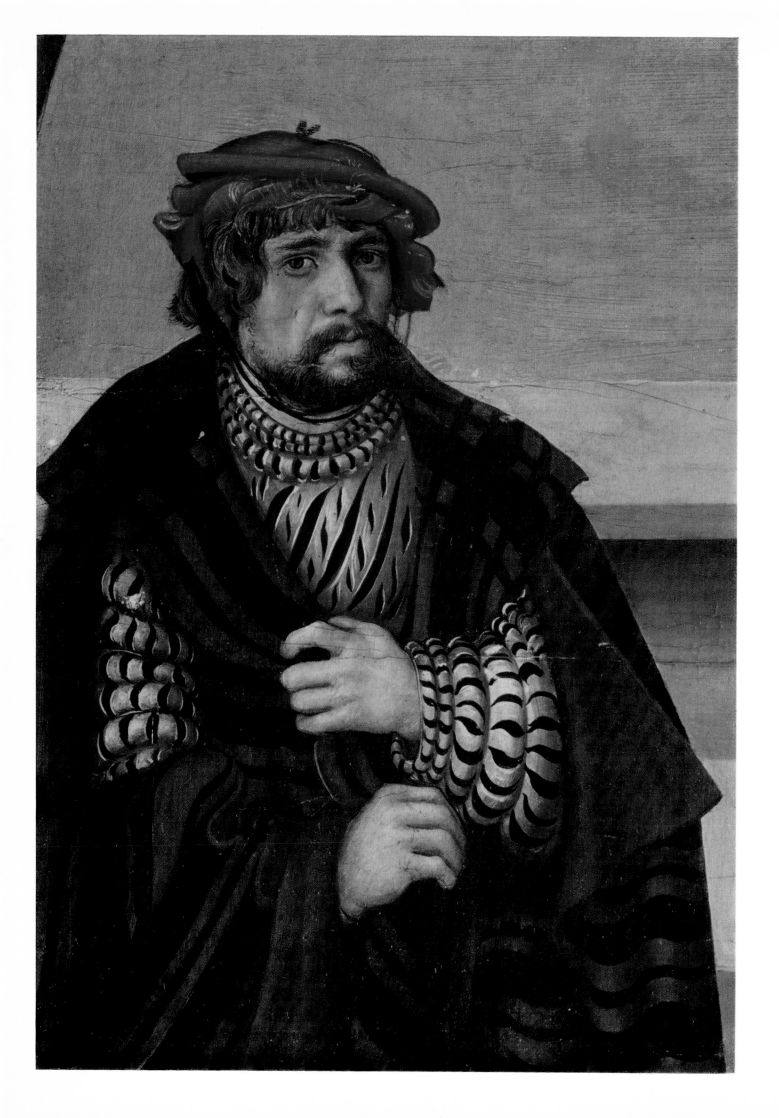

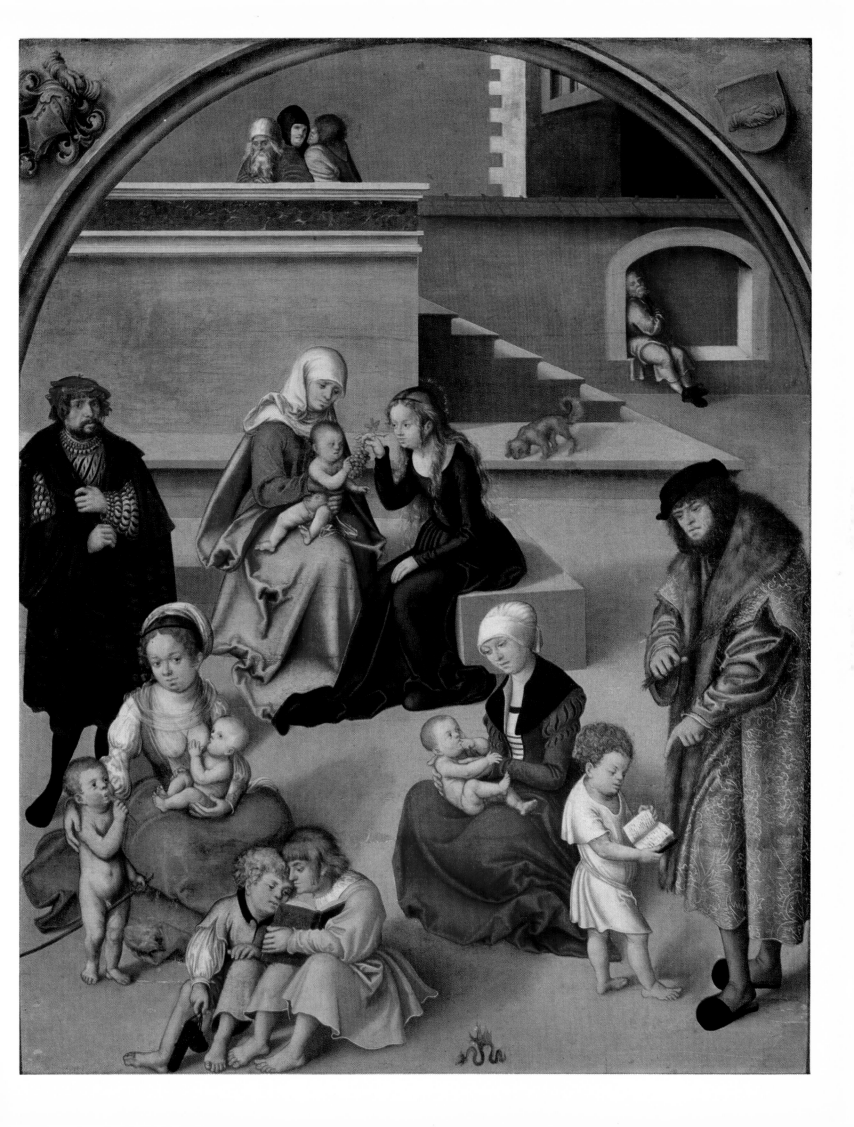

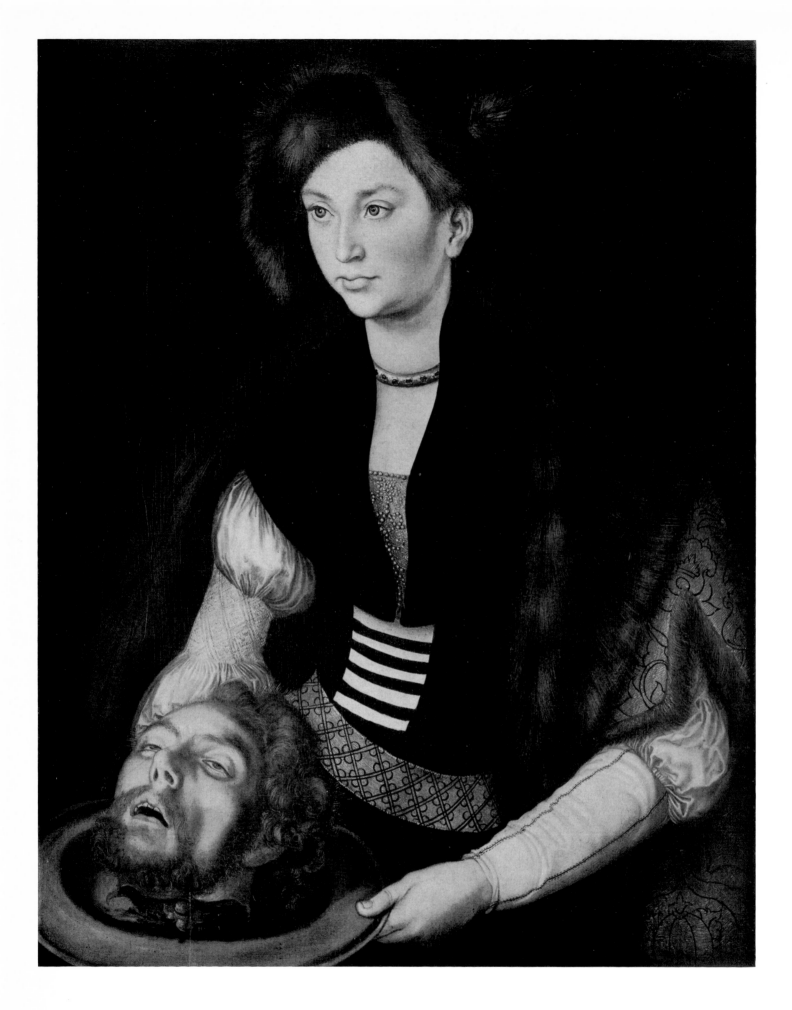

54 Salome. circa 1510. Lisbon

Preceding pages:
52 Self-Portrait. Detail of Plate 53
53 The Holy Family. circa 1510. Vienna

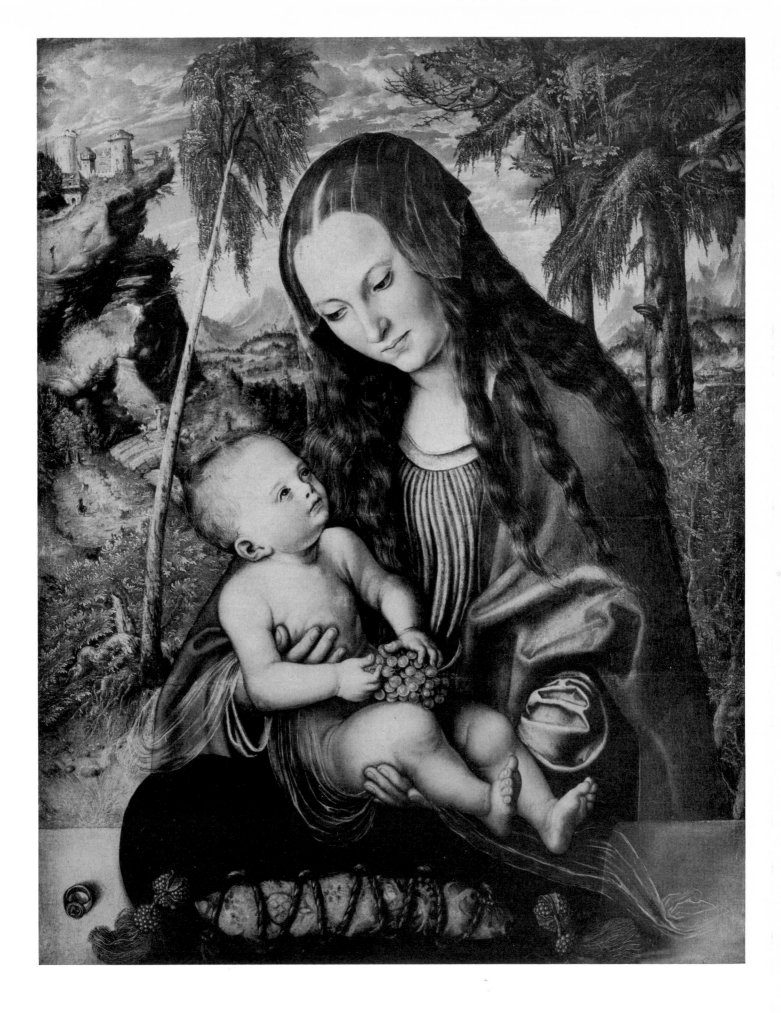

55 Madonna and Child. circa 1510. Breslau, lost

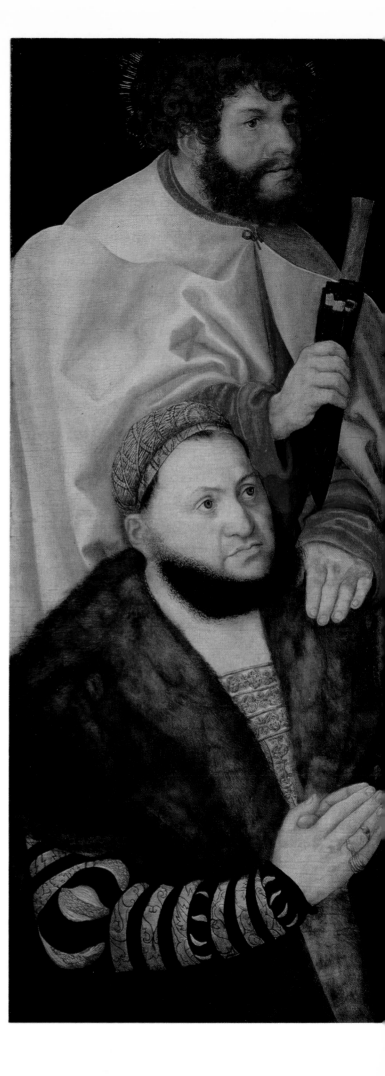

56 Altarpiece of the Princes. circa 1510–1512. Dessau
 a Frederick the Wise with St. Bartholomew
 b The Madonna and Child with St. Catherine and St. Barbara,
 attended by hovering Angels.
 c Duke John with St. James the Greater

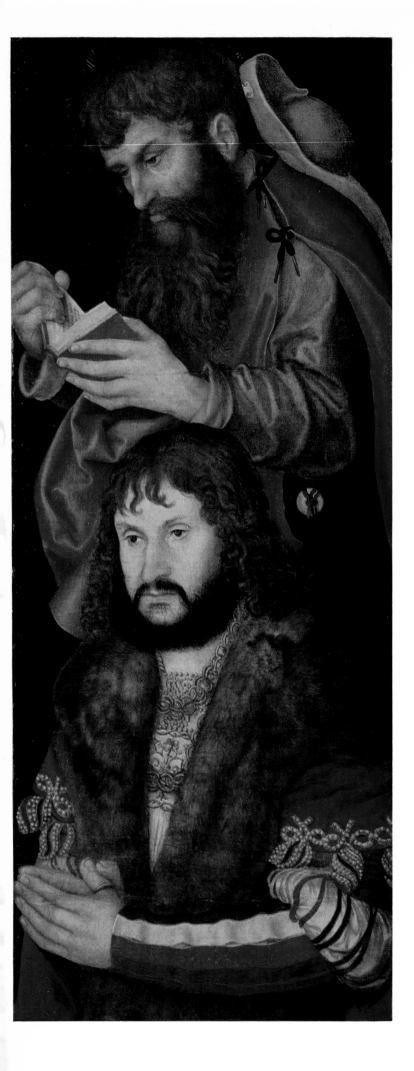

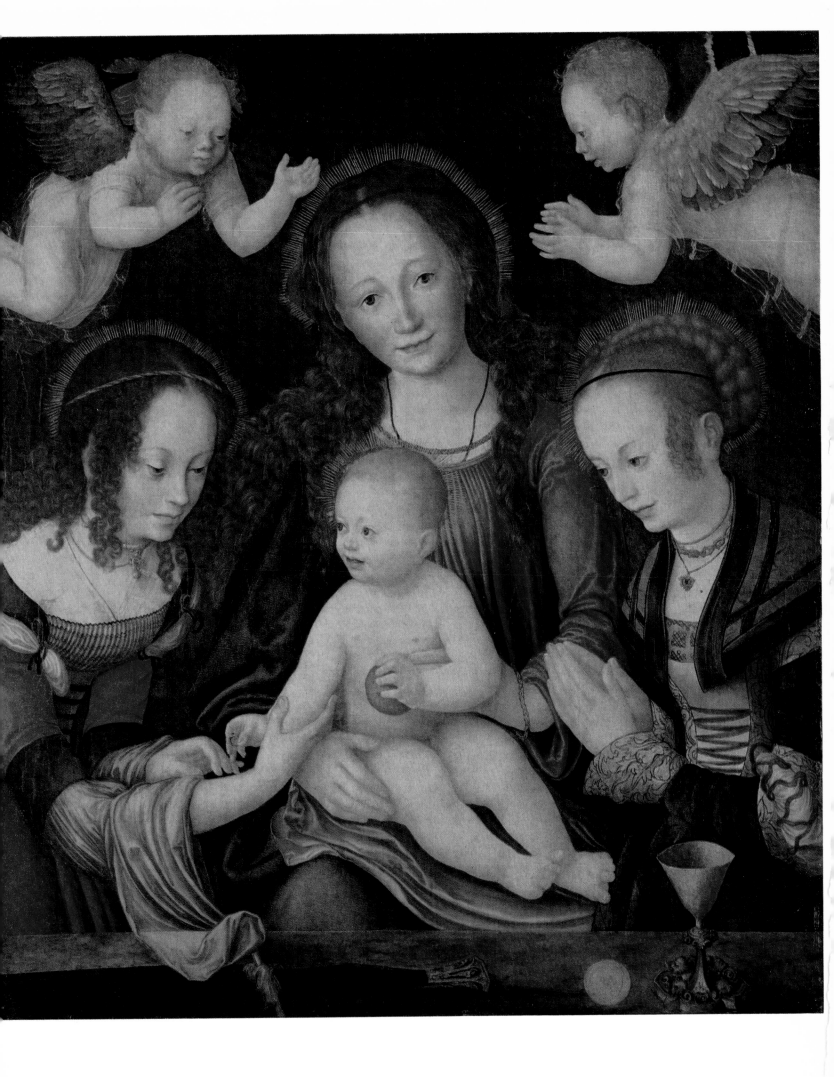

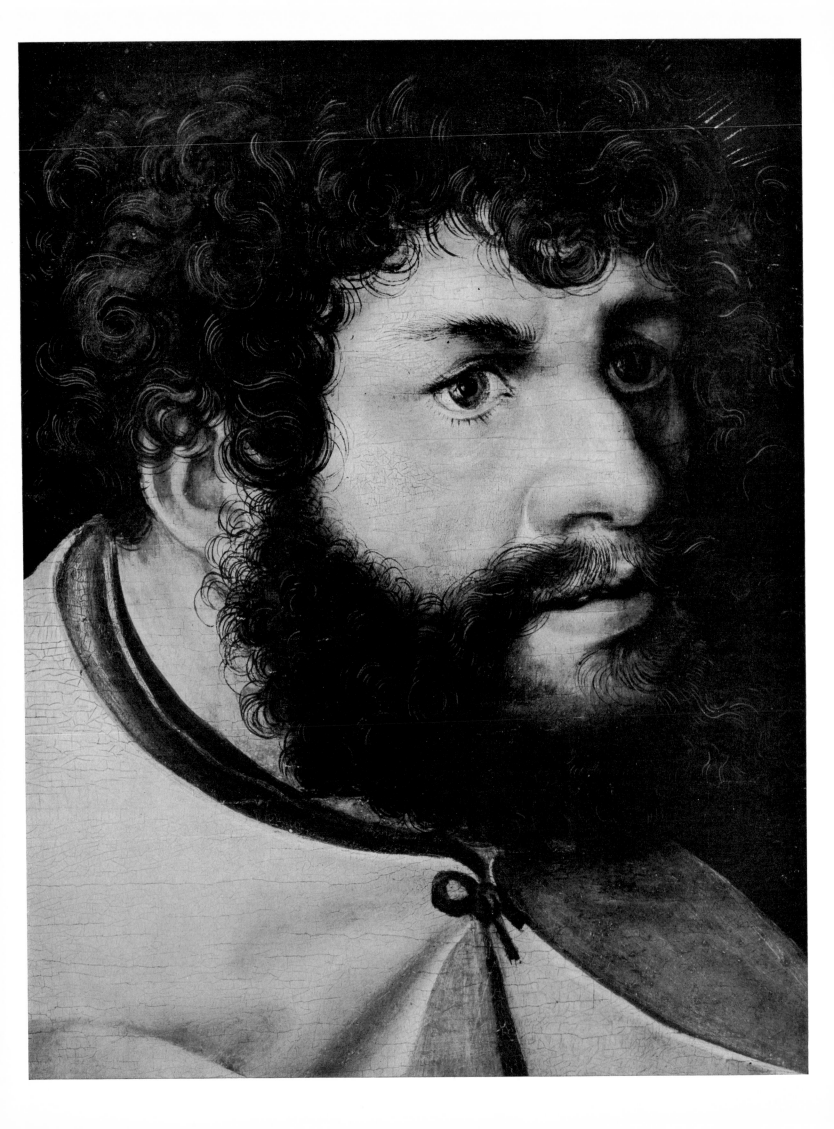

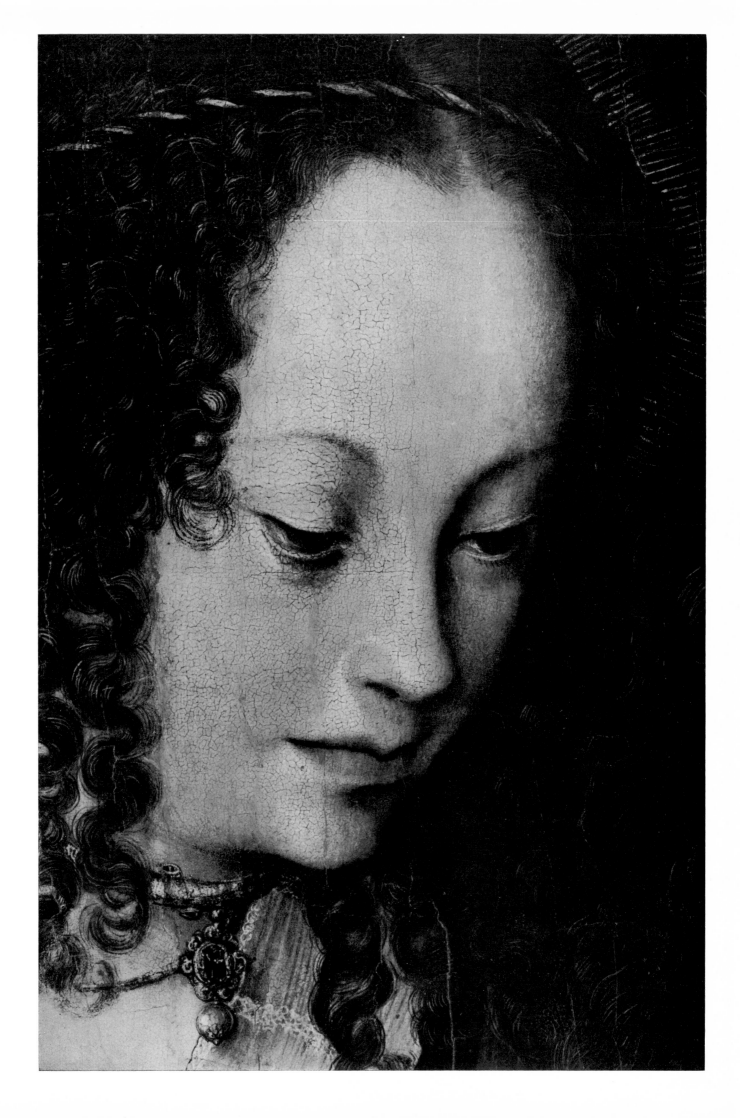

57 Detail of
Plate 56a
58 Detail of
Plate 56b

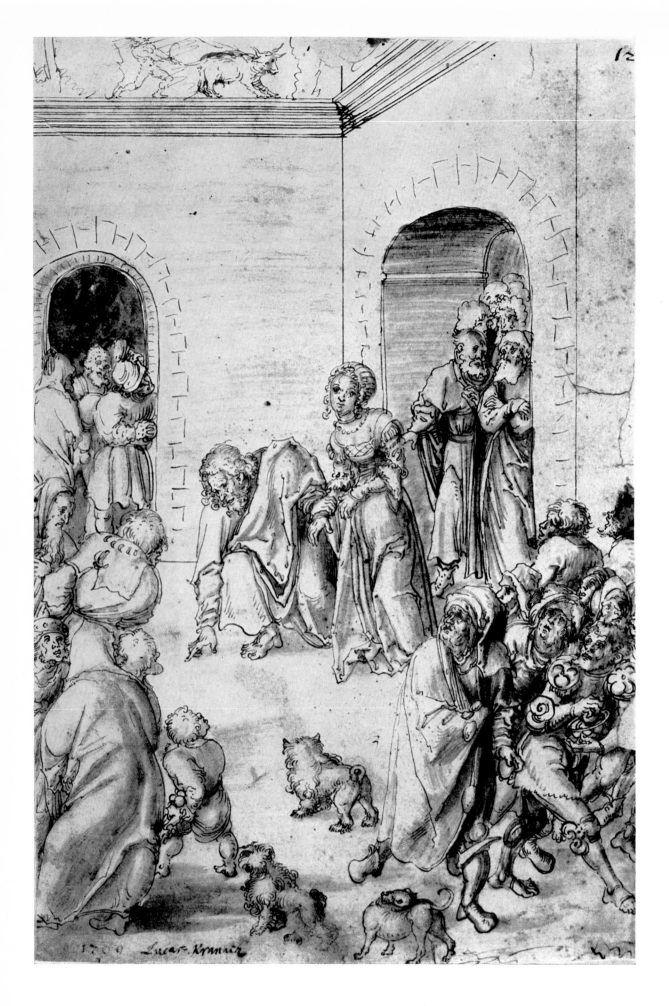

59 Christ and the Woman Taken in Adultery. 1509.
Drawing. Brunswick

60 The Expulsion of the Money Changers. circa 1509.
Dresden, loan

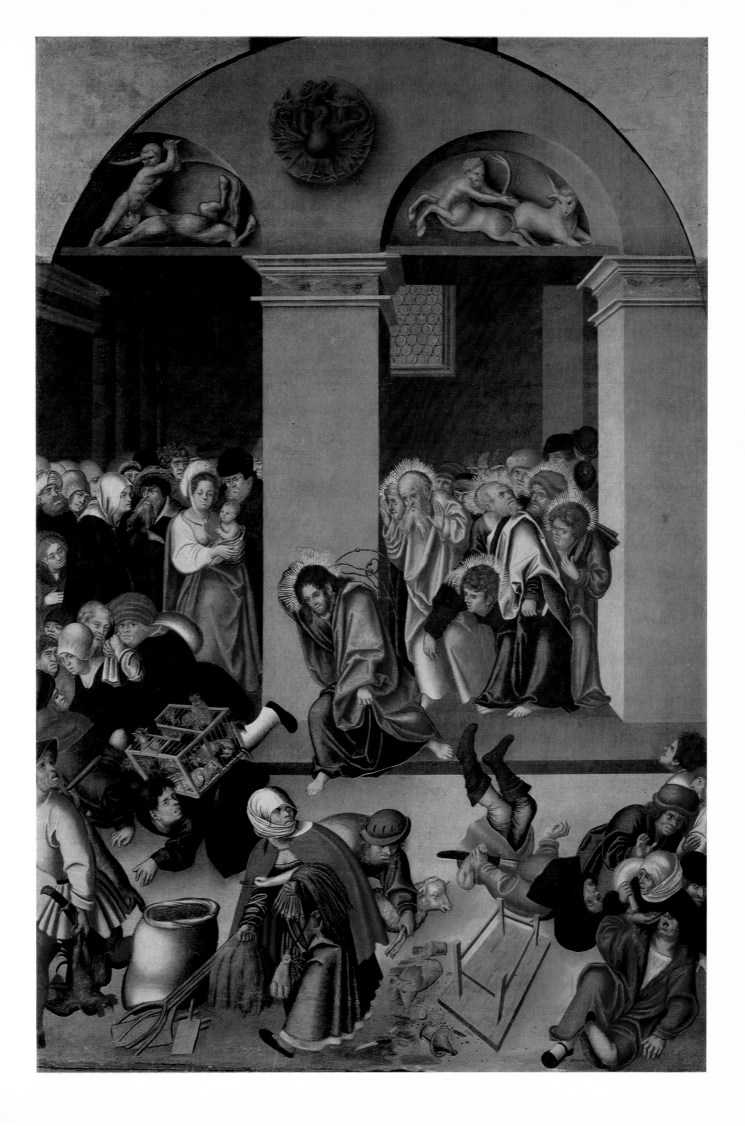

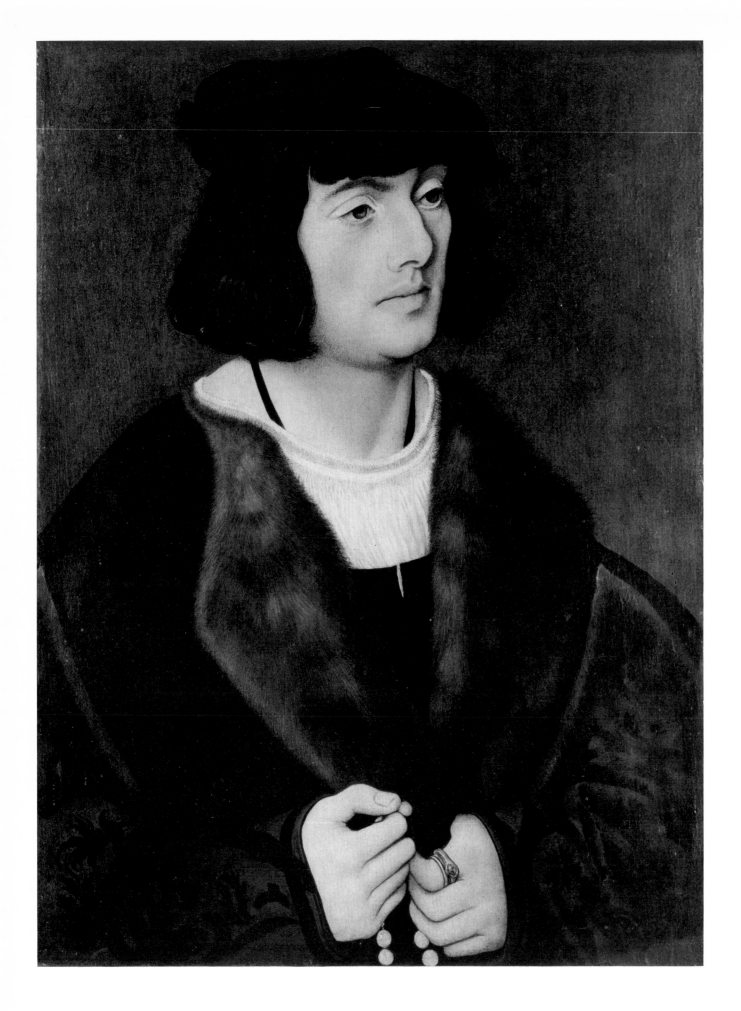

61 Portrait of a Young Man. circa 1510. New York

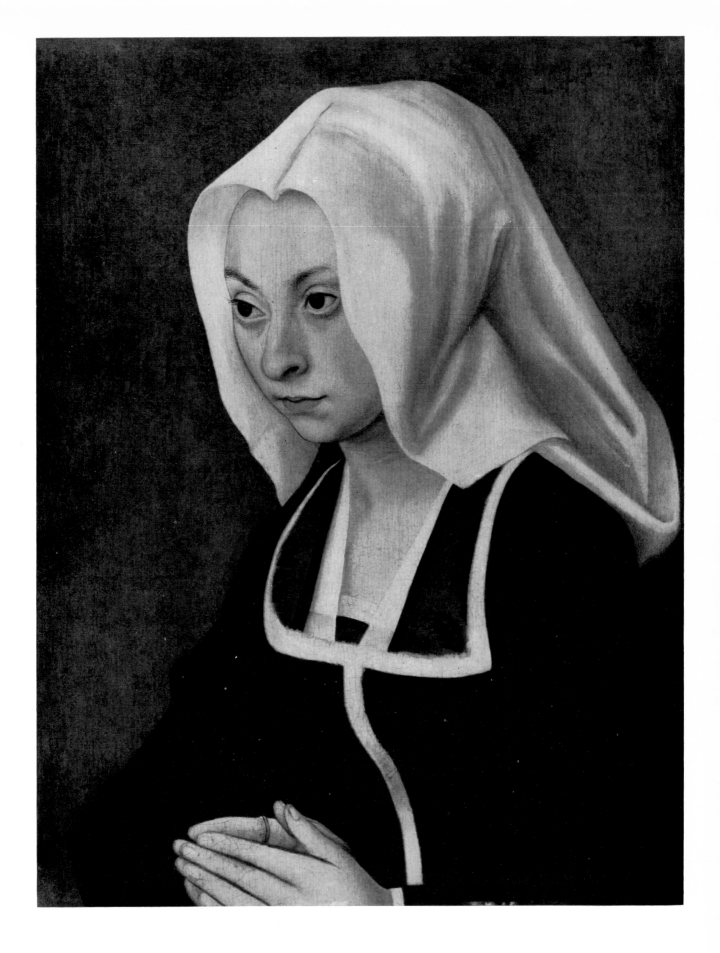

62 Portrait of Lady Praying. circa 1510. Zürich

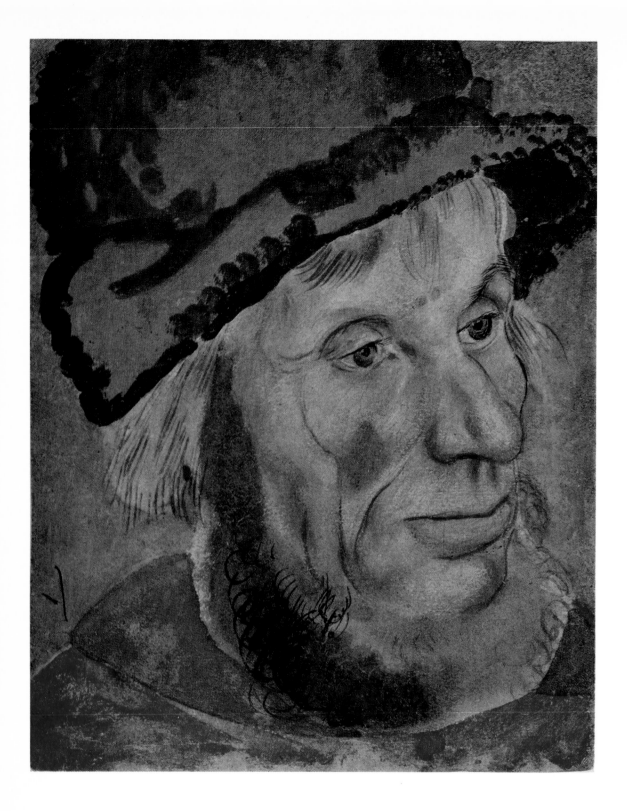

63 Head of a Peasant. circa 1515. Watercolor. Basel

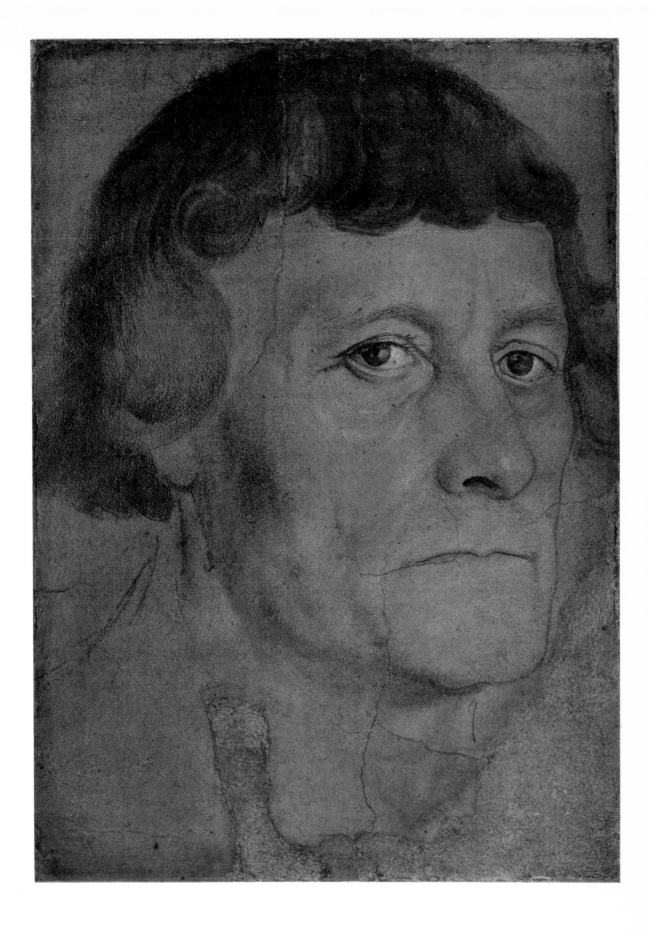

64 Head of a Beardless Man. circa 1515. West Berlin

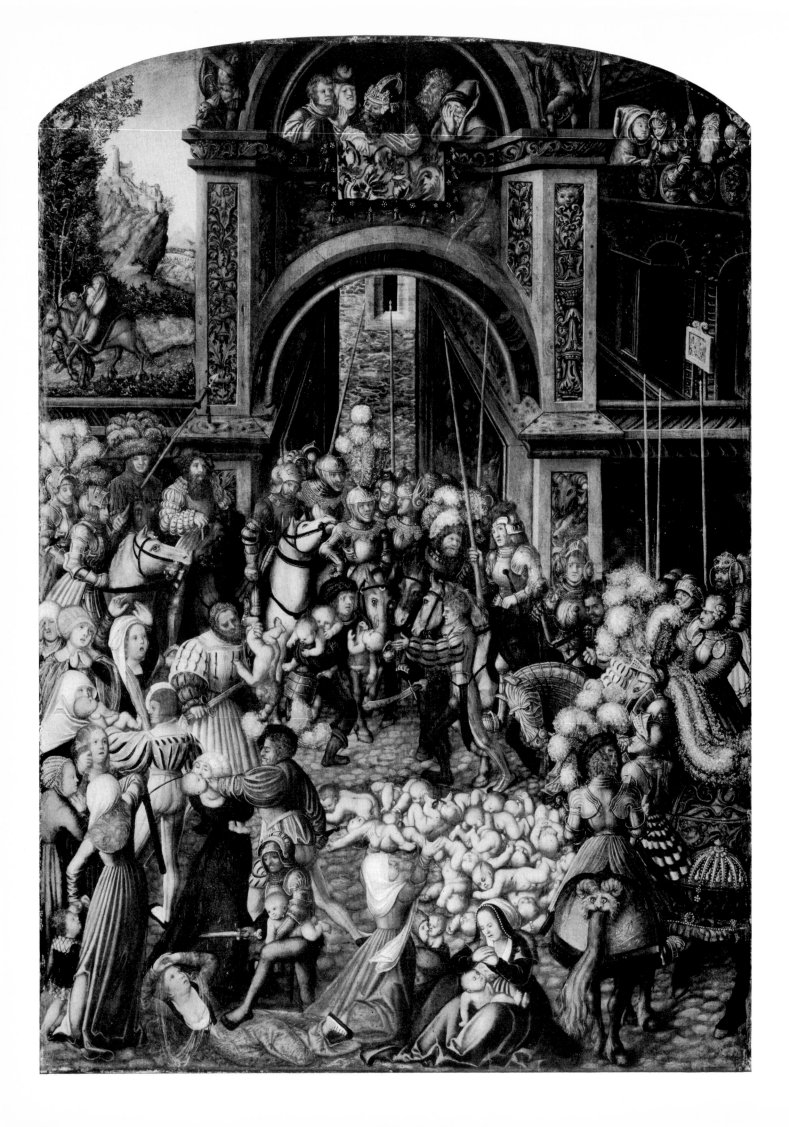

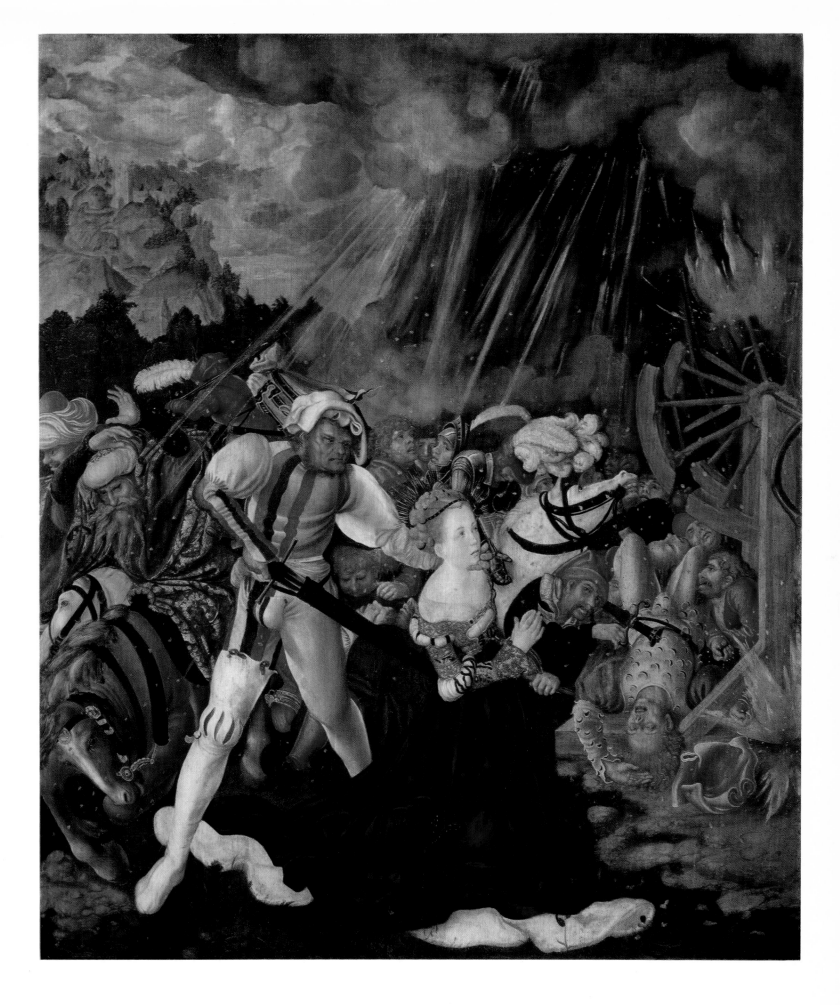

65 The Slaughter of the Innocents. circa 1515. Dresden

66 The Execution of St. Catherine. circa 1510. Budapest

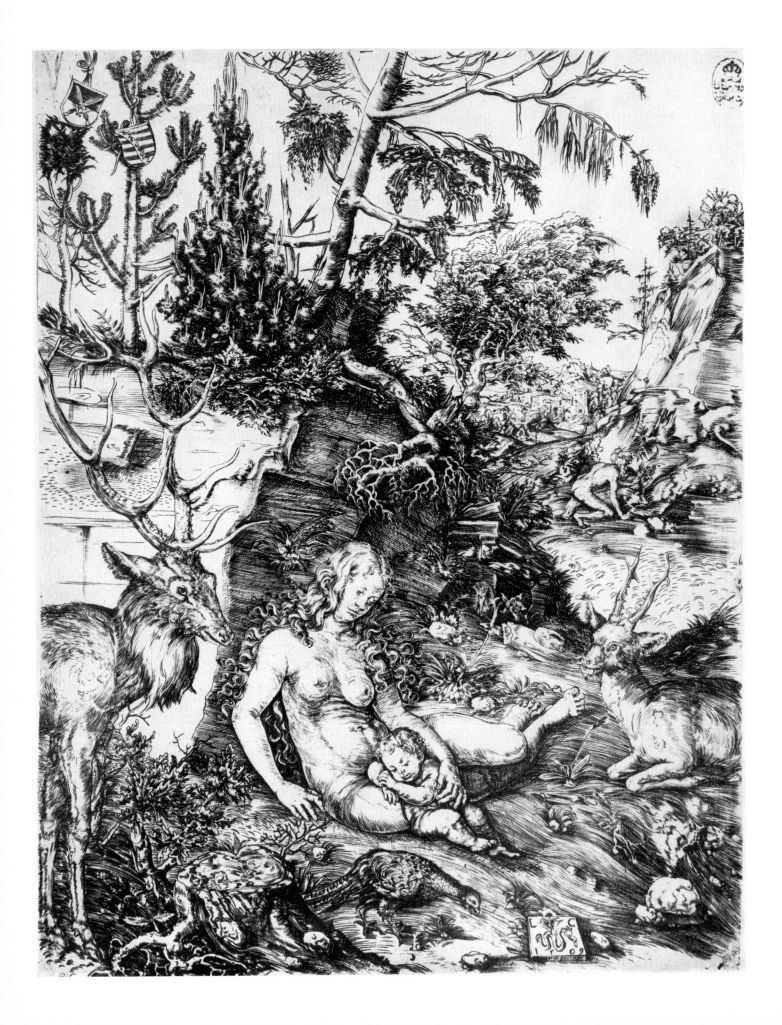

67 The Penitence of St. Chrysostom. 1509. Engraving 68 St. Bartholomew, worshipped by Frederick the Wise. circa 1510. Engraving

69 Christ before Annas. From the Passion series of 1509. Woodcut

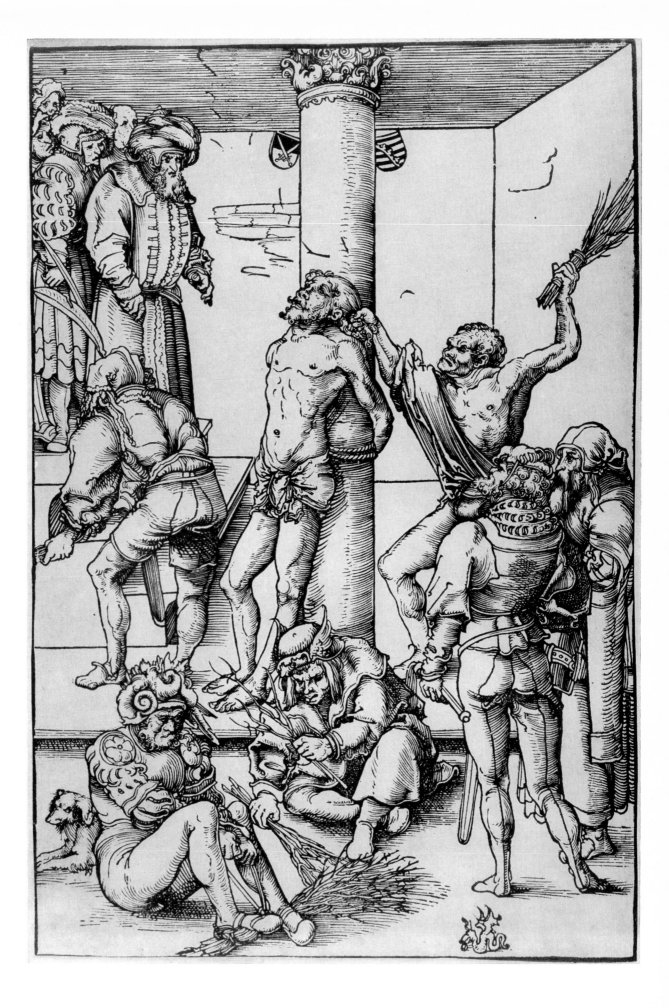

70 The Flagellation of Christ. From the Passion series of 1509. Woodcut

71 The Execution
of John the Baptist.
circa 1509. Woodcut

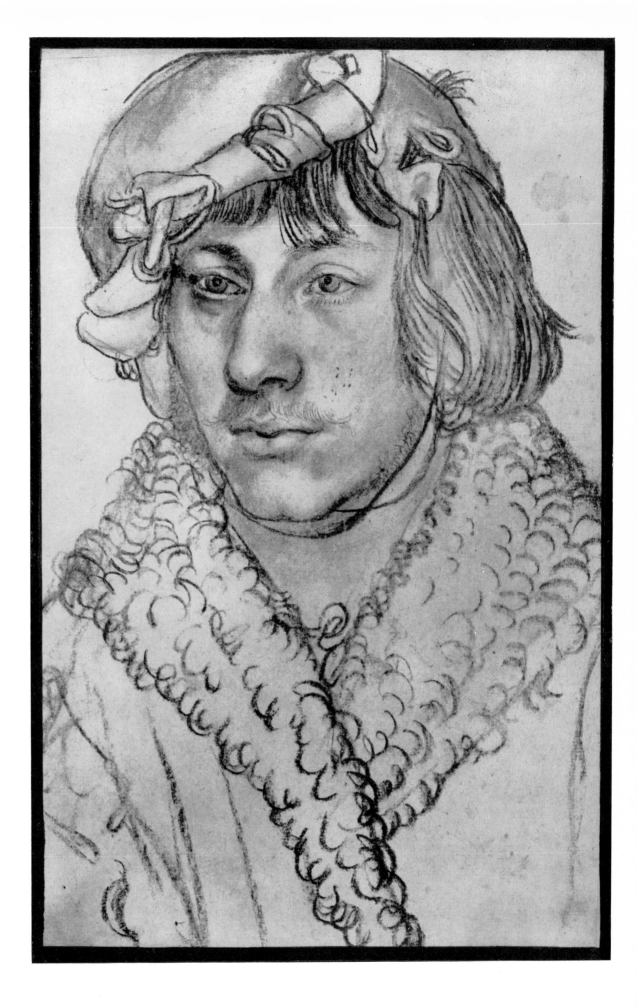

72 Head and Shoulders of a Gentleman. circa 1510. Drawing. Vienna

73 The First Tournament. 1506. Woodcut. Dresden

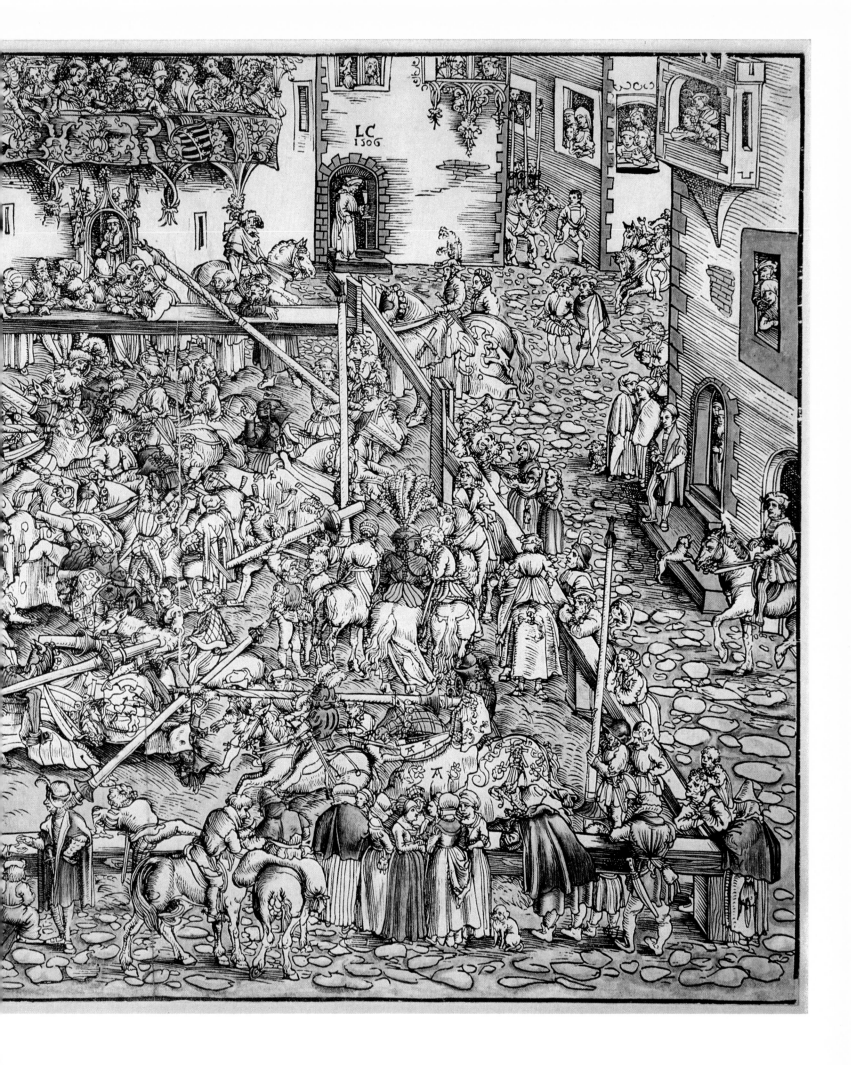

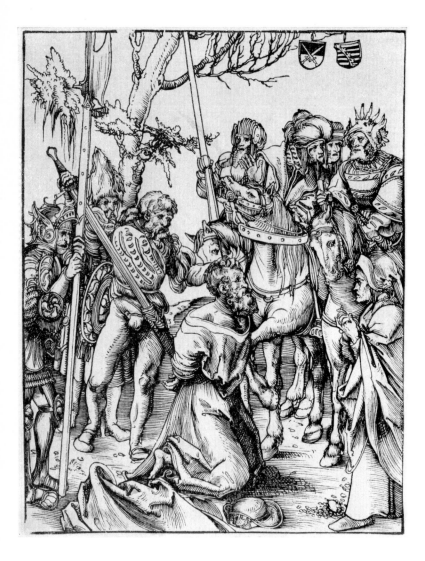

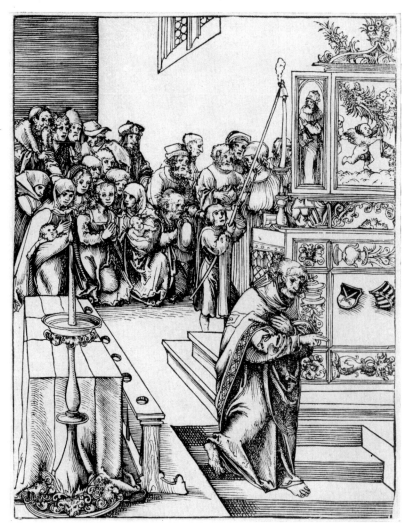

74–77 From the Series *The Deaths of the Apostles*. circa 1512. Woodcuts

74 The Execution of the Apostle James the Greater
75 The Death of the Apostle John

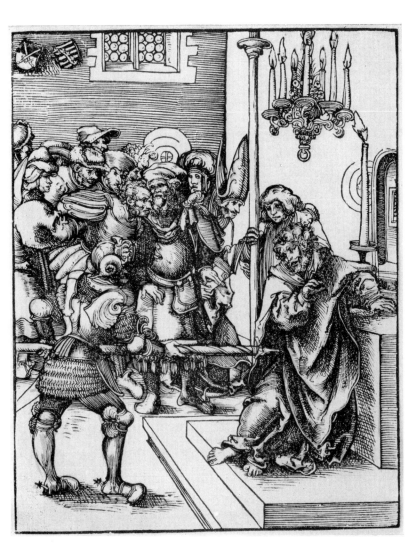
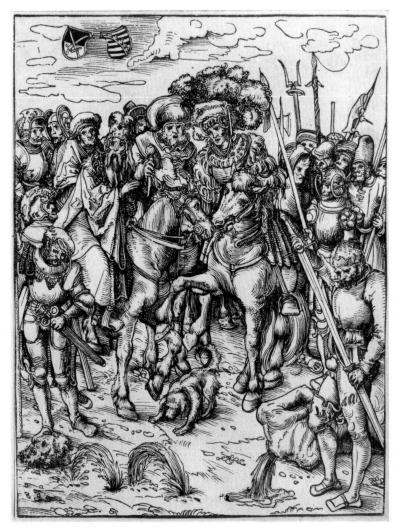

76 The Execution of the Apostle Thomas
77 The Execution of the Apostle Matthew

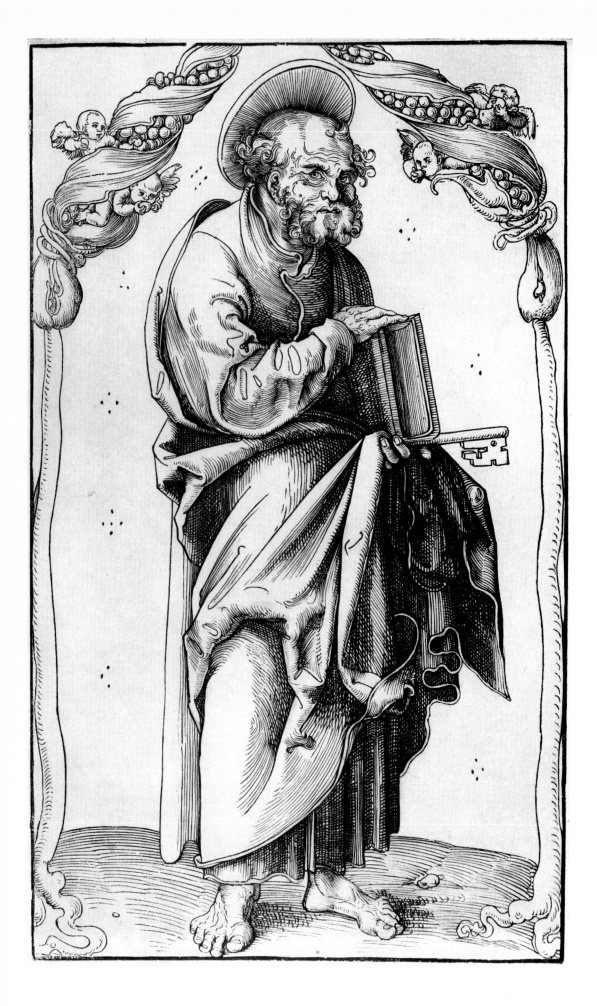

78 The Apostle Peter. From the Series *Christ and the Twelve Apostles with St. Paul*. circa 1515. Woodcut

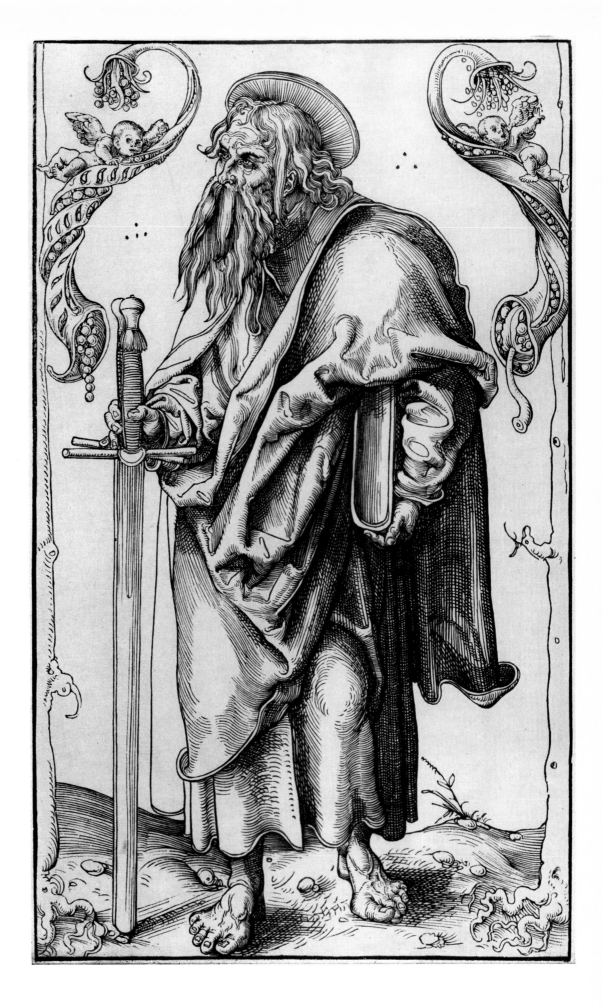

79 The Apostle Paul. From the Series *Christ and the Twelve Apostles with St. Paul.* circa 1515. Woodcut

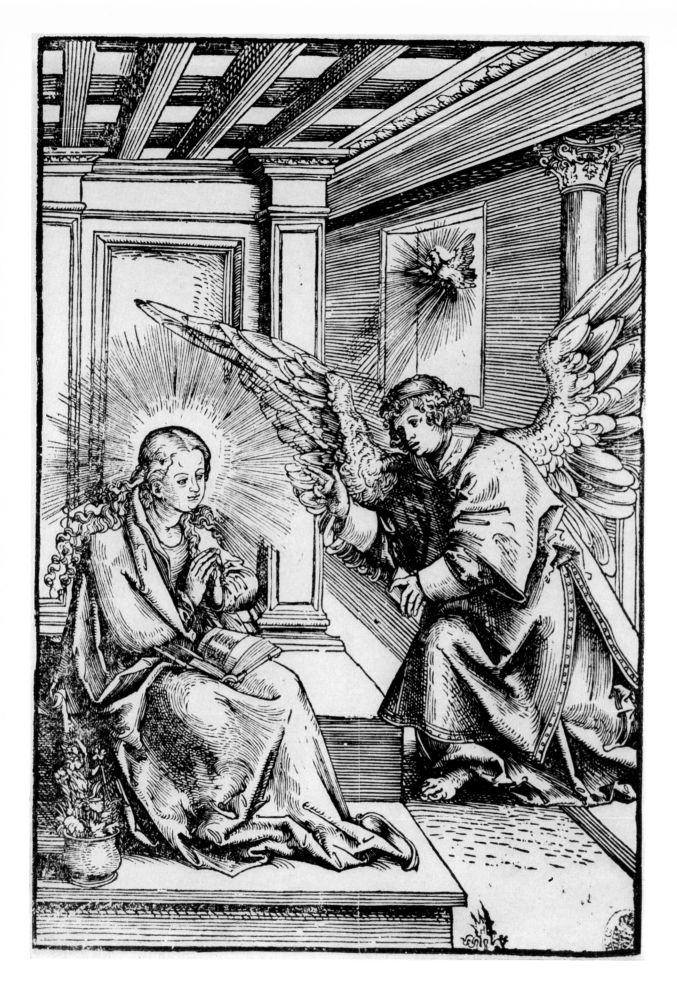

80 The Annunciation to the Virgin. circa 1511. Woodcut

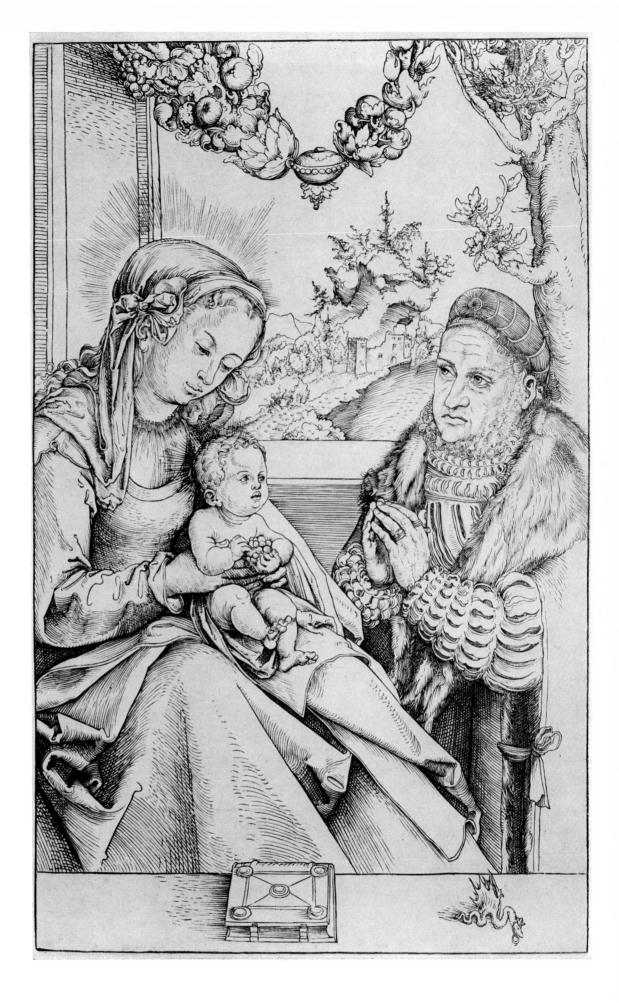

81 Virgin and Child, worshipped by Frederick the Wise. circa 1515. Woodcut. Dresden

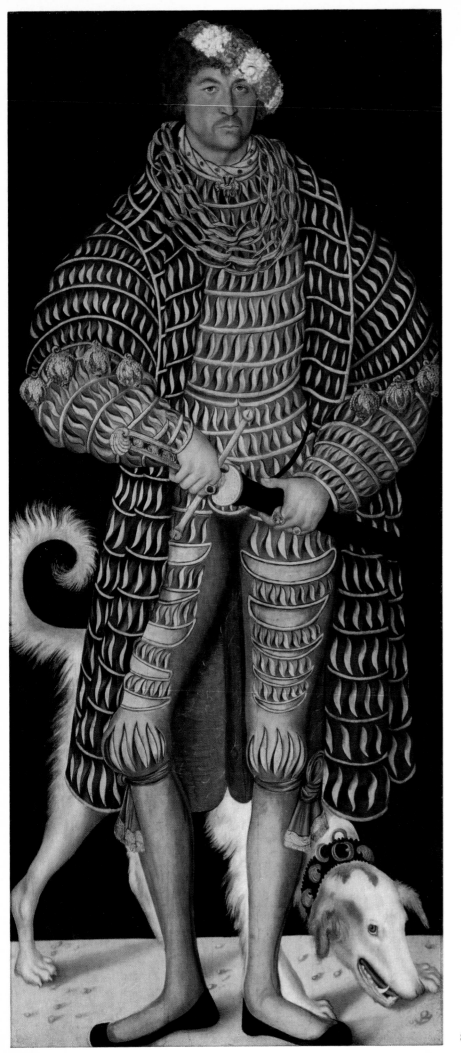

82 Duke Henry of Saxony. 1514. Dresden

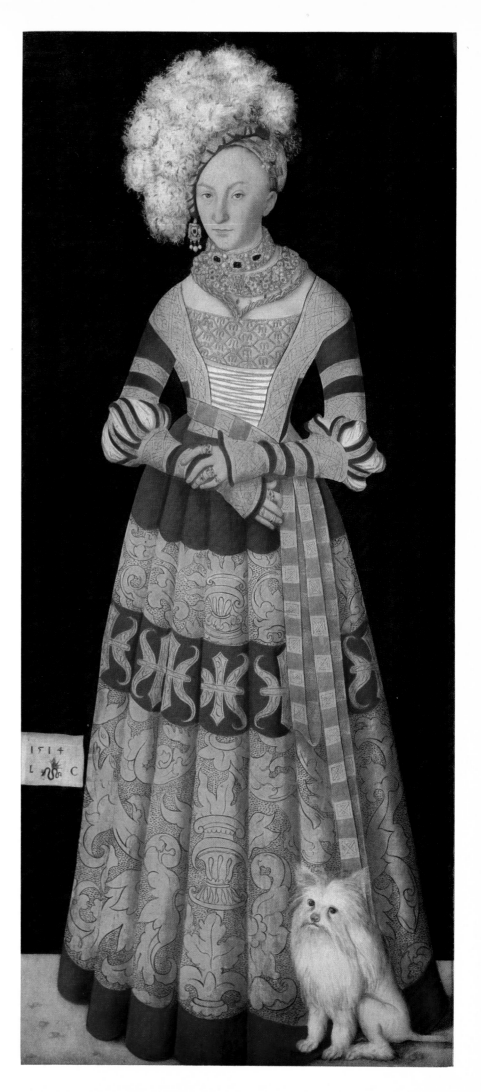

83 Duchess Catherine. 1514. Dresden

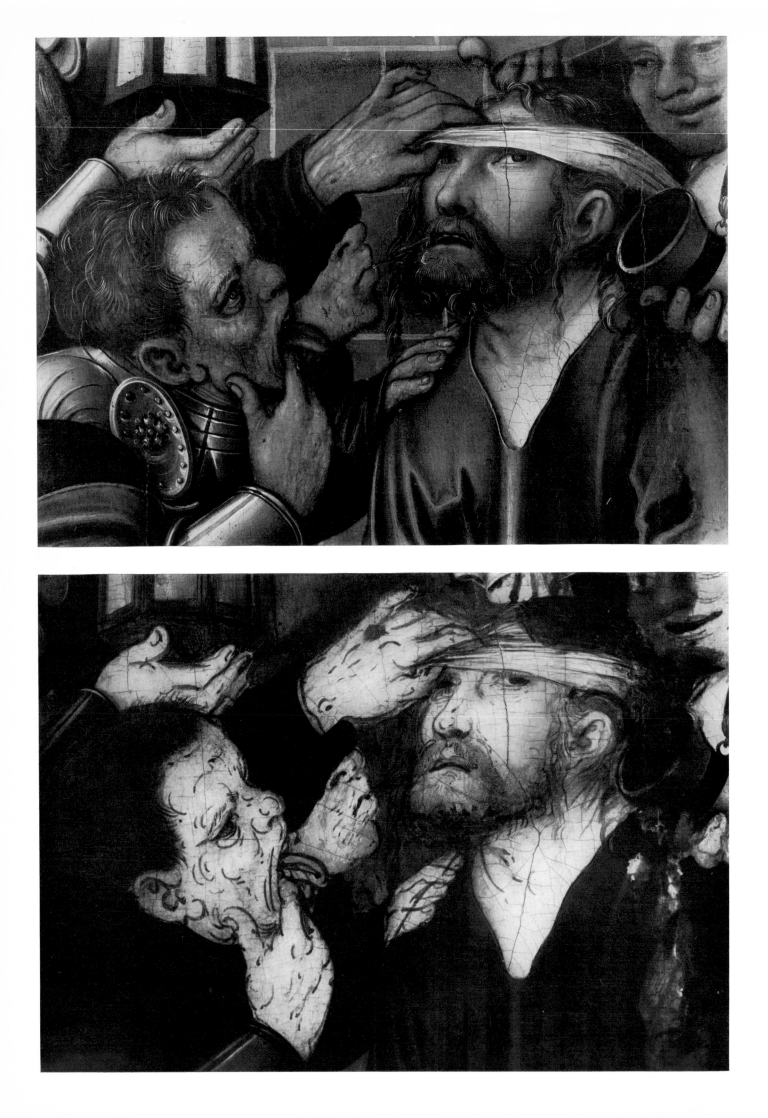

84–86

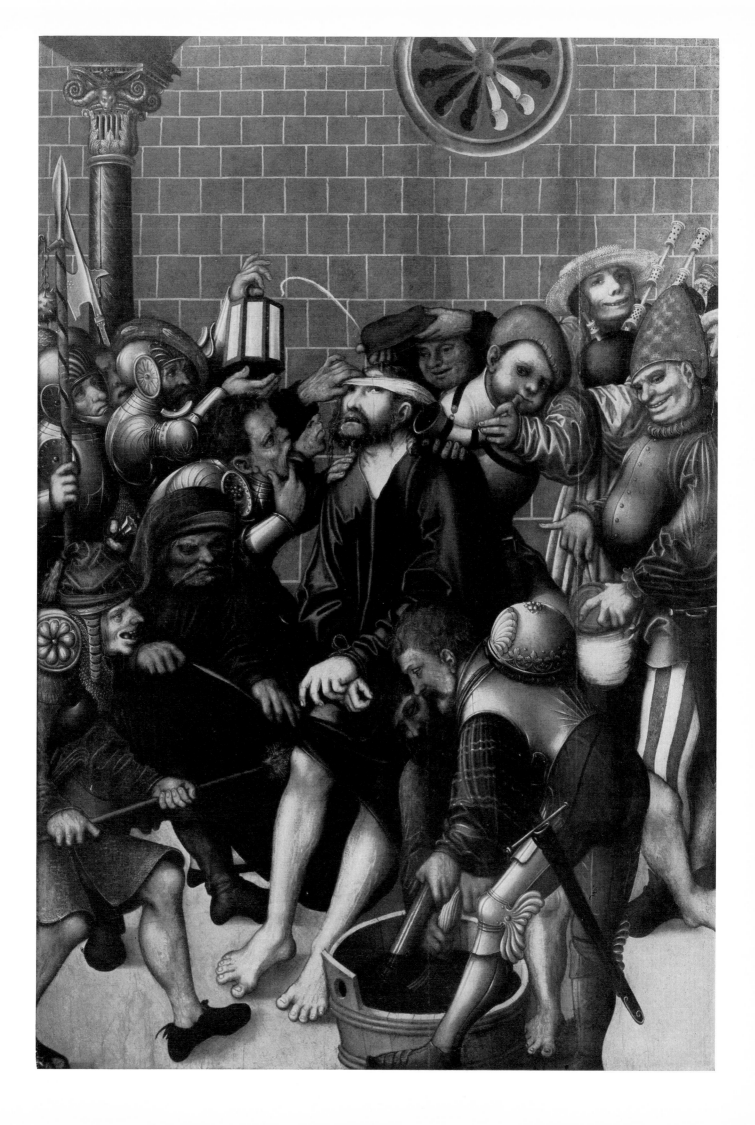

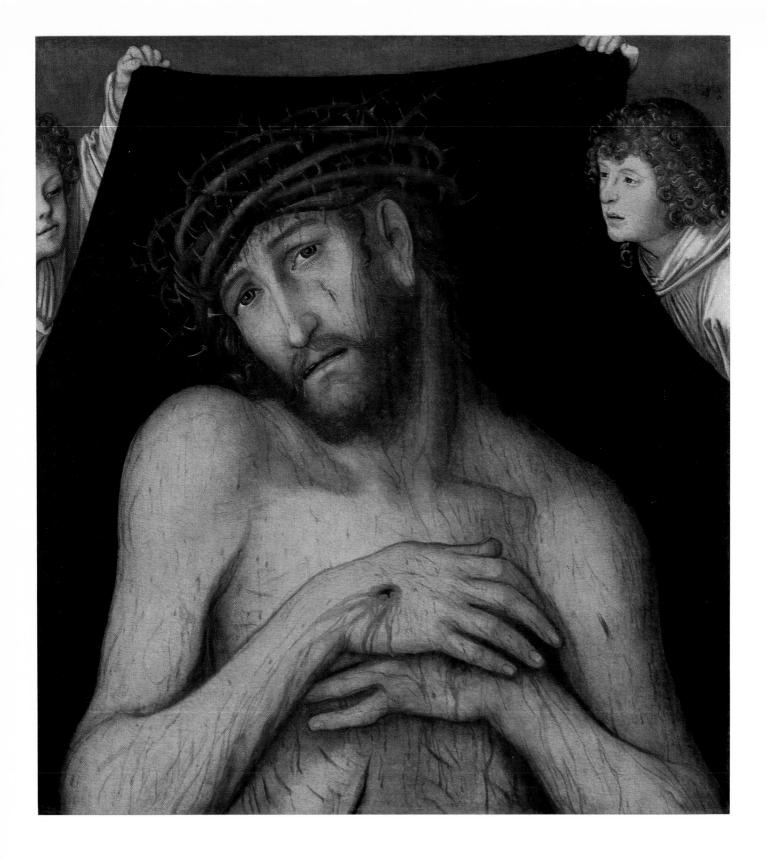

87 Christ, the Man of Sorrows. circa 1515. Weimar

Preceding pages:
84 Detail of Plate 86
85 Detail of Plate 86. Infrared photograph
86 The Mocking of Christ. circa 1515. Weimar

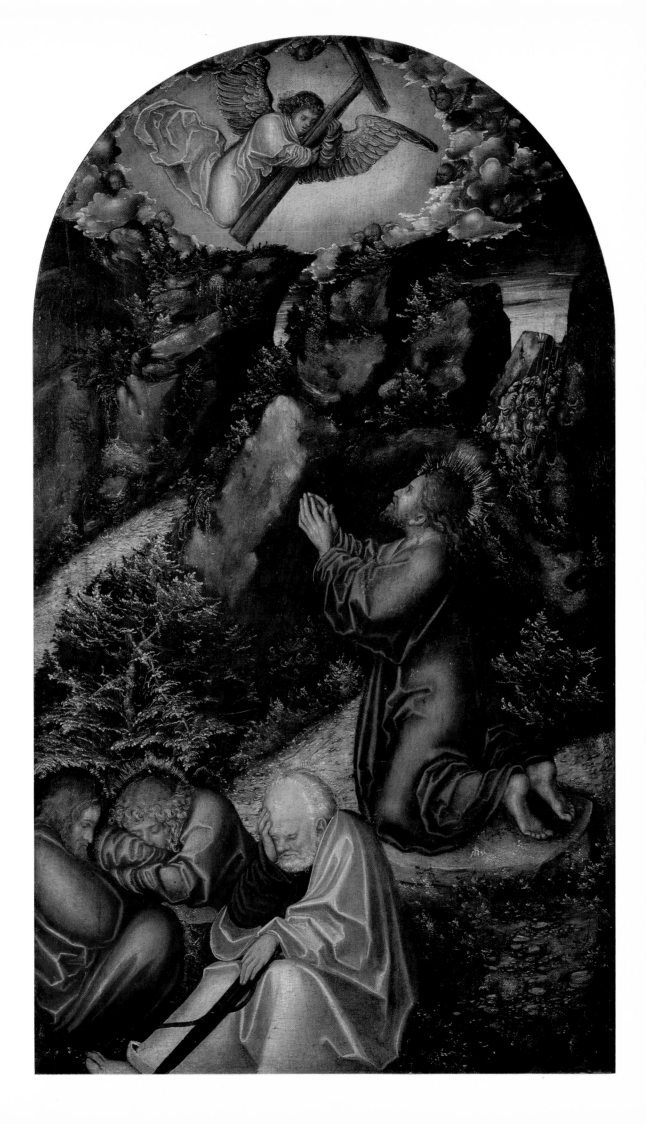

88 The Agony in the Garden.
circa 1515–1520. Dresden

in virtutibus eius: laudate eū
secundū multitudinem ma
gnitudinis eius. Laudate eū
in sono tube: laudate eum in
psalterio et cythara. Laudate
eum in tympano et choro: lau
date eum in cordis et organo.
Laudate eum in cymbalis be
nesonātibus: laudate eum in
cymbalis iubilationis: omnis
spiritus laudet dūm. Gloria.
Antiphona. Pulchra es et de
cora filia hierusalem: terribi
lis vt castroꝛ acies ordinata.

Capitulum

Iderũt eam filie syon et beatissimam predica uerunt: et regine laudauerũt eam. Deo gratias. Hynnus.

Gloriosa domina excel sa super sydera: qui te creauit prouide lactas sacrato vbere. Quod eua tristis abstu lit:tu reddis almo germine:in trent vt astra flebiles: celi fene stra facta es. Tu regis alti ia nua:et porta lucis fulgida: vi tam datã per virginẽ gentes

90 Marginal drawings from the Emperor Maximilian's Prayerbook. circa 1515. Munich

91 *The Cranach Workshop, after Baldung:* Christ Falls at the Flagellation Column. circa 1512–1515. Florence

92 The Adoration of the Magi.
circa 1514. Gotha

93 Recumbent Water Nymph.
 circa 1516. West Berlin
94 Recumbent Water Nymph.
 circa 1525. Drawing.
 Dresden, lost

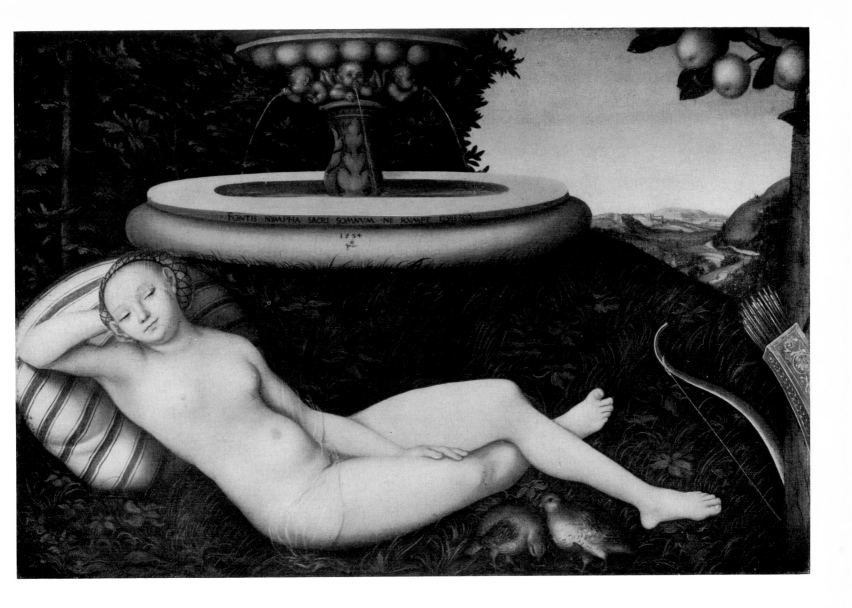

FONTIS NYMPHA SACRI SOMNVM NE RVMPE QVIESCO

1534

95 Recumbent Water Nymph. 1534. Liverpool

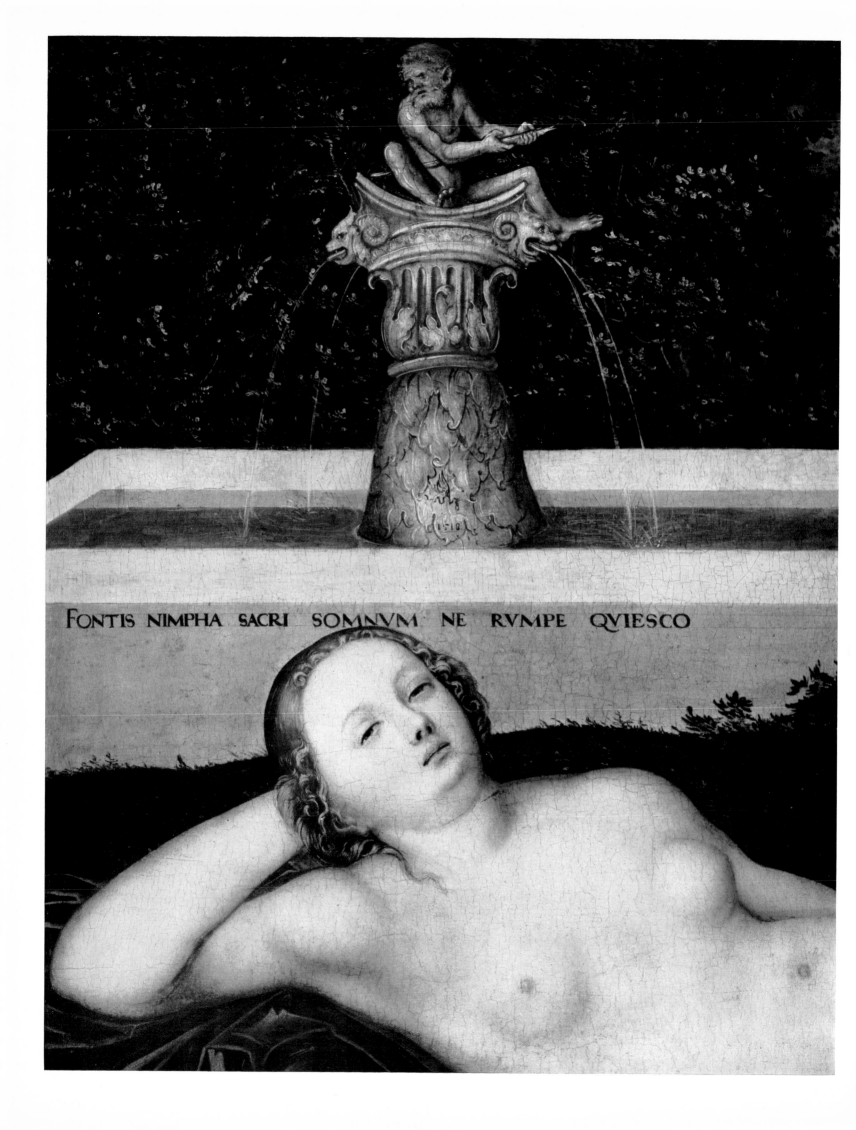

FONTIS NIMPHA SACRI SOMNVM NE RVMPE QVIESCO

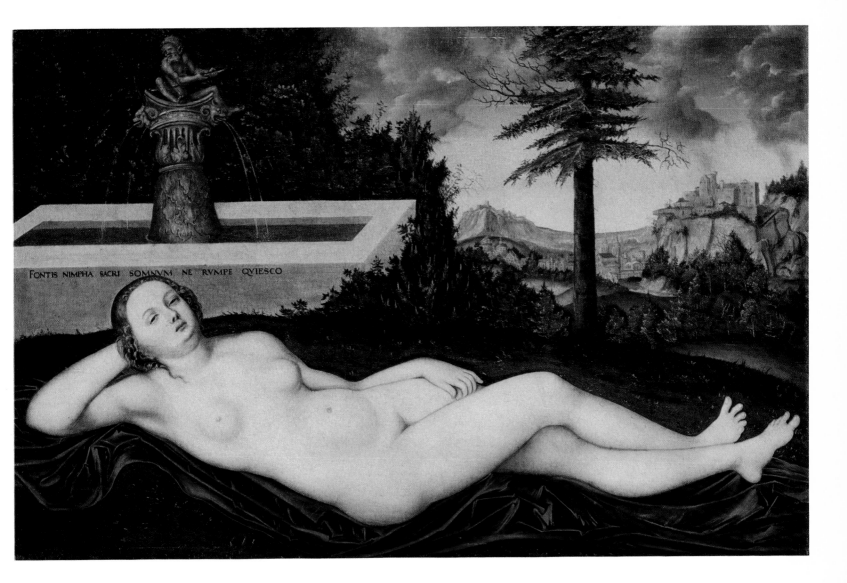

FONTIS NIMPHA SACRI SOMNVM NE RVMPE QVIESCO

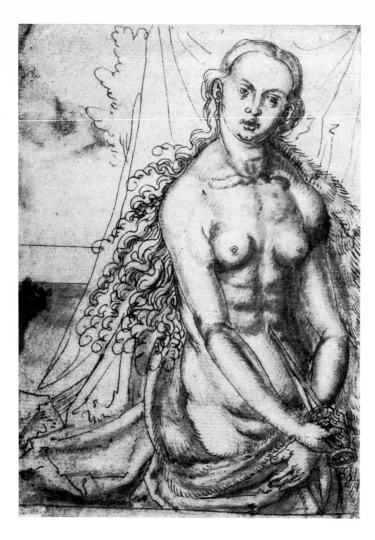

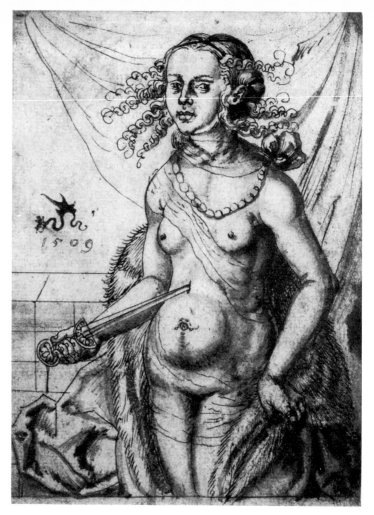

98 Lucretia. circa 1525. Drawing. West Berlin
99 Lucretia. circa 1525. Drawing. West Berlin
100 Man and Woman Playing Musical Instruments.
 circa 1530. Drawing. Erlangen

101 Hercules (rear view). circa 1527–1530. Drawing. West Berlin

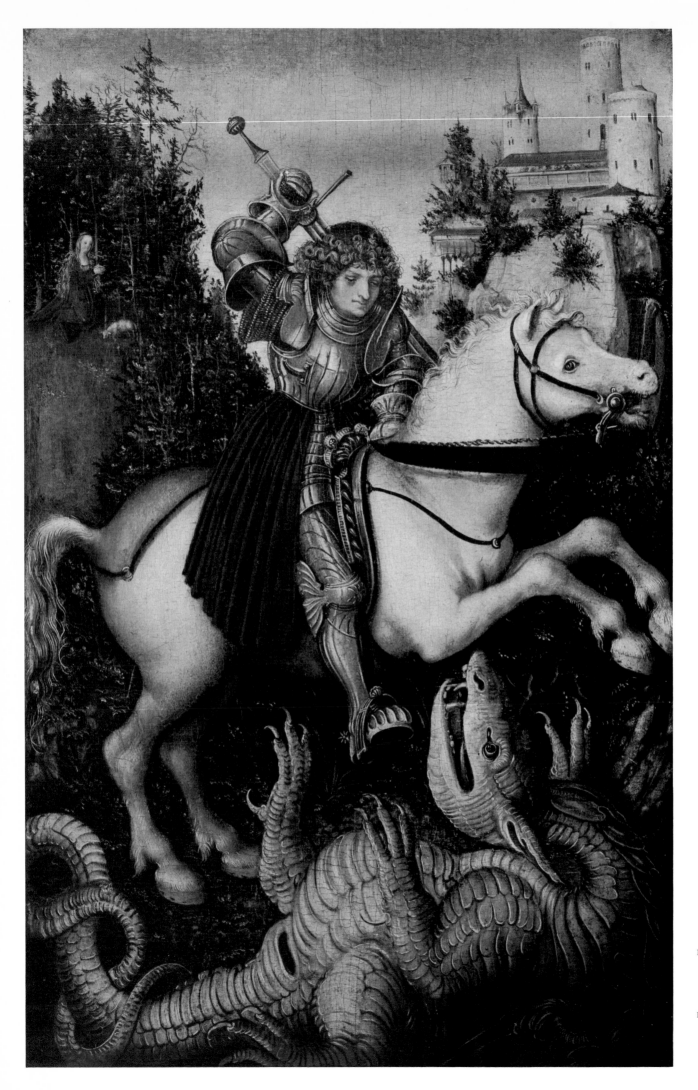

102 St. George on
 Horseback.
 circa 1520–1525.
 Dessau, lost

103 Samson
 and the Lion.
 circa 1520–1525.
 Weimar

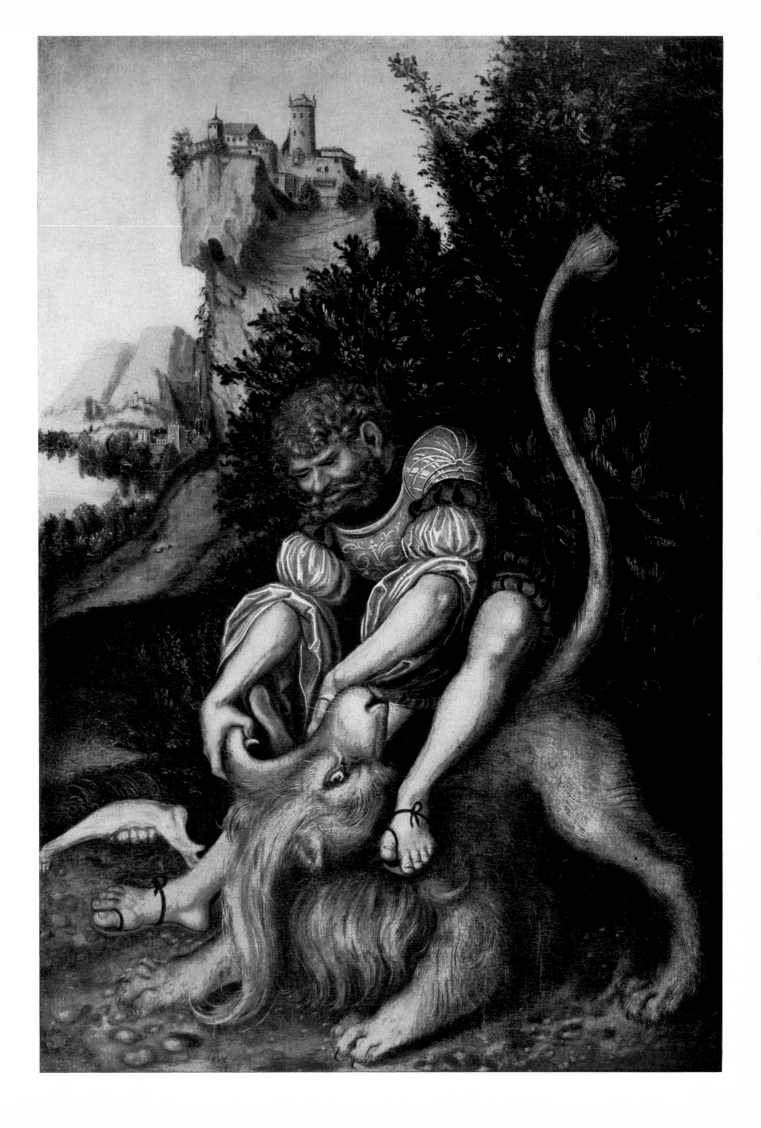

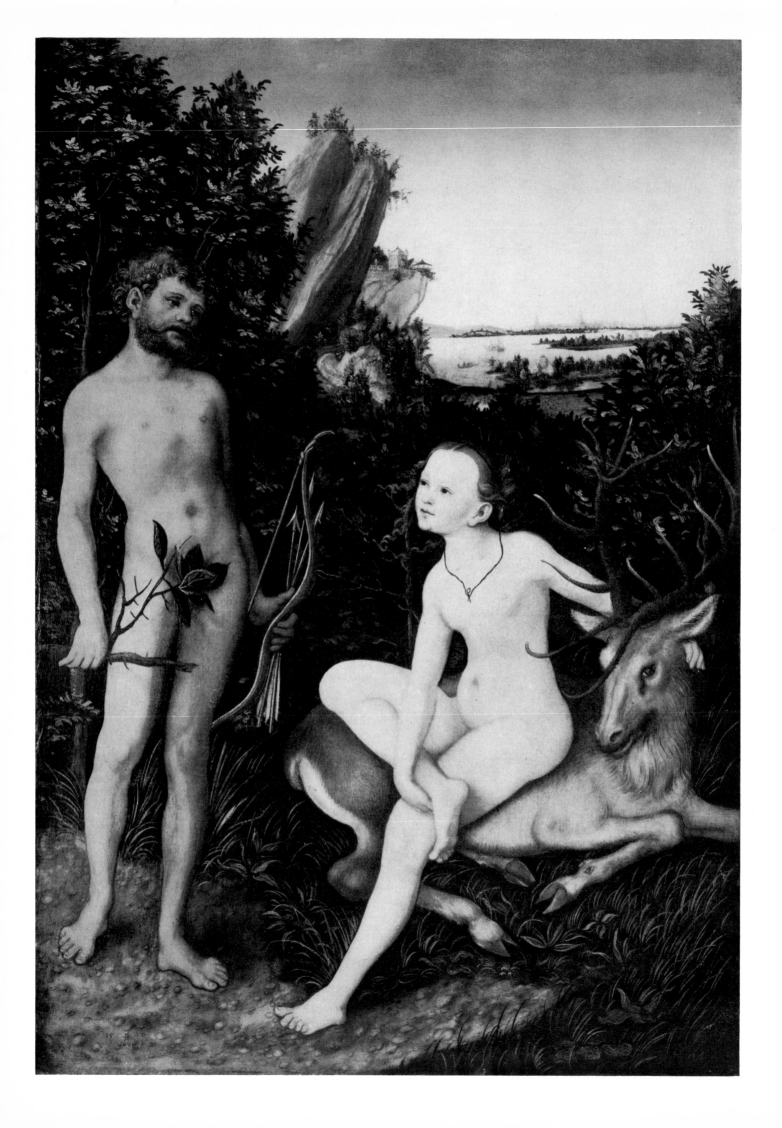

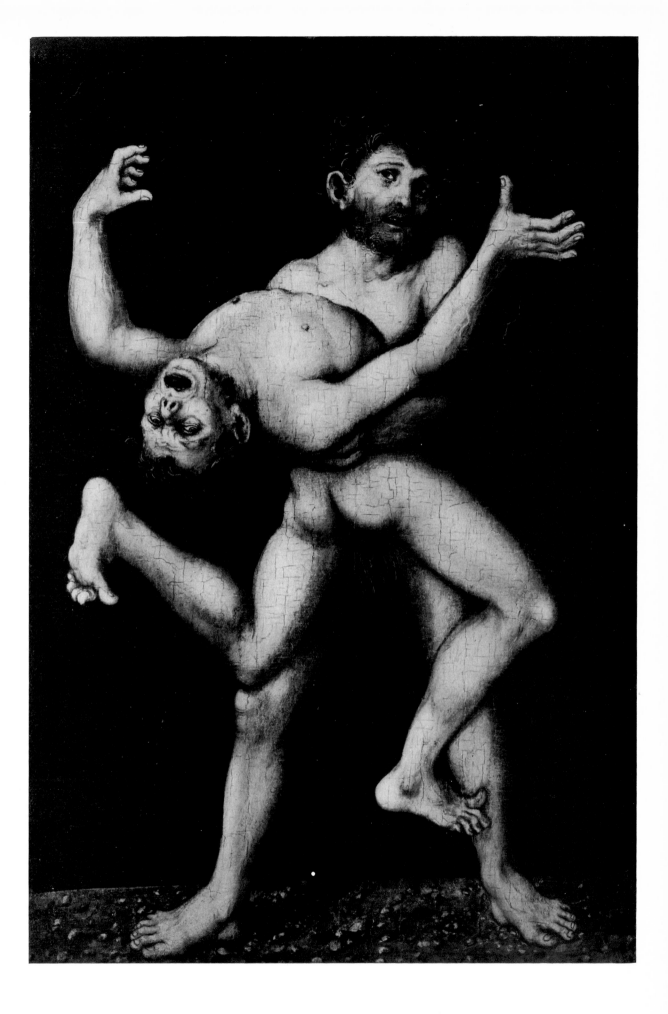

104 Apollo and Diana. 1530. West Berlin 105 Hercules and Antaeus. circa 1530. Formerly Munich

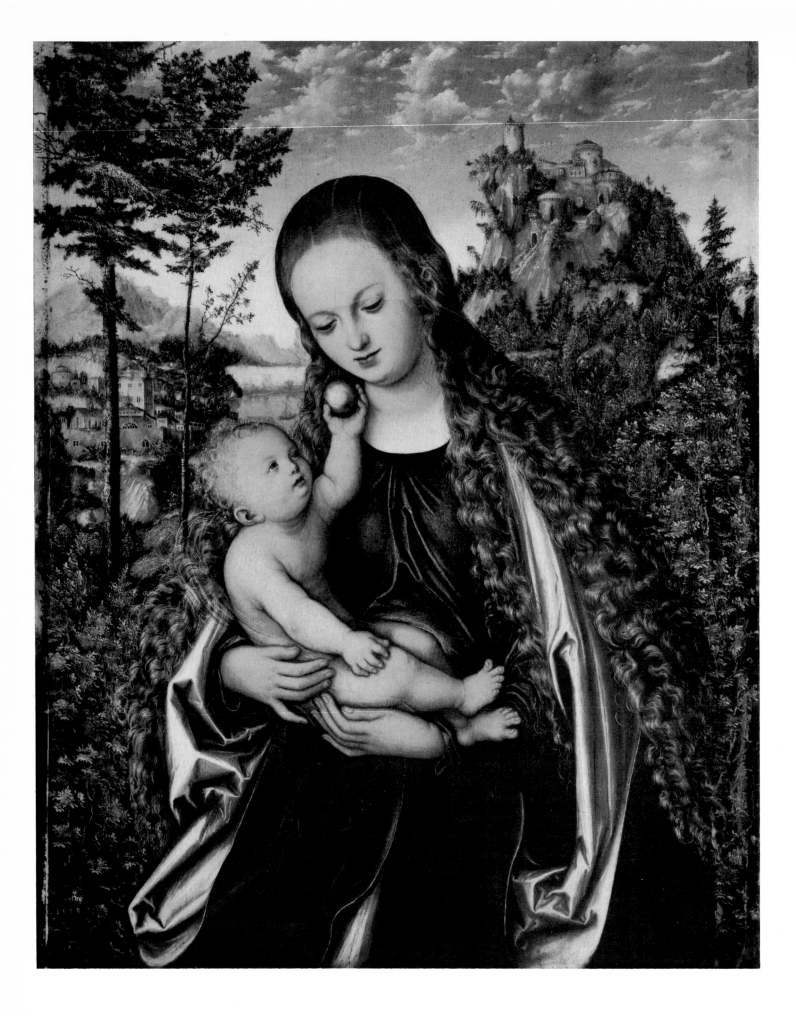

106 Madonna and Child. 1518. Glogau, missing

107 Madonna and Child under an Apple Tree. circa 1530. Leningrad

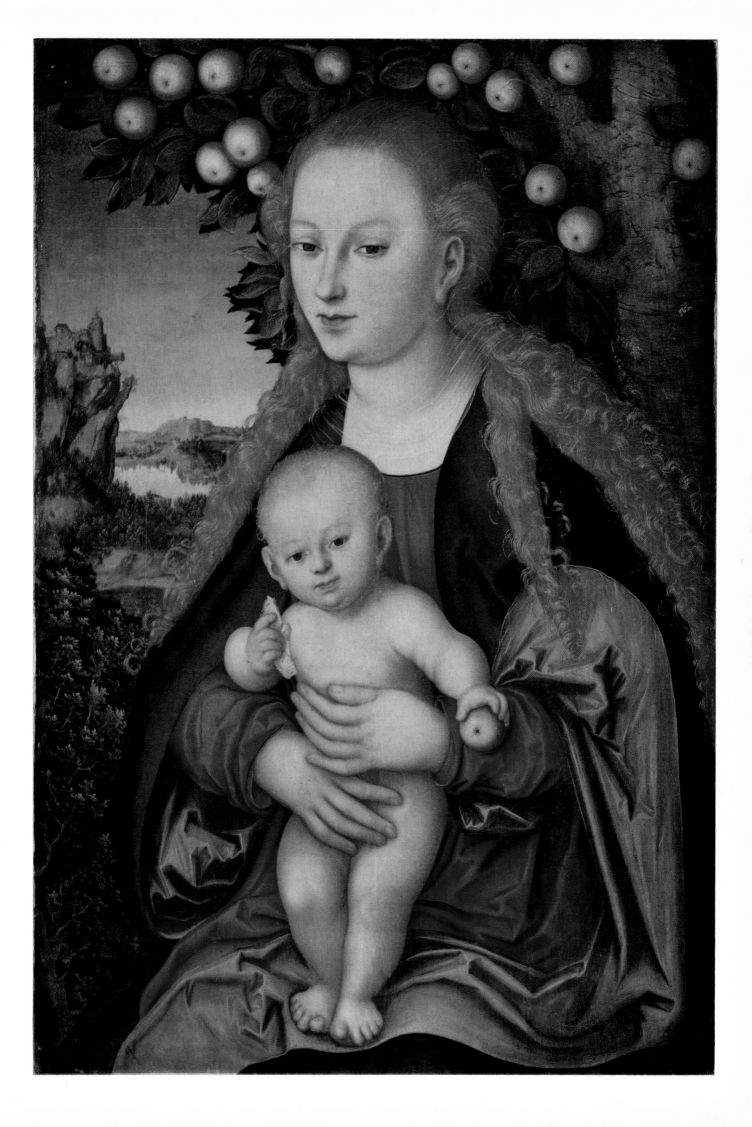

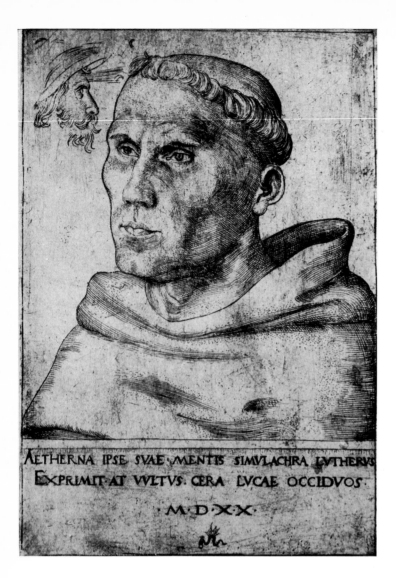

AETHERNA IPSE SVAE MENTIS SIMVLACHRA LVTHERVS
EXPRIMIT AT VVLTVS CERA LVCAE OCCIDVOS
· M·D·X·X·

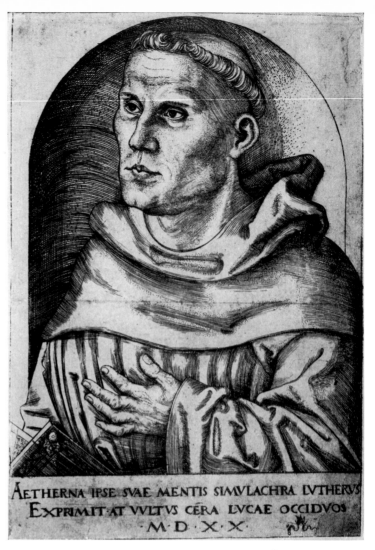

AETHERNA IPSE SVAE MENTIS SIMVLACHRA LVTHERVS
EXPRIMIT AT VVLTVS CERA LVCAE OCCIDVOS
M·D·X·X·

108 Martin Luther as a Monk. 1520. Engraving. Weimar
109 Martin Luther before a Niche. 1520. Engraving. Weimar

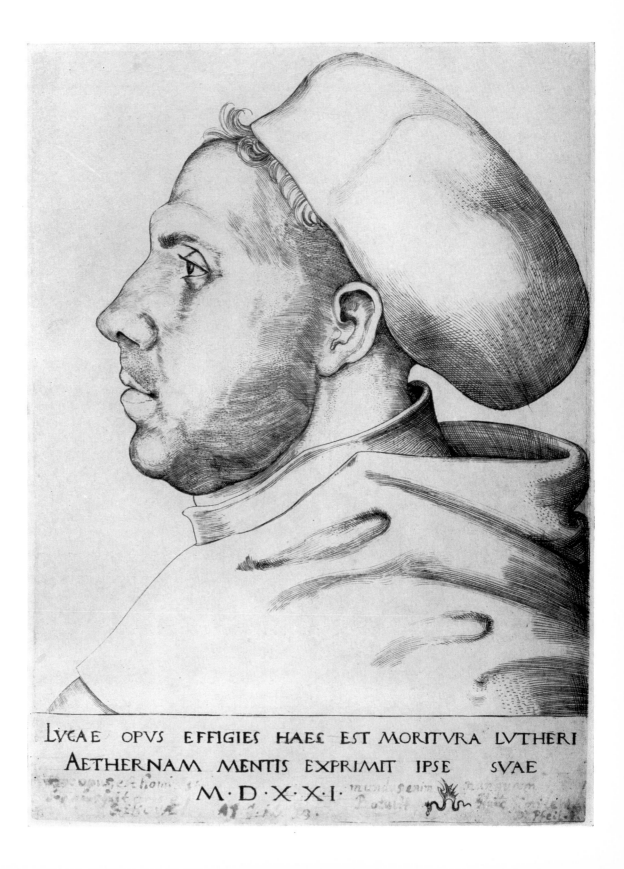

LVCAE OPVS EFFIGIES HAEC EST MORITVRA LVTHERI
AETHERNAM MENTIS EXPRIMIT IPSE SVAE
M·D·X·X·I·

110 Martin Luther Wearing
a Doctor's Cap.
1521. Engraving. Coburg

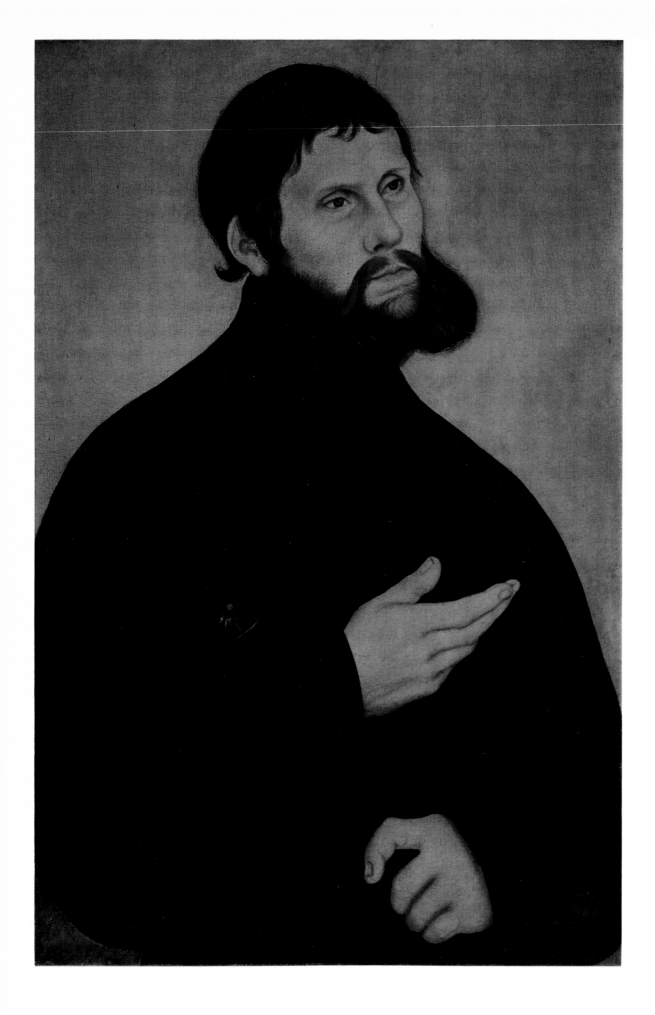

111 Martin Luther as Junker Jörg. circa 1521. Weimar

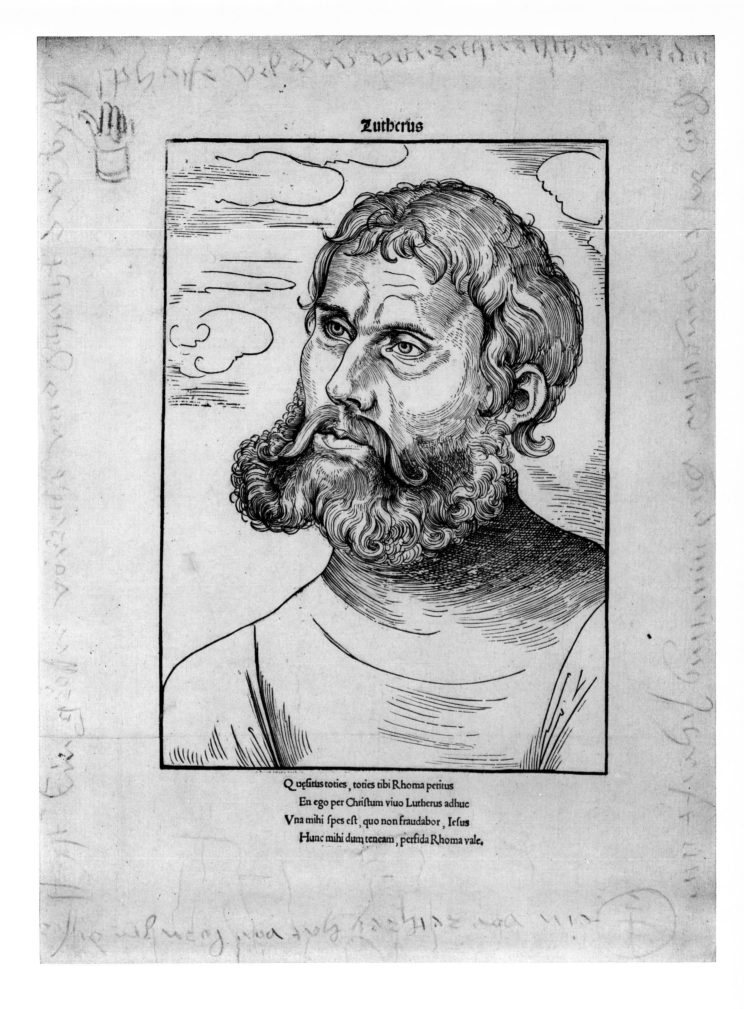

Lutherus

Quęsitus toties, toties tibi Rhoma petitus
En ego per Christum viuo Lutherus adhuc
Vna mihi spes est, quo non fraudabor, Iesus
Hunc mihi dum teneam, perfida Rhoma vale.

112 Martin Luther as Junker Jörg. 1522. Woodcut. Dresden

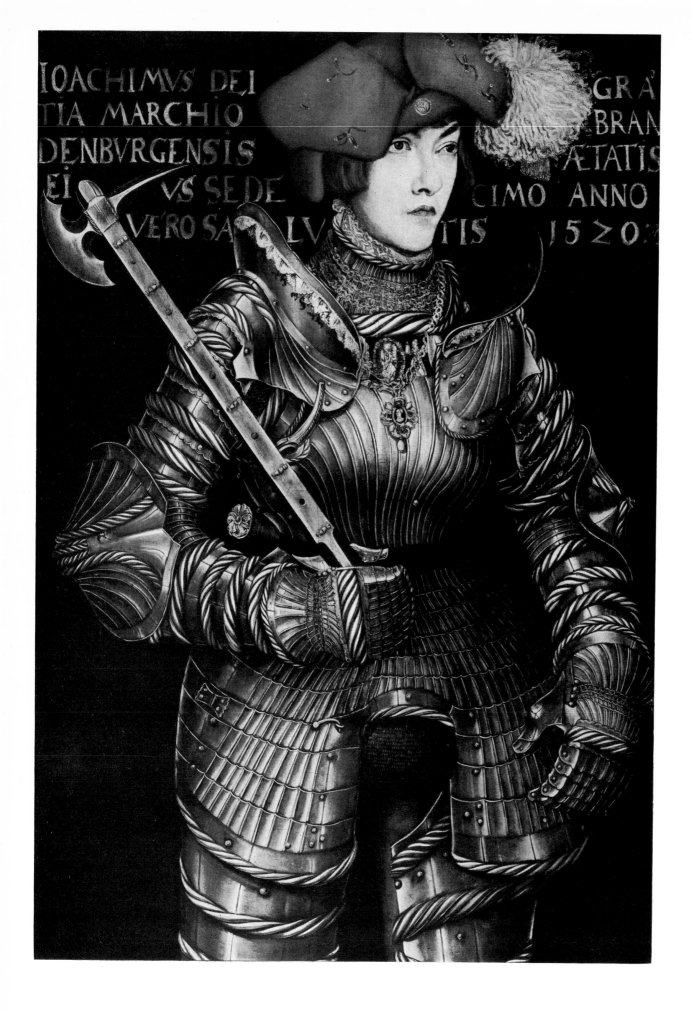

IOACHIMVS DEI
TIA MARCHIO
DENBVRGENSIS
EI VS SEDE VS SEDE VERO SA LV TIS

GRA
BRAN
ÆTATIS
CIMO ANNO
1520

113 Joachim of Brandenburg. 1520. West Berlin

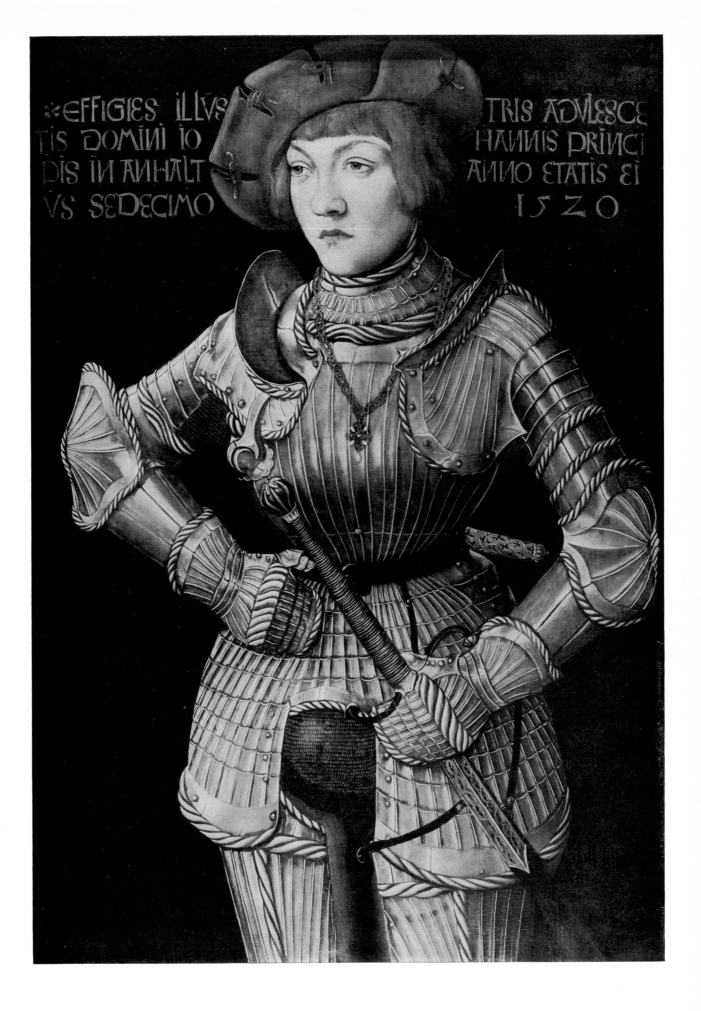

The text within the image reads:

✷EFFIGIES ILLVS TRIS ADVLESCE
TIS DOMINI IO HANNIS PRINCI
DIS IN ANHALT ANNO ETATIS EI
VS SEDECIMO 1520

114 John of Anhalt. 1520. West Berlin

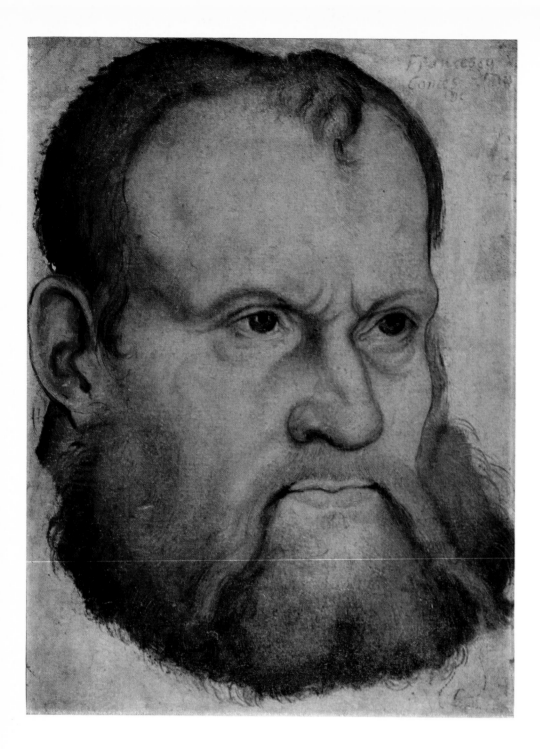

115 Count Philipp of Solms. 1520. Paper. Bautzen

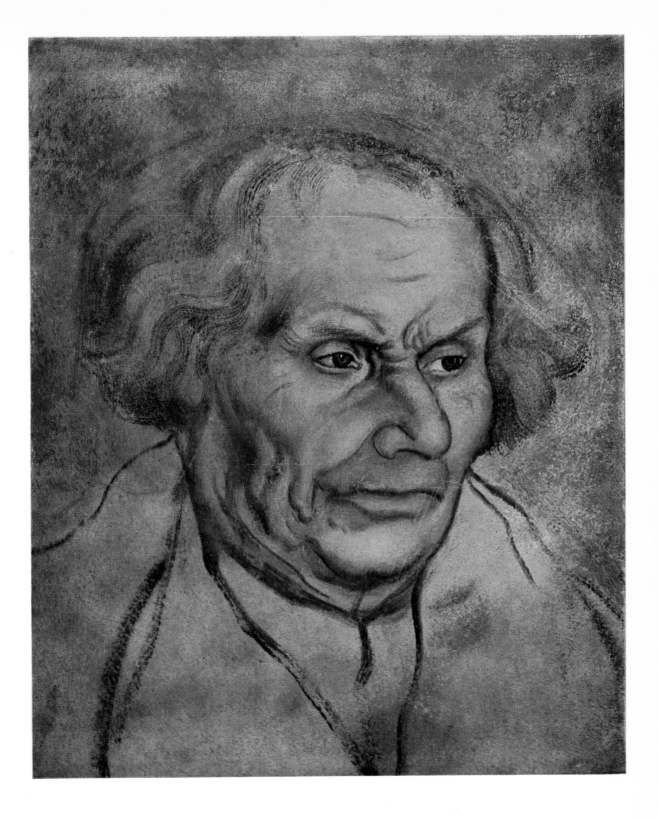

116 Hans Luther. 1527. Drawing. Vienna

Within the image: ANNO · 1530 · AM · 29 · TAG · IVNY · IST · HANS · LVTER
· D · MARTIИVS · · · VATER · INN · GOTT
VERSCHIE DENN

117 Hans Luther. 1527. Wartburg

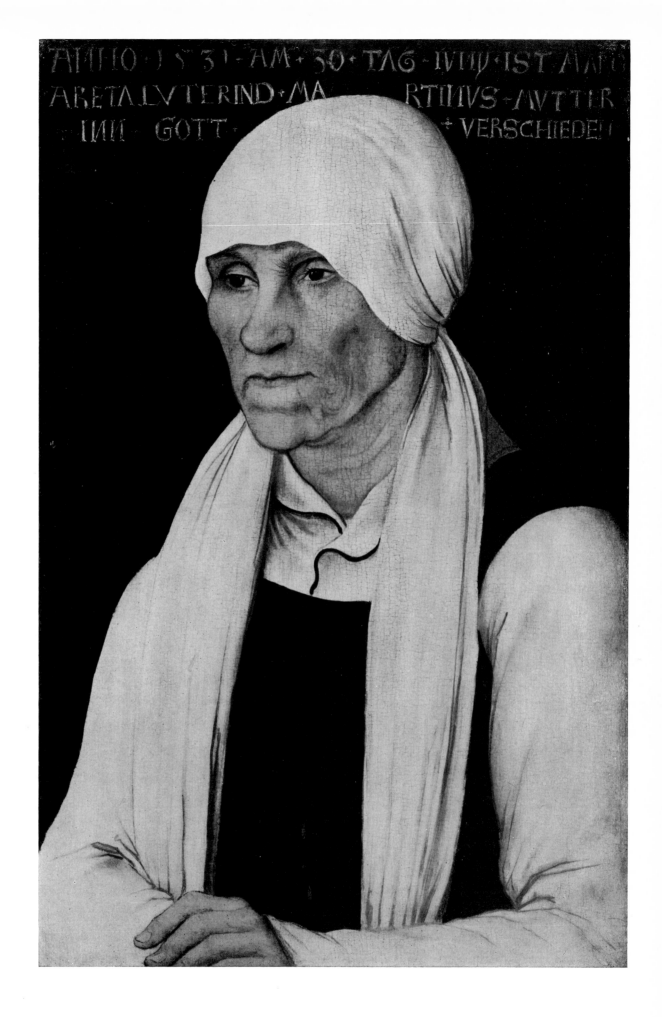

118 Margaretha Luther. 1527. Wartburg

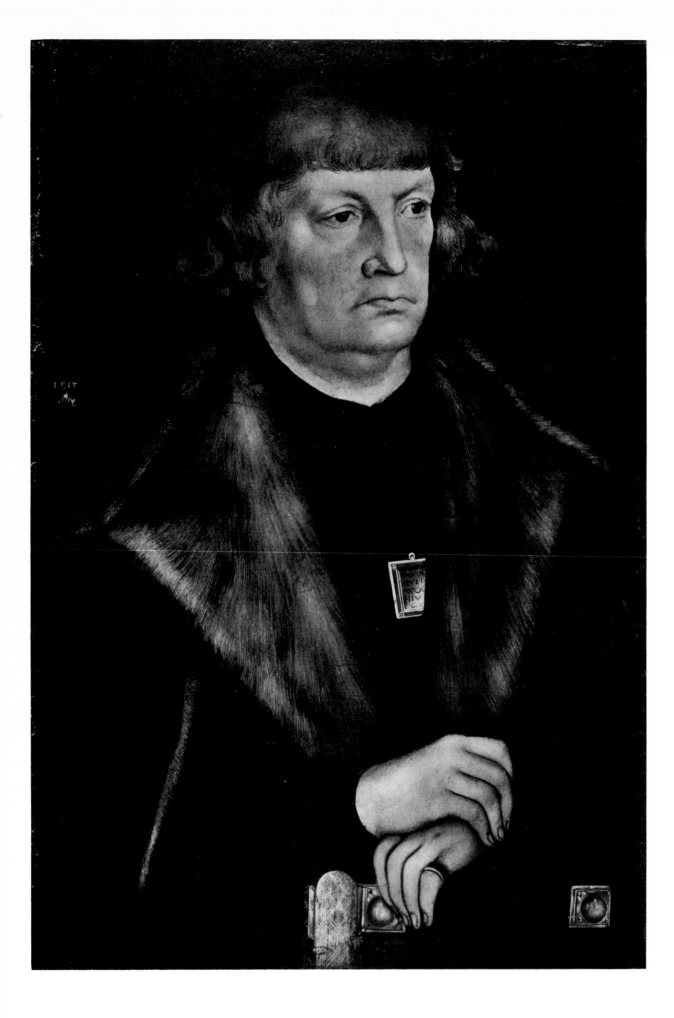

119 A Burgomaster of Weissenfels. 1515. West Berlin 120 Portrait of Asche von Cramm as a horseman. circa 1525. Drawing. Nuremberg

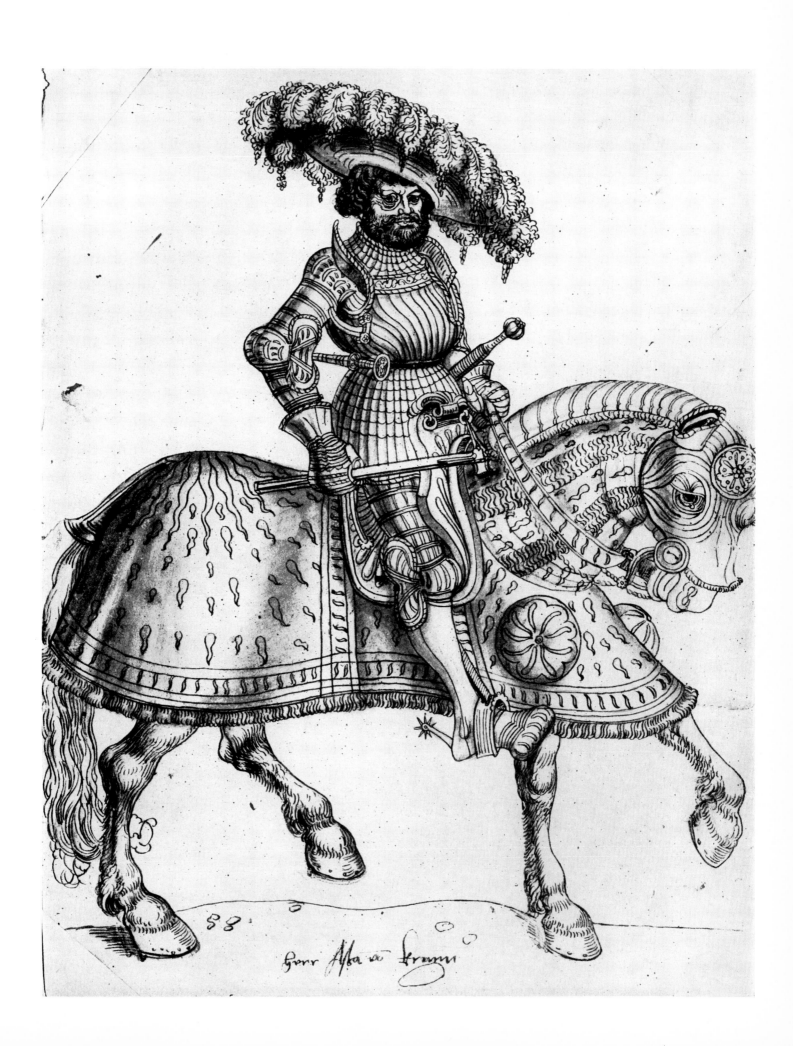

88.

Herr Asa va Krann

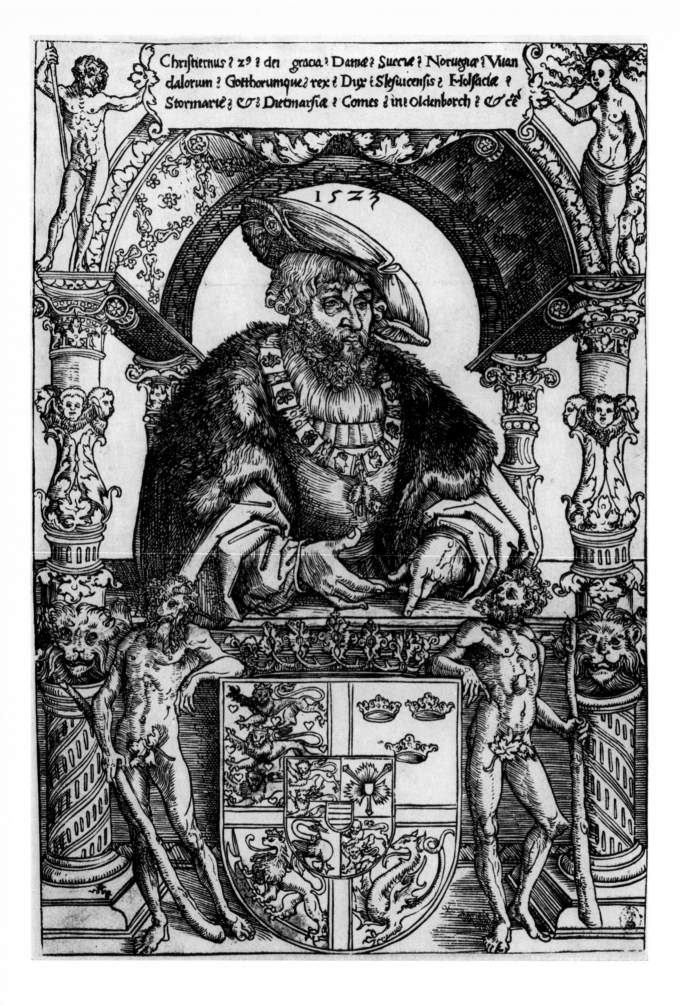

Christiernus ? z⁹ ? dei gracia ? Damæ ? Suecæ ? Noruegiæ ? Vuandalorum ? Gotthorumque ? rex ? Dux ? Slesuicensis ? Holsaciæ ? Stormariæ ? & ? Dietmarsiæ ? Comes ? in ? Oldenborch ? & cē

121 King Christian II of Denmark. 1523. Woodcut. West Berlin

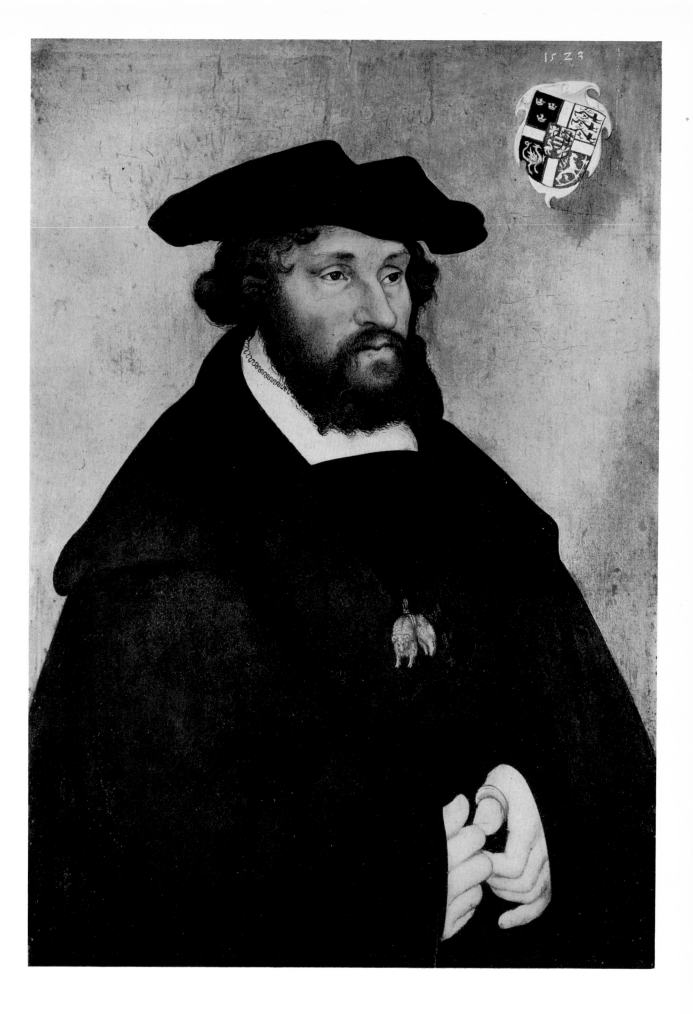

122 King Christian II of Denmark. 1523. Nuremberg

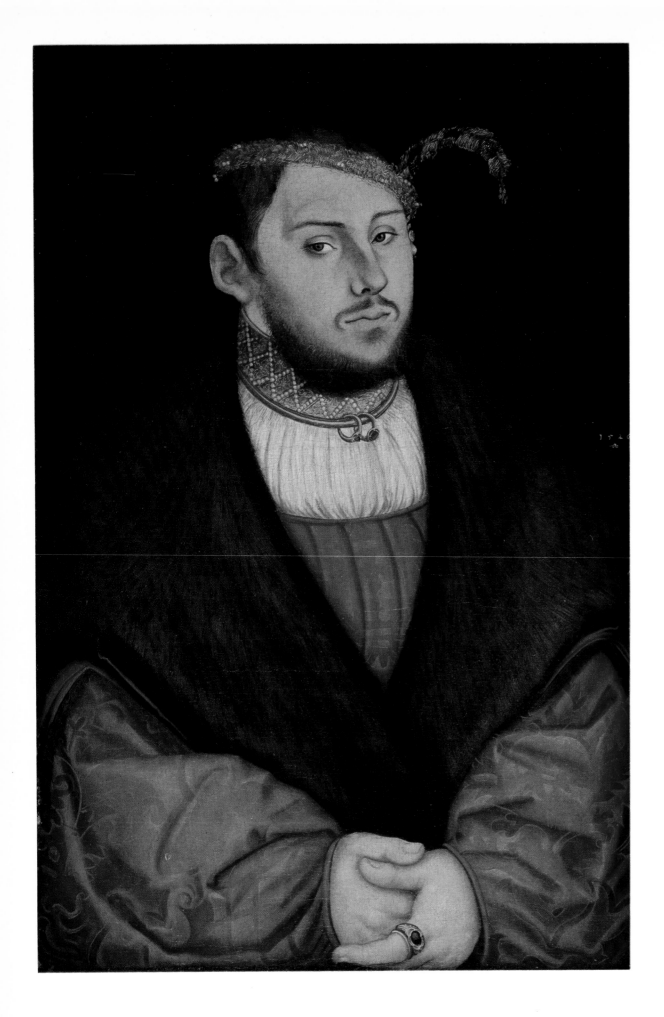

123 John Frederick of Saxony as a Bridegroom. 1526. Weimar

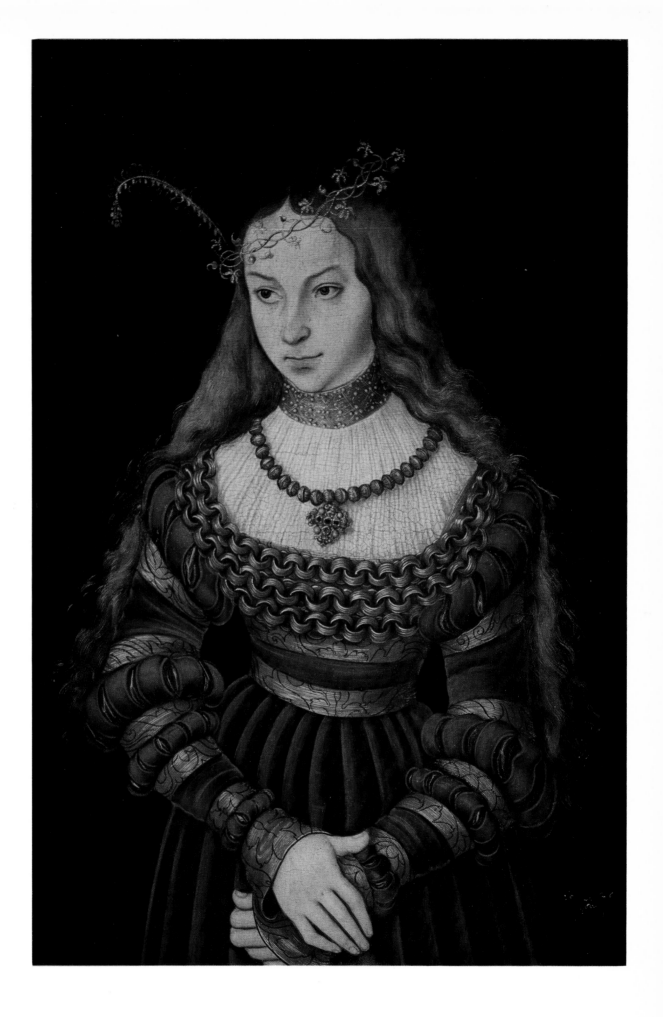

124 Sibylle of Cleve as a Bride. 1526. Weimar

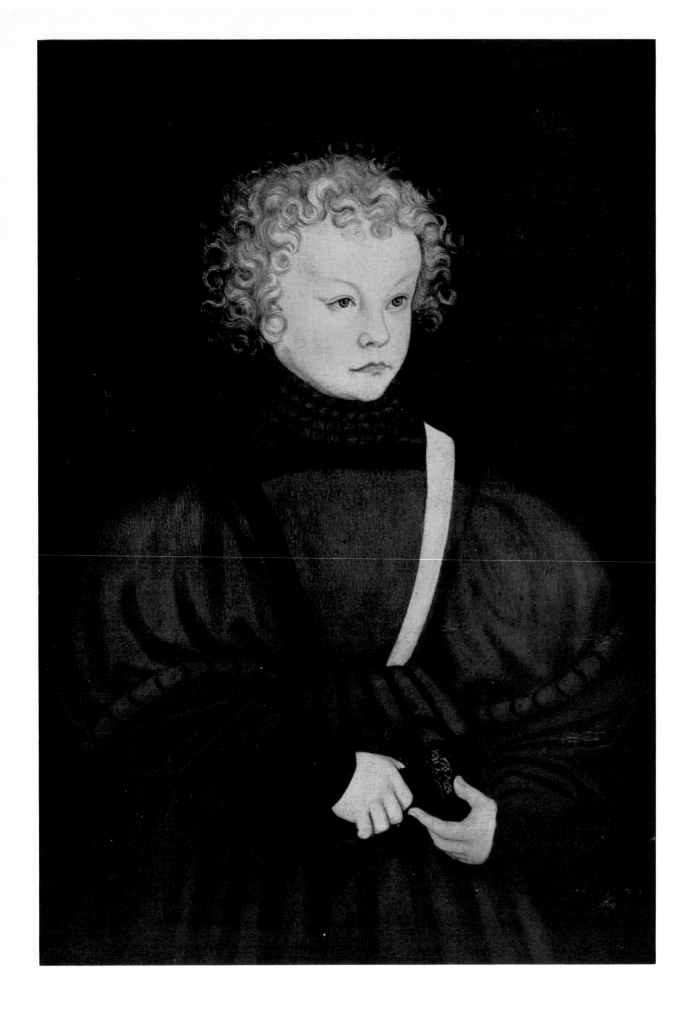

125 Maurice of Saxony as a Child. 1526. Darmstadt

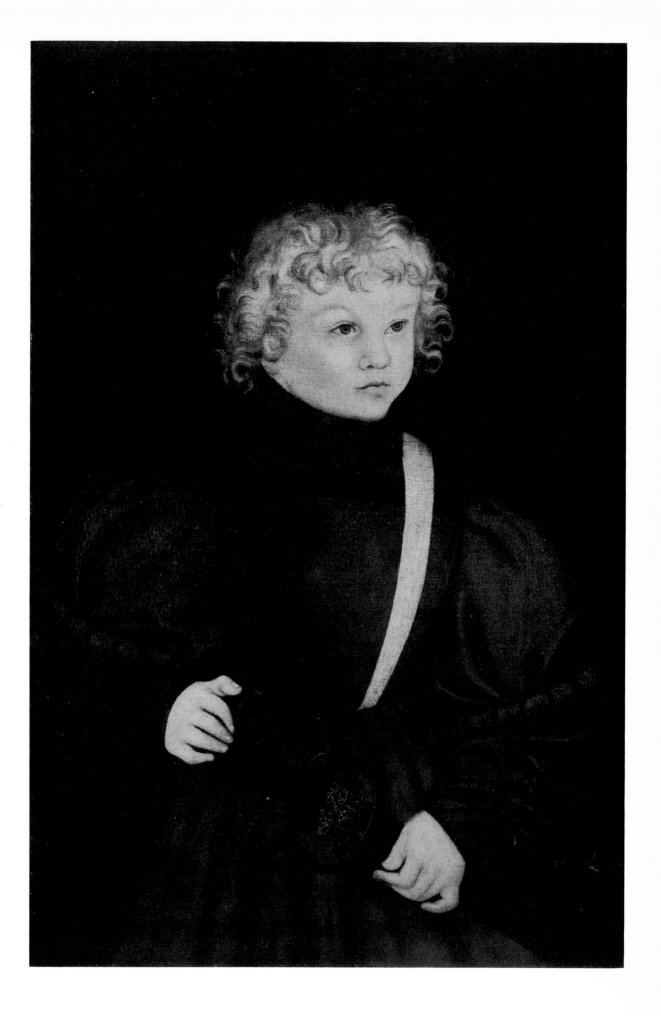

126 Severin of Saxony as a Child. 1526. Darmstadt

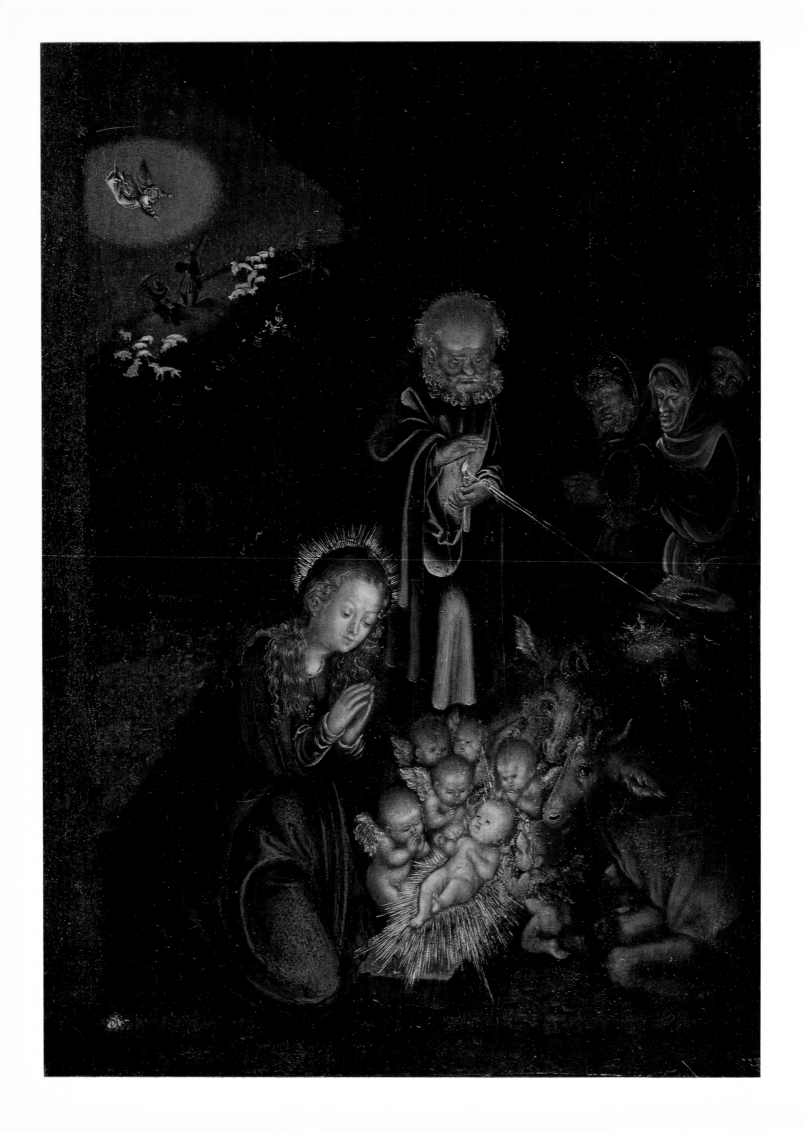

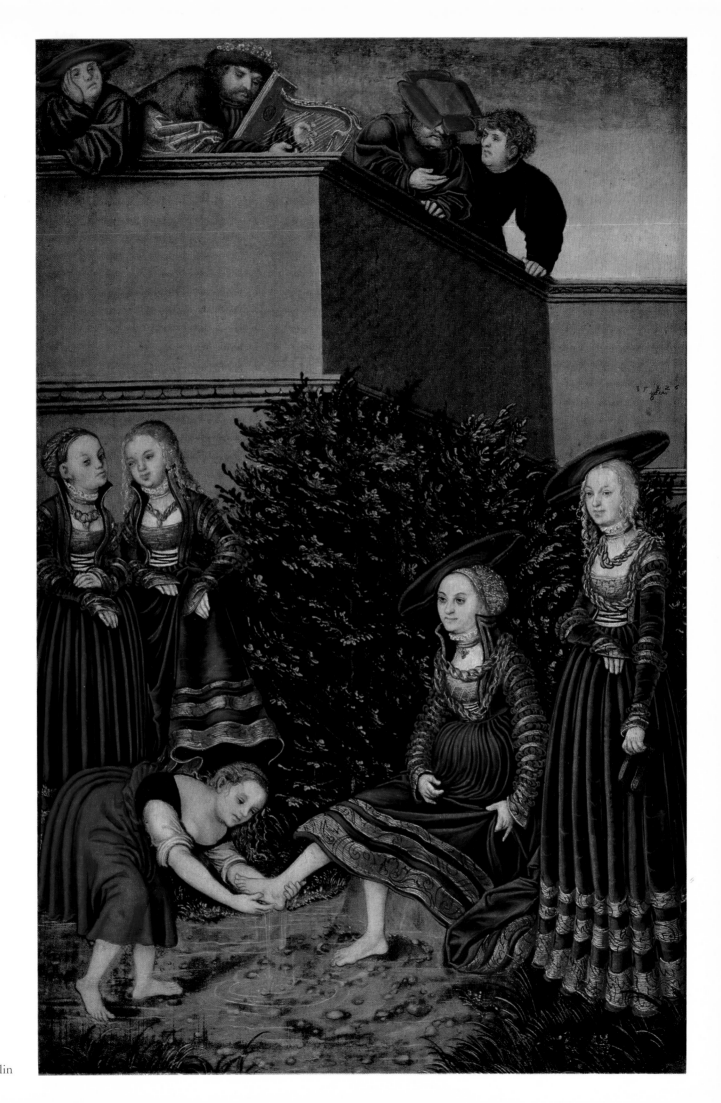

127 The Nativity
of Christ.
circa 1520.
Dresden
128 David and
Bathsheba.
1526. West Berlin

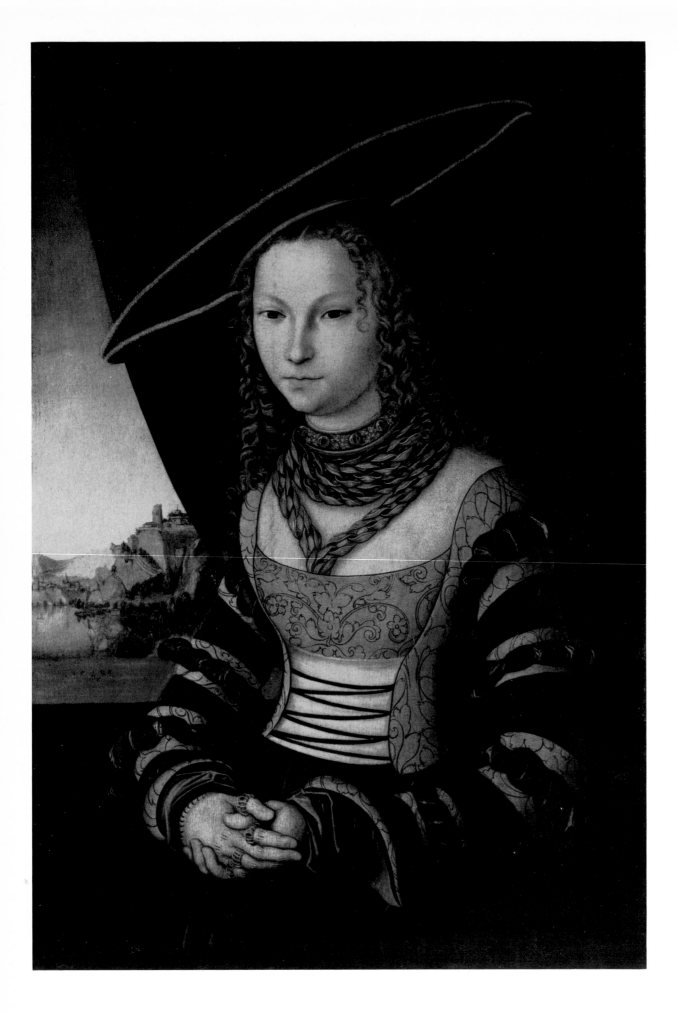

129 Portrait of a Young Lady. 1526. Leningrad

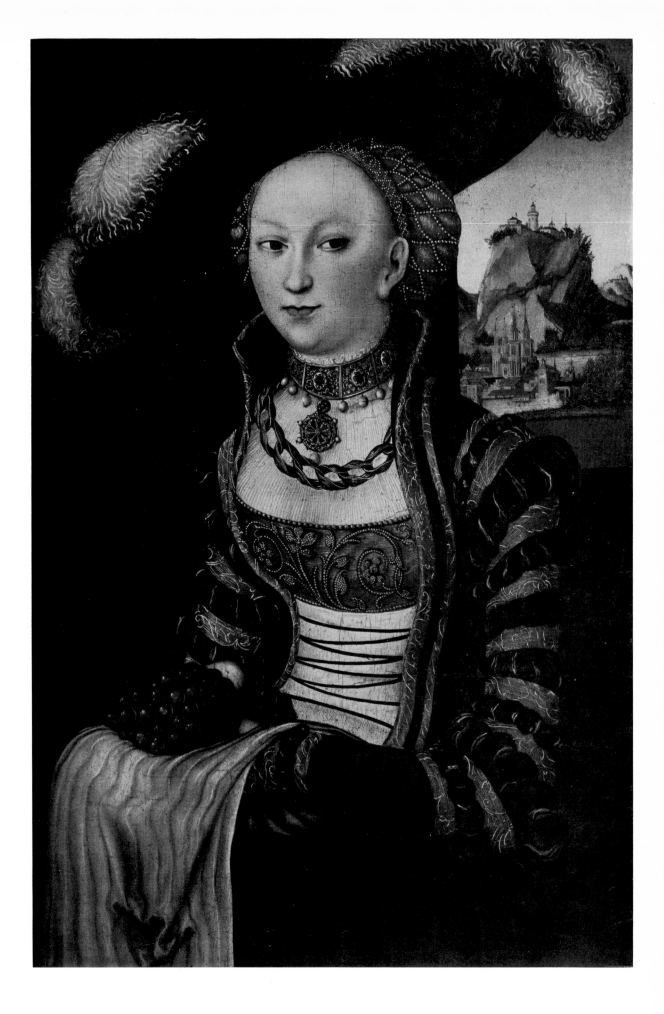

130 Portrait of a Young Lady with a Bunch of Grapes. Private Collection

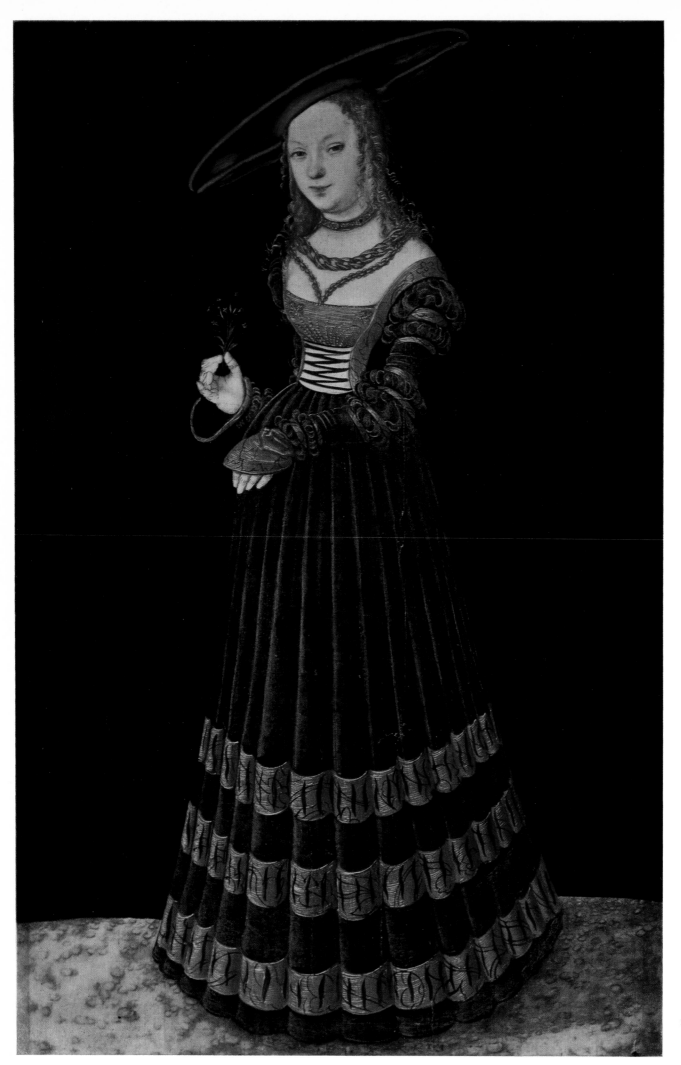

131 Portrait of a Lady
with a Flower. 1526.
Warsaw

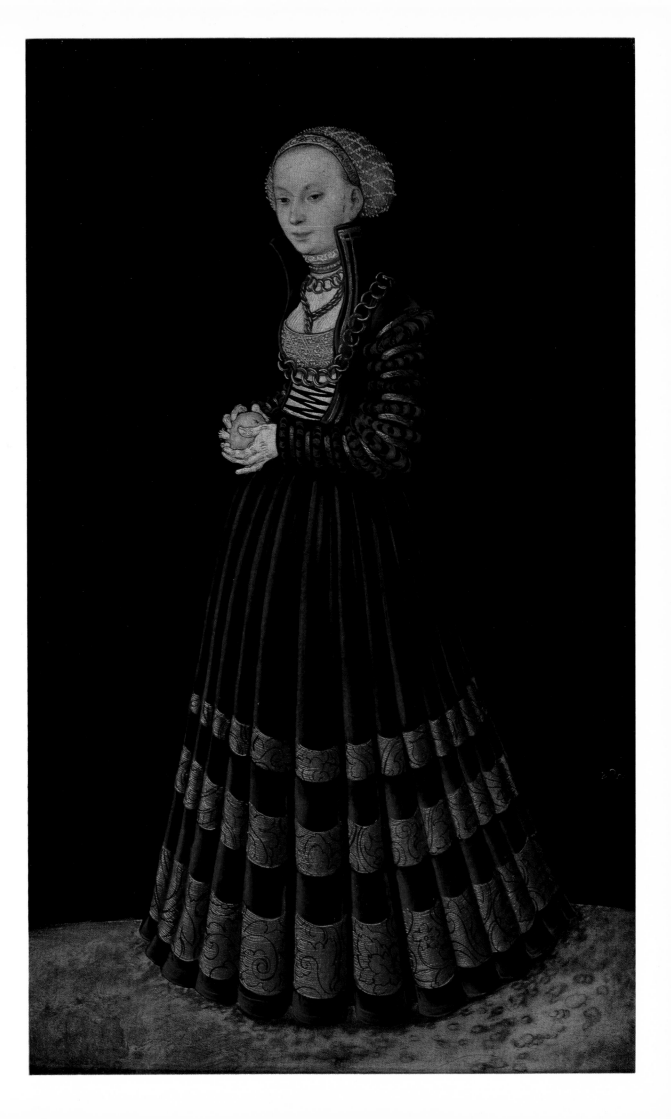

132 Portrait of a Lady
with an Apple. 1526.
Prague

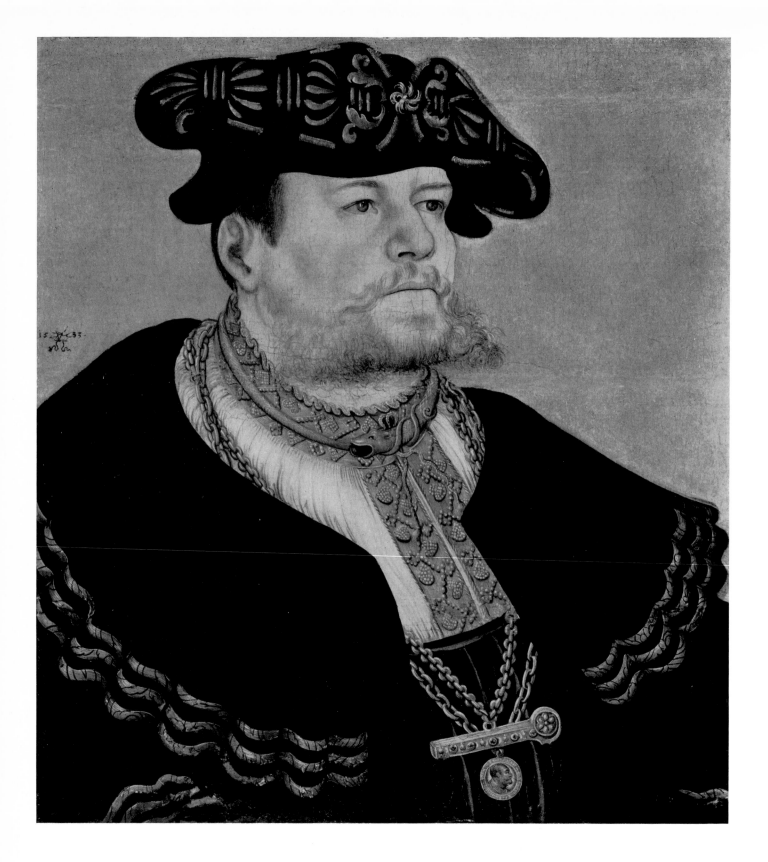

133 Chancellor Gregor Brück. 1533. Nuremberg

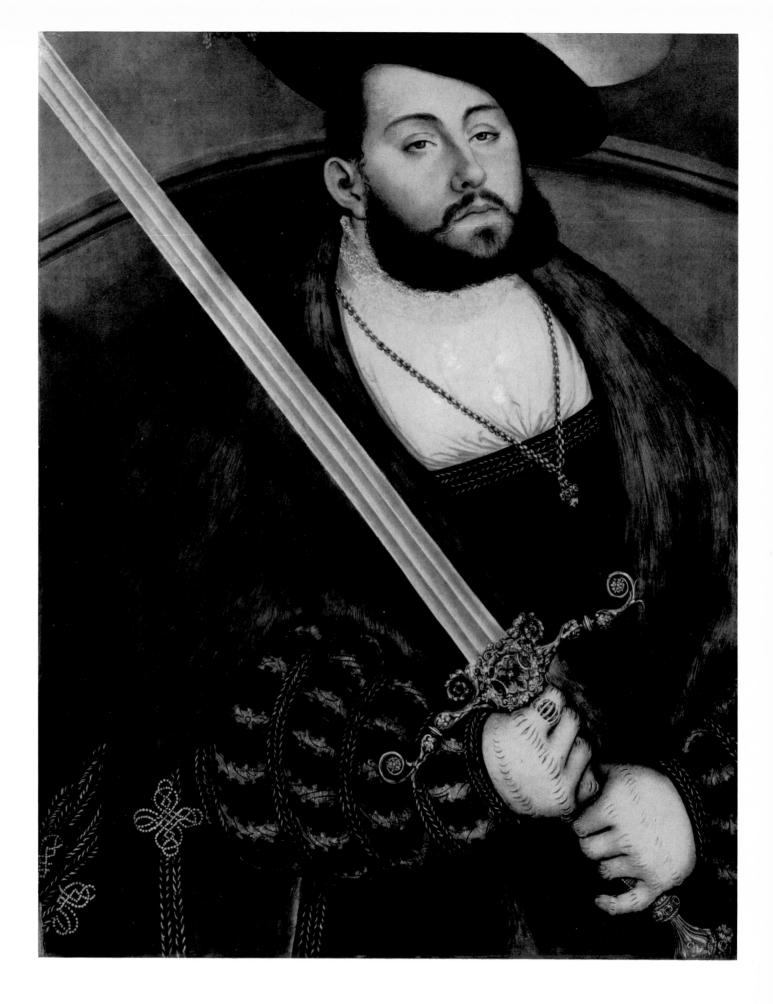

134 Elector John Frederick. *circa* 1532–1535. West Berlin

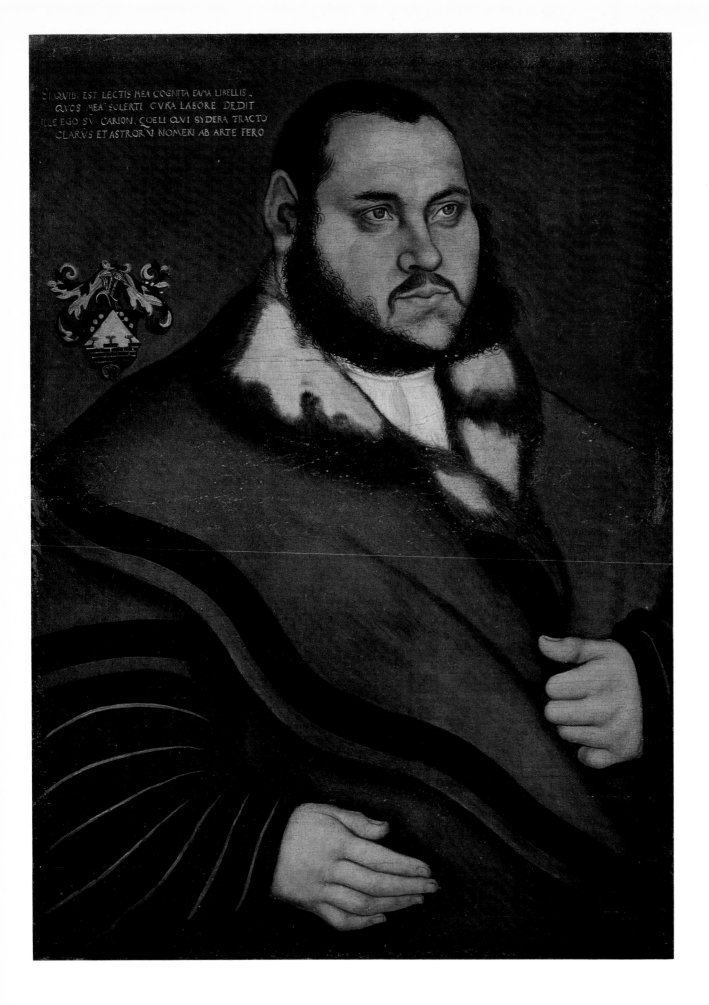

SI QVIB. EST LECTIS MEA COGNITA FAMA LIBELLIS,
QVOS MEA SOLERTI CVRA LABORE DEDIT.
ILLE EGO SV CARION, COELI QVI SYDERA TRACTO
CLARVS ET ASTROR V NOMEN AB ARTE FERO

135 Johannes Carion. circa 1530. East Berlin, Deutsche Staatsbibliothek

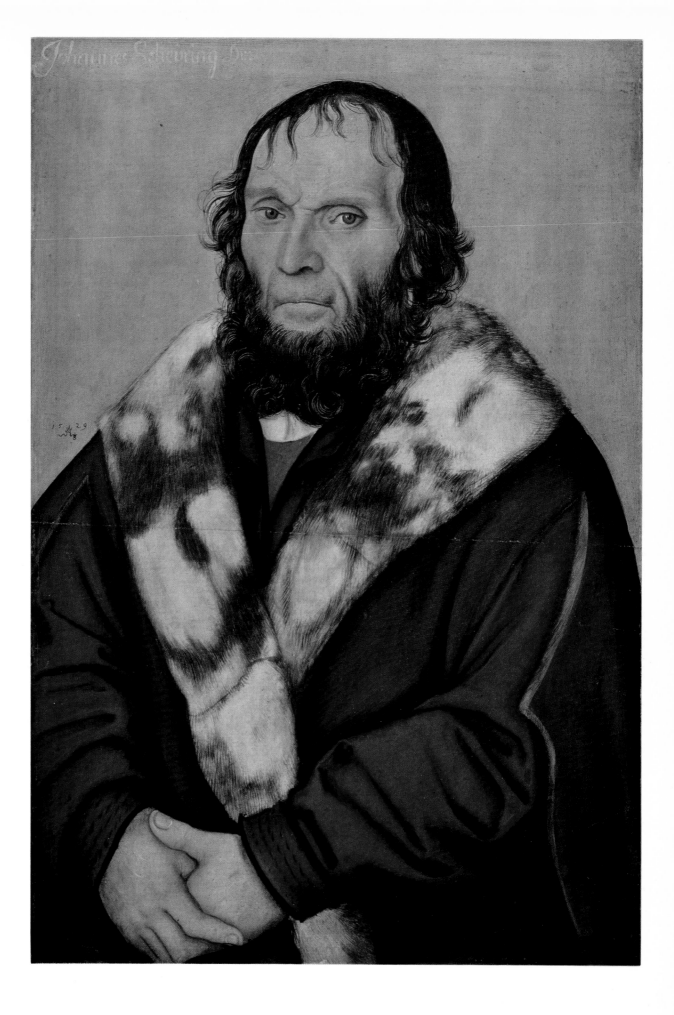

136 Dr. Johannes Scheyring (Ziring). 1529. Brussels

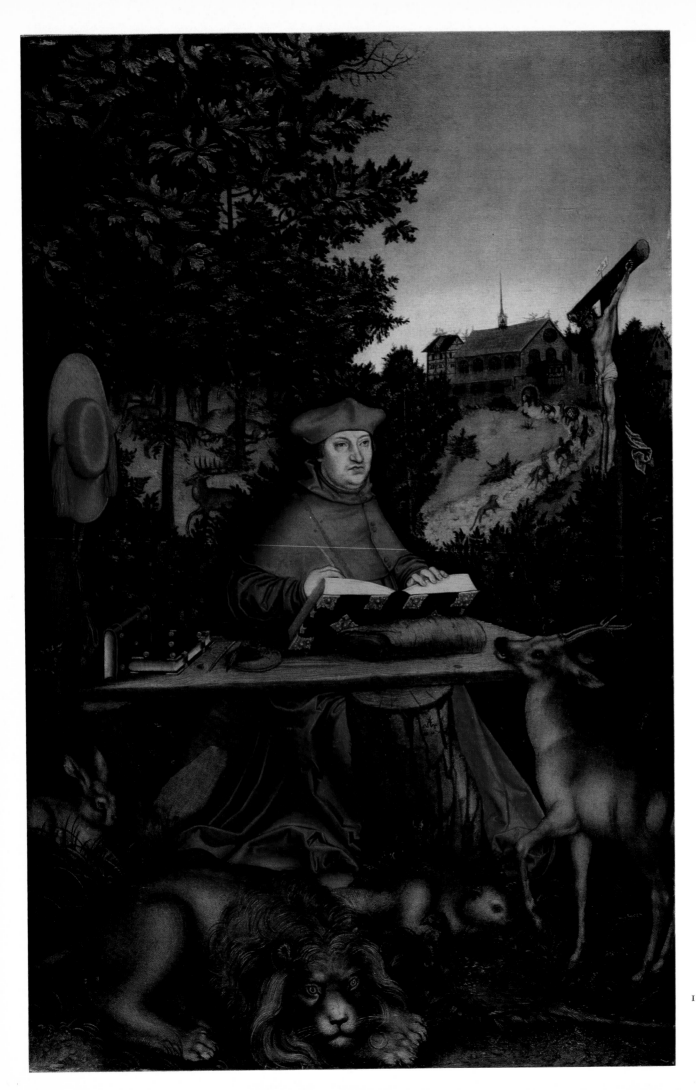

142 Cardinal Albrecht
of Brandenburg
as St. Jerome in the
Wilderness. 1527.
West Berlin

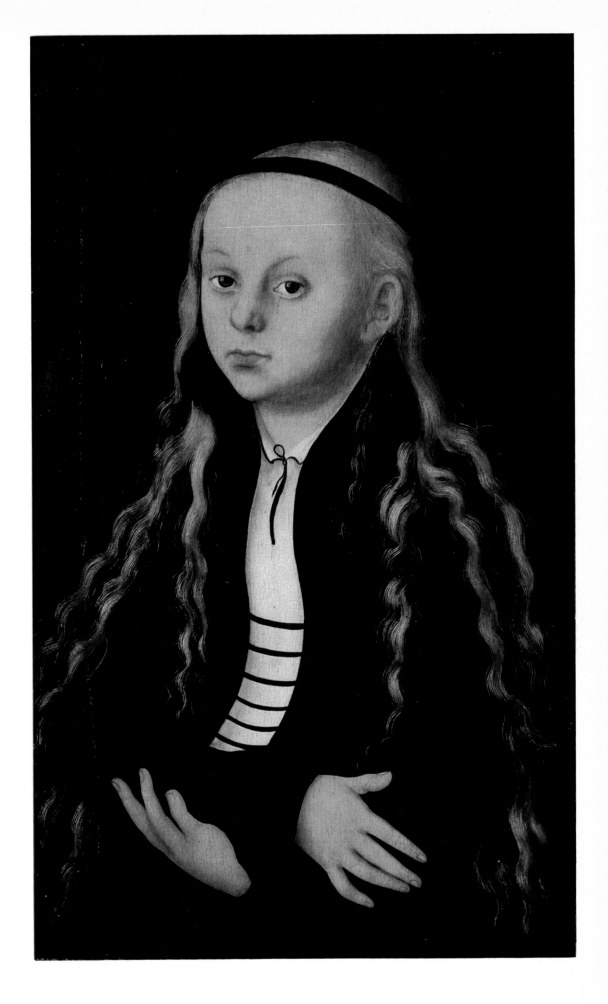

143 Portrait of a Girl. circa 1520. Paris

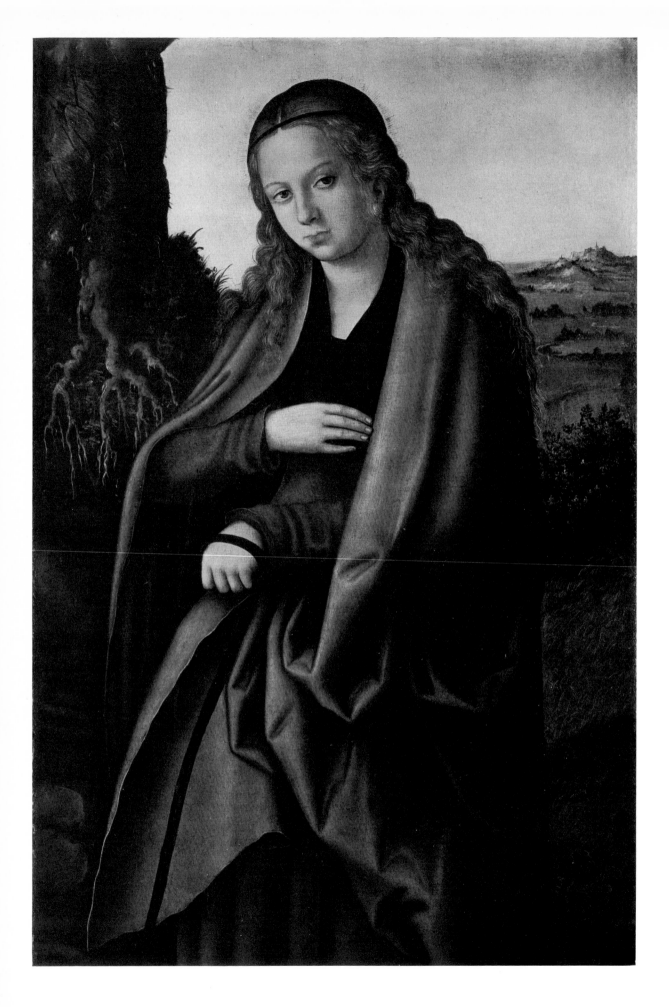

144 St. Margaret. circa 1513–1514. Minneapolis

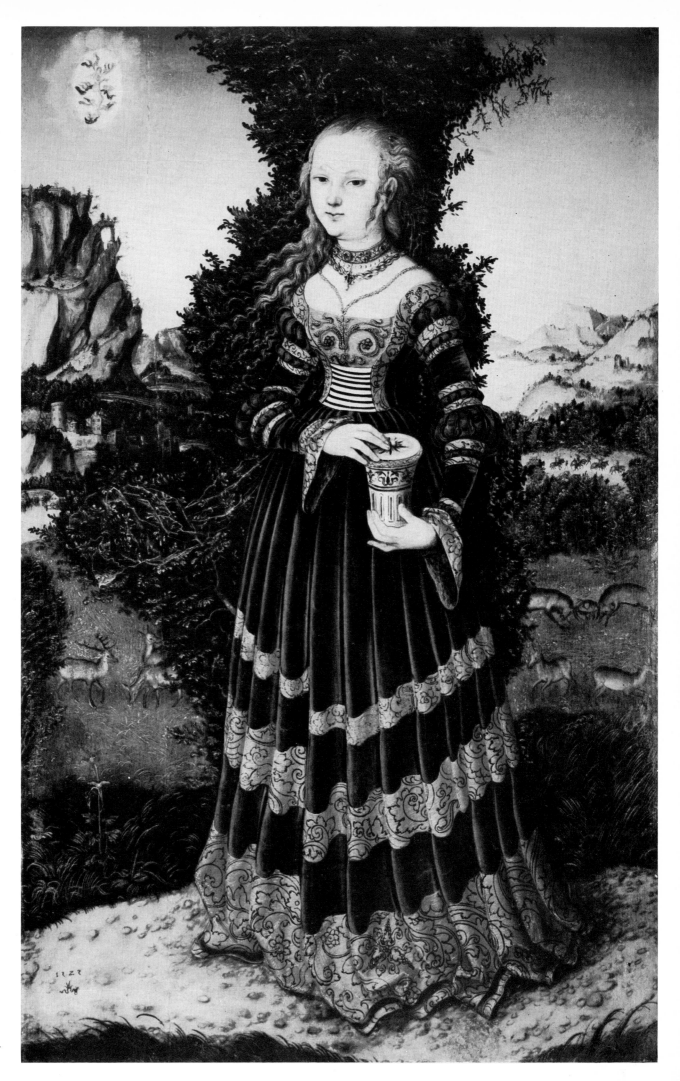

145 St. Mary Magdalene.
1525. Cologne

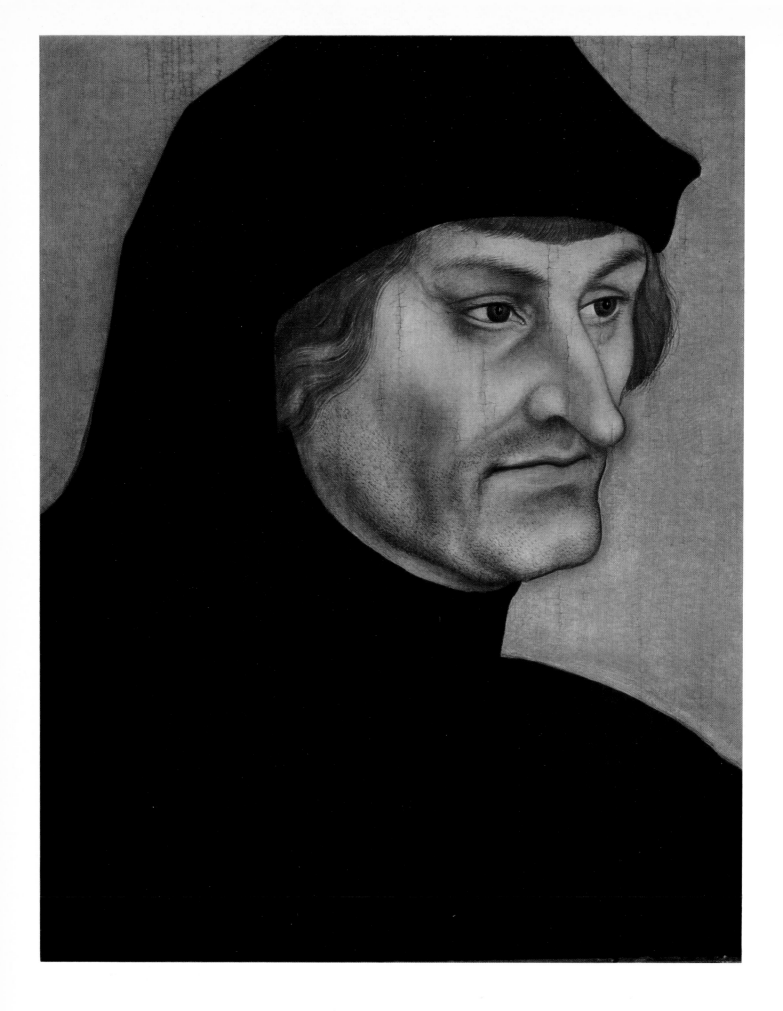

146 Rudolph Agricola. circa 1532. Munich

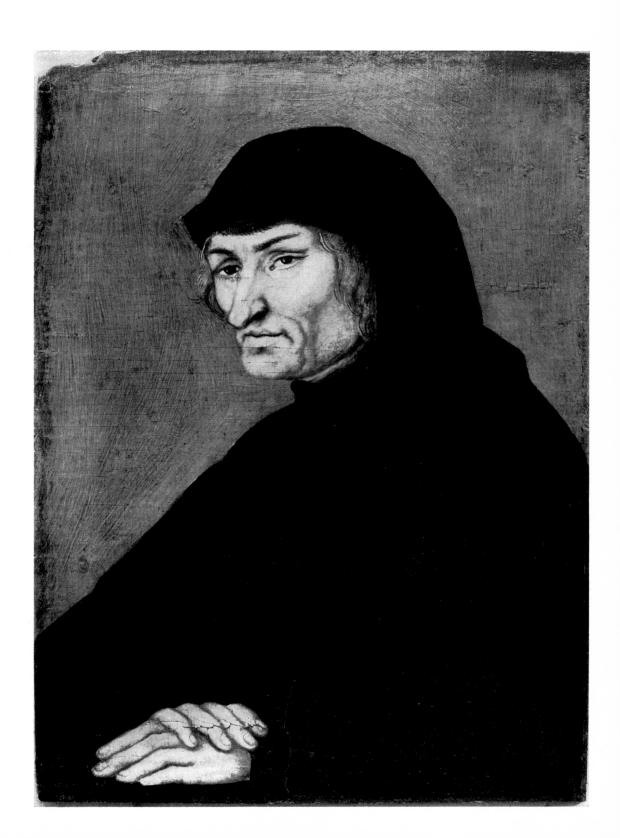

147 Rudolph Agricola. circa 1532.
Starnberg, private collection

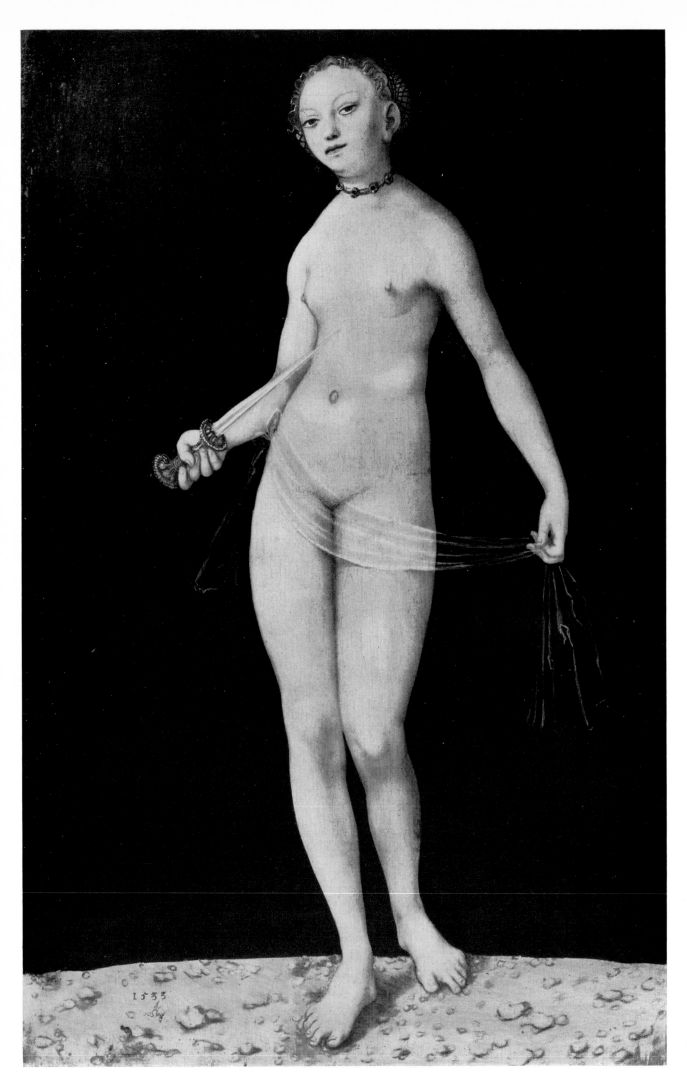

148 Lucretia. 1533.
West Berlin

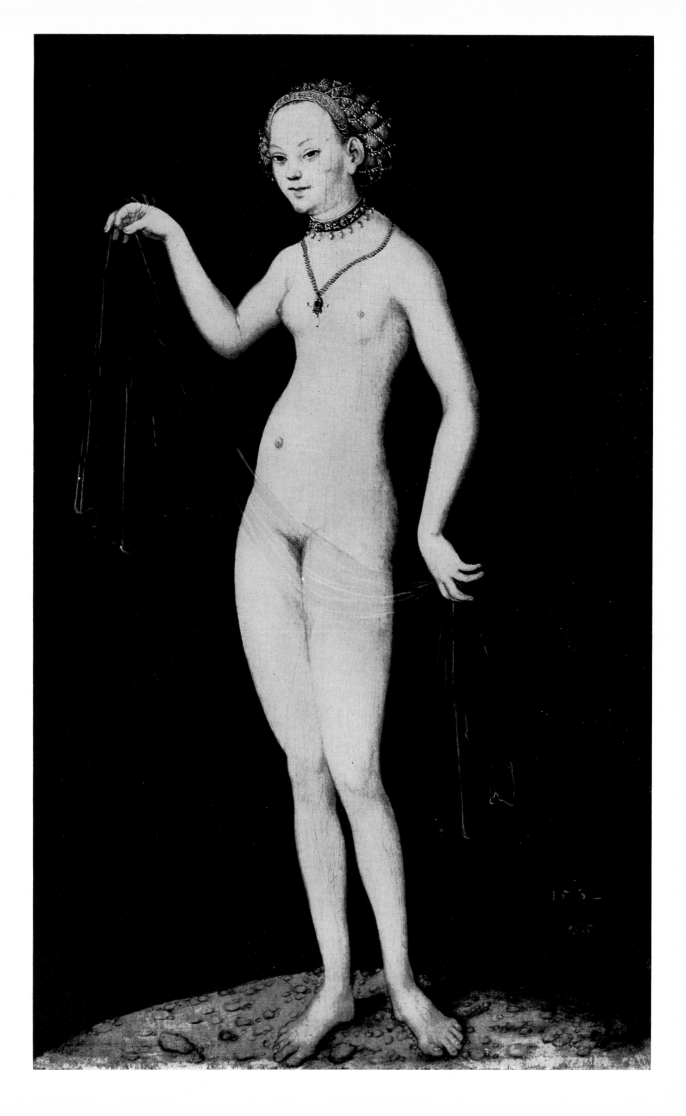

149 Venus. 1532.
Frankfurt-am-Main

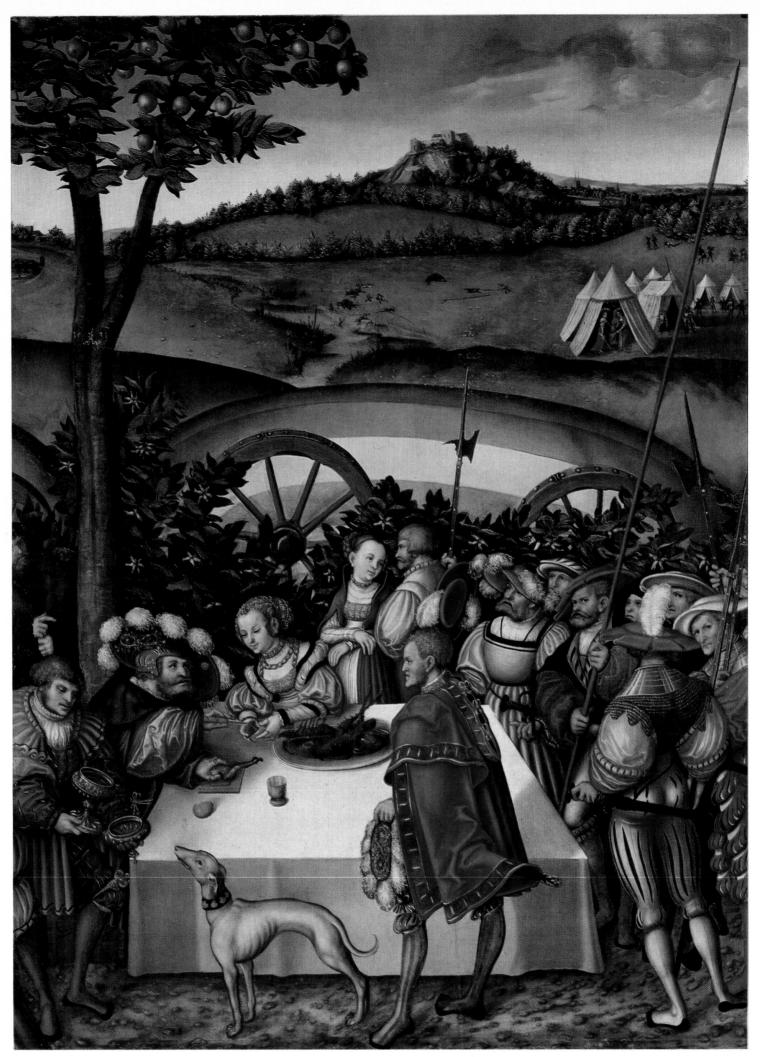

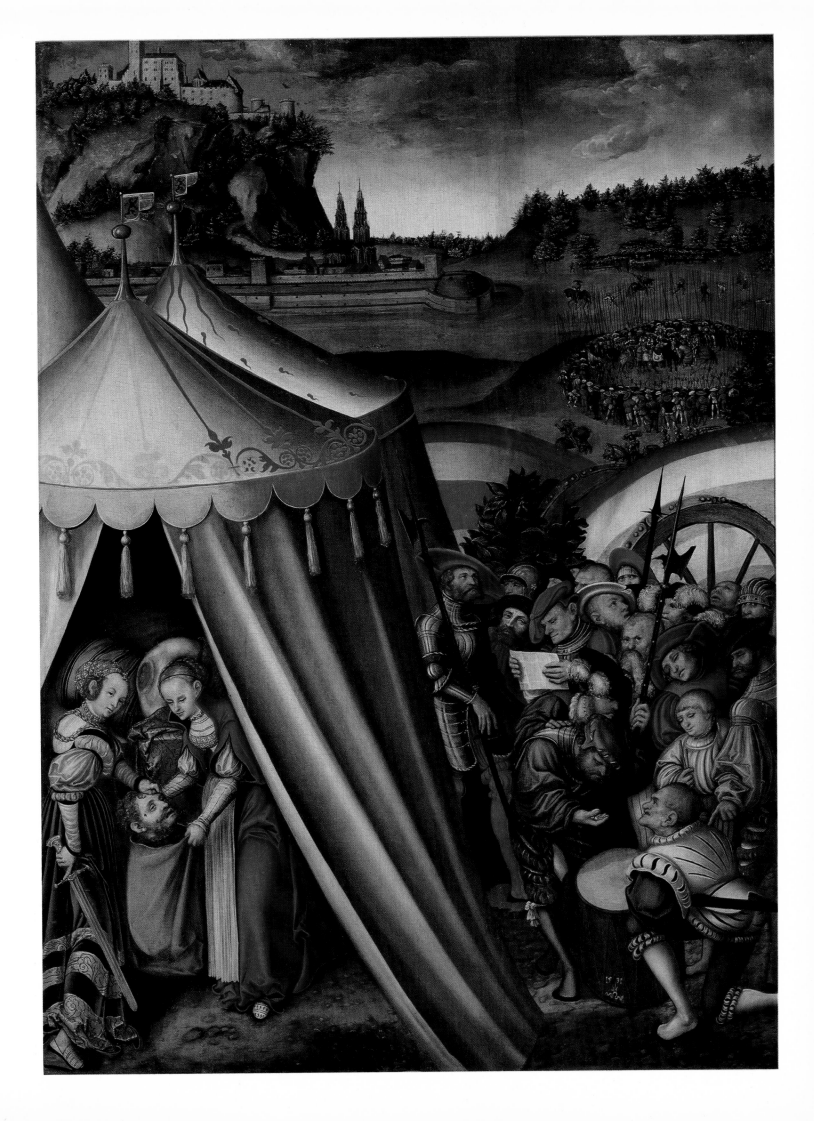

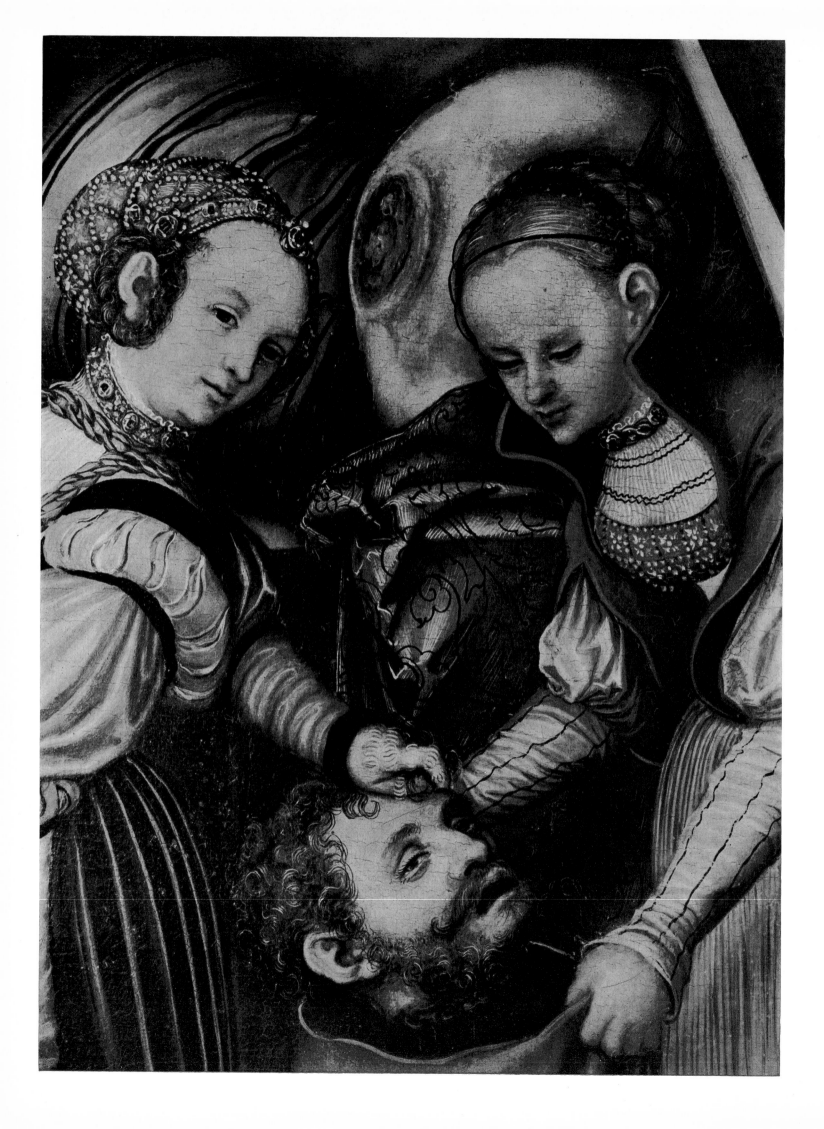

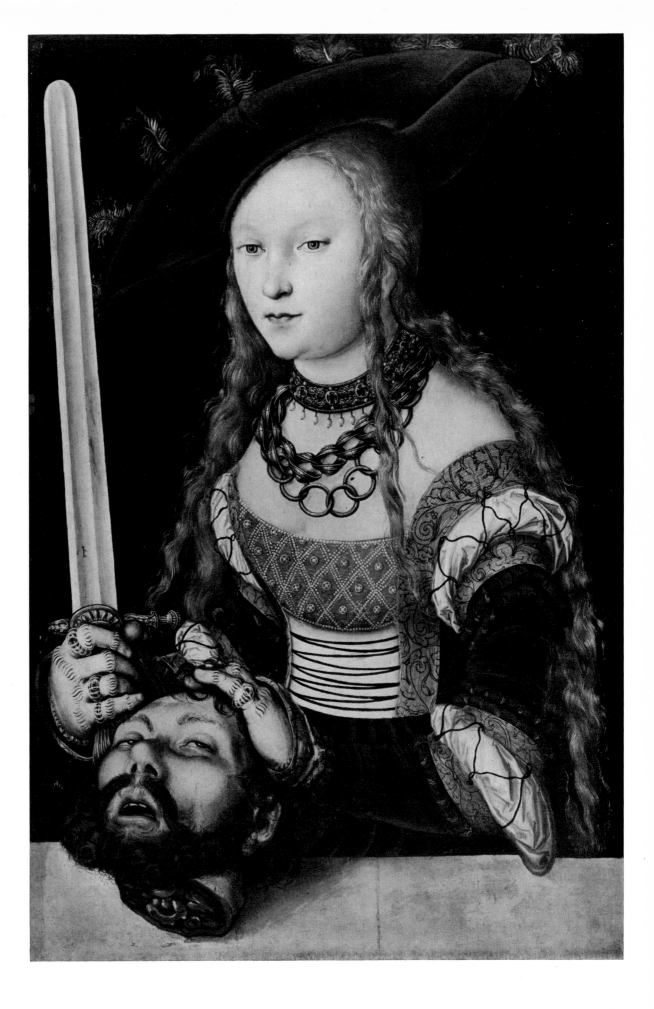

152 Detail of Plate 151

Preceding Pages:
150 Judith at the Table of Holofernes. 1531. Gotha
151 The Death of Holofernes. 1531. Gotha

153 Judith with the Head of Holofernes. circa 1530. Vienna

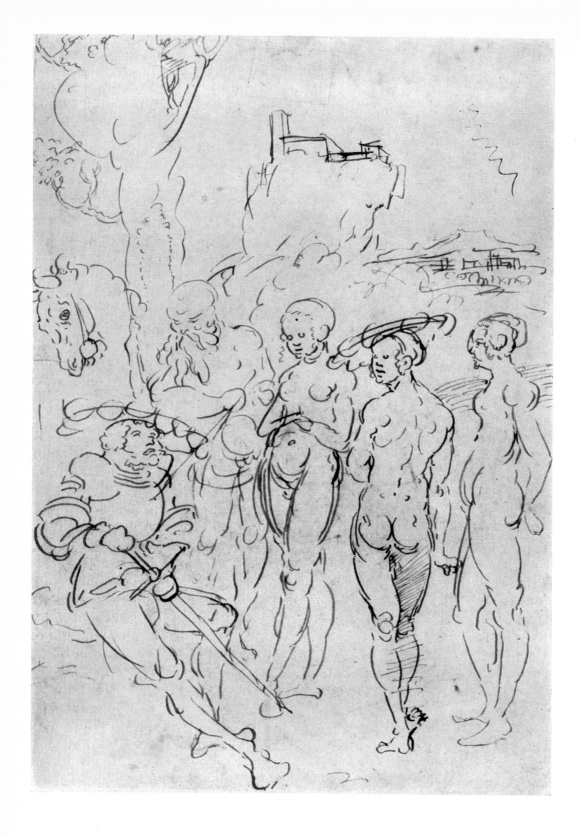

154 The Judgment of Paris. circa 1530. Drawing. On the back, Plate 141. Brunswick

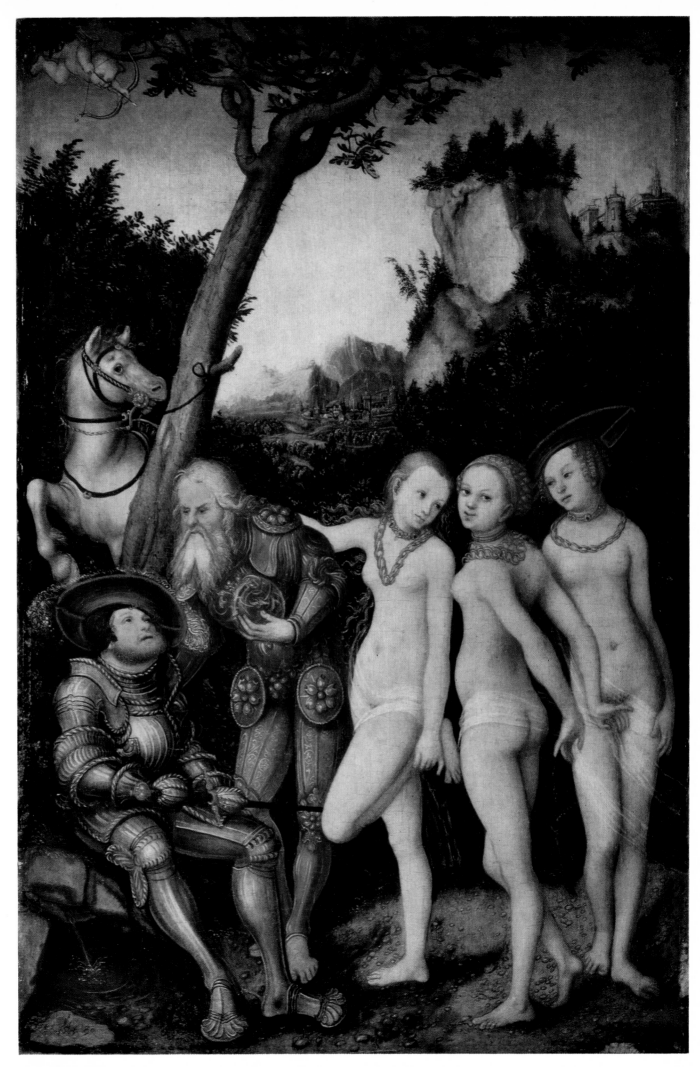

155 The Judgment
of Paris. 1530.
Karlsruhe

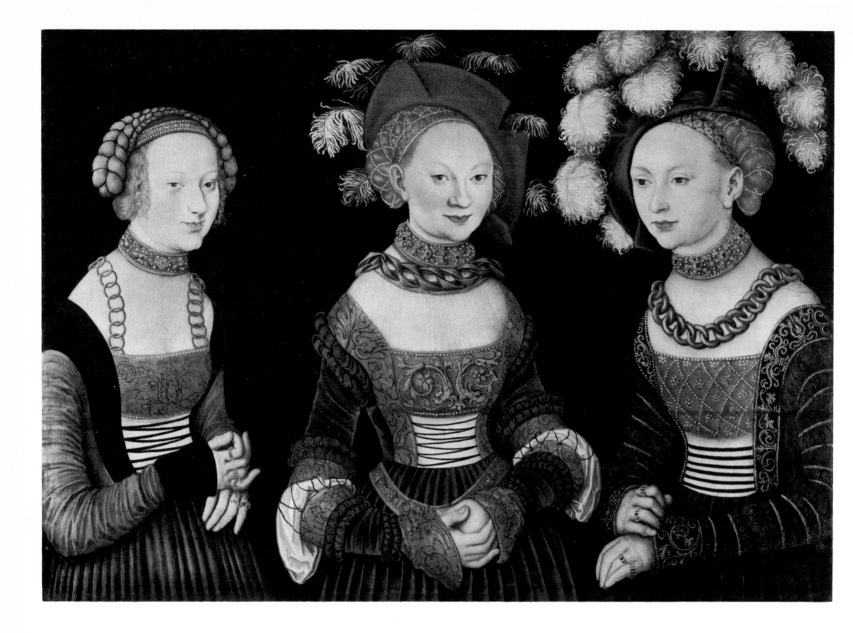

156 The Duchesses Sibylle, Emilia and Sidonia of Saxony. circa 1535. Vienna

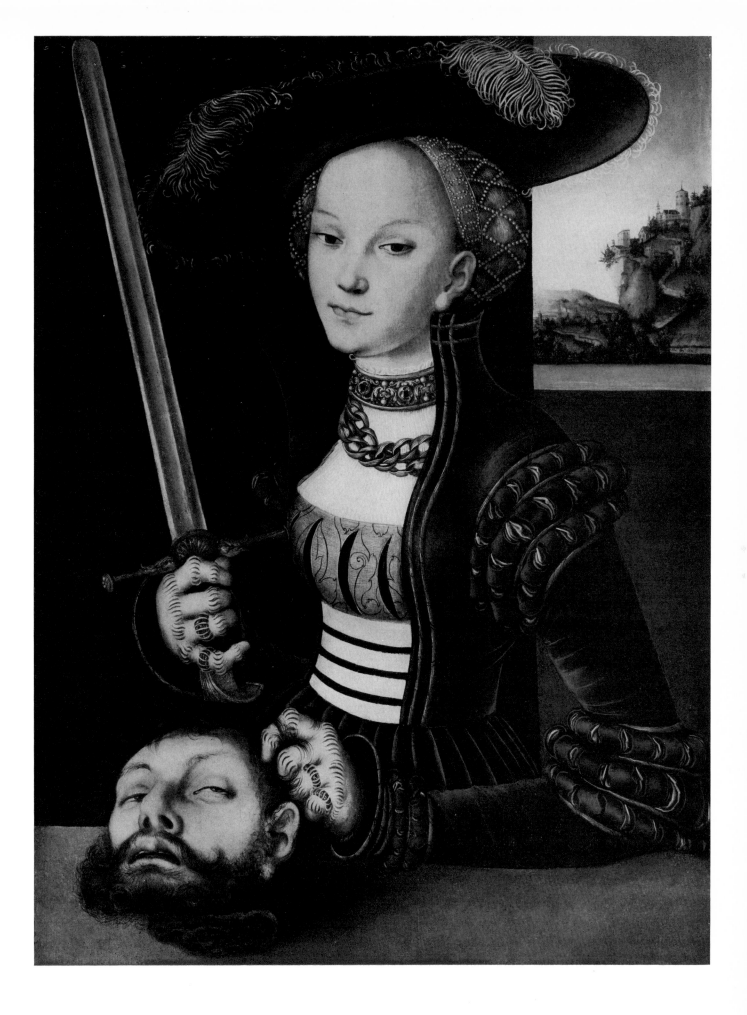

157 Judith with the Head of Holofernes. 1530. West Berlin

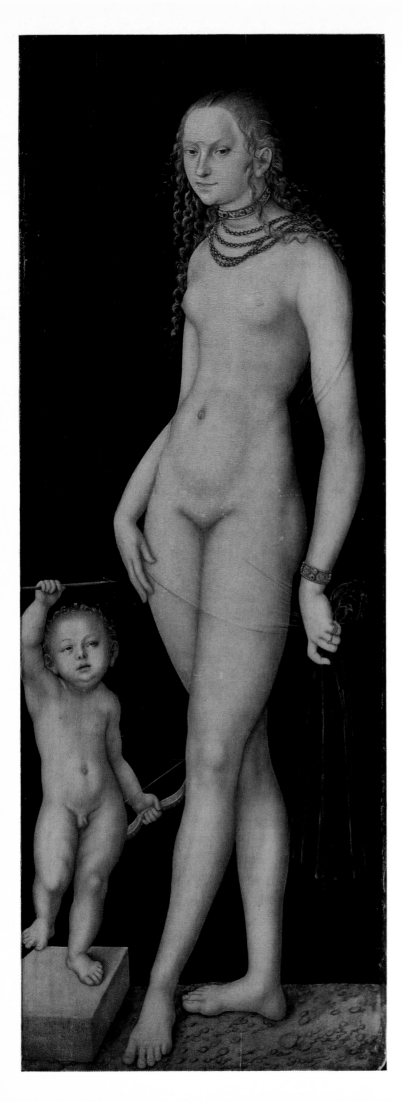

158 Venus and Cupid. circa 1530. West Berlin 159 Detail of Plate 160

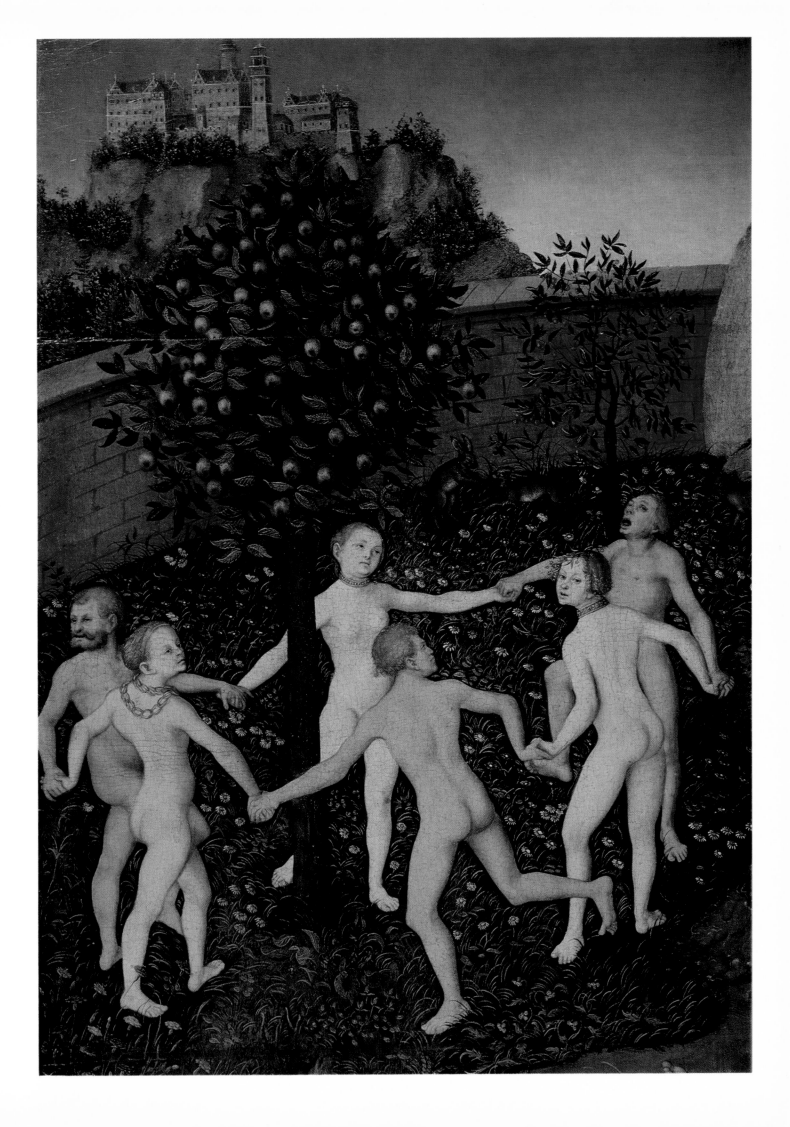

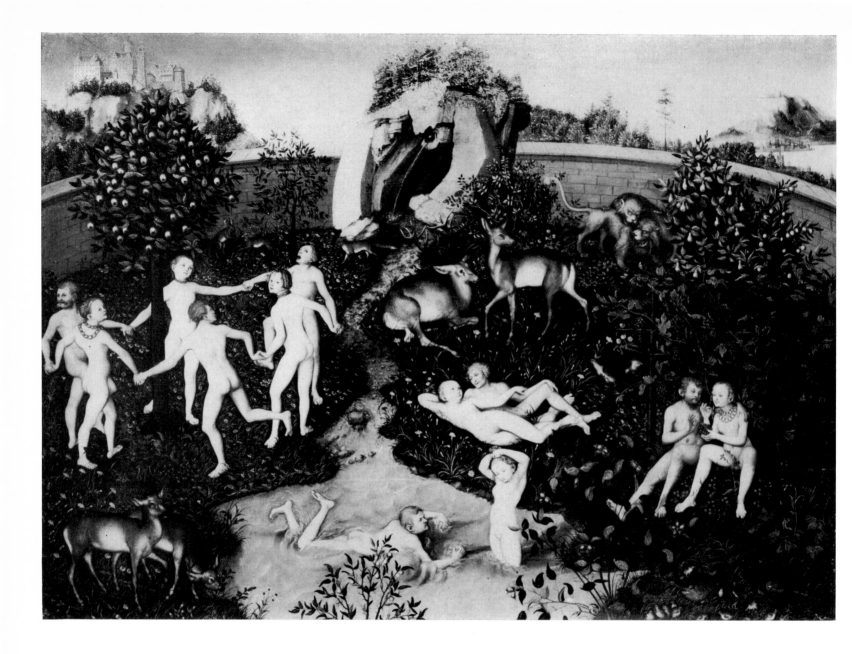

160 The Golden Age. circa 1530. Oslo

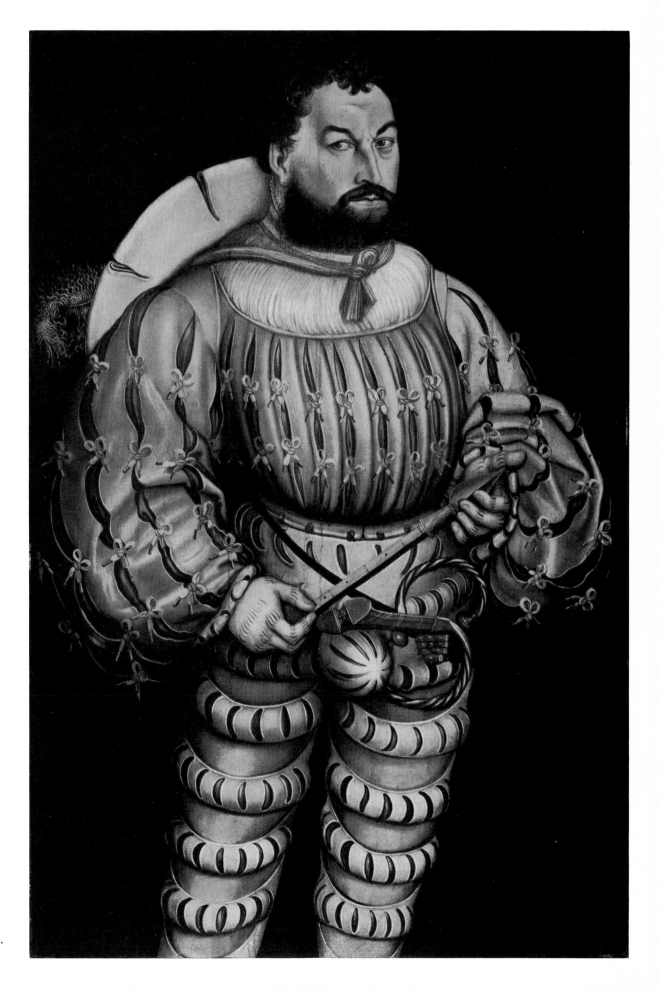

161 Portrait of a Gentleman
with an Arrow. circa 1530.
Dresden

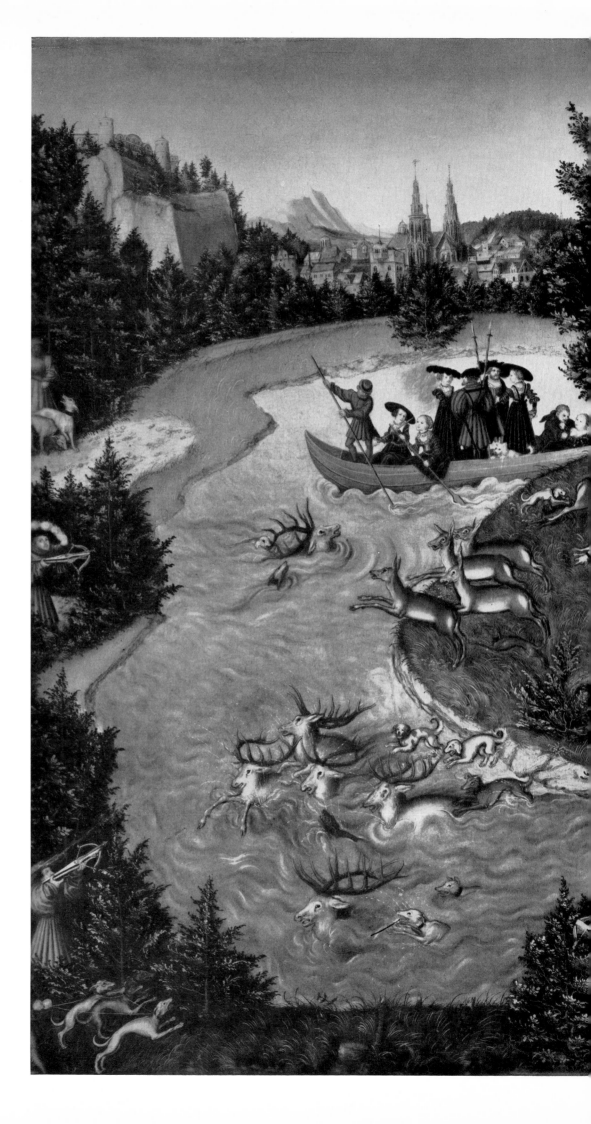

162 A Stag Hunt. 1529. Vienna

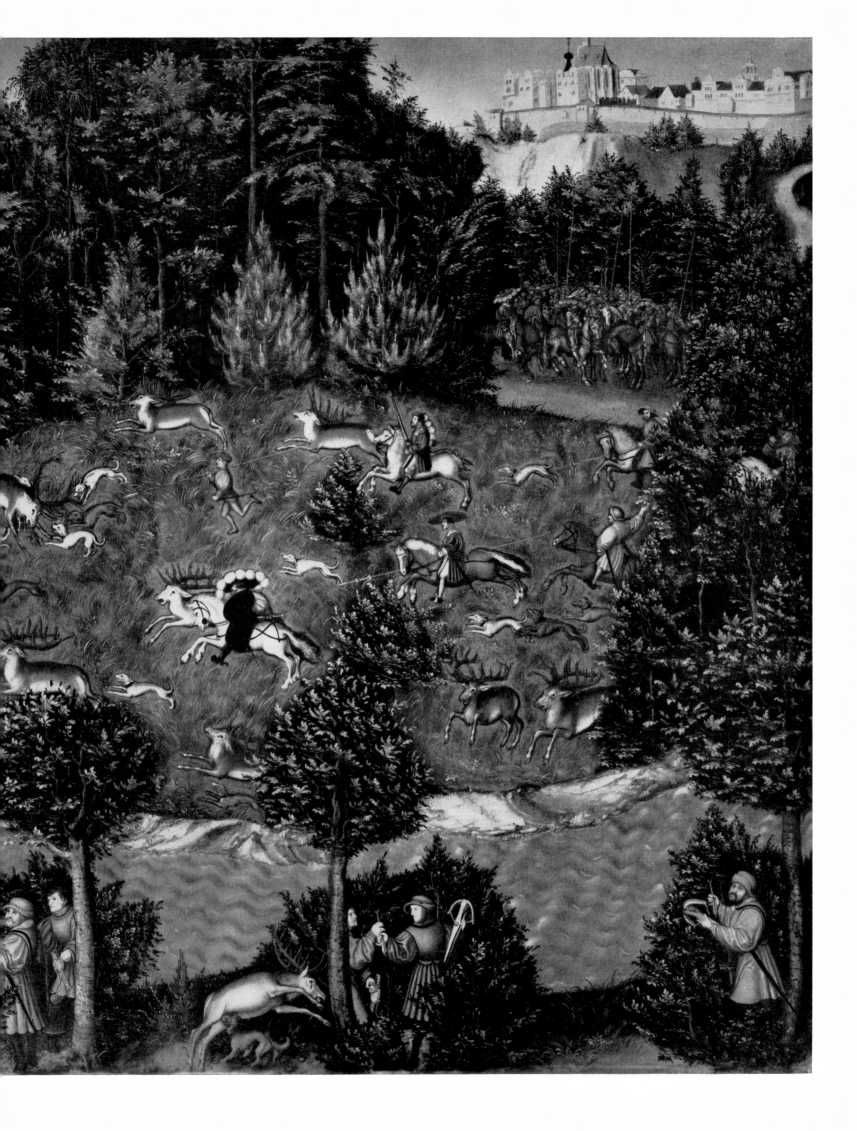

163–166

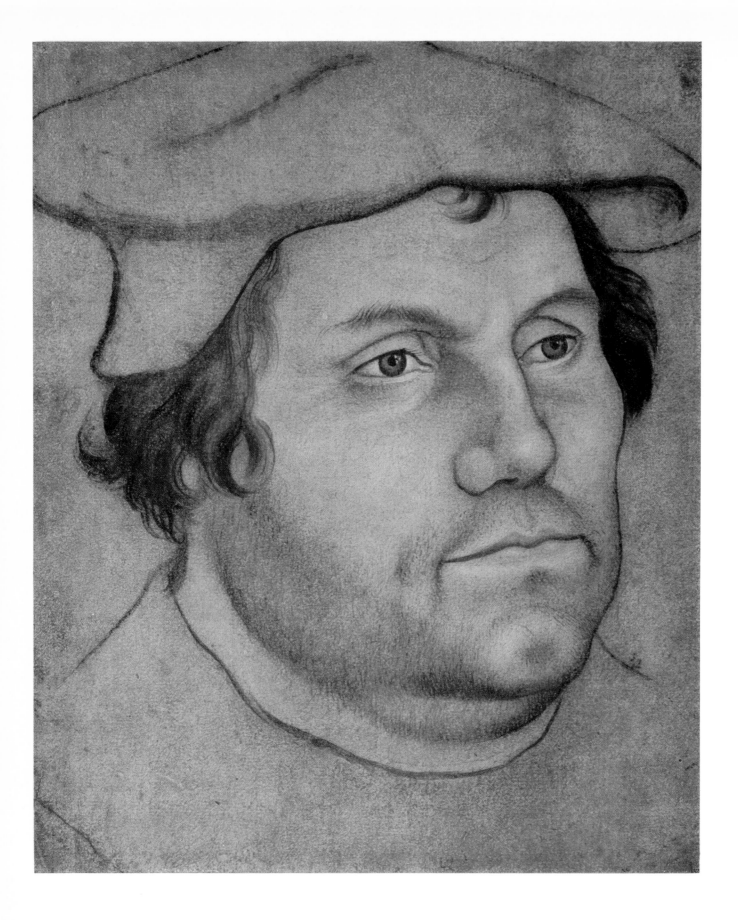

167 Martin Luther. circa 1532. Drawing. Private collection

Preceding pages:
163 A Hooded Crow. circa 1530. Drawing. Dresden
164 A Wild Boar. circa 1530. Drawing. Dresden
165 Wild Boar Brought to Bay by Hounds. circa 1530–1540.
 Drawing. West Berlin
166 Spotted Wild Boar. circa 1530. Drawing. Dresden

168 St. Eustace. circa 1530. Drawing. Boston

169 Two Waxwings. circa 1530. Drawing. Dresden

170 Four Partridges. circa 1532. Drawing. Dresden

171 Detail
of Plate 173:
Still Life with
Cheese, Grapes
and Pomegranate

172 Detail
of Plate 173:
Still Life with Fly

173 The Payment. 1532. Stockholm

174 Hercules with Omphale. circa 1537. Drawing. West Berlin

Within the painting:

HERCVLIS MANIBVS DANT LYDÆ PENSA PVELL
IMPERIVM DOMINAE FERT DEVS ILLE SVA
SIC CAPIT INGENTES ANIMOS DAMNOSA VOLVP
FORTIAQVE ENERVAT PECTORA MOLLIS AMOR

175 Hercules with Omphale. circa 1537. Gotha

Following Pages:
176 Hercules with Omphale. 1532. Berlin, war casualty
177 Hercules with Omphale. 1532. Munich
178 Hercules with Omphale. 1537. Brunswick
179 *Hans Cranach:* Hercules with Omphale. 1537. Lugano

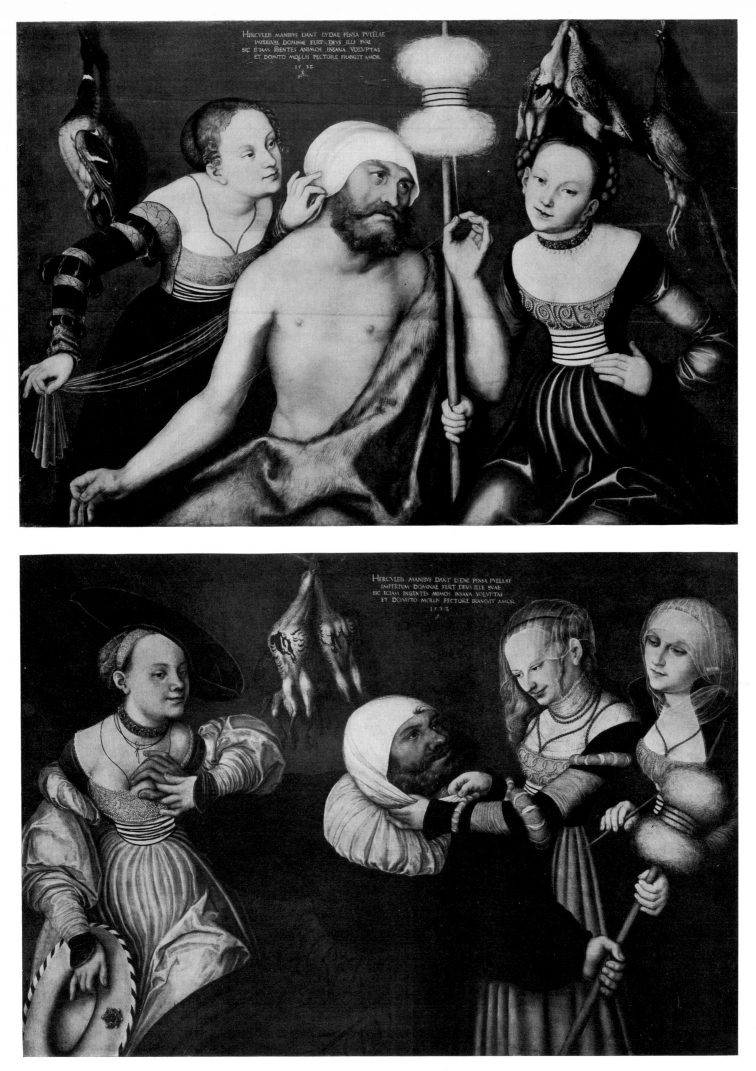

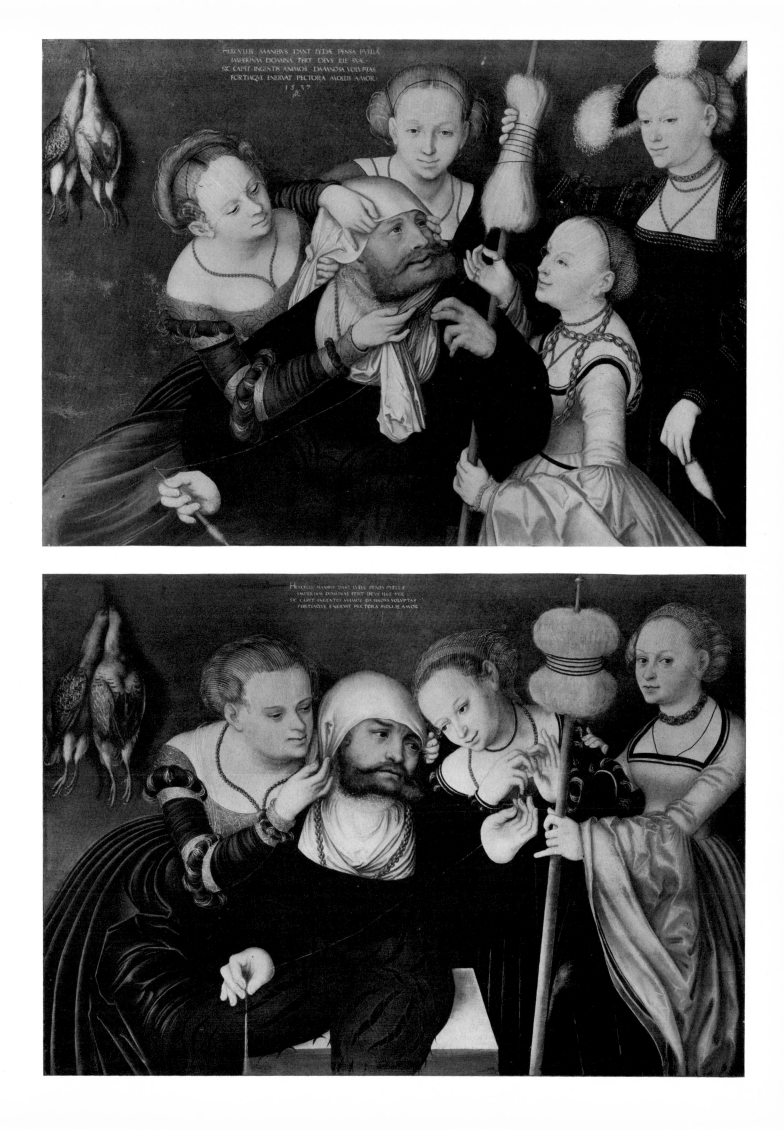

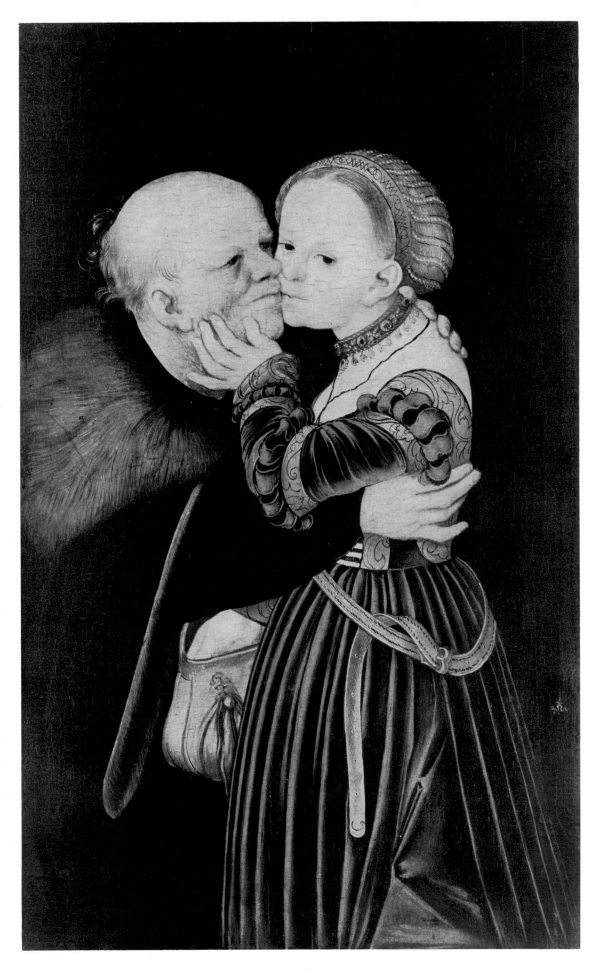

180 An Ill-matched Couple.
circa 1530. Prague

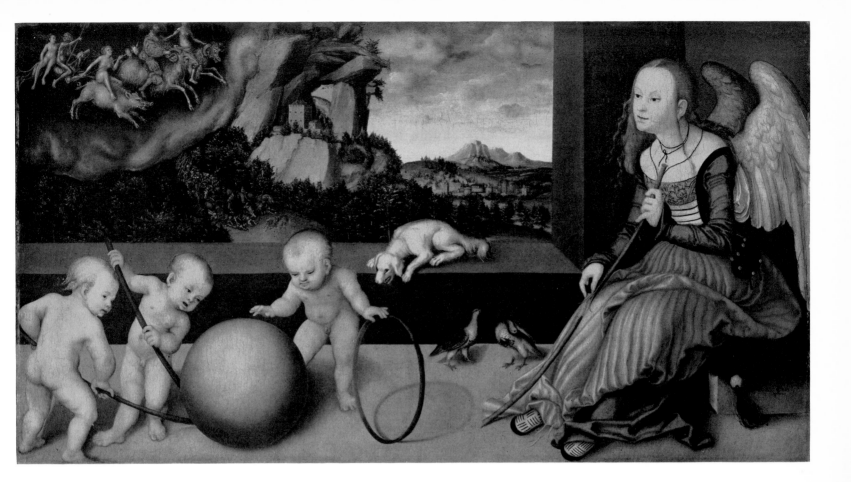

181 Melancholy. 1532. Copenhagen

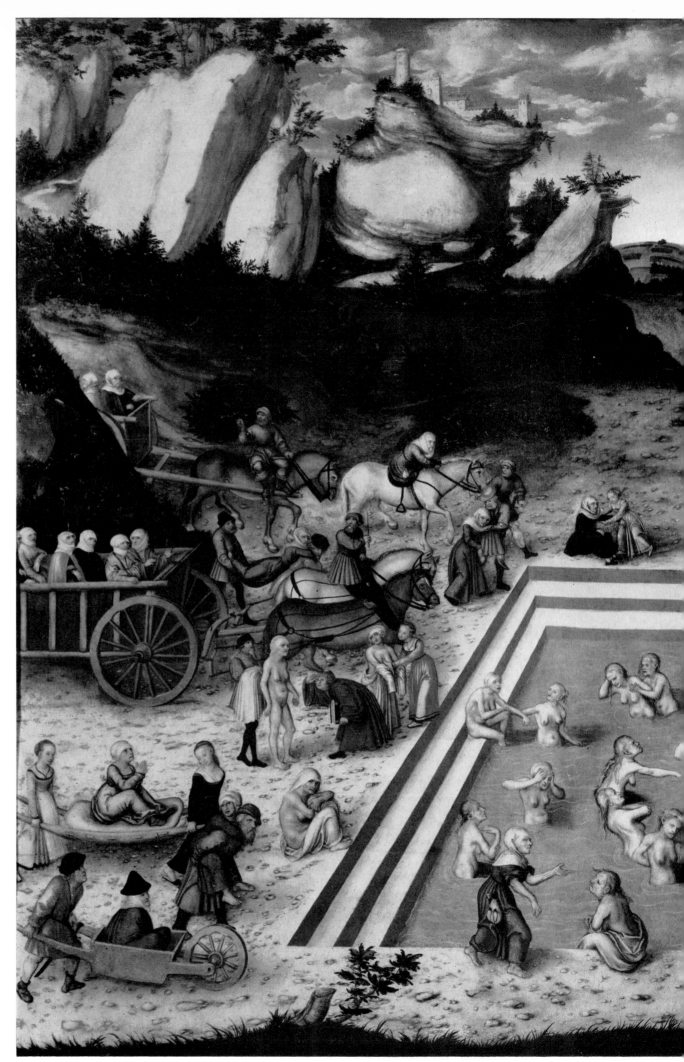

182 A Fountain
of Youth. 1546.
West Berlin

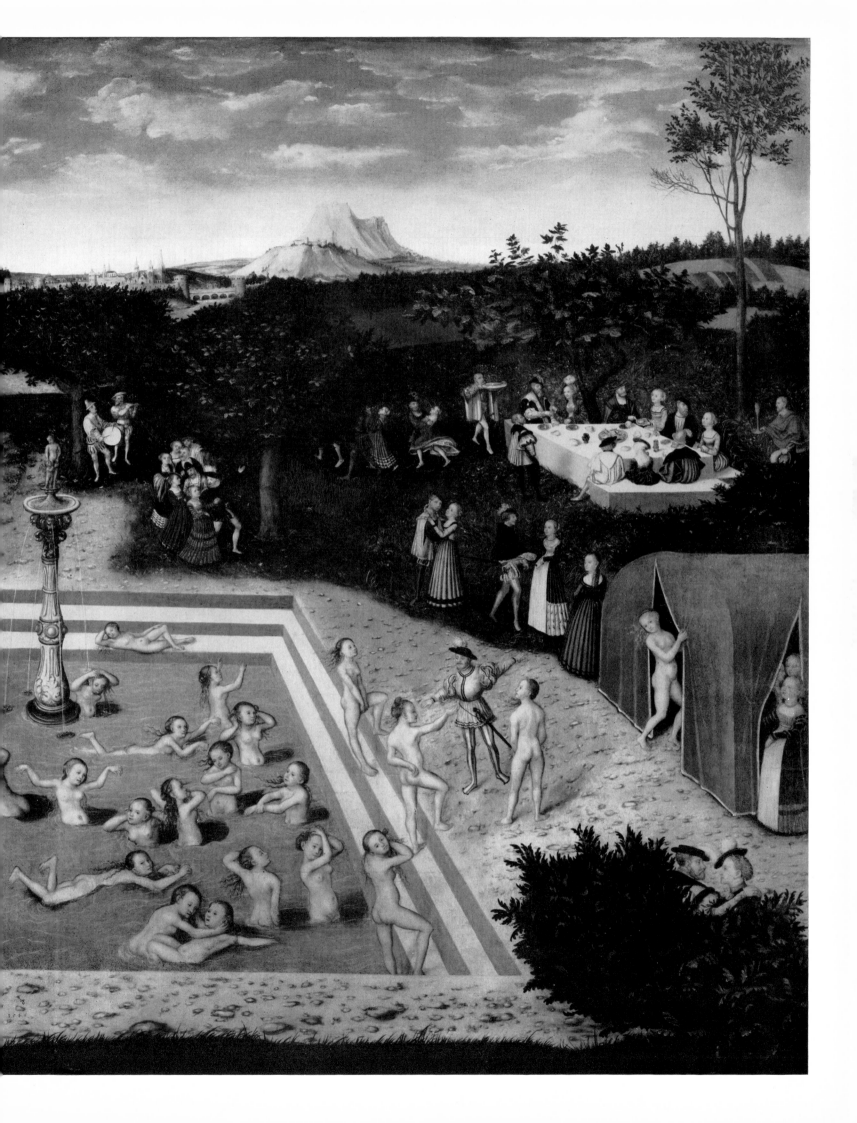

183 Detail of Plate 182
184 Bacchus at the Vat.
 1530. New York,
 private collection

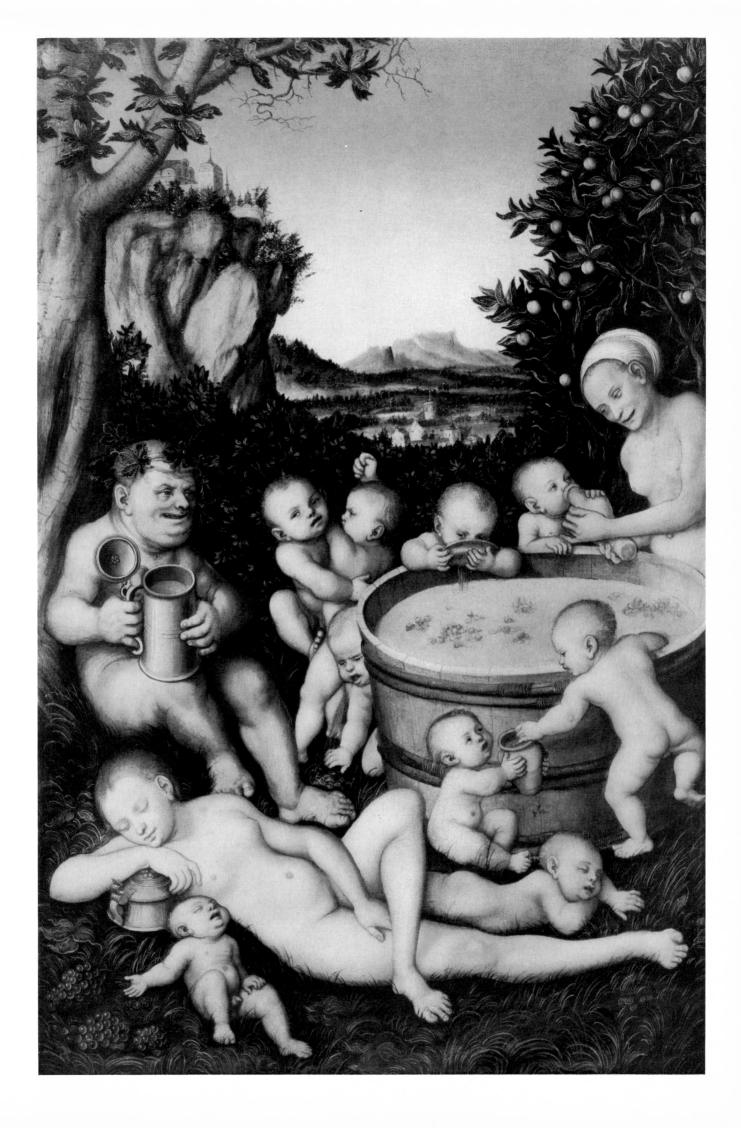

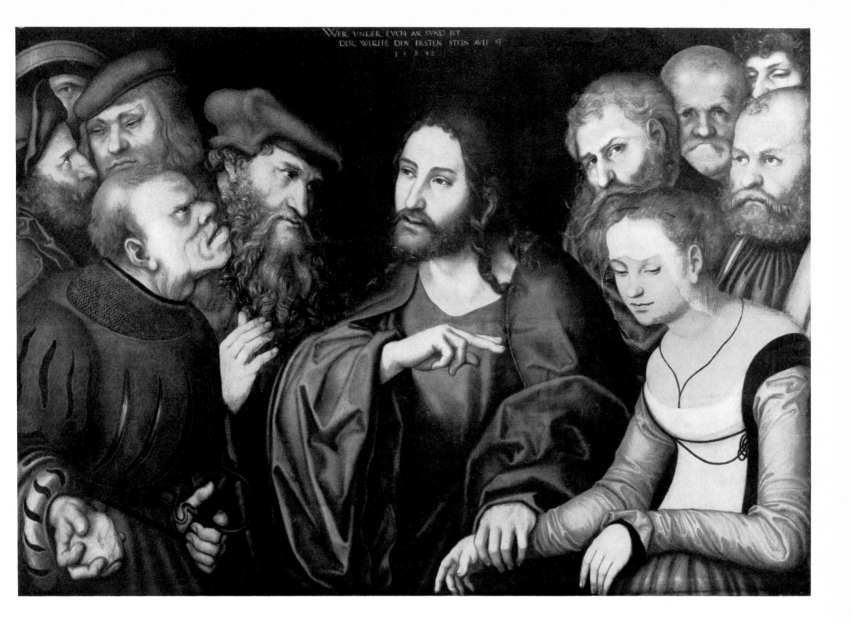

WER·VNDER·EVCH·AN·SVND·IST
DER·WERFFE·DEN·ERSTEN·STEIN·AVF·SI
1·5·3·2

185 The Fall and Redemption of Man. circa 1530. Drawing. Frankfurt-am-Main 186 Christ and the Woman Taken in Adultery. 1532. Budapest

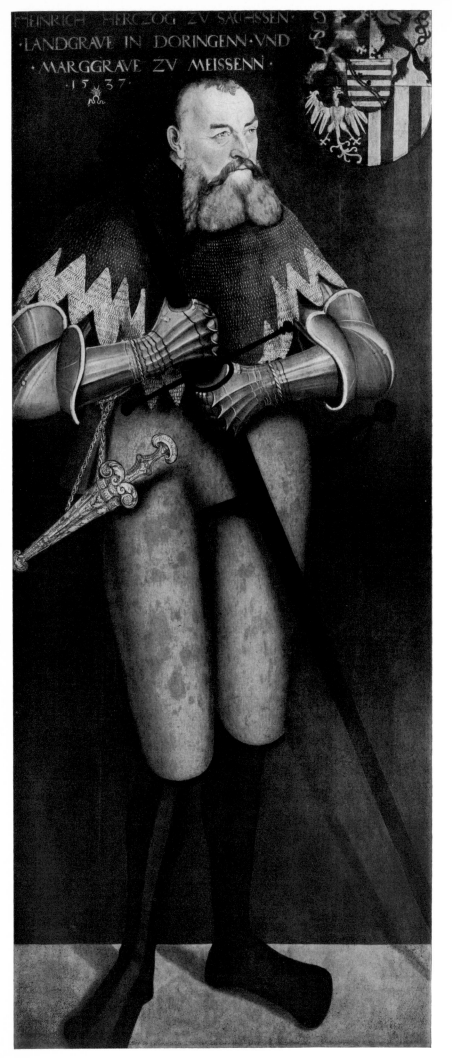

187 Duke Henry the Devout. 1537. Dresden, war casualty

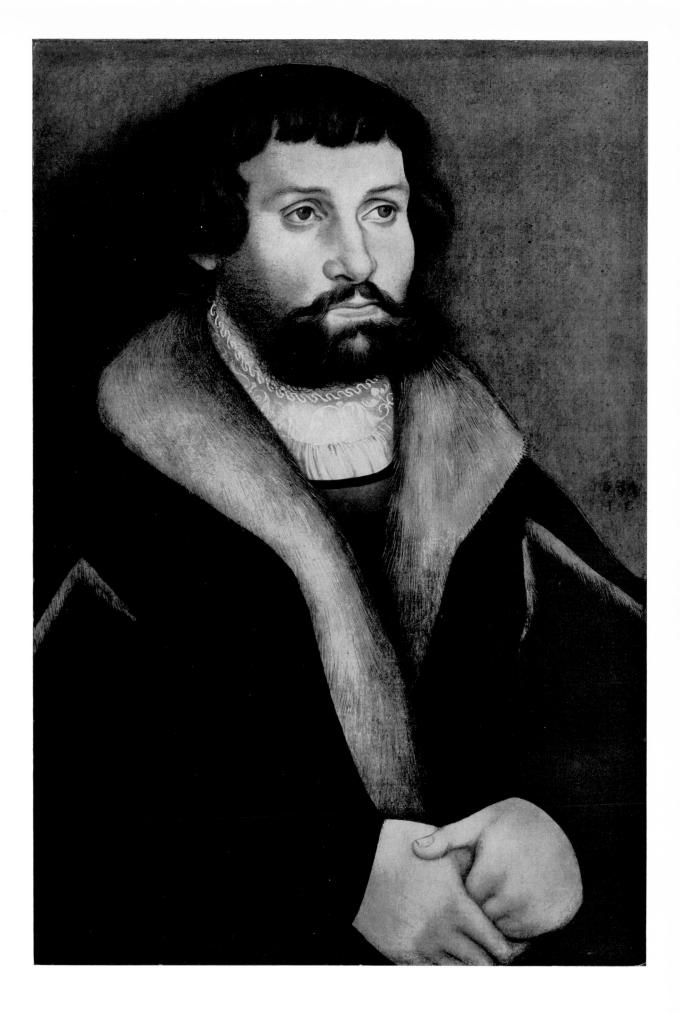

188 *Hans Cranach:* Portrait of a Young Man (Self-Portrait?). 1534. Lugano

189 *Hans Cranach*: Portrait of a Young Woman.
circa 1537. Drawing. Hanover

190 *Hans Cranach*: Portrait of a Master (?).
circa 1537. Drawing. Hanover

191 Judith. circa 1520.
Drawing. Dessau, war casualty

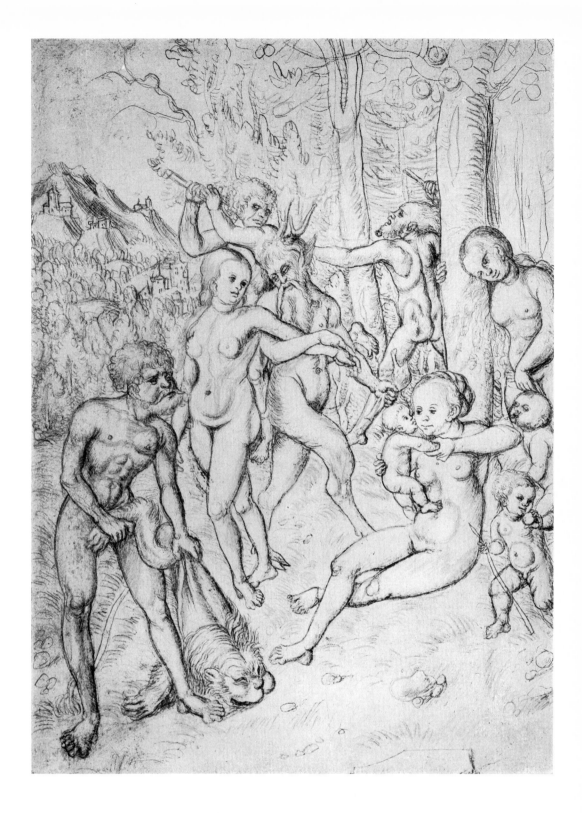

192 *Attributed to Hans Cranach:* The Silver Age. circa 1534. Drawing. West Berlin

193 *Hans Cranach:* Landscape with Sigmundsburg castle near Fernstein in Tirol. 1537. Drawing. Hanover

Gans maller von Cranach

det legen dll we als flandrages
wie oft manger malles Au
1 5 mariel Zuehaben 3

194 *Hans Cranach*: Studies of a Monkey. circa 1537. Drawing. Hanover

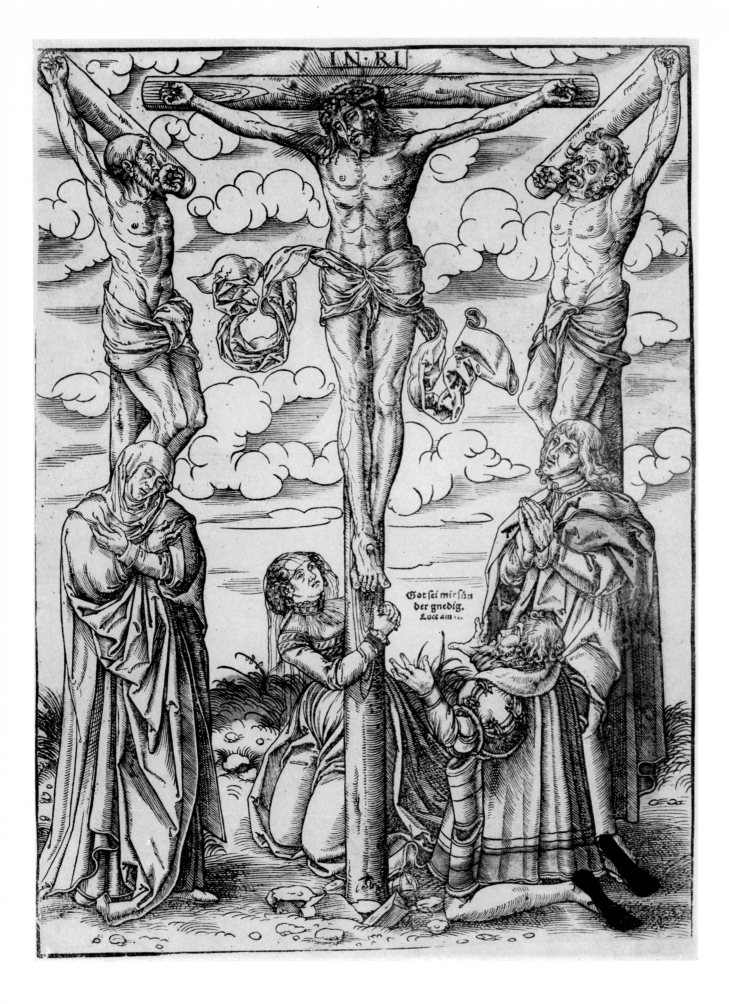

Got sei mir sün
der gnedig.
Luce am 10.

195 *Cranach the Younger:* The Crucifixion of Christ with Kneeling Sinners. circa 1545. Woodcut. Dresden

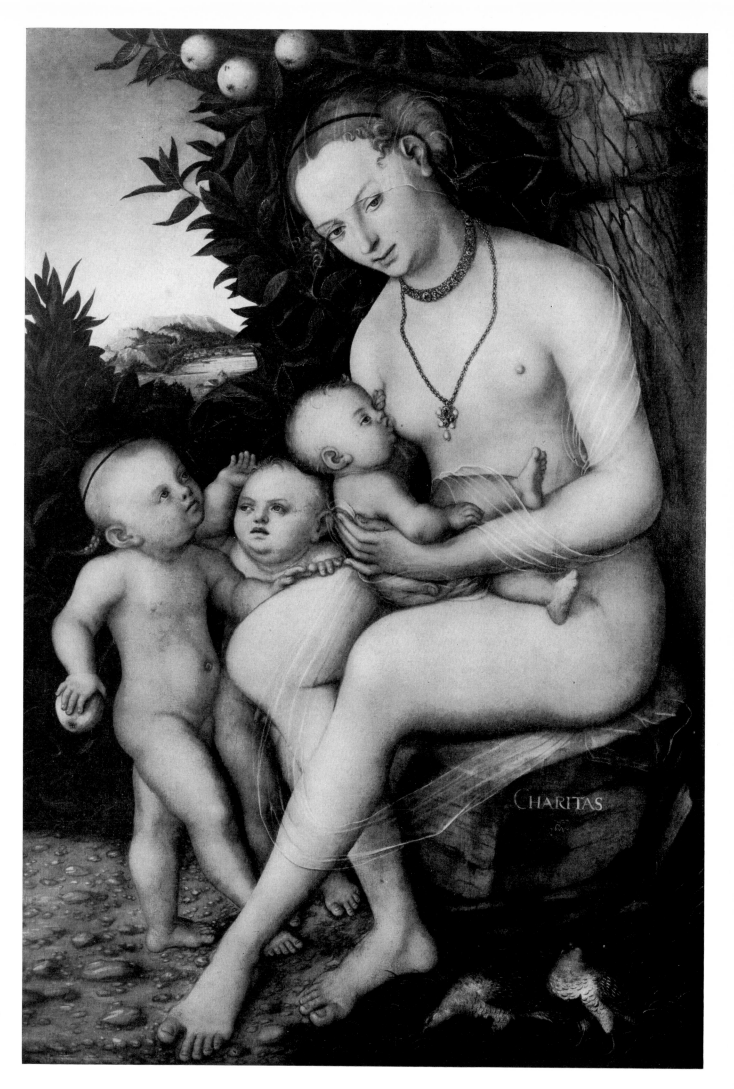

196 *Attributed to Cranach the Younger:* Charity. circa 1540. Weimar

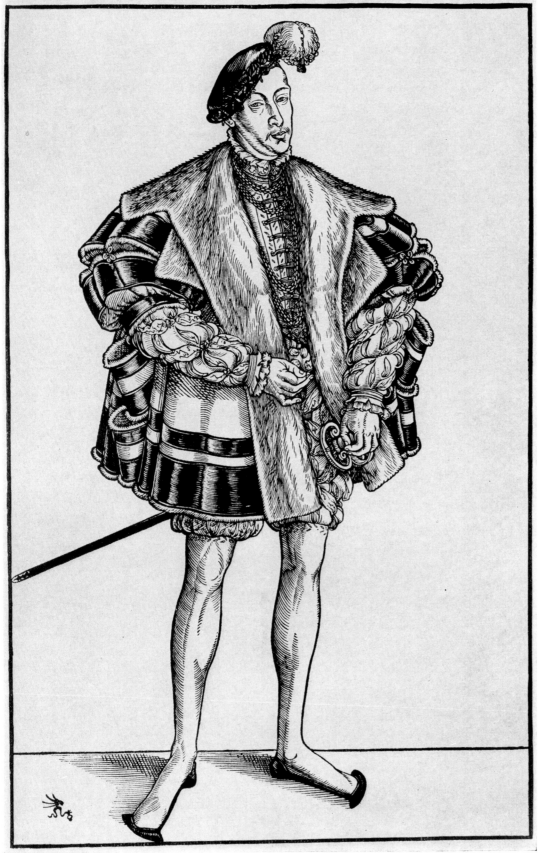

197 *Cranach the Younger*: Duke John William of Saxony. circa 1550. Woodcut. Vienna

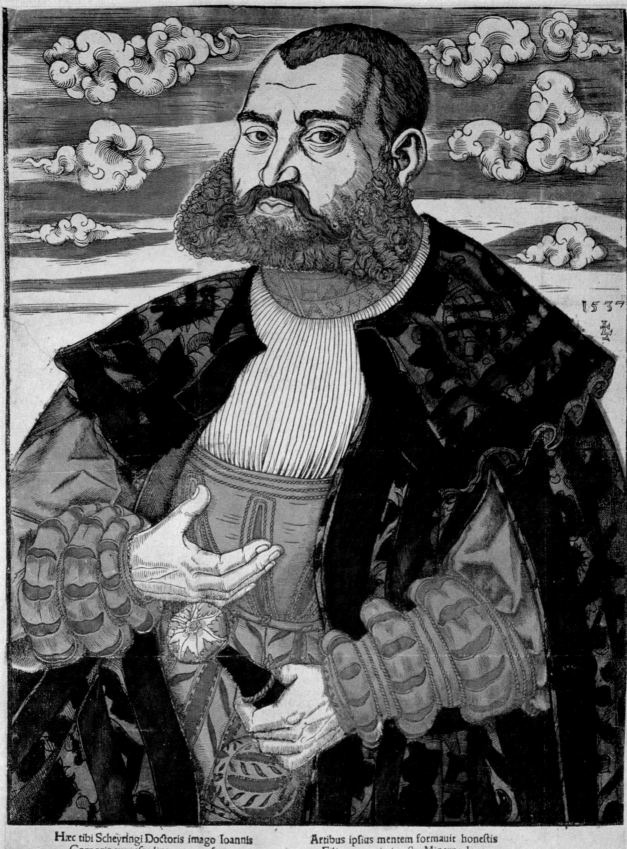

Hæc tibi Scheyringi Doctoris imago Ioannis
Corporis expreſſe lineamenta refert,
Ille duos ac ter decies ſuperauerat annos
Cum facies illi barbacↄ talis erat,
Ipſum præclaris aluit natalibus ortum,
Vrbs quæ virginea nomen ab arce tenet,

Artibus ipſius mentem formauit honeſtis
Filia magnanimi caſta Minerna Iouis
Illum etiam Sacras Leges Aſtræa tueri
A puero docuit, iuſticiamcↄ ſequi,
Sed licet expreſſis, facies ſit picta figuris,
Effingi nulla mens tamen arte poteſt.

198 *Cranach the Younger:* Johann Scheyring. 1537. Woodcut. West Berlin

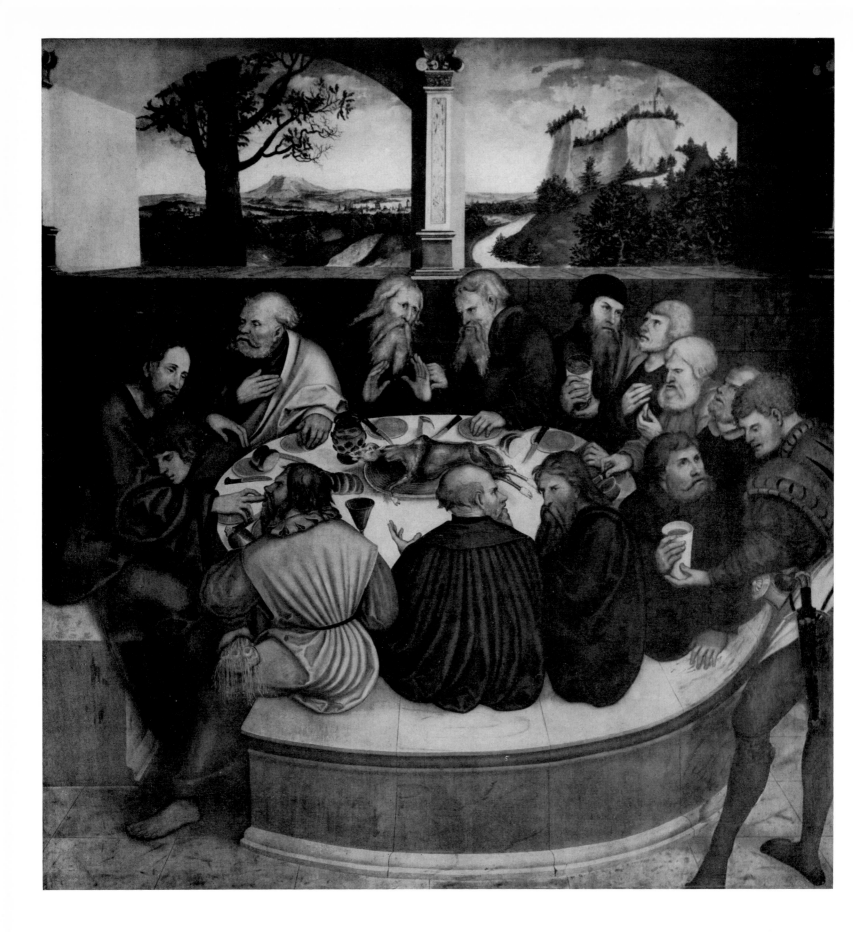

199 The Last Supper. circa 1547.
Center panel of the altarpiece. Wittenberg

200 *Cranach the Younger:* The Last Supper.
circa 1535. Drawing. West Berlin

201 *Cranach the Younger:* The Resurrection of Christ.
circa 1539. Drawing. Oslo

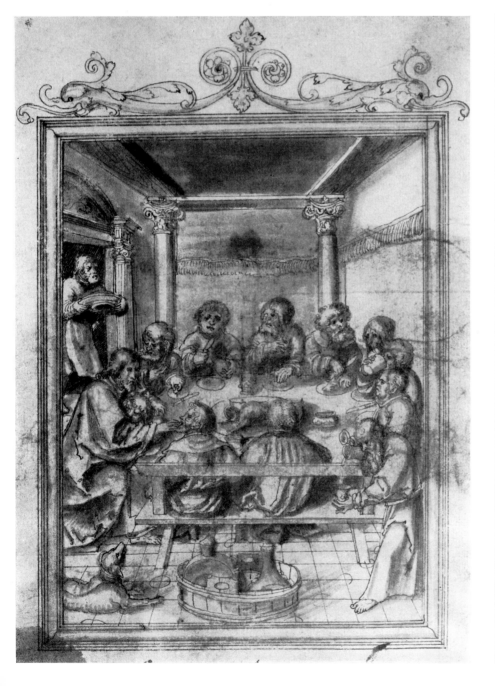

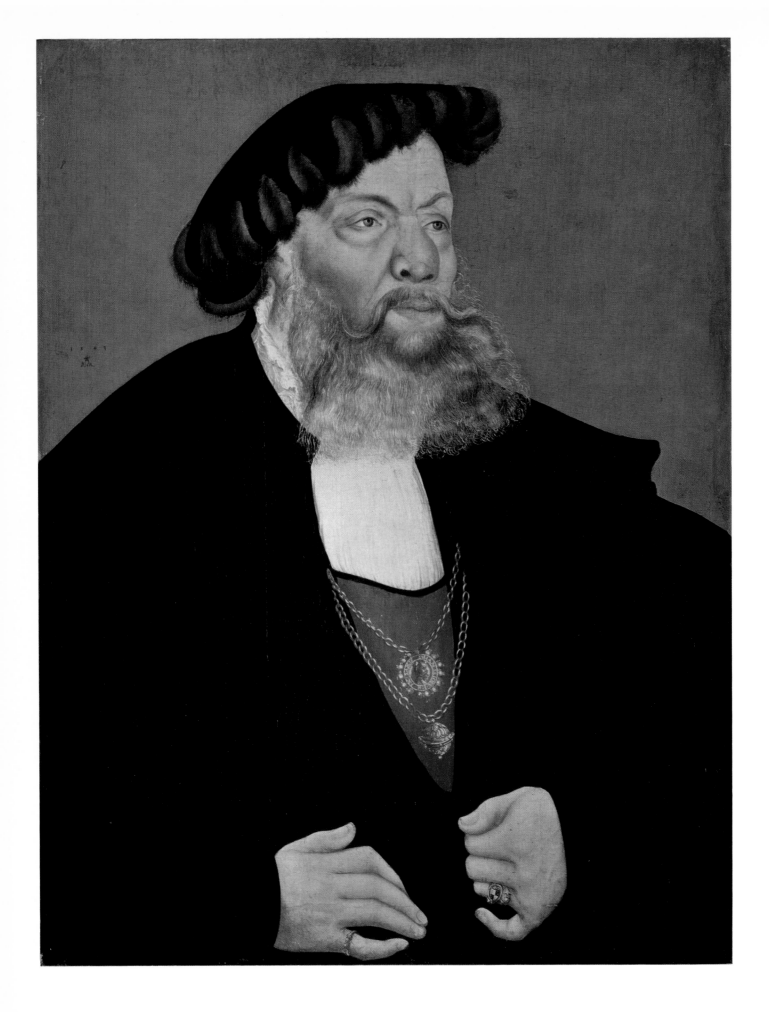

202 *Cranach the Younger:* Caspar von Minckwitz. 1543. Stuttgart

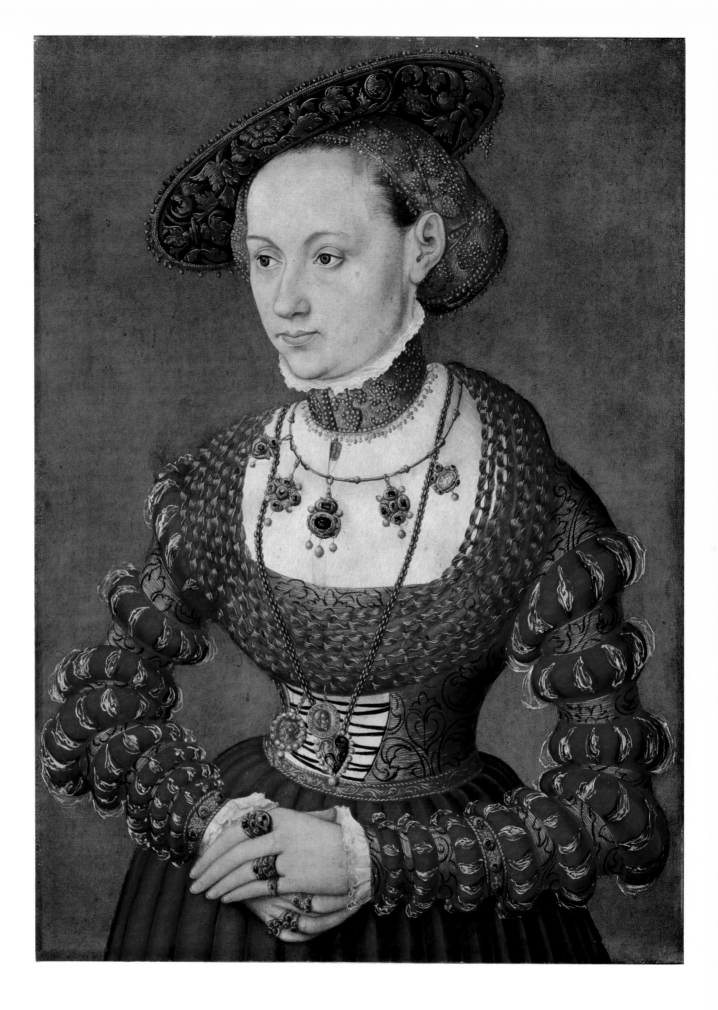

203 *Cranach the Younger*: Anna von Minckwitz. 1543. Stuttgart

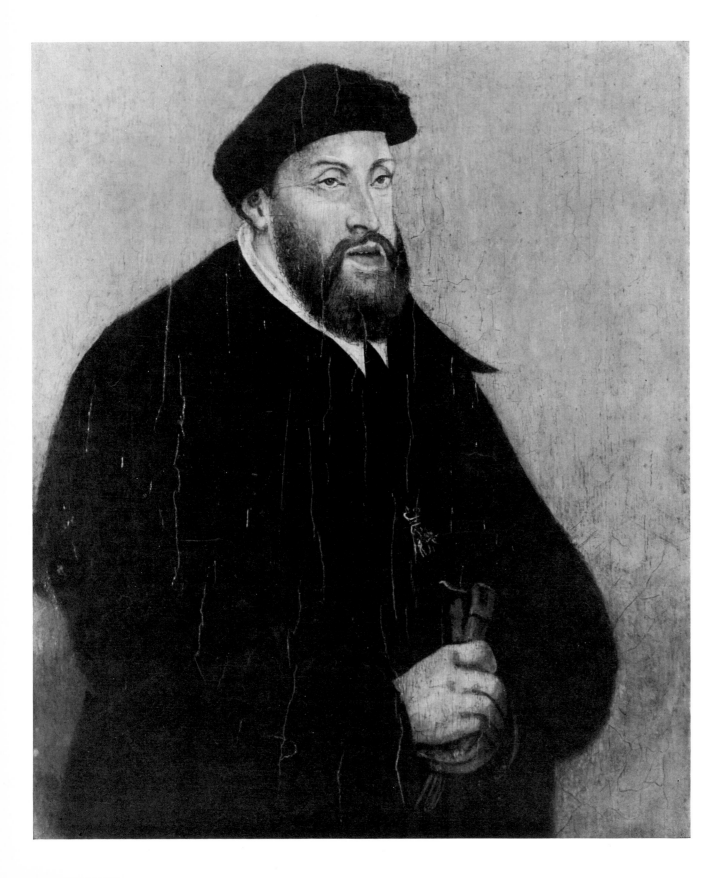

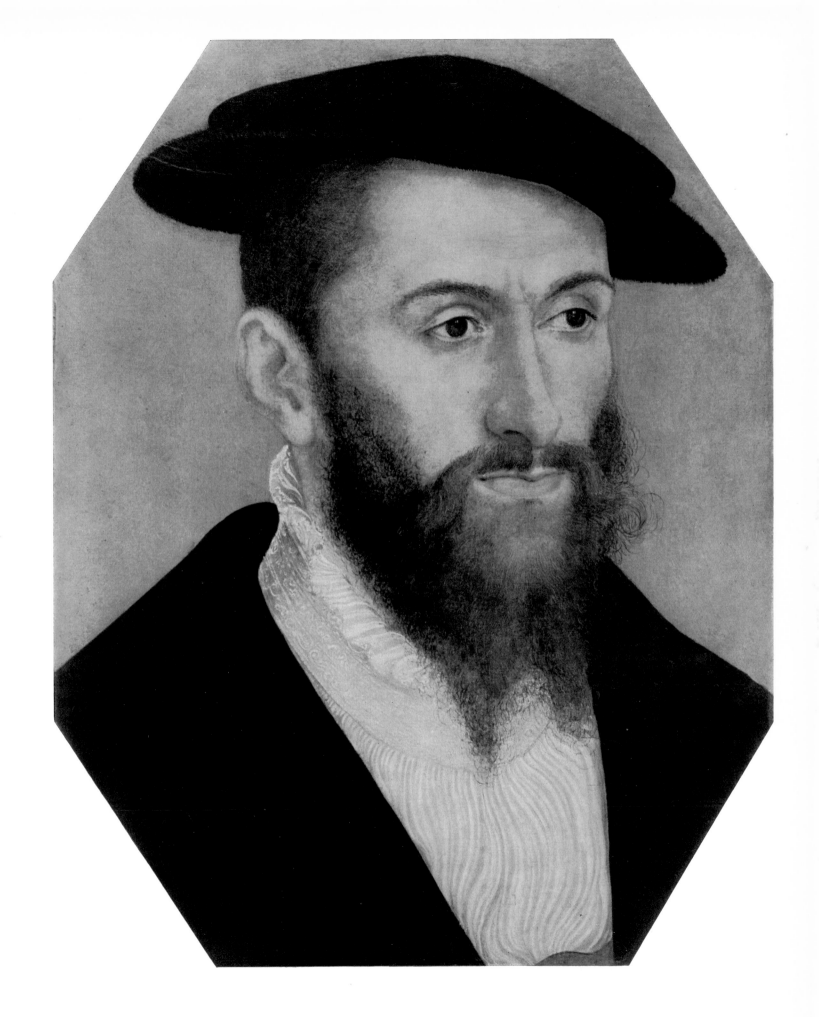

204 Emperor Charles V. circa 1550. Wartburg 205 *Cranach the Younger*: Portrait of a Gentleman. 1545. San Francisco

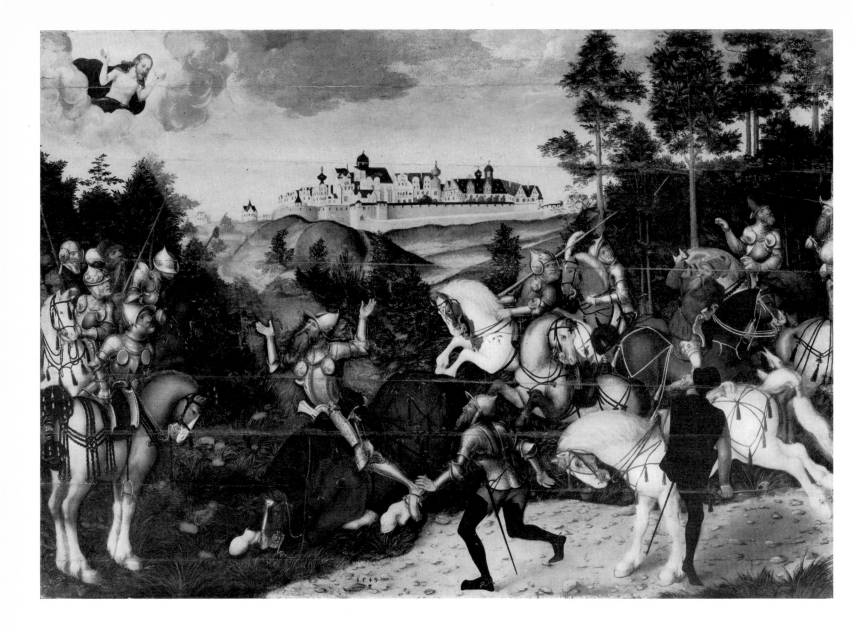

206 *Cranach the Younger:* The Conversion of St. Paul. 1549. Nuremberg 207 *Cranach the Younger:* Portrait of a Man of Twenty-Eight. 1546. Warsaw

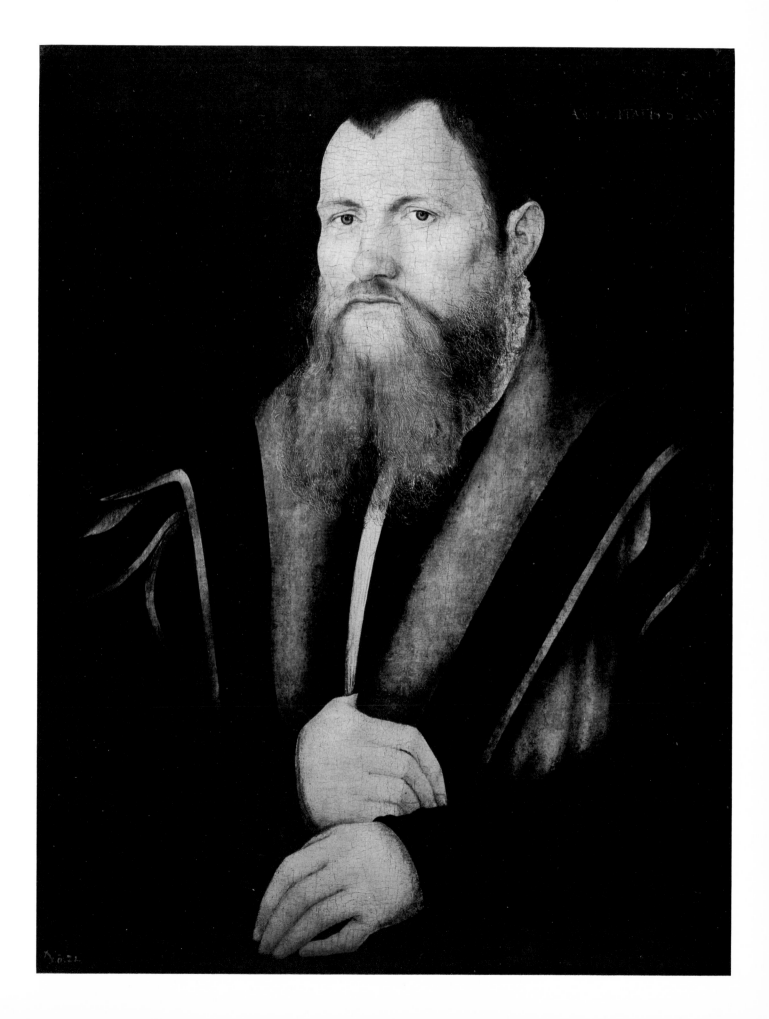

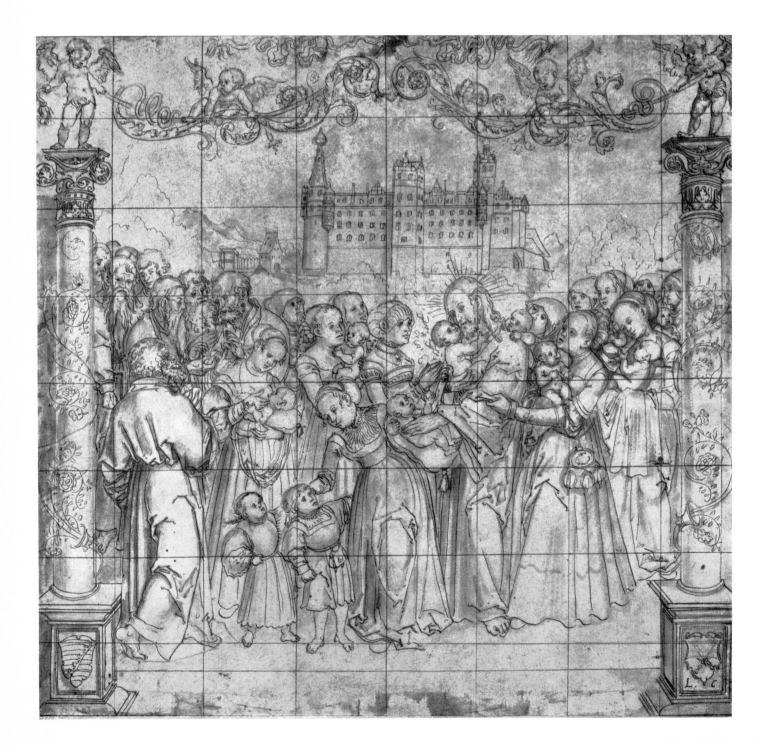

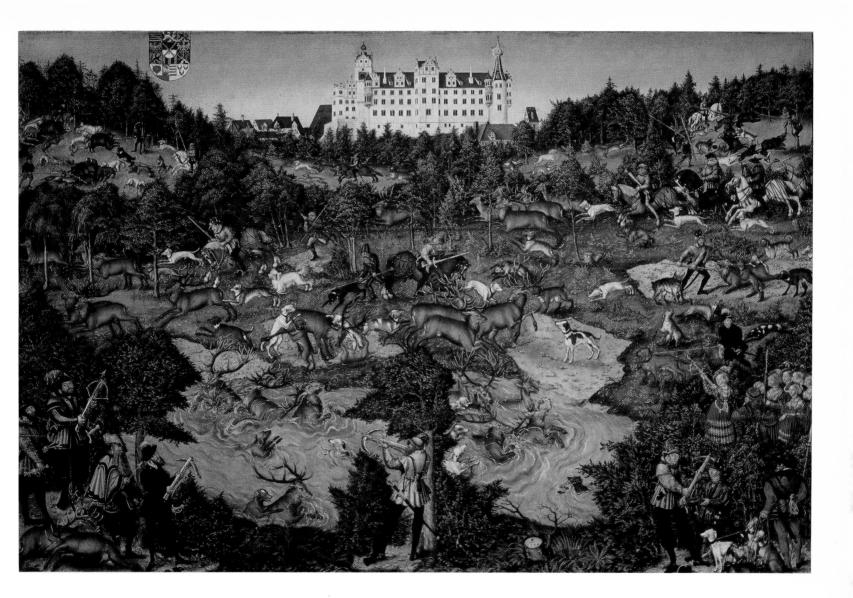

208 *Cranach the Younger*: Christ the Friend of Children.
circa 1540. Drawing. Leipzig

209 *Cranach the Younger*: The Court Hunts Stag, Boar and Foxes.
1544. Madrid

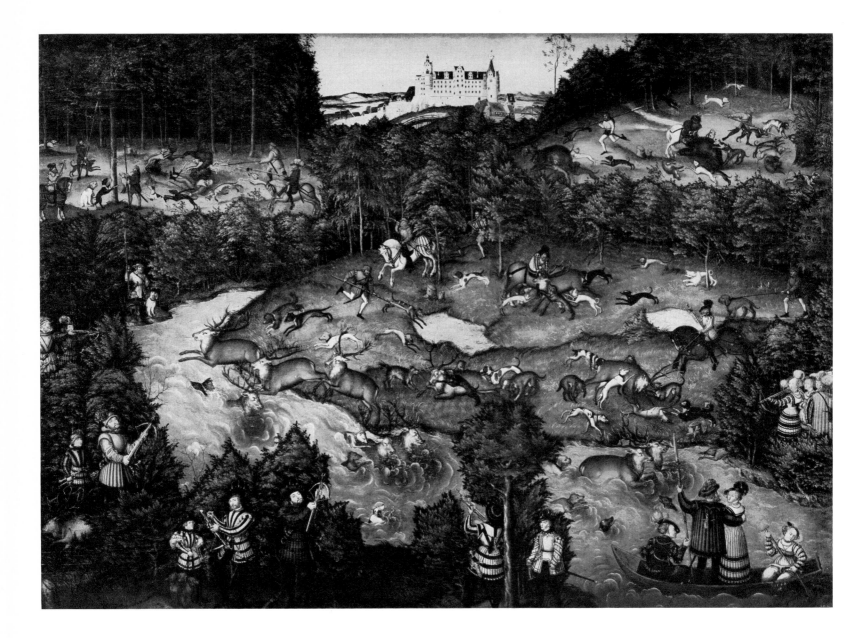

210 *Cranach the Younger:* The Court Hunts Stag and Bear. 1540. Cleveland

211 Detail of Plate 210: Schloss Torgau

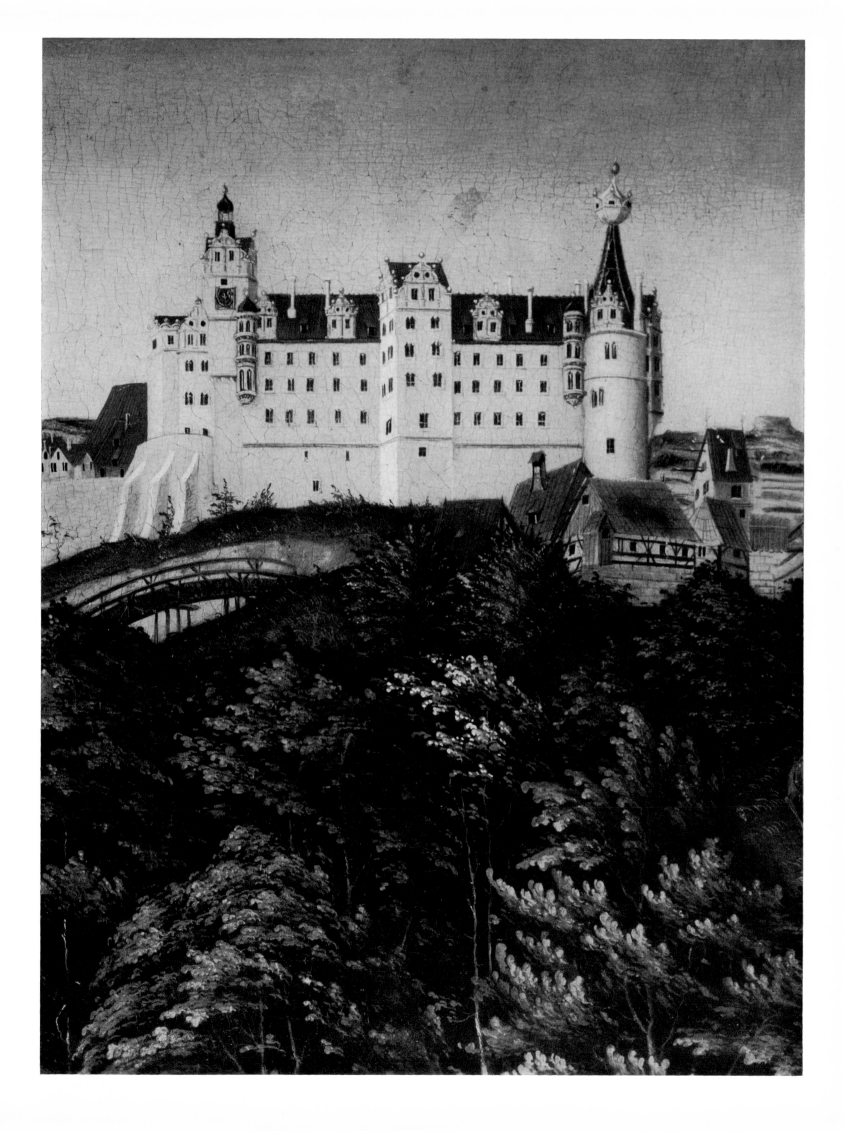

Ihr Hoff vnd Keichsleute laset euch an Euer besoldung begnü
ret noch vberseßet niemand vnd Finanßet den leuten ny
Denn wehr schanckung nimmet, kan nicht einem wie
techt vnd die gleichhait widerfahren lassen, Im lekt
XVj. Capittel:

212 *Cranach the Younger*:
John the Baptist Preaching.
1549. Brunswick

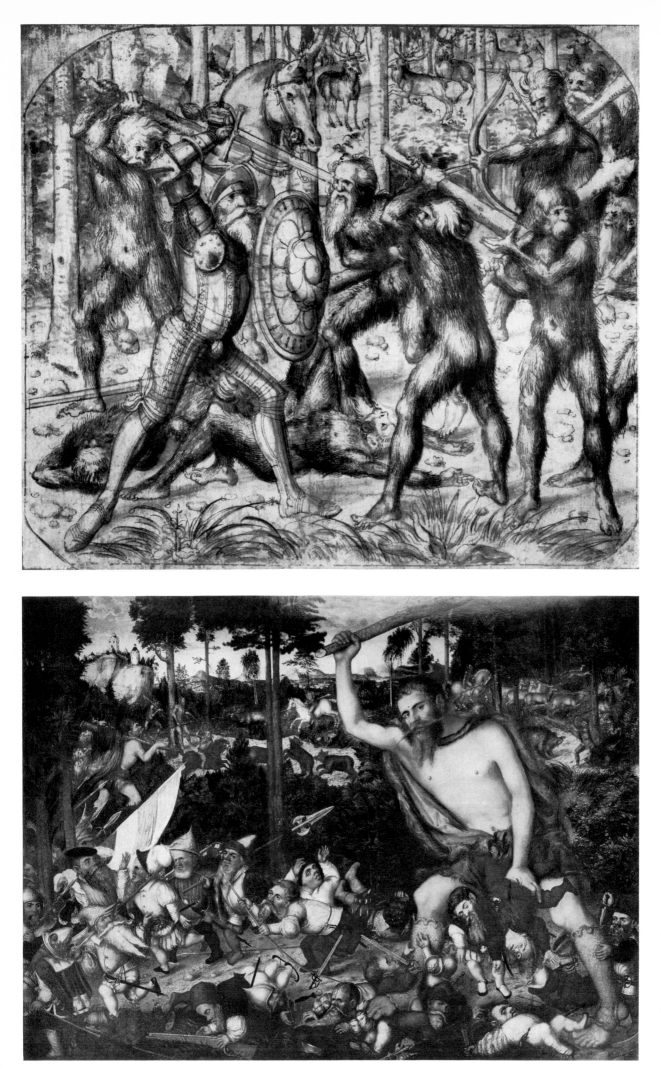

213 *Cranach the Younger:*
Hercules Fighting the
Wild Men of the Woods.
circa 1551. Drawing.
Private collection

214 *Cranach the Younger:*
Hercules Driving
Off the Pygmies. 1551.
Dresden

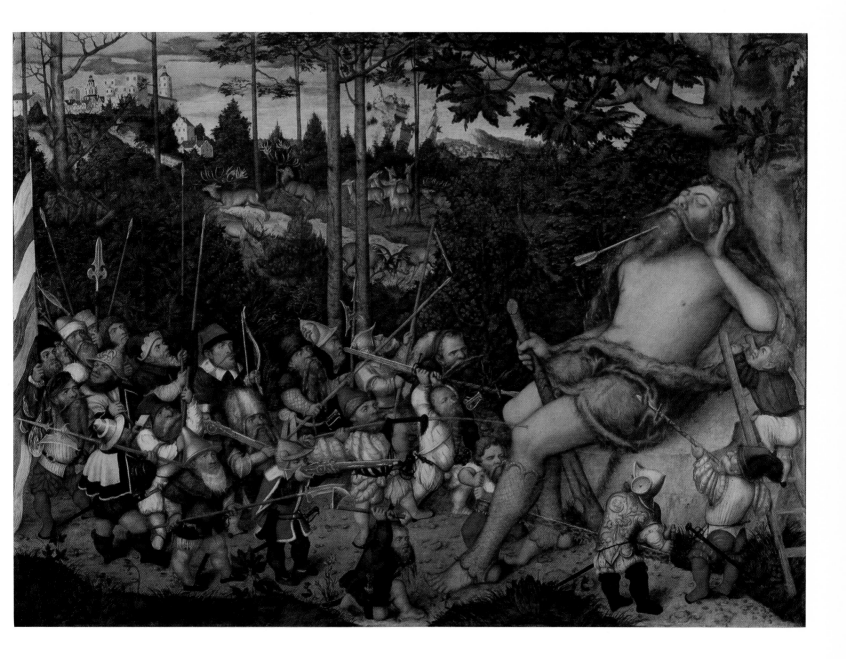

215 *Cranach the Younger:* Sleeping Hercules with Pygmies. 1551. Dresden

GREGORII FACIEM PONTANI HÆC MONSTRAT IMAGO NAM QVIA CREDE ⸻ BAT SE LOTVM SANGVINE CHRISTI
 CONSILIO PRÆSTANS QVI FVIT ATQVE FIDE . IVSTIFICA COLVIT TE DEVS ALME FIDE .
HVIVS ERAT NOSTRO FACVNDIA TEMPORE, QVANTA NEC VIRTVTVM VMBRAS HABVIT, SED PECTORA REXIT
 OLIM SEV PYLII SIVE PERICLIS ERAT . IPSE SIBI VIVENS ASSIMILATA ΛΟΓΟΣ
SED MELIOR CAVSA EST HÆC QVAM PONTANVS AGEBAT ÆTATIS SVÆ LXXIII ·
 DE GNATO SOLITVS DICERE VERA DEI . ANNO 1 5 5 7 ·

216 *Cranach the Younger*: Gregor Brück. 1557. Weimar

ÆTATIS SVÆ · LXXVII ·
· 1 5 5 0 ·

217 *Cranach the Younger*: Lucas Cranach the Elder. 1550. Florence

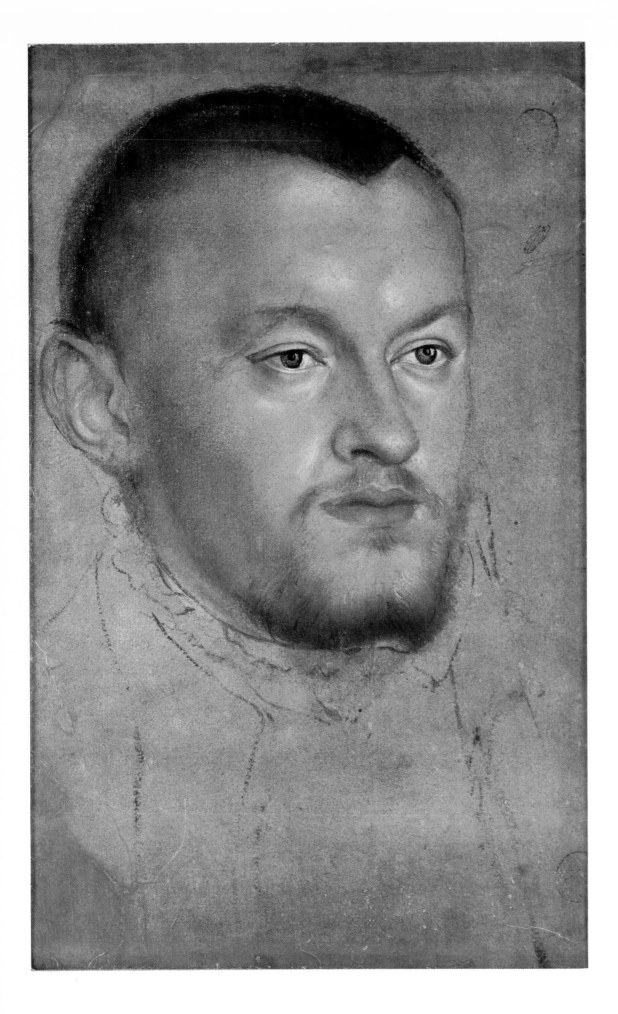

218 *Cranach the Younger:* Portrait Head of a Gentleman. circa 1545. Reims

219 *Cranach the Younger:* Portrait Head of a Gentleman. circa 1545. Reims

220 *Cranach the Younger:* The Baptism of Christ.
1556. West Berlin

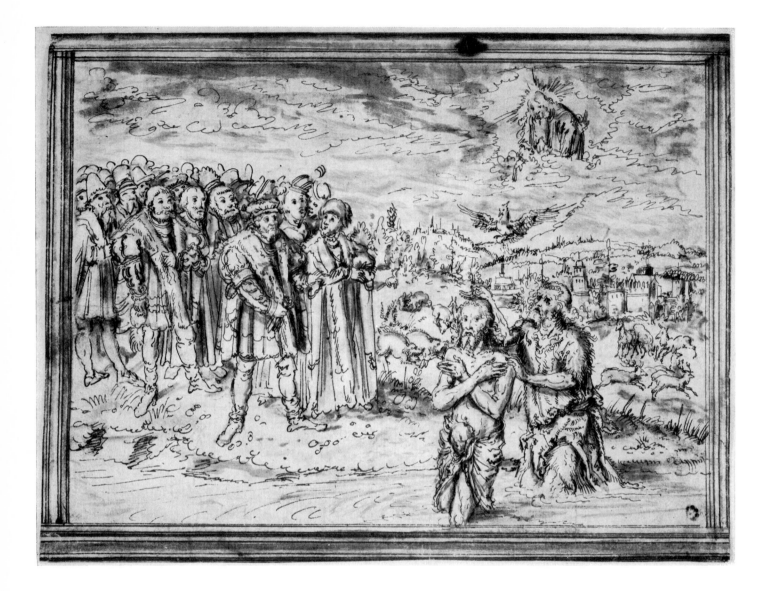

221 *Cranach the Younger:* The Baptism of Christ.
circa 1556. Drawing. Berlin

222 *Cranach the Younger:* Allegory of Virtue (The Hill of Virtue).
1548. Vienna

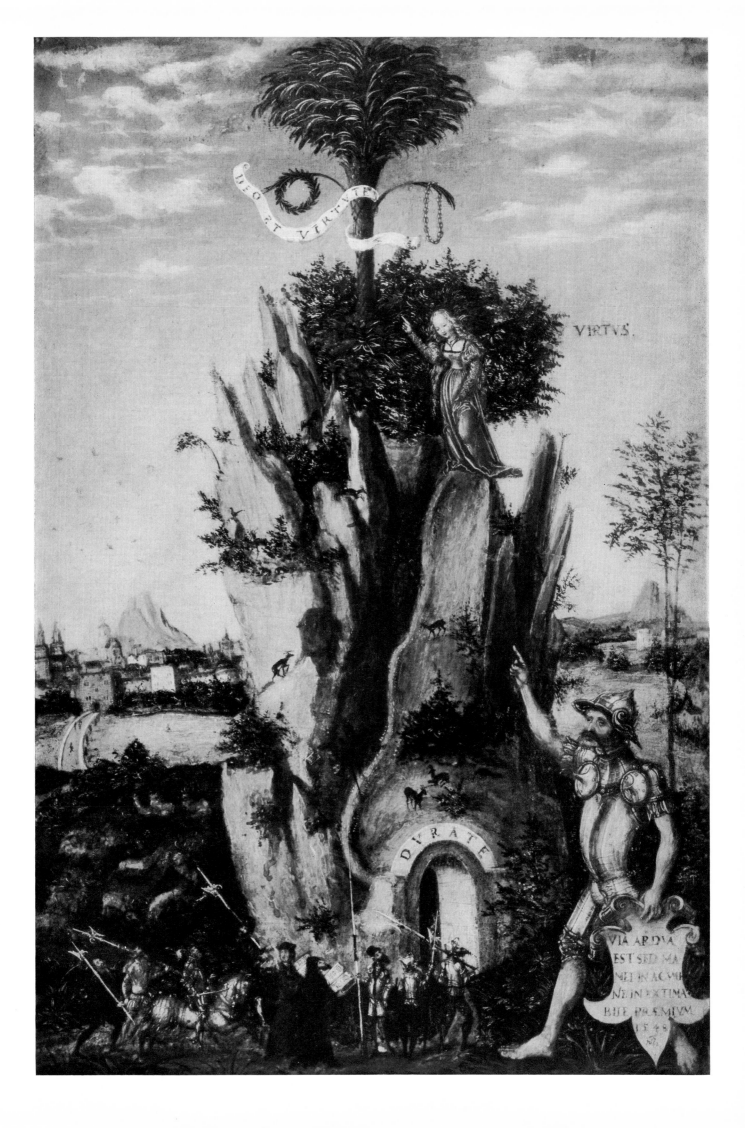

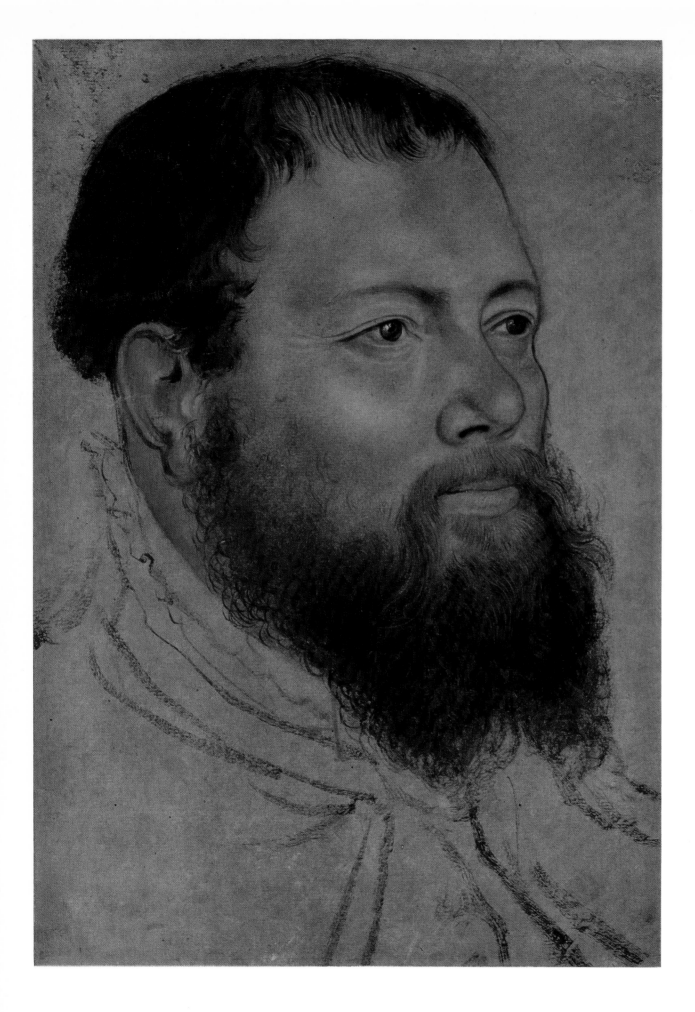

223 *Cranach the Younger*: Portrait of a Bearded Man. circa 1550. Drawing. West Berlin

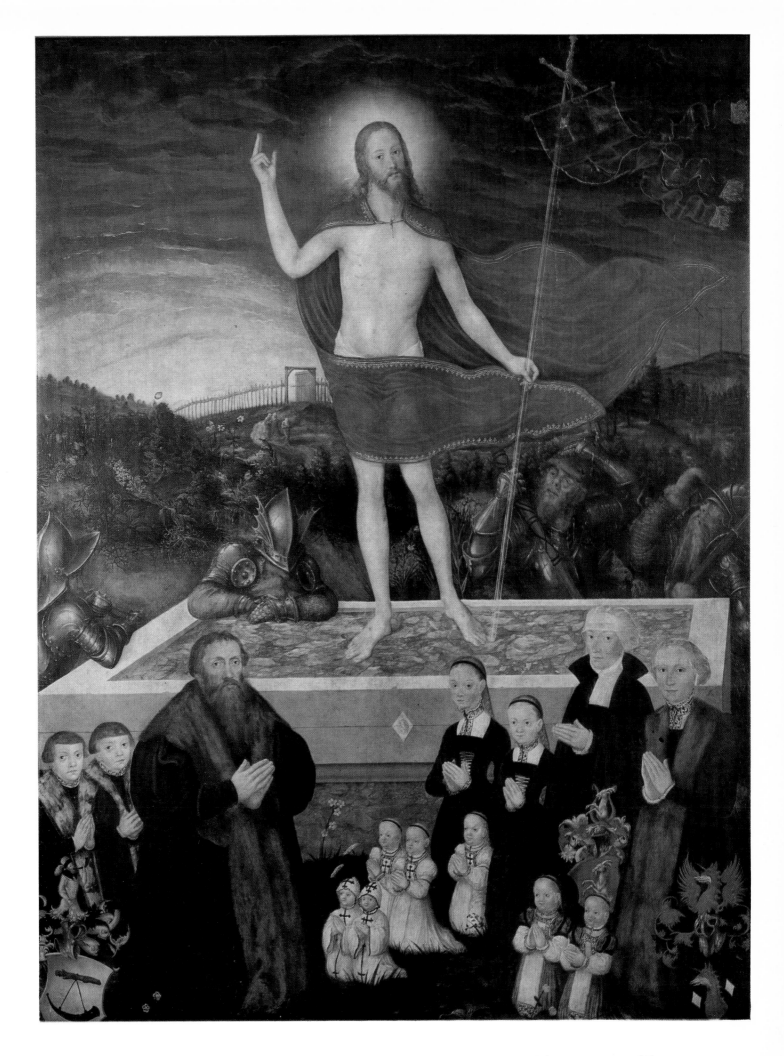

224 *Cranach the Younger*: The Resurrection of Christ. 1557. Leipzig

225 *Cranach the Younger:* Design for a Wall Painting with Stags. circa 1568 (?). Drawing. Leipzig

226 *Cranach the Younger:* Design for a Wall Painting with Foxes. circa 1568 (?). Drawing. Leipzig

Warhafftige Abconterfeiung
des Herrn Philippi Melanthonis.

So sichs vielleicht so hett begeben/
Das du Philippum bey sein Leben
Nicht hets gesehn/ Auch nicht den Mund/
Daraus sein sprach gar schön vnd rund/
Ja viel süsser zu aller frist
Denn honigsein geflossen ist.
Auch nicht gesehn hets die Brust sein/
Welch ist gewest Gottes wonung fein.
Auch nicht die Augen die fürwar
Ein Erbars Gmüt anzeigen klar.
Auch nicht das Heupt/Welchs stets vnd fest
Als ein Schatzkammer ist gewest/
Der Tugendt voll/ vnd auch zu gleich
Von allen guten Künsten reich.
So schaw an dis des Malers Werck/
Vnd auff all ding gar eben merck.
Denn es gibt dir gleich ein Bericht/
Wie sein lebendigs Angesicht.

Gewesen sey/ Denn hier ist gmalt/
Wie er gewest eusserlich gestalt.
Sein Augen/ Stirn/ Nas/Mund vn Wan=
Vnd wie er teglich ist gegangen. (gen/
Dis ist als wol getroffen hier/
Aber das seins verstandes zier/
Vnd sein Vernunfft vnd Gschickligkeit/
Dargeb/vnd sein Scharffsinnigkeit/
Ein solch Werck / so durch seine Kunst/
Ein Meister bgundt/wer all vmb sunst/
Er würds nicht enden mit der handt/
Hett er gleich Apellis verstandt.
Philippus aber selber hat
Ja seinen Schrifften mit der that
Ein Muster seins verstands gar eben
Vnd hohen Gmüts an tag gegeben/
Denn er hat selbs sein eigne gaben
Abmaln können, So du wilt haben

Derselben einen voln vorstandt/
So nim die Bücher vor die handt/
Die er mit hoher kunst geschrieben/
Vnd ordenlich mit ernst getrieben/
Die lies du durch : Denn sie gar eben
Jrs Meisters ebenbildt dir geben.
Aus den ist nicht allein sein Lahr/
Vnd seine meinung offenbar/
Von Gott vnd von Geistlichen sachen/
Sondern sie auch bekant thun machen/
Wie seine Sitten/ was sein handel
Gwest sey/vnd all seins Lebens wandele

Ex Latino.

227 *Cranach the Younger*: Philipp Melanchthon. 1560. Woodcut

228 *Cranach the Younger:* Philipp Melanchthon. 1559. Frankfurt-am-Main

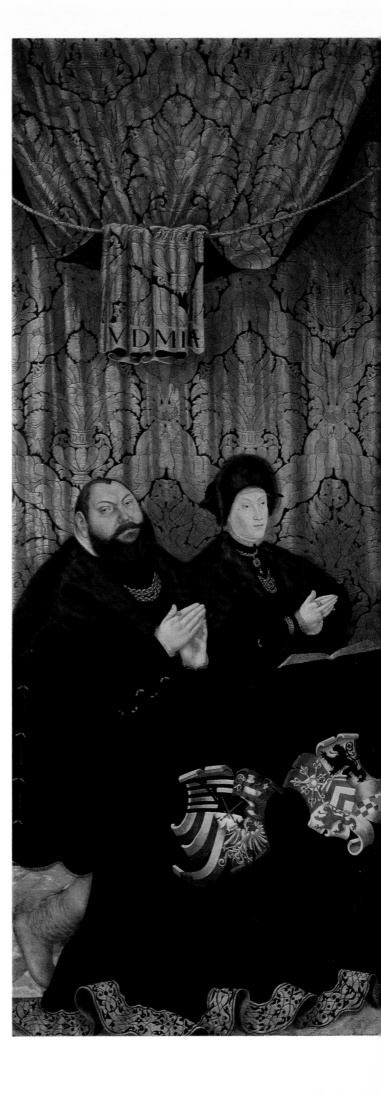

229 *Cranach the Younger:* Altarpiece.
 Memorial to Duke John Frederick of Saxony and his Family. 1555.
 Weimar
 a Left wing: John Frederick and Sybille von Cleve
 b Center panel: The Fall and Redemption of Man (with portraits
 of Luther and Cranach)
 c Right Wing: The Sons of John Frederick

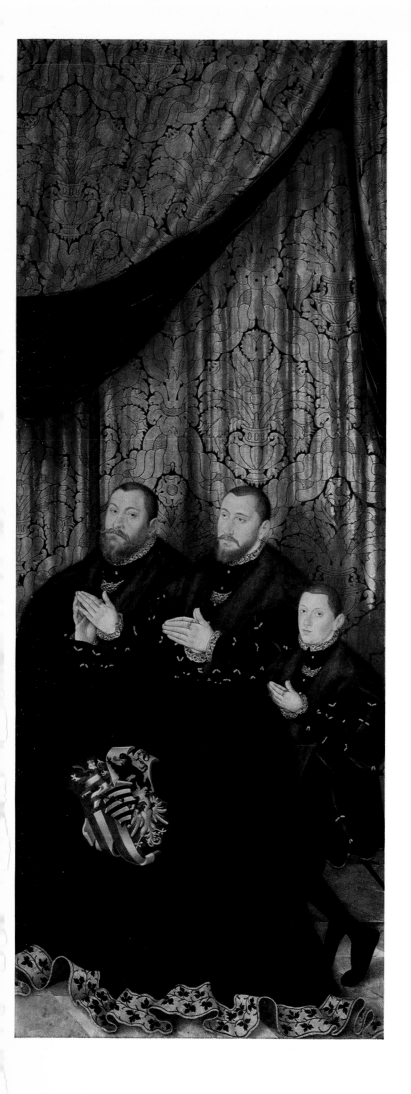

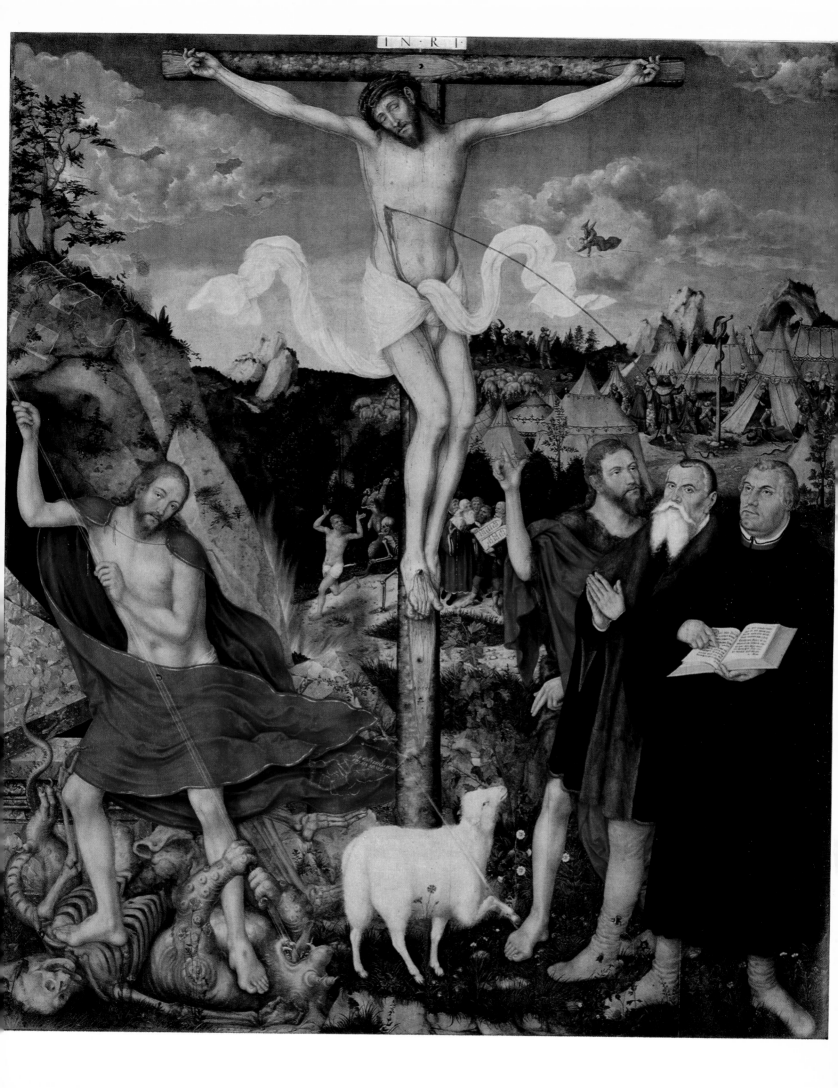

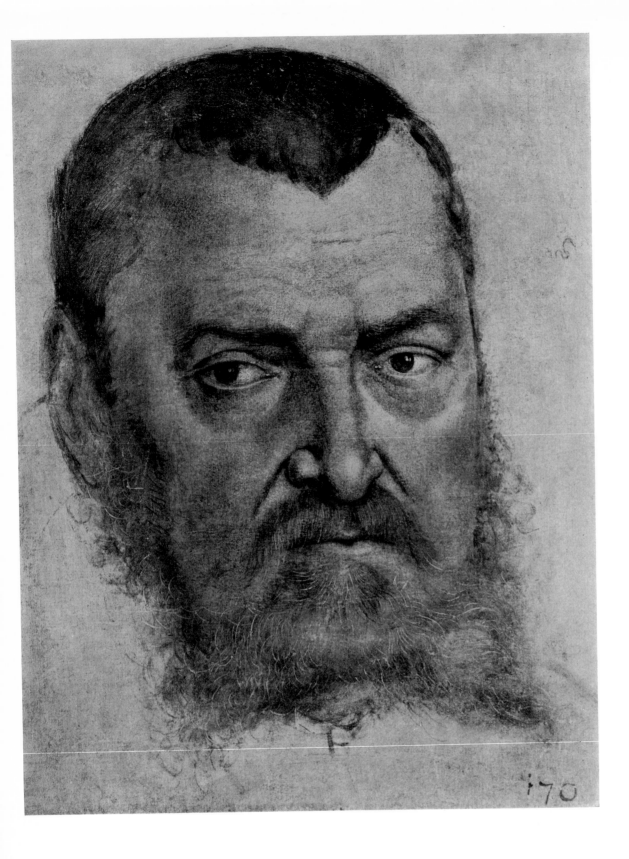

230 *Cranach the Younger:* Sketch for a portrait of
Elector Joachim II of Brandenburg.
circa 1555. Dresden, missing. See Plate 234

231 Detail of Plate 229a: Sybille von Cleve

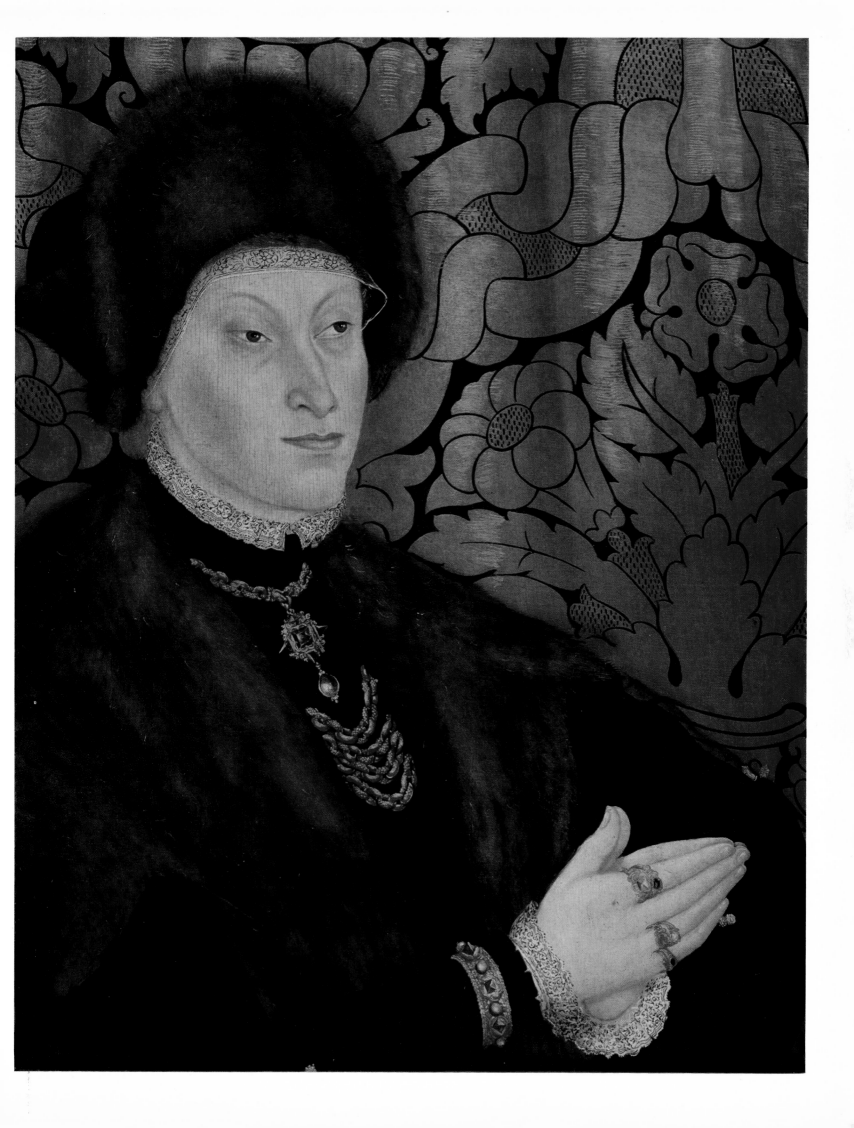

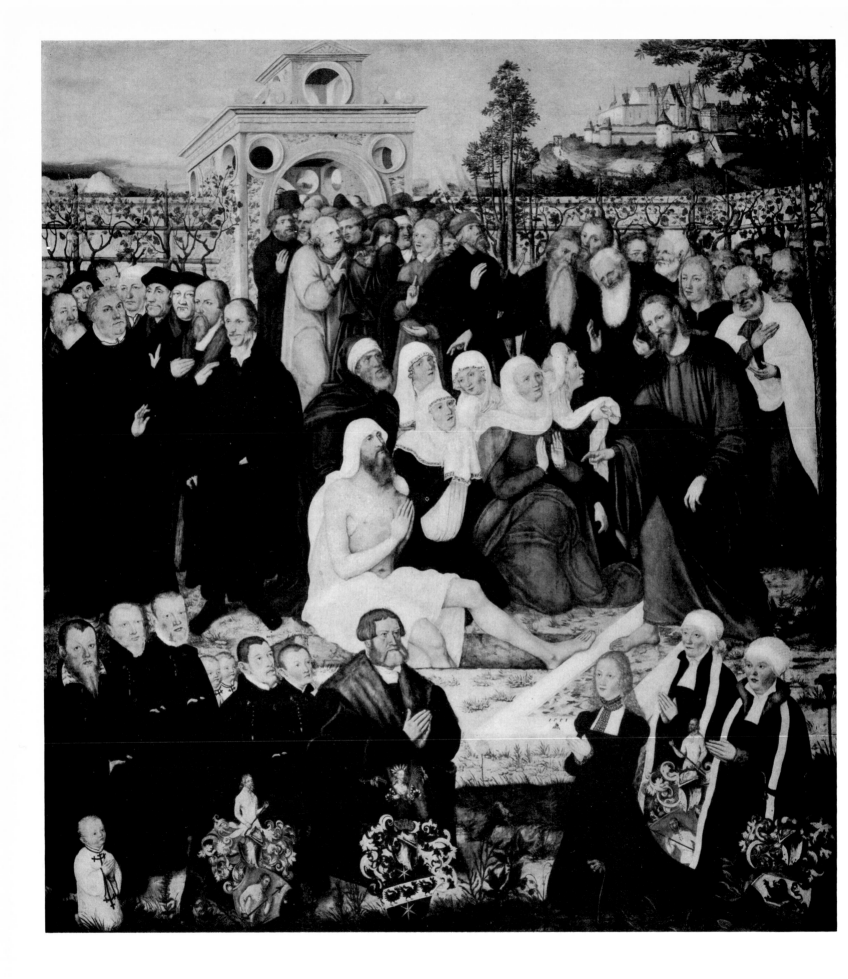

232 *Cranach the Younger:* The Raising of Lazarus. Memorial to Michael Meyenburg. 1558. Nordhausen, missing

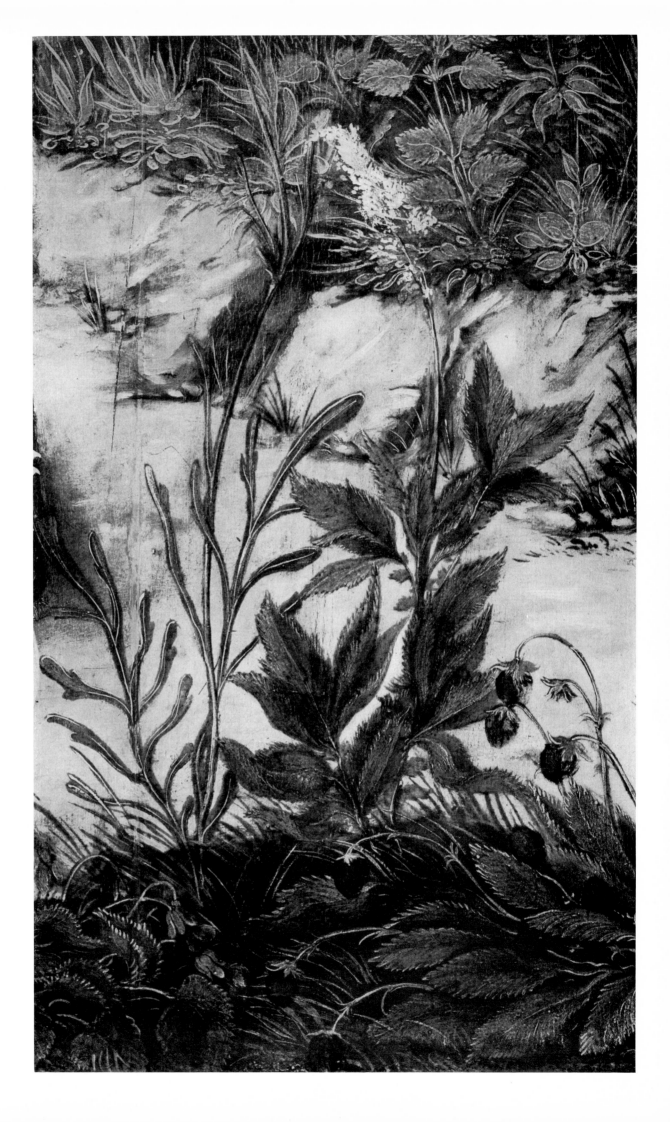

233 Detail of Plate 232

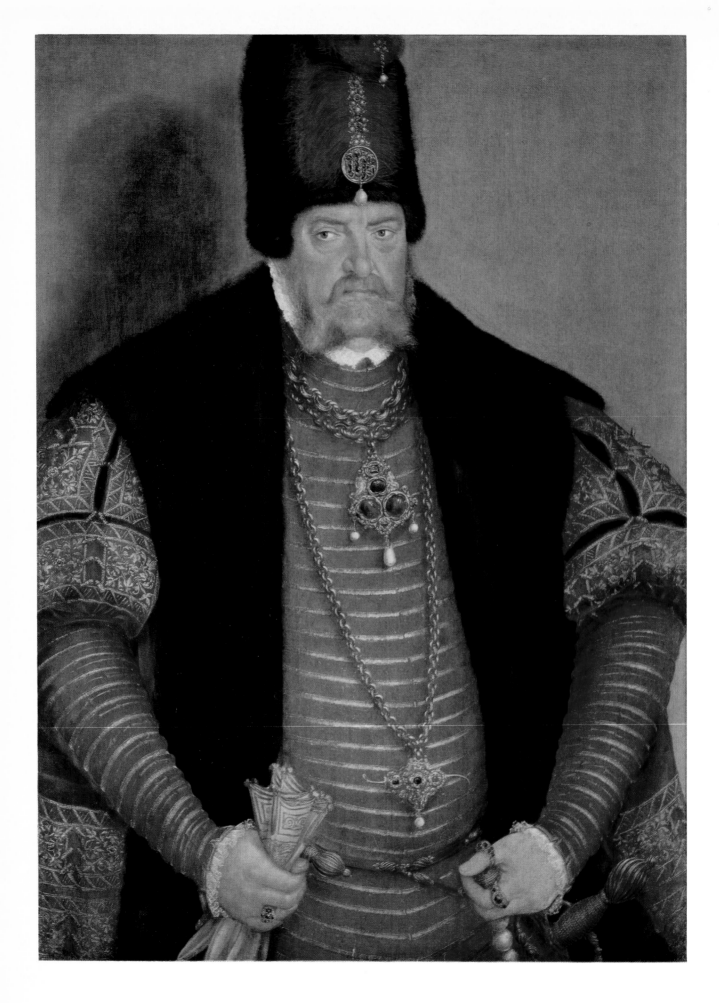

234 *Cranach the Younger*: Elector Joachim II of Brandenburg. circa 1555. West Berlin. See Plate 230

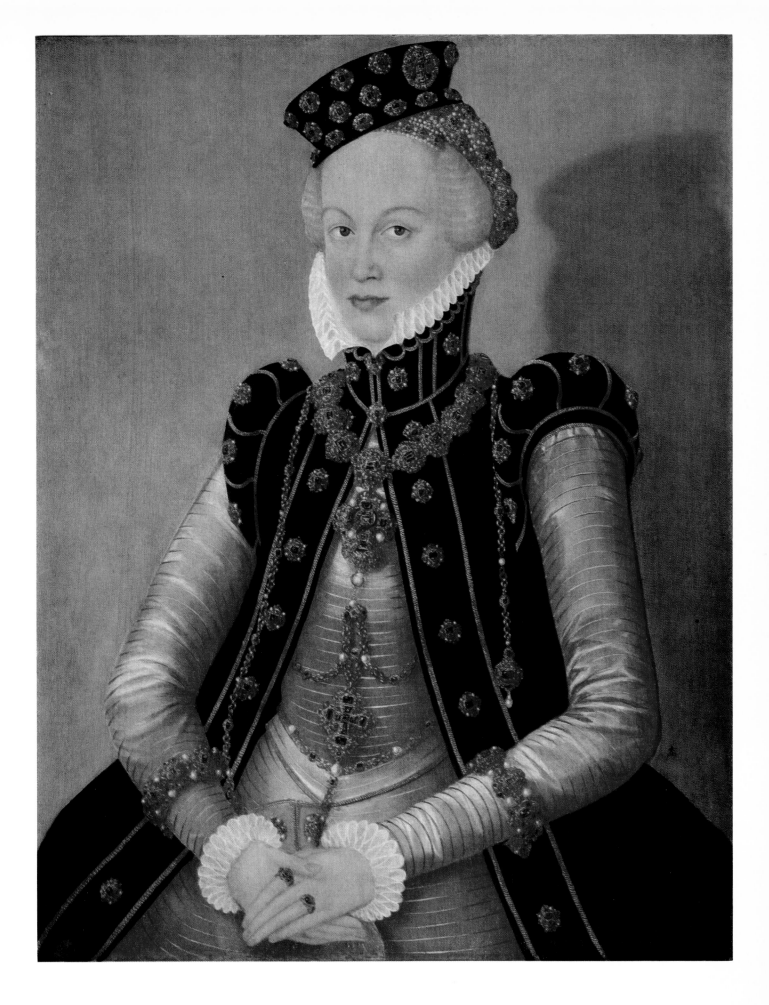

235 *Cranach the Younger:* Margravine Elizabeth von Ansbach-Bayreuth. circa 579. Munich

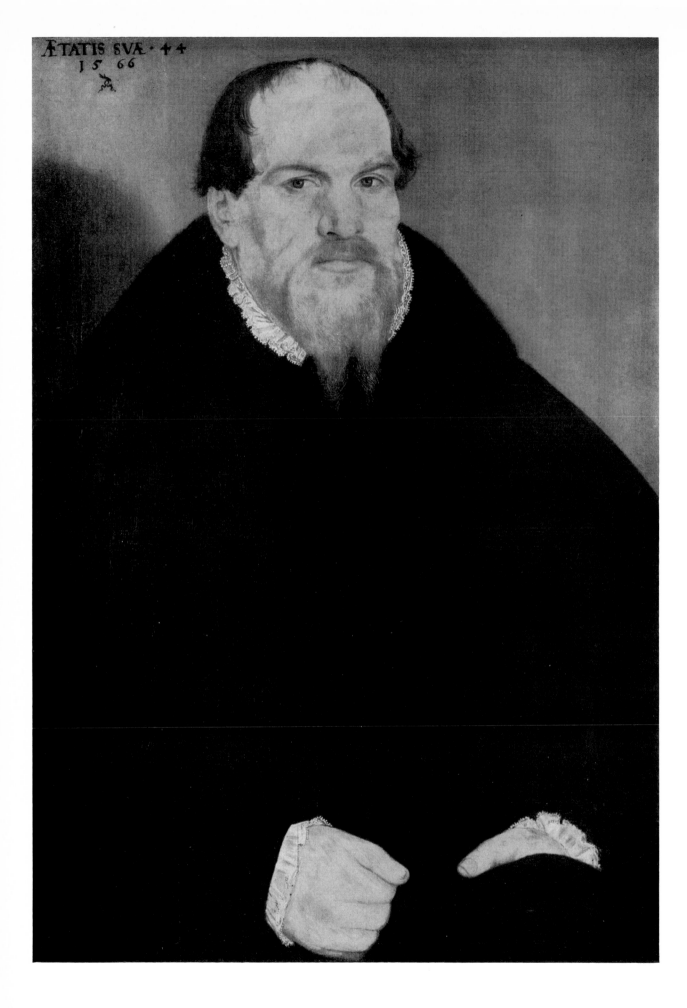

236 *Cranach the Younger*: Portrait of a Man of Forty-Four. 1566. Prague

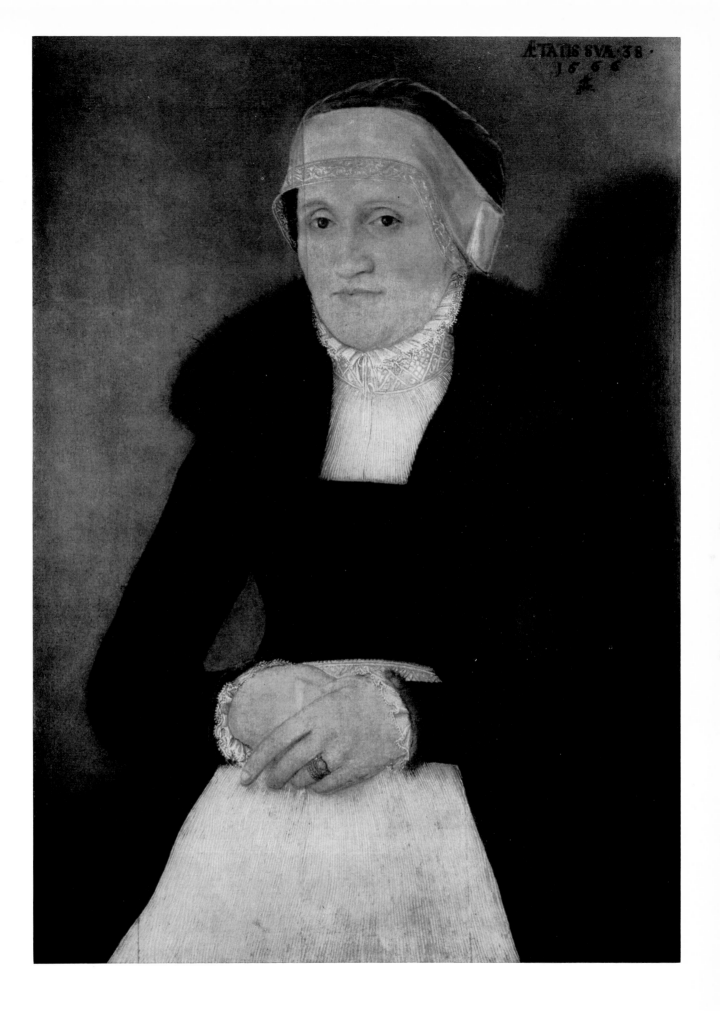

ÆTATIS SVA·38·
1566

237 *Cranach the Younger*: Portrait of a Woman of Thirty-Two. 1566. Prague

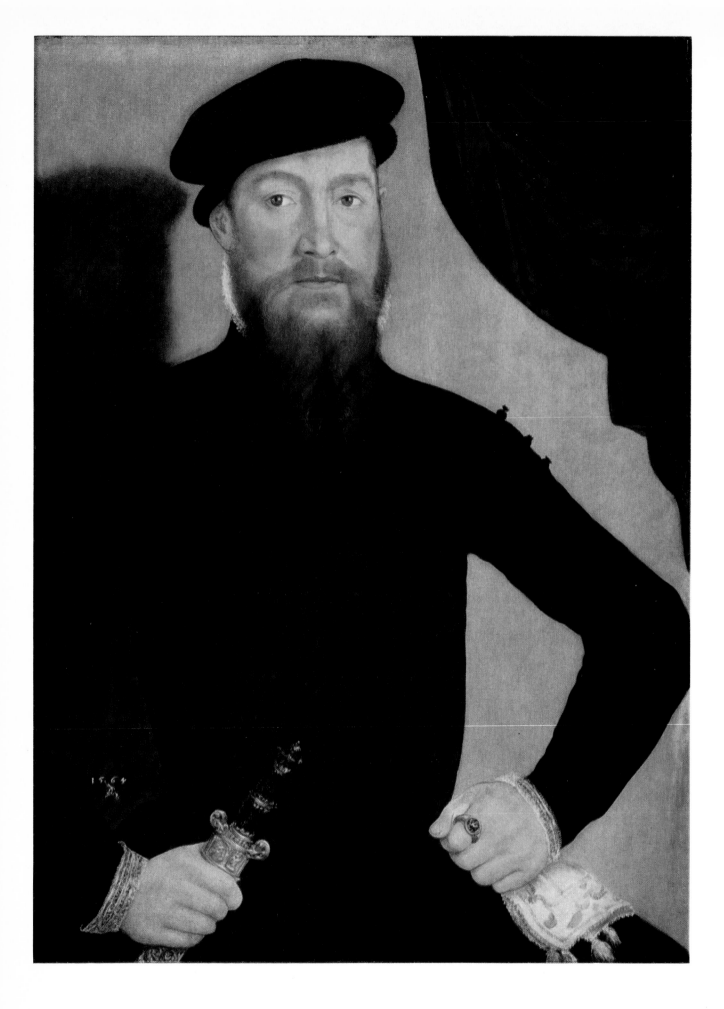

238 *Cranach the Younger*: Portrait of a Nobleman. 1564. Vienna

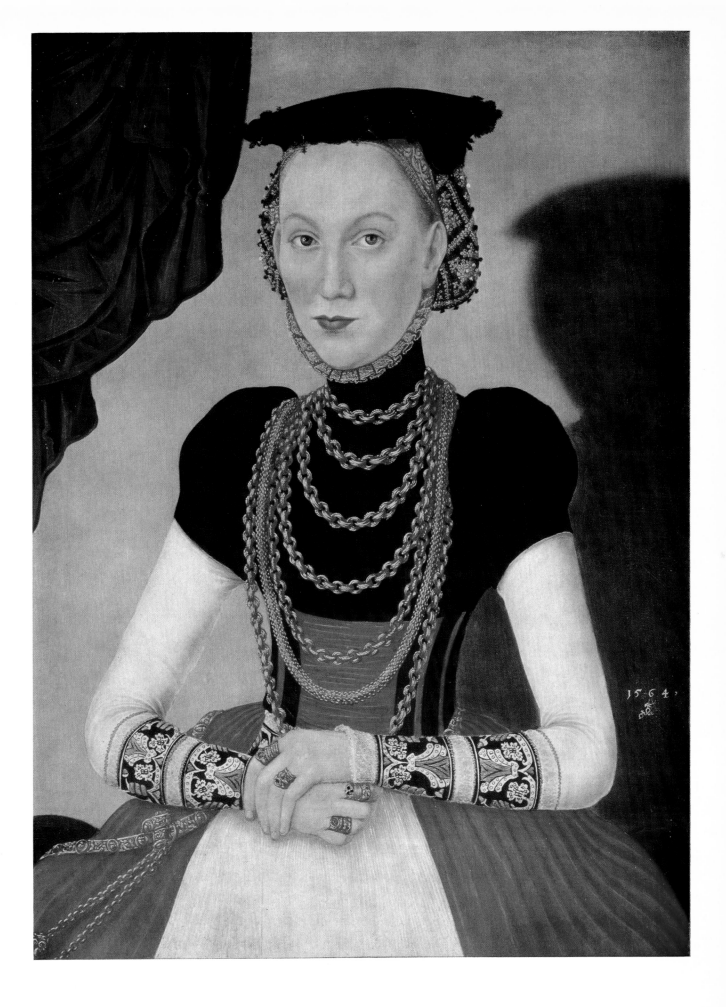

239 *Cranach the Younger:* Portrait of a Noblewoman. 1564. Vienna

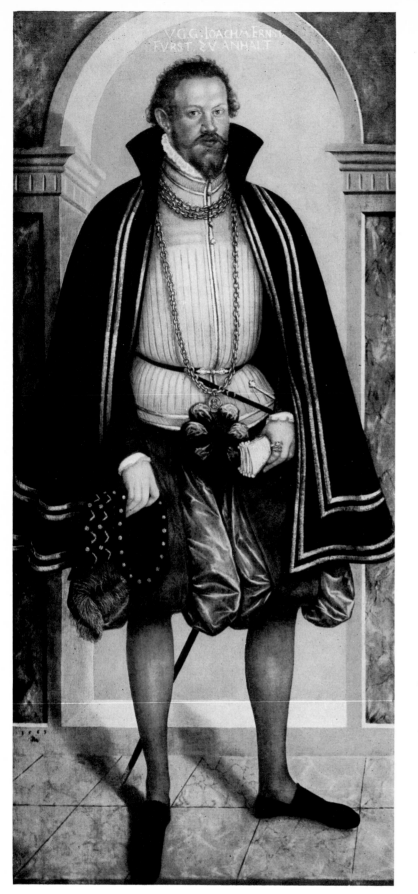
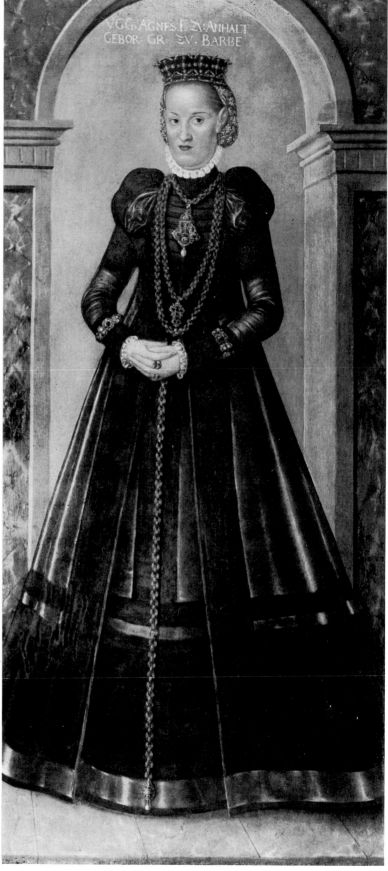

240 *Cranach the Younger*: Prince Joachim Ernest of Anhalt. 1563. Halle on the Salle
241 *Cranach the Younger*: Princess Agnes of Anhalt. 1563. Halle on the Salle

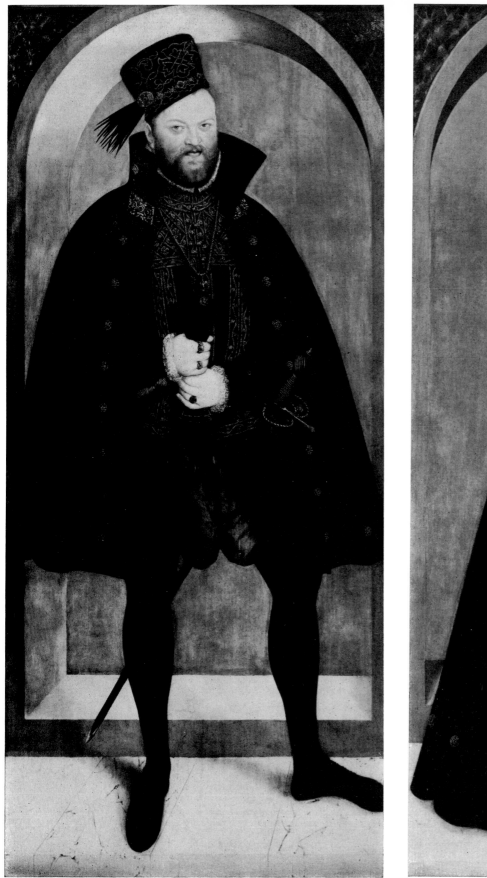
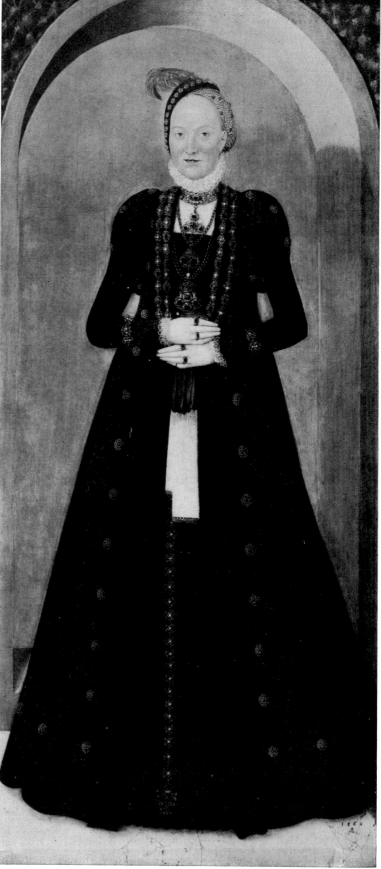

242 *Cranach the Younger:* Elector Augustus of Saxony. 1565. Dresden
243 *Cranach the Younger:* Electress Anna of Saxony. 1564. Dresden

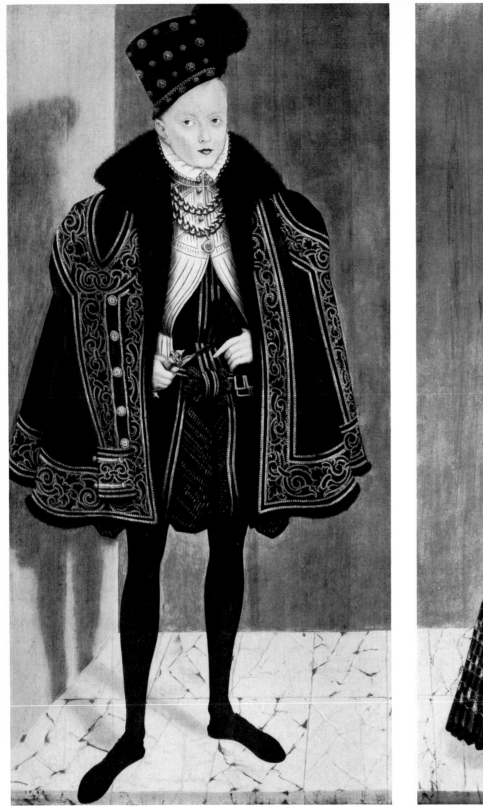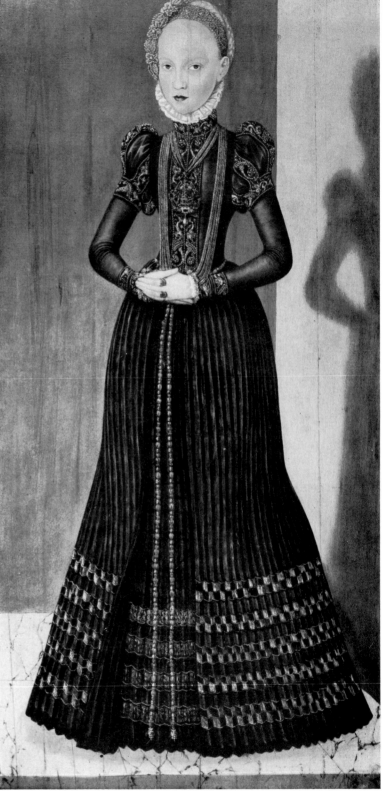

244 *Cranach the Younger:* Duke Alexander. 1564. Dresden
245 *Cranach the Younger:* Duchess Elizabeth. 1564. Dresden

246 *Cranach the Younger*: Sketch for a Portrait of Duchess Elizabeth. circa 1564. West Berlin

247 *Cranach the Younger*: Sketch for a Portrait of Duke Alexander. circa 1564. Vienna

248 *Cranach the Younger*: Sketch for a Portrait of Elector Augustus. circa 1564. Dresden

EHRE SEI GOT IN DER HOHE·

VND FRIDE AVFF ERDEN·

VND DEN MENSCHEN EIN WOLGEFALEN

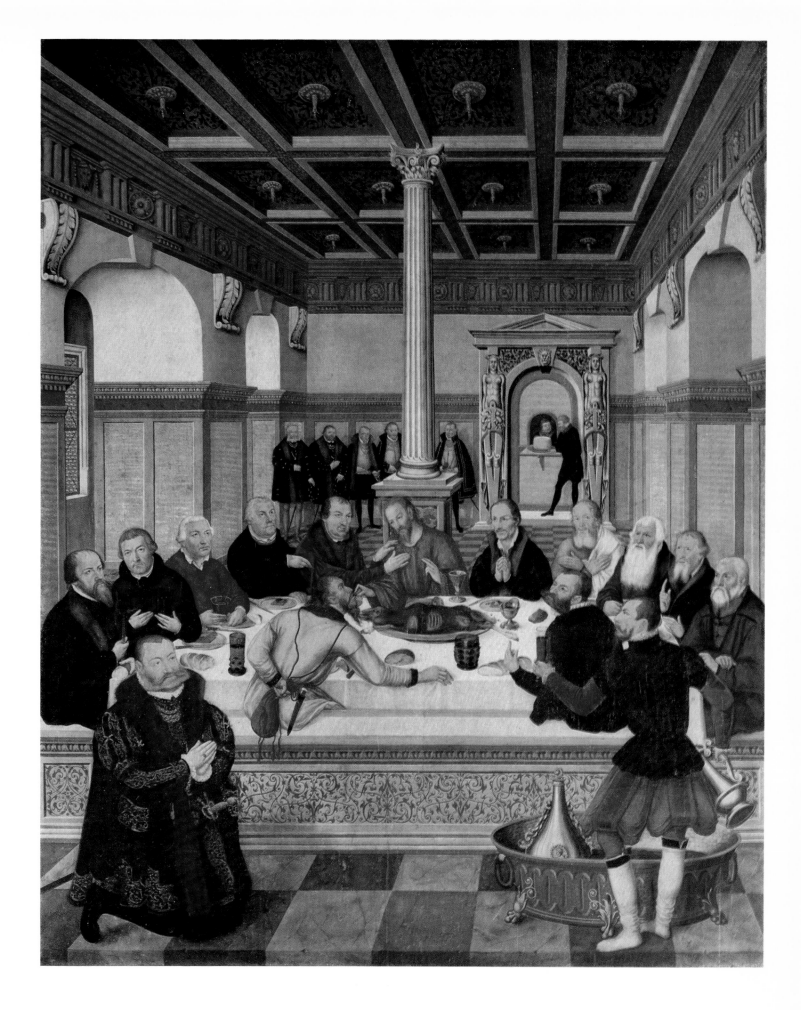

249 *Cranach the Younger:* The Nativity.
Memorial to Caspar Niemegk. 1564. Wittenberg

250 *Cranach the Younger:* The Last Supper. Memorial to Joachim of Anhalt.
1565. Dessau-Mildensee

251 *Hans Kreutter:* The Last Supper. 1564. Drawing. Schwerin

252 *Cranach the Younger:* The Last Supper. circa 1565. Drawing. Schwerin

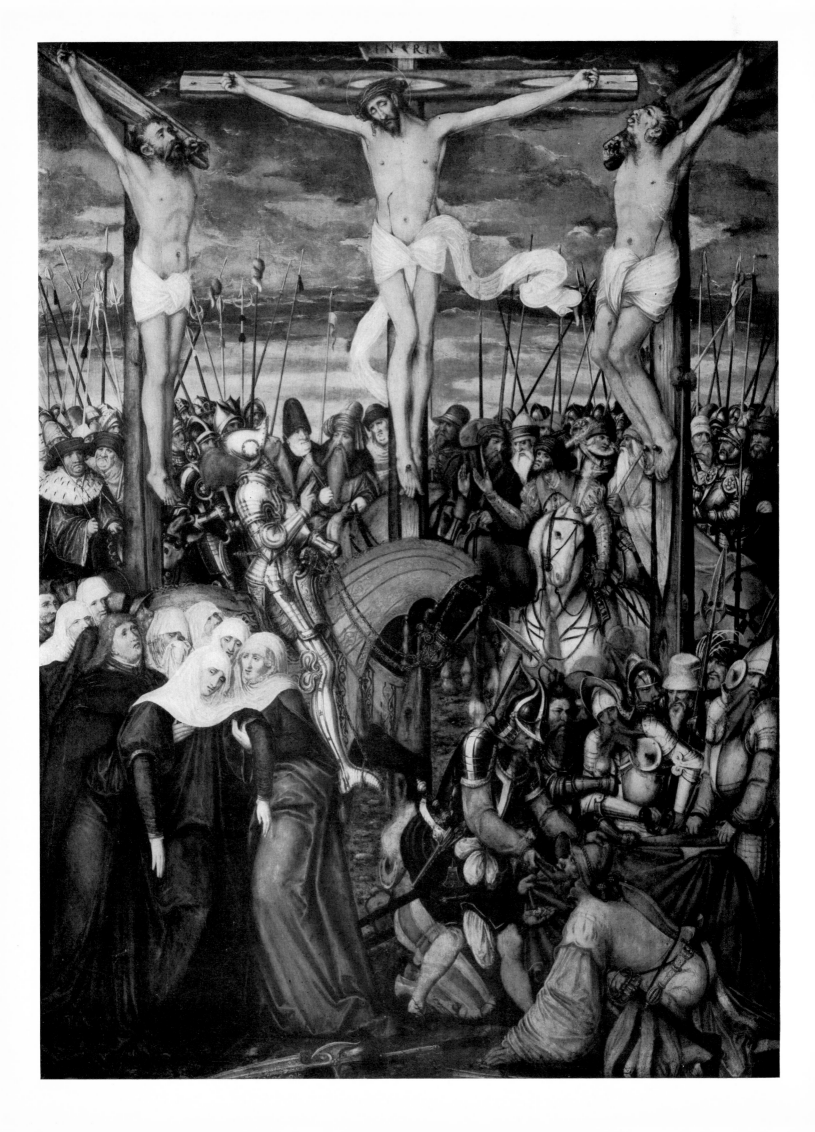

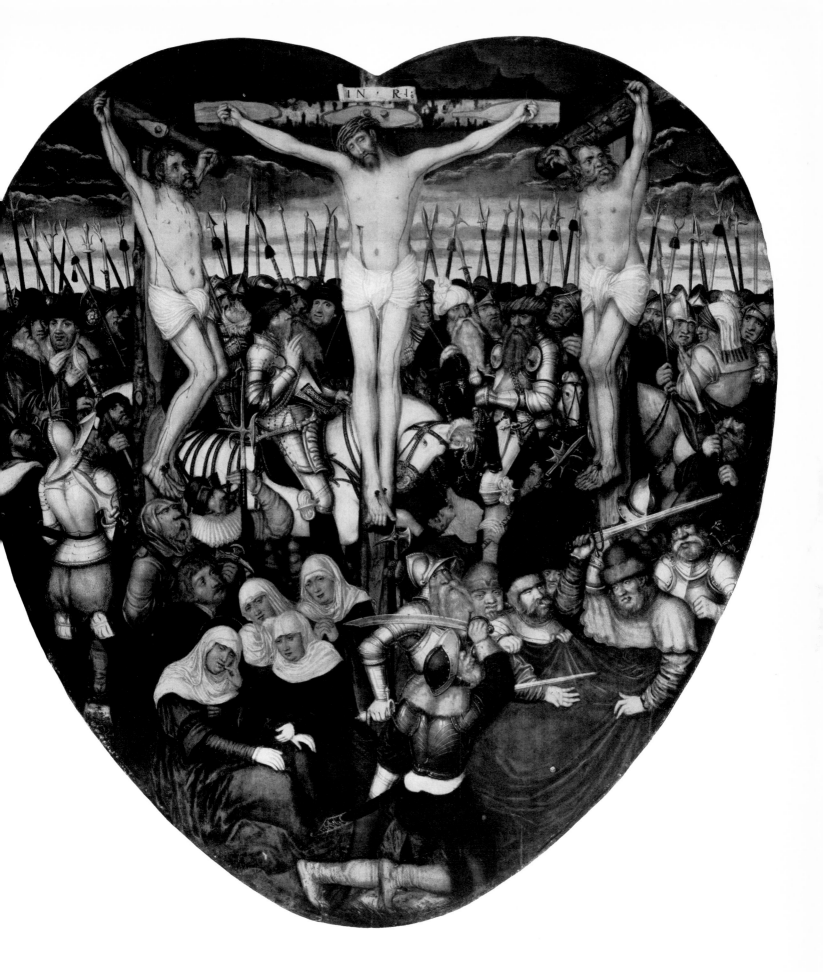

253 *Cranach the Younger:* The Crucifixion of Christ.
1573. Dresden, war casualty

254 *Cranach the Younger:* The Crucifixion of Christ.
Colditz Altarpiece. 1584. Nuremberg

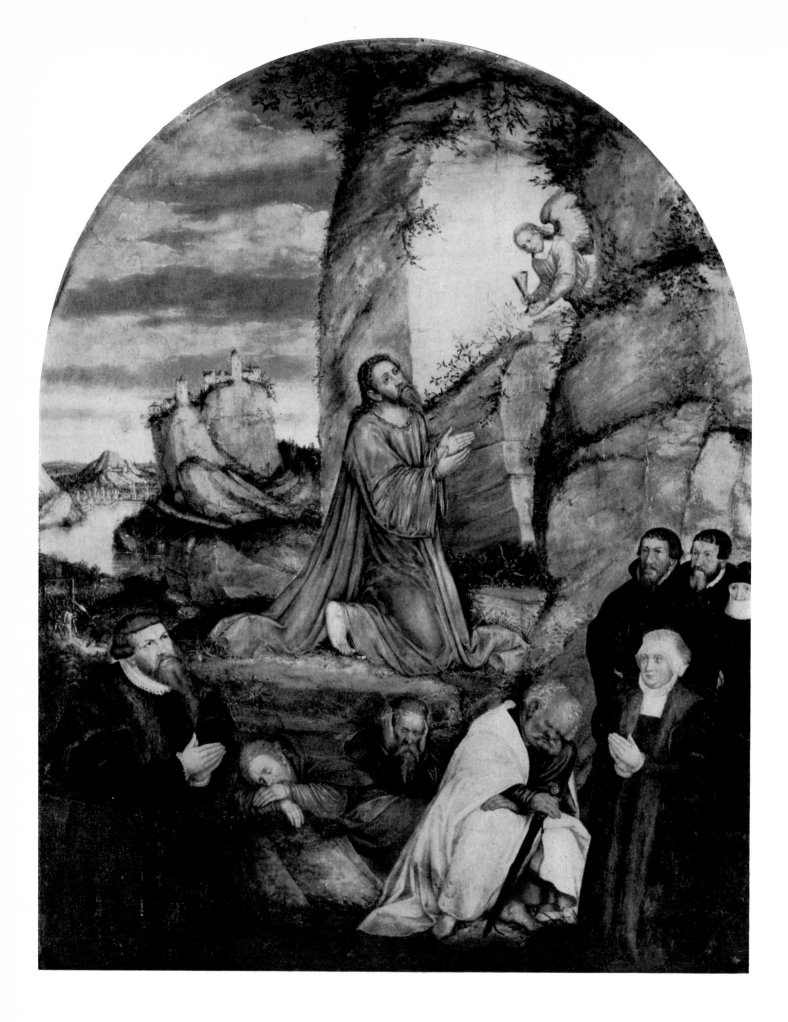

255 *Cranach the Younger:* The Agony in the Garden. Memorial to Anna Hetzer. 1575. Dietrichsdorf

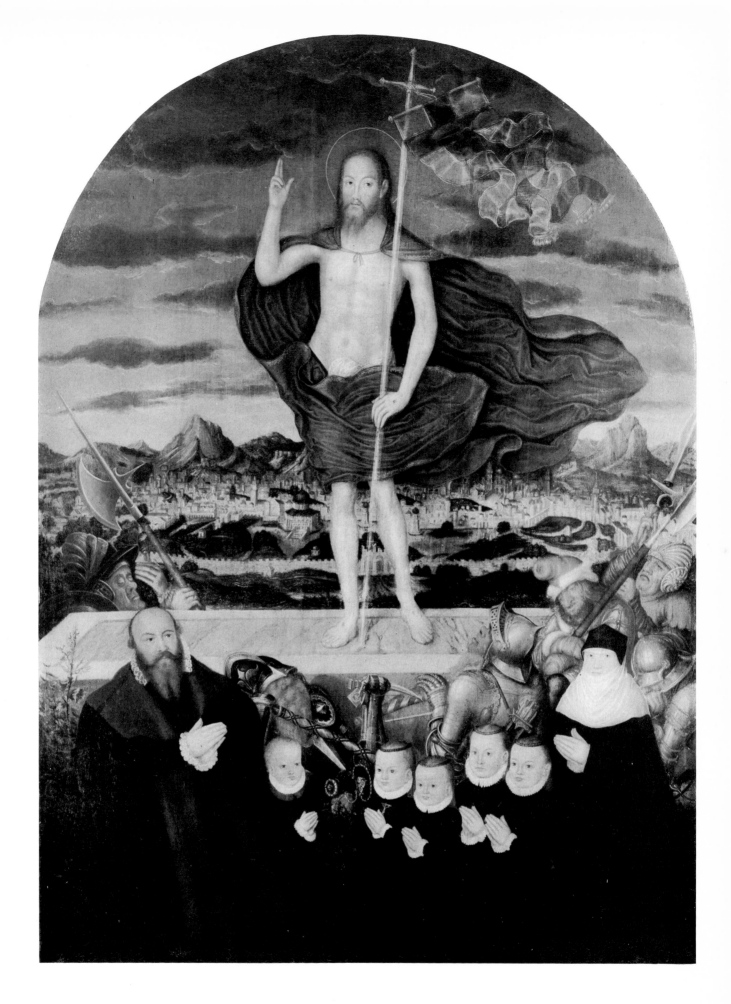

256 *Cranach the Younger:* The Resurrection of Christ. Memorial to Michael Teuber (?). circa 1580. Kreuzlingen, private collection

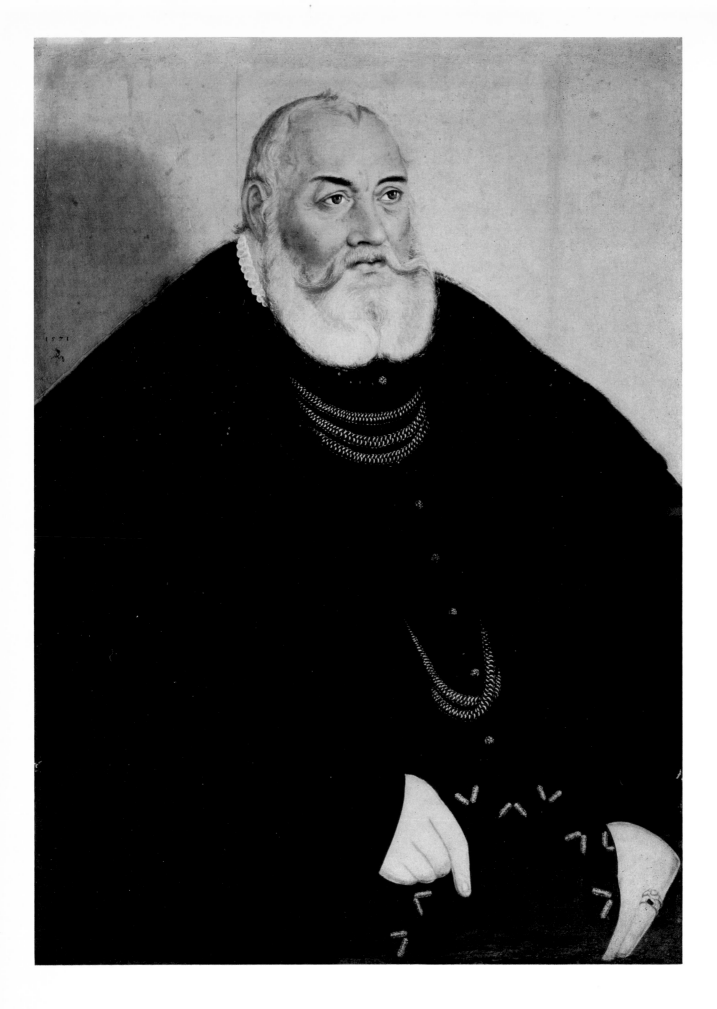

257 *Cranach the Younger:* Margrave George the Devout of Brandenburg-Anspach. 1571. West Berlin

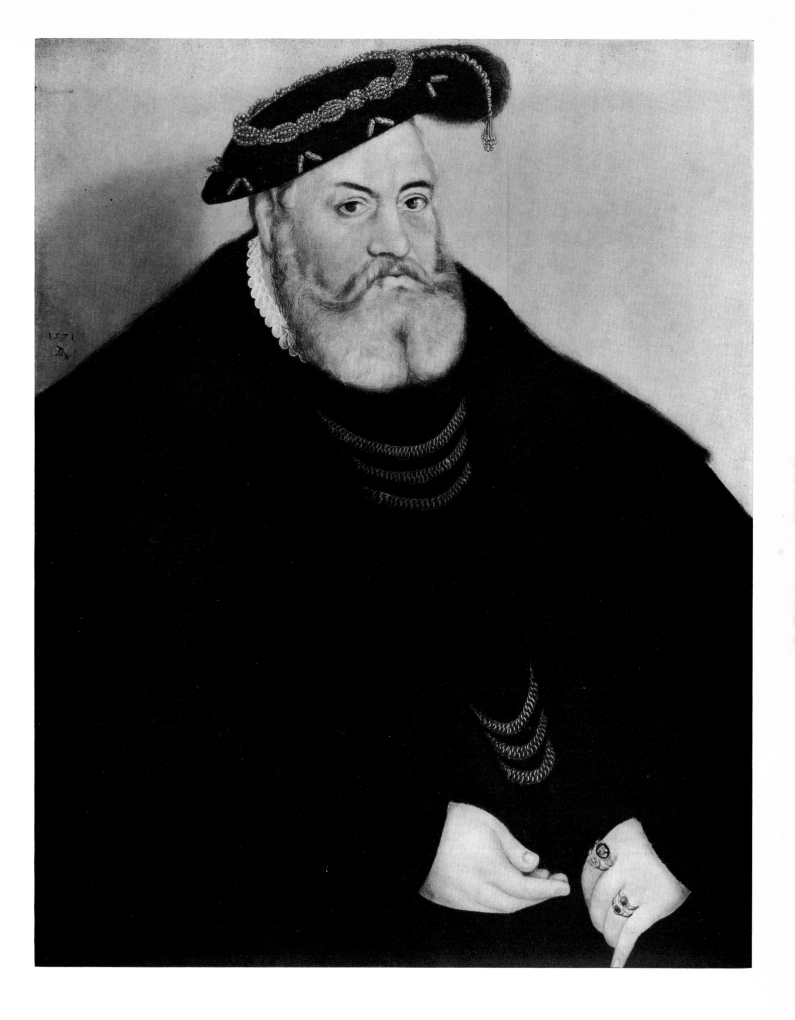

258 *Cranach the Younger:* Margrave George the Devout of Brandenburg-Anspach with Hat. 1571. West Berlin

259 *Cranach the Younger:* Head Study of a Dead Lynx. Drawing. Formerly Dresden

260 *Cranach the Younger:* Margrave George Frederick of Anspach-Bayreuth. circa 1564 (?). Potsdam

261 *Cranach the Younger:* Elector John Frederick of Saxony in the Armor He Wore at the Battle of Mühlberg. 1578. Dresden

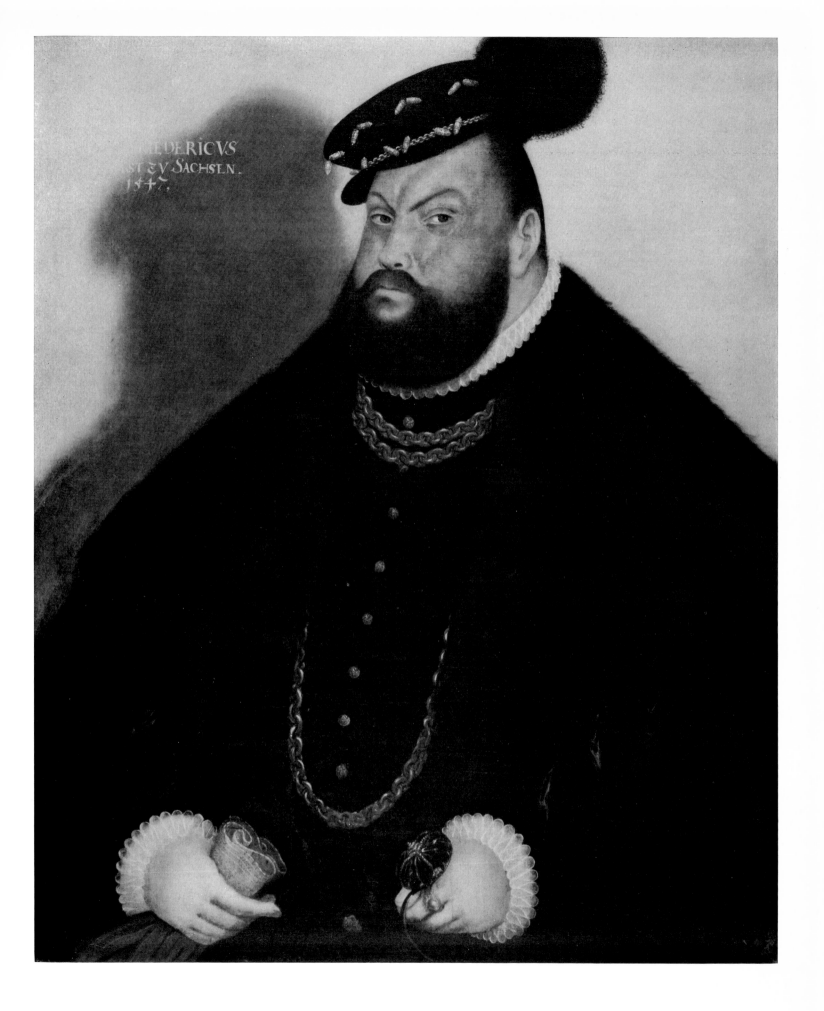

262 *Cranach the Younger*: Elector John Frederick in Everyday Dress. 1578. Weissenfels

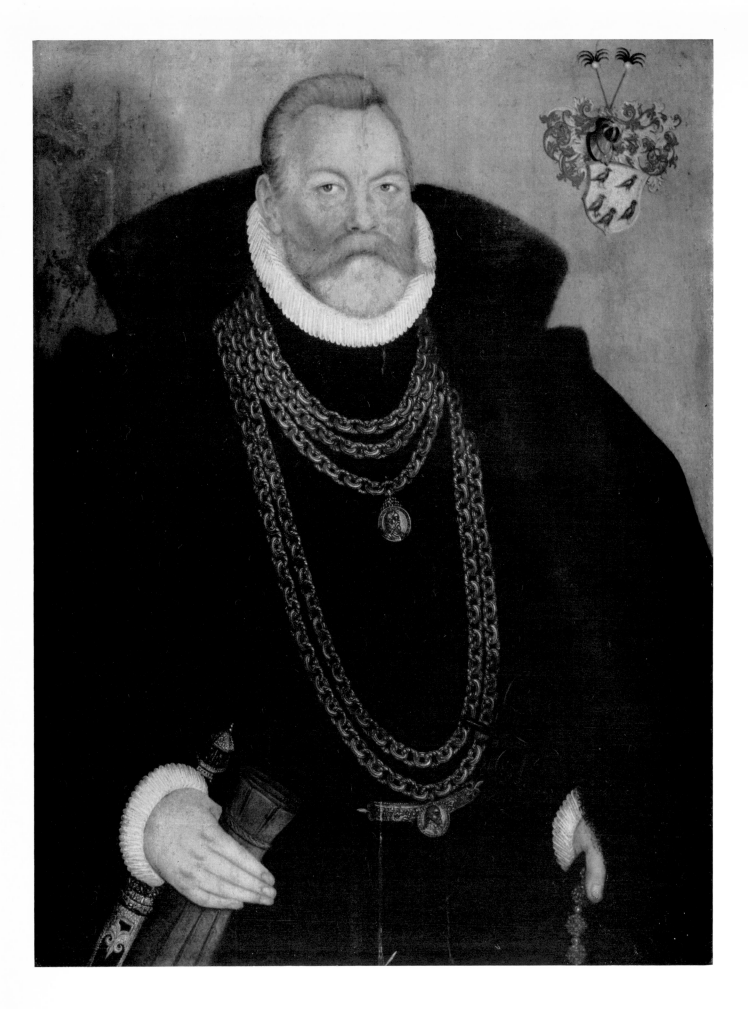

263 *Cranach the Younger:* Erich Volkmar von Berlepsch. 1580. Klein-Urleben

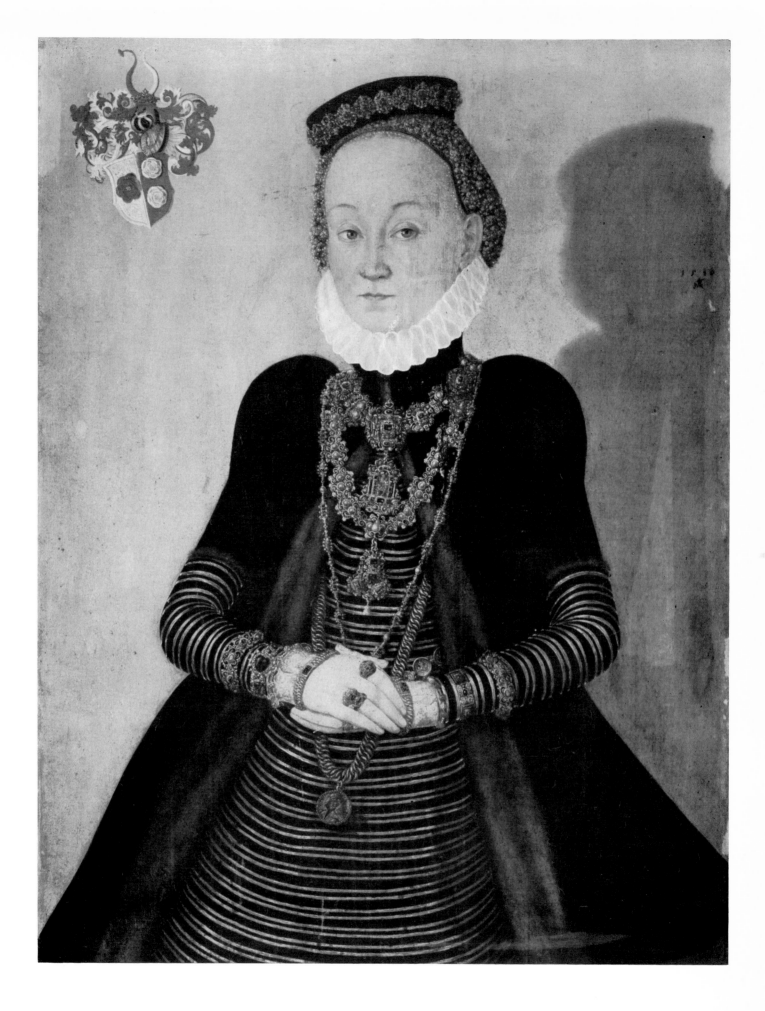

264 *Cranach the Younger:* Lucretia von Berlepsch. 1580. Klein-Urleben

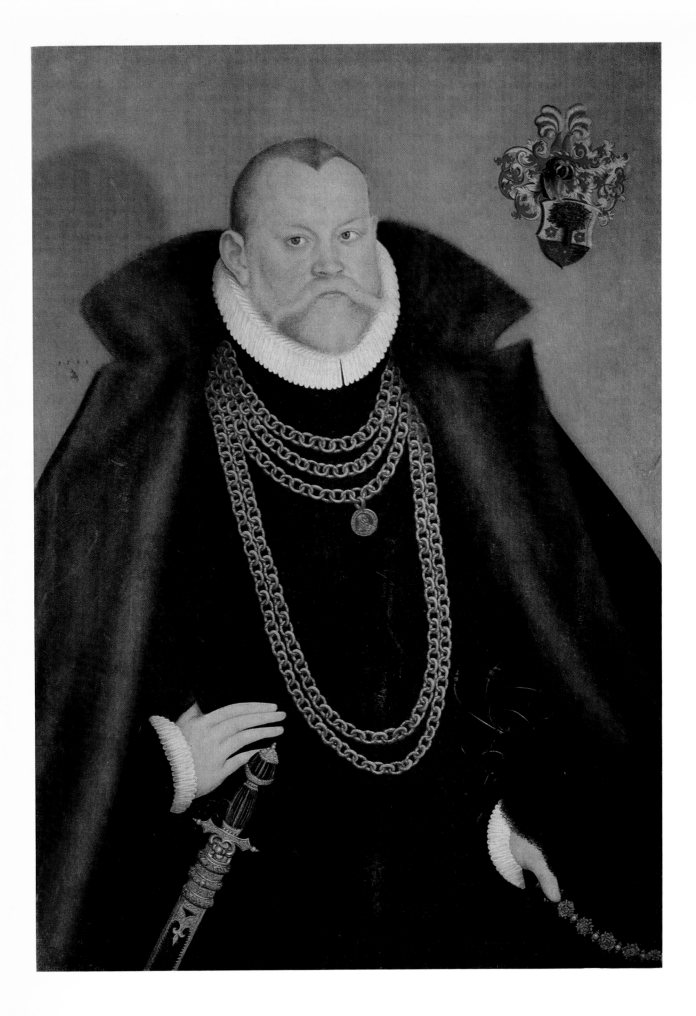

265 *Cranach the Younger:* Hans von Lindau. 1581. Ottendorf

 APPENDICES

 NOTES

For the full titles of works cited in the Notes, see the Bibliography, pp. 393–400.

1 Paracelsus, *Werke*, 11 (1928), 33. *Dürer* (ed. Rupprich), 1 (1956), 321.
2 Batkin (1972), 702–713, 854–862.
3 Lutz (1958), 199.
4 Schade (1968).
5 Glaser (1922), 5.
6 Schuchardt (1851), 109.
7 Karl Marx (1851–52). Marx-Engels, 8 (1969), 115.
8 Goethe, *Werke*, I/34, I, 189.
9 Girshausen (1957), 395. But see Koepplin (1966), 79.
10 Cf. Weixlgärtner (1949), 25.
11 Fehn, 3 (1953), 102ff. *Dürer* (ed. Rupprich), 1 (1956), 19.
12 Erroneous information on this matter is corrected in Fehn, 3 (1953), 107–117 with illustrations.
13 Information re Coburg in Feyler (1950), 16, without source reference.
14 Fehn, 1 (1950), 186.
15 Strack (1925), 233. Strack (1931), 472. Fehn, 3 (1953), 119ff.
16 But cf. Fehn, 3 (1953), 118.
17 Strack (1925), 233. Fehn, 3 (1953), 103ff.
18 Sitzmann (1950), 41. Fehn, 3 (1953), 125.
19 Fehn, 3 (1953), 119–125.
20 Röhricht-Meisner (1883), 37, 48. The photograph of a letter from Duke Christopher dated May 28, 1493 (also cited by Trautmann), lends credence to Trautmann's assertions. Röhricht (1900), 177.
21 The most comprehensive list of participants is given by Hans Hundt (Röhricht-Meisner, 1883). It partially coincides with the list of Johann Sebastian Müller (1701).
22 Duke Christopher was in touch with Thoman Burgkmair in 1492–93. In 1493, together with Elector Frederick, he donated a still-existing silver statuette to Kaisheim Monastery. (*Hans Holbein the Elder*, Augsburg [1965], 129, 203, Fig. 272).
23 Woodcut, G., 648; Holl., 123.
24 According to Gunderam, 1556 (Lüdecke [1953], 84).
25 Cf. Frauendorfer (1958).
26 The best example is Michael Wolgemut's 1479 altarpiece for Zwickau. (*Dürer-Zeit*. Dresden [1971], 273.)
27 Previously referred to in the literature as Master L Cz (Lehrs, VI, [1927]. Weinberger [1924], 169). For the deciphering of the monogram, see Anzelewsky (1965), 148.
28 Cf. p. 15.
29 Dodgson (1903), 284–290. Holl., 28.
30 Prints are preserved in Dresden; Vienna (from the collection of King Frederick Augustus II of Saxony); Krakow, Jagellonian Library, Ink, 2850; Weimar, Nationale Forschungs- und Gedenkstätten der klassischen deutschen Literatur, Goethe's art collection (Schuchardt [1848], 111, No. 57).
31 Ameisenova (1958), 153ff., No. 190, Pl. 220 (here, however, still listed as a painted book illustration executed in Krakow toward 1500). According to information kindly supplied by Mr. M. Radojewski of Wrocław and Mrs. C. Nesselstrauss of Leningrad, other copies of the Missale Cracowiense preserved in Krakow, Wrocław and Leningrad have either no liturgical Crucifixion at all or the weak woodcut Schramm, XVIII, No. 613, first used for the 1490 Missale Strigoniense.
32 Bayonne, Museum, W. 898.
33 Cf. Winkler (1936), 155.
34 An almost unused copy of Dürer's measurement instructions, formerly in Cranach's possession, came to Dresden in 1591 and is preserved (rebound) in the Sächsische Landesbibliothek in Dresden (*Buchmuseum* [1956], 13).
35 *Dürer* (ed. Rupprich), 2 (1966), 130, 132.
36 Levey (1964).
37 *Dürer* (ed. Rupprich), 1 (1956), 306.
38 *Dürer* (ed. Rupprich), 1 (1956), 327. Weniger (1932), 21.
39 Konrad Celtis (ed. Adel), 67.
40 Celtis: "Quid laus efficiat" (ed. Adel, 116ff.).
41 Scheurl (1509) (Lüdecke [1953], 50).
42 Koepplin (1964), 33ff. and (1966), 79, Note 5.
43 Vienna, Museum, F.-R., 1.
44 Cf. Dürer's drawing in Basel, W., 319. (Information from Dieter Koepplin.)
45 Woodcut, G., 558; Holl., 26. Only copy in West Berlin.
46 R., 2 and 3.
47 Woodcut, Holl., 29.
48 The model appears to be the woman standing beneath the cross in Dürer's woodcut, B., 11.
49 Cf. Note 288.
50 Woodcut, Holl., 89.
51 Woodcut, G., 557; Holl., 24. Only copy in New York.
52 Woodcut, G., 559; Holl., 25. New York and West Berlin.
53 It is unlikely that this was the mark of the block maker. Some slight resemblance to the serpent mark (cf. Geisberg [1929]) certainly exists. On workshop marks see Spruth (1965).
54 Dürer's woodcuts, B., 6 and 11.
55 The model for the landscape motif was Dürer's engraving, B., 61; the kneeling woman may be compared with the foreground figure in woodcut, B., 12.
56 Koepplin (1971), 9, refers to F.-R., 3, and F.-R., 207.

57 Vienna, Museum, F.-R., 4.
58 Winkler (1936), 151 ff. Thöne (1939), 16 ff.
59 Ankwicz-Kleehoven (von) (1959), 35, assumed that Cuspinian commissioned this painting. Koepplin (1964), 28, assumes that it was Johannes Fuchsmagen.
60 Ankwicz-Kleehoven (von) (1959).
61 Winterthur, Museum, F.-R., 6 and 7.
62 Pope-Hennessy (1966), 223.
63 Koepplin (1964), 89.
64 Koepplin (1964), 99.
65 Jung, 1 (1955), 96.
66 Koepplin (1964), 99.
67 A woodcut of God, the Creator, Ruler of the Universe, reproduced in Jung, 2 (1955), 271, Pl. 190, suggests this interpretation.
68 According to an observation by Koepplin (1964), 103 ff.
69 Jung (1955). Koepplin (1964).
70 Koepplin (1964), 146.
71 Evident in the case of Paracelsus. (Betschart [1952], 57).
72 Koepplin (1964), 61.
73 Scheurl (1509). (Lüdecke [1953], 50).
74 The story comes from Pliny. It has been applied to other artists; Boccaccio ascribed it to Giotto.
75 Nuremberg, Museum, F.-R., 8. The identification of the subject as Johann Stephan Reuss is justifiably questioned by Koepplin.
76 West Berlin, F.-R., 9.
77 See Note 80.
78 Buchner (1953), No. 187; cf. Signorelli's picture of an Italian jurist in West Berlin.
79 Buchner (1953), No. 167. Albrecht Dürer 1471–1971, Cat. No. 75.
80 Munich, F.-R., 5, dated 1503. Cf. Kuhn (1972).
81 Woodcut in the 1493 Strassburg Missal published by Johann Grüninger, Meder, 179.
82 Anzelewsky, No. 26.
83 Cf. Weinberger (1933), 10.
84 Crucifix in Dresden; most recently in Dürer-Zeit, Dresden (1971), No. 144. See Note 639.
85 Vienna, Academy, F.-R., 2.
86 Vienna, Academy, F.-R., 3.
87 Cf. Cima da Conegliano's St. Jerome in Milan, Brera (before 1496); Coletti (1959), No. 74.
88 Koepplin (1964), 56. Cf. Mänz (1934), 193.
89 F.-R., 10, signed and dated 1504.
90 The first reference to Dürer's woodcut, B., 102, of 1496–97 in this context is in M. Schütte's Der Schwäbische Schnitzaltar, Dissertation, Berlin (1903) (Thesis No. III).
91 An example of this is Cranach's painting of Christ Giving His Blessing, F.-R., 47, which refers back to Barbari's picture in Dresden but assigns most of the individual motifs to different contexts. Cranach's detachment and rearrangement of the figures recalls similar formal procedures in Picasso.
92 Cf. Cranach's woodcut, B., 3, of 1509. Claude Lorrain later associated morning with the representation of the Flight into Egypt. Dresden Gall., No. 730 (Röthlisberger [1961], 1, 274).
93 Behling (1957), 120 ff.
94 Munich, R., 5, signed and dated 1504.
95 Cf. R., 1, R., 4 and R., A 3 (St. George in Budapest, certainly by Cranach's own hand).
96 At all events the decisive battle of the war was fought at Regensburg, and Burgkmair hastily made a woodcut of it.
97 According to Johannes Carion, the example of the reformed University of Vienna inspired the founding of the universities of Wittenberg and Frankfurt-an-der-Oder. (Ulmann [1891], 733.)
98 The statutes of Prague, Paris and Oxford placed under the authority of the university all copyists, illuminators, parchment dealers, bookbinders, owners of libraries, of apothecary shops, etc.
99 Fritz Bellmann lists the artworks in the city church in his forthcoming Wittenberg Inventory, the manuscript of which he kindly made available to the author.
100 Harksen (1967), 352 ff.
101 This artist deserves more thorough study. The domiciles of his relatives – Mausis (?), Grosswalbur, Häselrieth (Eselreich) near Hildburghausen – suggest that he came from southern Thuringia.
102 Kirn (1925), 130–134. Servolini (1944), 105 ff. Dürer (ed. Rupprich), 1 (1956), 44.
103 Dresden Gall., No. 57. Cust (1892), 142. Venezianische Malerei (1968), No. 2.
104 Munich, No. 5066 (1443).
105 Formerly in the Wittenberg Castle church. Mentzius, 1 (1604), 48. Hainhofer (1629), 174. Meisner (1668), 146. Sennertus (1678), 165 ff.
106 Scheurl (1509) (Lüdecke [1953], 52).
107 For a survey see Schade (1961–62), 29–39.
108 A Weimar court document of 1552 explicitly states that Cranach received no written contract from Electors Frederick and John. The notation "lifetime tenure" in a document of 1534 also seems to refer to this situation. (Schuchardt, 1 [1851], 92.)
109 Cf. Eastlake (ed. Hesse), 1907, Huth (1923). The yearly sum of 100 guilders corresponded to Barbari's salary as the emperor's court painter. (Dürer [ed. Rupprich], 2, 33.)
110 Koch (1954–55).
111 According to Christian Egenolff, in 1533 Dürer, Barbari, "Wittenberg painter, and others" held such privileges. (Dürer [ed. Rupprich], 3, 454.)
112 The electoral coats of arms are not shown on the portraits of Luther or on many of the occasional works, notably the Execution of John the Baptist (B., 61) and Elector Frederick Adoring the Madonna (B., 77). In many cases they have been corrected, probably first in The Penance of St. John Chrysostom of 1509, where the new escutcheon had to be set a little higher. This indicates the importance attached to such precise identification of the prints.

113 Woodcut, B., 76; G., 609; Holl., 69.

114 The angel supporting the shield on the upper left is strikingly similar to the naked angel between the three clothed ones playing musical instruments in the painting. As the infrared photograph, kindly supplied by Wilhelm H. Köhler, shows, the head was first drawn with the eyes open.

115 The same group of saints appears at the feet of the Man of Sorrows in the painting of 1515, formerly in Dresden, F.-R., 63, indicating that both works were inspired by a similar concern.

116 The resemblance between St. Sebastian and the side panels of Dürer's Dresden altar (Anzelewsky, No. 40) is striking. The figure of the Virgin is derived from Dürer's woodcut, B., 12.

117 Woodcut, B., 67; G., 597; Holl., 83.

118 Anzelewsky, No. 52. Engraving of the Burgundian standard-bearer, B., 87.

119 Woodcut, B., 56; G., 593; Holl., 76; signed and dated 1506.

120 Cuttler (1956), 1.

121 Woodcut, B., 75; G., 604; Holl., 88; signed and dated 1506.

122 Woodcut, B., 72; G., 608; Holl., 94; signed and dated 1506.

123 Woodcut, B., 59; G., 595; Holl., 80; signed and dated 1506.

124 Woodcut, B., 117; G., 626; Holl., 114; dated 1506.

125 Woodcut, G., 628; Holl., 111; signed and dated 1506.

126 Woodcut, B., 124; G., 620; Holl., 116; signed and dated 1506.

127 Woodcut, B., 119; G., 632; Holl., 115; signed (1506).

128 The first-state print in Dresden is exquisitely colored. (Geisberg [1929], Sheet 82.)

129 F.-R., 12–14 (16). The order of the side panels has been revised as proposed by Koepplin. The motif of the continuous storm cloud clearly links the side panel showing SS. Barbara, Ursula and Margaret (F.-R. 12) with the right-hand margin of the center picture.

130 Falk (1968), 41 ff. Lossnitzer (1913) assumes this to be a counterpart of the St. Catherine altarpiece. Center panel in Munich; side panels in Nuremberg.

131 Woodcuts, B., 120 and 121; G., 629, 630; Holl., 109; signed.

132 The most recent suggestion is Torgau, proposed by Peter Findeisen in preparing his inventory of the historic artworks.

133 Her picture appears on the seal of the faculty still preserved in Wittenberg, Lutherhalle (on loan from the Martin Luther University of Halle-Wittenberg) and on the seventeenth-century university lectern in the Lutherhalle.

134 Jung (1955).

135 Probably a student of Celtis; in Cologne (?) toward 1500, in Wittenberg from 1505 to ca. 1520. Hartfelder (1892), 140 ff.

136 Sibutus (1507). Is this name the key to the identity of the unknown master of the St. Bartholomew altarpiece, who probably came from Utrecht and worked in Cologne until about 1510? Cf. K. G. Boon in the exhibition catalogue *Der Meister des Bartholomäusaltares, Der Meister des Aachener Altares*, Cologne (1961), 13–19.

137 Anzelewsky, No. 98. Arnolds (1959). Białostocki (1959). Winzinger (1966).

138 Weixlgärtner (1928).

139 Nuremberg Museum. Albrecht Dürer 1471–1971, No. 334.

140 Hentschel (1948), 41. The idea of painting a fly on an object as a tongue-in-cheek proof of its tangible reality apparently goes back to classical antiquity. Plutarch mentions it. (Henkel [1967], 1494.)

141 Scheurl (1509) (Lüdecke [1953], 49–55). *Dürer* (ed. Rupprich), 1 (1956), 292 ff.

142 Thulin (1955), 159 ff.

143 *Dürer* (ed. Rupprich), 1 (1956), 306. Jantzen (1959), 169.

144 Lüdecke (1953), 54.

145 F.-R., 18 and 20.

146 Scheurl's salutation in 1509 was "Ad Lucam Chronum." This coincides with Karlstadt's "Ad Lucam Chronum."

147 Strack (1925), 234. Fehn, 1 (1950), 83. Fehn, 3 (1953), 215 ff.

148 Cf. the text of the patent of nobility (Lüdecke [1953], 59 ff.). Authentic pen drawing in Erlangen; magnificently executed on the paintings, F.-R., 21 (1509), and F.-R., 54 (1514).

149 Henkel (1967), 442: "Art Shapes Nature."

150 The coat of arms was conferred by the emperor in 1516 (Falk, [1968], 10). The escutcheon with the bear's head in profile (Hupp [1928], Bl., 35; Rupé (1912), 32) occurs on the famous woodcut, G., 84, in the Triumphal Procession, Holl., 28, and drawn on the manuscript of the Triumphal Procession in the Dresden Kabinett. Hupp (1928) notes the derivation of the escutcheon from the lion's head of Helchner of Nuremberg and the eagle's head of Jan der Gmünder.

151 Siebmacher's *Wappenbuch* (ed. Seyler) (1898), 13, Pl. 14, 6. The device consists of a dragon's body, crowned, growing out of the left-hand margin. The Erfurt archives contain no record of its use as a guild seal.

152 Andreas Bodenstein of Karlstadt, Lower Franconia; in Wittenberg 1505–1522; dean of the faculty of theology in 1512. First an ally, then an opponent of Luther. Kähler 1955.

153 Philipp Engentinus of Engen (Hegau); in Wittenberg 1508–1514. Grimm (1959).

154 Through the intervention of the emperor, Riccardo Sbroglio of Friaul came to Wittenberg in 1505. Later he lived in Augsburg, where he translated into Latin the *Theuerdank* glorifying the life of Maximilian I.

155 See Geiger (1886), 108 ff. Koepplin (1966).

156 The serpent sign on the Berlin Lucretia drawing, R., 16, is obviously a forgery in the style of the signature on woodcut, Holl., 27. The drawing and its counterpart can be dated around 1525. Köhler and Steigerwald (1973), 43, agree.

157 We know of no other paintings signed with an emblem.

158 Dürer used his escutcheon as a signature on the big woodcut of the Triumphal Arch, 1512–1515, B., 138; M., 251, and on the Celestial Map of the Southern Hemisphere, B., 152; M., 259.

159 Cranach's patent of nobility of 1508, however, mentions only various customs of chivalry. (Lüdecke [1953], 60.)

160 Ulmann, 2 (1891), 338.

161 Pusikan (1877), 18.

162 *Dürer* (ed. Rupprich), 1 (1956), 53, Note 39: letter to Pirkheimer of August 18, 1506.

163 Grotemeyer (1970), 143.

164 Ulmann, 2 (1891), 354.

165 This is proved by the fact that Cranach did not receive summer clothing. He was expected in Nuremberg about July 8, 1508. Emperor Maximilian's presence in the Netherlands seems to have stimulated artists in general. According to Harbison (1968), Lucas van Leyden's engraving of Mohammed (B., 126) may have been connected with his opposition to drunkenness. Cf. Scheidig (1972).

166 Koch (1954–55), 18.

167 See Lüdecke (1953), 51.

168 According to Gunderam (1556) and Sternenboke (1609). See Lüdecke (1953), 86, 89ff. There is, however, no record of the estates having paid homage to Archduke Carl in 1508. He had appeared before the assembled estates in Malines on October 17, 1506; homage was paid in Brussels on January 5, 1515. (Information kindly supplied by J. Decavele, city archivist of Ghent, April 11, 1971.)

169 Cf. F.-R., 17, 18, 25, 27, 62.

170 Taubert (1967).

171 Works of Netherlands origin include the portrait of Duke Albert (1443–1500), Dresden Gall., No. 806 B, which Cranach copied (Buchner [1953], 168ff., No. 193ff.), and the altarpiece in Dresden Gall., No. 841, from the Wittenberg Castle church.

172 Berlin, Museum, F.-R., 88.

173 *Dürer* (ed. Rupprich), 1 (1956), 151, Note 100.

174 De Meyer (1942).

175 A Burgkmair drawing at Chatsworth was authenticated as a portrait of Wolfgang von Maen by Kämmerer in 1905.

176 *Le Siècle de Bruegel* (1963), 129ff.

177 Roosen-Runge (1940).

178 Hentschel (1948).

179 Vienna, Academy, F.-R., 33.

180 Schenk zu Schweinsberg (1926). Scheidig (1953).

181 Leningrad, Hermitage, F.-R., 21. The original format was only 1.7×0.84 meters, approx. Cf.

Kostrov (1954), 40ff.

182 Woodcut, B., 112; G., 618; Holl., 106.

183 Woodcut, B., 114; G., 617; Holl., 104.

184 Lippmann (1895), 2, with reproduction of the bronze plaque of Giovanni delle Opere (formerly in Berlin; lost during World War II). Bange (1922), No. 659, Table 58 (Inv. No. 1252).

185 See Scheurl (1513).

186 Engraving by Giovanni Antonio da Brescia, B., 21, and by Jacopo de'Barbari, B., 18.

187 Woodcut, B., 113; G., 616; Holl., 105.

188 Mutianus (ed. Gillert), I, 23, No. 15. Letter to Urban after August 21, 1505. Steinmetz (1971), 36.

189 Whereabouts unknown, F.-R., 23. The subject was identified by Sander (1950).

190 Private collection, F.-R., 22. The author is indebted to the owners for allowing him access to this painting.

191 Buchner (1953), No. 146.

192 A portrait of a man against a landscape background, painted in 1526, is preserved in Munich. WAF, 169.

193 Koepplin (1966), 82ff.

194 Scheurl's bookplate, woodcut, P., 211; Holl., 144. Good uniform contemporary colored prints in West Berlin and Wittenberg, Lutherhalle. Block's bookplate, woodcut, G., 643; Holl., 136

195 Woodcut of 1515, P., 165; G., 640; Holl., 133.

196 Schulte-Strathaus (1930).

197 The figure of St. Ottilia on the outer left side panel corresponds to the woodcut (Schuchardt, 13), that of St. Genevieve to the St. Barbara in the *Heilstumbuch* (Schuchardt, 26).

198 Engraved portrait of Elector Frederick, signed and dated 1509, Pass., 7; Holl., 5. This is the second attempt to produce an authentic likeness in a copperplate engraving, the first being the portrait of Emperor Frederick III. (Lehrs, VI, 312, No. 17). It was probably not Cranach's first copperplate engraving. *The Penance of St. John Chrysostom* with the conspicuously corrected coats of arms, also done in 1509 (B., 1; Holl., 1), probably preceded it.

199 Engraved portrait of the two princes, signed and dated 1510, B., 2; Holl., 3, used singly as the title page of the Wittenberg *Heiltumsbuch*.

200 Engraving, B., 1; Holl., 1.

201 Engraving, B., 4; Holl., 4.

202 Dürer's engraving, about 1496, B., 63.

203 The central figure in Dürer's engraving of *The Sea Monster*, about 1498, B., 71. (Dieter Koepplin has kindly confirmed this observation.)

204 Reichel (1926), 12–18. Lippmann (1895). Röttinger's attempt in 1943 to assign a major role in the development of the chiaroscuro print to Hans Wechtlin is, however, unconvincing. Wechtlin's Pyramus and Thisbe woodcut is clearly a copy of the Marcantonio engraving of 1505, as Parker recognized in 1923.

205 The matter was discussed in three letters: Peu-

tinger's to Elector Frederick, dated September 24, 1508 (Herberger [1851], 26); Peutinger's to Duke George of Saxony, dated September 25, 1508; and Duke George's to Peutinger, dated October 17, 1508 (König [1923], No. 57).

206 The Italian Ugo da Carpi petitioned the Venice Senate on July 24, 1516, for a privilege for the discovery of the color woodcut. (See Reichel [1926], 29 ff.)

207 Woodcut, B., 113; G., 616; Holl., 105, I. Gray tone print in Dresden.

208 Woodcut, B., 3; G., 540; Holl., 7. Good tone print in Nuremberg.

209 Woodcut, B., 58; G., 594; Holl., 79. Good gray tone print in Coburg.

210 Woodcut, B., 1; G., 537; Holl., 1. Supposedly the only tone print is in Aschaffenburg. It is accepted by Dodgson but disputed by Geisberg (1929), also by W. J. Strauss (1972), to whom the author is indebted for information concerning Cranach's supposed tone prints.

211 Woodcut, B., 122; G., 631; Holl., 3.

212 Woodcut, B., 63; G., 600; Holl., 84.

213 The woodcuts of *St. Christopher* (see Note 209) and of *Venus and Cupid* (see Note 207).

214 Anzelewsky, No. 25.

215 Woodcut, B., 61; G., 602; Holl., 86.

216 Dürer's engraving, B., 87. The motif resembles one of the observers in Dürer's more or less contemporary woodcut, B., 59.

217 Woodcut, B., 62; G., 603; Holl., 87.

218 Hoffmann (1954), 71.

219 Dürer's 1510 woodcut, B., 125.

220 Kroměříž (ČSSR), Museum, F.-R., 65. (Copies made before the heads of the followers on the left were painted over exist in the Erfurt and Bucharest museums. According to Bruckschlegel [1973], the Erfurt copy was made by Elias Hausmann in 1699.) Also F.-R., 66.

221 See the woodcut mentioned in Note 217.

222 The Kremsier self-portrait figure is probably derived from the standing figure in Dürer's woodcut of the martyrdom of St. John (B., 61).

223 Budapest, owned by the Reformed Church. V. Takácz (1909), 453. Fenyö (1955). Exhibited Danubian School, 1965.

224 Dessau, Gallery, F.-R., 19.

225 Woodcut series, B., 37–48; G., 581–592; Holl., 53–64.

226 Woodcut, B., 70; G., 605; Holl., 91.

227 Woodcut series, B., 23–36; G., 567–580; Holl., 31–44.

228 Woodcut of a knight, Pass., 169; G., 628; Holl., 111. Woodcut of a knight (Mauritius?), B., 123; G., 624; Holl., 112. *Knight and Lady on Horseback* (1506), B., 117; G., 626; Holl., 114.

229 Woodcut, B., 65; G., 598, 599; Holl., 81. Woodcut, B., 64; G., 596; Holl., 82.

230 Woodcut of a mounted boar hunter, B., 118; G., 625; Holl., 113. Woodcut of a stag hunt, B., 119; G., 632; Holl., 115.

231 Woodcut of 1506, B., 124; G., 620; Holl., 116. The other three were done in 1509: B., 126; G., 623; Holl., 117. B., 125; G., 621; Holl., 118. B., 127; G., 622; Holl., 119.

232 Woodcut, B., 116; G., 627; Holl., 110. Maedebach (1961), No. 1.

233 The drawing for a portrait on horseback of Asche von Cramm, a captain in the army of the electorate of Saxony, done about 1525, is preserved in Nuremberg (Zink [1968], No. 118). See Pl. 120.

234 Grotemeyer (1970), 143–159. The cameo referred to here was auctioned in December, 1969, at Jörg Stuker, Bern (No. 2078). (Information kindly supplied by Wolfgang Steguweit, Gotha.)

235 Burgkmair's tone woodcut portrait of Pope Julius II of 1511 is probably an adaptation of a medal. (B., 33.)

236 See Note 224.

237 Harksen (1967), 353, 364. *Dürer-Zeit*, Dresden (1971). (The reference to Harksen has been garbled in editing.)

238 Zülch has suggested to the author that the altar may have been commissioned by the Antonians for Lichtenberg or for their chapel in Wittenberg.

239 The influence of the Madonna of the Dresden altar is evident in several of Cranach's figures: the Breslau Madonna, F.-R., 28; the St. Anne on the left side panel in Wörlitz, F.-R., 34.

240 Dürer also reworked motifs borrowed from other artists, adapting, for example, the rear-view figure of an executioner in Schongauer's engraving, B., 11, to a front view. Cf. Koschatsky and Strobl (1971), 196.

241 Painting of 1532, F.-R., 227; of 1533, F.-R., 228.

242 Painting of 1525, F.-R., 157; of 1526, F.-R., 158.

243 R., 21–28. For most recent comments on Dürer's drawings, see Von Tavel (1965). Two paintings are direct copies of Dürer school works: *Christ Falls by the Wayside* (West Berlin, 564B) and *Christ Falls at the Flagellation Column* (Lapiccirella Galleries, Florence, see *Burlington-Magazine*, [March, 1971], LXXV) are copied from Baldung's woodcuts Oldenbourg 200 and Oldenbourg 202 of 1507. Also the woodcut series *The Papacy and Its Members* (Holl., 108) is copied from Sebald Beham, as Geisberg noted in 1929. Cf. Köhler and Steigerwald (1973), 17.

244 Stolen from Breslau after 1945, F.-R., 28. Müller-Hofstede (1958).

245 Lugano, Thyssen Collection, F.-R., 29.

246 Certosa di Galluzzo near Florence, F.-R., 45 (stolen).

247 Karlsruhe, Kunsthalle, F.-R., 80.

248 Cologne, Wallraf-Richartz Museum, F.-R., 82.

249 Formerly in Glogau, missing since 1945, F.-R., 81. Müller-Hofstede (1958).

250 The small format, the delicacy of rendering and the occasional coats of arms identify them as such (F.-R., 81).

251 Woodcut, B., 4; G., 541; Holl., 8.

252 Feyler (1950).

253 Teuschel was a Wittenberg city councillor from 1504 to 1539. Cf. the list in the records of annual council elections 1529–1675, 1681–1694, Wittenberg city archives, 37.

254 Polycarp Leyser (1552–1610) married Elizabeth Cranach in 1580. From 1576 to 1586 and from 1593 to 1610 he was in the service of the electorate of Saxony.

255 As indicated by the city treasury's accounts for 1513 in the Wittenberg city archives.

256 Also assumed by Koepplin (1966).

257 Fehn, 3 (1953), 107. Here, however, it is assumed that Matthew was an older brother of Lucas and that the matriculation applied to his son (!).

258 Fehn, 3 (1953), 107, Note 7.

259 Lüdecke (1953), 75.

260 Dürer's Netherlands diary of 1521 mentions the Danish king as his patron; Gossaert also worked for him in 1525.

261 Cf. city treasury accounts for 1513, Wittenberg city archives.

262 Cf. Behling (1957), 120 ff.

263 Höss (1956), 129. Volz (1954).

264 Zülch (1935), 295.

265 See Hentschel (1928), 43.

266 Christoph is mentioned as a collaborator of Cranach only in two bills from this year. The execution of the right side panel of the St. Catherine altarpiece of 1506 suggests his hand. Rieffel (1906), 272, already recognized this as journeyman's work.

267 See Note 185.

268 Because the workshop of the court painter Goeding had no vacancies for apprentices in 1571, the elector of Saxony had to send his scholarship holder Wehme to Wittenberg for training (Berling [1890]).

269 Schaefer (1917). Bruns (1941).

270 Schuchardt, 3 (1870), 125–127.

271 Ehlers (1919). Solms (1955), 5 ff., 9–11.

272 For the current research position see the catalogue of the Aschaffenburg Gallery (1964), 44 ff.

273 Friedländer (1905). F.-R., 368 a.

274 New York, Metropolitan Museum, wood, 1.52× 1.42 m. (from the Goseck Monastery near Naumburg). The author is indebted to Dieter Koepplin for this information and for a reproduction of the picture.

275 Hoffmann (1954), particularly 25–37.

276 Wittenberg, Lutherhalle, F.-R., 69, 70.

277 Zeitz, Church of St. Nicholas, F.-R., 71.

278 Flechsig, *Tafelbilder* (1900), 97–118. F.-R., 358 a.

279 F.-R., 353 g.

280 Thulin (1955), 9–32.

281 The use of assistants is surprising for such prestigious commissions as the Ten Commandments panel ordered by Frederick the Wise for the Wittenberg City Hall. F.-R., 69, 70.

282 Cranach painted several of the rectors' coats of arms in the Wittenberg matriculation book after 1508 (Halle, University Library, see Schuchardt 3 [1870] 160 ff.). The most important series of miniatures is in the album in the Dresden Landesbibliothek (Schuchardt 1, 32, 182; 2, 49–53).

283 See Sources 449 ff., 452.

284 Often mentioned in bills. The earliest extant examples are from the time of Cranach the Younger: the portrait of Gregor Brück, Weimar, Museum; crucifix of 1571, Wittenberg, Lutherhalle.

285 Zimmermann (1959). See Sources for the year 1555.

286 The only extant example of the numerous commissions of this kind is a fragment in the Mirror Room above the spiral staircase in Torgau Castle (Findeisen [1971]).

287 Roland Möller, Institut für Denkmalpflege, Erfurt, 1971, made a study and an attempted color reconstruction of the façade. G. Kaiser and R. Möller: Erfurter *Bürgerhausfassaden der Renaissance. Denkmale in Thüringen.* Weimar (1973), 127, Note 21.

288 The earliest mention of the imitation of ash paneling by means of woodcuts is the reference in that year to "grained paneling" in Wittenberg Castle. There are references to ceiling panels in veined paper in the electoral palaces at Dresden in 1553 and at Freiburg in 1575. A dated specimen from 1563 survives on a wall behind the high altar in the Church of St. Nicholas, Jüterbog. A ceiling (restored), transferred from Rödern Castle, Kreis Grossenhain to Rodewisch, is printed in part from the same blocks. Other examples are preserved in the Dresden City Museum (pulpit from St. Bartholomew's Church), in the Zittau Museum and in Dedelow, Kreis Prenzlau. (The latter information from Johannes Voss, Schwerin.) References to such works in the literature are most frequent after 1550 (Rott 3, [19] 18. Lehrs (1908), 192 ff.).

289 Altar reliquaries, which the Cranach workshop also produced, are preserved in Neustadt-an-der-Orla, Klieken near Dessau and Kade near Genthin. The sculpture of a Madonna on a crescent moon may belong to a side panel of the big altar in Naumburg Cathedral.

290 Grotemeyer (1970), 145.

291 In 1525 Cranach supplied a wooden model for the tomb of Frederick the Wise. Another wooden model for Luther's gravestone is preserved in Erfurt, St. Andrew's Church.

292 Weimar, Museum, R. A., 24. (Its authenticity has been unjustifiably questioned.)

293 Cf. accounts for the year 1513.

294 According to Schuchardt, 1, 49, a representative of Cranach sold arrows to the dukes in 1506.

295 On May 10, 1522, Cranach delivered jewels owned by the princes which Luther had asked to see in connection with his translation (Höss [1956], 225).

296 Formerly in Dresden, R., 33–35. The author is

indebted to Edmund Schilling for the photographs.

297 Brunswick, Museum, R., 46, 47.

298 Frankfurt-am-Main, Staedel, R., 53.

299 Leipzig, Museum, R., 56.

300 West Berlin, R., 60.

301 Bock (1929).

302 Cf. Note 292.

303 Thöne, *Niederdeutsche Beiträge* (1963), 183 ff., Figs. 157–159. Sketch for a chimneypiece. 1543, pen drawing in black ink with wash, 1.35 × .43 m.

304 Dresden, R. A., 13. (Authenticity unjustifiably questioned.)

305 Schuchardt, 1 (1851), 174 ff. Zimmermann (1959).

306 Torgau, St. Mary's Church, F.-R., 15. *Dürer-Zeit* (1971), No. 103.

307 Gotha, Museum, F.-R., 176, 177.

308 Leipzig, Museum, F.-R., 58.

309 Weimar, Museum, F.-R., (296), erroneously dated ca. 1537.

310 Weimar, Museum, F.-R., 307 d. In the Weimar catalogue of exhibitions 1953, No. 9 the date is corrected to ca. 1515.

311 Weimar, Museum, F.-R., 216.

312 Frankfurt-am-Main, Staedel, F.-R., 204.

313 In the big twin portraits of Electors Frederick and John in the Naumburg city archives, for example, and in the twin portraits of Luther and Melanchthon in West Berlin.

314 Schade (1963), No. 73.

315 Vienna, Albertina, R., 76.

316 Collection of the duke of Buccleuch (acquired in 1859 from the collection of Lord Northwick); watercolors on parchment 220 × 190 mm. Exhibited in Manchester, 1957.

317 West Berlin, R., 73.

318 Vienna, Albertina, catalogue of 1933, 45, No. 359 (3005). Winkler (1936), 151. Girshausen (1936), 93 (not Cranach, despite Friedrich Winkler's attribution).

319 Basel, Museum, R. A, 9. According to an unnamed Berlin art dealer and to Fischer (1937), from a Wittenberg album of 1590–1593. Rosenberg regards it merely as a copy. Its authenticity has been accepted (in some cases without mutual consultation) by Fischer, Dodgson and Koepplin and by Schilling in a reversal of his earlier opinion. (Information from Dieter Koepplin.) See also Koepplin (1968), Landolt (1972).

320 London, British Museum, R., 71 (as original).

321 Gotha, Museum, F.-R., (48). Cranach (ed. Lüdecke) (1953), Fig. 110.

322 Painting of Hans Kemmer. Head of the Virgin in reserves of the Bayerische Staatsgemäldesammlungen, Munich.

323 Dresden, F.-R., (184).

324 Maedebach (1961), Nos. 1–4.

325 Woodcut, B., 116; G., 627; Holl., 110.

326 Woodcut of 1506, B., 59; G., 595; Holl., 80.

327 *Adoration of the Heart of Mary* of 1505, B., 76; G., 609; Holl., 69. *Stag Hunt*, B., 119; G., 632; Holl., 115. (The castle on the left corresponds to the one on the center panel of the St. Catherine altarpiece of 1506.)

328 Painting in Vienna, F.-R., 231. Copy in Basel important for reconstruction of format.

329 Hunting pictures of 1540 in Cleveland (exhibited 1937, No. 122) and of 1544 and 1545 in Madrid, F.-R., 330 and 331.

330 Dresden, R., 64 (spotted animal), R., 66 (an almost white sport).

331 Paris, R., 61. Formerly in Dresden, R., 67. Dresden (Schade [1963], No. 80).

332 Formerly in Dresden. One of the few dated drawings of Cranach: 1530, R., 68.

333 Dresden, R., 69.

334 Dresden. Cf. Schade (1961–62). Schade (1963). Grate (1961).

335 Barbari participated in the decoration of the Lochau hunting seat and of the Wittenberg Castle.

336 Schade (1961–62). Grate (1961).

337 On the portrait studies in Reims cf. Rosenberg (1934) and Note 738.

338 Weimar, Museum, R., 14.

339 West Berlin. R., 13.

340 Erlangen, Library, R., 44.

341 Formerly in Dresden, R., 9 (later than 1510, however).

342 Dresden, R., 11 (probably no earlier than 1530), 12.

343 *Expulsion of the Money Changers from the Temple, Slaughter of the Innocents*, both paintings in Dresden; *Christ and the Adulteress*, drawing in Brunswick; *Christ before Annas, Christ Crowned with Thorns* from the woodcut "Passion" series.

344 West Berlin, R., 2 and 3.

345 Lille, Musée Wicar, R., 4.

346 Munich, R., 5.

347 Most recent study: Von Tavel (1965).

348 At least the Man of Sorrows on sheet 60r (R., 25) and the candleholder on sheet 61v (R., 27) are derived from Dürer.

349 For this reason some of Cranach's marginal drawings have been very adversely criticized (Hetzer, 2 [1957], 49).

350 An image from Paracelsus (*Werke* [ed. Sudhoff], 6, 313; 7, 373).

351 Engraving, B., 3; Holl., 4.

352 Woodcut, B., 77; G., 566; Holl., 72.

353 Munich, F.-R., 155.

354 Darmstadt (1525), F.-R., 157. Sarasota, Florida (1526), F.-R., 158.

355 West Berlin (1527), F.-R., 156.

356 Engraving, B., 4; H., 2 after Dürer's etching, B., 102.

357 Engraving, B., 5; H., 6. The profile head, sometimes taken for a self-portrait (Ficker [1931]), appears in full on the prints in Dresden, Kunstsammlungen, and in London, British Museum. It is still recognizable, for instance, on the copy in West Berlin (565-2).

358 Engravings, P., 8; H., 7. Authenticity rejected by Flechsig and Jahn.

359 Engraving B., 6; H., 8.

360 The only known first-state print, on a white ground, is in Coburg, Kunstsammlungen der Veste.

361 Engraving, Hind, V, 158, 30.

362 Weimar, Kunstsammlungen, F.-R., 126. The Leipzig version, F.-R., 125, is probably only a workshop copy. New versions of this portrait were produced in 1537 (for the anniversary of the Reformation?). Examples exist in a Swiss private collection and in Penig.

363 The earliest medal of Luther, made in 1519, already shows a phoenix on the reverse. That same year the Freiburg jurist Ulrich Zasius referred to him as the "phoenix of the theologians." (*Reformation* [1967], 34).

364 Treu (1959), 29–33, Fig. 10.

365 In Thorn in 1521 a papal legate burned a picture of Luther, probably a print. (*Korrespondenzblatt des Gesamtvereins der deutschen Geschichts- und Altertumsvereine*, 82 [1934], 22).

366 Print in Dresden.

367 F.-R., 159–160.

368 F.-R., 251.

369 F.-R., 252.

370 Drawing in the collection of the duke of Buccleuch. See Note 316.

371 F.-R., 340, of 1539.

372 Schwerin, Museum, mentioned in F.-R. (340). However, no counterpart is known.

373 Cf. Höss (1956), 174. Borth (1970), 143.

374 Woodcut of 1523 in the Danish translation of the New Testament, *Reformation* (1967), 209.

375 Woodcut, P., 192; Holl., 125. Prints in West Berlin (from the collection of King Frederick Augustus II of Saxony), in London and in Gotha.

376 Cranach's woodcut, G., 634; Holl., 129, after Dürer's famous etching, B., 104.

377 Buchner (1953), No. 194, Fig. 193.

378 On the evidence of a copy inscribed in the matriculation book of the University of Wittenberg and of its similarity to later engravings, the so-called *Portrait of the Lecher of Keisersberg* (F.-R., 249) can be identified as a portrait of Rudolph Agricola, admired by Erasmus.

379 Formerly in Gotha, F.-R., (252), dated 1553, 18 × 15 cm. (Aldenhofen [1890], 343.)

380 On Pencz see Gmelin (1966).

381 Inscription on the two Luther etchings of 1520.

382 Privately owned in Switzerland. I am indebted to Dieter Koepplin for informing me of the existence of these important, still unpublished twin portraits.

383 New York, Metropolitan Museum, F.-R., 49. Cf. Note 384.

384 Zurich, Kunsthaus, F.-R., 25. Dieter Koepplin recognized that these two portraits constitute a pair.

385 Dresden, F.-R., 53, 54.

386 West Berlin, F.-R., 56. Wilhelm H. Köhler kindly drew my attention to the fact that this picture is on parchment. An infrared photograph reveals a preliminary drawing of a St. Mary Egyptiaca surrounded by angels. The heads of Christ and the Virgin in Gotha (see Note 321) are also painted on parchment, as are the duke of Buccleuch's head of Luther (see Note 316) and the 1518 portrait of Gerhard Volk in Leipzig (F.-R., 107).

387 London, National Gallery, F.-R., 153.

388 Examples in the Wartburg, F.-R., 145; London, F.-R., 147; Copenhagen, F.-R., 148; Leningrad (1526), F.-R., 238; Vienna, F.-R., 240.

389 Weimar, Kunstsammlungen, F.-R., 243, 244.

390 Wartburg near Eisenach, F.-R., 253 and 254.

391 Brussels, F.-R., 266.

392 Berlin, Staatsbibliothek. Exhibited Berlin (1937), No. 84, Bildband 77.

393 Anzelewsky, 19.

394 Formerly in Berlin. War casualty. F.-R., 154.

395 West Berlin, F.-R., 269.

396 Formerly in Dresden. War casualty. F.-R., 286.

397 The accounts for 1551 and 1552, obviously in his own hand, include a whole list of these small formats.

398 Nuremberg, Museum, F.-R., 275.

399 According to Sternenboke (1609). See Lüdecke (1953), 89 (but also 86).

400 Cf. Note 232.

401 Woodcut, B., 5; G., 561; Holl., 71.

402 Detroit, F.-R., 104 and 105.

403 West Berlin, Grunewald Jagdschloss. Börsch-Supan (1964), 43 and 44 (F.-R., 121). The proposed identification of the subject as Joachim of Anhalt is questionable because it would place the younger brother in the more important position. Probably the erroneous inscription correctly names the subject.

404 Paris, F.-R., 130. Old copy in Wittenberg, Lutherhalle, from the Lichtwer and Lucanus collections.

405 Darmstadt, collection of the grand dukes, F.-R., 245, 246. Old copies by Daniel Glöckler (1625–1667) in Altenburg, castle museum, identified by inscriptions as Dukes Ernest and Albert, kidnapped in 1455.

406 Dresden, F.-R., 53 and 54. Transferred from wood to canvas but originally one picture, since the duke's scabbard extends into the other half of the painting. (Distel [1898].)

407 Dresden, Sächsische Landesbibliothek Ms., R., 3. Lippert (1891). Von Troschke (1939).

408 Prague, National Gallery, F.-R., 150. For date, now only partly legible, see Schuchardt, 2 (1851), 110.

409 See Note 233.

410 Scheurl (1509), translated in Lüdecke (1953), 51.

411 A list of preparatory notes concerning accessory details for portraits, prepared by a painter asso-

ciated with Cranach, exists in Dessau (Harksen 1959).

412 According to Johann Neudörfer, Cranach was famous for painting black velvet patterned in black (Schuchardt [1870], 85 ff.).

413 F.-R., 57.

414 Vienna, Academy, F.-R., 33.

415 F.-R., 47.

416 Florence, Uffizi, F.-R., 342.

417 F.-R., 33. For a comprehensive treatment of Cranach's self-portraits see Scheidig (1953), 128–139.

418 Cf. Note 220.

419 Gotha, Museum, F.-R., 176.

420 W., 898.

421 Cf. Note 416.

422 Stolzenfels Castle, included in the furnishings of King Frederick William IV's living room. (No. 66, GK, I, 2553, Preussische Schlösserverwaltung). Copper-beech wood, .45 × .35 m. Information concerning this painting from Dr. Caspary, Mainz, Dr. Helmut Börsch-Supan and Dr. Dieter Koepplin. The author thanks Schlossverwalter Lendeckel for facilitating a thorough study of this painting. Cf. Schade (1972), 427. He also thanks Gerd Bartoschek, Potsdam, for the important information that it was already in the possession of the king of Prussia at the beginning of the eighteenth century, presumably in the Berlin castle. A free copy dated 1736 is among the paintings done by King Frederick William I preserved in Potsdam, Staatliche Schlösser und Gärten (oil on canvas, .84 × .67 m., GK, I, 6052).

423 Dresden, Gall., No. 1941, originally from the chapel in Torgau Castle. Scheidig (1953), 136 ff., Fig. 132.

424 Koepplin (1966), 79.

425 Dürer (ed. Rupprich), 1 (1956), 327.

426 Dürer (ed. Rupprich), 1 (1956), 281.

427 Thieme (1892).

428 Budapest, Museum. Recently attributed by A. Czobor to "School of Giorgione." Venezianische Malerei, exhibition catalogue, Dresden (1968), No. 44.

429 Reuterswärd (1970).

430 Pope-Hennessy (1966), 223.

431 Berlin, F.-R., 88. The Bosch original is in Vienna, Academy.

432 Cranach executed the high altar (destroyed) in the Wittenberg Castle church and the Fourteen Helpers panel in St. Mary's Church, Torgau. The St. Catherine altarpiece of 1506 and the Altarpiece of the Princes in Dessau probably came from the Wittenberg Castle church. Also the Holy Family altarpiece of 1509.

433 Hoffmann (1954).

434 F.-R., (57).

435 F.-R., (57).

436 Braunsdorf (1958).

437 F.-R., 368a.

438 F.-R., 368b.

439 See Note 491.

440 Leipzig, F.-R., 58.

441 Probably preserved in Nuremberg, Museum (exhibited Berlin [1937], No. 9, with the early dating 1505–06).

442 Beschreibende Darstellung der Bau- und Kunstdenkmäler der Provinz Sachsen, 21, Halle (1898). On the predella are the coats of arms of the Von Werder and Von Stechow families.

443 Donated by a member of the clergy. Old photograph of the Bildstelle des Instituts für Denkmalpflege.

444 See Note 101.

445 Holy Cross altar, supposedly 1526; memorial to Duke George of Saxony and his wife (F.-R., 180, 181).

446 This was probably originally a cruciform altar whose center panel is painted on both sides. Cf. Dekkert (1935).

447 Side panel of a big altarpiece to which a surviving carved Madonna probably belonged, originally in the west choir of Naumburg Cathedral. See Note 289.

448 F.-R., 368e.

449 F.-R., 71, supposedly also F.-R., 72.

450 F.-R., 115. According to Kunstdenkmale Erfurt 1 (1929), 278, the painting was donated by Georg Hirschbach.

451 Steinmann (1968), 69–104.

452 Steinmann (1968), 88–91.

453 Inventory, Dessau, St. Mary's Church.

454 Two Passion panels were found in 1971; still unpublished.

455 St. Sebastian altarpiece with twin side panels, about 1530, in the village church at Margrafpieske (Fait [1971], 139).

456 See Note 244.

457 See Note 249.

458 Center panel in Bamberg, Museum (F.-R., 114), side panels in Eichstätt, Palace of the Archbishops.

459 According to Aventin. See Neuhofer (1934), 129.

460 Neuhofer (1934), 97 ff.

461 Höss (1956), 173.

462 Schuchardt, 1 (1851), 74 ff. Lindau (1883), 179 ff.

463 Particularly for Cardinal Albrecht of Brandenburg and for Duke George of Saxony.

464 Steinmann (1968), 71–88.

465 Rieffel (1906).

466 Woodcut, B., 4; G., 541; Holl., 8.

467 Woodcut of the Missale Pragense of 1508, Holl., 27.

468 Painting in Innsbruck, F.-R., 144.

469 Painting in Nuremberg, exhibited 1937, No. 9, Fig. 14.

470 Friedländer (1963), 51, 87. Möhle (1935).

471 Dürer's Life of the Virgin, B., 77, 92.

472 Paintings, F.-R., 18 and 33; woodcut, B., 5, G., 561, Holl., 71.

473 Woodcut, B., 3; G., 540; Holl., 7.

474 Woodcut, B., 4; G., 541; Holl., 8.

475 Wörlitz, *Gotisches Haus*, F.-R., 34. The correct order is determined by the electoral coats of arms on the reverse sides.

476 Unpublished, on wood, .77×.61 m. Possibly the picture in Merseburg Castle mentioned by Heller (1821).

477 Dessau, Museum, F.-R., 79.

478 See Anzelewsky (1971), 134ff., Fig. 17.

479 Dessau, F.-R., 78; supplemented by a band on the left margin.

480 Swiss private collection, F.-R., 140.

481 Cologne, Museum, F.-R., 143. This painting, like the preceding one (see Note 480), is among those with decorative background scenes, as is the Wartburg panel referred to on p. 61 of the text. F.-R., 145.

482 As, for example, in the altarpiece models for Halle, R., 29–32, 36–37.

483 Moscow, Pushkin Museum, F.-R., 138.

484 Early examples: F.-R., 92, 111, 137.

485 Picture dated 1558 by Augustus Cordus, a pupil of Cranach, formerly in Berlin, 614A (name given as "Corvus").

486 Gotha, Museum, F.-R., 43.

487 Anzelewsky, No. 82.

488 Wölfflin (1943), 161.

489 In Erlangen (Bock [1929], No. 1311) and Dresden (from the collection of John George of Saxony, Boerner catalogue 203, under No. 1171).

490 Woodcut, B., 77; G., 566; Holl., 72. A colored print (old) exists in Coburg (Maedebach 1972). On the Dresden print an almost imperceptible wash has been used for the highlights. The subdued tone is probably the result of restoration.

491 Naumburg, Church of St. Wenceslas, F.-R., 44. The picture must have been executed after the serious fire of 1518.

492 Painting, formerly in Wittenberg, collection of Dr. Lichtwer (F.-R., 44). Later variations in Warsaw, National Museum, from a private collection in Breslau.

493 The Virgin's dress and head are modeled on Dürer's Madonna of 1511 (B., 41) and 1513 (B., 35).

494 Crucifixion, formerly in Strassbourg, F.-R., 61. Crucifixion of 1515, Bonn, F.-R., 64. Front-view Crucifixion, Frankfurt-am-Main, F.-R., 84.

495 *The Agony in the Garden*, woodcut, Holl., 24. Woodcut of 1509, Holl., 10. Painting, Dresden, F.-R., 83.

496 Weimar, Museum, F.-R., (296). Here, and when exhibited Weimar-Wittenberg (1953), No. 44, dated "about 1537."

497 Dürer's "Small Passion" woodcut series, about 1509, B., 30.

498 Cf. *Dürer-Zeit* (1971), No. 103.

499 Title page of the engraved "Passion," B., 3, 1509.

500 Formerly in Dresden. War casualty. F.-R., 63.

501 Weimar, Kunstsammlungen, F.-R., 307d. More acceptably dated "about 1515" in exhibition catalogue Weimar (1953), No. 9. The strong preliminary drawing revealed by the infrared photograph suggests that this is an original.

502 Marriage bed of Margaret of Anhalt, 1513, according to Philipp Engelbrecht painted with classical scenes (Lüdecke [1953], 56ff.). A similar Frankish marriage bed of 1525 is preserved in Burg Eltz near Cochem-an-Mosel (Kreisel, 1 [1968], Fig. 263).

503 Cf. Dürer's drawings, W., 662–664.

504 Coburg, F.-R., 102. Authenticity as a Cranach original justifiably questioned by Dieter Koepplin.

505 Dresden, Gall., No. 49A.

506 Kreuzlingen, Kisters collection. Information from Dieter Koepplin.

507 Basel, Museum.

508 Ehlers (1919), 198.

509 R., 15, 16. Both drawings must have been made after 1520, at the same time as R., 40. Cf. Note 156.

510 Ladendorf (1953), 93.

511 Börsch-Supan (1964), 41.

512 Only on the Leipzig painting, F.-R., 100. *Dürer-Zeit* (1971), No. 110.

513 On the drawing R., 40, and on the paintings F.-R., 101, 211, 323, 324.

514 On the Liverpool painting of 1534, F.-R., 211.

515 On the spring of Bernardus Trevisanus see Jung (1955), 74, 172 ("whose water is consecrated to the virgin Diana"), 177, 181, 186.

516 Dürer's drawing, W., 663.

517 Fendt (1574), No. 104.

518 Painting, F.-R., 329c–e.

519 Several paintings of 1532 (F.-R., 223, 224) and of about 1537 (F.-R., 225, 226, 328).

520 Augsburg, Museum, F.-R., 175. Dresden, Gall., No. 1929; F.-R., 288e (from Torgau).

521 West Berlin, F.-R., 327. Cf. Köhler and Steigerwald (1973), 26.

522 West Berlin, Jagdschloss Grunewald, F.-R., (100). Börsch-Supan (1964), No. 42.

523 Leipzig, F.-R., 100.

524 Liverpool, Museum, F.-R., 211.

525 F.-R., 319–321. The theme goes back to a combination of Alciato, as Rubensohn (1897), 80, showed. Cf. also Henkel (1967), Col. 1759.

526 F.-R., 227–228.

527 Gotha, Museum, F.-R., 176, 177.

528 Weimar, Museum, F.-R., 216. Also F.-R., 215 and 217.

529 Vienna, Museum, F.-R., 167. Catalogue, Vienna (1972), No. 10, Fig. 11, linden wood, 81× 114 cm. Dresden Gall., No. 1908A; poplar wood, 80×117 cm. Both signed and dated 1530. F.-R., (167).

530 Munich, F.-R., 213. Oslo, Museum, F.-R., 214.

531 West Berlin, F.-R., 222.

532 Barbari's engraving, Hind, 5, 153, No. 14.

533 Dürer's etching, B., 68.

534 Painting, F.-R., 328.

535 Panofsky (1930), 127.

536 Painting, F.-R., 219 and 220.

537 Painting, F.-R., 220, imitating Giovanni Antonio da Brescia (B XIII 324, No. 13).

538 Painting in Weimar, F.-R., 118. Exhibited Weimar (1953), No. 23.

539 See Note 519.

540 Treatments of this theme have been collected by Jörg Göpfert in a term paper for Karl Marx University, Leipzig. The most important paintings are in Budapest: F.-R., 132 (1522), F.-R., 131; Prague: F.-R., 233; Nuremberg: F.-R., 235; Düsseldorf: F.-R., 235a (replica in Sibiu, Rumania).

541 Dresden, Gall., No. 1936, F.-R., (237), in particular probably belongs to a Torgau series on the power of women, as do Gall. Nos. 1928, 1929, 1930 and 1923 (?).

542 Drawing in West Berlin, R. A, 6.

543 Pairs of partridges occur on pictures of the water nymph (see Note 513), Cardinal Albrecht as St. Jerome (F.-R., 157, 158), the Fall of Man (F.-R., 161), Paradise (F.-R., 167), Samson (F.-R., 175), and the Golden Age (F.-R., 214). Cf. S. Braunfels (1971), 504 ff.

544 Grate (1961). Schade (1961–62), 29–41.

545 Pieper (1964).

546 Grisar-Heege (1921).

547 Cf. Drobna (1970), 27, with references to additional literature.

548 Traeger (1970), 112, 114.

549 Bainton (1967), 21–25.

550 Hentschel (1948), 35–42.

551 Ibid., 35 ff.

552 *Expulsion of the Money Changers from the Temple, The Woman Taken in Adultery, The Healing of the Blind and of the Leper* are certainly related. See Schiller (1968), 33.

553 Drawing in Brunswick, R., 18. Schiller (1968), 33.

554 Von Welck (1900). Vossler (1957).

555 Woodcut, G., 612; Holl., 95. In addition to the known copy in Hamburg, Dr. von Rabenau, Naumburg, has found prints in the Wittbrietzen church and the Church of St. Blasius, Nordhausen (the latter fragmentary, with Latin text).

556 Schmidt (1962), 12, 29.

557 Woodcuts, B., 61–75.

558 Schuchardt, 2 (1851), 209. Schmidt (1962), 93.

559 Schmidt (1962), 106.

560 Schramm, 17 (1934), Pl. 187, No. 459.

561 Volz (1954), 25.

562 Cf. Volz (1954), 68. Schmidt (1962).

563 Schmidt (1962), 274.

564 Cranach and Döring became city councillors together in 1519 and in 1522 and 1531 held the two chancellors' positions of the city of Wittenberg.

565 Thulin (1955), 126–148.

566 Frankfurt-am-Main, Städel, R., 53.

567 Gotha, Museum, F.-R., 183.

568 Preserved in two sections, the left-hand one in West Berlin (R., 58), the larger right-hand one in Nuremberg (R., 59). Cf. Hoffmann (1972); also Köhler and Steigerwald (1973), 47 ff.

569 Delius (1953), 85.

570 Naumburg, Church of St. Wenceslas, F.-R., 179.

571 Schenk zu Schweinsberg (1966); the Fulda picture is dated too early (ca. 1506–1509).

572 Cf. Klein (1962), 22, 143.

573 Knod (1899), 488 ff., No. 3311.

574 Schuchardt, 1 (1851), 98–114.

575 Lugano, Thyssen collection, F.-R., 276.

576 Ibid., 226.

577 Lippmann (1895), 4 ff. Adversely criticized in *Die Graphischen Künste* 34. Vienna (1911), 8. Wille (1967), 13 ff., No. 4, Fig. 3–6.

578 West Berlin, R., 57.

579 A significant example is Dürer's painting of *Christ Among the Scribes* (1506), Anzelewsky, No. 98. Arnolds (1959). Białostocki (1959).

580 Formerly in Dessau. War casualty. R., 50, 51. Certainly not the preliminary drawing for the San Francisco painting. To be dated about 1530.

581 West Berlin, R., 49. Attribution as yet unchallenged. The formal awkwardness and inept adaptation of motifs from Dürer's engravings of a "Sea Monster," B., 71, and "Hercules," B., 73 make it very unlikely that this is a work of Lucas Cranach the Elder. Köhler and Steigerwald (1973), 44 ff. differ.

582 The motto "In silentio et spe erit fortitudo vestere" also occurs among Luther's maxims. (Information from Michael Krille, Wittenberg.)

583 The model for the portrait of Savonarola has not yet been identified.

584 Cf. Rein (1919), 196.

585 Friedländer (1946), 200.

586 For the most recent study of the change in the device, see Giesecke (1955).

587 Portrait woodcut of Johann Scheyring, B., 142; Holl., 53.

588 Portrait of Johann Bugenhagen, Wittenberg, Lutherhalle, F.-R., 285.

589 How demanding this office was can be seen from the words of the printer Hans Lufft before the mayoral election of 1577 asking to be exempted (Wittenberg city archives, 37, records of the annual city elections ... 1529–1694, sheet 39).

590 Probably for the first time in 1541 on the painting on the gallery of St. Mary's church in Dessau. For the same reason his father in 1550 called himself *der Eltist* (the Eldest). (Source No. 383.)

591 For an account of this see Scheidig, *Lucas Cranach d. Ä.* (ed. Lüdecke) (1953), 164–167.

592 Student rioting in May, 1543. Abduction of two students in Oct., 1544. Serious riots in Feb., 1545. In 1546 students threw fireworks in the city. In 1543 Cranach was acting burgomaster.

593 According to Gunderam (Lüdecke [1953], 86 ff.).

594 Anzelewsky, 105.

595 Anzelewsky, 82.

596 Anzelewsky, 39–40 (center picture copied from

Dürer).

597 Dresden, Gall., No. 841. Mayer-Meintschel (1966), 37 ff.

598 Anzelewsky, 72–75 (connection with Anzelewsky 82 disputed).

599 See Note 130.

600 Troescher (1927), 9 ff.

601 One example is certainly Cranach the Younger's woodcut showing the deposed prince with his coat of arms, B., 132; Holl., 33. A print with the arms deleted exists in Dresden. Other woodcuts made for the Ernestines are: Holl., 18, 32.

602 Schade (1968), 30–36.

603 Cranach's position must have been adversely affected by the Grumbach feuds for which his son-in-law Christian Brück was executed as one of the two chief culprits.

604 The wine-selling privilege was renewed in 1554.

605 Klein (1962), 152.

606 Sturmhoefel (1905), 144.

607 Martin (1949). Hutter (1968).

608 Hamburg, Kunsthalle, unpublished. (Information from Dieter Koepplin.)

609 Martin Luther, *Werke*, Gesamtausgabe 8, Weimar (1889), 5.

610 *Dürer* (ed. Rupprich), 2, 119.

611 Holl., 30d.

612 *Dürer* (ed. Rupprich), 2, 48, 125. (Melanchthon's allusion to Cranach's father refers to Lucas Cranach the Elder, not to Hans Maler, who had died in 1528.)

613 Koepplin (1971), 23.

614 See Note 350.

615 See, for instance, the versions of the *Ill-matched Pair* in Prague (F.-R., 233) and the Gotha *Hercules and Omphale*. See Note 626.

616 Prague, National Gallery, F.-R., 150. Cf. Note 408.

617 Warsaw, National Museum. Catalogue of Paintings. Foreign Schools, I (1969), No. 263. Signed and dated, 1526, on wood, 34 × 24 cm.

618 Frankfurt-am-Main, Städel, F.-R., 204.

619 West Berlin, F.-R., 173.

620 Karlsruhe, Kunsthalle, F.-R., 210.

621 West Berlin, F.-R., 156.

622 West Berlin, Jagdschloss Grunewald, F.-R., 193. Börsch-Supan (1964), No. 46, 14. Restored as a Judith in 1973 by removal of the overpainting. Helmut Börsch-Supan made this possible.

623 Anzelewsky, 9, 14, 187 K (preserved in a copy). Also the Dresden crucifix not mentioned here; see Note 639.

624 Kassel, Museum, F.-R., 17.

625 Vienna, Museum, F.-R., 60.

626 Gotha, Museum, No. 47/7. 14.5 × 19.2 cm. (Aldenhofen [1890], No. 367.)

627 Wartburg near Eisenach, on wood, 21 × 18 cm.

628 Schneeberg, St. Wolfgang, F.-R., (304). Thulin (1955), 33 ff.

629 The majority now in West Berlin, Staatliche Schlösser und Gärten, F.-R., 294–299. The author is indebted to Helmut Börsch-Supan for the opportunity to see these paintings.

630 The drawing, R., A 16 and A 17, in Brunswick and R., A 18, in Oslo are preliminary sketches for panels in the Schneeberg altarpiece. The drawing, R., A 23, in Paris is accepted as the *Visierung* for an altarpiece for the collegiate church in Cölln (Steinmann [1968]).

631 This was probably one reason for the execution of the Reims series of portrait studies (Rosenberg [1934]).

632 See Note 571.

633 See Note 570.

634 Both themes seem to have reached their peak just before 1540.

635 Washington, National Gallery, F.-R., 403. Hausherr (1971), 29.

636 Chicago, Art Institute, F.-R., 302.

637 Hubala (1967). Schiller (1968), 244. Hausherr (1971).

638 Dublin, National Gallery, signed and dated 1540. .25 × .19 m. Kehrer (1917), 204.

639 Dresden, Gall., No. 1870. Cf. *Dürer-Zeit*, Dresden (1971), No. 144. Not mentioned in Anzelewsky 1971. Unfortunately the evaluation of the picture is still controversial. Cf. F. Anzelewsky (who rejects it in a letter to the author) and M. Gosebruch ("bears discussion") in *Kunstchronik*, 25 (1972), 194; D. Kuhrmann in *Kunstchronik*, 26 (1973), 294; J. K. Rowlands in *Zeitschrift für Kunstgeschichte*, 36 (1973), 212.

640 Cf. Hausherr (1971). The chain of tradition leading from Dürer to Cranach the Younger is ignored here, although the more significant one leading from Michelangelo to El Greco and Rubens is stressed. The earlier links in this chain and the thinking out of the theme have been thoroughly exposed by Reiner Hausherr; they now need to be related to Dürer's rendering (suggested by Staupitz?).

641 Examples of the crucifix with head-and-shoulders portrait of the donor are: F.-R., (303), formerly in Paris, signed and dated, 153 (8), inscription: PROTECTOR ET REDEMPTOR MEVS IN IPSO SPERAVIT COR MEVM ET ADIT SVM, and one with a portrait of Prince Joachim (?) of Anhalt, ownership unknown, wood, .5 × .34 m. (Deutsche Fotothek, Dresden 53, 183).

642 *Cardinal Albrecht of Brandenburg Adoring the Crucified Christ*, Munich, F.-R., 155. *Georg Spalatin Adoring the Crucifix*, woodcut, G., 640; Holl., 133.

643 For a survey see Thulin (1955), 126–148.

644 See Note 423.

645 Weimar, Kunstsammlungen, F.-R., 326.

646 West Berlin, F.-R., 327. See Note 521.

647 See Note 329.

648 Dresden, Gall., No. 1925. Exhibited Weimar (1953), No. 72.

649 Brunswick, Museum, No. 29. Exhibited (1937), No. 134, Fig. 98. Adriani (1969), 48.

650 Nuremberg, Museum, F.-R., 351. The painting from Hohenaltheim dated 1549 with the picture of Mansfeld Castle was probably a memorial to Count Wolff (I) von Mansfeld, who died in 1646 on one of Charles V's campaigns and was buried in Stuttgart.

651 See Note 587.

652 Thulin (1955), 24 ff., F. 27.

653 Woodcut, G., 653; Holl., 17. The coat of arms in the frame surmounting the picture seems to be that of Elector Maurice of Saxony (1547–1553).

654 Dresden, Gemäldegalerie (Gall. No. 1941), 1.28 × 2.42 m., signed and dated 1545.

655 Woodcut of 1516, B., 60; G., 601; Holl., 85. The assertion that John the Baptist is represented as an itinerant revolutionary preacher can probably not be positively sustained. (See Jahn [1955], 68, Note 40.)

656 See Lüdecke (1953), 73, 114ff.

657 Woodcut, G., 675; Holl., 22.

658 See Note 521.

659 Vienna, Museum, Gall. No. 1468 A. Linden wood, 32 × 22 cm., cf. catalogue Vienna (1972), No. 26.

660 Exhibited Berlin (1937), Nos. 135, 136. Schade (1968).

661 See Note 647.

662 Schade (1968), 32, Fig. 2.

663 Only a few of the tapestries mentioned in old Saxon inventories are preserved in Dresden. Some of these are displayed in the Tapestry Hall of the gallery.

664 Schade (1968), 35, Fig. 5.

665 Ibid. 34.

666 Justi (1951). Thulin (1955), 54–74. Schade (1966), 66 ff.

667 Leipzig, Museum, signed and dated 1557. Thulin (1955), 134 ff., Fig. 169. This is presumably Jakob Grieben the Elder's memorial to his wife Margaret (born Dörrien), who died in 1556. Wood, 2.6 × 2 m.

668 Bronze casting in Jena, St. Michael's Church, executed by Heinrich Ziegler the Younger of Erfurt. Cf. Junius (1926), 232.

669 Erected in the choir of the Weimar city church; replaced in the Jacobi churchyard by a copy. (Thulin [1955], Fig. 189.)

670 Grotemeyer (1970), 165. The only surviving copy of the medal is in the Hohenlohe Museum, Neuenstein.

671 Erfurt, St. Andrew's Church. See Note 291.

672 Dessau-Mildensee, from St. Mary's Church, Dessau. On wood, 2.35 × 1.84 m. Exhibited Weimar (1953), No. 74. Old copy in Nienburg city church.

673 Vienna, Albertina, R., A 19.

674 Dürer's engraving of 1508, B., 4.

675 Von Troschke (1938).

676 West Berlin, Jagdschloss Grunewald, signed and dated, 1556. Linden wood, .62 × .82 m. Börsch-Supan (1964), No. 54.

677 Cf. woodcut of Jakob Lucius.

678 Ozarowska Kibish (1955).

679 Berlin, acquired from the Geipel collection in 1936; formerly owned by the Leningrad Hermitage (Betzkoy collection). See Schade (1963), 35.

680 See Note 676. The view of Dessau identified by Börsch-Supan (1964) and again by Sibylle Harksen.

681 Wäschke (1913).

682 Cf. Findeisen (1971).

683 Formerly in Nordhausen, St. Blasius. Exhibited Berlin (1937), No. 139, Fig. 106. Thulin (1955), 75–95. Müller (1954), 176–178. Schade (1966), 70.

684 Leipzig, Museum; signed and dated, 155(7). On wood, 1.63 × 1.24 m. The memorial of Leonhard Badehorn, the jurist, to his wife.

685 See Note 667.

686 Lossnitzer, see Lehrs, VIII, No. 258.

687 Wittenberg, tower hall in the city church; presumably a memorial to Gregor von Lambergk (d. 1558).

688 Mansfeld, St. George's Church; signed and dated 1545, on wood, 1.39 × .88 m. Dieckmeyer (1937), 52.

689 Nienburg, castle church, signed and dated 1570, wood, 3.05 × 2.4 m. Prince Joachim of Anhalt's memorial to his wife Agnes, born Countess of Barby (d. 1569). Schade (1966), 74, Fig. 3.

690 Augustusburg, castle church; signed and dated on the predella: 1571, wood, 3.2 × 2.4 m. Family memorial of Elector Augustus of Saxony. Preliminary drawing (?) in Dresden.

691 Wittenberg, Lutherhalle; signed and dated, 1571, canvas, 2.47 × 1.57 m. According to Suevus (1655), included in the inventory of the Augustinian monastery. Kehrer (1916), Fig. 9.

692 Wittenberg, city church; signed and dated, 1564, wood 1.65 × 1.12 m. Memorial to Caspar Niemegk, presumably donated by his wife.

693 Dessau-Mildensee, village church (from St. Mary's Church in Dessau), signed and dated, 1565, on wood, 2.47 × 2.02 m. Memorial to Prince Joachim of Anhalt (d. 1561), presumably donated by his nephews, Joachim Ernest and Bernard of Anhalt. (See also Thulin [1955], 96 ff.)

694 Kemberg, city church, signed and dated on the inner left side panel: 1565, on wood, 1.77 × 1.35 m. (center panel), 1.76 × .61 m. (side panels). Heller (1821), 301. Thulin (1955), 111. Bilder aus der Geschichte Kembergs, Kemberg (1910), 8 ff., 34.

695 Formerly in Dresden. War casualty. Gall. No. 1946, signed and dated, 1573, on wood, 1.74 × 1.26 m. Exhibited Berlin (1937), No. 152, Fig. 118. Zimmermann (1924–25), 174. Bock (1929), 310. Ebert (1963), 26.

696 Dietrichsdorf, village church, Agony in the Garden, signed and dated, 1575, on wood, 1.43 × 1.18 m. The portrayed donor, Anna Hetzer (d. 1573), is presumably identical with the donor of the memorial to Caspar Niemegk (see Note 692), Mentzius, 2 (1604), 84. Suevus (1655), 2b.

697 Coswig (Anhalt), city church, *Agony in the Garden*, signed and dated, 1578, on wood, 1.31×1.62 m. Center picture of the completely preserved memorial to Otto von Bock (d. 1577), donated by his widow, Margaret, born Robils.

698 Kreuzlingen, Kisters collection, *Resurrection of Christ*, on wood, 1.85×1.36 m. The author is indebted to Dieter Koepplin for the information and for a good photograph of the panel. This may be the memorial to Michael Teuber (d. 1581) from the Wittenberg city church.

699 Nuremberg, Museum. Altarpiece from Colditz, signed and dated, 1584 on the center panel. On wood, 1.60×1.45 m. (center panel), 1.59×.62 m. (side panels). Zimmermann (1924–25). Exhibited Berlin (1937), No. 153. Zimmermann (1953), 209 ff.

700 Wittenberg, city church, *The Vineyard of the Lord*, on wood, 1.28×1.48 m. Memorial to the reformer Paul Eber (d. 1569). Exhibited Berlin (1937), No. 140, Fig. 107. Zimmermann (1941), 34. Thulin (1955).

701 Salzwedel, Museum, altarpiece, signed and dated on the center panel, 1582, on wood, 1.66× 1.47 m. (center panel), 1.66×.6 m. (side panels). From the Mönchskirche, Salzwedel.

702 Schade (1969), 15–18.

703 Ibid., 52. This incomplete information is supplemented in Berling (1887), 290–346, and Schuchardt (1855), 94–101.

704 Wittenberg, city church, signed and dated, 1560, on wood, 1.09×1.57 m. Memorial to the reformer Johannes Bugenhagen. According to a city treasury bill, Cranach was paid 188 guilders and 12 groschen for this picture.

705 See Note 694. The panel with the baptism of Christ also bears the artist's signature.

706 Zerbst, Church of St. Bartholomew, signed and dated, 1568, on wood (transferred to a new base in 1952 at the Institute für Denkmalpflege, Halle), 2.78×2.06 m. Memorial to Prince Wolfgang of Anhalt, with numerous portraits and the first view of the city of Wittenberg preserved in a painting.

707 Augustusburg, castle church, pulpit. The balustrade panels (format: .64×.62 m.) contain the following paintings: *Annunciation* (signed and dated 1573), *Birth of Christ*, *Baptism*, *Crucifixion* (signed and dated, 1573), *Deposition* and *Resurrection of Christ*.

708 See Note 693.

709 This arrangement seems to go back to Dürer. Cf. the 1523 drawing in Vienna (Dürer, 1471–1971, No. 621. Koschatzky and Strobl [1971], No. 137). The most important example in Cranach's work is the center panel of the altarpiece in the Wittenberg city church.

710 Schade (1963), No. 83.

711 Ibid.

712 So-called Crypto-Calvinist dispute.

713 See Note 692.

714 Von Troschke (1938).

715 Cf. Schade (1963), No. 83. G. Pfeiffer (1967), 395.

716 Cf. in general Würtenberger (1957).

717 Zimmermann (1954). Zimmermann (1971).

718 Cf. Ortloff (1868).

719 Sturmhoefel (1905), 144.

720 See Note 684.

721 Inner right side panel of the Kemberg altarpiece. See Note 694.

722 Complementary scene on the Augustusburg altar painting. See Note 690.

723 See Note 698.

724 See Note 699.

725 See Note 689.

726 See Note 695.

727 See Note 699.

728 Dresden, Sächsische Landesbibliothek. Heart-shaped bindings on Johann Mathesius, *Oeconomia*, a prayer book and a calendar, executed by Caspar Meuser before 1585 (*Buchmuseum* [1956], 15).

729 Wittenberg, city church, on wood, 1.16×.84 m. Memorial to Nicolaus von Seidlitz (d. 1582).

730 Wittenberg, city church, *Conversion of St. Paul*, on wood, 1.65×1.32 m. Memorial to Professor Windsheim (d. June 1, 1586). Mylius refers to this as Cranach's last work; obviously Augustin was primarily responsible for the execution.

731 Lucas van Leyden's engraving of 1509, B. 107.

732 Copies by Fritsch in Wörlitz, *Gotisches Haus* (1586), and Berlin-Tempelhof, village church.

733 Cf. Klein (1962).

734 Cf. p. 47 and Notes 284–287.

735 See Sources 1583.

736 See Sources 1564.

737 See Sources 1555.

738 The author, who has not seen the originals, accepts the opinion of Heinrich Zimmermann (1962), 9. Halm (1956), 31, seems to agree.

739 Some of the illustrations in Rosenberg (1934 and 1960) have been retouched in a peculiar manner, and the sketching of the necks and shoulders is imperfectly reproduced.

740 England, Winch collection, R., 91.

741 The portraits of Bugenhagen (F.-R., 285) and Spalatin (F.-R., 285) belong to this series.

742 Scotland, collection of the duke of Buccleuch. See Notes 316, 370.

743 Wittenberg, Lutherhalle, Portrait of Duke Ernest IV of Brunswick-Grubenhagen, on wood, .63×.48 m. Exhibited Weimar–Wittenberg (1953), No. 51.

744 F.-R., 338 and 339.

745 Zimmermann (1962), 12. San Francisco, M. H. de Young Memorial Museum.

746 Warsaw, National Museum, F.-R., 344.

747 Florence, Uffizi. F.-R., 342. Winkler, *Deutsche Kunst*, 10, 3.

748 Anzelewsky, No. 2.

749 Falk (1968), 59, 84.

750 The following formats seem to have been most

commonly used for portraits in the Cranach workshop (dimensions in centimeters): smallest (approx. 20×15); small (ranging from approx. 31×23 or 38×26 to 42×28.5); medium (approx. 48–55×35–37) and a large format reserved primarily for princes (59–67×45–49). In later years even larger formats of 84–90×64–70 were often used, and the portrait of Elector Joachim II measures 113×91.

751 Cf. the Stuttgart portrait of a gentleman of 1543.

752 One of the best examples is the study, R., 92, attributed to Cranach the Younger by Zimmermann (1942 and 1962).

753 Formerly in Dresden. War casualty. Exhibited Berlin (1937), No. 150, Fig. 117. Ebert (1963), 87. The sheet on which the study was executed has been considerably extended on all sides. These extensions have been omitted from Pl. 230.

754 West Berlin, Jagdschloss Grunewald, exhibited Berlin (1937), No. 149, Fig. 116. Gall, *Deutsche Kunst*, 9, 11. Börsch-Supan (1964), No. 53.

755 Anzelewsky, No. 19.

756 West Berlin, F.-R., 269.

757 Suggested by Börsch-Supan (1964).

758 Potsdam, Sans Souci, picture gallery. Exhibited Berlin (1937), No. 142, Fig. 115. Reproduction showing date: 1564, later removed, in Ehrenberg (1899).

759 Schade (1961–62), 41 ff.

760 Schade (1968), 42 ff.

761 Cf. State archives, Dresden, Copial 260. 1553–1556, Sheet 538b. (Schade [1968], 42, Note 48a.)

762 In spite of several research studies (Von Holst, Bukolska), Krell remains an elusive personality.

763 Moritzburg, castle, on loan from the Staatliche Kunstsammlungen, Dresden. Exhibited Berlin (1937), Nos. 143–146. The portraits of Duke Christian and Duchess Maria from the same series (exhibited [1937], Nos. 147–148) are now in a Swiss private collection. (Information from Dieter Koepplin.)

764 Halle-an-der-Saale, Moritzburg Gallery, from Ballenstedt Castle. E. von Frankenberg (1894).

765 Woodcut, B., 128; Holl., 27. B., 129; Holl., 28. B., 132; Holl., 33. B., 133; Holl., 38. B., 174; Holl., 46.

766 Cf. F.-R., 286.

767 Portrait study in Dresden, Gall. No. 1947.

768 Portrait study of Duchess Elizabeth, Bock-Friedländer, 55. Bock (1921), 21. Halm (1956), 31, No. 51.

769 Portrait study of Duke Alexander, Albertina catalogue, *Deutsche Schulen* (1933), 47, No. 371.

770 Vienna, Museum, F.-R., 347–348.

771 Prague, National Gallery (Z 469 and 470), signed and dated, 1566, on wood, 84×58.5 cm. (Exhibited Prague [1949], Nos. 92 and 93.)

772 Schwerin, Museum, F.-R. (340).

773 See Note 676.

774 See Note 683.

775 Frankfurt-am-Main, Städelsches Kunstinstitut.

776 Melanchthon, *Opera* 9, 442. For the translation of the Latin and Greek texts the author thanks Wolfgang Schössler, Brandenburg.

777 West Berlin, Staatliche Schlösser und Gärten, signed and dated, 1571, on wood, 1×.72 m. Exhibited Berlin (1937), No. 151.

778 West Berlin, Jagdschloss Grunewald, signed and dated, 1571, on wood, .94×.77 m. Börsch-Supan (1964), No. 55.

779 In 1523 he acquired by marriage the little Silesian dukedom of Jägerndorf.

780 See Sources 1565.

781 See Sources 1569, 1571.

782 See Sources 1573.

783 See Sources 1572.

784 Peltzer (1911–12), 107.

785 Letter of Electress Anna to Maria of Bavaria of July 22, 1577 (Sturmhoefel [1905], 218).

786 Sponsel (1906). Catalogue Vienna (1972), Nos. 34–81.

787 See Sources 1578.

788 Moritzburg, castle, on loan from the Staatliche Kunstsammlungen, Dresden. Schade (1961–62), 41, Fig. 15.

789 Meissen, city archives. Sponsel.

790 Weissenfels, castle museum. Authenticated as a Cranach in 1971 by the discovery of the signature when the painting was restored in the workshop of the Staatliche Schlösser und Gärten, Potsdam, Sans Souci.

791 Schade (1961–62), 47, Fig. 16.

792 Vienna, Museum, No. 100.

793 See Sources 1578, 1579.

794 Munich, Bayerische Staatsgemäldesammlungen, No. 13112. Zimmermann (1969), 287–293, with color plate.

795 Cf. in particular the Vienna portrait, F.-R., 348.

796 Drawings in Dessau. See Note 411.

797 Klein-Urleben, village church; also the counterpart to this portrait. *Zeitschrift für Bildende Kunst*, Kunstchronik, 7 (1871), 49. Zimmermann (1969), 287, Fig. 12.

798 Ottendorf near Pirna, village church. Information from Walter Henschel and Glaubrecht Friedrich.

799 Weixlgärtner (1949).

800 Virgil Solis, *Folge der Vier Temperamente*, Vol. IX, 178–181.

801 Dresden, city archives. Loc. 8523. Note to Elector Augustus I. Book (1570–1574), Sheet 303, letter from Hans Jenitz, November 7, 1572.

802 Klein (1962). Zschäbitz (1965), 505–509.

803 See Sources 1541.

804 Schuchardt, 1 (1851), 79–81.

805 See Sources 1579.

806 Hentschel (1966), No. 77.

807 Cf. Notes 676, 773. In 1555 Margrave Hans of Küstrin ordered the date of the establishment of the Protestant Church to be given as 1536, although the first contacts with the Protestants date back only to 1537 (Mollwo [1927], 90).

Woodcut
from the Wittenberg
Heiltumsbuch.
1509

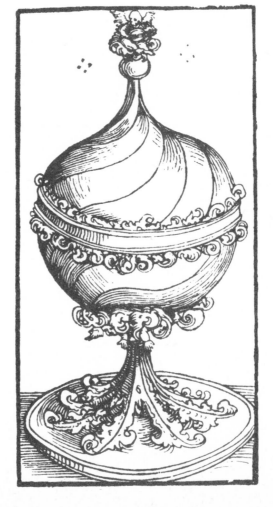

 # BIBLIOGRAPHY

Adriani, G.: Herzog-Anton-Ulrich-Museum Braunschweig. Verzeichnis der Gemälde. Braunschweig 1969

Aldenhofen, C.: Herzogliches Museum zu Gotha, Katalog der Herzogl. Gemäldegalerie. Gotha 1890

Ameisenowa, Z.: Rękopisy i pierwodruki iluminowane Biblioteki Jagiellonskiej. Wrocław 1958

Ankwicz-Kleehoven, H. v.: Cranachs Bildnisse des Dr. Cuspinian und seiner Frau. Jb. d. preuss. Kunstsammlungen 48 (1927) 230–234

–: Der Wiener Humanist Johannes Cuspinian. Graz and Cologne 1959

Anzelewsky = Anzelewsky, F.: Albrecht Dürer, Das malerische Werk. Berlin 1971

–: Eine spätmittelalterliche Malerwerkstatt, Studien über die Malerfamilie Katzheimer in Bamberg. Zeitschr. d. deutsch. Ver. f. Kunstwiss. 19 (1965) 134–150

Arnolds, G.: Opus quinque dierum. Festschrift Friedrich Winkler. Berlin (1959) 187 ff.

Ausst. 1937 = Lucas Cranach d. Ä. und Lucas Cranach d. J. Exhibition in the Deutsches Museum. Berlin 1937

Ausst. 1953 = Katalog der Lucas-Cranach-Ausstellung Weimar und Wittenberg, compiled by W. Scheidig. 1953

Ausst. 1972 = Lucas-Cranach-Ausstellung zu seinem 500. Geburtstag. Weimar 1972

Ausst. Donau-Schule = Die Kunst der Donau-Schule, 1490–1540. Linz 1965

B. = A. v. Bartsch: Le peintre graveur. Vol. 7. New edition. Leipzig 1866

Bainton, R. H.: Erasmus and Luther and the Dialog Julius Exclusus. Vierhundertfünfzig Jahre lutherische Reformation. Berlin (1967) 17–26

Baldass, L.: Die Bildnisse der Donauschule. Städel-Jb. 2 (1922) 73–86

–: Cranachs büssender Hieronymus von 1502. Jb. d. preuss. Kunstsammlungen 49 (1928) 76–81

Bandmann, G.: Melancholie und Musik. Wiss. Abhandlungen d. Arbeitsgem. f. Forschung d. Landes Nordrhein-Westfalen 12. Cologne 1960

Bardeleben, C. v.: Zwei bisher unbeachtete Briefe von Lucas Cranach d. J. aus dem Jahr 1579. Repert. f. Kunstwiss. 32 (1909) 260–265

Batkin, L.: Der Renaissance-Mythos vom Menschen. Kunst und Literatur 20. Berlin (1972) 702–713. 854–862

Bauch, G.: Zur Cranachforschung. Repert. f. Kunstwissenschaft 17 (1894) 421–435

Behling, L.: Die Pflanze in der mittelalterlichen Tafelmalerei. Weimar 1957

–: Der Brautkranz der Prinzessin Sibylle von Cleve. Pantheon 29 (1971) 145–150

Benesch, O.: The Art of the Renaissance in Northern Europe. Cambridge, Mass. 1947

–: Meisterzeichnungen der Albertina. Salzburg 1964

–: Die deutsche Malerei von Dürer bis Holbein. Geneva 1966

Berling, K.: Der kursächsische Hofmaler und Kupferstecher Heinrich Goeding. Neues Archiv f. Sächs. Gesch. 8 (1887) 290–346

–: Die Dresdner Malerinnung. Neues Archiv f. Sächs. Gesch. 11 (1890)

Beth, J.: Zu Cranachs Missalien-Holzschnitten. Repert. f. Kunstwissenschaft 30 (1907) 501–513

Betschart, I.: Der Begriff "Imagination" bei Paracelsus. Nova Acta Paracelsica 6. Einsiedeln (1952) 52–67

Białostocki, J.: "Opus quinque dierum." Journal of the Warburg and Courtauld Institutes 22 (1959) 18 ff.

Bock, E.: Die Zeichnungen in der Universitätsbibliothek Erlangen. Frankfurt-am-Main 1929

Born, K. E.: Moritz von Sachsen und die Fürstenverschwörung gegen Karl V. Historische Zeitschrift 191. Munich (1960) 18–66

Bornkamm, H.: Cranach und die Reformation. Theologische Zeitschrift 8 (1952) 72–74

Börsch-Supan, H.: Die Gemälde im Jagdschloss Grunewald. Berlin (1964)

Borth, W.: Die Luthersache. 1517–1524. Historische Studien 414. Lübeck and Hamburg 1970

Braunfels, S.: Rebhuhn. Lexikon der christlichen Ikonographie 3. Rome–Freiburg–Basel–Vienna (1971) 504 ff.

Braunsdorf, I.: Der Hochaltar von St. Marien in Bernau. Doctoral Thesis. Humboldt-University Berlin 1958

Bruck, R.: Friedrich der Weise als Förderer der Kunst. Strasbourg 1903

Bruns, F.: Der Lübecker Maler Johann Kemmer. Zeitschr. d. Vereins f. Lübecker Geschichte u. Altertumskunde 31 (1941) 113–116

Buchmuseum der Sächsischen Landesbibliothek, Das: Dresden 1956

Buchner, E.: Das deutsche Bildnis der Spätgotik und der frühen Dürerzeit. Berlin 1953

Buchwald, G.: Allerlei Wittenbergisches aus der Reformationszeit (1–5) Luther 10/10. 1928/29

–: Lutherana. Kleine Notizen aus Rechnungsbüchern des Thüringischen Staatsarchivs zu Weimar. Archiv für Reformationsgeschichte 25 (1928) 1–98; 31 (1934) 192–218; 28 (1931) 265–274; 30 (1933) 82–100

Bukolská, E.: A Portrait of Hedwig of Brandenburg-Ansbach. Museum Studies 5. Chicago 1970. 31–37

Celtis, Konrad: Fünf Bücher Epigramme. Edited by K. Hartfelder. Berlin 1881

–: Poeta laureatus. Edited by K. Adel. Stiasny-Bücherei 62. Graz and Vienna 1960

Clemen, O.: Die Wittenberger Verleger Bartholomäus Vogel, Christoph Schramm und Moritz Goltz. Gutenberg-Jahrbuch (1942/43) 114–119

Cnollius, J.: Memorabilia Wittenbergensia. Wittenberg 1702

Coletti. L.: Cima. Venice 1959

Cranach d. Ä., Lucas. Der Künstler und seine Zeit. Edited by H. Lüdecke. Berlin 1953

Cranach, Lucas 1472/1972. Contributions by G. Fehr, F. Winzinger, F. Seibt. Bonn–Bad Godesberg 1972

Cranach, M. A. v.: Über die Heimat der Cranachs. Heimatjahrbuch des Kreises Soldin (Neumark) 13 (1938) 105–106

Cust, L.: Barbari und Cranach d. J. Jahrb. d. preuss. Kunstsammlungen 13 (1892) 142

Cuttler: Some Grünewald Sources. Art Quarterly 19 (1956) 101–124

Deckert, H.: Dom und Schloss zu Merseburg. Burg bei Magdeburg 1935

Delius, W.: Die Reformationsgeschichte der Stadt Halle. Berlin 1953

Deutschmann, J.: Templum Omnium Sanctorum. Wittenberg 1696

Dieckmeyer, A.: Zwei echte Lucas-Cranach-Bilder in Mansfeld. Mansfelder Heimatkalender (1937) 52

Distel, Th.: Lukas Kranach d. J. als Tiermaler. Zs. f. bild. Kunst. Kunstchronik 25. NF 1 (1890) 418

–: Zu einem Doppelporträt des älteren Kranach. Zeitschr. f. bild. Kunst. Kunstchronik. NF 9 (1898) 156–157

Dodgson, C.: Fünf unbeschriebene Holzschnitte Lucas Cranachs. Jb. d. preuss. Kunstsammlungen 24 (1903) 284–290

–: Catalogue of Early German and Flemish Woodcuts, Preserved in the British Museum II. London 1911

Dölling, R.: Byzantinische Elemente in der Kunst des 16. Jahrhunderts. Aus der byzantinistischen Arbeit der DDR 2. Berlin (1957) 149–186

Dornhöffer, F.: Ein Jugendwerk Lukas Cranachs. Jb. d. kk. Zentralkommission. NF II 2 (1904) 175–198

Dornik-Eger, H.: Die Druckgraphik Lucas Cranachs und seiner Zeit. Schriften der Bibliothek des österreichischen Museums für angewandte Kunst 8. Vienna 1972

Dreyer, P.: Tizian und sein Kreis. Berlin 1972

Drobná, Z.: Der Jenaer Kodex. Prague 1970

Dürer, Albrecht. 1471–1971. Exhibition in the Germanischen Nationalmuseums Nürnberg. Munich 1971

Dürer, Albrecht: Das Tagebuch der niederländischen Reise. Edited by J.-A. Goris and G. Marlier. Brussels 1971

Dürer = Dürer. Schriftlicher Nachlass. Edited by H. Rupprich. 1–3. Berlin 1956–1969

Dürer-Zeit, Dresden 1971 = Deutsche Kunst der Dürer-Zeit. Exhibition Catalogue, Dresden 1971

Duverger, J.: Lucas Cranach en Albrecht Dürer aan het Hof van Margareta van Oostenrijk. Jaarbock van het Koninklig Museum voor Schone Kunsten. Antwerp (1970) 5–28

Eastlake, Ch. L.: Materials for a History of Oil Painting. Edited by Hesse. Vienna and Leipzig 1907

Ebert, H.: Kriegsverluste der Dresdener Gemäldegalerie. Dresden 1963

Eckert, W.: Reformation. Lexikon der christlichen Ikonographie 3. Rome, Freiburg, Basel, Vienna (1971) 516–521

Ehlers, E.: Hans Döring. Darmstadt 1919

Ehrenberg, H.: Die Kunst am Hofe der Herzöge von Preussen. Leipzig and Berlin 1899

Eschenhagen, E.: Beiträge zur Sozial- und Wirtschafts-geschichte Wittenbergs. Rechts- und Staatswiss. Dissertation. Halle 1927

F.-R. = M. J. Friedländer and J. Rosenberg: Die Gemälde von Lucas Cranach. Berlin 1932

Faber, M.: Historische Nachricht von der Schloss- und Academischen Stiftskirche in Wittenberg. Wittenberg 1717[1], 1720[2]

Fabian, E.: Dr. Gregor Brück. Schriften zur Kirchen- und Rechtsgeschichte 2. Tübingen 1957

Fait, J.: Deutsche Kunstdenkmäler. Bezirke Cottbus, Frankfurt/Oder, Potsdam und Berlin. Leipzig 1971

Falk, T.: Hans Burgkmair. Munich 1968

Fehn, G.: Chronik von Kronach 1–6. Kronach 1950ff.

Fendt, T.: Monumenta sepulcrorum cum epigraphis ingenio et doctrina excellentium virorum ... de archetypis expressa. Breslau 1574

Fenyö, I.: An Unknown Early Cranach. Burlington Magazine 97 (1955) 68–71

Feyler, G.: Lucas Cranach und Coburg. Frankenspiegel 1 (1950) H. 3. 16–18

Ficker, J.: Die Erstgestalt von Cranachs erstem Lutherbildnis. Studien und Kritiken zur Theologie 103 (1931) 285–291

–: Die Bildnisse Luthers aus der Zeit seines Lebens. Luther-Jahrbuch 16 (1942) 103–161

Findeisen, P.: Neue Forschungen zum Johann-Friedrich-Bau des Torgauer Schlosses. Unpublished Manuscript, delivered at the Dürer-Tagung in Leipzig on July 2, 1971

Flechsig, E.: Die Tafelbilder Lucas Cranachs d. Ä. Leipzig 1900

–: Cranachstudien. Leipzig 1900

Förstemann: Neue Mitteilungen auf dem Gebiet histor. antiquar. Forschungen II (1836) 649

Fraenger, W.: Jörg Ratgeb. Dresden 1972

Frankenberg, E. von: Anhaltinische Fürstenbildnisse. Dessau 1894

Frauendorfer, A.: Ein unbekannter Holzschnitt aus der Frühzeit von Lucas Cranach d. Ä. Alte u. moderne Kunst 3 (1958) 9/10, 14–16

Friedländer, M. J.: Die frühesten Werke Cranachs. Jb. d. preuss. Kunstsammlungen 23 (1902) 232–234

–: Die Tafelmalerei des 15. und 16. Jahrhunderts (in Sachsen und Thüringen). Meisterwerke der Kunst aus Sachsen und Thüringen. Magdeburg (1905) 3–18

–: Burgkmairs hl. Georg von 1508. Jb. d. preuss. Kunstsammlungen 46 (1925) 1–2

–: Zwei Bildnisse von Lucas Cranach. Kunst und Künstler 24 (1926) 381–383

–: Die Gemälde Dürers auf der Nürnberger Ausstellung. Albrecht Dürer, Festschrift. Edited by G. Biermann. Leipzig and Berlin 1928

–: Von Kunst und Kennerschaft. Zürich 1946

–: Erinnerungen und Aufzeichnungen. Edited by R. M. Heilbrunn. Mainz and Berlin 1967

–: Lucas van Leyden. Edited by F. Winkler. Berlin 1963

–: Der Holzschnitt. 4th edition. Compiled by H. Möhle. Berlin 1970

G. = Geisberg, M.: Der deutsche Einblattholzschnitt in der ersten Hälfte des 16. Jahrhunderts. Munich 1924–1930

Gall, E.: Lucas Cranach d. J. Bildnis des Kurfürsten Joachim II. Hektor von Brandenburg. Deutsche Kunst. Edited by L. Roselius. Lief. IX/112. Bremen and Berlin 1942

Geiger, L.: Mutian. Allg. Deutsche Biographie 23. Leipzig (1886) 108 ff.

Geisberg, M.: Ein früher Cranach-Holzschnitt. Cicerone 19 (1927) 173

–: Die 111 Einblattholzschnitte Lukas Cranachs d. Ä. Munich 1929

Giesecke, A.: Wappen, Siegel und Signet Lucas Cranachs und seiner Söhne und ihre Bedeutung für die Cranach-Forschung. Zs. f. Kunstwissenschaft 9 (1955) 181–192

Gillsch, V.: Weimarische Zeitung No. 79, April 3, 1881

Girshausen, Th. L.: Die Handzeichnungen Lucas Cranachs d. Ä. Dissertation. Frankfurt-am-Main 1936

–: Cranach, Malerfamilie. Neue Deutsche Biographie 3. Berlin (1957) 394–400

Glaser, C.: Lukas Cranach. Leipzig 1921

–: L. Cranach d. Ä. Handzeichnungen. Druck der Gesellschaft f. zeichnende Künste 2. Munich 1922

Gmelin, H. G.: Georg Pencz als Maler. Münchner Jahrbuch der bildenden Kunst 17 (1966)

Goldberg, G., and Ch. Altgraf Salm: Altdeutsche Malerei. Alte Pinakothek. Catalog 2. Munich 1963

Gollob, H.: Systematisches Verzeichnis der mit Wiener Holzschnitten illustrierten Wiener Drucke vom Jahre 1460–1552. Studien z. dt. Kunstgeschichte. Strasbourg 1925

–: Der Wiener Holzschnitt in den Jahren 1490–1550. Vienna 1926

–: Renaissance-Probleme in Wiener Frühdruckinitialen. Baden-Baden 1973

Goethe: Werke. Weimarer Ausgabe. 1887–1919

Grate, P.: Analyse d'un tableau. L'Oeil 78 (1961) 30–37, 80

Grimm, H.: Engentinus, Philipp. Neue Deutsche Biographie 4. Berlin (1959) 529 ff.

Grimschitz, B.: Ein unbekanntes Frühwerk Lukas Cranachs. Die bildenden Künste 4 (1921) 148–150

Grisar, H., and F. Heege: Luthers Kampfbilder. Freiburg in Breisgau 1921 and 1922

Gronau, H.-J.: Beobachtungen an Gemälden Lucas Cranachs d. Ä. aus dem ersten Wittenberger Jahrzehnt unter Berücksichtigung von Infrarot-, Röntgen- und mikroskopischen Untersuchungen. Dissertation. Berlin 1972

Grote, L.: Die Vorder-Stube des Sebald Schreyer. Anzeiger d. German. Nationalmuseums (1954) 59, (1960) 43 ff.

Grotemeyer, P.: Die Statthaltermedaillen des Kurfürsten Friedrich des Weisen von Sachsen. Münchner Jb. 21 (1970) 143–159

Gümbel, A.: Der kursächsische Kämmerer Degenhart von Pfeffingen. Strasbourg 1926

Gurlitt, C.: Die Kunst unter Kurfürst Friedrich dem Weisen. Archivalische Forschungen II. Dresden 1897

Hagmeier, J.: Inscriptiones Wittenbergenses. Wittenberg 1637

Halbauer, F.: Mutianus Rufus und seine geistesgeschichtliche Stellung. Leipzig and Berlin 1929

Halm, P.: Deutsche Zeichnungen 1400–1900. Munich 1956

Haenel, E.: Waffen und Kleidung des Kurfürst Moritz von Sachsen am 9. Juli 1553. Zeitschr. f. Hist. Waffen- und Kostümkunde 1 (1923/25)

Hantzsch, V.: Die ältesten gedruckten Karten der sächsisch-thüringischen Länder (1550–1593). Leipzig 1905

Harbison, C.: The Problem of Patronage in a Work by Lucas van Leyden. Oud Holland 83 (1968) 211–216

Harfelder, K.: Sibutus. Allg. Deutsche Biographie 34. Leipzig 1892

Harksen, J.: Alte Handzeichnungen in der Staatlichen Galerie Dessau. Kunstmuseen der DDR 2 (1959) 45–51

Harksen, S.: Schloss und Schlosskirche in Wittenberg. 450 Jahre Reformation. Edited by L. Stern and M. Steinmetz. Berlin (1967) 341—365

Hartlaub, G. F.: "Paracelsisches" in der Kunst der Paracelsuszeit. Nova Acta Paracelsica 7. Einsiedeln (1954) 132–163.

Hasselt–von Ronnen, C. J. van: Hercules en de Pygmeën bij Alciati, Dossi en Cranach I. Simiolus 4 (1970) 13–18

Haussherr, R.: Michelangelos Kruzifixus für Vittoria Colonna. Bemerkungen zu Ikonographie und theolog. Deutung. Wiss. Abhandlungen der Rhein.-Westfäl. Akademie d. Wiss. 44. Opladen 1971

Heller, J.: Lucas Cranach. Leben und Werke. Bamberg 1821

Henkel, A., and A. Schöne: (Editors): Emblemata. Stuttgart 1967

Hentschel, W.: Cranach und seine Schule im Erzgebirge. Glückauf 48 (1928) 43–48

–: Ein unbekannter Cranach-Altar. Zeitschr. für Kunstwissenschaft 2 (1948) 35–42

Herberger, Th.: C. Peutinger in seinem Verhältnis zu Kaiser Maximilian. Augsburg 1851

Hetzer, Th.: Über Dürers Randzeichnungen im Gebetbuch Kaiser Maximilians (1941). Aufsätze und Vorträge. Vol. 2. Leipzig (1957) 47–74

Hevesy, A. de: Jacopo de'Barbari. Paris 1925

Hind, A. M.: Early Italian Engraving. London 1938–1948

Hoffmann, K.: Der Neustädter Altar von Lucas Cranach und seiner Werkstatt. Jena and Berlin 1954

–: Cranachs Zeichnungen "Frauen überfallen Geistliche." Zeitschr. d. Deutsch. Ver. f. Kunstwiss. 26 (1972) 3–14

Holbein d. Ä., Hans, und die Kunst der Spätgotik. Exhibition Catalogue. Augsburg 1965

Holl. = F. W. Hollstein: German Engravings, Etchings and Woodcuts ca. 1400–1700 VI. Edited by K. G. Boon and R. W. Scheller. Amsterdam 1959

Holst, N. von: Die deutsche Bildnismalerei zur Zeit des Manierismus. Strasbourg 1930

–: Die ostdeutsche Bildnismalerei des 16. Jahrhunderts. Zeitschr. für Kunstgeschichte 1 (1932) 19–43

Höss, I.: Georg Spalatin. Weimar 1956

Hupp, O., and *M. Geisberg:* Heraldische Einblattholzschnitte aus der 1. Hälfte des 16. Jh. Munich 1929

Huth, H.: Künstler und Werkstatt der Spätgotik. Augsburg 1923

Hutter, H.: Picasso und Wien. Alte und moderne Kunst 97 (1968) 36

–: Lucas Cranach d. Ä. in der Akademie der bildenden Künste in Wien. Exhibition Catalog. Vienna 1972

Jahn, J.: Lucas Cranach als Graphiker. Leipzig 1955

Jahresberichte 1936–1939. Öffentliche Kunstsammlung Basel

Jantzen, H.: Albrecht Dürer. Neue Deutsche Biographie 4 (1959) 169

Jeremias, A.: Johannes von Staupitz. Berlin 1926

Jung, C. G.: Psychologie und Alchemie². Zürich 1952

–: Mysterium Coniunctionis 1–3. Psycholog. Abhandlungen 10. Zürich 1955–1957

Junius, W.: Das Grabmal Friedrichs des Weisen. Zeitschr. f. bild. Kunst. Kunstchronik 57. NF 33 (1921/1922) 524–526

–: Martin Luthers Grabplatte in der Jenaer Stadtkirche St. Michael. Zeitschr. f. bild. Kunst. Kunstchronik 58. NF 34 (1922/1923) 150–153

–: Aus der Gefangenschaft des Kurfürsten Johann Friedrich. Zeitschrift d. Vereins f. Thür. Gesch. u. Altertumskunde NF 26 (1926) 226–260

–: Grabdenkmäler sächsischer Fürsten des Reformationszeitalters. Thüringisch-Sächsische Zeitschr. f. Gesch. u. Kunst 15 (1926) 98–110

–: Meister des thüringisch-sächsischen Cranachkreises. Zeitschrift d. Vereins f. Thür. Gesch. u. Altertumskunde NF 31 (1934) 64–112

Jursch, H.: Der Cranach-Altar in der Stadtkirche in Weimar. Wiss. Zeitschr. d. Fr.-Schiller-Universität Jena. Ges.-wiss. u. spr.-wiss. Reihe 3 (1953/54) 69–80

Justi, L.: Giorgione. Berlin 1908

–: Das grosse dreiteilige Gemälde aus der Herderkirche zu Weimar. Berlin 1951

Kähler, E.: Bodenstein, Andreas. Neue Deutsche Biographie 2. Berlin 1955. 356 ff.

Kämmerer, L.: Mitteilungen des Österr. Vereins für Bibliothekswesen 9 (1905) 42

Kauffmann, G.: Das 16. Jahrhundert. Propyläen Kunstgeschichte. Berlin 1970

Kehrer, H.: Über die Echtheit von Dürers Crucifixus. Zeitschr. f. bild. Kunst NF 27 (1916) 168–169

–: Noch ein Wort zum Dresdener Kruzifix. Zeitschr. f. bild. Kunst NF 28 (1917) 204

Keisch, C.: Zum sozialen Gehalt und zur Stilbestimmung deutscher Plastik 1550–1650: Sachsen, Brandenburg, Anhalt, Stifter Magdeburg und Halberstadt. Dissertation. Humboldt University Berlin 1969

Kirn, P.: Friedrich der Weise und Jacopo de' Barbari. Jb. d. preuss. Kunstsammlungen 46 (1925) 130–134

Klein, Th.: Der Kampf um die Zweite Reformation in Kursachsen 1586–1591. Mitteldeutsche Forschungen 25. Cologne and Graz 1962

Knaake, K.: Über Cranachs Presse. Centralblatt für Bibliothekswesen 7 (1890) 196–207

Knod, G. C.: Deutsche Studenten in Bologna. 1899

Koch, H.: Unbekannte Aktennotizen zur thüringischen Kunstgeschichte. Wiss. Zeitschr. d. Friedrich-Schiller-Universität Jena 4 (1954/55) 186–189

Köhler, W. H., and *F. Steigerwald:* Lucas Cranach. Gemälde, Zeichnungen, Druckgraphik. Exhibition Catalog. Berlin-Dahlem 1973

König, E.: Peutingers Briefwechsel. Munich 1923

Koepplin, D.: Cranachs Ehebildnis des Johannes Cuspinian von 1502. Seine christlich-humanistische Bedeutung. Doctoral Thesis. Basel 1964, printed 1973

–: Lucas Cranachs Heirat und das Geburtsjahr des Sohnes Hans. Zeitschr. d. Deutschen Ver. f. Kunstwiss. 20 (1966) 79–84

–: (Contribution in) Das grosse Buch der Graphik. Edited by H. Boekhoff and F. Winzer. Braunschweig (1968) 97–98

–: Eine Cranach zuschreibbare Bildzeichnung eines Liebespaares von 1503 und die frühe Graphik Dürers. 1971 (Ms.)

–: Lucas Cranach d. Ä. Neue Zürcher Zeitung No. 457, October 1, 1972. 49–50

–: Zu Cranach als Zeichner – Addenda zu Rosenbergs Katalog. Kunstchronik 25 (1972) 345–347

–: Zwei Fürstenbildnisse Cranachs von 1509. Pantheon (1974) 25–34

Koschatzky, W., and *A. Strobl:* Die Dürerzeichnungen der Albertina. Salzburg 1971

Kostrov, P.: Podlinnij format kartin L. Kranacha Starševo "Venera i Amur." Soobščenija Gos. Ermitaža 6 (1954) 40 ff.

Kreisel, H.: Die Kunst des deutschen Möbels. Vol. 1. Von den Anfängen bis zum Hochbarock. Munich 1968

Kuhn, R.: Cranachs Christus am Kreuz als Marienklage. Alte und moderne Kunst 113 (1972) 12–15

Kühne, H.: Lucas Cranach d. Ä. als Bürger Wittenbergs. Wittenberg 1972

Kunstdenkmale Erfurt = Die Kunstdenkmale der Provinz Sachsen 1. Die Stadt Erfurt. Burg 1929

Kunze, I.: Der Meister HB mit dem Greifenkopf. Zeitschr. d. Deutsch. Vereins für Kunstwiss. 8 (1941) 209

Ladendorf, H.: Cranach und der Humanismus. In: Lucas Cranach d. Ä., der Künstler und seine Zeit. Berlin (1953) 82–98

Landolt, H.: Hundert Meisterzeichnungen des 15. und 16. Jahrhunderts aus dem Basler Kupferstichkabinett. Basel 1972

Langenn, F. A.: Züge aus dem Familienleben der Herzogin Sidonie. Mitt. d. kgl. Sächs. Altert. Vereins 1. Dresden 1852

Langer, O.: Der Kampf des Pfarrers Joh. Petrejus gegen den Wohlgemutschen Altar in der Marienkirche. Mitt. d. Altert.-Vereins Zwickau 11 (1914) 31 ff.

Lehrs, M.: Die dekorative Verwendung von Holzschnitten im 15. und 16. Jahrhundert. Jb. d. preuss. Kunstsammlungen 29 (1908) 183–194

Levey, M.: Dürer. Masters and Movements. London 1964

Lewy, M.: Schloss Hartenfels bei Torgau. Doctoral Thesis. Dresden 1908

Leyser, P.: Aulicus Christianus, Leichpredigt für Stellanus von Holtzendorff. Dresden 1605

Liebmann, M.: On the Iconography of the Nymph at the Fountain by Lucas Cranach the Elder. Journal of the Warburg and Courtauld Institutes 31 (1968) 434–437

Lindau, M. B.: Lucas Cranach. Leipzig 1883

Lippert, W.: Das Sächsische Stammbuch. Neues Archiv f. Sächs. Gesch. 12 (1891) 64–85

Lippmann, F.: Farbenholzschnitte von Lucas Cranach. Jb. d. Preuss. Kunstsammlungen 16 (1895) 138–142

–: Lucas Cranachs Holzschnitte und Kupferstiche. Berlin 1895

–: Der Kupferstich. 6th ed. Berlin and Leipzig 1926

Lisch, F.: Über den Maler Erhard Gaulrap. Jahrbücher d. Ver. f. Mecklenburg. Gesch. u. Altertumskunde 21 (1856) 297–309

Lossnitzer, M.: Die frühesten Bildnisse Kurfürst Friedrichs des Weisen. Mitt. a. d. Sächs. Kunstsammlungen 4 (1913) 8–18

Lüdecke, H.: Lucas Cranach d. Ä. im Spiegel seiner Zeit. Berlin 1953

–: Lucas Cranach d. Ä. Berlin 1972

Luther, J.: Der Besitzwechsel von Bildstöcken im Zeitalter der Reformation. Zeitschr. f. Bücherfreunde 6 (1902) 129–136

Lutz, H.: Conrad Peutinger. Abhandlungen zur Geschichte der Stadt Augsburg 9. Augsburg 1958

M. = Meder, J.: Dürer-Katalog. Vienna 1932

Maedebach, H.: Das Bild der Veste Coburg. Exhibition Catalog. Coburg 1961

Mader, F.: Die Kunstdenkmäler von Bayern 5, 1 Stadt Eichstätt. Munich 1924

Mänz, H.: Die Farbgebung in der italienischen Malerei des Protobarock und Manierismus. Doctoral Thesis. Munich 1934

Martin, K.: Picasso und Cranach. Das Kunstwerk 3 (1949) 10–15

Mayer, A.: Wiens Buchdrucker-Geschichte. 1. Band. Vienna 1883

Mayer-Meintschel, A.: Niederländische Malerei 15. und 16. Jahrhundert. Dresden 1966

Meinhard, Andreas: Dialogus illustrate ac augustissime urbis Albiorene. Leipzig 1508

Meisner, J.: Descriptio Ecclesiae Collegiatae … Wittenberg 1668

Mejer, W.: Der Buchdrucker Hans Lufft zu Wittenberg². 1923

Melanchthon, Philipp: Forschungsbeiträge. Edited by W. Elliger. Göttingen 1961

Mentzius, B.: Syntagma Epitaphiorum … in Metropoli Witeberga 1–4. Magdeburg 1604

Meyer, Chr. D. de: L'Iconographie de Cranach. Apollo 8 (1942) 7–12

Meyer, H.: Über die Altar-Gemälde von Lucas Cranach in der Stadtkirche zu Weimar. Weimar 1813

Möhle, H.: Hans Baldung Grien. Pantheon 8. 15 (1935) 1–13

–: Lucas Cranach d. Ä., Maria und Johannes unter dem Kreuz. Deutsche Kunst 2 (1936) 116–118

–: Lucas Cranach d. Ä., Ruhe auf der Flucht nach Ägypten. Deutsche Kunst Meisterwerke 9. 3

Mollwo, L.: Beiträge zur Geschichte des Markgrafen Hans von Küstrin. Forschungen zur Brand.-Preuss. Gesch. 39 (1927) 89–100

Müller, R. H. W.: Das Cranachgemälde in der Blasiikirche und die Familie Meyenburg. Der Nordhäuser Roland (1954) 176–178

Müller-Hofstede, C.: Zwei schlesische Madonnen von Lucas Cranach. Schlesien 11 (1958)

Mutianus = Der Briefwechsel Mutians. Edited by K. Gillert. 1. 2. Halle 1890

Mylius, G.: Christliche Predigt bey der trawrigen Leich und Begrebnis des … Lucas Cranachs. Wittenberg 1586

Neudörfer, J.: Nachrichten von Künstlern und Werkleuten in Nürnberg (1547). Edited by W. K. Lochner. Quellenschr. z. Kunstgesch. Vienna 1875

Neuhofer, Th.: Gabriel von Eyb. Eichstätt 1934

Oldenbourg, M. C.: Die Buchholzschnitte des Hans Baldung Grien. Studien z. Deutschen Kunstgesch. 335. Baden-Baden and Strasbourg 1962

–: Die Buchholzschnitte des Hans Schäuffelein. Studien z. Deutschen Kunstgesch. 340/341. Baden-Baden and Strasbourg 1964

Ortloff, F.: Geschichte der Grumbachischen Händel 1. Jena 1868

Osiander, R.: Porträts von Andreas Osiander. Theolog. Zeitschr. 15 (1959) 255–266

Ozarowska Kibish, Ch.: Lucas Cranach's Christ Blessing the Children. Art Bulletin 37 (1955) 196–203

Panofsky, E.: Herkules am Scheideweg. Leipzig 1930

Paracelsi Werke. Sämtliche Werke 1–15. Edited by K. Sudhoff. Munich 1922–1933

Perger, R.: Neue Hypothesen zur Frühzeit des Malers Lukas Cranach d. Ä. Wiener Geschichtsbl. 21 (1966) 3, 70–77

Pfeiffer, G.: Judas Iskarioth auf Lucas Cranachs Altar der Schlosskirche zu Dessau. Festschrift Karl Oettinger. Erlangen (1967) 389–400

Philippovich, E. von: Quodlibets eine Abart des Stillebens. Alte u. Moderne Kunst 11 (1966) No. 89. 20

Pieper, P.: Ludger tom Ring d. J. und die Anfänge des Stillebens. Münchner Jb. d. bild. Kunst 3/15 (1964) 113–122

Pignatti, T.: Carpaccio. Geneva 1958

Pohl, H.: Zu Dürers Bildformat. Das Verhältnis von Höhe zu Breite bei seinen Bildnisgemälden. Zeitschr. d. Deutsch. Ver. f. Kunstwiss. 25 (1971) 37–44

Pope-Hennessy, J.: The Portrait in the Renaissance. Bollingen Series 35. 12. Washington 1966

Posse, H.: Lucas Cranach d. Ä. Vienna 1942

Prinz, W.: Die Sammlung der Selbstbildnisse in den Uffizien. Berlin (1971)

Pusikan (i.e.: O. Göschen): Über die Bedeutung der

Wappenfiguren. Nuremberg 1877

Reformation in Europa. Edited by Thulin. Berlin 1967

450 Jahre Reformation. Edited by L. Stern, M. Steinmetz. Berlin 1967

Reichel, A.: Die Clair-obscur-Schnitte des 16. bis 18. Jahrhunderts. Zürich–Leipzig–Vienna 1926

Rein, A.: Über die Entwicklung der Selbstbiographie im ausgehenden deutschen Mittelalter. Archiv für Kulturgeschichte 14 (1919) 193–213

Renner, A. M.: Die Kunstinventare der Markgrafen von Baden-Baden. Bühl-Baden 1941

Reuterswärd, P.: Hieronymus Bosch. Stockholm 1970

Richstätter, K.: Die Herz-Jesu-Verehrung des deutschen Mittelalters. Munich and Regensburg 1924

Rieffel, F.: Kleine kunstwissenschaftliche Kontroversfragen. Repert. f. Kunstwiss. 18 (1895) 424–428

–: Der neue Cranach in der Sammlung des Städelschen Kunstinstitutes. Zeitschr. für bild. Kunst. Kunstchronik 41. NF 17 (1906) 264–273

Riemann, K.: Ein Beitrag zur Maltechnik Lucas Cranachs d. Ä. Weimar 1972

Röhricht, R.: Deutsche Pilgerreisen nach dem Heiligen Lande. Innsbruck 1900

Röhricht, R., and *H. Meisner:* Hans Hundts Rechnungsbuch 1493–94. Neues Archiv f. Sächs. Geschichte 4 (1883) 37–100

Romminger, C.: Eine bisher unbekannte Anbetung der Könige von L. Cranach dem Älteren. Zeitschr. f. bildende Kunst. Kunstchronik 50. NF 26 (1915) 249–252

Roosen-Runge, H.: Die Gestaltung der Farbe bei Quentin Metsys. Doctoral Thesis. Munich 1940

Rosenberg, J.: Deutsche Bildniszeichnungen des 16. Jahrhunderts im Museum zu Reims. Jb. d. Preuss. Kunstsammlungen 55 (1934) 181–189

R.–: Die Zeichnungen Lucas Cranachs d. Ä. Berlin 1960

Rott, H.: Quellen u. Forschungen z. südwestdeutschen u. Schweiz. Kunstgesch. im 15. u. 16. Jahrhundert. Parts 1–3. Stuttgart 1933–1938

Röttinger, H.: Erhard Schön und Niklas Stör. Strasbourg 1925

–: Hans Wechtlin und der Helldunkelschnitt. Gutenberg-Jahrbuch 1942/43. 107–113

Rubensohn, M.: Griechische Epigramme und andere kleinere Dichtungen in deutschen Übersetzungen d. 16. u. 17. Jh. Bibliothek älterer deutscher Übersetzungen 2–5. Weimar 1897

Ruhmer, E.: Cranach. London 1963

Sammlung vermischter Nachrichten zur sächsischen Geschichte 1. 1767

Sander, H.: Zur Identifizierung zweier Bildnisse von Lucas Cranach d. Ä. Zeitschr. f. Kunstwiss. 4 (1950) 35–48

Schade, W.: Zum Werk der Cranach. Jahrbuch 1961/62 Staatl. Kunstsammlungen Dresden 29–49

–: Altdeutsche Zeichnungen. Dresden 1963

–: Die Epitaphbilder Lucas Cranachs d. J. (1966). Ze studiów nad sztuka XVI wieku a Šląsku i w krajach sąsiednich. Wrocław (1968) 63–76

–: Maler am Hofe Moritz' von Sachsen. Zeitschr. d. deutsch. Ver. f. Kunstwiss. 22 (1968) 29–44

–: Dresdener Zeichnungen 1550–1650. Dresden 1969

–: Beobachtungen zur Arbeitsweise in Cranachs Werkstatt. Kunsterziehung 1972. 7/8. 7–10

–: Das unbekannte Selbstbildnis Cranachs. Dezennium 2. Zwanzig Jahre VEB Verlag der Kunst. Dresden (1972) 368–375, 427

–: Lucas Cranachs Kupferstiche. Bildende Kunst (1973) 539–543

Schade, W., and *H.-J. Gronau:* Lucas Cranach cel Bătrin, Lucas Cranach cel Tinăr, Jacob Lucius cel Bătrin. Pictură şi xilogravură din colec ţiile Republicii Democrate Germane. (Exhibition Catalog). Bucharest 1973

Schaefer, K.: Der Lübecker Maler Hans Kemmer. Monatshefte f. Kunstwiss. 10 (1917) 1–7

Schaffran, E.: Neuerwerbungen der Gemäldegalerie im kunsthistorischen Museum zu Wien. Die Kunst und das schöne Heim 55 (1957) 206

Scheidig, W.: Lucas Cranachs Selbstbildnisse und die Cranach-Bildnisse. In: Lucas Cranach d. Ä. Der Künstler und seine Zeit. Berlin (1953) 128–139

–: Lucas Cranach und die Niederlande. Bildende Kunst (1972) 301–302

Schenk zu Schweinsberg, E.: Ein unbeachtetes Selbstbildnis L. Cranachs. Belvedere 9/10 (1926) 67–69

–: Die früheste Fassung des Gemäldes der Ehebrecherin vor Christus von Lucas Cranach d. Ä. Kunst in Hessen und am Mittelrhein 6 (1966)

Scheurl, Chr.: Libellus de laudibus Germaniae et Ducum Saxoniae. Bologna 1506. Leipzig 1508

–: Oratio attingens litterarum prestantiam necnon laudem ecclesiae collegiatae Vittenburgensis. Leipzig 1509

–: Libellus de praestantia sacerdotum ac rerum ecclesiasticarum. Nuremberg 1513

Schiller, G.: Ikonographie der christlichen Kunst 2. Gütersloh 1968

Schmidt, Ph.: Die Illustrationen der Lutherbibel 1522–1700. Basel 1962

Schmidt, W.: Über die frühere Zeit von Lucas Cranach. Monatsberichte über Kunst u. Kunstwissenschaft 3 (1903) 117–118

Schollius, Hector: Elegia gratulatoria in nuptiis clarissimi viri, Domini Johannis Hermanni ... ac Barbara filia ornatissimi viri Domini Lucae Crannachii Senatoris Vuitebergensis et in arte pingendi facile princeps. Wittenberg 1564

Schramm, A.: Die Illustration der Lutherbibel. Luther und die Bibel 1. Leipzig 1923

–: Der Bilderschmuck der Frühdrucke. Vols. 1–23. Leipzig 1920–1943

Schröder, Chr.: Breviarium Wittenberg 1689

Schuchardt, C.: Goethes Kunstsammlungen I. Jena 1848

–: Lucas Cranach d. Ä. Leben und Werke. Parts 1 and 2 Leipzig 1851. Part 3 Leipzig 1870

–: Heinrich Goeding, Archiv für die zeichnenden Künste 1. Leipzig (1855) 94–101

Schultze-Strathaus, E.: Die Wittenberger Heiligtumsbücher vom Jahre 1509 mit Holzschnitten von

Lucas Cranach. Gutenberg-Jahrbuch (1930) 175–188

Schumacher, A.: Gelehrter Männer Briefe an die Könige in Dänemark. Volume II (1758)

Schütz, K.: Lucas Cranach d. Ä. und seine Werkstatt. Jubiläumsausstellung museumseigener Werke. Kunsthistorisches Museum. Vienna 1972

Seidel, P.: Die Taufe Christi mit den Bildnissen des Markgrafen Johann von Brandenburg-Küstrin ... Hohenzollernjahrbuch 11 (1907) 275–278; 12 (1908) 269

Sennertus, A.: Athenae itemque inscriptiones Wittebergenses. Wittenberg 1678

Servolini, L.: Jacopo de'Barbari. Padua 1944

Sibutus Daripinus, Georg: Carmen in tribus horis editum de musca Chilianea. Leipzig 1507 (Univers.-Bibliothek Leipzig, Post-Inkunabel Landsberg 98)

Siècle de Bruegel, Le: Exhibition Catalog. 2nd ed. Brussels 1963

Sitzmann, K.: Fränkische Blätter 2 (1950) 41

Solms, Ernstotto Graf zu: Bildnisse des 16. Jahrhunderts im Schloss zu Laubach. Laubach 1955

Soenke. J.: Jörg Unkair. Minden 1958

Spruth, H.: Die Hausmarke, Wesen und Bibliographie. Aktuelle Themen zur Genealogie 4/5. 2nd edition. Neustadt-am-Aisch 1965

Stange, A.: Malerei der Donauschule. Munich 1964

Stankiewicz, D.: Wrocławski obraz Łukasza Cranacha Starszego "Madonna pod jodłami." Biuletyn Historii Sztuki 4 (1965) 348–357

Stechow, W.: "Lucretiae Statua." Beiträge für Georg Swarzenski. Berlin (1951) 114–125

Steinmann, U.: Der Bilderschmuck der Stiftskirche zu Halle. Forschungen und Berichte 11 (1968) 69–104, 124–134

Steinmetz, M.: Der deutsche Humanismus. Albrecht Dürer. Zeit und Werk. Leipzig (1971) 25–40

Strack, P.: Lukas Cranachs Herkunft. Familiengeschichtliche Blätter 23 (1925) 233–240

–: Festgabe d. Ges. f. Familienforschung in Franken (1931) 472

Sturmhoefel, K.: Kurfürstin Anna von Sachsen. Leipzig 1905

Suevus, G.: Academia Witebergensis. Wittenberg 1655

Swarzenski, G.: Cranachs Altarbild von 1509 im Städelschen Kunstinstitut zu Frankfurt am Main. Münchener Jahrb. d. bild. Kunst 2 (1907) 49–65

Takácz, Z. von: Budapest (Notice about two new paintings on exhibition in the Museum of Art.) Cicerone 1 (1909) 453

Taubert, J.: Zur Oberflächengestalt der sog. ungefassten spätgotischen Holzplastik. Städel-Jahrbuch NF 1 (1967) 119–139

Tavel, H. Chr. von: Die Randzeichnungen Albrecht Dürers zum Gebetbuch Kaiser Maximilians. Münchner Jb. d. bild. Kunst 16 (1965) 55

Tenzel: Supplementum historiae Gothanae. Jena 1702

Thieme, U.: Hans Leonhard Schäufeleins malerische Tätigkeit. Leipzig 1892

Thöne, F.: Lukas Cranach des Älteren Meisterzeichnungen. Burg 1939

–: Bemerkungen zu Zeichnungen in der Herzog-August-Bibliothek zu Wolfenbüttel. Niederdeutsche Beitr. zur Kunstgesch. 6 (1963) 167–206

–: Wolfenbüttel. Geist und Glanz einer alten Residenz. Munich (1963)

–: Lucas Cranach d. Ä. Königstein-im-Taunus 1965

Thulin, O.: Cranach-Altäre der Reformation. Berlin 1955

Traeger, J.: Der Reitende Papst. Münchner Kunsthistorische Abhandlungen 1. Munich and Zürich 1970

Treu, E.: Die Bildnisse des Erasmus von Rotterdam. Basel 1959

Troescher, G.: Conrat Meit von Worms. Freiburg-im-Breisgau 1927

Troschke, A. v.: Studien zu Cranachscher Kunst im Herzogtum Preussen. Doctoral Thesis. Königsberg 1938

–: Miniaturbildnisse von Cranach d. J. in Lutherbibeln. Zeitschr. d. Deutsch. Vereins für Kunstwiss. 6 (1939) 15–28

–: Das sächsische Fürstenstammbuch der Landesbibliothek. Neues Archiv f. sächs. Gesch. 60 (1939) 294–296

Ulmann, H.: Kaiser Maximilian I, 2. Stuttgart 1891

Urban, W.: Na tropach proweniencji "Madonny Wrocławskiej." Wiadomości Urzędowy Kurii Bis. Slas. Opole R. 20 (1965) 7, 162–168

Valerianus, J. P.: Hieroglyphica. Leyden 1610

Végh, J.: Deutsche Tafelbilder des 16. Jahrhunderts. Budapest 1972

Venezianische Malerei 15.–18. Jh. Exhibition. Dresden 1968

Vogel, J.: Lucas Cranach in Wien. Monatshefte f. Kunstwissenschaft 2 (1909) 545

Vögelin, S.: Ergänzungen und Nachweisungen zum Holzschnittwerk Hans Holbeins d. J. Repertorium für Kunstwiss. 2 (1879) 162–190

Voigt, J.: Des Markgrafen Albrecht von Brandenburg Briefwechsel mit den beiden Malern Lucas Cranach und dem Buchdrucker Hans Lufft. Beiträge zur Kunde Preussens 3 (1820) 242–272, 293–298

Volz, H.: Hundert Jahre Wittenberger Bibeldruck 1522–1626. Göttingen 1954

Vorbrodt, G. W.: Der Cranach-Schüler Peter Roddelstedt als Maler Jenaer Professoren. Ruperto-Carola 25. Heidelberg (1959) 94–120

–: Das Scheffer-Epitaph in Jena-Lobeda. Die Mitte. Frankfurt-am-Main (1964) 122–136

–: Gottland, Peter. Neue Deutsche Biographie 6. Berlin (1964) 682ff.

Voss, H.: Der Ursprung des Donaustils. Leipzig 1907

Vossler, O.: Herzog Georg der Bärtige und seine Ablehnung Luthers. Histor. Zeitschr. 187 (1957)

W. = Winkler, F.: Die Zeichnungen Albrecht Dürers 1–4. Berlin 1936–39

Wagner, E.: Cranach und der Wiener Holzschnitt. Mitt. d. Ges. f. vervielfältigende Kunst (1927) 56–59

Walzer, A.: Das Herz im christlichen Glauben. Das Herz im Umkreis des Glaubens 1. Biberach-am-Riss (1965) 107ff.

Warburg, A.: Heidnisch-antike Weissagung in Wort und Bild zu Luthers Zeiten. Sitzungsberichte d. Akad. d. Wiss. Phil.-hist. Kl. Heidelberg 1919 (1920) 26

Warnecke, F.: Lucas Cranach d. Ä. Görlitz 1879

–: Das Künstlerwappen. Berlin 1887

Wäschke, H.: Geschichte Anhalts im Zeitalter der Reformation. Köthen 1913

Wehle, H. B. and *M. Salinger:* A Catalogue of Early Flemish, Dutch and German Paintings. The Metropolitan Museum of Art. New York 1947

Weinberger, M.: Über die Herkunft des Meisters L Cz. Festschrift Heinrich Wölfflin. Munich (1924) 169–182

–: Wolfgang Huber. Leipzig 1930

–: Zu Cranachs Jugendentwicklung. Zs. f. Kunstgesch. 2 (1933) 10–16

Weisskunig = Kaiser Maximilian I. Weisskunig. New edition. Stuttgart 1956

Weixlgärtner, A.: Die Fliege auf dem Rosenkranzfest. Mitt. d. Ges. f. vervielfältigende Kunst, Beilage der Graphischen Künste 2/3 (1928) 20–22

–: Dürer und Grünewald. Göteborgs Kungl. Vetenskaps och Vitterhets-Samhälles. Handlingar F. 6 Ser. A 4 No. 1. Gothenburg 1949

Welck, H. Frbr. von: Georg der Bärtige. Braunschweig 1900

Weltwirkung der Reformation. 2 Vols. Edited by M. Steinmetz and G. Brendler. Berlin 1969

Weniger, H.: Die drei Stilcharaktere der Antike in ihrer geistesgeschichtlichen Bedeutung. Langensalza 1932

Werl, E.: Herzogin Elisabeth von Sachsen, die Schwester Landgraf Philipps von Hessen. Hess. Jb. f. Landesgeschichte 15 (1965) 23–37

Wille, H.: Deutsche Zeichnungen 16.–18. Jahrhundert. Bildkataloge des Kestner-Museums Hannover 10. Hanover 1967

Winkler, F.: Die Bilder des Wiener Filocalus. Jb. d. Preuss. Kunstsammlungen 57 (1936) 141–155

–: Lucas Cranach d. J. Bildnis des Vaters. Deutsche Kunst 10. Lief. 3 Bremen n. d.

–: Ein Titelblatt und seine Wandlungen. Zs. f. Kunstwissenschaft 15 (1961) 149–163

Wölfflin, H.: Die Kunst Albrecht Dürers. Edited by K. Gerstenberg. 1943[6]

Wollgast, S.: Der deutsche Pantheismus im 16. Jahrhundert. Berlin 1972

Wotschke, Th.: Aus Wittenberger Kirchenbüchern. Archiv für Reformationsgesch. 29 (1932) 169 ff.

Würtenberger, F.: Pieter Bruegel d. Ä. und die deutsche Kunst. Wiesbaden 1957

Zeitler, R.: Handlung und Individualität. Albrecht Dürer. Zeit und Werk. Leipzig (1971) 153–160

Zimmermann, H.: Der Dresdener Crucifixus und die Cranach-Werkstätte. Zeitschr. f. bild. Kunst NF 27 (1916) 228

–: Ein herzförmiges Altarwerk Lucas Cranachs d. J. Anzeiger des German. Nat. Mus. (1924/25) 171 ff.

–: Lucas Cranach d. J. Velhagen u. Klasings Monatshefte 53 (1938) 1–12

–: Ein zerstörtes Jagdbild Lukas Cranach d. J. Zeitschr. d. Deutsch. Vereins f. Kunstwiss. 8 (1941) 31 ff.

–: Ein Bildnisentwurf Lucas Cranachs d. J. Berliner Museen 63 (1942) 2–4

–: Beiträge zur Ikonographie Cranachscher Bildnisse. Zeitschr. d. Deutsch. Vereins f. Kunstwiss. 9 (1942) 23–52

–: Über das Bildnis Lucas Cranachs d. Ä. in den Uffizien zu Florenz. Zeitschr. f. Kunstwissenschaft 1 (1947) 51–53

–: Original und Werkstattwiederholung. Berliner Museen NF 2 (1952) 40–44

–: Beiträge zum Werk Lucas Cranachs d. J. Zeitschr. f. Kunstwiss. 7 (1953) 209–215

–: Peter Spitzer. Kunstchronik 7 (1954) 289–290

–: Der Kartonnier des Croy-Teppichs. Jahrbuch der Berliner Museen 1 (1959) 155–160

–: Über einige Bildniszeichnungen Lucas Cranachs d. J. Pantheon 20 (1962) 8–12

–: Zur Ikonographie von Damenbildnissen des älteren und des jüngeren Cranach. Pantheon 27 (1969) 283–293

–: Ein früher Zeichnungsentwurf von Peter Spitzer. Pantheon 29 (1971) 143–145

Zink, F.: Kataloge des Germanischen Nationalmuseums Nürnberg. Die deutschen Handzeichnungen 1. Nuremberg 1968

Zitzlaff, E.: Die Grabdenkmäler der Pfarrkirche zu Wittenberg. Wittenberg 1896

Zöllner, W.: Der Untergang der Stifter und Klöster im sächsisch-thüringischen Raum während des Reformationszeitalters. 450 Jahre Reformation. Edited by L. Stern and M. Steinmetz. Berlin (1967) 157–169

Zschäbitz, G.: Zur Problematik der sogenannten "Zweiten Reformation" in Deutschland. Wiss. Zeitschr. d. Karl-Marx-Universität Leipzig 14 (1965), ges.-wiss. Reihe 505–509

Zülch, W. K.: Lucas Cranach d. Ä. als Kaufmann. Cicerone 18 (1926) 38–39

–: Frankfurter Künstler 1223–1700. Frankfurt-am-Main 1935

–: Der historische Grünewald. Munich 1938

Zykan, M. M.: Der Buchschmuck Johann Winterburgers und der Donaustil. Werden und Wandlung, Studien zur Kunst der Donauschule. Linz (1967) 37–43

LIST OF CRANACH SOURCES

The archive documents for the life and work of the Cranach family of artists have not yet been completely collected. The following list attempts a survey in strict chronological order. Documents whose date could not be precisely determined are listed at the end of the year in question. The list of brief facts about Cranach's business transactions in Frankfurt-am-Main, chiefly concerning the apothecary shop, which Zülch published in 1935 (310ff.), is not included.

The literature references are to the Bibliography and to the card index of Walther Scheidig, used with his kind permission.

Abbreviations

*	holograph document
AA	Stadtarchiv, Augsburg
AC	Stadtarchiv, Coburg
AK	Stadtarchiv, Kronach
AN	Stadtarchiv, Naumburg
AW	Stadtarchiv, Wittenberg
KAN	Kirchenarchiv, Neustadt (Orla)
KKD	Kupferstich-Kabinett, Dresden
LHW	Lutherhalle, Wittenberg
Scheidig, Kart.	Card index of Dr. Walther Scheidig, Weimar
SLBD	Sächsische Landesbibliothek, Dresden
StAD	Staatsarchiv, Dresden
StAK	former Staatsarchiv, Königsberg, now in the Staatliche Archivlager, Göttingen
StAM	Staatsarchiv, Magdeburg
StAN	Stadtarchiv, Nuremberg
StAS	Staatsarchiv, Schwerin
StAW	Staatsarchiv, Weimar
UBH	Universitätsbibliothek, Halle
UBJ	Universitätsbibliothek, Jena
fl.	florin, guilder, guilder-groschen
gr.	groschen, zinsgroschen
pf.	pfennig
sch.	schock
thlr.	taler

For the region discussed here, the mint exchange rate was as follows:

ca. 1500–1558: 1 fl. = 21 gr. = 252 pf. (1 gr. = 12 pf.)
1558–1571: 1 fl. = 24 gr. = 288 pf.
1 fl. = 1 thlr.

Other monetary units mentioned in the list:

1 sch. = 60 gr. 1 ducat = 36 gr.
1 pound = 20 gr., the equivalent of 1 livre (French) = 20 sol

1492

1 *November 6, Kronach.* According to the inheritance suit brought by Heinz Reichtz of Burgkunstadt against Hans Maler (and the shoemaker Hans Hubner), Hans Maler's wife has died, within the previous twelve months.
AK Gerichtsbuch 1492–99, Bl. 33 (Fehn, 3, 103)

1493

2 *February 5, Kronach.* According to a subsequent suit of Hans *(sic)* Reichtz against Hans Hubner, Hans Maler owed 10 fl. to Hubner's deceased wife, Allheit, a sister of Hans Maler's wife.
AK Gerichtsbuch 1492–99, Bl. 41 (Fehn, 3, 103 ff.)

1495

3 *March 31, Kronach.* Hans Maler brings a suit against the daughter of Kunz Donat (city councillor, 1492; burgomaster of Kronach, 1497) and against her grandmother Anna Weltsch, born Reif. Donat's rejoinder dated May 19, 1495.
AK Gerichtsbuch 1492–99. Bl. 112 (Fehn, 3, 119)

4 *June 2, Kronach.* Hans Maler brings suit against the wife of Kunz Donat, claiming that she beat his daughter, little Ann, on the street; also against Anna Weltsch for slander. Court dates: June 16 and 20, 1495. Lucas is mentioned as a principal in a dispute on February 2, 1495.
AK Gerichtsbuch 1492–99 Bl. 122, 125, 127 ff. (Fehn, 3, 120)

5 *August 25, Kronach.* The countersuit of Kunz Donat is temporarily postponed by the court.
AK Gerichtsbuch 1492–99, Bl. 131 (Fehn, 3, 121)

6 *September 15, Kronach.* Suit by Hans Maler: Anna Weltsch alleged to have pushed his daughter, who was carrying a child up from the bath.
AK Gerichtsbuch 1492–99, Bl. 134 (Fehn, 3, 121)

7 *November 23, Kronach.* After hearing further witnesses, the court fines Anna Weltsch $22\frac{1}{2}$ pd., Kunz Donat's wife 2 pd. Decision announced December 15, 1495.
AK Gerichtsbuch 1492–99, Bl. 141 (Fehn, 3, 121)

1496

8 *June 18, Kronach.* Kunz Donat brings suit against Hans Maler and his son Lucas in consequence of the events of February 3, 1495. Court dates: July,

5, December 13, 1496, February 14, 1497 (*statement by Hans Maler), April 22. Verdict of June 7, 1497 (pronounced June 28): Hans Maler and Lucas are fined 45 pd. each. On September 13, payment of the fine is postponed for one year. Further court dates: September 27, 1497, June 19, 1498 (see No. 10).
AK Gerichtsbuch 1492–99, Bl. 169–218 (Fehn, 3, 121–125)

1498

9 *May 22, Kronach.* The court orders postponement of a suit brought by Kunz Donat against Margarethe Maler because Lucas is absent.
AK Gerichtsbuch 1492–99, Bl. 241 (Fehn, 3, 125)

10 *June 19, Kronach.* Hans Maler and his children Lucas and Margarethe take oath of purgation (*Reinigungseid*) imposed by the court decision of June 7, 1497.
AK Gerichtsbuch 1492–99, Bl. 244 (Fehn, 3, 125)

1501

11 *No date, Coburg.* Lucas Maler sues for 20fl. for a delivered painting.
AC (no reference) (Sitzmann [1950])

1505

12 *April 14, Torgau.* First payment (40fl.) to Lucas Maler of Cronach after his entering the service of Saxony.
StAW Reg. Bb. 4188, Bl. 15a (Gurlitt [1897])

13 *May 1 to July 7, Wittenberg.* Cranach supplied from the Wittenberg court kitchen.

StAW Reg. Bb. 2746, Bl. 16a–22b

14 *May 13, Lochau.* A messenger brought paint from Wittenberg for Cranach.
StAW Reg. Bb. 1770, Bl. 12a

15 *May 29, Wittenberg.* Expenses for Cranach's journey from Torgau to Wittenberg.
StAW Reg. Bb. 2746, Bl. 52a

16 *June 24.* Cranach (Lucas, the painter of Wittenberg) is paid the first installment of his salary, 50fl., having completed first quarter of his appointment.
StAW Reg. Bb. 4189, Bl. 37a (Scheidig, Kart. 5)

17 *July 6, Lochau.* Meals for Cranach in Lochau. Also board and lodging for four days of work in Lochau.
StAW Reg. Bb. 1770, Bl. 64b and 65b (Scheidig, Kart. 6–7)

18 *July 17, Wittenberg.* First mention of a journeyman of Cranach's; he is supplied by the Wittenberg court kitchen.
St.AW Reg. Bb. 2746, Bl. 23

19 *Ca. September 29, Leipzig.* Christoph, painter of Munich, receives 12fl. for the purchase of paint, glue, etc., by order of the elector. A second, undated entry concerning payment to the same painter notes that he has worked with Cranach in Wittenberg.
StAW Reg. Bb. 4183, Bl. 183b; Bb. 4190, Bl. 15a (Schuchardt [1851], 47)

20 *September 29, Leipzig.* Cranach receives 17fl. 15gr. for the purchase of gold and silver leaf.
StAW Reg. Bb. 4183, Bl. 184a (Scheidig, Kart. 10)

21 *October 19, Lochau.* Cranach is paid for painted "caracteres" in the palace chapel.
St.AW Reg. Bb. 1770, Bl. 30a (Scheidig, Kart. 9)

22 *December 11, Lochau.* Cranach receives payment of 10fl. 15gr. for blue paint (azurite).
StAW Reg. Bb. 4188, Bl. 36b

23 *December 19, Lochau.* Jacopo de'Barbari's servant is paid 25fl. in the presence of Cranach.
StAW Reg. Bb. 4188, Bl. 36b

1506

24 *January 11, Lochau.* Cranach works with his journeymen in the palace.
StAW Reg. Bb. 1775, Bl. 130a; Bb. 1772, Bl. 27a (Scheidig [1972], 302)

25 *January 19, Lochau.* A messenger brings material for Cranach from Torgau to Lochau. Cranach sends printing type to Coburg by messenger.
StAW Reg. Bb. 1775, Bl. 14a, 14b (Scheidig, Kart. 14 and 15)

26 *February 21.* The elector authorizes a purchase from Cranach in the amount of 3 fl. 13 gr. 6 pf.
StAW Reg. Bb. 4193, Bl. 7b (Scheidig, Kart. 16)

27 *March 25, Weimar.* Board and lodging for Cranach, with horse. Four horses have delivered equipment of Cranach's from Ichtershausen.
StAW Reg. Bb. 2527, Bl. 121a (Scheidig [1972], 302; Scheidig, Kart. 17 and 18)

28 *June 12.* Cranach receives a present from the elector in the amount of 8 grains of nuts (?) and wine.
StAW Reg. Bb. 4193, Bl. 38a (Scheidig, Kart. 20)

29 *September 6, Lochau.* Cranach works with his journeymen in the palace.
StAW Reg. Bb. 1773, Bl. 41b (Scheidig [1972] 302)

30 *October 12, Coburg.* Cranach and his apprentice receive their summer clothing.
StAW Reg. Bb. 5923, Bl. 10a

31 *No date, Coburg.* Cranach and his apprentice receive their winter clothing.
StAW Reg. Bb. 5923, Bl. 25a, 25b

32 *No date.* "One of Cranach's men" sells arrows to the dukes of Saxony.
StAW Kämmerei (Schuchardt [1851], 49)

1507

33 *September 9, Wittenberg.* Refund to Cranach for one night, with horse.
StAW Reg. Bb. 2750, Bl. 28b.

34 *September 30, Wittenberg.* On the elector's orders Cranach receives payment of 1 sch. 8 gr. for several panels and boards.
StAW Reg. Bb. 2750, Bl. 53b

35 *October 7, Nuremberg.* Anton Tucher and Anton Tetzel refer to an inquiry by Pfeffinger and make an application to the elector concerning the medal commemorating his appointment as imperial governor-general on August 8, 1507.
StAW Reg. Aa 2299

36 *October 9, Weimar.* Cranach and his apprentice receive their summer clothing.
StAW Reg. Bb. 5923, Bl. 42a, 42b

37 *October 21.* Payment for joiner's work on a panel which Cranach is to paint.
StAW Reg. Bb. 2750, Bl. 84a (Scheidig, Kart. 24)

1508

38 *January 6, Nuremberg.* Elector Frederick of Saxony grants Cranach his winged serpent coat of arms.

(Schuchardt [1851], 51 ff.)

39 *January 27, Wittenberg.* Cranach takes letters of the elector from Weimar to Lochau. Refund for two nights for Cranach, with horse.
StAW Reg. Bb. 2750, Bl. 67a, 42b

40 *February 24, Weimar.* Cranach and his apprentice receive their winter clothing.
StAW Reg. Bb. 5924, Bl. 6a, 7b

41 *May 20, Wittenberg.* Payment to a messenger who brought Cranach a letter from the elector at Lochau.
StAW Reg. Bb. 1781. Bl. 17b (Scheidig [1972], 301)

42 *June 15–18 (Altenburg)* Cranach, together with the goldsmith Christian Döring, travels from Wittenberg to Altenburg and back. Expenses of 1 fl. 7 gr. 4 pf.
StAW Reg. Aa 3012, Bl. 33a; Reg. Aa 3011, Bl. 17a (Scheidig [1972], 301)

43 *July 6, 8, 13, Nuremberg.* Correspondence concerning the matrix for the governor-general's medal for Elector Frederick indicates that Cranach is expected in Nuremberg.
StAN (Gümbel [1926])

44 *September 24, Augsburg.* Conrad Peutinger sends to Elector Frederick woodcuts printed on parchment in silver and gold which he had commissioned after seeing prints by the Saxon court painter sent to him by Pfeffinger the previous year.

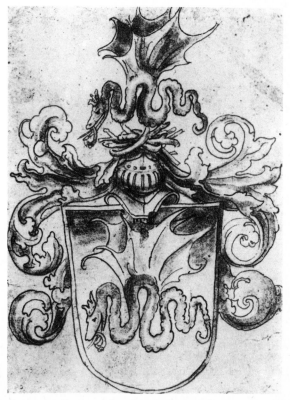

Cranach School:
Cranach coat of arms.
Erlangen
(see Source No. 38)

AA Peutinger-Selekt (Herberger [1851], 26, Note 81. Falk [1968], 115)

45 *September 29, Torgau*. Only Cranach's apprentice is present when the summer clothing is issued.
StAW Reg. Bb. 5924, Bl. 6a, 39a

46 *October 6, Antwerp*. Through Peter Stolze in Antwerp Cranach is paid the sum of 100 fl.
StAW Reg. Bb. 4198. Bl. 158a; Reg. Bb. 4204, Bl. 16a (no date, before January 27, 1509) (Schuchardt [1851], 59)

47 *October 7, Nuremberg*. Anton Tucher expects Pfeffinger or Cranach to inspect Hans Krug's work on the matrix for the governor-general medal in Nuremberg.
(Gümbel [1926])

48 *November 23, Wittenberg*. Expenses for two nights for Cranach, with horse.
StAW Reg. Bb. 2751, Bl. 31b (Scheidig [1972], 301, with different dating)

49 *November 30, Nuremberg*. Anton Tucher has received Cranach's portrait of the elector incised in stone (onyx cameo, formerly in Gotha?). A sample in stone mentioned again on December 16, 1508.
StAW Reg. Aa 2299, Bl. 18 (Gümbel [1926])

50 *December 16, Wittenberg*. Christoph Scheurl's address on the superiority of the sciences and encomium of the Collegiate Church of All Saints in Wittenberg. Published October 1, 1509, with the well-known dedication to Cranach.
(Lüdecke [1953], 49–55. *Dürer* [ed. Rupprich] 1 [1956], 292ff.)

51 *December 17, Torgau*. Cranach and his apprentice receive their winter clothing.
StAW Reg. Bb. 5924, Bl. 54a, 58b

52 *No date, Malines*. Governor-General Margarethe orders the sum of 108 livres, 8 sols and 50 livres, respectively, paid to two painters, "maistre Lucas van a Cranac" and "maistre Christoffele," presumably for work executed. Lille, Archives Départementales du Nord, Namelijk van de rekeningen van Margareta van Oostenrijk, gehouden door haar tresorier Diego Florès.
B 19167 Bl. 53 (Duverger [1970], 9)

1509

53 *Ca. January 1, Leipzig (New Year's Fair)*. On Pfeffinger's instructions Cranach is paid 80 fl.
StAW Reg. Bb. 4204, Bl. 16a, b; Reg. Bb. 4214, Bl. 37a (amount: 50 fl.)

54 *Before January 27*. Payment of cartage for "Lucas Maler's barrel" for the distance Antwerp-Mainz-Frankfurt-Torgau (4 fl. 15 gr. 7 pf.). In addition, two barrels packed by Cranach, together with sweet wine, are sent from the Leipzig New Year's Fair to Torgau (freight 15 gr.).
StAW Reg. Bb. 4204, Bl. 28a; Reg. Bb. 4198, Bl. 169b (Schuchardt [1851], 60)

55 *January 13, Nuremberg*. Anton Tucher reports to the elector that Hans Krug is waiting for a portrait model from Cranach in order to proceed with his die cutting.
StAW Reg. Aa 2299, Bl. 20a (Schuchardt [1851], 62)

56 *February 15, Wittenberg*. Expenses for Cranach for three days, with horse.
StAW Reg. Bb. 2751, Bl. 37b

57 *April 6, Nuremberg*. Anton Tucher sends the elector a cast portrait of a lady (metal relief) by Dürer and mentions the latter's refusal to evaluate the elector's "Pfennige" (pennies) – the governor-general medal.
(*Dürer* [ed. Rupprich], 1, 255)

58 *Ca. April 8, Leipzig (Easter Fair)*. Cranach is paid 40 fl. for colors. Also 76 fl. 20 gr. 9 pf. for further purchases.
StAW Reg. Bb. 4205, Bl. 17b (Schuchardt [1851] 61)

59 *To April 8, Lochau*. Cranach's journeymen work in the palace.
StAW Reg. Bb. 2751, Bl. 35b–43a (Scheidig [1972], 301ff.)

60 *Before May 1, Coburg*. For the restoration of two paintings of apostles in the palace Cranach receives payment of 1 fl. in the fiscal year May 1, 1508, to May, 1509.
StAW Reg. Bb. 818., Bl. 118a

61 *May 20, Wittenberg*. Cranach works in the palace with six painters and receives board and lodging, with horse, for six days of Exaudi Week.
StAW Reg. Bb. 2754, Bl. 20b (Scheidig, Kart. 29)

62 *July 15, Torgau*. Cranach and his two apprentices receive their summer clothing.
StAW Reg. Bb. 5925, Bl. 10a, 13a

63 *July 31, Wittenberg*. Gold and silver for Cranach are brought from Torgau to Leipzig (to the gold beater), then to Wittenberg. Freight: 12 fl.
StAW Reg. Bb. 4205, Bl. 40b

64 *September 8, Wittenberg*. Cranach works in the palace with six painters, receives board and lodging, with one horse, for five days during the Week of the Virgin's Nativity.
StAW Reg. BB. 2754, Bl. 30b (Scheidig, Kart. 30)

65 *No date (June 27 to September 29)*. Payments for gold, silver, *Zwischgold*, and colophony (rosin); the material has been sent to Cranach.
StAW Reg. Bb. 4207, Bl. 27a

66 *No date*. Cranach has painted "a little chest" and sent it from Torgau to Wittenberg.
StAW Reg. Bb. 2751, Bl. 60a (Scheidig, Kart. 28)

1509–10

67 *No date, Wittenberg.* A tiled stove is installed in the "painters' room" in Torgau Castle and a door lock is repaired for Cranach.
StAW Reg. Bb. 2754, Bl. 71b, 72a (Scheidig, Kart. 31)

1510

68 *January 17, Torgau.* A letter is dispatched to Cranach, who is in Düben.
StAW Reg. Bb. 2413, Bl. 92b

69 *February 7, Wittenberg.* Board and lodging for Cranach for one night, with horse.
StAW Reg. Bb. 2754, Bl. 45b (Scheidig, Kart. 32)

70 *April 18, Wittenberg.* Board and lodging for Cranach, with horse, for four days in the week following Jubilate.
StAW Reg. Bb. 2754, Bl. 52a (Scheidig, Kart. 33)

71 *July 28, Lochau.* Board and lodging for Cranach for two days. From May 5 to October 27, three or four journeymen painters are usually working in the palace.
StAW Reg. Bb. 1784, Bl. 93a (Scheidig, Kart. 34)

72 *August 1.* Cranach receives the down payment on an altarpiece commissioned for Neustadt-an-der-Orla.
KAN Kirchenrechnungen 1496–1528, A. IV. 1. 31, Regal 1, Fach 14, Bl. 70b
(Hoffmann [1954] 122)

73 *September 22, Wittenberg.* Four of Cranach's journeymen are working in the palace. Board and lodging for Cranach, in the elector's retinue, with horse, for three nights.
StAW Reg. Bb. 2756, Bl. 33b (Scheidig, Kart. 35)

74 *September 30, Nuremberg.* Anton Tucher confirms receipt of the portrait model made by Cranach from which Hans Kraft is said to have cut the iron die. It is not to be tempered until after Cranach's anticipated visit.
StAW Reg. Aa 2299, Bl. 41a (Schuchardt [1851], 63)

75 *October 6, Wittenberg.* Five of Cranach's journeymen work in the palace. Board and lodging for Cranach, with horse, for five days.
StAW Reg. Bb. 2756, Bl. 35a (Scheidig, Kart. 36)

76 *October 13, Wittenberg.* Six of Cranach's journeymen work in the palace. Board and lodging for Cranach, and horse, for five days.
StAW Reg. Bb. 2756, Bl. 35b (Scheidig, Kart. 37)

1510–11

77 *Fiscal year from beginning of February to beginning of February of the following year.* First mention of Cranach in the accounts of the city of Wittenberg. In the levy for building the great bastions on the city wall, Geres Seiler, Marius Otto, *Lucas Moler*, Peter Hütterin and Jacob Kleinschmidt were assessed (jointly) 8 gr.
AW Kämmereirechnung 1510

1511

78 *January 3, Wittenberg.* Eight of Cranach's journeymen work in the palace. Board and lodging for three days for Cranach, with his horse and his brother-in-law.
StAW Reg. Bb. 2756, Bl. 44b (Scheidig, Kart. 38)

79 *January 6, Torgau.* Payment to a messenger for a letter to Cranach in Düben (?).
StAW Reg. Bb. 2413, Bl. 92b (Scheidig, Kart. 39)

80 *Ca. April 20, Leipzig (Easter Fair).* Cranach receives 47 fl. 14 gr. in payment for gold leaf, paint, etc.
StAW Reg. Bb. 4212, Bl. 55a

81 *September 3, Torgau.* A letter to Cranach from Weimar is brought to Wittenberg from Torgau.
StAW Reg. Bb. 2514, Bl. 34a (Scheidig, Kart. 40)

82 *Ca. September 29, Leipzig (Michaelmas Fair).* * Cranach acknowledges receipt of 50 fl. from the City Council of Neustadt-an-der-Orla for his work on the altarpiece.
KAN (cf. No. 72), Bl. 108a (Hoffmann [1954], 15 ff.)

1511–12

83 *No date, Wittenberg.* Cranach receives 10 bushels of wheat and 50 bushels of rye.
StAW Reg. Bb. 2758, Bl. 139a, 143a (Scheidig, Kart. 41 and 42)

84 *No date, Wittenberg.* Cranach goes to Torgau, accompanied by the clerk Johannes.
StAW Reg. Bb. 2758, Bl. 73a

1512

85 *January 5, Leipzig (New Year's Fair).* Cranach receives payment of 50 fl. for two pictures of the Virgin which the elector presented to Duke

George of Saxony and his spouse on New Year's Day.
StAW Reg. Bb. 4214, Bl. 37a (Gurlitt [1897], 43)

86 *January 10, Wittenberg*. Expenses paid for Cranach, with horse, for five days; nine painters are at work.
StAW Reg. Bb. 2758, Bl. 51a (Scheidig, Kart. 44)

87 *January 17, Wittenberg*. A team of four horses brings Cranach, with panel paintings, from Torgau to Wittenberg. Expenses paid for one night. Eight painters work in the palace.
StAW Reg. Bb. 2758, Bl. 52a (Scheidig, Kart. 45)

88 *February 3, Torgau*. Payment to a messenger for bringing letters to Cranach from Torgau to Wittenberg.

Cranach the Elder:
Bill 1513.
Detail
(see Source No. 106)

StAW Reg. Bb. 2514, Bl. 34b (Scheidig, Kart. 46)

89 *February 6, Torgau*. A letter delivered by messenger is sent posthaste to Cranach in Wittenberg.
StAW Reg. Bb. 2514, B. 34b (Scheidig, Kart. 47)

90 *February 16, Wittenberg*. Two panel paintings (by Cranach?) are brought from Wittenberg to Weimar.
StAW Reg. Bb. 2758, Bl. 68a (Scheidig, Kart. 48)

91 *Ca. April 11, Leipzig (Easter Fair)*. Cranach receives 40 fl. for a painting commissioned by the grand marshal which the elector afterward presented to the latter on All Saints' Day (1511) in Wittenberg.
StAW Reg. Bb. 4215, Bl. 70a

92 *May 2, Wittenberg*. Expenses paid for Cranach for two days in Wittenberg.
StAW Reg. Bb. 2768, Bl. 16a (Scheidig, Kart. 50)

93 *June 14, Neustadt-an-der-Orla*. The altarpiece arrives from Wittenberg, accompanied by Matthäus Cranach, journeyman, his wife and two burghers of Neustadt.
KAN Kirchenrechnungen (cf. No. 72) Bl. 107ff. (Hoffmann [1954], 10, 122)

94 *June 24, Neustadt-an-der-Orla*. Matthäus Cranach accepts 105 sch., old currency, for work on the altarpiece.
KAN Kirchenrechnungen (cf. No. 72) Bl. 107a (Hoffmann [1954], 122)

95 *June 27, Neustadt-an-der-Orla (year given as 1513)*. *Matthäus Cranach acknowledges receipt of 100 fl. (Rhenish) on behalf of his brother. Formerly StAW Reg. B. 31904, Bl. 49a (Gillsch, Hoffmann [1954], 16)

96 *Ca. September 29, Leipzig (Michaelmas Fair)*. Cranach, together with Simprecht and his apprentices, receives 36 fl., also 41 fl. 13 gr. for work not previously paid for.
(Buchwald, Luther [1928], 109)
The wife of Hans Zinkeisen, master joiner of Wittenberg, receives a loan of 20 fl. in the presence of "Lucas von Granach, Maller."
StAW Reg. Bb. 4216. Bl. 50b
Cranach receives payment of 40 fl. 8 gr. through Stephan Strohl, clerk of the court treasury, for several works executed for the wedding of Duke Henry of Saxony.
StAW Reg. Bb. 4216, Bl. 60b

97 *September, Wittenberg*. Matriculation note: "Mattheus Pictoris de Cranach."
UBH, Matriculation Book of the University of Wittenberg

98 *October 31, Wittenberg*. Expenses paid for Cranach for three days.
StAW Reg. Bb. 2768, Bl. 35b (Scheidig, Kart. 51)

99 *No date, Wittenberg.* Cranach receives 80 bushels and one measure of oats for his horse per half year.
StAW Reg. Bb. 2759, Bl. 52a (Scheidig, Kart. 43)

1512–13

100 *No date, Wittenberg.* Cranach receives 10 bushels of wheat, 50 bushels of rye, 40 bushels of barley. Also 145 bushels and one measure of oats for his horse for one year.
StAW Reg. Bb. 2768, Bl. 102b, 104b, 106a, 109b (Scheidig, Kart. 52)

101 *No date, Neustadt-an-der-Orla.* The church treasury makes a payment of 42 sch. to the City Council for Cranach's altarpiece.
(Hoffmann [1954], 123)

102 *No date, Wittenberg.* First mention of Cranach as owner of two houses; previous owners: Caspar Teuschel, Blasius Welmsdorff (whose house Cranach rented out, according to a note concerning the collection of table and water taxes). Because of extensive construction work on the property at No. 1 Schlossstrasse, Cranach is exempted from taxes for five years on this lot, from 1513 to 1517. Also owns a garden.
AW Kämmereirechnung 1513

103 *No date, Wittenberg.* In the levy for the construction of the Elb Gate bastions Cranach is assessed 20 gr. but is exempted from payment because of the poor condition of his two houses. Purchase of 40 cartloads of lime. Debts amounting to 2 sch. 16 gr. 10 pf. and 1 sch. 40 gr., also 6 gr. 10 f.
AW Kämmereirechnung 1513

1513

104 *Beginning of January, Leipzig (New Year's Fair).* Cranach receives payment of 17 fl., to be debited to Duke John, for three coats of arms ordered through Gangulf von Witzleben.
StAW Reg. Bb. 4217, Bl. 23b

105 *February –April, Torgau.* Hans and Jacob, two of Cranach's journeymen, receive board and lodging in Torgau.
StAW Reg. Bb. 2514, Bl. 129b (Scheidig, Kart. 53)

106 *May 24 (Belzig).* Bill from Cranach for delivered items of tournament equipment (jousting and racing caparisons, painted prints of coats of arms, various helmet crests) which Duke John took with him on his journey to Mecklenburg, Pomerania and Brandenburg. Total amount: 18 fl. 14 gr. StAW Reg. Bb. 5531, Bl. 16a, 17a

107 *September 13, Grimma.* Degenhart Pfeffinger reports to Anton Tucher that Cranach will cut a

new model, portrait and eagle, in stone, for the mint die.
(Ehrenberg [1899]; Grotemeyer [1970], 144)

108 *November 12 and subsequent days, Torgau.* Cranach receives various payments for work executed for the wedding of Duke John. Expenses paid for 13 days (13 gr.), sleeping quarters for ten journeymen over a period of four weeks (2 fl. 14 gr. 8 pf.), for racing and jousting caparisons, helmet crests, a painting, coats of arms (165 fl. 10 gr.), for paint pots (2 gr.).
StAW Reg. Bb. 4226, Bl. 35b, 46a, 56a (Schuchardt [1851], 63ff.)

109 *December 21, Nuremberg.* Anton Tucher sends the elector the lower mold, broken in the trial striking (die from Cranach's portrait).
(Ehrenberg [1899], 100)

1513–14

110 *No date, Wittenberg.* Cranach receives 100 bushels of rye. Also 145 bushels and two measures of oats for his horse, for one year.
StAW Reg. Bb. 2762, Bl. 164b and 171b (Scheidig, Kart. 54)

111 *No date, Wittenberg.* Cranach pays the assessment for the Altenburg meeting of the Diet.
AW 64 Steuerausschreiben and Generalia 1495–1710

112 *No date, Kronach.* Hans and Mathes Maler, Cranach's father and brother, are living in the house at No. 1 Marktplatz in Kronach.
AK Weihsteuerrechnung 1514, Bl. 4a (Fehn, 3, 114)

1514

113 *March 29, Wittenberg.* Cranach has evaluated the gallery in the Wittenberg Castle church.
StAW Reg. S. Fol. 23b. Nos. 1–24b, No. 1, Bl. 10

114 *April 10–June 4.* *Cranach acknowledges receipt from Hans von Taubenheim of 20 fl. on April 10 and of 50 fl. on June 4 for work done.
KKD C 2182

115 *Ca. April 16, Leipzig (Easter Fair).* Cranach receives payment of 50 fl. for work executed.
StAW Reg. Bb. 4239, Bl. 70a (Schuchardt [1851], 65)

116 *Ca. April 16, Leipzig.* Cranach receives 6 fl. for a "Man of Sorrows" which the elector has acquired.
StAW Reg. Bb. 4239, Bl. 29b

117 *May 18, Torgau.* A messenger brings a report to the elector from Wittenberg that the students and painters had "a rough fight."
StAW Reg. Bb. 2764, Bl. 128b (Scheidig, Kart. 59)

118 *Ca. September 29, Leipzig (Michaelmas Fair)*. Cranach is paid 20 fl. for his work on the tower of Torgau Castle.
StAW Reg. Bb. 4240, Bl. 78b, 93a (Gurlitt [1897], 44)

1514–15

119 *No date, Wittenberg*. Cranach receives 23 bushels of rye. Also 121 bushels of oats for his horse.
StAW Reg. Bb. 2764, Bl. 184b (Scheidig, Kart. 56)

120 *No date*. Cranach is paid 65 fl. for the altar painting of the Holy Trinity commissioned by the St. Sebastian Brotherhood of Leipzig.
(F. Ostarhild, Church of St. Nicholas, Leipzig. Berlin [1964], 18)

1515

121 *Beginning of January, Leipzig (New Year's Fair)*. Cranach is paid 70 fl.

122 *January 8, Wittenberg*. Two carters with four horses move equipment for Cranach from Torgau to Wittenberg.
StAW Reg. Bb. 2764, Bl. 83b (Scheidig, Kart. 57)

123 *February 14, Wittenberg*. Cranach is driven from Torgau to Wittenberg with a team of two horses.
StAW Reg. Bb. 2764, Bl. 92b (Scheidig, Kart. 58)

124 *April 8, Easter Evening*. *Cranach acknowledges receipt of 10 fl. from Hans von Taubenheim.
KKD C 2182

125 *April 24*. *Cranach acknowledges receipt of 10 fl. for board from Hans von Taubenheim.
KKD C 2182

126 *Ca. September 29, Leipzig (Autumn Fair)*. Through Master Adolf Fischer Cranach is paid 60 fl. for work on the castle towers at Wittenberg and Torgau.
StAW Reg. Bb. 4251, Bl. 49a

127 *Ca. September 29, Leipzig (Michaelmas Fair)*. *Cranach acknowledges receipt from Degenhart von Pfeffinger of 60 fl. in part payment for work done.
KKD C 2182

1515–16

128 *No date, Wittenberg*. Cranach receives the annual ration of 145 bushels and two measures of oats for his horse.
StAW Reg. Bb. 2765, Bl. 205b (Scheidig, Kart. 60)

1516

129 *Beginning of January, Leipzig (New Year's Fair)*. Lucas Cranach and Christian Döring jointly re-

ceive, through Hans von Taubenheim, 207 fl. 12 gr. for work done.
StAW Reg. Bb. 4258, Bl. 16b. Reg. 4259, Bl. 25b

130 *Ca. March 23, Leipzig (Easter Fair)*. Cranach, who has been driven from Torgau to Leipzig, is paid 10 fl. $17^1/_2$ gr., including 5 fl. for a reliquary. He is paid 2 fl. 17 gr. for work on the gallery of the Wittenberg Castle church.
StAW Reg. Bb. 4262, Bl. 83b, 84a

131 *June 16*. Grand Master Albert of Prussia orders payment of 23 fl. for four paintings acquired from Cranach through his counselor, Dietrich von Schönberg. They are to be sent to Berlin to Christoph Wins, who will arrange the forwarding.
Formerly StAK Flt der Ordenzeit 38, Bl. 111 (Ehrenberg [1899], 4)

132 *August 30, Wittenberg*. Cranach is a guest of Degenhart von Pfeffingen.
StAW Reg. Bb. 2767, Bl. 55b (Scheidig, Kart. 61)

133 *No date, Kronach*. Cranach's father is mentioned as living on the outskirts of the town. ("Jung maler," presumably his grandson, is living close by.) Also Mathes Maler, Cranach's brother, has given up his quarters in the house on the Marktplatz; Barthel Sonders (the brother-in-law) has moved in.
AK Weihsteuerrechnung, 1516, Bl. 15a; Stadtlehnbuch 1514–55, Bl. 8a, 52a, 91a, 111a

1516–17

134 *No date, Wittenberg*. Cranach receives the yearly ration of 145 bushels and two measures of oats for his horse.
StAW Reg. Bb. 2767, Bl. 205b (Scheidig, Kart. 62)

1517

135 *Beginning of January, Leipzig (New Year's Fair)*. Cranach is paid 18 fl. for a small painted panel.

136 *January 6, Grimma*. Elector Frederick explains to Duke George that Cranach has not been to see him for a long time and he has therefore been unable to advise him of the duke's wishes.
StAD (from Langenn [1852], 103, No. 21)

137 *January 20, Königsberg*. Grand Master Albert of Prussia commissions Cranach to paint the struggle between Hercules and Antaeus, specifying the dimensions.
Formerly StAK Flt. der Ordenzeit 39, Bl. 75a (Ehrenberg [1899], No. 5)

138 *January 20, Lochau*. Elector Frederick advises Duke Henry of Saxony that Cranach is ill. (He was unable to travel until March.)
StAD (from Langenn 1852, 104, No. 22; Lindau [1883], 111)

139 *March 8, Torgau.* Elector Frederick asks Cranach, who has recovered from his illness, to take a letter to Duke George. Discussion of a small panel to be painted by Cranach.
StAD (from Langenn [1852], 106, No. 27)

140 *March 25, Altenburg.* Elector Frederick has learned from Cranach that Duke George liked the sketch for the small panel. The elector attempts to allay the duke's doubts about "what the little panel might serve to decorate."
StAD (from Langenn [1852], 107, No. 28)

141 *Ca. April 12, Leipzig (Easter Fair).* Cranach receives 12 fl. for a small panel of the Holy Trinity, also 10 fl. for painting two sleds.
StAW Reg. Bb. 4273, Bl. 25 a (Schuchardt [1851], 67)

142 *August 10, Zwickau.* The elector instructs Veit Warbeck in Wittenberg to ask the French king's ambassador, then in Wittenberg, whether he would like to have some (printed?) *Flaserwerk* [simulated veined woodwork] and paintings he had admired. According to Krencker, however, Warbeck failed to carry out these instructions.
StAW Reg. C. 366, Bl. 25 a, 23 a (Scheidig [1953], No. 23)

143 *August 29, Eisenach.* Johann Osswalt, village mayor of Eisenach, who supplies the elector with veined ash wood (for paneling), mentions that a table board which he had given to Cranach had been picked out of the firewood at Gerstungen Castle and trimmed with an adze.
StAW Reg. S. Fol. 227 a–229 a, Nos. 1 and 2; (Schlossbau zu Weimar) Bl. 32 a (Scheidig, Kart. 63)

144 *October 9, Wittenberg.* Matriculation of Johannes Sonder de Wittenbergk (Hans Cranach?), who is exempted from the university oath on account of his age.
UBH University Matriculation Book

145 *November 22, Wittenberg.* In response to a letter from Duke George of November 17, Elector Frederick again expresses his opinion about the panels painted for the duke by Cranach. In addition to these panels, a painting of the Virgin has been sent to Duchess Barbara.
StAD (from Langenn [1852], 108, No. 29)

146 *No date, Wittenberg.* Cranach is now in the last year of the tax exemption he has enjoyed since 1513. First mention of Cranach's real estate: one hide of land within the village limits of Rothemark, west of Wittenberg.
AW Kämmereirechnung 1517

147 *No date, Wittenberg.* Cranach receives 42 gr. for gilding work on the shooting yard.
(Förstemann [1836], 650)

1517–18

148 *No date, Wittenberg.* Cranach receives 84 bushels of oats for his horse for thirty weeks.
StAW Reg. Bb. 2769, Bl. 110 a (Scheidig, Kart. 64)

149 *No date, Wittenberg.* Cranach receives 42 gr. for painting banners in the shooting yard.
AW Kämmereirechnung 1518 (Schuchardt [1851], 67)

1518

150 *March 24.* Cranach mentioned as owner of a house in Gotha.
(Schuchardt [1851], 83)

151 *May 13, Altenburg.* Christian Döring acknowledges receipt of 5 fl. 10 gr. from Cranach. (On the back of this sheet the following bill): *Cranach's bill for joiner's work on a picture of Lucretia (1 fl.), a small picture of Lucretia (4 fl.) and two cases for the pictures (10 gr.).
StAW Reg. Aa 2975, between Bl. 2 and 3 (Scheidig [1953], No. 25, partially incomplete)

152 *November 4, Torgau.* Four of Cranach's journeymen with their equipment are taken to Wittenberg by horse and wagon.
StAW Reg. Bb. 2423, Bl. 17 a (Scheidig, Kart. 66)

1519

153 *May 1, Dresden.* Cranach receives a payment of 25 fl. from Duke George of Saxony.
StAD (Lindau [1883], 232)

154 *May 16, Torgau.* Letters, including some from Grimma, are forwarded to Cranach in Wittenberg.
StAW Reg. Bb. 2424, Bl. 51 a (Scheidig, Kart. 68)

155 *May 28, Weimar.* Elector Frederick is pleased that the mother of the king of France is willing to exchange a relic for "several small panels by our painter" (Cranach).
StAW Reg. O. 214, Bl. 28 a (here also Krencker's note mentioned above in No. 142, August 10, 1517) (Scheidig [1953], No. 24)

156 *August 3, Nuremberg.* Christoph Scheurl acknowledges to Karlstadt receipt of the "Wagon" woodcut and asks to be remembered to Cranach.
(*Dürer* [ed. Rupprich], 1 [1956], 264)

157 *No date, Wittenberg.* Cranach is elected a member of the City Council and a treasurer. Mention of Andreas, Master Lucas' wine-shop keeper.
AW Kämmereirechnung 1519

158 *No date, Wittenberg.* Cranach receives 72 bushels and two measure of oats for his horse for twenty-six weeks.
StAW Reg. Bb. 2772, Bl. 65 b (Scheidig, Kart. 67)

159 *No date, Wittenberg.* Cranach is paid expenses for work in the castle church.
StAW Reg. Bb. 2773, Bl. 23 b (Scheidig, Kart. 69)

160 *No date, Wittenberg.* Cranach receives 53 bushels and one measure of oats for his horse for nineteen weeks.
StAW Reg. Bb. 2773, Bl. 61 a (Scheidig, Kart. 70)

1520

161 *March 3, Wittenberg.* Jacob Rentz is sent to Lochau with a message concerning the apothecary privilege of Master Lucas Cranach.
AW Kämmereirechnung 1520

162 *May 5, Wittenberg.* Luther tells Spalatin that Mathäus Adrianus is often to be found in Cranach's apothecary shop.
(Luther, *Werke*, Vol. II, Correspondence, Weimar [1931], 101)

163 *June 3, Wittenberg.* *Cranach acknowledges receipt of 4 fl. paid to him by Georg Spalatin on a debt of Degenhart Pfeffinger (deceased). (Total debt: 26 fl.)
StAW Reg. Bb. 2215, Bl. 118, 104a, 105 (Scheidig, Kart. 72)

164 *July 12 to July 30, Wittenberg.* Student unrest, in

Cranach the Elder and Christian Döring: Receipts of August 8, 1520 (see Source No. 165)

which Cranach's journeymen are involved. The elector orders the town occupied by troops; guilty students to be sought out.
StAW Reg. O. 460, Bl. 7–33 (Scheidig [1953], 164–167)

165 *August 8.* *Cranach acknowledges receipt of 5 fl.

paid to him by Georg Spalatin on a debt of Degenhart Pfeffinger (deceased).
StAW Nachlass Spalatin, Reg. Gg 2215, Bl. 112 (Schuchardt [1851], 73)

166 *December 6, Lochau.* Elector Frederick grants Cranach apothecary privilege.
LHW (Loan from the Adler Apotheke, Wittenberg). Copy: AW 102 Privilegienbuch 1512 ff. Bl. 84a (Schuchardt [1851], 69 ff.

167 *No date, Wittenberg.* Cranach receives 14 bushels of oats for his horse.
StAW Reg. Bb. 2776, Bl. 12 a (Scheidig, Kart 73).

1520–21

168 *No date, Wittenberg.* Cranach supervises two stonemasons in installing two marble sculptures (of the elector and his brother, Duke John) in pillars in the castle church. Payments to stonemasons, carpenters, day laborers and smiths.
StAW Reg. Bb. 2774, Bl. 54a

169 *No date, Wittenberg.* Cranach receives the annual ration of 145 bushels and two measures of oats for his horse.
StAW Reg. Bb. 2747, Bl. 119a (Scheidig, Kart. 75)

170 *No date, Weimar.* Cranach's journeymen worked seven weeks and four days on the casing of the organ in the palace church. They have received board, also living expenses for the return journey to Wittenberg.
StAW Reg. S. Fol. 241 b. Nos. 11–14/15, Bl. 22b (Scheidig, Kart. 77)

1521

171 *April 28, Frankfurt-am-Main.* Martin Luther tells Cranach about his appearance in Worms and indicates that he will go into hiding. He sends greetings to Christian Döring and his wife and thanks the City Council for furnishing transportation.
Copy: Jena University Library, Rose q 245, Bl. 39b (Schuchardt [1851], 74 ff.)

172 *July 22, Torgau.* The steward at Torgau requests the elector to ask Cranach to send a journeyman to restore a fallen painting on the premises of Torgau Castle.
StAW Reg. S. Fol. 282a, No. 1f, Bl. 1a (Scheidig, Kart. 76)

173 *Ca. September 29, Leipzig (Michaelmas Fair).* Cranach is paid 66 fl. for painting the organ in Weimar Palace.
StAW Reg. Bb. 4309, Bl. 59a (Schuchardt [1851], 74)

1522

174 *Beginning of January, Wittenberg.* The Wittenberg

news sheet (of Ambrosius Wilkens) mentions Martin Luther's visit from the Wartburg (December 22–24, 1521) and especially the meeting with his friend Cranach.
(G. Th. Strobel, *Miscellaneen literarischen Inhalts*, 5 Sammlung, Nuremberg [1781], 117 ff. Müller [1911], 159)

175 *May 11, Lochau.* Cranach is paid for two panel paintings, a *Judgment of Paris* and a portrait of the elector.
StAW Reg. Bb. 1795, Bl. 68 b (Scheidig, Kart. 80)

176 *May 29, Lochau.* Cranach is paid for the following paintings: a picture of the Virgin, larks, four otters.
StAW Reg. Bb. 1795, Bl. 92 b (Scheidig, Kart. 81)

177 *May 29, June 8, Lochau.* Cranach sells wine and wine casks to the court. He receives a present of game.
StAW Reg. Bb. 1795, Bl. 92 a, 104 a (Scheidig, Kart. 82, 87)

178 *June 10, Lochau.* Cranach sells "some ancient coins" to the elector. (A collection of old coins had been bequeathed to Spalatin in Pfeffinger's will.) StAW Reg. Bb. 1795, Bl. 106 a (Scheidig, Kart. 83)

179 *September 25, Lochau.* Cranach, with two horses, receives board and lodging for three nights in Lochau.
StAW Reg. Bb. 1795, Bl. 118 b (Scheidig, Kart. 84)

180 *October 11, Lochau.* The elector sends a letter to Cranach in Wittenberg.
StAW Reg. Bb. 1795, Bl. 131 b (Scheidig, Kart. 85)

181 *November 9, Lochau.* Cranach sells wine to the court. He spends two days in Lochau (payment for hire of three horses) and is paid, among other things, for printed copies of the New Testament (the so-called September Testament in Luther's translation) and for a gratuity to "the old Seiler woman."
StAW Reg. Bb. 1795, Bl. 137 b, 138 a (Scheidig, Kart. 87 and 86)

182 *No date, Wittenberg.* *Cranach acknowledges receipt of 12 guilders (Rhenish) paid to him by Spalatin on a debt of Pfeffinger (of 15 fl.). (Cf. earlier receipts by Cranach of June 3 and August 8, 1520.)
StAW Reg. Gg. 2215, Bl. 88 (Scheidig, Kart. 78)

183 *No date, Wittenberg.* Cranach asks the elector to have alleged irregularities in his apothecary shop investigated.
StAW Reg. O. pag. 119, V. V. 121, bl. 1 f. (Scheidig, Kart. 79)

1522–23

184 *No date, Wittenberg.* Cranach receives the annual ration of 145 bushels and two measures of oats for his horse.
StAW Reg. Bb. 2778, Bl. 72 a (Scheidig, Kart. 88)

185 *No date (ca. October 10), Wittenberg.* King Christian II of Denmark has been living in Cranach's house.
SLBD (Lindau [1883], 158)

186 *No date, Wittenberg.* Cranach has made a sketch for the two main gables of the castle.
(Harksen [1967], 351)

1523

187 *March 10, Wittenberg.* Luther intercedes with Spalatin, asking further clemency for Hans of Schmalkalden, hired painter, accused of homicide, who works and lives at Cranach's.
Zerbst, Archive (Lindau [1883], 151. Martin Luther, *Werke*, kritische Gesamtausgabe, Correspondence, Vol. III, Weimar [1933], 44, No. 592)

188 *April 8, Wittenberg.* Luther tells his friend Wenzel Linck that the substantial number of wedding guests at the marriage in Altenburg will include Cranach. (Lindau [1883], 201)

189 *July 11, Wittenberg.* Martin Luther to Georg Spalatin: "But Lucas' press needs support. ... I have become other people's profit or a slave to their greed."
Zerbst, Archive (Lindau [1883], 161. Martin Luther, *Werke*, kritische Gesamtausgabe, Correspondence, Vol. III, Weimar [1933], 109, No. 633)

190 *August 28, Wittenberg.* Cranach sells paper to the court.
StAW Reg. Bb. 2780, Bl. 78 a (Scheidig, Kart. 89)

191 *Ca. September 29, Leipzig.* Cranach is paid 50 fl. An account for artist's colors (12 fl. 8 gr. 3 pf.) is also settled, together with board during the "Maler's" stay in Weimar.
StAW Reg. Bb. 4321, Bl. 33 a, 33 b, 34 b.

1523–24

192 *No date, Wittenberg.* Cranach receives the annual ration of 145 bushels and two measures of oats for his horse.
StAW Reg. Bb. 2780, Bl. 99 b (Scheidig, Kart. 90)

193 *No date, Wittenberg.* Cranach's journeymen have been brought from Lochau with their equipment. Expenses for four horses.
StAW Reg. Bb. 2780, Bl. 102 a (Scheidig, Kart. 91)

1524

194 *March 20, Wittenberg.* Cranach sells paper to the court.

StAW Reg. Bb. 2780, Bl. 79a (Scheidig, Kart. 92)

195 *May 3, Lochau.* Cranach receives payment for a bill of 24 fl. and 14 gr.
StAW Reg. Bb. 1796, Bl. 6a (Scheidig, Kart. 93)

196 *May 7, Lochau.* A messenger is paid 2 gr. 8 pf. for taking letters to Cranach in Wittenberg.
StAW Reg. Bb. 1796, Bl. 12a (Scheidig, Kart. 94)

197 *May 28, Lochau.* Cranach is driven from Wittenberg and back, with panel paintings. (Transportation: 21 gr. 6 pf.)
StAW Reg. Bb. 1796, Bl. 31a

198 *June 5, Cölln an der Spree.* Elector Joachim of Brandenburg reminds Dietrich von Schönberg, counselor of Grand Master Albrecht, that 1,000 fl. are outstanding. Among other items, the 24 fl. for Cranach is to be paid out of this sum.
Formerly StAK Ordensbriefarchiv (Ehrenberg [1899], No. 10)

199 *June 6, Lochau.* Cranach delivers wine and Wittenberg beer to Schweinitz in the amount of 20 fl. 10 gr.
StAW Reg. Bb. 1796, Bl. 48b (Scheidig, Kart. 96)

200 *June 18, Lochau.* Cranach is paid 4 fl. for procuring *Geschoss Eisen* ("cannonball iron").
StAW Reg. Bb. 1796, Bl. 69b (Scheidig, Kart. 97)

201 *August 1, Lochau.* A messenger is paid 2 gr. to take letters to Cranach in Wittenberg. Cranach's wine is "broken"; to make up for it, a barrel of Wittenberg beer is brought from Jessen.
StAW Reg. Bb. 1796, Bl. 90b

202 *August 6, Lochau.* Cranach's servant brings a small cask of wine from Wittenberg (a replacement for the "broken" cask?). Stabling: $\frac{1}{2}$ gr.
StAW Reg. Bb. 1796, Bl. 99a (Scheidig, Kart. 98)

203 *August 15, Lochau.* Cranach receives 23 fl. 3$\frac{1}{2}$ gr. for three pieces of linen, including 222 ells which are to be stored in Colditz. Also 6 fl. for a canvas for a portrait of the elector.
StAW Reg. Bb. 1796, Bl. 118b (Scheidig, Kart. 99)

204 *August 15, Lochau.* Cranach delivers wine and beer in the amount of 14 fl. 4 gr. 3 pf.
StAW Reg. Bb. 1796, Bl. 117b (Scheidig, Kart. 101)

205 *August 19, Lochau.* Cranach's letters are brought fom Wittenberg. Charge: $\frac{1}{2}$ gr.
StAW Reg. Bb. 1796, Bl. 124b (Scheidig, Kart. 100)

206 *September 16, Lochau.* Cranach delivers wine and beer from Wittenberg in the amount of 7 fl. 7 gr.
StAW Reg. Bb. 1796, Bl. 149a (Scheidig, Kart. 103)

207 *September 16, Lochau.* Cranach is paid 16 fl. for two painted canvases, a Paris (*Judgment of Paris*) and an Aristotle (*Aristotle and Phyllis*).
StAW Reg. Bb. 1796, Bl. 150a (Scheidig, Kart. 102)

208 *September 17, Lochau.* Cranach receives a present of two head of game.
StAW Reg. Bb. 1796, Bl. 155a (Scheidig, Kart. 104)

209 *September 24, Lochau.* A consignment of Cranach's is brought from Wittenberg for 4 gr.
StAW Reg. Bb. 1796, Bl. 166a (Scheidig, Kart. 105)

210 *December 11, Lochau.* Cranach receives a present of game: one boar.
StAW Reg. Bb. 1796, Bl. 208a

211 *December 11, Lochau.* Cranach is paid 38 gr. for shipment of wine, hire of two horses for three days and stabling.
StAW Reg. Bb. 1796, Bl. 209a (Scheidig, Kart. 106)

212 *December 11, Lochau.* *Cranach acknowledges receipt of a certain amount of silver (7 pieces weighing 28 marks and 12 lots), which he promises to return in Leipzig at the time of the Christmas Fair.
StAW Reg. Aa 2975, Bl. 3a

213 *December 20, Lochau.* Cranach receives 21 fl. for 4 small painted canvases.
StAW Reg. Bb. 1796, Bl. 221a (Scheidig, Kart. 108)

214 *December 26, Lochau.* Cranach delivers wine from Wittenberg in the amount of 8 fl. 6 pf.
StAW Reg. Bb. 1796, Bl. 231a (Scheidig, Kart. 109)

215 *December 26, Lochau.* Cranach receives 1 fl. 6 pf. for a model of the tower at Colditz made by Niklas Tischler.
StAW Reg. Bb. 1796, Bl. 231b (Scheidig, Kart. 112)

216 *December 29, Lochau.* Cranach sends some "little books" from Wittenberg. Messenger's pay: 3 gr. 4 pf.
StAW Reg. Bb. 1796, Bl. 235a (Scheidig, Kart. 110)

1524-25

217 *No date, Wittenberg.* Cranach receives the yearly ration of 145 bushels, two measures of oats for his horse.
StAW Reg. Bb. 2782, Bl. 102b (Scheidig, Kart. 111)

218 *No date, Wittenberg.* The court has bought two reams of paper from Christoph Schramm at Cranach's bookshop for 36 gr.
(Heller [1821], 7)

219 *No date, Wittenberg.* Cranach has received payment for painting the ceiling of the wine room of the City Hall (42 gr.) and the staircases and windows of the building (1 sch. 20 gr.)
(Schuchardt [1851], 86)

1525

220 *January 13, Lochau.* Cranach has brought a small painted canvas from Leipzig and receives 4 fl. 2 gr. for it.
StAW Reg. Bb. 1796, Bl. 259a (Scheidig, Kart. 113)

221 *January 16, Lochau.* Cranach delivers wine in the amount of 8 fl. 8 gr.
StAW Reg. Bb. 1796 (Scheidig, Kart. 114)

222 *February 8, Lochau.* A messenger is paid 2 gr. to take letters to Cranach in Wittenberg.
StAW Reg. Bb. 1796, Bl. 293a (Scheidig, Kart. 115)

223 *February 9, Lochau.* Cranach receives 2 fl. 18 gr. for procuring two pairs of knives.
StAW Reg. Bb. 1796, Bl. 294a (Scheidig, Kart. 116)

224 *February 17 (?), Lochau.* Expenses paid for a sevant of Cranach who spent one night in Lochau, with two horses: 1 gr.
StAW Reg. Bb. 1796, Bl. 308b (Scheidig, Kart. 117)

225 *March 26, Lochau.* Cranach receives 2 fl. for six turned iron (points) with "thorns" for crossbow bolts which he had purchased.
StAW Reg. Bb. 1796, Bl. 362a (Scheidig, Kart. 118)

226 *March 30, Lochau.* Cranach delivers wine to Lochau and Torgau.
StAW Reg. Bb. 1796, Bl. 366b (Scheidig, Kart. 119)

227 *March 31, Lochau.* Cranach spends the night in Lochau, with two horses.
StAW Reg. Bb. 1796, Bl. 366b (Scheidig, Kart. 120)

228 *April 9, Torgau.* A messenger is paid for a shipment of Cranach's from Wittenberg.
StAW Reg. Bb. 1796, Bl. 386a (Scheidig, Kart. 121)

229 *April 10, Wittenberg.* Luther informs Spalatin that at the moment Cranach has nothing to print at his press.
Zerbst, Archive (Lindau [1883], 161. Martin Luther, *Werke*, kritische Gesamtausgabe, Correspondence, Vol. III, Weimar [1933], 470, No. 854)

230 *April 20, Lochau.* Cranach delivers wine.
StAW Reg. Bb. 1796, Bl. 403b (Scheidig, Kart. 122)

231 *May 8, Lochau.* Spalatin is paid for some printed works sent by Cranach.
StAW Reg. Bb. 1797, Bl. 88b (Scheidig, Kart. 123)

232 *June 13, Wittenberg.* According to Melanchthon's

Cranach the Elder:
To Elector John.
August 3, 1525.
Detail
(see Source No. 233)

report to Camerarius, Cranach, with Bugenhagen and Johann Apel, served as a witness at Luther's marriage to Catherine von Bora. Cranach's wife was also present at the wedding on June 14.
(Lindau [1883], 216)

233 *August 3, Wittenberg.* *Cranach sends Elector John three sectional drawings to scale for the tomb of Frederick the Wise. The portrait head seems also to have been submitted in the form of a relief in wood. Cranach promises to paint the bronze cast later.
StAW Reg. D. 211, Bl. 12a (Junius 1921, 524)
September 14. Cranach receives his quarterly salary as court painter.
StAW Reg. O No. 236, Verzeichnis des Quatembergeldes (Müller [1911], 289)

1525–26

234 *No date, Wittenberg.* Cranach receives the yearly ration of 145 bushels and two measures of oats for his horse.
StAW Reg. Bb. 2785, Bl. 118b (Scheidig, Kart. 124)

1526

235 *January 30, Torgau.* Elector John orders from Cranach 100 copies of the German missal, several copies of which Luther had already sent him.
StAW Reg. O. 228, Bl. 1a (Scheidig [1953], No. 41)

236 *June 7, Wittenberg.* Johann Pfister names Cranach,

together with Justus Jonas, godfathers of Luther's first son, Johannes.
SLBD, note on the flyleaf of a Bible translation "*Alle Propheten . . . verdeutscht*," Augsburg, Stayner 1527–28 (Lindau [1883], 219)

237 *September 29.* Grand Master Albrecht writes to Cranach about procuring good books.
Formerly StAK Flt. 26. S 40 (Ehrenberg [1899], No. 27)

238 *November 24.* (Grand Master Albrecht to Cranach, a canceled draft?)
Formerly StAK Flt. 26 5. 46 (Ehrenberg [1899], No. 29)

239 *No date, Wittenberg.* Cranach receives the yearly ration of 145 bushels and two measures of oats for his horse.
StAW Reg. Bb. 2787, Bl. 123b (Scheidig, Kart. 126)

1526–27

240 *No date, Wittenberg.* Cranach procures glue for joiner's work.
StAW Reg. Bb. 2787, Bl. 73b (Scheidig, Kart. 125)

241 *No date, Wittenberg.* Cranach receives 200 fl. for work on the fortification of Wittenberg.
StAW Reg. S. fol. 29a, No. 1, Bl. 6b (Scheidig, Kart. 127)

1527

242 *Before February 3, Wittenberg.* Cranach receives 6 gr. from the City Council for sealing wax.
AW Kämmereirechnung 1526

243 *February 1, Wittenberg.* Luther informs his friend Eberhard Brisger in Altenburg that he is in no position to pay a sum of 8 fl. on his behalf, since Cranach and Döring have refused to stand surety for him again.
Copy: Wolfenbüttel, Library 214 Gud. Lat. 4° (Lindau [1883], 203. Martin Luther, *Werke*, kritische Gesamtausgabe, Correspondence, Vol. IV, Weimar [1933], 164, No. 1078)

244 *July 27, Wittenberg.* 221 fl. 10 pf. charged as miscellaneous expenses for painting work for the wedding of Duke John Frederick.
StAW Reg. D. 58 V, Bl. 45–46b (Scheidig [1953], No. 44)

245 *Ca. July 27.* On the same occasion Cranach is paid expenses for two days and three nights (3 fl.?).
StAW Reg. Bb. 4342, Bl. 68b

246 *No date.* Cranach is charged 20 gr. for a base into which the brass plaque (commemorating Frederick the Wise) was fitted before being affixed.
StAW Reg. Bb. 2789, Bl. 43b

247 *No date, Wittenberg.* Cranach receives 81 bushels and four measures of oats for his horse for twenty-nine weeks.

StAW Reg. Bb. 2789, Bl. 87b (Scheidig, Kart. 129)

1528

248 *March 27, Kronach.* Hans Maler, Cranach's father, is mentioned as deceased. The heirs: Mathes (on his own behalf and that of his brother, Lucas), also the brothers-in-law, Hans Krauss, Michael Fleischmann, Barthel Sunder, sell meadowland for 61 fl.
AK Stadtlehenbuch 1514–55, Bl. 20a (Fehn 3, 105)

249 *October 18, Weimar.* Cranach receives his quarterly salary of 25 fl.
StAW Reg. Bb. 4345, Bl. 16 (Scheidig, Kart. 130)

1528–29

250 *No date, Wittenberg.* Cranach receives the yearly ration of 145 bushels and two measures of oats for his horse.
StAW Reg. Bb. 2790, Bl. 115a (Scheidig, Kart. 131)

1529

251 *Before February 7, Wittenberg.* For a war tax assessment Cranach declares assets of 4,016 fl., making him the second richest burgher after Chancellor Gregor Brück.
AW Kämmereirechnung 1528 (Förstemann [1836], 651)

252 *Before February 7, Wittenberg.* The City Council pays:
8 gr. for sealing wax and ink materials which the city clerk bought at Cranach's apothecary shop.
2 sch. 37 gr. 1 pf. for lumber and worked items, lent by Cranach for the construction of the City Hall and barn, which "are still outstanding [and] are repaid to him this year for the first time."
3 sch. 30 gr. for painting work on a gatehouse of the City Hall.
AW Kämmereirechnung 1528

253 *April 2 or 23, Leipzig (Friday during the Easter Fair)* *Cranach reminds Duke Albert of Prussia that full payment is due for a shipment of books delivered in 1527 (total amount: 183 fl. 6 gr. 8 pf.)
Formerly StAK Schbl. LXII, No. 21 (Ehrenberg [1899], No. 42)

254 *May 24, Kronach.* Cranach (Lucas Maler of Wittenberg) signs a receipt for 150 fl. inherited from Regina von Guttenberg, together with Mathes Maler, Michael Fleischmann, Hans Krauss and Barthel Sunder.
AK (Fehn, 3 105)

255 *July 11, Lochau.* Cranach receives feed for his horse for one day.

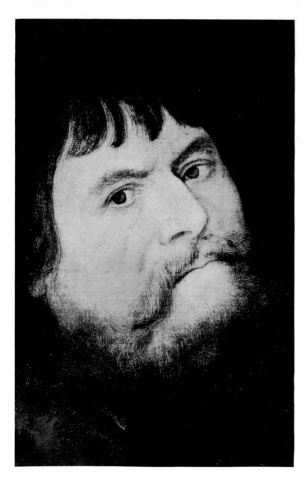

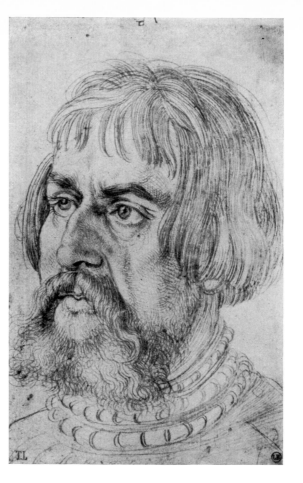

a *Cranach the Elder*:
Self-Portrait.
circa 1530.
Detail from
Frontispiece

b *Albrecht Dürer*:
Portrait
of Lucas Cranach
the Elder 1524.
Silverpoint.
Bayonne

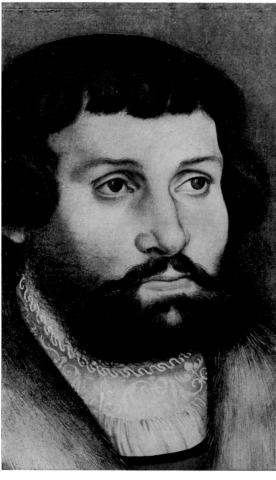

c *Hans Cranach*:
Self-Portrait. 1534
(see Plate 188)

d *Cranach the Younger*:
Self-Portrait 1565
(see Plate 250)

415

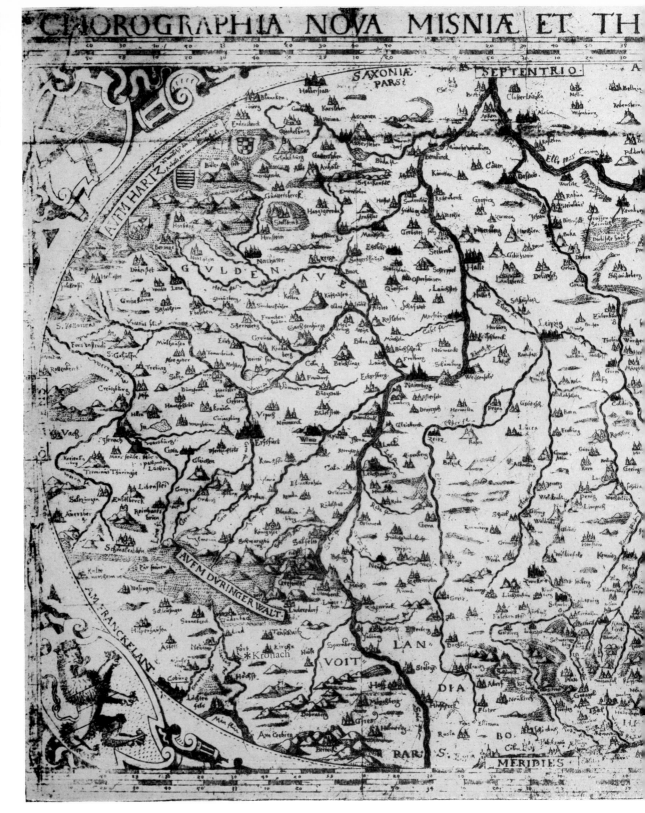

Balthasar Jenichen:
Map of Saxony and
Thuringia.
Nuremberg circa 1570.
Dresden.
The places
where Cranach lived
and worked
are shown in red.

416

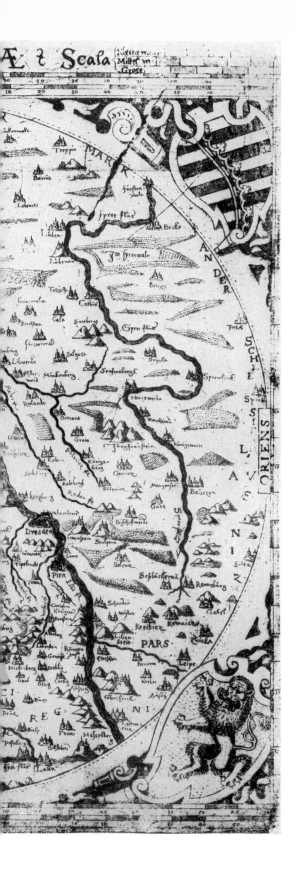

a The house where Cranach was born, in Kronach, Rossmarkt No. 58. Part of the 15th Century façade.

b Kronach City Seal of 1461.

c Cranach's House in Wittenberg, corner of the Marktplatz and Elbgasse, showing the windows of what was presumably the workshop

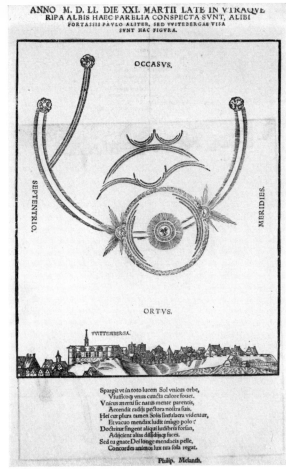

ANNO M. D. LI. DIE XXI. MARTII LATE IN VTRAQVE
RIPA ALBIS HAEC PARELIA CONSPECTA SVNT, ALIBI
FORTASSIS PAVLO ALITER, SED VVITEBERGAE VISA
SVNT HAC FIGVRA.

OCCASVS.

SEPTENTRIO.

MERIDIES.

ORTVS.

VVITTEMBERGA.

Spargit vt in toto lucem Sol vnicus orbe,
Viuificocȝ vnus cuncta calore fouet.
Vnicus æterni sic natus mente parentis,
Accendit radijs pectora nostra suis.
Hei cur plura tamen Solis simulacra videntur,
Et vacuo mendax ludit imago polo?
Doctrinæ fingent aliqui ludibria forsan,
Adijcient alias dissidijsȝ faces.
Sed tu gnate Dei longe mendacia pelle,
Concordes animos lux tua sola regat.

Philp. Melanth.

a Brück-Pestel Houses,
 Weimar, Markt

b *Monogrammist MS:*
 View of Wittemberg
 1551 (Broadsheet).
 Woodcut

c Gotha, Markt.
 Arms of the Cranach
 and Dasch families
 on the House of
 George Dasch

418

a Impression of
Lucas Cranach
the Younger's seal
(1571)

b Impression of a
Greco-Roman gem.
Omphale with
arms of Hercules (?).
Used as a signet
by Lucas Cranach
the Younger in 1573

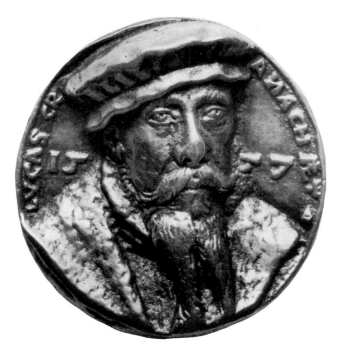

c, d *Unknown master:*
Portrait
of Lucas Cranach
the Elder (1557).
Silver gilt medal.
Neuenstein
Hohenlohe Museum.
Obverse and Reverse.
Enlarged

419

a *Cranach the Elder:*
1502 (from Plate 5)

b *Cranach the Elder:*
1505 (from Plate 25)

c *Cranach the Elder:*
1506 (from Plate 28)

d *Cranach the Elder:*
1506 (from Plate 30)

e *Cranach the Elder:*
1506 (from Plate 27)

f *Cranach the Elder:*
1508 (from Plate 46)

g *Cranach the Elder:*
1509 (from Illustration
on page 35)

h *Cranach the Elder:*
1509 ("1506" incorrect)
(from Plate 50)

i *Cranach the Elder:*
1509 (from Plate 41)

k *Cranach the Elder:*
1509 (from Plate 42)

l *Cranach the Elder:*
circa 1515
(from Plate 81)

m *Cranach the Younger:*
1551 (from illustration
on page 93)

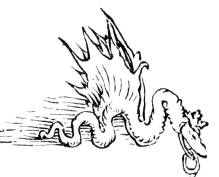

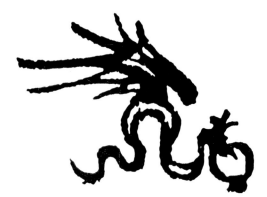

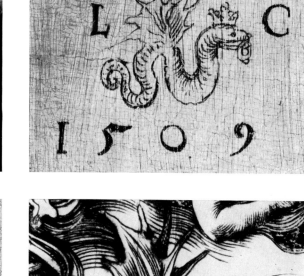

a *Cranach the Elder:*
1504 (from Plate 21)

b *Cranach the Elder:*
1509 (from Plate 48)

c *Cranach the Elder:*
1514 (from Plate 83)

d *Cranach the Elder:*
1510 (from Plate 68)

e *Cranach the Elder:*
1521 (from Plate 110)

f *Hans Cranach:*
1534 (from Plate 188)

g *Hans Cranach:*
1537 (from Plate 179)

h *Cranach the Younger:*
1558 (from Plate 232)

a *Albrecht Dürer:*
Christ on the Cross,
panel of the Seven
Sorrows of the Virgin,
made in 1496 for the
Wittenberg castle
church.
1496. Dresden

b *Cranach the Elder:*
Crucifixion. 1503.
Munich (Plate 17)

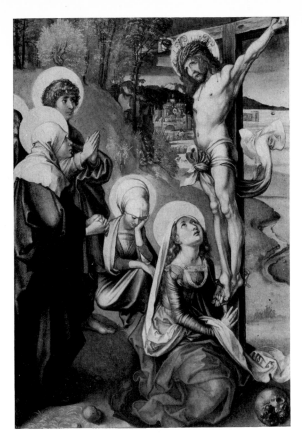
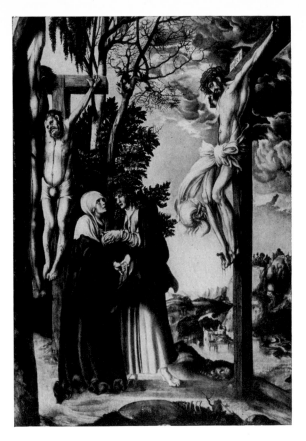

c *Albrecht Dürer:*
Crucifixion. 1506.
Woodcut

d *Cranach the Elder:*
The Crucifixion
of Christ. 1502
(Plate 2)

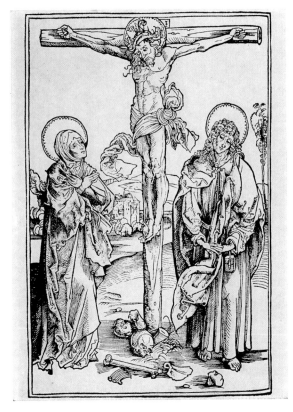
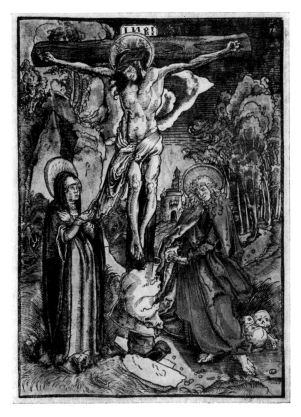

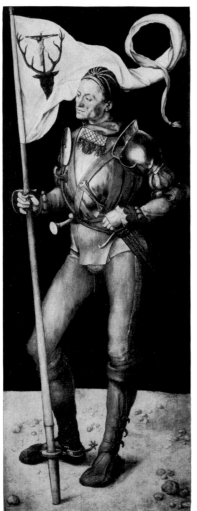

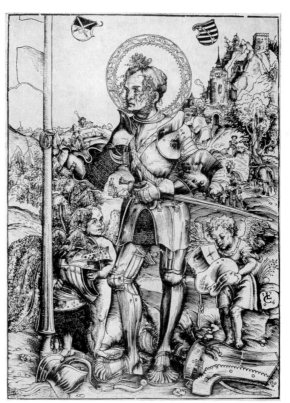

a *Hans Burgkmair:*
St. Christopher. 1505.
Right panel
of the St. Sebastian
altarpiece for
Wittenberg.
Nuremberg.

b *Cranach the Elder:*
St. Christopher.
Detail from The
Fourteen Helpers in
Time of Need,
Torgau (Plate 37)

c *Albrecht Dürer:*
St. Eustace.
Inner right side panel
of the Paumgartner
altar. 1498. Munich

d *Cranach the Elder:*
St. George. 1506
(Plate 28)

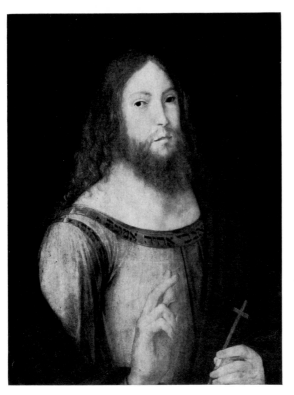

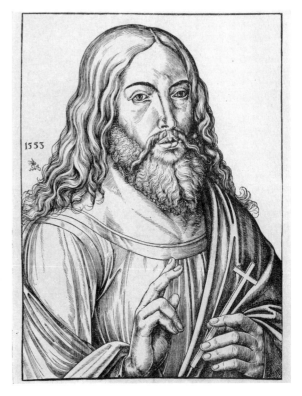

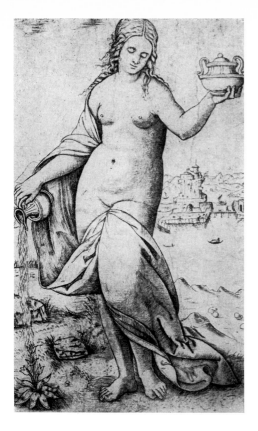

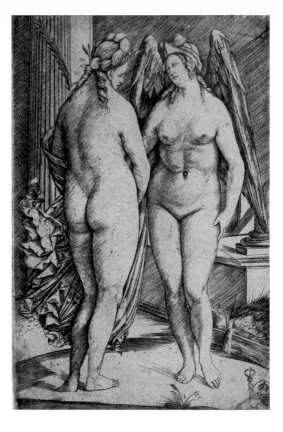

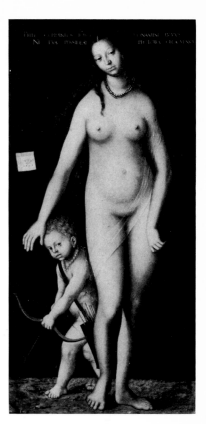

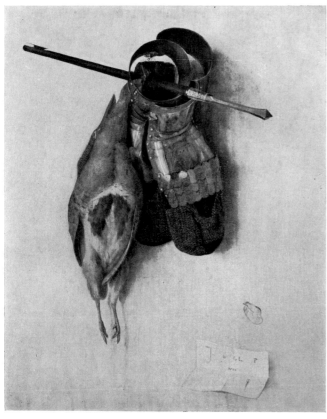

a *Giovanni Antonio da Brescia:*
Allegorical Figure.
Engraving

b *Jacopo de' Barbari:*
Victory and Fame.
Engraving

c *Cranach the Elder:*
Venus and Cupid. 1509.
Leningrad (Plate 48)

d *Jacopo de' Barbari:*
Still life. 1504.
Munich

e *Cranach the Elder:*
Two Waxwings.
circa 1530. Dresden
(Plate 169)

a *Albrecht Dürer:*
Portrait of Frederick
the Wise of Saxony.
1496. West Berlin

b *Peter Vischer:*
Tomb of Elector
Frederick.
Wittenberg Castle
church. Detail

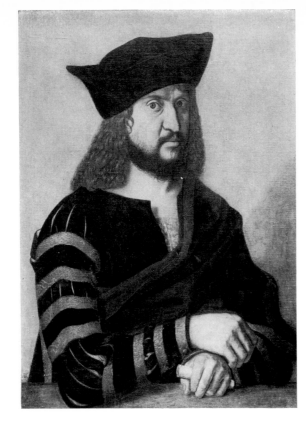

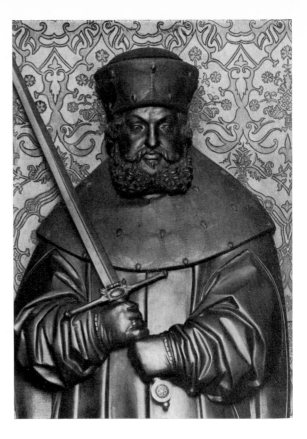

c *Cranach the Elder:*
Portrait of Elector
Frederick. 1509.
Engraving

d *Cranach the Elder:*
Frederick the Wise
and John the Constant.
1510. Engraving

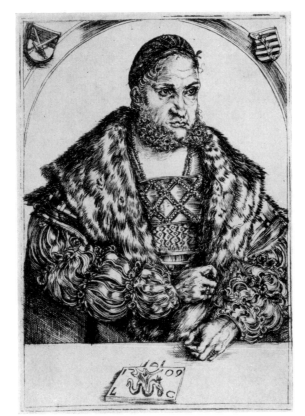

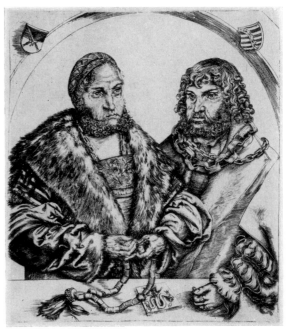

426

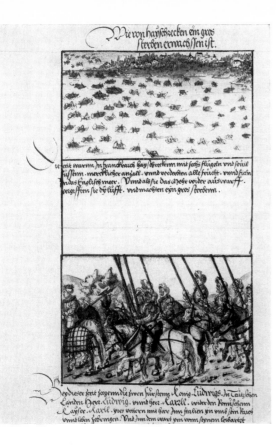

Die von hayschrecken ein grosz sterben erwachssen ist.

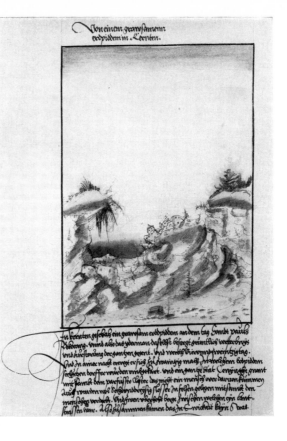

Von einem grawsamem erdpidem in Kerntten.

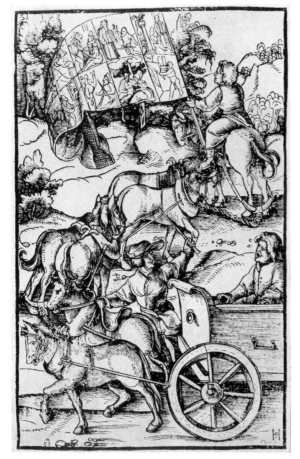

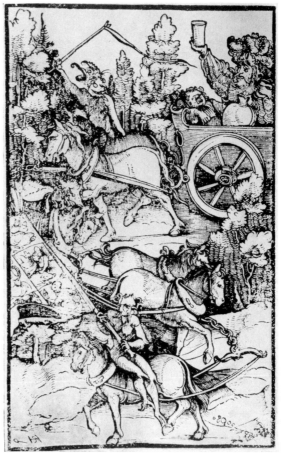

a *Unknown Master:*
Portrait of Elector
Frederick the Wise
Wearing a Cap. 1507.
Lead. Herzogenburg,
Stiftsammlung

b *Unknown Master:*
Reverse of Medal c

c *Unknown Master:*
Portrait of Elector
Frederick the Wise
with Woven Wire Cap.
1507. Silver. Gotha.
Obverse

d *Unknown Master:*
Portrait of Duke John.
1507. Silver.
Dresden

e *Cranach the Elder (?):*
Portrait of Elector
Frederick. 1512.
Onyx Cameo (Plaster
cast). Formerly Gotha

f/g *Hans Kraft:*
Portrait of Elector
Frederick. 1512.
Silver. Berlin.
Obverse and Reverse

h *Ulrich Ursenthaler:*
Portrait of Elector
Frederick. 1512.
Silver. Berlin

428

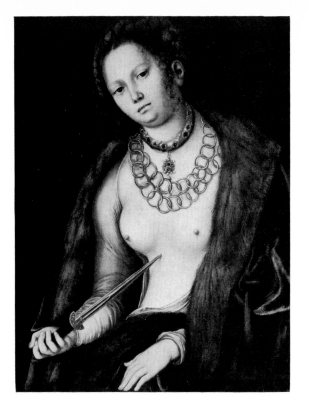

HVIVS NYMPHA LOCI SACRI CVSTODIA FONTIS
DORMIO, DVM BLANDE SENTIO MVRMVR AQVÆ
PARCE MEO QVIS QVISTANGIS CAVA MARMORA SOMNVM
RVPERE, SIVE BIBAS, SIVE LAVARE, TACE.

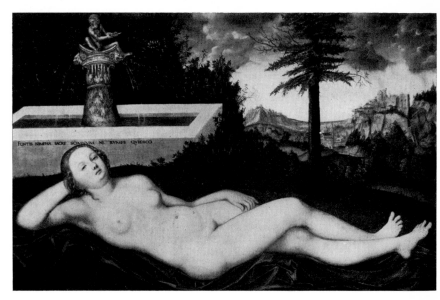

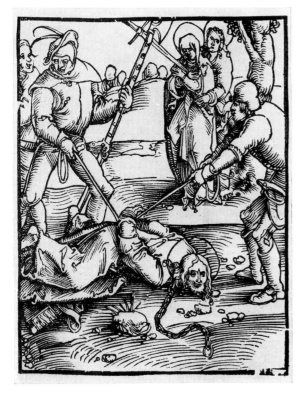

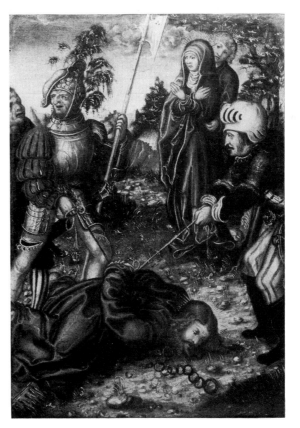

a *Albrecht Dürer:*
Portrait of Cardinal
Albrecht of Branden-
burg. 1519.
Engraving

b *Cranach the Elder:*
Portrait of Cardinal Al-
brecht of Brandenburg.
1520. Engraving

c *Hans Baldung:*
Christ's Fall on the
Road to Calvary.
Woodcut. Nuremberg
1507

d *Cranach Workshop:*
Christ's Fall on the
Road to Calvary.
West Berlin

431

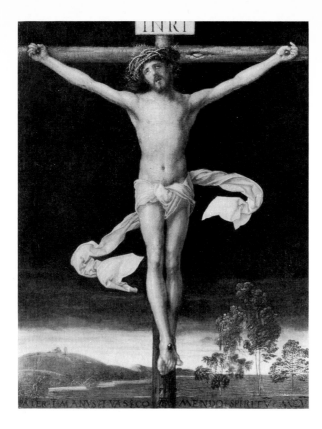

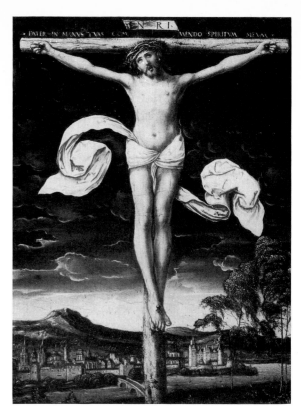

a *Albrecht Dürer:*
Small Crucifix. 1500.
Dresden

b *Cranach the Younger:*
Small Crucifix. 1540.
Dublin

c *Cranach the Younger:*
Christ on the Cross.
1543.
Book illustration.
West Berlin

d *Cranach the Younger:*
Christ on the Cross.
1571.
Wittenberg, Lutherhalle

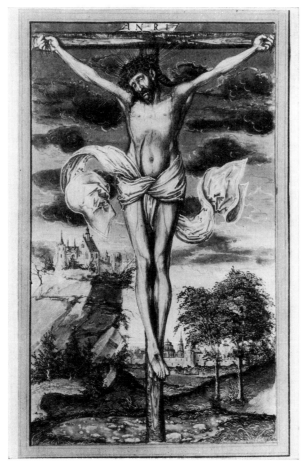

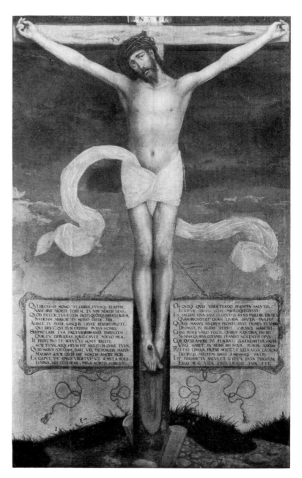

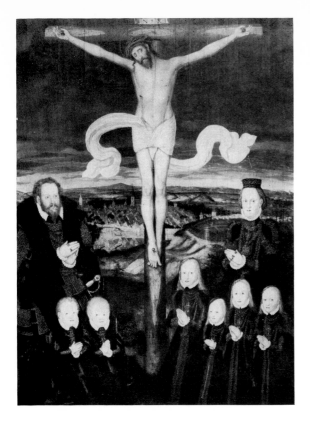

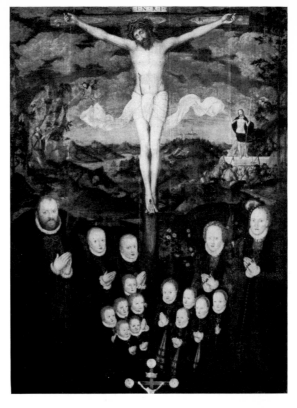

a *Cranach the Younger:*
Christ on the Cross.
1570.
Nienburg

b *Cranach the Younger:*
Christ on the Cross,
with the Family of
Elector Augustus
of Saxony. 1571.
Augustusburg,
palace church

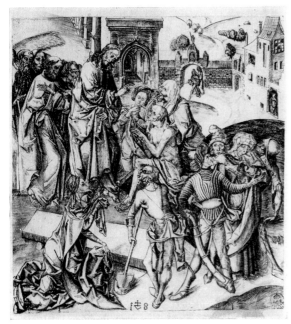

c *Veit Stoss:*
The Raising of Lazarus.
Engraving

d *Cranach the Younger:*
The Raising of Lazarus.
1558. Nordhausen,
Church of St. Blasius;
missing since 1945
(Plate 232)

433

a *Dirck Bouts:*
The Last Supper.
Center Panel of the
Holy Sacraments Altar-
piece, circa 1464–1468.
Louvain, St. Pierre

b *Cranach the Younger:*
The Last Supper. 1565.
Dessau-Mildensee
(Plate 250)

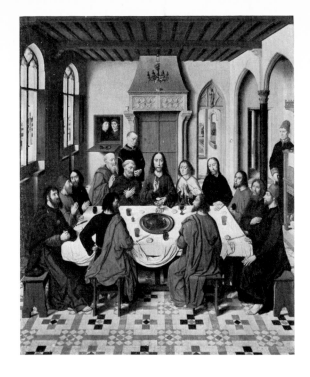

c *Augustin Cranach (?):*
The Resurrection
of Christ.
Memorial to Nicholas
von Seidlitz. 1582.
Wittenberg, city church

d *Zacharias Wehme:*
Christ on the Cross,
with the Family
of Elector Christian I
of Saxony. Dresden

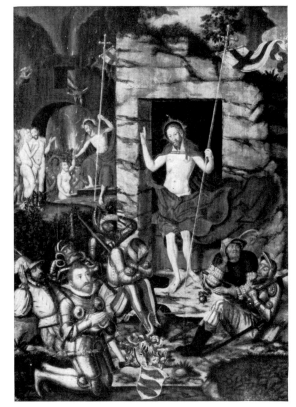

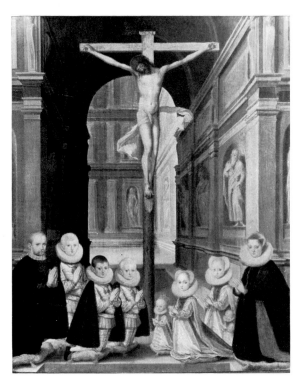

434

StAW Reg. Bb. 1809, Bl. 38b (Scheidig, Kart. 132)

256 *August 2, Freiberg.* Duke Henry of Saxony reminds Cranach of a portrait of Duchess Catherine commissioned some three years ago and also paid for.
(Lindau [1883], 233)

257 *September 14, Torgau.* Cranach receives his quarterly salary of 25 fl.
StAW Reg. Bb. 4348, Bl. 7a (Scheidig, Kart. 133)

258 *October 3–9, Leipzig (Michaelmas Fair).* *Cranach reminds Duke Albert of Prussia of his debt for books.
Formerly StAK Schbl. LXII, No. 21 (Ehrenberg [1899], No. 51)

1530–31

259 *No date, Wittenberg.* Cranach is paid for earlier work on some rooms in the castle.
StAW Reg. Bb. 2794, Bl. 58b (Scheidig, Kart. 134)

260 *No date, Wittenberg.* Cranach receives the yearly ration of 145 bushels and two measures of oats for his horse.
StAW Reg. Bb. 2794, Bl. 106b (Scheidig, Kart. 135)

1531

261 *January 18, Wittenberg.* *Cranach reports the quantity and kind of wine sold by him since December 13, 1530.
LHW J. 104/4157

262 *February 8, Torgau.* Cranach is paid for a large painted canvas.
StAW Reg. Bb. 4352, Bl. 33b (Scheidig, Kart. 139)

263 *After February 19, Wittenberg.* Cranach is paid for work on the fortification of Wittenberg.
StAW Reg. S. fol. 31b, No. 1, Bl. 115a (Scheidig, Kart. 140)

264 *May 19, Torgau* Cranach is paid his quarterly salary of 25 fl.
StAW Reg. Bb. 4354, Bl. 15a (Scheidig, Kart. 141)

265 *No date, Wittenberg.* Cranach uses 90 ells of linen for small painted canvases in the castle.
StAW Reg. Bb. 2795, Bl. 45a (Scheidig, Kart. 136)

266 *No date, Wittenberg.* Cranach pays for 10 lanterns.
StAW Reg. Bb. 2795, Bl. 68a (Scheidig, Kart. 137)

267 *No date, Wittenberg.* Elector John receives a report on Cranach's work in the castle.
StAW Reg. S. fol. 31b, No. 1, Bl. 80 (Scheidig, Kart. 138)

1531–32

268 *No date, Torgau.* Cranach is paid for gold, silver and verdigris used for painting a chest.
StAW Reg. Bb. 2452, Bl. 16a (Scheidig, Kart. 142)

269 *No date, Lochau.* Cranach is paid for painting and carving work.
StAW Reg. Bb. 1812, Bl. 45b (Scheidig, Kart. 143)

1532

270 *No date, Naumburg.* The Naumburg City Council acquires from Cranach two portraits of the elector (still extant) for 2 sch. 28 gr.
AN Kämmereirechnung 1530–33, Bl. 176

271 *No date, Wittenberg.* Cranach receives payment for house-painting work on loopholes and gates in the fortress.
StAW Reg. S. fol. 34a, No. 1, Bl. 95 (Scheidig, Kart. 144)

272 *No date, Wittenberg.* Cranach is paid for house-painting work in the arsenal.
StAW Reg. Bb. 2796, Bl. 102b (Scheidig, Kart. 145)

273 *No date, Wittenberg.* Cranach is paid for painting a staghorn candelabra with a coat of arms for the tax office.
StAW Reg. Bb. 2796, Bl. 107 (Scheidig, Kart. 146)

274 *No date, Wittenberg.* Cranach receives the yearly ration of 145 bushels and two measures of oats for his horse.
StAW Reg. Bb. 2799, Bl. 125b (Scheidig, Kart. 149)

275 *No date, Wittenberg.* Cranach is paid for wall paintings in a room and for painting a staghorn candelabra in the castle.
StAW Reg. Bb. 2799, Bl. 49b (Scheidig, Kart. 148)

1533

276 *May 10, Leipzig.* Cranach is paid 109 fl. 14 gr. for 60 pairs of small portraits of electors (ca. 19 gr. per small panel) and 3 gr. for a cabinet for them.
StAW Reg. Bb. 4361, Bl. 44a (Schuchardt [1851], 88)

277 *August 24, Lochau.* Cranach receives feed for his horse. At this time three of his journeymen are at work in the palace.
StAW Reg. Bb. 1817, Bl. 17b, 22a, 56b (Scheidig, Kart. 152)

278 *August 31, Altenburg.* Spalatin writes to Elector John Frederick about the 16 pictures (or coats of arms?) of his ancestors which Cranach is to paint on a ceiling in the Altenburg Palace.
StAW Reg. O. pag. 169, XXX 1 Bl. 3 and ff. (Schuchardt [1851], 91)

279 *Ca. September 29, Leipzig.* Cranach receives an advance of 30 fl. for some works he is to execute in Lochau. The payment is accepted on his behalf by his son Hans.
StAW Reg. Bb. 4371, Bl. 30a

280 *No date, Wittenberg.* Cranach sells linseed oil for work in the Wittenberg Arsenal.
StAW Reg. Bb. 2804, Bl. 69b (Scheidig, Kart. 151)

281 *No date.* Cranach is paid 94 fl. 17 gr. for books he has supplied.
(Schuchardt [1851], 71)

1534

283 *February 25–28, Leipzig (Lenten Quarter Day).* *Cranach gives Sebastian Schad a receipt for his quarterly salary of 25 fl.
StAW Reg. Rr 937, Bl. 8a

284 *February 27, Rochlitz.* Duchess Elizabeth of Saxony to Elector John Frederick: On February 26 Cranach painted her portrait at the elector's request. She asks for pictures of the electoral family and mentions that Cranach still has the picture of her mother, Anna of Hesse (known as "Lady Venus"), and a portrait of herself in her youth.
StAD Loc. 9131 Schriften der Herzogin von Rochlitz 1534, Bl. 11, 24 (Werl [1965])

285 *May 1–2, Wittenberg.* Cranach receives feed for his horse.
StAW Reg. Bb. 2809 (Scheidig, Kart. 157)

286 *May 16, Wittenberg.* Payment for Cranach's journeymen's return journey from Torgau.
StAW Reg. Bb. 2809 (Scheidig, Kart. 157)

287 *Ca. September 29, Leipzig.* Cranach's son is paid 150 fl., instead of the 175 fl. 6 gr. asked, for a considerable number of his father's works, since the elector decides that the charge for the work was too high.
(Schuchardt [1851], 92)

288 *October 2, Leipzig (Michaelmas Fair).* *Hans von Cronach receives half of his father's annual salary – 50 fl. for the period May 1 to September 29 – and by order of his father formally absolves the pay clerk of all earlier salary payments.
StAW Reg. Rr 397, Bl. 1

289 *No date, Wittenberg.* Cranach supplies wine casks for the court cellars.
StAW Reg. Bb. 2807. Bl. 59b (Scheidig, Kart. 155)

290 *No date.* Cranach is paid 84 fl. 16 gr. for some paintings.
(Schuchardt [1851], 93)

291 *No date.* According to one of the elector's clerks, Cranach has life tenure as court painter. (He had been erroneously listed among those employed until further notice.)
(Schuchardt [1851], 92)

Hans Cranach:
Receipt. October 2, 1534
(see Source No. 288)

1533–34

282 *No date, Wittenberg.* Cranach receives the yearly ration of 145 bushels and two measures of oats for his horse.
StAW Reg. Bb. 2801, Bl. 148a (Scheidig, Kart. 151)

1534–35

292 *No date, Wittenberg.* For the last time Cranach receives 108 bushels of oats for his horse for twenty-eight weeks.
StAW Reg. Bb. 2805, Bl. 129a (Scheidig, Kart. 159)

293 *No date, Torgau.* Four of Cranach's journeymen are working in the green tower of the Castle.
StAW Reg. Bb. 2459, Bl. 45 b (Scheidig, Kart. 160)

1535

294 *June 27 to July 2, Weimar.*
1. The elector decides, after prolonged hesitation, on the color proposed by Cranach for painting the garden house at Torgau.
2. Undated payment of 70 fl. for the work done.
1. StAW Reg. S. fol. 286a No. 1 s, Bl. 20b, Bl. 22a, Bl. 25a, Bl. 26a, Bl. 31a
2. StAW Reg. S. fol. 284a, No. 1, p. Bl. 1b (Schuchardt [1851], 94; Scheidig, Kart. 165)

295 *July 6, Weimar.* Cranach has painted a portrait of the elector's sister in Weimar. The portrait is intended for the duke of Pomerania, with whom marriage negotiations are to be conducted.
StAW Reg. D. 73, Bl. 8a–10b (Scheidig, Kart. 162)

296 *September 5, Torgau.* Cranach receives wages for eleven journeymen who have been working in Torgau Castle.
StAW Reg. S. fol. 286a, No. 1 S., Bl. 5 (Scheidig, Kart. 163)

297 *December 6, Wittenberg.* A messenger to Cranach is paid. A Wittenberg print of the *Carmina* (Johann Walther's hymnbook, new edition of 1534) is to be sent to Prince Wolf von Anhalt in Weimar.
StAW Reg. Bb. 2810, Bl. 69a (Scheidig, Kart. 164)

298 *December 7 and 26, Torgau.* At the request of the elector, Cranach is to make more sketches for painted windows *(mosirte scheiben)* in Torgau Castle.
StAW Reg. S. fol. 284a, No. 1 r, Bl. 20a, 25a, b (Schuchardt [1851], 93)

1536

299 *January 8, Torgau.* Cranach is paid for the cleaning and varnishing of the big "picture of the mass" in Torgau Castle.
StAW Reg. S. fol. 287b, No. 1 t, Bl. 205a (Scheidig, Kart. 166)

300 *May 14 to December 17, Torgau.* Cranach works on the castle with two sons, four journeymen and two apprentices. Gilding of the clock hands, the big finial on the Hausmann tower and the 86 finials on the gables.
StAW Reg. S. fol. 288a, No. 1 n, Bl. 141ff. (Scheidig, Kart. 167)

301 *September 3.* Cranach is paid 28 fl.

302 *Ca. September 29, Leipzig (Michaelmas Fair).* *Cranach acknowledges receipt of his salary for two quarters, from Pentecost (should read: Easter, April 16) to September 21, 1536.
StAW Reg. Rr. 937, Bl. 9a

303 *October 1, Torgau.* Cranach is paid expenses for material for his painting work in the Castle.
StAW Reg. S. fol. 288a, No. 1. n, Bl. 93a (Scheidig, Kart. 169)

304 *No date.* Cranach is paid 200 fl. for work on the construction of Wittenberg Castle.
(Schuchardt 1851, 95)

1537

305 *April 18, Torgau.* Hans Cranach buys gold leaf for tower finials and blue paint for benches.
StAW Reg. S. fol. 288b, No. IX, Bl. 136a (Scheidig, Kart. 172)

306 *May 3, Wittenberg.* Wedding presents to a Cranach daughter:
(a) from the City Council, wine valued at 19 gr. 4 pf.
AW Kämmereirechnung 1537
(b) from the court, 10 Doppel-Schaugroschen
StAW Reg. Bb. 4420, Bl. 19a
(c) one stag and two deer.
StAW Reg. Bb. 5585, Bl. 387b (Schuchardt [1851], 84ff.)

307 *October 30, Torgau.* Cranach is paid 18 fl. 1 gr. for a panel depicting the story of John the Baptist and for various other works.
StAW Reg. Bb. 4428, Bl. 15a (Schuchardt [1851], 121)

308 *December 1, Wittenberg.* Martin Luther pays a visit of condolence after Hans Cranach's death in Bologna on October 9, 1537.
Luther, *Werke,* Tischreden, Vol. IV, Weimar [1916], 505–508

309 *December 7, Wittenberg.* *Cranach thanks Pastor Friedrich Myconius of Gotha for his letter of condolence on the death of his son Hans, transmitted by Magister Jan Woezer. "I would have much to write to you but have much work to do. Almighty God wants to make me quite weary of the world. . . ." Emden, *Gesellschaft für bildende Kunst und vaterländische Altertümer.* (Copy in Gotha, Forschungsbibliothek) (E. Friedländer [1873]; Steinmann [1968], 133ff.)

310 *No date, Torgau.* Detailed list of Cranach's work for the castle, itemizing transportation, overnight lodging, work material.

StAW Reg. S. fol. 289, No. 1 z, Bl. 154ff. (Scheidig, Kart. 170)

1538

311 *March 5, Wittenberg.* *Letter from Cranach to Hans von Taubenheim, treasurer of the electorate of Saxony.
Auctioned, Stargardt, Marburg, November 27, 1962, No. 559

Cranach the Elder:
Letter to F. Myconius.
1537. Emden
(see Source No. 309)

312 *May 12, Leipzig (Easter Fair).* *Cranach acknowledges receipt of half his yearly salary in the amount of 50 fl.
StAW Reg. Rr. 937, Bl. 6a

313 *No date, Torgau.* Payment of sum due to Hans Cranach (now deceased), who worked for twenty-one weeks on the castle.
StAW Reg. S. fol. 289, No. 1 z, Bl. 151a (Scheidig, Kart. 173)

314 *No date, Torgau.* Cranach is paid for the following: two canvases, the *Ascension of Christ* and the *Pope's Descent into Hell*; portraits of Philipp of Brunswick, the archbishop of Cologne, Emperors Otto and Sigismund; 11 canvases for the ancestral room.

StAW Reg. S. fol. 289, No. 1 z, Bl. 152, 153a (Scheidig, Kart. 175)

315 *No date, Wittenberg.* Cranach acknowledges debt of 619 fl. to Hans vom Hofe.
StAD Loc. 10399. 1544–1550

1539

316 *April 8, Leipzig (Easter Fair).* *Cranach acknowledges receipt of half his yearly salary in the amount of 50 fl.
StAW Reg. Rr 937, Bl. 7a

317 *September 20, Wittenberg.* Governor *(Landvogt)* Bernhard von Mila sends to the elector Cranach's "faithful likeness" of a bunch of grapes grown in the electoral vineyard at Schweinitz.
StAW Reg. S. fol. 36b, No. 1, Bl. 36b (Scheidig, Kart. 177 and information from S. Harksen)

318 *October 15, Eilenburg.* For various works executed Cranach is paid 209 fl. 12 gr. on verbal instructions from Treasurer Hans von Ponickau, through Philipp Reichenbach, burgomaster of Wittenberg.
(Schuchardt 1851, 121ff.)

319 *No date, Weimar.* The elector sends a reminder about several painted cavases which Hans von Taubenheim was to order from Cranach.
(Schuchardt [1851], 124)

1540

320 *April 24, Wittenberg.* Christoph Jonas, stipendiary of Duke Albert of Prussia, sends portraits of Luther and Melanchthon, painted by Cranach, to Königsberg. Letter of thanks from the duke, June 15, 1540.
Formerly StAK III, 40. 5. – Flt. 28, S. 708 (Ehrenberg [1899], No. 144, 147)

321 *July 8, Wittenberg.* Cranach supplies olive oil for the arsenal.
StAW Reg. Bb. 2823, Bl. 94b (Scheidig, Kart. 179)

322 *October 1.* The elector orders Hans von Taubenheim to settle the bills of the court tailor and of Cranach, to be presented at the current Michaelmas Fair in Leipzig.
(Schuchardt [1851], 125)

323 *No date.* Cranach receives 23 fl. 17 gr. (= 500 gr.) for two panels "on which two love scenes are painted" in the mirror room of Torgau Castle.
(Schuchardt [1851], 125)

1541

324 *February 11, Wittenberg.* Governor Bernhard von Mila reports to Hans von Taubenheim that Burgomaster Cranach is in the Mark Brandenburg by request of the elector.
StAW (Schuchardt [1851], 154)

438

325 *February 19, Wittenberg.* The City Council presents Gregor Brück and Cranach with wine (to the value of 3 sch. 34 gr.) and carp (to the value of 1 sch. 8 gr.) for the wedding of Lucas the Younger to Barbara Brück.
AW Kämmereirechnung 1541
(Schuchardt [1851], 82; correction in Lindau [1883], 327)

326 *May 11, Leipzig.* Caspar Pfreundt, Cranach's servant, receives a payment of 193 fl. 3 gr. 4 pf. on his master's behalf. Individual pictures are mentioned, also portraits, caparisons and a large number (590) of coats of arms (woodcuts).
(Schuchardt [1851], 156 ff.)

327 *October, Wittenberg.* Printed poem of sympathy by Johannes Richius on the death of Cranach's wife: "Ad ... Lucam Cranachium ... de morte uxoris eius ... carmen consolatorium."
(Schuchardt [1851], 129–148)

328 *No date.* The artist's wife, Barbara Cranach, daughter of Jost Brengbier, bequeathes 50 nfl. to the lepers of Gotha for linen shirts at Christmas.
(Tenzel, *Supplementum historiae gothanae,* Jena [1702]; Schuchardt [1851], 126)

1542

329 *January 5, Leipzig.* Caspar Pfreundt, Cranach's servant, receives a payment of 200 fl. for various work.
(Schuchardt [1851], 158)

330 *Ca. April 9, Leipzig (Easter Fair).* *Cranach acknowledges receipt of half his yearly salary in the amount of 50 fl.
StAW Reg. Rr. 937, Bl. 5 a
June 28, Bologna. Mention of a "magistro Lucha qu. Coradi Maler de Allamania habitatore" as witness in the chapel Sanctae Mariae de Baronella. (In the same year, 1542, Christian Brück, brother-in-law of Cranach the Younger, is matriculated at the University of Bologna.)
(Knod [1899], 705 [417])

331 *July 8, Gotha.* Duke John Frederick sends Landgrave Philipp of Hesse a picture of the town of Wolfenbüttel.
(Thöne [1963], 249)

332 *July 16, Weimar.* Carpenters make frames for Cranach "in which he colors the little flags."
StAW Reg. S. fol. 231 b, No. 8 a, Bl. 34 (Scheidig, Kart. 180)

333 *Ca. September 29, Leipzig (Michaelmas Fair).* *Cranach acknowledges receipt of half his yearly salary in the amount of 50 fl. (for the period of May 28 to September 29).
StAW Reg. Rr 937, Bl. 4

334 *December 14, Fürstenberg.* Philipp of Hesse thanks John Frederick for Cranach's picture of the siege of Wolfenbüttel.
(Schuchardt [1870], 288)

1543

335 *January 31, Wittenberg.* Cranach is mentioned as one of the witnesses to the will of Court Marshal Hans von Dolzig.
(Müller [1911], 371)

336 *March 17.* Cranach receives 4 fl. for painting a parchment Bible; binding it in black velvet is estimated at 18 fl. 15 gr.
StAW Reg. Bb. 4517, Bl. 15 b

337 *April 14, Torgau.* Cranach receives 17 fl. for the binding of a Bible by the Wittenberg bookbinders.
StAW Reg. Bb. 4517, Bl. 15 b

338 *October 4, Torgau (Michaelmas Fair).* Cranach is paid 123 fl. 10 gr. 8 pf. for various works at Torgau, including caparisons, a hunting picture presented to Duke Maurice (presumably the one now in Cleveland, dated 1540), a painted female nude, portraits of the elector and electress given to Bernhard von Mila and Christoph von Taubenheim, and 10 colored woodcuts of the siege of Wittenberg, printed on parchment.
StAW Reg. Bb. 4551, Bl. 24 b (Schuchardt [1851], 162 ff.)

339 *October 18.* *Cranach acknowledges receipt of 40 Talergroschen for painting the tower room and elector's council chamber (in Torgau Castle).
StAW Reg. Aa 2975, Bl. 5 a

340 *October 18, Torgau.* Cranach is paid 45 fl. 15 gr. for painting the lower tower room at Torgau Castle.
StAW Reg. Bb. 4541, Bl. 14 a (Schuchardt [1851], 160)

Cranach the Elder:
Receipt. Circa September 29, 1542
(see Source No. 333)

341 *October 25, Torgau.* Cranach is paid 135 fl. 9 gr. 2 pf. for various works, including pictures of Wolfenbüttel and a Lucretia picture for Count Philipp von Solms; also the sum of 4 fl. 12 gr. for portraits of the Dukes of Brunswick borrowed from Peter Spitzer.
StAW Reg. Aa. 2975, Bl. 5 (Schuchardt [1851], 160 ff.; Scheidig, Kart. 184)

342 *November 23, Torgau.* Account for painting work in the castle, with details. (Finished February 15, 1545.)
StAW Reg. S. fol. 290b, No. 1 z, g, Bl. 15 ff. (Scheidig, Kart. 185)

1543–44

343 *No date, Torgau.* Cranach receives a total of 793 fl. 6 gr. 6 pf. as painters' pay (for small canvases in the castle) and for cartage from Wittenberg.
StAW Reg. S. fol. 290, No. 1 z, e. 1, Bl. 145 a (Scheidig, Kart. 183)

1544

344 *Ca. April 13 (Easter Fair), Leipzig.* Cranach is paid 100 fl. for work done, according to vouchers of his son (Lucas Cranach the Younger).
StAW Reg. Bb. 4562, Bl. 23 b

345 *June 13.* Hans vom Hof sues for 619 fl. owed to him by Cranach. The court recognizes the claim of 500 fl. as valid.

Cranach the Elder:
Letter to Hans von Ponickau. April 24, 1545 (see Source No. 353)

StAD Loc. 10399, 1500 (Schuchardt [1851], 165)

346 *June 24, Wittenberg.* Melanchthon recommends Cranach's son-in-law Georg Dasch to the Prince of Anhalt – with no result, as a letter from Melanchthon to Camerarius indicates.
(*Corpus Reformator.* V, 426 ff.; Schuchardt [1851], 78)

347 *October 7.* Cranach is paid 235 fl. 17 ½ gr. for work on the new rooms at Weimar.
(Schuchardt [1851], 164 ff.)

348 *No date, Wittenberg.* Ownership of the house at the corner of Schlossstrasse and Elbgasse in Wittenberg passes from Cranach to his son.
AW Urbarium (Lindau [1883], 348)

1545

349 *April 2.* By order of Prince John of Anhalt, Johannes Schultz and Urbanus Parig settle accounts with Cranach the Younger ("Lucas Mhalern dem Jungern") for a Bible painted by the latter. 132 figures at 10 gr. each; 134 capital letters at 1 gr. each; 1,318 small letters at 6 pf. each, for a total of 100 fl. 14 gr. (One wood block, however, would cost 20 thlr.)
Copenhagen, Royal Archives (Schumacher [1758], 226; Lindau [1883], 341 ff.)

350 *April 7.* Cranach, with two journeymen, is paid for thirty-six weeks of work from July 27, 1544, to April 5, 1545.
StAW Reg. Aa. 2975, Bl. 6 a

351 *Ca. April 5, Leipzig (Easter Fair).* *Cranach acknowledges to Hans von Ponickau receipt of half his yearly salary for the period from December 13, 1544, to March 1, 1545.
StAW Reg. Rr. 937, Bl. 2 (Schuchardt [1851], 166)

352 *Ca. April 5 (Easter Fair).* Heinrich von Hohemühl, tapestry maker, is paid for a tapestry made to Cranach's design. The work is destined for the new vaulted tower room in Torgau Castle.
(Schuchardt [1851], 174)

353 *April 24, Wittenberg.* *Cranach sends Hans von Ponickau three bills totaling 100 fl. and a painting of the Madonna by the painter who is to be trained at Ponickau's request. He mentions the work on the altarpiece for the elector.
StAW Reg. Rr. 937, Bl. 10 (Schuchardt [1851], 175)

354 *April 24.* *Cranach acknowledges receipt of half his yearly salary in the amount of 50 fl.
StAW Reg. Rr. 937, Bl. 10

355 *June 9, Torgau.* The architect Nickel Gromann reports to the elector on building work at the castle, including Cranach's work.
StAW Reg. S. fol. 290b, No. 1 z. g., Bl. 1 a 3 a (Scheidig, Kart. 190)

356 *Ca. August 30.* *Extensive bill from Cranach for work at Torgau for the period of June 7 to August 30, 1545: 237 fl. 17 gr. A charge of 300 fl. is made for work at Wittenberg. List of items still unpaid.
StAW Reg. Aa. 2975, Bl. 13–14 (Schuchardt [1851], 168 ff.)

357 *Ca. August 30.* Charges for a Last Supper altar painted by Cranach include the following: cartage from Wittenberg (June 5), erection in Torgau (June 14) and erection of a grille around the altar (August 30).
StAW Reg. Aa. 2975, Bl. 6b

358 *September 29.* *Cranach acknowledges to Hans von Ponickau receipt of half his yearly salary (50 fl.) for the period May 24 to September 14, 1545.
StAW Reg. Rr. 937, Bl. 2 (Schuchardt [1851], 165 ff.)

359 *November 16.* *Cranach acknowledges to Paymaster Jakob von Koseritz receipt of 131 fl. for work done. (Noted on the office record for November 19, 1545.)
StAW Reg. Aa. 2975, Bl. 8

360 *December 5, Torgau.* Hans von Ponickau writes to Paymaster Jakob von Koseritz about payment for Cranach's work on the castle.
StAW Reg. S. fol. 290b, No. 1 z. g., Bl. 7a (Scheidig, Kart. 192)

361 *No date.* *Cranach acknowledges receipt of payment for work for Lichtenburg, various small painted canvases and a panel with portraits of the spouses of John Frederick, Maurice and John Ernest.
StAW Reg. Aa. 2975, Bl. 9 (Schuchardt [1851], 167 ff.)

362 *No date (presumably July 27, 1544, to ca. April 5, 1545).* Cranach, with two journeymen, has worked a total of thirty-six weeks at Torgau.
StAW Reg. Aa. 2975. Bl. 6

363 *No date (presumably 1545).* The cost of painting a parchment Bible with 125 figures and 75 (?) initials is estimated at 65 fl. 52 gr.
StAW Reg. Aa. 2975, Bl. 7

1546

364 *January 21, Königsberg.* Duke Albert of Prussia orders from Cranach portraits on canvas of the electoral family of Saxony and of Duke Ernest of Brunswick. (Also a substantial order to Hans Krell of Leipzig.)
Formerly StAK Flt. 30, S. 535 (Schuchardt [1851], 152; Ehrenberg [1899], No. 246)

365 *March 12, Torgau.* Cranach is paid 25 fl. 15 gr. for six canvas portraits ordered from the Leipzig painter Hans Krell.
StAW Reg. Bb. 4598 (Schuchardt [1851], 182)

366 *April 27 (April 25?).* *Cranach is paid 184 fl. 6 gr. for work at Torgau and Lichtenburg.
StAW Reg. Aa. 2975, Bl. 10 (Schuchardt [1851], 182ff.)

367 *May 19.* *(written in a shaky hand) Cranach acknowledges to Jakob von Koseritz receipt of 150 fl. 30 taler.
StAW Reg. Aa. 2975, Bl. 10

368 *No date (May 19).* *Settlement of Cranach's account for painting work in the building of Torgau Castle, including canvas paintings (rutting stags, Venus, Lucretia), gilding the bronze tablet cast in Freiberg, miniature portraits of twenty-one princes and princesses in a book (the *Fürstenstammbuch* in the Dresden Landesbibliothek?) and painting the big table for Duke Maurice in Dresden.
StAW Reg. Aa. 2975, Bl. 11

369 *June 26, Wittenberg.* Cranach the Younger sends the elector in Weimar a letter for his father, whom he erroneously believes to be there, together with a bundle of painted coats of arms.
(Schuchardt [1851], 183)

370 *December 29, Zwickau.* The Zwickau City Council advises Cranach that it cannot help him recover a claim against the heirs of the city physician Dr. Leonhard Natter (d. October 4, 1545) because the debt was denied by the deceased and is not recognized by his heirs.
Zwickau City Archives, Konzeptbuch Bl. 16b, 17a, 17b (Kühne [1972], 29ff.)

1547

371 *End of April, Wittenberg.* In his printed account of *How We in the City of Wittenberg Fared in This Late War* Johannes Bugenhagen mentions a deformed calf portrayed by Cranach.
(Schuchardt [1851], 184)

372 *August 14, Wittenberg.* *Letter in Cranach's name but written by Cranach the Younger to the elector in reply to the latter's letter received the same day. Excuses his absence by reason of illness.
StAW Reg. J. pag. 577 Y, No. 16, Bl. 84 (Junius [1926], 230)

373 *Ca. September 29.* The large stone portrait of Elector John Frederick is taken from the castle church to Cranach's house (where it remained).
(Schuchardt [1851], 179)

374 *No date.* *Cranach deplores the arrest of Elector John Frederick to Duke Albert of Prussia: "There is a proverb: when you tighten the strings too much, it breaks. Now God will break it because they attack His mercy and honor."
Formerly StAK Schbl. LXII, No. 21 (*Beiträge zur Kunde Preussens*, III, 251ff.; Lindau [1883], 373ff.; Ehrenberg [1899], No. 295)

375 *No date.* Cranach asks John Frederick for the return of 5,000 fl. advanced a few weeks earlier (presumably before the beginning of the war). The shares of Cranach and Hans von Ponickau amount to 3,942 fl. 18 gr. Bugenhagen and Cruziger each lent 100 taler; Gregor Brück lent

Cranach the Younger:
Letter written
for his father
to Elector John Frederick.
Detail
(see Source No. 372)

200 taler; Caspar Pfreundt, 200 fl.; Christoph Schramm, 400 fl.

StAW Reg. L. Fol. 12–13 Fasc. EE 8, Bl. 34 q and r (Junius [1926], 229)

1548

376 *August 2, Weimar.* John Frederick *der Mittlere* and John William ask Cranach to send to Marcus Bucher in Leipzig the canvas picture from Lichtenburg and Dürer's panel of the *Martyrdom of the Ten Thousand*, both of which he has in safekeeping.
StAW Reg. L. pag. 231–239 C. 1, Bl. 9–10

377 *August 13, Weimar.* The sons of John Frederick advise their father that Dürer's *Martyrdom of the Ten Thousand* has been sent to Antwerp via Frankfurt-am-Main. Cranach has also shipped the following canvas paintings: *John Frederick with His Counselors*, from Lichtenburg; *The Hares Catch the Hunters; Lot and His Daughters;* the *Parable of the Wicked Husbandmen.*
StAW Reg. L. pag. 231–239 C. 1, Bl. 75

378 *No date.* Cranach is said still to have many paintings in safekeeping. The tablet above Luther's grave is to go to the church in Weimar.
StAW Reg. L. pag. 231–239 C. 1, Bl. 75

1549

379 *February 8, Antwerp.* Letter from John Frederick

442

in captivity to his sons in Weimar concerning Dürer's paintings and works of Cranach for the Wolfersdorf hunting lodge.
StAW Reg. L. pag. 231–239 C. 1, Bl. 15 (Scheidig, Kart. 197)

1550

380 *January 14, Dresden.* (Letter never dispatched.) Elector Maurice to the Wittenberg City Council asking that Cranach present the Leipzig witnesses in the lawsuit against Hans vom Hof within six weeks.
StAM Rep. Cop. No. 1217, 1550–1551, Bl. 8 b

381 *January 30.* *Cranach gives his cousin Matthias Gunderam power of attorney in the lawsuit against Hans vom Hof over a purchase of spices for his apothecary shop.
StAD Loc. 10399 Hans vom Hof against Lucas Kranachen 1544–1550, Bl. 10

382 *March 4, Dresden.* Elector Maurice requests information from the Wittenberg tax collector about a meadow in Wittenberg about which Cranach the Younger *(der Mittlere)* has asked.
StAW Rep. Cop. No. 1217, Bl. 39

383 *April 17, Wittenberg.* *Cranach the Elder *(der Eltist)* to Ulrich Mordeisen, chancellor of the electorate of Saxony, concerning the lawsuit against Hans vom Hof and confirmation of the apothecary privilege.
StAD Loc. 10399 1544–1550, Bl. 11 (Lindau [1883], 157)

384 *June 12, Cologne.* John Frederick advises his sons that Christian Brück has told him that Cranach is determined to come to Weimar and then to him in Augsburg. He wants provision to be made.
StAW Reg. L. pag. 333–344 D, No. 4, Bl. 21

385 *June 29, Weimar.* John Frederick's sons express their intention of sending a carriage to Wittenberg (to bring Cranach back?).
StAW Reg. L. pag. 333–344 D. No. 4, Bl. 26

386 *July 11, Dresden.* Elector Maurice asks the Weimar councillors to send him the records for Hans vom Hof's lawsuit against Cranach.
StAW Rep. Cop. 1217 1550–1551, Bl. 105 b

387 *July 23, Augsburg.* Cranach joins John Frederick. (Schuchardt [1851])

388 *December 8, Nuremberg.* The widow of the theologian Veit Dietrich tells Duke Albert of Prussia that a portrait of her husband painted from the death mask by Cranach the Younger in Wittenberg is so poor that it was not fit to be sent. (Reply to the duke's letter of June 22, 1550, commissioning the portrait.)
Formerly StAK I, 22, 136 (Ehrenberg [1899], No. 363)

389 *December 15, Augsburg.* John Frederick sends his wife his portrait (by Cranach?).
StAW Reg. L. Fol. 807N, No. 1a, Bl. 124 (Scheidig 1953, No. 67)

390 *No date.* John Frederick asks for the portraits of his wife and his youngest son which he thinks Cranach the Younger may have painted during a visit to Weimar.
(Schuchardt [1851], 204)

1551

391 *January 10, Augsburg.* John Frederick promises his wife to ask Cranach to copy the picture of the Seven Virtues, "printed in quince juice," which was sent on December 15, 1550.
StAW Reg. L. Fol. 807 N, No. 1b, Bl. 3 (Junius [1926], 250)

392 *February 27, Augsburg.* John Frederick asks that Johannes Stigel be commissioned to compose new Latin and German verses for the pictures of the Virtues.
(Schuchardt [1851], 205)

393 *March 10, Kronach.* Matthes Maler, Cranach's brother, appears as lawyer for Franz Thiem in Wittenberg in the libel suit brought against the latter by Hans Greuling.
AK Gerichtsbuch 1549-55, Bl. 149 (Fehn [1950])

394 *March 17, Augsburg.* John Frederick sends canvases that Cranach has painted for the hunting lodge in Wolfersdorf, Thuringia.
(Schuchardt [1851], 205)

395 *April 22, Augsburg.* John Frederick asks his wife to have the finished pictures of the Virtues installed in an alcove at the Wolfersdorf hunting lodge.
StAW Reg. L. Fol. 807-808 Fasc. No. 1b, Bl. 14b (Junius [1926], 254)

396 *(May 1), Augsburg.* Detailed list of works completed by Cranach: pictures of the Virtues, hunting scenes, six portraits of electors, given away as presents.
StAW Reg. Bb. 4711, Bl. 26 (Schuchardt [1851], 287)

397 *May 22, Weimar.* Duchess Sibylle acknowledges to John Frederick receipt of the pictures of the Virtues, which she wants to keep until the new construction work is started at Wolfersdorf.
StAW Reg. L. Fol. 807 N, No. 2b, Vol. 2, Bl. 19b (Scheidig [1953], No. 70)

398 *June 9, Kronach.* Matthes Maler, Cranach's brother, is mentioned as lawyer for Friedrich Dhan in Wittenberg in his lawsuit against Hans Greul(ing) for payment for some oxen he had bought.
AK Gerichtsbuch 1549-1555, Bl. 178 (Fehn [1950], 107)

399 *October 8, Augsburg.* Memorandum of Secretary Hans Rudolf concerning John Frederick's decision as communicated to Cranach. The outstanding half year's salary for the period of fall, 1546, to spring, 1547, is to be paid after the records have been checked. By agreement with Cranach, however, there will be no payment for the period of Easter, 1547, to July 23, 1550. From this date on, the painter is awarded 100 fl. annually for life, on condition that he settle in Ernestine territory and not serve foreign patrons. The first payment was due on July 23, 1551; the next one, after July 23, 1552, is to be made to Cranach directly, not to his son.
StAW Reg. Rr. 937, Bl. 11

400 *November 27, Augsburg.* John Frederick mentions the pictures of Cranach the Younger.
StAW Reg. Aa. 2975, Bl. 22

1552

401 *January 24, Königsberg.* Duke Albert of Prussia asks that Heinrich Königswieser, son of his trumpeter Veit Königswieser, be trained in Cranach's workshop.
Formerly StAK Flt. 31, S. 272 (*Beiträge zur Kunde Preussens*, III, 256; Schuchardt [1851], 152; Ehrenberg [1899], No. 373)

402 *March 31, Kronach.* Matthes Maler sells the house he has owned since 1516.
(Fehn [1950])

403 *August 20, Wittenberg.* Cranach the Younger to Duke Albert of Mecklenburg.
StAS 1 B 21/17 Hofstaatsachen – Bestallungen, Entlassungen, Beauftragungen/Lucas Cranach (reference supplied by Dr. W. Timm)

404 *August 30, Kronach.* Matthes is sued for a payment of 15 fl. owed Contz and Christoffel Hasselmann
AK Gerichtsbuch, Bl. 258 (Fehn, 3, 107)

405 *October 27, Weimar.* John Frederick authorizes a payment of 100 fl. to Cranach for the payment of debts, in addition to the 35 taler he has already received.
StAW Reg. Rr. 397, Bl. 14 (Schuchardt 1851, 196)

406 *November 2, Weimar.* Appointment of Cranach the Elder as court painter on condition that he shall serve only John Frederick and his sons. The terms include an annual salary of 100 fl., winter and summer clothing, board at the court. The earlier appointment under Electors Frederick and John was never put in writing.
StAW Reg. Rr. 397, Bl. 13 (Schuchardt [1851], 200ff.)

407 *No date, Weimar.* Cranach and his two apprentices receive board at court.
(Schuchardt [1851], 203)

408 *No date.* *(written in a shaky hand) Detailed bill from Cranach for thirty-one itemized works executed in Augsburg. The following individuals are mentioned: Cardinal Granvella, Titian ("thucia …, painter of Venice"), Hans Welser's

Cranach the Elder: List of pictures painted in Augsburg. 1552. Detail (see Source No. 408)

woman, Duetecum (?, later a copperplate engraver in the Netherlands: "*ein caritas Ducatwum Arzt*"), Gotland (? "… Gotsmann"). Payment of 100 fl.
StAW Reg. Aa. 2975, Bl. 18, 19b (Schuchardt [1851], 206)

1553

409 *January 13, Weimar.* Cranach the Younger to Duke Albert of Prussia. In the absence of his father he has accepted Königswieser for three years. Now an epidemic has forced him to flee to Weimar with his family and apprentice painters. He hopes to be able to send a painting by his pupil after his return to Wittenberg at Shrovetide.
Formerly StAK Schbl. LXII, No. 21 (*Beiträge zur Kunde Preussens*, III, 257; Schuchardt [1851], 153 ff.; Ehrenberg [1899], No. 382)

410 *March 31, Königsberg.* Duke Albert agrees to Königswieser's entering the workshop of Cranach the Younger and asks the latter, together with his father, to supervise his training.
Formerly StAK Flt. 31, S. 371 (*Beiträge zur Kunde Preussens*, III, 258; Ehrenberg [1899], No. 384)

411 *May 8, Wittenberg.* Cranach the Younger sends Duke Albert a sample of Königswieser's work. Königswieser sends the duke a canvas painting and asks that a loan of 10 fl. he had assumed (dated May 11, 1553) be paid.
Formerly StAK Schbl. LXII, No. 21 (*Beiträge zur Kunde Preussens*, III, 258 ff.; Ehrenberg [1899], No. 387, 388)

412 *October 16, Weimar.* Death of Lucas Cranach the Elder at the age of eighty-one. The tombstone is in Weimar, Church of St. Peter and St. Paul, replaced on the grave in St. Jacob's Cemetery by a copy.

1554

413 *Ca. March 25, Weimar.* Christian Brück receives 250 fl. in full payment for the services of Cranach the Elder. Only now is the payment made on the amount due for the period from autumn, 1546, to spring, 1547, that was agreed to by John Frederick on October 8, 1551. (Cf. No. 399)
(Schuchardt 1851, 196)

414 *May 3, Wittenberg.* Heinrich Königswieser thanks Duke Albert for an art book he has lent him and sends a small painted panel.
Formerly StAK Schbl. LXII, No. 21 (*Beiträge zur Kunde Preussens*, III, 261; Ehrenberg [1899], No. 393)

415 *September 12, Dresden.* Elector Augustus renews the apothecary privilege for Caspar Pfreundt, who has inherited the Wittenberg pharmacy.
LHW (Loan from the Adler Apotheke, Witten-

berg). Copy in StAD Loc. 14275, Vol. III, Bl. 332

(Grotemeyer [1970], p. 157)

1555

416 *July 1, Schweinitz (Elster).* Elector Augustus invites Cranach to a hunt in Schweinitz on July 4 so that he may make drawings and paint the scene on canvas or on a panel.
StAD Copial 260, 1553–1556, Bl. 519b

417 *October 14, Wittenberg.* Cranach releases Heinrich Königswieser upon completion of his training, leaving the fee to the discretion of Duke Albert. (Königswieser is appointed the duke's court painter on April 7, 1559.)
Formerly StAK Schbl. LXII, No. 21 (*Beiträge zur Kunde Preussens*, III, 262; Ehrenberg [1899], No. 406)

418 *December 23, Dresden.* Elector Augustus has received the picture of the hunt at Gorrenberg near Schweinitz and paid 12 fl. for it. Because the fee asked for designs for tapestries is too high, this will have to be discussed in Dresden.
StAD Copial 271, 1555–1557, Bl. 84b

419 *December 23, Dresden.* The Elector asks the architect Hans von Dehn-Rothfelser to speed up the preparation of designs for the hunting tapestries because the tapestry maker is out of work.
StAD Copial 271, 1555–1557, Bl. 84b

1556

420 *Beginning of January (New Year's Fair).* Cranach receives the substantial payment of 571 fl. 10 gr. (no doubt for the Weimar altarpiece).
(Schuchardt [1851], 222)

421 *Before May 31, Weimar (fiscal period of June 9, 1555, to May 31, 1556).* Cranach is paid 77 fl. 16 gr. for various expenses in connection with the altarpiece in the city church.
(Schuchardt [1851], 218)

422 *No date (1555–56).* Peter Gottlandt-Roddelstedt is paid 4 fl. for the design for a tapestry with the portraits of Cranach the Elder and Wolturny (M. Luthery?)
(Schuchardt [1851], 211)

1557

423 *December 9.* The etching apprentice (Erhard Gaulrap) receives 14 fl., which he is to take to Cranach in the name of Duke John Albert of Mecklenburg for portraits of Luther and Melanchthon.
StAS 1 C 3/02 Renterei-Register for Mecklenburg-Schwerin (Lisch [1856], 302)

424 *No date.* Date of a medal commemorating Cranach the Elder; only extant copy in Neuenstein, Hohenlohe Museum.

1558

425 *March 26, Wittenberg.* Cranach to Georg Maior concerning the commission for King Christian III of Denmark. Through Maior the king has two Wittenberg Bibles painted. The commissions go to Cranach (who is said always to have six or seven skilled journeymen painters) and to Pastor Balthasar Kinast in Cöln near Meissen. Cranach is mentioned in Maior's letters of April 1, July 27, and December 4, 1558.
Copenhagen, Rigsarkivet. T.K.U.A., Almindelig del, Diverse sager nr. 58. Breva fra udenlandske universiteter og "laerde maend" (Schumacher [1758], 227–30, 232, 233, 240; Lindau [1883], 343 ff.)

426 *July 21, Königsberg.* Duke Albert thanks Cranach for the portraits of Luther and Melanchthon and orders portraits of Duke John Frederick (d. March 3, 1554) and Duchess Sibylle (d. February 21, 1554).
Formerly StAK Schbl. LXII, No. 21 (Konzept) and Flt. 31, S. 955 (*Beiträge zur Kunde Preussens*, III, 263; Ehrenberg [1899], No. 423)

1559

427 *January 10, Dresden.* Elector Augustus reminds Cranach of the watercolor hunting canvases recently commissioned in Schwarzburg. Count Palatine Elector John George intends to take the finished canvases with him to the Augsburg Diet.
StAD Copial 261, 1554–1565, Bl. 256a

428 *April 27, Wittenberg.* *Cranach thanks Duke Albert for the payment of 100 fl. (30 double ducats) for portraits ordered.
Formerly StAK Schbl. LXII, No. 21 (*Beiträge zur Kunde Preussens*, III, 263 ff.; Ehrenberg [1899], No. 429)

429 *September 20, Lochau.* The elector asks Barthel Lauterbach for information about the hay barn in Wittenberg because Cranach has again asked for the lease.
StAD Copial 300, 1550–1563

430 *November 11.* Dr. Caspar Peucer, Cranach, Caspar Pfreundt and Conrad Rühel are granted one head of game for the wedding of their ward Caspar Straub.
StAD Copial 356a, 1569–1570, Bl. 230

431 *December 15, Königsberg.* Through Aurifaber Duke Albert has received the portraits of John Frederick and his wife ordered from Cranach (on July 21, 1558) and pays 40 taler for them.
Formerly StAK Flt. 31, S. 1035 and Konzepte A. 4, 1559 (*Beiträge zur Kunde Preussens*, III, 264; Ehrenberg [1899], No. 432)

1560

432 *April 16, Wittenberg.* *Cranach thanks Duke Albert for payment of the 40 taler.
Formerly StAK Schbl. LXII, No. 21 (*Beiträge zur Kunde Preussens*, III, 265; Ehrenberg [1899], No. 436)

433 *May 8.* A payment of 12 taler for Erhard Gaulrap ("Gert Maler") is sent to his master (Cranach) in Wittenberg.
StAS 1 C 3/02 Renterei-Register for Mecklenburg-Schwerin (Lisch [1856], 303)

434 *May 30.* Duke Albert communicates with the Wittenberg printer Hans Lufft in reply to his letter of April 16, 1560, about a portrait model to be forwarded to Cranach. (At the same time a letter is sent to Cranach.)
Formerly StAK Flt. 31. 5. 1081 (Ehrenberg [1899], No. 437a)

435 *June 22, Wittenberg.* Hans Lufft reports to Albert that he will inform Cranach of the portrait commission after the latter's return.
Formerly StAK Schbl. LXII, No. 21 (Ehrenberg [1899], No. 438)

436 *August 26, Wittenberg.* According to Hans Lufft, Cranach has not yet finished the woodcut portrait and the molding. For painting the Bible, they have in mind the Meissen pastor; he would ask about 65 taler for this work.
Formerly StAK Schbl. LXII, No. 21 (Ehrenberg [1899], No. 439)

437 *No date (fiscal year February 4, 1560, to February 9, 1561), Wittenberg.* Cranach pays taxes on two houses, one plot of land, a meadow; for wine selling and brewing rights. He pays for 68 cartloads of lime and 900 roofing tiles.
AW Kämmereirechnung 1560

438 *No date (February 4, 1560, to February 9, 1561), Wittenberg.* Cranach receives 188 fl. 12 gr. (66 sch.) from the Wittenberg City Council for the memorial (dated 1560) to Johannes Bugenhagen (d. April 20, 1558).
AW Kämmereirechnung 1560

1561

439 *November 6, Wittenberg.* *Cranach sends John Frederick *der Mittlere* six small portraits at 3 taler each, ordered in 1559. He asks for a gold medal with the duke's portrait.
StAW Reg. Aa. 2975, Bl. 24 (Schuchardt [1851], 233)

1562

440 *Before February 8 (fiscal year February 9, 1561, to February 8, 1562), Wittenberg.* Cranach pays for 66 cartloads of lime, 3,300 roofing tiles, 2,600

building blocks. As a member of the City Council he draws 3 fl. 17 gr. and as treasurer 2 fl. 18 gr.
AW Kämmereirechnung 1561

441 *Wittenberg.* *Letter from Cranach to Pastor Johannes Sommer of Gotha. Gotha, Forschungsbibliothek Cod. Goth. Chart. A 1048, No. 188, Bl. 137

442 *No date (fiscal year February 1562, to February, 1563), Wittenberg.* Cranach is paid 10 fl. 6 gr. 6 pf. for the painting of the coat of arms and the sundial on the tower of the Wittenberg city church.
AW Kämmereirechnung 1562

1563

443 *February 15, Wittenberg.* The booksellers' syndicate submits to the Dresden court sketches for portraits of Duke Henry, Elector Maurice and Elector Augustus, to be printed in all Bibles published with the electoral privilege. Virgil Solis, with whom they had been in touch about better Bible illustrations, died in Nuremberg while the project was under way (August 1, 1562). They inquire whether the commission for the electoral portraits should not be given to Cranach, who has recently been discharged.
StAD Loc. 10061, 3. Hofräte [1563], Bl. 62

444 *March 16, Dresden.* The court counselors ask the elector whether the portraits (to be used for making the woodcuts) are to be returned or whether Cranach is to make new drawings from them.
StAD Loc. 10061, 3. Hofräte [1563], Bl. 62

445 *September 29, Wittenberg.* With other guardians, Cranach signs the promissory note of the widow of Professor Jacob Milichius (d. 1559).
LHW IV, 3, S. 162, No. 913

446 *October 13, Wittenberg.* Hans Lufft reports receipt of payment for work on the Bible of Duke Albert of Prussia, which payment Cranach has also received.
Formerly StAK Schbl. LXII, No. 21 (Ehrenberg [1899], No. 471)

1564

447 *October 27, Dresden.* At the request of the old countess, Elector Augustus orders for Count Peter Ernest of Mansfeld one or two canvases of stag and boar hunts, in specified dimensions.
StAD Copial 321, 1563–1566, Bl. 147

448 *No date, Kemberg.* 43 gr. 2 pf. are listed as (initial) expenses for the altarpiece for the Kemberg town church. Cranach is paid 1 fl. for a site visit.
Kemberg, Kirchenarchiv

1565

449 *June 22, Bayreuth.* Elector Augustus asks Cranach to have a copy made of an armorial, said to have been in the possession of Cranach the Elder. There seem to have been errors in regard to several helmet crests.
StAD Copial 321, 1563–1565, Bl. 494

450 *July 3, Frauenstein.* Elector Augustus confirms receipt of the armorial from Cranach. The doubts that had arisen have been allayed. An expanded copy of the book is commissioned.
StAD Copial 326 (Beicopial 1564–1567), Bl. 176b

451 *November 8, Wittenberg.* Cranach reminds Duke John Albert of Mecklenburg about the 100 taler still outstanding for the training of Erhard Gaulrap (total debt: 155 thlr. 18 gr.)
StAS 1 B 21/17 Hofstaatsachen-Bestallungen, Entlassungen, Beauftragungen/Lucas Cranach (Lisch [1856], 304, 307ff.)

452 *November 20, Torgau.* Elector Augustus presses Cranach for the armorial. So far only a sample of the copy is to hand. The two journeymen available are to copy all Saxon coats of arms first. As for the other commission (pictures of the Temperaments?), he refers Cranach to Peucer. Cranach may keep the offices of burgomaster and revenue collector, since at this time they could not be filled by a more competent and industrious person.
StAD Copial 321, 1563–1565, Bl. 573b

453 *November 22, Torgau.* Elector Augustus acknowledges receipt of a letter from Cranach and urges the execution of the portraits (of the four Temperaments?).
StAD Copial 326 (Beicopial 1564–1567), Bl. 224b

454 *December 12, Dresden.* Elector Augustus acknowledges receipt of the first batch of the armorial and promises to help Cranach's son-in-law Dr. Johannes Hermann.
StAD Copial 321, 1563–1565, Bl. 588b

1566

455 *April 6, Wittenberg.* *Cranach asks Duke John Frederick *der Mittlere* to pay him, on June 29, the sum of 1,000 taler which he has invested in the electoral revenue office. This sum breaks down into 500 taler in cash and 500-taler remuneration for the (Weimar) altarpiece.
StAW Reg. L. pag. 231–239, C. 1, Bl. 104

447

1567

456 *January 29, Goldbach*. The elector requests Cranach as burgomaster to advance one month's pay to a company of lansquenets at the Wittenberg fortress. (Similar letters go to both burgomasters of Leipzig.)
StAD Copial 343, 1567–1568, Bl. 12
No date. A list made in 1583 records petitions (now lost) by Lucas Cranach the Younger supporting the claims of his sister, Christian Brück's widow, for restitution of properties confiscated after the sentencing of her husband. According to the same source, the petitions were granted as a grace.
StAW Reg. P. Abschnitt K No. 5, 4, S. 246

1568

457 *January 12, Wittenberg*. The City Council asks the elector to confirm Cranach as burgomaster. In the copy this is changed to read: "to relieve him of the office of burgomaster."
AW 37 Acta der ... Ratswahlen, 1529–1675, Bl. 37

458 *February 19, Wittenberg*. *Cranach makes an urgent request to Duke John Albert of Mecklenburg for payment of the 105 thlr. 18 gr. still outstanding for the training of Erhard Gaulrap. Total debt: 155 thlr. 18 gr.
StAS location uknown (Lisch [1856], 304, 308 ff.)

459 *July 29, Bockendorf near Nossen*. Elector Augustus acknowledges receipt from Cranach of the design for painted ceilings and vaulting. Asks for designs with animals and birds, but each type of animal is to be on a separate field. (Drawings presumably made for this commission are preserved in Leipzig and Vienna.)
StAD Copial 345, 1567–1570, Bl. 210

1569

460 *February 26, Wittenberg*. *Cranach asks Electress Anna for a list of any of her children not yet painted by him, with ages and likenesses, for the (Augustusburg) altarpiece.
StAD Loc. 8532 Schreiben an die Kurfürstin zu Sachsen, 1568–1571, Bl. 13

461 *June 13, Dresden*. Confirmation of privilege by Elector Augustus: Cranach the Elder was granted the right to sell wine over the counter in perpetuity, and Cranach the Younger has exercised this right for many years.
StAD Copial 222, 1554–1570, Bl. 389

1570

462 *October 8*. A head of game is presented to Cranach for the wedding of his son (Lucas the youngest, married to Anna Gareis, daughter of an electoral secretary).
StAD Copial 356a, 1569–1570, Bl. 365

1571

463 *February 23, Dresden*. Elector Augustus asks Cranach to take the boy Zacharias Wehme as an apprentice, at his expense.
StAD Copial 367, 1571–1572, Bl. 29

464 *March 6, Wittenberg*. Peucer reports to the elector that Cranach has finished the series of princes' portraits (for Augustusburg), except for those of Dukes Albert, Henry and George.
StAD Loc. 8522 Dr. Caspar Peucers Schreiben an Kurfürst August, 1565–1573, Bl. 143

465 *July 20, Wittenberg*. *Cranach acknowledges receipt of the elector's letter of July 17. Preparation of the panels for the portraits has caused a delay; the joiner will deliver them in fourteen days. The forty-eight portraits will probably be ready by next Easter; the shipment is to be combined with the installation of the altarpiece (in Augustusburg).
StAD Loc. 8523 Schreiben Kurfürst Augusts 1570–1585, 1. Buch, Bl. 142

466 *August 1, Stolpen*. Elector Augustus acknowledges receipt of letter and agrees to the proposed date of delivery. The reformers' portrait series is to be painted. He expresses thanks for congratulations on the birth of Duke Adolph.
StAD Copial 368, 1571–1573, Bl. 49b

467 *August 1, Stolpen*. The elector instructs the architect Hieronymus Lotter to install the series of princes' portraits in Augustusburg after the Wittenberg model.
StAD Copial 368, 1571–1573, Bl. 50

468 *August 15*. Peucer reports to the elector that Cranach is working on the pictures of the doctors. The German verses for the princes' portraits have been written. He hopes to get the portrait of Duke Frederick in Prussia (for a model) through Dr. Stoi.
StAD Loc. 8522 Dr. Caspar Peucers Schreiben an den Kurfürsten, 1565–1573, Bl. 150

469 *August 20, Dresden*. The elector reminds Peucer about the Latin couplets for the theologians' pictures.
StAD Copial 368, Bl. 64

470 *September 24*. Cranach is to be told about the altar picture and the portraits for Augustusburg.
StAD Loc. 4450 Augustusburg Schlossbau, 1567–1579, Bl. 255

471 *October 17, Augustusburg*. Lotter reports to the elector that a room has been made ready for

Cranach and that the base for the altar painting has been prepared.
StAD Loc. 4450 Augustusburg Schlossbau, 1567–1579, Bl. 259

472 *October 17, Wittenberg.* Peucer to Elector Augustus.
StAD Loc. 8522 Dr. Caspar Peucers Schreiben an den Kurfürsten, 1565–1573, Bl. 151

473 *No date (fiscal year February, 1571, to February, 1572).* Cranach procures 12 cartloads of lime, 2,500 roofing tiles and 200 building blocks. Payment for the twin coats of arms on two gates of the City Hall. (1 sch. 7 gr.).
AW Kämmereirechnung 1571

1571–72

474 *No date, Augustusburg.* Augustin Cranach is working for Heinrich Goeding as a journeyman. (Schuchardt [1855], 95)

1572

475 *March 29, Dresden.* Elector Augustus hopes to procure the outstanding pictures of Dukes Albert, Henry, George and Frederick at the Leipzig Fair, so that Cranach can complete the series of princes' portraits.
StAD Copial 367, 1571–1572, Bl. 219

476 *March 29, Dresden.* The elector commissions from Peucer the German verses for the portraits which Cranach is to make after the Leipzig Fair.
StAD Copial 367, 1571–1572, Bl. 219b

477 *April 21, Stolpen.* Elector Augustus asks Cranach to have such princes' pictures as are finished shipped to Dresden by boat; there they will be forwarded to Augustusburg. A similar series of portraits of theologians or scholars is envisaged; Peucer is to compose Latin verses for them.
StAD Copial 367, 1571–1572, Bl. 229b

478 *May 28, Dresden.* Order from the elector to Treasurer Hans Harrer to credit 200 fl. to Cranach for the finished portraits and the ones he is working on.
StAD Copial 367, 1571–1572, Bl. 244b

479 *November 11, Dresden.* The elector mentions to treasury clerk Hans Jenitz that the big painting for Annaburg has already been assigned to Cranach and that the commission can therefore not be given to Hans Schroer, who has recently emigrated from the Netherlands.
StAD Copial 367, Bl. 327

480 *November 12, Augustusburg.* Heinrich Goeding reports that the extensive painting work at Augustusburg was completed on November 8. He and two journeymen and two apprentices still

have to paint several hundred shields and windowpanes; he asks that a room be assigned to them for a workshop.
StAD Loc. 8523 Schreiben an Kurfürst August 1570–1585, Bl. 324

481 *November 13.* The elector agrees to the salary for Hans Schroer as negotiated with Jenitz, but the altar painting for Annaburg is to be painted by Cranach.
StAD Loc. 8523, Schreiben an Kurfürst August 1570–1585, Bl. 320

482 *November 26, Sitzenroda.* Elector Augustus commissions Cranach to paint a head-and-shoulders portrait of him in electoral dress.
StAD Copial 369, Reise-Copial 1571–1573, Bl. 239b

1573

483 *January 4, Torgau.* The elector informs the paymaster at Wittenberg that Cranach has permission to have a kiln of lime burned in the government brickworks at his own expense.
StAD Copial 384, 1573–1574, Bl. 2b

484 *April 14, Wittenberg.* Peucer informs the elector that the portrait of Duke Frederick, Grand Master of the German Order in Prussia, has now been procured.
StAD Loc. 8522 Dr. Caspar Peucers Schreiben an den Kurfürsten 1565–1573, Bl. 169

485 *April 20, Wittenberg.* *Cranach, whose right to sell foreign wine over the counter has been challenged, requests the court counselors to confirm his privilege of June 15, 1569.
StAD Loc. 14275 Vol. I, Confirmationes 1572–1577, Bl. 2

486 *April 25, Torgau.* The elector advises the Danish king that the game canvases (by Cranach?) are ready.
StAD Copial 376, 1572–1574, Bl. 63

487 *April 26, Torgau.* The elector acknowledges to Peucer receipt of the portrait of Duke Frederick, Grand Master of the German Order in Prussia.
StAD Copial 376, 1572–1574, Bl. 64

488 *April 26, Torgau.* Elector Augustus orders from Cranach the outstanding portrait of Duke Frederick from the model brought by Magister Eusebius Mauro.
StAD Copial 376, 1572–1574, Bl. 64

489 *April 27, Wittenberg.* *Cranach acknowledges to Elector Augustus receipt of his letter and of the portrait model, with the aid of which the portrait series is now being completed. The pulpit for Augustusburg is finished; one of his men is to accompany it to Dresden.
StAD Loc. 8523 Schreiben an Kurfürst August 1570–1585, Bl. 409

490 *April 29, Torgau.* The elector instructs the treasurer to have the pulpit made by Cranach sent from Dresden to Augustusburg by special conveyance.
StAD Copial 384, 1573–1574, Bl. 48 b

491 *April 29, Torgau.* Elector Augustus asks Cranach to send off the Augustusburg pulpit together with the man who is to install it.
StAD Copial 384, 1573–1574, Bl. 48 b

492 *May 9, Torgau.* The elector instructs the treasurer to see that the Augustusburg paymaster opens the church and the room for Cranach's journeyman when he arrives.
StAD Copial 384, 1573–1574, Bl. 56 b

493 *May 25, Wittenberg.* *Cranach informs Electress Anna that completion of the altar painting for Annaburg is delayed. Joiners and wood carvers cannot complete their work until August 24, rather than June 24. After completing the Augustusburg pulpit, all journeymen and apprentices fell sick with a fever. He asks for the portraits of the elector and electress so that he can include them in the panel for Annaburg.
StAD Loc. 8534 Allerlei gemeine Schreiben an die Kurfürstin zu Sachsen 1572–1575, Bl. 118

494 *October 24, Annaburg.* Electress Anna to an unnamed correspondent (Cranach). The portraits he asks for are difficult to detach from the settings, "but we have no doubt that you still have sketches of such likenesses." The Annaburg church is finished except for the paintings.
StAD Copial der Kurfürstin 517, 1573–1574, Bl. 118

495 *December 19, Wittenberg.* *Cranach reports to the electress that work on the altar painting is finished except for the portraits, the inclusion of which will require fourteen days. The captain at Annaburg has inspected the work.
StAD Loc. 4449 Schreiben und Berichte, belangend das Schloss zu Annaburg, 1572–1573, Bl. 167

496 *December 21, Annaburg.* Captain Wolf von Kanitz mentions to the electress his visit to Cranach on December 19.
StAD Loc. 4449 Schreiben und Berichte ... 1572–1573, Bl. 169

497 *December 31, Augustusburg.* The elector asks Wolf von Kanitz to inform Cranach that the portraits he needs for the Annaburg panel cannot be dispatched from Dresden until the court returns.
StAD Copial 384, 1573–1574, Bl. 369

498 *No date (fiscal year February, 1573, to February, 1574), Wittenberg.* Cranach's own estimate of his assets (as a basis for the tax assessment for building the City Hall): 3,230 fl. (= 1,130 sch. 30 gr.). He thus ranks fifth among the wealthy burghers of the city.

AW Kämmereirechnungen 1573

1574

499 *March 12, Wittenberg.* *Cranach informs Wolf von Kanitz that he has completed the work on the altar panel for Annaburg although the portrait models and inscriptions have not arrived from the court. Sixty six-inch boards and tarpaulins to cover the wagons are required for shipment.
StAD Loc. 4449 Schreiben und Berichte ... 1572–1573, Bl. 201

500 *March 24, Dresden.* The elector asks Wolf von Kanitz to write Cranach that he wants the Annaburg panel executed without portraits of the electoral family, simply as "a Biblical *historia* from the New Testament, as is appropriate for an altar." A Bible text in German or Latin is to be placed beneath it.
StAD Copial 384, 1573–1574, Bl. 376 b

501 *June 22, Torgau.* Elector Augustus asks Cranach to have the Annaburg panel installed while the Netherlands painter Hans Schroer is still there. Schroer has just finished work on the pulpit and gallery.
StAD Copial 384, 1573–1574, Bl. 193

502 *October 30, Wittenberg.* The City Council consults Georg Ernst zu Henneberg about a bond of Cranach's.
Auctioned Stargardt, Marburg, October 28, 1955, 524

1575

503 *March 4, Annaburg.* Elector Augustus reminds Cranach of two full-length portraits of himself and his wife commissioned a considerable time ago.
StAD Copial 404, 1575, Bl. 63

504 *July 25, Annaburg.* In response to a request by Cranach, the elector instructs the treasurer to settle accounts with him for various works executed during the past ten years.
StAD Copial (Beicopial 1575), Bl. 119 b

505 *July 25.* The elector consults Ernst von Pottens, Michael Teuber and the Wittenberg City Council about the disputes between Dr. Veit Windsheim and Lucas Cranach over an imprisoned miller.
StAD Nachtrag Copial 397, 1574–1576, Bl. 284 b

1576

506 *April 19.* Elector Augustus instructs Cranach to keep Zacharias Wehme, apprenticed to him five years earlier, for two more years, "so that he may become a distinguished good painter."
StAD Copial 414 (Beicopial 1576)

507 *Date unknown.* Cranach asks Elector Augustus for repayment of the 2,000 fl. bond for Georg Dasch,

released on June 2, 1567.
(Lindau [1883], 347)

1577

508 *September 17, Wittenberg*. In an oration Dr. Joachim von Beust recalls the printing press run by Cranach and Döring.
(Lindau [1883], 159)

509 *Date unknown*. Electress Anna to Duchess Maria of Bavaria: "Truly we lack in this country such good painters as are to be found abroad who can make really good likenesses."
(Sturmhöfel [1905], 218)

1578

510 *June 4, Dresden*. At a friend's request Elector Augustus inquires of Margrave George Frederick of Brandenburg-Ansbach whether he can furnish the favorite armor and a portrait of Margrave Albert of Brandenburg.
StAD Copial 440, 1578, Bl. 112

511 *June 6, Dresden*. At the request of a friend Elector Augustus orders from Cranach portraits of Elector Maurice and Duke John Frederick.
StAD Copial 440, 1578, Bl. 114 (Lindau [1883], 273)

512 *June 16, Dresden*. Elector Augustus acknowledges Cranach's answer concerning the commissioned portraits. They are to be painted in oil on canvas in whatever dimensions he chooses. One portrait is to show them in the armor they wore at the Battle of Mühlberg, the other in everyday dress.
StAD Copial 440, 1578, Bl. 123 (Lindau [1883], 274)

513 *September 25, Plassen*. The elector consults the Weimar counselors about a sum of 200 fl. deposited with Erhard Schnepf through Cranach concerning Ursula Dasch.
StAD Copial 425, 1576–1579 (= Loc. 7551), Bl. 286

514 *December 1, Wermsdorf*. Elector Augustus asks Cranach for an estimate for the series of portraits of princes of Saxony requested by Archduke Ferdinand of Austria (for his collection at Ambras Castle).
StAD Copial 439, 1578, Bl. 263b

515 *No date*. Cranach appeals to the elector, as guardian of the young duke, in the matter of a bond for Georg Dasch, deceased.
AW

1579

516 *January 4*. Elector Augustus to Hans von Bern-

stein: From accounts rendered it is clear that Gregor Martheiss and Cranach have been guilty of serious irregularities in the sale of wine and beer. The embezzled tax moneys are to be collected; the elector reserves to himself the right to punish them.
StAD Copial 456. 1580, Bl. 256

517 *February 24, Annaburg*. Elector Augustus advances Cranach 60 taler for the series of 44 princes' portraits (commissioned by Archduke Ferdinand). He promises to send the models for the portraits of his sons Alexander and Christian, "but you are not to make them public but (keep them for yourself alone [this addition canceled in the draft]) and send them back to us as soon as you have no more need of them."
StAD Copial 448, 1579, Bl. 90

518 *April 21, Bayreuth*. Margrave George Frederick of Brandenburg-Ansbach orders two portraits from Cranach on the occasion of his betrothal to Duchess Sophie of Brunswick-Celle.
(Bardeleben [1909], 262)

519 *August 7, Annaburg*. The elector instructs the paymaster at Torgau to lend Cranach various portraits from the Knaufturm at the castle for a specified period (evidently for the completion of Archduke Ferdinand's commission).
StAD Copial 448, 1579, Bl. 260b

520 *August 10*. The elector consults Hans von Bernstein about a sum of 500 fl. owing to Cranach since 1571.
StAD Copial 448, 1579, Bl. 266b

521 *October 13, Annaburg*. Through Paul Zehenter von Zehendgrub, the servant of Archduke Ferdinand of Austria, the elector sends the archduke the princes' portraits so far completed (by Cranach).
StAD Copial 448, 1579, Bl. 309b

522 *October 17, Annaburg*. Instructions from the elector to the treasurer: In addition to the 60 taler already paid to Cranach, another 200 taler are to be paid to him for fifty portraits and 60 taler for a total of eight portraits of Maurice and John Frederick. Portraits of Dukes Alexander and Christian are still on order from Cranach.
StAD Copial 448, 1579, Bl. 312 (Lindau [1883], 274)

523 *November 13*. Elector Augustus consults the Weimar counselors about the sum of 200 fl. in connection with Ursula Dasch, Cranach's sister.
StAD Copial 425, 1576–1579, Bl. 374b

1581

524 *July 7, Wittenberg*. *Cranach sends Zacharias Wehme back to Elector Augustus with some samples of the work he has done.

StAD Loc. 8524, das 5. Buch der Schreiben an Kurfürst August, Bl. 116

525 *November 9.* The elector instructs the treasurer to pay Cranach 200 fl., in addition to the 100 fl. paid three and a half years ago for Wehme's training, although Cranach's claim seems exorbitant. Cranach's son Lucas (III) is to accept payment.
StAD Copial 466, 1581, Bl. 294

526 *November 24, Dresden.* Hans Jenitz reports to the elector that Zacharias Wehme has begun the copying of the "Turks' book" (*Türkenbuch*, preserved in the Dresden Kupferstich Kabinett). The young painter is staying with his mother until agreement is reached concerning his keep.
StAD Loc. 8524, das 5. Buch der Schreiben an Kurfürst August, Bl. 208

527 *December 7, Dresden.* The elector instructs the treasurer to pay Zacharias Wehme 1 guilder a week for his keep from November 1 until further notice.
StAD Copial 466, 1581, Bl. 305b

1583

528 *November 8, Colditz.* Elector Augustus instructs Cranach to paint a round or heart-shaped altarpiece for the Colditz Castle church. (Vaulting of the church building [finished?], July 22, 1583.) Terms and fee to be determined after submission of a sketch.
StAD Copial 484, Bl. 399b

529 *November 11, Wittenberg.* Cranach replies to the elector's letter of November 8. He has been to Colditz, where he took measurements of the old panel, the space and all pertinent dimensions. He advises against a round panel, because of the figures. The altarpiece, including side panels, is to be 6½ ells wide.
StAD Loc. 9126, Artillerie- und Bausachen 1576–1584, Bl. 438

530 *November 29, Wittenberg.* *Cranach sends the elector two sketches for the Colditz altar, a heart-shaped one "and also one of a different kind." Estimate: 500 taler for all painting, woodwork, carving and joiner's work.
StAD Loc. 9126, Artillerie- und Bausachen 1576–1584, Bl. 446

531 *November 29, Wittenberg.* *Cranach replies to a letter from the elector of November 27 ordering six pictures of wild boar. (In fact, he has not seen a wild boar for a long time.) The Colditz altarpiece is to be 6 ells wide and 7 ells high.
StAD Loc. 9126, Artillerie- und Bausachen 1576–1584, Bl. 447–448

532 *December 3, Augustusburg.* Elector Augustus decides on the heart-shaped model for the Colditz altar and agrees to the price of 500 taler. Seven more copies of the boar taken on October 13,

1583, are needed. Cranach receives an invitation to the boar hunt.
StAD Copial 484, 1583, Bl. 415b

1584

533 *January 2.* The elector instructs the treasurer to pay Cranach a total of 40 fl. for eight pictures of the big wild boar and 150 fl. for the Colditz altarpiece.
StAD Copial 492, 1584, Bl. 2

534 *January 2.* The elector advises Cranach that the sum requested from Treasurer Gregor Schilling has been approved. He hopes for quick completion of the Colditz commission.
StAD Copial 492, 1584, Bl. 3

535 *January 20, Augustusburg.* Duke Ludwig of Württemberg has received two different wild boar pictures.
StAD Copial 492, Bl. 208b

536 *June 1, Mainz.* Elector Augustus asks Hans Jenitz to send a picture of the Colditz wild boar.
StAD Copial 492, Bl. 75b

537 *July 3, Mainz.* Request for another wild boar picture to be presented to Count Palatine John Casimir.
StAD Copial 492, 1584, Bl. 271

538 *August 28, Colditz.* Elector Augustus asks Cranach to have the altarpiece, which, according to the painter's report of August 26, is now finished, brought to Colditz by special conveyance.
StAD Copial 492, Bl. 100b

1585

539 *March 26, Dresden.* Through Cranach's grandchild, daughter of Dr. Herrmann, the elector sends the painter 5 taler in payment of the last wild boar picture. The elector has not yet inspected the Colditz altarpiece.
StAD Copial 501, 1585, Bl. 25b

540 *March 26, Dresden.* The bishop of Halberstadt (Duke Henry Julius of Brunswick) has received a picture of the wild boar of Colditz.
StAD Copial 501, Bl. 25b

541 *August 19, Dresden.* The elector tells the bailiff at Belzig that he has approved the purchase of the Klepzig farm by Cranach's son Christoph.
StAD Copial 502, Bl. 227b

542 *No date.* The Wittenberg treasury accounts show that Cranach owes taxes in the amount of 6 sch.

51 gr. 8 pf. This sum is not paid until the fiscal year 1586–87, by Cranach's widow.
AW Kämmereirechnungen, 1585, 1586

1586

543 *January 27, Wittenberg*. Lucas Cranach the Younger is buried in Wittenberg city church.

544 *November 10, Dresden*. Second renewal of the apothecary privilege by Elector Christian I.
Copy: StAD Loc. 14275, Vol. III, 1585–1589, Bl. 332

1592

545 *August 1, Weimar*. Administrator Friedrich Wilhelm assigns the pharmacy privilege to Conrad Fluth, who bought the apothecary shop from Cranach's heirs under Elector Christian I.
LHW. Loan from the Adler Apotheke, Wittenberg

1593

546 *November 27, Dresden*. In the name of the Dresden painters' guild, Heinrich Goeding declares that twenty years ago Cranach was among those who advocated the founding of the guild. Goeding states that he was selected to train Wehme. Because the apprenticeship was already held by Cranach's son (Augustin), Wehme was sent to Wittenberg for training.
StAD Loc. 8747, Röder and Wehme against the guild on the question whether painting is a free art, 1594, Bl. 2, 34b

1607

547 *February 2*. Polycarp Leyser, son-in-law and heir of Cranach, requests confirmation of his ownership of a little garden between the Hinterhaus and the city wall which Cranach the Elder had laid out and Cranach the Younger had used. He receives the privilege on July 16, 1607.
StAD Loc. 7318, Kammersachen 1607, 2. Teil

CRANACH FAMILY TREE

For data concerning the first three generations,
following Hans Werner, Kronach 1925,
the author is indebted to City Archivist Hans Kremer.
(See "Fränkischer Tag," May 26, 1972,
special supplement, p. 5.)
The corrections of Dr. Hans Gerber, Koblenz,
have been incorporated.

LUCAS MALER?
* 1420
† 1488
∞ 1445 Margareta
* 1422
† 1480

HANS MALER
* 1448
† 1527/28
∞ 1471 Barbara
* 1451
† 1491/92

LUCAS CRANACH
* 1472 Kronach
† Weimar 10/16/1553
∞ Barbara Brengbier
* 1477 Gotha
† Wittenberg Dec. 1540

a daughter
* 1474
† 1475

Margareta
* 1476
† 1530
∞ 1518 Michael
Fleischmann
* 1470

a son
* 1479
† 1483

a daughter
* 1482
† 1485

Anna
* 1485
† 1577
∞ 1516
Bartholomäus
Sunder
* 1493

Kuni
* 1488
† 1555
∞ 1511
Hans Kraus-
Klopfsberger
* 1486

Agnes
* 1489

MATTHÄUS
* 1491/92
† 1553
∞ 1514 . . . Panzer
* 1495
† 1560

† Bologna 10/9/1537

* 10/4/1515 Wittenberg
† Wittenberg 1/25/1586

a) ∞ 2/20/1541
Barbara Brück
* 1518
† Wittenberg
2/10/1550

b) ∞ (4/12 – 5/25)
1551
Magdalena Schurff
* 8/19/1531
† 1/3/1606

∞ (before 6/24)
1544
Georg Dasch
* Würzburg
1500
† Gotha 1578

* 1520
† 1601
∞ 1543
Dr. Christian
Brück
* 1510
† Gotha
4/18/1567

* 1527
† Wittenberg
6/30/1577
∞ (9/14 – 12/13)
1550
Caspar Pfreundt
* 1517 Saalfeld
† Wittenberg
6/16/1574

Lucas
* 1541
† Meissen
2/16/1612
∞ 10/17/1570
Anna Gareis
† 6/10/1610

Barbara
∞ 11/28/1564
Dr. Johannes
Herrmann
* 10/16/1527
Nördlingen
† 5/7/1605
Breslau

Johann
† 5/2/1548

Christian
† 1556

Magdalena
† 1554

AUGUSTIN
* 1554
† 7/26/1595
∞ 11/26/1577
Maria Selfisch
* 1/27/1558
† 1/15/1626
Delitzsch

Agnes
† 1560

Christoph
† 2/23/1596
∞ 2/5/1583
Veronika Vogel
* 9/14/1563
† 4/29/1629

Elisabeth
* 12/3/1561
† 9/16/1645
∞ 5/17/1580
Dr. Polycarp
Leyser
* 3/18/1552
Winnenden
† 2/22/1610
Dresden

Euphrosina
* 1585 Torgau
† 8/8/1627
∞ 11/25/1604
Abel Volck
* 7/26/1575
Merseburg
† 1/19/1622

Elisabeth(?)
∞ 11/27/1610
Martin John

**Maria
Magdalena**
* 3/17/1579
† 11/13/1617
Dresden
∞ 1/25/1597
Leonhard
Cöppel
* Nuremberg
† 1637

Elisabeth
* 1/8/1581
† 12/14/1581

Barbara
* 9/30/1582
† 9/25/1586

**Anna
Maria**
* 8/2/1584
† 1/2/1585

LUCAS
* 3/6/1586
† 9/15/1645
a) ∞ 1608
Martha
Hildebrand
* 9/24/1586
† 4/18/1624
Wachsdorf
c) ∞ 10/29
1633
Sybilla
Richter

Samuel
* 5/12/1588

Euphrosina
* 11/4/1590
† 3/25/1665
∞ 1/20/1607
Aegidius
Strauch
* 6/22/1583
† 1/22/1657
Dresden

Augustus
* 10/10/1592

**Hans
Christoph**
* 1/8/1594
∞ Maria
Schuffer

Elisabeth
* 12/16/1595
∞ Siegfried
Neuhofen

Cranach the Younger:
The Creation
and Fall of Man.
From the Bible.
Leipzig. 1541.
Woodcut

LIST OF ILLUSTRATIONS

Unless otherwise stated, the work is by Cranach the Elder.

ILLUSTRATIONS ACCOMPANYING THE TEXT

PLATES

29 Knight and Lady on Horseback. Signed and dated 1506. Woodcut, 178×124 mm. Holl., 114 I. Dresden, Staatliche Kunstsammlungen, Kupferstichkabinett

30 Lansquenet and Lady. Signed ca. 1506. Two woodcuts, both 243×92 mm., usually printed on one sheet. Holl., 109. Dresden, Staatliche Kunstsammlungen, Kupferstichkabinett

31a Statuette of St. Ottilia. 1509. Woodcut, 131× 55 mm. From the Wittenberg *Heiltumsbuch*, Simphorian Reinhart, Wittenberg, 1509 (first edition). Sch., 13. London, British Museum

 b Statuette of St. Barbara. 1509. Woodcut, 129× 45 mm. From the Wittenberg *Heiltumsbuch*, Simphorian Reinhart, Wittenberg, 1509 (first edition). Sch., 26. London, British Museum

32a St. Christina and St. Ottilia. Left side panel (outer side) of the St. Catherine altarpiece of 1506. Linden wood, 1.22×.65 m. FR, 16. Wantage, Lockinge House, Loyd Collection

 b St. Genevieve and St. Apollonia. Right side panel (outer side) of the St. Catherine altarpiece of 1506. Linden wood, 1.25×.62 m. FR, 16. Wantage, Lockinge House, Loyd Collection

33 a, b, c St. Catherine altarpiece, opened. Martyrdom of St. Catherine (signed and dated 1506). SS. Dorothy, Agnes and Cunigunde (left side panel). SS. Barbara, Ursula and Margaret (right side panel). Linden wood, 1.26×1.40 m. and 1.24× .67 m., resp. FR, 14. Dresden, Staatliche Kunstsammlungen, Gemäldegalerie (Gall. No. 1906 A.B.C.)

34 Detail from Pl. 33b

35 Detail from Pl. 33a

36 Christ, the Man of Sorrows. Reverse of the Fourteen Helpers panel. Ca. 1505. Linden wood, .85×1.28 m. FR, 15. Torgau, St. Mary's Church

37 The Fourteen Helpers in Time of Need. (Reverse: see Pl. 36.) Ca. 1505. Linden wood, .85×1.28 m. FR, 15. Torgau, St. Mary's Church. From left: SS. Eustace (stag), Achatius (rod of thorns), Mauritius (flag), Pantaleon (hands nailed to his head), George (dragon), Blasius (candle), Christopher (with the Christ Child), Dionysius (holding his severed head), Aegidius (hind), Vitus (cock), Erasmus (windlass), Cyriacus (dragon), Margaret (dragon), Barbara (tower)

38 Head of St. Christopher. Signed and dated 150(5). Drawing, 124×160 mm. R, A 10. Weimar, Staatliche Kunstsammlungen (KK 99)

39 Detail from Pl. 37 (infrared photograph)

40 Detail from Pl. 37

41 St. Jerome in Penitence. Signed and dated 1509. Woodcut, 335×226 mm. Holl., 84

42 Rest on the Flight into Egypt. Signed and dated 1509. Woodcut, 285×185 mm. Holl., 7

43 St. Valentine. Ca. 1510. Drawing, 286×80 mm. R, A 4. Munich, Staatliche Graphische Sammlung

44 Virgin and Child. St. Anne. Exterior of the side panels, St. Anne altarpiece, 1509. Wood, 1.2× .44 m. FR, 20. Frankfurt-am-Main, Städelsches Kunstinstitut

45 St. Anne altarpiece, opened. The Holy Family. Signed on a little framed notice on the right-hand column: Lucas Chronus Faciebat Anno 1509. Wood, 1.20×.99 m.; side panels 1.20× .44 m. FR, 18. Frankfurt-am-Main, Städelsches Kunstinstitut

46 The Judgment of Paris. Signed and dated 1508. Woodcut, 363×252 mm. Holl., 104

47 St. Christopher. Signed and dated "1506" (1509). Tone woodcut, 281×194 mm. Holl., 79

48 Venus and Cupid. Signed and dated 1509. Transferred from wood to canvas. Dimensions extended on all sides; original format of 1.70×.84 m. reproduced here. FR, 21. Leningrad, Hermitage

49 Detail from Pl. 48

50 Venus and Cupid. Signed and dated "1506" (sic). 1509. Tone woodcut, 277×189 mm. Holl., 105. Dresden, Staatliche Kunstsammlungen, Kupferstichkabinett

51 Adam and Eve. Ca. 1510. Linden wood, .59× .44 m. FR, 40, Warsaw, National Museum

52 Self-portrait. Detail from Pl. 53

53 The Holy Family. Signed ca. 1510. Linden wood, .88×.71 m. FR, 33. Vienna, Akademie der Bildenden Künste, Gemäldegalerie (Inv. No. 542)

54 Salome with the Head of John the Baptist. Ca. 1510. Wood, .60×.50 m. FR, 32. Lisbon, Museum of Fine Arts

55 Madonna and Child. Signed with the colorful signet ring with monogram, left foreground. Ca. 1510. Wood, .71×.51 m. FR, 28. Breslau, cathedral; lost since 1945

56 Altarpiece of the Princes, opened. Madonna and Child attended by hovering angels, with St. Catherine and St. Barbara. Elector Frederick the Wise (1463–1525) with St. Bartholomew. Duke John (1486–1532) with St. James the Greater. Ca. 1510–1512. Linden wood, 1.06× .925 m., side panels 1.06×.925 m. FR, 19. Probably originally intended for the west choir of the Wittenberg Castle church. Dessau, Staatliche Galerie

57 Detail from Pl. 56

58 Detail from Pl. 56

59 Christ and the Woman Taken in Adultery. Dated 1509. Drawing, 299×196 mm. R, 18. Brunswick, Herzog Anton Ulrich Museum

60 The Expulsion of the Money Changers. Ca. 1509. Center panel of an altarpiece; side panels burned in 1945. Linden wood, 1.44×.98 m. Dresden, Staatliche Kunstsammlungen, Gemäldegalerie

61 Portrait of a Young Man. Ca. 1510. Oak wood, .49×.36 m. FR, 49. On the back, traces of a figure painted in grisaille. The coat of arms on the signet ring is believed to indicate the Dutch Sixte Hillegom family. Recognized by Koepplin as paired with the Portrait of a Lady (Pl. 62). New York, Metropolitan Museum of Art (29. 100.24)

62 Portrait of a Lady Praying. Ca. 1510. Oak wood, .43×.36 m. (Original format shortened at the bottom.) FR, 25. Recognized by Koepplin as paired with the Portrait of a Young Man (Pl. 61). Zurich, Kunsthaus

63 Head of a Peasant. Ca. 1515. Drawing, 193× 157 mm. R, A 9. Basel, Öffentliche Kunstsammlung, Kupferstichkabinett

64 Head of a Beardless Man. Ca. 1515. Paper, 223× 150 mm. R, 73. West Berlin, Staatliche Museen Preussischer Kulturbesitz, Kupferstichkabinett

65 The Slaughter of the Innocents. Ca. 1515. Linden wood, 1.23×.87 m. (upper edge rounded off later). Dresden, Staatliche Kunstsammlungen, Gemäldegalerie (Gall. No. 1906 C)

66 The Execution of St. Catherine. Ca. 1510. Wood, 1.12×.95 m. Budapest, Reformed Church

67 The Penitence of St. Chrysostom. Signed and dated 1509. Engraving, 256 × 200 mm. Holl., 1

68 St. Bartholomew, Worshipped by Frederick the Wise. Signed, ca. 1510. Engraving, 187×165 mm. Holl., 4

69 Christ Before Annas. From the "Passion" series of 1509. Woodcut, 250×172 mm. Holl., 12

70 The Flagellation of Christ. From the "Passion" series of 1509. Signed. Woodcut, 250×172 mm. Holl., 15

71 The Execution of John the Baptist. Signed, ca. 1509. Woodcut, 401 × 277 mm. Holl., 86

72 Head and Shoulders of a Gentleman. Ca. 1510. Drawing, 282×184 mm. Vienna, Staatliche Graphische Sammlung Albertina (Cat. No. 359)

73 The First Tournament. Signed and dated 1506. Woodcut, presumably colored by the artist, 256×372 mm. Holl., 116 I. Dresden, Staatliche Kunstsammlungen, Kupferstichkabinett

74 The Execution of the Apostle James the Greater. From the "Deaths of the Apostles" series, ca. 1512. Woodcut, 163×126 mm. Holl., 55

75 The Death of the Apostle John. Woodcut from the same series as Pl. 74. Holl., 56

76 The Execution of the Apostle Thomas. Woodcut from the same series as Pl. 74. Holl., 59

77 The Execution of the Apostle Matthew. Woodcut from the same series as Pl. 74. Holl., 60

78 The Apostle Peter. From the series "Christ and the Twelve Apostles," with St. Paul. Ca. 1515 (one sheet signed). Woodcut, 309×182 mm. Holl., 32

79 The Apostle Paul. Woodcut from the same series as Pl. 78. Holl., 44

80 The Annunciation to the Virgin. Signed, ca. 1511. Woodcut, 243×166 mm. Holl., 6

81 Virgin and Child, Worshipped by Frederick the Wise (1463–1525). Signed ca. 1515. Woodcut, 369×230 mm. Holl., 72. Dresden, Staatliche Kunstsammlungen, Kupferstichkabinett

82–83 Twin Portraits of Duke Henry of Saxony (1473–1541) and His Wife, Catherine (1477–1561). Signed and dated 1514. Transferred from linden wood to canvas; presumably divided then, certainly not later. Estimated original format: 1.85×1.65 m. FR, 53 and 54. Dresden, Staatliche Kunstsammlungen, Gemäldegalerie (Gall. No. 1906 G and H)

84 Detail from Pl. 86

85 Detail from Pl. 86 (infrared photograph)

86 The Mocking of Christ. Ca. 1515. Wood, .89× .59 m. (FR, 296, erroneously dated "ca. 1537"). Weimar, Kunstsammlungen

87 Christ, the Man of Sorrows. Ca. 1515. Fragment of a painting believed by Helmut Müller to have been damaged by fire. Wood, .56×.52 m. FR, 307 d (erroneously dated "after 1537"). Weimar, Kunstsammlungen

88 The Agony in the Garden. Signed, ca. 1515–1520. Linden wood. .58×.41 m. FR, 83. Dresden, Staatliche Kunstsammlungen, Gemäldegalerie (Gall. No. 1908)

89–90 Marginal Drawings for Emperor Maximilian's Prayer Book. Sheets 57b and 58a. Ca. 1515. Drawings on parchment, both 278×194 mm. R, 22 and 23. Munich, Bayrische Staatsbibliothek (2° L. impr. membr. 64)

91 Christ Falls at the Flagellation Column (Cranach workshop). From a series of "The Falls of Christ" after Hans Baldung's woodcuts, ca. 1512–1515. Wood, .25×.18 m. Florence, Lapiccirella Galleries

92 The Adoration of the Magi. Signed, ca. 1514. Fir wood, 1.22×.73 m. FR, 43. Gotha, Schlossmuseum

93 Recumbent Water Nymph. Signed, ca. 1516. Linden wood, .58×.87 m. FR, 100. West Berlin, Verwaltung der Staatlichen Schlösser und Gärten, Jagdschloss Grunewald (GK I 1926)

94 Recumbent Water Nymph. Ca. 1525. Drawing, 116×206 mm. R, 40. Dresden, Staatliche Kunstsammlungen, Kupferstichkabinett. Lost since 1945.

95 Recumbent Water Nymph. Signed and dated 1534. Wood, .51×.77 m. FR, 211. Liverpool, Royal Institution (No. 49)

96 Detail from Pl. 97

97 Recumbent Water Nymph. Signed and dated 1518. Wood, .54×.85 m. FR, 100. Leipzig, Museum der Bildenden Künste

98 Lucretia. Ca. 1525. Drawing, 134×96 mm. R, 15. West Berlin, Staatliche Museen Preussischer Kulturbesitz, Kupferstichkabinett

99 Lucretia. Ca. 1525. (The author believes the signature to be forged.) Drawing, 131×95 mm. R, 16. West Berlin, Staatliche Museen Preussischer Kulturbesitz, Kupferstichkabinett

100 Man and Woman Playing Musical Instruments. Ca. 1530. Drawing, 75×107 mm. R, 44. Erlangen, University Library

101 Hercules (rear view). Ca. 1527–1530. Drawing, 254×132 mm. R, 45. West Berlin, Staatliche Museen Preussischer Kulturbesitz, Kupferstichkabinett

102 St. George on Horseback. Ca. 1520–1525. Lin-

den wood, .41×.28 mm. FR, 117. Dessau, Staatliche Galerie. Lost since 1945

103 Samson and the Lion. Signed, ca. 1520–1525. Wood, .56×.38 m. FR, 118. Weimar, Kunstsammlungen

104 Apollo and Diana. Signed and dated 1530. Copper-beech wood, .51×.36 m. FR, 222. West Berlin, Staatliche Museen Preussischer Kulturbesitz, Gemäldegalerie

105 Hercules and Antaeus. Signed, ca. 1530. Wood, .27×.18 m. FR, 219. Formerly Munich; now in a private collection

106 Madonna and Child. Signed and dated 1518. Linden wood, .41×.30 m. FR, 81.
On the back, coat of arms of Provost Joachim Lidlau (d. 1565). Glogau, cathedral; missing since 1945

107 Madonna and Child Under an Apple Tree. Ca. 1530. Transferred from wood to canvas, .87×.59 m. FR, 187. Leningrad, Hermitage (No. 684)

108 Portrait of Martin Luther (1483–1546) as a Monk. Signed and dated 1520. Engraving, 138×97 mm. Holl., 6 (unlisted first state, with profile head, upper left). Weimar, Kunstsammlungen

109 Portrait of Martin Luther Before a Niche. Signed and dated 1520. Engraving, 165×118 mm. Holl., 7. Weimar, Kunstsammlungen

110 Portrait of Martin Luther Wearing a Doctor's Cap. Signed and dated 1521. Engraving, 205×150 mm. Holl., 8 I. Coburg, Kunstsammlungen der Veste (Inv. No. 1, 47, 7)

111 Portrait of Martin Luther as Junker Jörg. Ca. 1521. Wood, .52×.34 m. FR, 126. Weimar, Kunstsammlungen

112 Portrait of Martin Luther as Junker Jörg. 1522. Woodcut, 283×204 mm. Holl., 132a. Dresden, Staatliche Kunstsammlungen, Kupferstichkabinett

113 Portrait of Joachim of Brandenburg (1505–1571). 1520. Linden wood, .59×.42 mm. FR, 121. West Berlin, Verwaltung der Staatlichen Schlösser und Gärten, Jagdschloss Grunewald (GK I 10809)

114 Portrait of John of Anhalt (1504–1551). 1520. Linden wood, .63×.44 m. FR, 121. West Berlin, Verwaltung der Staatlichen Schlösser und Gärten, Jagdschloss Grunewald (GK I 30029)

115 Portrait of Count Philipp von Solms (1468–1544). 1520. Paper, 179×132 mm. Bautzen, City Museum (Inv. No. L 83)

116 Portrait of Hans Luther (d. 1530). 1527. Paper, 196×183 mm. R, 76. Vienna, Staatliche Graphische Sammlung Albertina

117 Portrait of Hans Luther (d. 1530). Signed and dated 1527. Copper-beech wood, .38×.25 m. FR, 253. Eisenach, Wartburg Stiftung

118 Portrait of Margaretha Luther (d. 1531). 1527. Copper-beech wood, .38×.25 m. FR, 254. Eisenach, Wartburg Stiftung

119 A Burgomaster of Weissenfels. Signed and dated 1515. Parchment; transferred from linden wood

to canvas, then back to wood, .42×.28 m. FR, 56. West Berlin, Staatliche Museen Preussischer Kulturbesitz, Gemäldegalerie (Gall. No. 618A)

120 Portrait of Asche (Ascanius) von Cramm as a Horseman. Ca. 1525. Drawing, 267×208 mm. Nuremberg, Germanisches Nationalmuseum (Hz. 59)

121 Portrait of King Christian II of Denmark (1481–1559; reigned 1513–1523). Signed and dated 1523. Woodcut, 252×172 mm. Holl., 125. West Berlin, Staatliche Museen Preussischer Kulturbesitz, Kupferstichkabinett

122 Portrait of King Christian II of Denmark (1481–1559; reigned 1513–1523). Signed and dated 1523. Wood, .56×.38 m. FR, 127. Nuremberg, Germanisches Nationalmuseum

123 Portrait of John Frederick of Saxony (1503–1554) as a Bridegroom. Signed and dated 1526. Paired with Pl. 124. Copper-beech wood, .55×.36 m. FR, 243. Weimar, Kunstsammlungen

124 Portrait of Sibylle of Cleve (1512–1554) as a Bride. Signed and dated 1526. Paired with Pl. 123. Copper-beech wood, .55×.36 m. FR, 244. Weimar, Kunstsammlungen

125 Portrait of Maurice of Saxony (1521–1553) as a Child. Signed and dated 1526. Paired with Pl. 126. Linden wood, .57×.39 m. FR, 245. Darmstadt, Landesmuseum

126 Portrait of Severin of Saxony (1522–1533) as a Child. Signed and dated 1526. Paired with Pl. 125. Linden wood, .57×.39 m. FR, 246. Darmstadt, Landesmuseum

127 The Nativity of Christ. Signed, ca. 1520. Linden wood, .30×.23 m. FR, 90. Dresden, Staatliche Kunstsammlungen, Gemäldegalerie (No. 1907A)

128 David and Bathsheba. Signed and dated 1526. Copper-beech wood, .36×.24 m. FR, 173. West Berlin, Staatliche Museen Preussischer Kulturbesitz, Gemäldegalerie

129 Portrait of a Young Lady. Signed and dated 1526. Copper-beech wood, .89×.59 m. FR, 238. Leningrad, Hermitage (No. 683)

130 Portrait of a Young Lady with a Bunch of Grapes. Wood, .80×.54 m. FR, 238c. Collection of Princess von Schenck-Winterstein

131 Portrait of a Lady with a Flower. Signed and dated 1526. Wood, .34×.26 m. Warsaw, National Museum (No. 263)

132 Portrait of a Lady with an Apple. Signed and dated 1527 (date as given by Schuchardt, now almost illegible). Oak wood, .38×.25 m. FR, 150. Prague, National Gallery

133 Portrait of Chancellor Gregor Brück (1485/86–1557). Signed and dated 1533. Wood, .41×.38 m. FR, 275. Nuremberg, Germanisches Nationalmuseum

134 Portrait of Elector John Frederick (1503–1554). Ca. 1532–1535. Linden wood, .90×.70 m. FR, 269. West Berlin, Staatliche Museen Preussischer Kulturbesitz, Gemäldegalerie

135 Portrait of Johannes Carion (1499–1538), Court

461

Astrologer to the Electors of Brandenburg. Ca. 1530. Copper-beech wood, .52×.37 m. Berlin, Deutsche Staatsbibliothek

136 Portrait of the Magdeburg Theologian Dr. Johannes Scheyring (Ziring; ca. 1454–1516). Signed and dated 1529. Wood, .52×.35 m. FR, 266. Brussels, Musée des Beaux Arts

137 Christ Before Caiaphas. Ca. 1519–1525. Pen drawing, 127×93 mm. R, 33. Dresden, Staatliche Kunstsammlungen, Kupferstichkabinett; missing since 1945

138 Christ Before Pilate. Ca. 1519–1525. Pen drawing, 140×96 mm. R, 34. Dresden, Staatliche Kunstsammlungen, Kupferstichkabinett; missing since 1945

139 The Flagellation of Christ. Ca. 1519–1525. Pen drawing, 140×96 mm. R, 35. Dresden, Staatliche Kunstsammlungen, Kupferstichkabinett; missing since 1945

140 Sketch for the St. Augustine Altar for the Collegiate Church at Halle-an-der-Saale. Ca. 1519–1525. Drawing, 250×240 mm. R, 37. Leipzig, Museum der Bildenden Künste

141 Sketch for a Memorial. Ca. 1527–1530. Pen drawing, 201×144 mm. On the back of Pl. 154. R, 47. Brunswick, Herzog Anton Ulrich Museum

142 Cardinal Albrecht of Brandenburg (1490–1545) as St. Jerome in the Wilderness. Signed and dated 1527. Linden wood, .57×.37 m. FR, 156. West Berlin, Staatliche Museen Preussischer Kulturbesitz, Gemäldegalerie (No. 589)

143 Portrait of a Girl. Signed, ca. 1520. Wood, .39×.25 m. FR, 130. Paris, Musée du Louvre (Cat. No. 2702A)

144 St. Margaret. Ca. 1513–1514. Wood, .93×.63 m. FR, 46. Minneapolis, Institute of Arts

145 St. Mary Magdalene. Signed and dated 1525. Oak wood, .47×.30 m. FR, 143. Cologne, Wallraf-Richartz Museum

146 Portrait of the Humanist Rudolph Agricola (1443–1485). Ca. 1532. Beech wood, .30×.23 m. FR, 249. Munich, Bayerische Staatsgemäldesammlungen, Alte Pinakothek

147 Portrait of the Humanist Rudolph Agricola (1443–1485). Signed, ca. 1532. Wood, .20×.15 m. Starnberg, Collection of Dr. Robert Purrmann

148 Lucretia. Signed and dated 1533. Copper-beech wood, .36×.22 m. FR, 197. West Berlin, Staatliche Museen Preussischer Kulturbesitz, Gemäldegalerie

149 Venus. Signed and dated 1532. Copper-beech wood, .37×.25 m. FR, 204. Frankfurt-am-Main, Städelsches Kunstinstitut

150 Judith at the Table of Holofernes. Signed and dated 1531. Paired with the following painting. Self-portrait of the artist as an observer on the left margin. Linden wood, .97×.72 m. FR, 176. Gotha, Schlossmuseum

151 The Death of Holofernes. Signed and dated 1531. Paired with the preceding painting. Old retouching (eighteenth century?) in a vertical strip to the right of center. Linden wood, .97×.72 m. FR, 177. Gotha, Schlossmuseum

152 Detail from Pl. 151

153 Judith with the Head of Holofernes. Ca. 1530. Poplar wood, .87×.56 m. FR, 190a. Vienna, Kunsthistorisches Museum (Inv. No. 858)

154 The Judgment of Paris. Ca. 1530. Pen drawing, 201×144 mm. On the back, Pl. 141. R, 46. Brunswick, Herzog Anton Ulrich Museum

155 The Judgment of Paris. Signed and dated 1530. Copper-beech wood, .35×.24 m. FR, 210. Karlsruhe, Kunsthalle

156 The Duchesses Sibylle (1515–1592), Emilia (1516–1591) and Sidonia (1518–1575) of Saxony. Ca. 1535. Linden wood, .62×.89 m. FR, 240. Vienna, Kunsthistorisches Museum (Inv. No. 877)

157 Judith with the Head of Holofernes. Signed and dated 1530. Linden wood, .80×.56 m. FR, 193. West Berlin, Staatliche Schlösser und Gärten, Jagdschloss Grunewald (GK I 1182)

158 Venus and Cupid. Ca. 1530. Linden wood, 1.65×.60 m. FR, 199. West Berlin, Staatliche Museen Preussischer Kulturbesitz, Gemäldegalerie (No. 594)

159 Detail from Pl. 160

160 The Golden Age. Ca. 1530. Wood, .75×1.05 m. FR, 214. Oslo, National Gallery

161 Portrait of a Gentleman with an Arrow (Duke Henry the Devout, 1473–1541). Ca. 1530. Wood, 1.25×.82 m. Dresden, Staatliche Kunstsammlungen, Gemäldegalerie (Historisches Museum, H. 74), currently at Schloss Moritzburg

162 A Stag Hunt. Signed and dated 1529. Mansfeld Castle in the right background. The following participants in this imaginary hunt have been identified: Elector Frederick the Wise, Elector John the Constant, Emperor Maximilian I: one of the figures on the left margin is presumably a Count Mansfeld. Poplar wood, .80×1.14 m. (Original format preserved in a late copy in Basel, Kunstmuseum; here the bottom and left-hand edges have been trimmed.) FR, 231. Vienna, Kunsthistorisches Museum (Inv. No. 3560)

163 A Hooded Crow. Ca. 1530. Watercolor on paper, 191×280 mm. Dresden, Staatliche Kunstsammlungen, Kupferstichkabinett (C 1960–30)

164 A Wild Boar. Ca. 1530. Watercolor on paper, 142×229 mm. R, 66. Dresden, Staatliche Kunstsammlungen, Kupferstichkabinett; lost between 1945 and 1967

165 Wild Boar Brought to Bay by Hounds. Ca. 1530–1540. Pen drawing, 150–241 mm. R, 60. West Berlin, Staatliche Museen Preussischer Kulturbesitz, Kupferstichkabinett (K. d. Z. 386)

166 Spotted Wild Boar. Ca. 1530. Watercolor on paper, 164×241 mm. R, 64. Dresden, Staatliche Kunstsammlungen, Kupferstichkabinett (C 2174)

167 Portrait of Martin Luther. Ca. 1532. Watercolor on parchment, 220×190 mm. Thornhill (Scotland), Drumlanrig Castle, collection of the duke

of Buccleuch (acquired in 1859 from the collection of Lord Northwick). Not in Rosenberg

168 St. Eustace. Ca. 1530. Drawing, 234×181 mm. R, 54. Boston, Museum of Fine Arts (53. 5), Frederick Brown Fund

169 Two Waxwings. Ca. 1530. Watercolor on paper, 346×203 mm. R, 69. Dresden, Staatliche Kunstsammlungen, Kupferstichkabinett (C 2179)

170 Four Partridges. Ca. 1532. Drawing, 450×323 mm. Dresden, Staatliche Kunstsammlungen, Kupferstichkabinett (C 1193)

171 Detail from Pl. 173: Still Life with Cheese, Grapes and Pomegranate

172 Detail from Pl. 173: Still Life with Fly

173 The Payment. Signed and dated 1532. Wood, 1.08×1.19 m. FR, 236, Stockholm, National Museum

174 Hercules with Omphale. Ca. 1537. Drawing, 145×208 mm. R, 57. West Berlin, Staatliche Museen Preussischer Kulturbesitz, Kupferstichkabinett

175 Hercules with Omphale. Ca. 1537. Wood, .14×.19 m. Gotha, Schlossmuseum (Cat. No. 1890)

176 Hercules with Omphale. Signed and dated 1532. Beech wood, .79×1.16 m. FR, 224. Berlin, Staatliche Museen (No. 576), war casualty

177 Hercules with Omphale. Signed and dated 1532. Canvas, .83×1.23 m. FR, 223. Munich, Scheidwinner Gallery (1966)

178 Hercules with Omphale. Signed and dated 1537. Copper-beech wood, .82×1.19 m. FR, 225. Brunswick, Herzog Anton Ulrich Museum (No. 25)

179 *Hans Cranach:* Hercules with Omphale. Signed and dated 1537. Wood, .56×.84 m. FR, 226. Lugano, Thyssen Collection (No. 102)

180 An Ill-Matched Couple. Ca. 1530. Linden wood, .38×.25 m. FR, 233. Prague, National Gallery (Inv. No. 0-455)

181 Melancholy. Signed and dated 1532. Wood, .51×.97 m. FR, 227. Copenhagen, State Museum of Art

182 A Fountain of Youth. Signed and dated 1546. Linden wood, 1.21×1.84 m. FR, 327. West Berlin, Staatliche Museen Preussischer Kulturbesitz, Gemäldegalerie (No. 593)

183 Detail from Pl. 182

184 Bacchus at the Vat. Signed and dated 1530. Wood, .58×.39 m. FR, 212. New York, private collection

185 The Fall and Redemption of Man. Ca. 1530. Pen drawing, 143×197 mm. R, 53. Frankfurt-am-Main, Städelsches Kunstinstitut

186 Christ and the Woman Taken in Adultery. Signed and dated 1532. Linden wood, .83×1.21 m. FR, 178. Budapest, Fine Arts Museum

187 Portrait of Duke Henry the Devout (1473–1541). Signed and dated 1537. Linden wood, 2.09×.90 m. FR, 286. Dresden, Gemäldegalerie (No. 1915); war casualty

188 *Hans Cranach:* Portrait of a Young Man (self-portrait?) Signed and dated 1534. Wood, .52×.35 m. FR, 276. Lugano, Thyssen Collection (Gall. No. 193)

189 *Hans Cranach:* Portrait of a Young Woman. Ca. 1537. Silverpoint drawing. From sheet 1, recto, of the sketchbook. Hanover, Kestner Museum

190 *Hans Cranach:* Portrait of a Master (?). Ca. 1537. Silverpoint drawing. From sheet 40, verso, of the sketchbook. Hanover, Kestner Museum

191 Judith. Ca. 1520. Silverpoint drawing, 149×141 mm. R, 50. Dessau, Gemäldegalerie (Inv. No. 22); war casualty

192 *Attributed to Hans Cranach:* The Silver Age. Ca. 1534. Silverpoint drawing, 194×144 mm. R, 49. West Berlin, Staatliche Museen Preussischer Kulturbesitz, Kupferstichkabinett (K. d. Z. 385)

193 *Hans Cranach:* Landscape with Sigmundsburg Castle (built about 1460) near Fernstein in the Tyrol. 1537. Silverpoint drawing, 160×203 mm. Sketchbook, sheet 2, verso. Hanover, Kestner Museum

194 *Hans Cranach:* Studies of a Monkey. Ca. 1537. Silverpoint dawing, 203×160 mm. Sketchbook, sheet 5, recto. Hanover, Kestner Museum

195 *Cranach the Younger:* The Crucifixion of Christ with Kneeling Sinners. Signed ca. 1545. Colored woodcut, 356×262 mm. Dresden, Staatliche Kunstsammlungen, Kupferstichkabinett (C 1909–689)

196 *Attributed to Cranach the Younger:* Charity. Signed ca. 1540. Wood, 1.19×.81 m. FR, 326. Weimar, Kunstsammlungen

197 *Cranach the Younger:* Portrait of Duke John William of Saxony (1530–1573). Signed ca. 1550. Woodcut, 355×218 mm. Holl., 38. Vienna, Staatliche Graphische Sammlung Albertina

198 *Cranach the Younger:* Portrait of Johann Scheyring (mentioned 1521–1542). Nephew of Dr. Johannes Scheyring (see Pl. 136). Signed and dated 1537. Colored woodcut, 370×270 mm, Holl., 53. West Berlin, Staatliche Museen Preussischer Kulturbesitz, Kupferstichkabinett. (A similarly colored print in Gotha, Schlossmuseum.)

199 The Last Supper. Center panel of the altarpiece, Wittenberg city church. Ca. 1547. Wood, 2.56×2.42 m.

200 *Cranach the Younger:* The Last Supper. Ca. 1535. Drawing, 187×136 mm. West Berlin, Staatliche Museen Preussischer Kulturbesitz, Kupferstichkabinett (K. d. Z. 4262)

201 *Cranach the Younger:* The Resurrection of Christ. Ca. 1529. Drawing, 190×90 mm. R, A 18. Oslo, National Gallery

202 *Cranach the Younger:* Portrait of Caspar von Minckwitz. Paired with the following portrait. Signed and dated 1543. Beech wood, .64×.49 m. FR, 338. Stuttgart, Staatsgalerie (Inv. No. 1521)

203 *Cranach the Younger:* Portrait of Anna von Minckwitz, née Morgenthal. Paired with the preceding portrait. 1543. Beech wood, .60×.44 mm. FR, 339. Stuttgart, Staatsgalerie (Inv. No. 633)

204 Portrait of Emperor Charles V. Ca. 1550. Wood, .21×.18 m. Eisenach, Wartburg Stiftung

205 *Cranach the Younger:* Portrait of a Gentleman. 1545. Oil on parchment, mounted on wood, 318×251 mm. San Francisco, M. H. de Young Memorial Museum (43.9.3; M. H. de Young Endowment Fund)

206 *Cranach the Younger:* The Conversion of St. Paul. Signed and dated 1549. Wood, 1.15×1.66 m. FR, 351. Nuremberg, Germanisches National-museum (No. 226)

207 *Cranach the Younger:* Portrait of a Man of Twenty-Eight. Signed and dated 1546. Linden wood, .65×.49 m. FR, 344. Warsaw, National Museum

208 *Cranach the Younger:* Christ the Friend of Children. Sketch for a tapestry. In the background. Torgau Castle. Signed, ca. 1540. Drawing, 327×353 mm. Leipzig, Museum der Bildenden Künste (Inv. No. NJ 16)

209 *Cranach the Younger:* The Court Hunts Stags, Wild Boar and Foxes. In the background, Torgau Castle. Among the participants in this imaginary hunt Emperor Charles V and Elector John Frederick are recognizable. Signed and dated 1544. Wood, 1.14×1.75 m. FR, 330. Madrid, Museo del Prado (No. 2175)

210 *Cranach the Younger:* The Court Hunts Stags and Bear. In the background, the earliest view of Torgau Castle, to the right the mountains of the Elbsandstein range. Electors John and John Frederick are among the huntsmen. Signed and dated 1540. Wood, .63×.82 m. FR, 331a. Cleveland, Museum of Art

211 Detail from Pl. 210

212 *Cranach the Younger:* John the Baptist Preaching. Signed and dated 1549. Copper-beech wood, 1.14×1.68 m. Brunswick, Herzog Anton Ulrich Museum (No. 29)

213 *Cranach the Younger:* Hercules Fighting the Wild Men of the Woods. Ca. 1551. Drawing, 183×220 mm. Edgeware, Schilling Collection

214 *Cranach the Younger:* Hercules Driving Off the Pygmies. Signed and dated 1551. Wood, 1.88×1.61 m. Dresden, Staatliche Kunstsammlungen, Gemäldegalerie (Gall. No. 1944)

215 *Cranach the Younger:* Sleeping Hercules with Pygmies. Signed and dated 1551. Wood, 1.89×1.59 m. Dresden, Staatliche Kunstsammlungen, Gemälde-galerie (Gall. No. 1943)

216 *Cranach the Younger:* Portrait of Gregor Brück (1485-86–1557). Signed and dated 1557. Tempera on canvas, 1.06×.85 m. (later varnished). Weimar, Kunstsammlungen

217 *Cranach the Younger:* Portrait of Lucas Cranach the Elder. Signed and dated 1550. Wood, .67×.49 m. FR, 342. Florence, Uffizi (No. 1631)

218 *Cranach the Younger:* Portrait Head of a Gentleman. Ca. 1545. Tempera and oil on paper, 390×255 mm. Reims, Musées (No. 718)

219 *Cranach the Younger:* Portrait Head of a Gentleman. Ca. 1545. Tempera and oil on paper, 390×250 mm. Reims, Musées (No. 719)

220 *Cranach the Younger:* The Baptism of Christ. In the background, the oldest picture of the town of Dessau; among the spectators, the ruling family of Anhalt, Margrave John of Kustrin, reformers, members of the court, including Cranach the Elder. Signed and dated 1556. Linden wood, .62×.82 m. West Berlin, Staatliche Schlösser und Gärten, Jagdschloss Grunewald (GK I 2087)

221 *Cranach the Younger:* The Baptism of Christ. Ca. 1556. Drawing, 138×187 m. Berlin, Staatliche Museen, Kupferstichkabinett

222 *Cranach the Younger:* Allegory of Virtue (Hill of Virtue). Signed and dated 1548. Linden wood, .32×.22 m. Inscriptions: encircling the palm tree, "Deo et Virtute" (To God and Virtue); beside the allegorical figure at the top, "Virtus" (Virtue); above the door at the bottom of the hill, "Durate" (Persevere); on Hercules' coat of arms, "Via ardua est sed manet in acumine inextimabile praemium" (The road is steep, but at the top waits an inestimable prize). Vienna, Kunsthistorisches Museum (Gall. No. 1468 A)

223 *Cranach the Younger:* Portrait of a Bearded Man. Ca. 1550. Watercolor on paper, 253×177 mm. R, 92. West Berlin, Staatliche Museen Preussischer Kulturbesitz, Kupferstichkabinett (K. d. Z. 2378)

224 *Cranach the Younger:* The Resurrection of Christ. Memorial to the first wife of the jurist Dr. Leonhard Badehorn (1510–1587). Signed and dated 1557 (falsified [?] to 1554). Wood, 1.63×1.24 m. Leipzig, Museum der Bildenden Künste (No. 47)

225 *Cranach the Younger:* Design for a Wall Painting with Stags. Ca. 1568 (?). Drawing, 210×285 mm. Leipzig, Museum der Bildenden Künste (Hz. 3, Bl. 79)

226 *Cranach the Younger:* Design for a Wall Painting with Foxes. Ca. 1568 (?). Drawing, 213×287 mm. Leipzig, Museum der Bildenden Künste (Hz. 3, Bl. 79)

227 *Cranach the Younger:* Portrait of Philipp Melanchthon (1497–1560). Signed and dated 1560. Woodcut, 275×213 mm. Holl., 49

228 *Cranach the Younger:* Portrait of Philipp Melanchthon (1497–1560). Signed and dated 1559. Wood, .81×.61 m. Frankfurt-am-Main, Städelsches Kunstinstitut (Inv. No. SG 349)

229 *Cranach the Younger:* Altarpiece. Memorial to Duke John Frederick of Saxony and his family. Center panel, The Fall and Redemption of Man (with portraits of Luther and Cranach); inner side panels, portraits of the family. Signed and dated 1555. Wood, center panel, 3.60×3.11 m.; side panels, 3.60×1.55 m. FR, 352. Weimar, Church of SS. Peter and Paul.

230 *Cranach the Younger:* Sketch for a Portrait of Elector Joachim II of Brandenburg (1505–1571). Ca. 1555. Oil on cardboard, 405×355 mm. Dresden, Gemäldegalerie (Gall. No. 1948 A); missing since 1945

231 Detail from Pl. 229a: Sibylle von Cleve

232 *Cranach the Younger:* The Raising of Lazarus. In

the background, the Coburg Fortress. The group of Wittenberg reformers includes Erasmus of Rotterdam (!) and Gregor Brück. Memorial to Michael Meyenburg (1491–1558) and his family. Signed and dated 1558. Wood, 2.33 × 2.00 m. Nordhausen, Church of St. Blasius; missing since 1945

233 Detail from Pl. 232

234 *Cranach the Younger:* Portrait of Elector Joachim II of Brandenburg (1505–1571). Ca. 1555. Linden wood, 1.12 × .87 m. West Berlin, Staatliche Schlösser und Gärten, Jagdschloss Grunewald (GK I 1113)

235 *Cranach the Younger:* Portrait of Margravine Elizabeth of Ansbach-Bayreuth (1540–1578). Signed ca. 1579. Wood, .88 × .69 m. Munich, Bayerische Staatsgemäldesammlungen. Alte Pinakothek (13112)

236 *Cranach the Younger:* Portrait of a Man of Forty-Four. Signed and dated 1566. Paired with the following portrait. Wood, .84 × .59 m. Prague, National Gallery (DO-4146)

237 *Cranach the Younger:* Portrait of a Woman of Thirty-Two. Signed and dated 1566. Paired with the preceding portrait. Wood, .84 × .59 m. Prague, National Gallery (DO-4145)

238 *Cranach the Younger:* Portrait of a Nobleman. Paired with the following portrait. Signed and dated 1564. Linden wood, .84 × .64 m. The curtain at the right was added later; it hides a painted coat of arms. FR, 347. Vienna, Kunsthistorisches Museum (Inv. No. 885)

239 *Cranach the Younger:* Portrait of a Noblewoman. Paired with the preceding portrait. Signed and dated 1564. Linden wood, .83 × .64 m. The curtain at the left was added later; it hides a painted coat of arms, perhaps that of the Von Witscher family (three lilies). FR, 348. Vienna, Kunsthistorisches Museum (Inv. No. 886)

240 *Cranach the Younger:* Portrait of Prince Joachim Ernest of Anhalt (1536–1586). Paired with the following portrait. Signed and dated 1563. Canvas, 2.06 × .98 m. Halle-an-der-Saale, Staatliche Galerie Moritzburg (I/410)

241 *Cranach the Younger:* Portrait of Princess Agnes of Anhalt (d. 1569). Paired with the preceding portrait. Signed and dated 1563. Canvas, 2.06 × .98 m. Halle-an-der-Saale, Staatliche Galerie Moritzburg (I/411)

242 *Cranach the Younger:* Portrait of Elector Augustus of Saxony (1526–1586). Signed and dated 1565. Wood, 2.14 × .97 m. Dresden, Staatliche Kunstsammlungen, Gemäldegalerie (Inv. No. H 94), currently at Schloss Moritzburg

243 *Cranach the Younger:* Portrait of Electress Anna of Saxony (1532–1585). Signed and dated 1564. Wood, 2.02 × .92 m. Dresden, Staatliche Kunstsammlungen, Gemäldegalerie (Inv. No. H 95), currently at Schloss Pillnitz

244 *Cranach the Younger:* Portrait of Duke Alexander (1554–1565). Signed and dated 1564. Wood,

164 × .80 m. Dresden, Staatliche Kunstsammlungen, Gemäldegalerie (Inv. No. H 96), currently at Schloss Moritzburg

245 *Cranach the Younger:* Portrait of Duchess Elizabeth (1552–1590). Signed and dated 1564. Linden wood, 1.64 × .80 m. Dresden, Staatliche Kunstsammlungen, Gemäldegalerie (Inv. No. H 97), currently at Schloss Moritzburg

246 *Cranach the Younger:* Sketch for a Portrait of Duchess Elizabeth (1552–1590), married in 1570 to Count Palatine John Casimir. Ca. 1564. Oil on paper, 387 × 283 mm. West Berlin, Staatliche Museen Preussischer Kulturbesitz, Kupferstichkabinett (K. d. Z. 4452)

247 *Cranach the Younger:* Sketch for a Portrait of Duke Alexander (1554–1565). Ca. 1564. Oil on paper, 325 × 240 mm. Vienna, Staatliche Graphische Sammlung Albertina (Inv. No. 3202)

248 *Cranach the Younger:* Sketch for a Portrait of Elector Augustus (1526–1586). Ca. 1565. Oil on paper, 405 × 325 mm. Dresden, Staatliche Kunstsammlungen, Gemäldegalerie (Gall. No. 1947)

249 *Cranach the Younger:* The Nativity. Memorial to Caspar Niemegk (1516-17–1562) and his wife. Signed and dated 1564. Wood, 1.65 × 1.12 m. Wittenberg city church

250 *Cranach the Younger:* The Last Supper. The Wittenberg reformers, including Prince George of Anhalt (1507–1553), are portrayed as apostles. Memorial to Prince Joachim of Anhalt (1509–1561). Signed and dated 1565. Wood, 2.47 × 2.02 m. Dessau-Mildensee, village church (from the Church of St. Mary in Dessau)

251 *Hans Kreutter:* The Last Supper. Signed and dated 1564. Drawing, 262 × 199 mm., trimmed (on the back, a letter, also trimmed). Schwerin, Staatliches Museum (Inv. No. Hz. 1501)

252 *Cranach the Younger:* The Last Supper. Ca. 1565. Drawing, 227 × 182 mm. Schwerin, Staatliches Museum (Inv. No. Hz. 1506)

253 *Cranach the Younger:* The Crucifixion of Christ. Signed and dated 1573. Wood, 1.74 × 1.26 m. From the Annaburg Palace church. Dresden, Gemäldegalerie (Gall. No. 1946); war casualty

254 *Cranach the Younger:* The Crucifixion of Christ. Center panel of the altarpiece in the Colditz Castle church. Signed and dated 1584. Wood, 1.59 × 1.44 m. Nuremberg, Germanisches Nationalmuseum

255 *Cranach the Younger:* The Agony in the Garden. Memorial to Anna Hetzer (d. 1573). Signed and dated 1575. Wood, 1.43 × 1.18 m. From the Wittenberg city church. Dietrichsdorf near Wittenberg, village church

256 *Cranach the Younger:* The Resurrection of Christ. Memorial (possibly to Michael Teuber, Wittenberg, d. 1576). Ca. 1580. Linden wood, 1.85 × 1.36 m. Kreuzlingen, Kisters Collection

257 *Cranach the Younger:* Portrait of Margrave George the Devout of Brandenburg-Ansbach (1483–1543). Signed and dated 1571. Wood, 1.00 × .72 m.

West Berlin, Staatliche Schlösser und Gärten, Schloss Charlottenburg (GK I 1192)

258 *Cranach the Younger:* Portrait of Margrave George the Devout of Brandenburg-Ansbach with Hat. Signed and dated 1571. Linden wood, .94× .77 m. West Berlin, Staatliche Schlösser und Gärten, Jagdschloss Grunewald (GK I 1048)

259 *Cranach the Younger:* Head Study of a Dead Lynx. Brush drawing in colors, 217×279 mm. Formerly Dresden, Collection of Frederick Augustus II

260 *Cranach the Younger:* Portrait of Margrave George Frederick of Ansbach-Bayreuth (1539–1603). Ca. 1564 (?). Wood, 1.00×.74 m. Potsdam, Sans Souci, Staatliche Schlösser und Gärten, Bildergalerie (GK I 1121)

261 *Cranach the Younger:* Portrait of Elector John Frederick of Saxony (1503–1554) in the Armor He Wore at the Battle of Mühlberg, 1547. Signed and dated 1578. Canvas, 1.20×.93 m. Dresden, Staatliche Kunstsammlungen, Gemäldegalerie (from the Historical Museum, H 73)

262 *Cranach the Younger:* Portrait of Elector John Frederick in Everyday Dress. Signed and dated 1578. Canvas, 1.14×.92 m. Weissenfels, castle museum

263 *Cranach the Younger:* Portrait of Erich Volckmar von Berlepsch (d. 1589). Signed and dated 1580. Paired with the following portrait. Wood, 1.12×.83 m. Klein-Urleben near Langensalza, village church

264 *Cranach the Younger:* Portrait of Lucretia von Berlepsch. Signed and dated 1580. Paired with the preceding portrait. Wood, 1.12×.83 m. Klein-Urleben near Langensalza, village church

265 *Cranach the Younger:* Portrait of Hans von Lindau. Signed and dated 1581. Linden wood, 1.15× .80 m. Ottendorf near Pirna, village church

ILLUSTRATIONS TO THE DOCUMENTATION
(Pp. 415–434)

415a *Cranach the Elder:* Self-Portrait. Ca. 1530. Detail from the frontispiece

b *Albrecht Dürer:* Portrait of Lucas Cranach the Elder. 1524. Silverpoint, 162×110 mm. Bayonne, Musée Bonnat

c *Hans Cranach:* Self-Portrait. 1534. Detail from Pl. 188

d *Cranach the Younger:* Self-Portrait. 1565. Detail from Pl. 250

416 *Balthasar Jenichen:* Map of Saxony and Thuringia. Chorographia nova Misniae et Thuringiae. Nuremberg, ca. 1570. Dresden, Sächsische Landesbibliothek. The places where Cranach lived and worked are shown in red

417a The house in Kronach, No. 58 Rossmarkt, where Cranach was born. Part of the fifteenth-century façade

b Kronach city seal of 1461 (Kronach City Archive, Urkundenbehälter III/15)

c Cranach's house in Wittenberg, corner of the Marktplatz and Elbgasse, showing the window embrasures of what was presumably the workshop

418a Brück-Pestel Houses, Weimar, Markt

b *Monogrammist MS:* View of Wittenberg, 1551 (Broadsheet: Apparition of a Wondrous Sun at Wittenberg). Woodcut, 329×193 mm.

c Gotha, Markt. Coats of arms of the Dasch and Cranach families on the house of Georg Dasch, Cranach's son-in-law

419a Impression of Lucas Cranach the Younger's seal (1569). Dresden, City Archive

b Impression of a Greco-Roman gem. Omphale with the arms of Hercules (?) Used as a signet by Cranach the Younger in 1573. Dresden, City Archive, Loc. 8534, allerlei Schreiben an die Kurfürstin zu Sachsen 1572-75, Bl. 119

c, d *Unknown master:* Portrait of Lucas Cranach the Elder (1557). Silver gilt medal, 27 mm. Neuenstein, Hohenlohe Museum. Obverse and reverse. Enlarged
Signatures

420a Monogram 1502 (from Pl. 5)

b Monogram 1505 (from Pl. 25)

c Monogram 1506 (from Pl. 28)

d Monogram 1506 (from Pl. 30)

e Monogram 1506 (from Pl. 27)

f Monogram 1508 (from Pl. 46)

g Monogram 1509 (from Illustr. on p. 35)

h Monogram 1509 ("1506" incorrect) (from Pl. 50)

i Monogram 1509 (from Pl. 41)

k Monogram 1509 (from Pl. 42)

l Monogram ca. 1515 (from Pl. 81)

m *Cranach the Younger:* Monogram 1551 (from Illustr. p. 93)

421a Monogram 1504 (from Pl. 21)

b Monogram 1509 (from Pl. 48)

c Monogram 1514 (from Pl. 83)

d Monogram 1510 (from Pl. 68)

e Monogram 1521 (from Pl. 110)

f *Hans Cranach:* Monogram 1537 (from Pl. 188)

g *Hans Cranach:* Monogram 1537 (from Pl. 179)

h *Cranach the Younger:* Monogram 1558 (from Pl. 232)

422a *Albrecht Dürer:* Christ on the Cross. From a panel, later sawed into sections, of the "Seven Sorrows of the Virgin" made in 1496 for the Wittenberg castle church. Coniferous wood, .635×.46 m. Acquired from Cranach's estate in 1588. Dresden, Staatliche Kunstsammlungen, Gemäldegalerie (1880)

b Crucifixion. 1503. Munich (Pl. 17)

c *Albrecht Dürer:* Crucifixion. From Revelationes Sanctae Birgittae. Nuremberg, 1500. Woodcut, 247×165 mm.

d The Crucifixion of Christ. 1502 (Pl. 2)

423 a *Hans Burgkmair:* St. Christopher. Signed and dated 1505. Fir wood, 1.15×.56 m. Right side panel (interior) of the St. Sebastian altarpiece for Wittenberg. Nuremberg, Germanisches Nationalmuseum (Gm 281)

b St. Christopher. Detail from "The Fourteen Helpers in Time of Need" in Torgau (Pl. 37)

c *Albrecht Dürer:* St. Eustace. Inner right side panel of the Paumgartner altar, 1498. Linden wood, 1.67×.61 m. Munich, Bayerische Staatsgemäldesammlungen (702)

d St. George. 1506 (Pl. 28)

424 a *Albrecht Dürer:* The Nailing to the Cross. From a panel, later sawed into sections, of the "Seven Sorrows of the Virgin" made in 1496 for the Wittenberg Castle church. Coniferous wood, .62×.47 m. Acquired in 1588 from Cranach's estate. Dresden, Staatliche Kunstsammlungen, Gemäldegalerie (1879). Detail

b The Flagellation of Christ. 1509 (Pl. 70). Detail

c *Jacopo de' Barbari:* Christ Giving His Blessing (1503). Transferred from linden wood to canvas, .61×.48 m. Acquired from Cranach's estate in 1588. Dresden, Staatliche Kunstsammlungen, Gemäldegalerie (57)

d *Cranach the Younger:* Christ Giving His Blessing. 1553. Woodcut, 384×387 m. Holl., 13

425 a *Giovanni Antonio da Brescia:* Allegorical Figure. Engraving, 179×107 mm. B, 21

b *Jacopo de' Barbari:* Victory and Fame. Engraving, 182×123 mm. B, 18

c Venus and Cupid. 1509. Leningrad (Pl. 48)

d *Jacopo de' Barbari:* Still Life. 1504. Wood, .52×.42 m. Munich, Bayerische Staatsgemäldesammlungen (5066)

e Two Waxwings. Ca. 1530. Dresden (Pl. 169)

426 a *Albrecht Dürer:* Portrait of Frederick the Wise of Saxony. 1496. Tempera on canvas, .76×.57 m. West Berlin, Staatliche Museen Preussischer Kulturbesitz, Gemäldegalerie (557 C)

b *Peter Vischer:* Tomb of Elector Frederick. Wittenberg Castle church. Detail

c Portrait of Elector Frederick. Signed and dated 1509. Engraving, 128×88 mm. Holl., 5

d Frederick the Wise and John the Steadfast 1510. Engraving, 132×118 mm. Holl., 3

427 a–b *Cranach the Elder and Workshop:* Two pages from the *Spalatin Chronicle.* 1513. Drawing with watercolor, 315×172 mm. Weimar, Staatsarchiv
 1 Plague of Locusts and Military Campaign
 2 Earthquake in Carinthia

c–d *Hans Schäufelein:* The Wagon to Heaven and the Wagon to Hell. Woodcut, both 150×96 mm. From Hans von Leonrodt: Hymelwag ... Helwag, Augsburg, 1517. Munich, Staatsbibliothek

428 a *Unknown Master:* Portrait of Elector Frederick Wearing a Cap. 1507. Cast medal, lead, 38 mm. Herzogenburg, Stiftsammlung

b *Unknown Master:* Reverse of medal c

c *Unknown Master:* Portrait of Elector Frederick with Woven Wire Cap. 1507. Cast medal, silver, 40.5 mm. Gotha, Schlossmuseum

d *Unknown Master:* Portrait of Duke John. 1507. Cast medal, silver, 40 mm. Dresden, Staatliche Kunstsammlungen, Münzkabinett

e *Cranach the Elder* (?): Portrait of Elector Frederick. 1512. Onyx cameo, 35×30 mm. Photographed from plaster cast. Formerly Gotha, Schlossmuseum. Acquired by a Swiss art dealer in 1969

f–g *Hans Kraft:* Portrait of Elector Frederick. 1512. Struck medal, silver, 49 mm. Berlin, Staatliche Museen, Münzkabinett. Obverse and reverse

h *Ulrich Ursenthaler:* Portrait of Elector Frederick. 1512. Struck medal, silver, 48 mm. Berlin, Staatliche Museen, Münzkabinett

429 a *Francesco Francia:* Lucretia. Ca. 1510. Canvas, .64×.48 m. Dresden, Staatliche Kunstsammlungen, Gemäldegalerie (49A)

b Lucretia. Before 1514. Linden wood, .60×.48 m. Kreuzlingen, Kisters Collection. Date established by Hans Döring's copy of 1514. A second, slightly larger workshop version in Basel

c *Tobias Fendt:* Water Nymph: Inscription Tablet. From *Monumenta sepulcrorum cum epigraphis ingenio et doctrina excellentium virorum ... de archetypis expressa,* Breslau, 1574. Etching

d Recumbent Water Nymph. 1518. Leipzig (Pl. 97)

430 a *Hans Schäufelein:* The Expulsion of the Money Changers from the Temple. From Ulrich Pinder, *Speculum passionis,* Nuremberg, August 30, 1507. Woodcut, 236×161 mm. Nuremberg, Germanisches Nationalmuseum (Rl 2841 m)

b Expulsion of the Money Changers. Ca. 1509. Dresden (Pl. 60)

c *Hans Baldung:* Christ Falls at the Flagellation Column. Woodcut, 94×72 mm. From Ulrich Pinder, *Speculum passionis,* Nuremberg, August 30, 1507. Nuremberg, Germanisches Nationalmuseum

d *Cranach Workshop:* Christ Falls at the Flagellation Column. Ca. 1512–1515. Florence, Lapiccirella Galleries (Pl. 91)

431 a *Albrecht Dürer:* Portrait of Cardinal Albrecht of Brandenburg. Signed and dated 1519. Engraving, 148×96 mm. B, 102

b Portrait of Cardinal Albrecht of Brandenburg. Signed and dated 1520. Engraving, 168×115 mm. Holl., 2. Dresden, Staatliche Kunstsammlungen, Kupferstichkabinett

c *Hans Baldung:* Christ's Fall on the Road to Calvary. Woodcut, 93×73 mm. From Ulrich Pinder, *Speculum passionis,* Nuremberg, August 30, 1507. Nuremberg, Germanisches Nationalmuseum

d *Cranach Workshop:* Christ's Fall on the Road to Calvary. Wood, 245×175 mm. West Berlin, Staatliche Museen Preussischer Kulturbesitz,

Gemäldegalerie (564B)

432 a *Albrecht Dürer:* Small Crucifix. Signed and dated 1500. Fruit wood, 199×158 mm. Dresden, Staatliche Kunstsammlungen, Gemäldegalerie (1870)

b *Cranach the Younger:* Small Crucifix. Signed and dated 1540. Wood, 250×190 mm. Dublin, National Gallery of Ireland

c *Cranach the Younger:* Christ on the Cross. From Cranach's *Stammbuch* (1543). Book illustration on parchment, 263×167 mm. West Berlin, Staatliche Museen Preussischer Kulturbesitz, Kupferstichkabinett

d *Cranach the Younger:* Christ on the Cross. 1571. Tempera on canvas, 2.47×1.57 m. From the Augustinian monastery. Wittenberg, Lutherhalle

433 a *Cranach the Younger:* Christ on the Cross. Memorial to Agnes of Anhalt (d. 1569), wife of Joachim Ernest of Anhalt. In the background, the city of Nienburg. Signed and dated 1570. Wood, 3.05×2.40 m. Nienburg, parish church

b *Cranach the Younger:* Christ on the Cross, with the Family of Elector Augustus of Saxony. Signed and dated 1571. Wood, 3.20×2.40 m. Augustusburg, Palace church

c *Veit Stoss:* The Raising of Lazarus. Engraving, 220×225 mm. B, 1

d *Cranach the Younger:* The Raising of Lazarus. Memorial to Michael Meyenburg and his family. 1558. Nordhausen, Church of St. Blasius; missing since 1945

434 a *Dirck Bouts:* The Last Supper. Center panel of the Holy Sacrament altarpiece of 1464–1468. Wood, 1.80×1.51 m. Louvain, St. Pierre

b *Cranach the Younger:* The Last Supper. 1565. Memorial to Prince John of Anhalt. Dessau-Mildensee, village church (Pl. 250)

c *Augustin Cranach (?):* The Resurrection of Christ. Memorial to Nicolaus von Seidlitz. 1582. Wood, 1.16×.84 m. Wittenberg, city church

d *Zacharias Wehme:* Christ on the Cross, with the Family of Elector Christian I of Saxony. Copper, .45×.36 m. Dresden, Staatliche Kunstsammlungen, Gemäldegalerie (Mo 1951)

FACSIMILES OF HANDWRITING ACCOMPANYING THE LIST OF SOURCES

402 *Jacopo de' Barbari:* "De Ecclentia de Pitura," essay addressed to Frederick the Wise ca. 1503. Weimar, Staatsarchiv, Reg. 0156, Bl. 209. Detail

403 *Cranach School:* Cranach's coat of arms (see Source No. 38). Erlangen, University Library

406 *Cranach the Elder:* Bill. 1513 (see Source No. 106). Weimar, Staatsarchiv, Reg. Bb. 5531, Bl. 17a. Detail

410 *Cranach the Elder and Christian Döring:* Receipts. August 8, 1520 (see Source No. 165). Weimar, Staatsarchiv, Reg. Gg. 2215 Bl. 112

413 *Cranach the Elder:* To Elector John. August 3, 1525 (see Source No. 233). Weimar, Staatsarchiv, Reg. D. 211, Bl. 12a. Detail

436 *Hans Cranach:* Receipt. October 2, 1534 (see Source No. 288). Weimar, Staatsarchiv, Reg. Rr. 397, Bl. 1

437 *Hans Cranach:* Signature. Ca. 1537. From the sketchbook, sheet 5a. Hanover, Kestner Museum (cf. Pl. 194)

438 *Cranach the Elder:* Letter to F. Myconius. Gotha. December 7, 1537 (see Source No. 309). Emden, Altertumsverein

439 *Cranach the Elder:* Receipt. Ca. September 29, 1542 (see Source No. 333). Weimar, Staatsarchiv, Reg. Rr. 937, Bl. 4

440 *Cranach the Elder:* Letter to Hans von Ponickau. April 24, 1545 (see Source No. 353). Weimar, Staatsarchiv, Reg. Rr. 937, Bl. 10

442 *Cranach the Younger:* Letter written for his father to Elector John Frederick. August 14, 1547 (see Source No. 372). Weimar, Staatsarchiv, Reg. J., pag. 577 Y, No. 16, Bl. 84. Detail

444 *Cranach the Elder:* List of pictures painted in Augsburg. 1552 (see Source No. 408). Weimar, Staatsarchiv, Reg. Aa 2975, Bl. 18. Detail

447 *Cranach the Younger:* Letter to John Frederick *der Mittlere.* November 6, 1561 (see Source No. 439). Weimar, Staatsarchiv, Reg. Aa 2975, Bl. 24

ACKNOWLEDGMENT
OF REPRODUCTION RIGHTS
AND PHOTOGRAPHS

Antella, Scala: Plates 136, 209, 217

Basel, Öffentliche Kunstsammlung: Plates 26, 63

Basel, Colorphoto Hans Hinz: Plates 12, 13, 14, 63

Bautzen, Stadtmuseum: Plate 115

Bayonne, Musée Bonnat, Photo Aubert: page 415b

Berlin, Staatliche Museen: Plates 3, 24, 25, 41, 46, 54, 55, 77, 102, 104–106, 117–119, 121, 122, 125, 126, 130, 134, 144, 148, 176, 177, 187, 207, 210, 214, 221, 230, 232, 233, 242–245, 253, 260; pages 22, 44, 68, 72–74, 76, 77, 84, 87, 88, 90, 110, 418b, 420a–c, f–h, 421e, h, 422c, 423d, 426a, c, d, 427c, d, 428a, e–g, 431a, b, d, 432b, 433d

Berlin, Institut für Denkmalpflege: Plates 57, 58, 84 85, 152; page 415d

Berlin, Deutsche Staatsbibliothek: Plate 135; page 429c

Berlin, Dr. Schade: page 417c

Boston, Museum of Fine Arts, Frederick Brown Fund: Plate 168

Brunswick, Herzog Anton Ulrich Museum: Plates 59, 141, 154, 178, 212

Brussels, Musée des Beaux Arts: Plate 136

Budapest, Fine Arts Museum: Plates 27, 186

Budapest, Reformed Church, Photograph Corvina-Verlag: Plate 66

Cleveland, Museum of Art: Plates 210, 211

Coburg, Kunstsammlung der Veste: Plate 110

Cologne, Wallraf-Richartz Museum: Plate 145

Cologne, Rheinisches Bildarchiv: Plates 133, 145

Copenhagen, Statens Museum for Kunst: Plate 181

Copenhagen, Det Kongelige Bibliothek: page 53

Darmstadt, Landesmuseum: Plates 125, 126

Dessau, Staatliche Gemäldegalerie: Plates 56, 102, 191

Dresden, Staatliche Kunstsammlungen, Gemäldegalerie und Kupferstichkabinett: Plates 29, 30, 42, 50, 60, 65, 67, 69, 70, 73, 80–83, 88, 93, 112, 127, 161, 163, 164, 166, 169, 170, 195, 248, 253, 263, 264; pages 422a, 424a, c, 428d, 429a, 432a

Dresden, Staatsarchiv: Page 419a, b

Dresden, Deutsche Fotothek: Plates 30, 33a, b, c, 34–37, 40, 42, 48, 49, 56a, b, c, 60, 67, 69, 73, 80–83, 88, 94, 112, 115, 127, 135, 161, 164, 166, 195, 216, 225, 226, 248, 261, 262, 265; pages 90, 93, 420d, l, 421b, c, 422a, 423b, d, 429d, 430b, 433b, c, 434b, d

Dresden, VEB Verlag der Kunst, Archiv: Plates 47, 96, 143

Dresden, Walter Zorn: Plate 170

Düsseldorf, Laenderpress: Frontispiece

Edgware, Dr. Edmund Schilling: Plate 213

Eisenach, Wartburg Stiftung: Plates 117, 118, 204

Emden, Altertumsverein: Page 438

Erlangen, Universitätsbibliothek, Graphische Sammlung: Plate 100

Florence, Uffizi: Plate 217

Florence, Lapiccirella Galleries, Photograph Barsotti: Plate 91; page 430d

Frankfurt-am-Main, Städelsches Kunstinstitut: Plates 45 (Photograph Blauel), 44, 149 (Photograph Edelmann), 185, 228 (Photograph Hauck)

Gotha, Schlossmuseum: Plates 92, 150–152, 175; page 428b, c, e

Halle-an-der-Saale, Staatliche Galerie Moritzburg, Photograph Danz: Plates 240, 241

Halle-an-der-Saale, Institut für Denkmalpflege (Arbeitsstelle): Plate 39; pages 432d, 434c

Hanover, Kestner Museum: Plates 189, 190, 193, 194

Karlsruhe, Staatliche Kunsthalle: Plate 155

Kreuzlingen, Kisters Collection: Plate 256; page 429b

Kronach, Hans Kremer: Page 417a, b

Leipzig, Museum der Bildenden Künste: Plates 96, 97, 140, 208, 224–226; page 83

Leipzig, VEB E. A. Seemann Verlag: Block 224

Leningrad, Hermitage: Plates 48, 49, 107, 129

Leningrad, Verlag Aurora: Plate 107

Lille, Musée, Photograph Gérondal: Plate 22

Lisbon, Museum: Plate 54

Liverpool, Walker Art Gallery, Photo John Mills: Plate 95

London, British Museum: Plates 31a, b; pages 32, 65

London, Courtauld Institute of Art, Witt Library: Plates 32a, b, 213

Lugano, Thyssen Gallery, Photograph Brunel: Plates 179, 188; pages 415c, 421f, g

Madrid, Museo del Prado: Plate 209

Mainz, Landesamt für Denkmalpflege Rheinland-Pfalz, Schloss Stolzenfels: Frontispiece and page 415a

Minneapolis, Institute of Art: Plate 144

Munich, Bayerische Staatsgemäldesammlungen: Plates 16, 17, 146, 235; page 425d

Munich, Staatliche Graphische Sammlung: Plates 23, 28, 43

Munich, Bayerische Staatsbibliothek: Plates 89, 90; page 427c, d

Munich, Verlag Joachim Blauel: Plates 16, 17, 45, 235

Munich, Hirmer Verlag: Page 419c, d

New York, Metropolitan Museum: Plates 4, 5 (Harris Brisbane Dick Fund 1927), 61 (H. O. Havemeyer Collection)

New York, Private collection: Plate 184

Northampton, Photo Henry Cooper: Plate 167 (Collection duke of Buccleuch, Thornhill)

Nuremberg, Germanisches Nationalmuseum: Plates 6, 14, 120, 122, 133, 206, 254; pages 423a, 430a, c, 431c

Oslo, Nasjonalgalleriet, Photograph Vaering: Plates 159, 160, 201

Paris, Musée du Louvre: Plate 143

Paris, Photograph Giraudon: Plates 131, 146, 218, 219; page 434a

Potsdam, Staatliche Schlösser und Gärten: Plate 260

Prague, Narodní Galerie: Plates 132, 180, 236, 237

Reims, Musées: Plates 218, 219

San Francisco, M. H. de Young Memorial Museum, De Young Endowment Fund: Plate 205

Schwerin, Staatliches Museum: Plates 251, 252

Starnberg, D. Robert Purrmann: Plate 147

Stockholm, Nationalmuseum: Plates 171–173

Stuttgart, Württembergische Staatsgalerie: Plates 202, 203

Vienna, Akademie der Bildenden Künste, Gemäldegalerie: Plates 9–11, 52, 53

Vienna, Staatliche Graphische Sammlung Albertina: Plates 2, 72, 116, 197, 247

Vienna, Kunsthistorisches Museum: Plates 1, 8, 153, 156, 162, 222, 238, 239

Vienna, Photograph Meyer: Plates 1, 8–11, 52, 53, 238, 239

Warsaw, Nationalmuseum: Plates 51, 131, 207

Weimar, Kunstsammlungen: Plates 38, 86, 87, 108, 109, 111, 123, 124, 150, 151, 171–173, 175, 199, 215, 229a, b, c, 231, 249, 250, 255, 263, 264; pages 418a, c, 426b

Weissenfels, Schlossmuseum: Plate 262

West Berlin, Staatliche Museen Preussischer Kulturbesitz, Photograph Walter Steinkopf: Plates 7, 15, 18, 19, 20, 21, 64, 68, 71, 74–76, 78, 79, 98, 99, 101,

Woodcut
from the Wittenberg
Heiltumsbuch.
1509

INDEX OF NAMES AND PLACES

The figures in parentheses refer to the Note or Source number

PEOPLE

Abel, Jacob 45
Adam, Sebastian 46
Adolph, Duke of Saxony 448 (466)
Adrianus, Mathäus 410 (162)
Agnes of Barby, Princess of Anhalt 102, 389 (689); *Plate 241, p. 433a*
Agricola, Rudolph 54, 384 (378); *Plate 146, 147*
Albert, Duke of Mecklenburg 443 (403)
Albert, Duke of Prussia 44, 97, 107, 408 (131, 137), 412 (198), 414 (237, 238, 253), 435 (258), 438 (320), 441 (364, 374), 442 (388), 443 (401), 444 (409–411), 445 (417, 426, 428, 431), 446 (432, 434, 435, 446)
Albert, Duke of Saxony 384 (405)
Albert, Duke of Saxony 54, 380 (171)
Albert Achilles, Margrave of Brandenburg 105, 451 (510)
Albrecht of Brandenburg, Cardinal, Archbishop of Mainz 33, 48, 52, 54, 55, 64, 74, 84, 94, 385 (463), 387 (543), 388 (642); *Plate 142, p. 431a, b*
Albrecht (painter) 22
Alciato, Andrea 91, 386 (525)
Alexander (Cranach's apprentice) 46
Alexander, Duke of Saxony 102–104, 451 (517, 522); *Plate 244, 247*
Altdorfer, Albrecht 21, 53, 62
Andreas (Cranach's servant) 43
Anna, Electress of Saxony 104, 448 (460), 450 (493–495), 451 (509); *Plate 243*
Anna, Landgravine of Hesse 436 (284)
Anna (Cranach's mistress) 31
Apel, Johann 413 (232)
Apelles 27
Augustus, Elector of Saxony 81, 94, 97, 102, 104, 105, 107–109, 111, 389 (690), 444 (415), 445 (416–418), 447 (449, 450, 452–454), 448–453; *Plate 242, 248, p. 433b*
Aurifaber, Andreas 445 (431)
Aventin 385 (459)

Badehorn, Leonhard 389 (684); *Plate 224*
Baldung, Hans 26, 53, 65, 381 (243); *p. 430c, 431c*
Barbara, Duchess of Saxony 405 (85), 409 (145)
Barbari, Jacopo de' 9, 22, 23, 27, 30, 40, 45, 50, 52, 70, 378 (91, 109, 111), 380 (186), 383 (335), 386 (532), 402 (23); *p. 424c, 425b, d*
Bartel (Cranach's apprentice) 46
Basil the Great 103
Beham, Sebald 53, 381 (243)
Bellini, Giovanni 22
Benedictus (painter) 46
Berlepsch, Erich Volkmar von 106; *Plate 263*
Berlepsch, Lucretia von 106; *Plate 264*
Bernardus, Trevisanus 69, 386 (515)

Bernhard, Prince of Anhalt 390 (693)
Bernstein, Hans von 451 (516, 520)
Beust, Joachim von 451 (508)
Block, Dietrich 31, 380 (194)
Block, Gesa 31
Boccaccio, Giovanni 378 (74)
Bock, Margareta, born Robils 390 (697)
Bock, Otto von 390 (697)
Bora, Catherine von (Luther's wife) 53, 413 (232)
Bosch, Hieronymus 30, 40, 59
Bouts, Dirck 97; *p. 434a*
Brengbier, Barbara (Cranach's wife) 41, 42, 439 (327, 328)
Brengbier, Jobst 42
Brisger, Eberhard 414 (243)
Brück, Barbara 42, 79, 80, 439 (325)
Brück, Christian 42, 47, 80, 81, 97, 107, 108, 111, 439 (330), 442 (384), 444 (413), 448 (456); *p. 100*
Brück, Gregor 9, 41, 42, 55, 79, 95, 382 (284), 414 (251), 439 (325), 441 (375); *Plates 133, 216, 232*
Brueghel, Pieter the Elder 62, 97
Bucher, Marcus 442 (376)
Bugenhangen, Johannes 95, 96, 387 (588), 390 (704), 413 (232), 441 (371–375), 446 (438)
Burgkmair, Hans 9, 24, 27, 34, 40, 80, 101, 378 (96), 380 (175), 381 (235); *p. 423a*
Burgkmair, Thoman 377 (22)

Calvin, John 8
Camerarius 413 (232)
Carion, Johannes 55, 56, 378 (97); *Plate 135*
Catherine, Duchess of Saxony 54, 435 (256); *Plate 83*
Celtis, Konrad 15, 21, 25, 379 (135)
Charles V, German Emperor 8, 28, 54, 55, 80, 86, 389 (650); *Plates 204, 209*
Christian I, Elector of Saxony 99, 104, 111, 391 (763), 451 (517, 522), 453 (544, 545); *p. 434d*
Christian II, King of Denmark 43, 54, 382 (260), 411 (185); *p. 53, Plate 121, 122*
Christian III, King of Denmark 445 (425), 449 (486)
Christopher, Duke of Bavaria 13, 25, 377 (20, 22)
Christoph of Munich (painter) 28, 45, 382 (266), 402 (19), 404 (52)
Cima de Conegliano 378 (87)
Claude Lorrain 378 (92)
Colonna, Vittoria 88
Cordus, Augustus 386 (485)
Cramm, Asche (Ascanius) von 381 (233); *Plate 120*
Cranach, Augustin 80, 96, 98, 453 (546); *p. 434c*
Cranach, Christoph 453 (541)
Cranach, Hans 42, 77–79, 436, (279, 287, 288), 437 (305, 308), 438 (313); *Plates 179, 188–190, 192–194*
Cranach, Mattheus 42, 406 (93–95, 97), 407 (112), 408 (133), 414 (248, 254), 443 (393, 398, 402, 404)
Cranach, Ursula (?) 437 (306)
Cruziger, Caspar 95, 441 (375)
Cuntz (painter) 22